Col. Trumbull has the hand and spirit of a painter.
Skill has given her aid to deepen the impressions
which the subjects so forcibly strike.
Altogether this Gallery must be considered
the most interesting collection of pictures
in the country. They are American.

—*Connecticut Journal*
November 6, 1832
on the opening of the Trumbull Gallery.

[His] fame is interwoven, not merely
with the history of the arts of design,
but also with the political history of the country.

—Samuel F. B. Morse
November 14, 1843, announcing Trumbull's death
to the National Academy of Design.

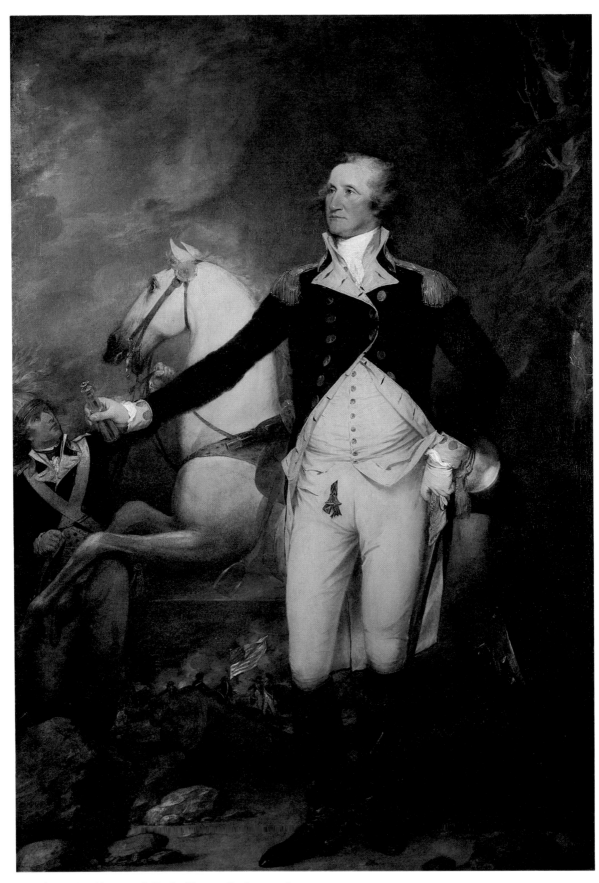

General George Washington at the Battle of Trenton. Catalogue number 42

John Trumbull
The Hand and Spirit of a Painter

Helen A. Cooper

with essays by

Patricia Mullan Burnham · Martin Price

Jules David Prown · Oswaldo Rodriguez Roque

Egon Verheyen · Bryan Wolf

Yale University Art Gallery · New Haven

This catalogue was published in conjunction with
the exhibition "John Trumbull: The Hand and Spirit of a Painter,"
October 28, 1982–January 16, 1983, celebrating the 150th anniversary
of the founding of the Yale University Art Gallery.

Cover or jacket illustration: John Trumbull, *Self-Portrait*, detail, c. 1802 (Cat. 114).

Sponsors

National Endowment for the Arts

Merrill Lynch

H. J. Heinz II, Charitable and Family Trust

Lila Acheson Wallace Fund

DeWitt Wallace Fund

Friends of American Arts at Yale

William Bernhard, B.A. 1954, and Catherine Cahill
 (The Bernhill Fund)

Mr. and Mrs. S. Sidney Kahn, B.A. 1959

Mr. and Mrs. Wilbur L. Ross, B.A. 1959

Contents

xi Foreword *by Alan Shestack*

xii Preface *by Helen A. Cooper*

xiv Lenders to the Exhibition

xv Notes *&* Abbreviations

2 John Trumbull: A Life *by Helen A. Cooper*

History Paintings

22 John Trumbull as History Painter *by Jules David Prown*

42 Catalogue

Portraits

94 Trumbull's Portraits *by Oswaldo Rodriguez Roque*

Catalogue

106 Early Portraits

125 Portrait Miniatures

148 Portrait Drawings

156 Late Portraits

173 *Figure Drawings:* Catalogue

Religious Paintings

180 Trumbull's Religious Paintings: Themes and Variations *by Patricia Mullan Burnham*

194 Catalogue

Landscapes

206 Revolution in the Landscape: John Trumbull and Picturesque Painting *by Bryan Wolf*

216 Catalogue

Literature & Allegory

232 The Power of Imagination: Trumbull's Works on Literary Themes *by Martin Price*

244 Catalogue

Architectural Designs

260 John Trumbull and the U.S. Capitol: Reconsidering the Evidence *by Egon Verheyen*

272 Catalogue

287 List of Figures

290 Index of Trumbull's Works

292 Credits

Foreword

It was natural, and even inevitable, that the Yale University Art Gallery chose to organize an exhibition devoted to the work of John Trumbull to celebrate the Gallery's 150th anniversary. The oldest college art museum in America, the Gallery was founded when Trumbull gave a group of his portraits and his scenes of the American Revolution to Yale in return for an annuity of $1000 a year and a promise that Yale would construct a suitable building, designed by the artist, to house the collection. On October 25, 1832, the Trumbull Gallery— built in Greek Revival style on Yale's Old Campus— was opened to the public. Trumbull continued to add to his original gift, in some cases actually painting certain elevated subjects because he felt the Gallery, as part of a teaching institution, needed to have them represented. In the years since Trumbull's death in 1843, some of his descendents and other donors have generously given Trumbull works to the University. Today, Yale has the largest collection of Trumbull objects, as well as Trumbull family manuscripts and archival material.

Trumbull's original deed of gift included the restriction that the paintings could never leave Yale's campus. Since without these paintings no other institution could mount a comprehensive Trumbull exhibition, it became clear that only by organizing such a show at Yale could a full and meaningful appraisal of Trumbull's artistic achievement be possible. Because individuals and institutions responded generously to our loan requests, the full range of Trumbull's artistic interests can be seen for the first time in the context of his most important paintings.

Helen Cooper, Curator of American Paintings and Sculpture, chose the objects and prepared this catalogue. In the best tradition of university museums, *John Trumbull: The Hand and Spirit of a Painter* was a collaborative effort, involving faculty and graduate students from the Departments of the History of Art, American Studies, and English, as well as the staff of the American Arts Office in the Art Gallery. In addition, several distinguished scholars from other institutions contributed essays to the catalogue. In the preface, Helen Cooper expresses gratitude to all those who were involved in this major undertaking. It remains for me to thank the sponsors of this exhibition, listed on p. vii, for their generous support. In these days of fiscal austerity and diminishing sources of funds for the arts, their warm response was critical to the realization of this project. We are also grateful to Mr. and Mrs. George Hopper Fitch, Marshall Hill Clyde, Jr., and the Wyeth Endowment for American Art, who contributed funds toward the conservation and restoration of several of the Trumbull paintings. Finally, we are grateful to the individuals and institutions which have been willing to part with their objects for the duration of the exhibition.

John Trumbull once referred to his paintings as his "children." It seems fitting that on the sesquicentennial of his gift to Yale, so many of them have been reunited.

— *Alan Shestack, Director*

Preface

"John Trumbull: The Hand and Spirit of a Painter" brings together for the first time John Trumbull's best-known paintings, as well as lesser-known examples of his work. The 170 objects— drawn from public and private collections— demonstrate that Trumbull's artistic interests ranged wide: besides the history themes and portraits, he painted landscapes, religious, literary, and allegorical subjects, and produced fine Neoclassical figure drawings and architectural studies.

Trumbull's life spanned an era of tremendous change in America, both politically and in the arts. His *Autobiography*, the first written by an American artist, together with his extensive correspondence, reveal an observant, thoughtful man who held strong views on art, culture, society, and politics. He was, at various times, soldier, diplomat, entrepreneur, perhaps even a spy, but from the beginning, and throughout his life, he saw himself as an artist. In a sense, his fame as the chief visual recorder of the great events of the American Revolution has obscured his artistic concerns. The primary aim in choosing the objects for the exhibition, and in organizing the catalogue, has been to illuminate those concerns.

The catalogue begins with a short life of the artist, recounted whenever possible in his own words and those of his contemporaries. In the first essay, Jules D. Prown discusses Trumbull as a history painter— his sources in Benjamin West and John Singleton Copley and his effort to create moral rather than nationalistic scenes. Oswaldo Rodriguez Roque addresses Trumbull's conflicting attitudes toward portrait painting. Patricia Burnham considers Trumbull's religious subjects in relation to the Renaissance and Baroque models on which they are based, and Trumbull's own religious attitudes. Bryan Wolf analyzes Trumbull's landscapes, focusing on the moment when the artist surpassed the conventions of the picturesque to develop a new mode of landscape composition similar in structure to the work of later Romantic painters. Martin Price's discussion of Trumbull's literary themes— a small but important group of paintings and drawings— relates them to contemporaneous literature. Trumbull considered the commission to decorate the Capitol Rotunda the crowning achievement of his career and, in his *Autobiography*, implies it was a relatively easy prize to win. But, as Egon Verheyen shows, Trumbull conducted an intense campaign to influence Congress and the architects. Each author has studied Trumbull according to his or her own sphere of interest. The varying interpretations that result are indicative of the richness of Trumbull's art. The essays are followed by chronologically arranged entries for the exhibited objects in each category. Although Trumbull's works can be separated out by subject matter, they are in fact often interrelated. Thus the entries in each thematic section occasionally make references to or recapitulate material in other sections.

In the fall of 1979, during the preliminary stage of planning for the exhibition, Professor Prown conducted a graduate seminar on Trumbull at Yale, in the course of which basic research was begun. Subsequently, the work was continued by members of the American Arts office of the Yale University Art Gallery, graduate students, research assistants, and interns. Elizabeth Pratt Fox, Lisa Jandorf, and Virginia Wagner, National Museum Act Interns in 1978, 1979, and 1980, respectively, helped to gather material. Jennifer Ackerman provided research assistance for Trumbull's biography. The history entries (Cats. 4–32) were prepared by David Barquist, National Museum Act Intern, 1981–82,

and Esther Thyssen, Marcia Brady Tucker Fellow, Fall 1980 and Rose Herrick Jackson Fellow, Spring 1982. David Steinberg, Curatorial Assistant, and David Barquist worked on the miniatures (Cats. 46–100). Barquist also prepared the entries for Cats. 3, 32, 43, 45, 113, 124, 157; Sarah Cohen, National Museum Act Fellow, 1981–82, for Cats. 33–36, 38, 114–15, 118–20, 122, 156, 158; David Steinberg, Cats. 1, 2, 40, 44, 123, 153; Esther Thyssen, Cats. 139–46; Rebecca Zurier, Rose Herrick Jackson Fellow, Spring 1981 and Marcia Brady Tucker Fellow, Spring 1982, Cats. 37, 116–17, 147–50, 165–71. Some catalogue entries were generously contributed by Oswaldo Rodriguez Roque (Cats. 10–13, 39, 41, 42, 121), Patricia Burnham (Cats. 133, 135–37, 159), and Egon Verheyen (Cats. 161–64).

Trumbull's *Autobiography* of 1841 and the various manuscript collections of Trumbull family papers (see p. xvi) formed the foundation of our research. Of crucial importance in locating works of art was Theodore Sizer's *The Works of Colonel John Trumbull* (1950, revised edition, 1967). This checklist, and his articles on the artist, together with the files he gathered in their preparation, represent a lifetime of scholarship, and we are indebted to Professor Sizer's achievement. We also relied on Irma Jaffe's definitive biography, *John Trumbull: Patriot-Artist of the American Revolution* (1975). In addition, Professor Jaffe graciously responded to our many queries.

In the course of borrowing objects for the show and preparing the manuscript for this catalogue, many colleagues offered important suggestions and help: Linda Ayres, Mary Black, John Brealey, John Caldwell, Susan Casteras, Clement E. Conger, Thomas Dunnings, Harold F. Pfister, John K. Howat, Patricia E. Kane, Mary Alice Kennedy, Joseph LoSchiavo, Anne-Imelda Radice, Richard Saunders, Wendy J. Shadwell, Natalie Spassky, Allen Staley, Theodore E. Stebbins, Jr., Diana Strazdes, Larry E. Sullivan, and Gerald W. R. Ward. I am especially indebted to Sheila Schwartz for her scrupulous editing of the manuscript, and her expert and invaluable advice throughout. Greer Allen is responsible for the beautiful design of this book, and his enthusiastic response to the project made our work together a pleasure. For their generous assistance, I am indebted to Judith A. Schiff and the staff at Manuscripts and Archives, the staff of Beinecke Rare Book and Manuscript Library, and Patrick Noon, Angela Bailey and the staff at the Yale Center for British Art. Grateful thanks are given to members of the Art Gallery staff. Caroline Rollins, coordinator of Membership, Sales, and Publications, helped us track down a number of Trumbull pictures. William Cuffe, Rights and Reproductions, coordinated photography. Joseph Szaszfai made numerous superb photographs, many of them at short notice. Administrative matters were ably handled by Diane Hoose, Business Manager, and by Olise Mandat and Lorraine McKerral, past and present secretaries. C. Allen Waddle impeccably typed most of the numerous drafts of the manuscript, and Sally Brogden helped prepare the index. Richard Porterfield, Bursary Assistant, provided much needed help at every stage of the project. I wish to extend particular thanks to Rosalie Reed, Registrar, and Robert Soule, Superintendent, and their staffs for their assistance, and to Richard S. Field, Curator of Prints, Drawings and Photographs, and his assistant Lucia Iannone, who prepared the Trumbull drawings for exhibition. Special acknowledgment and appreciation go to David Steinberg and David Barquist, who have been invaluable colleagues in coordinating the countless tasks associated with the catalogue and the exhibition. The cleaning and restoration of a number of the Yale pictures was superbly accomplished by Wynne Beebe, Diane Dwyer, Mark Leonard, and Dorothy Mahon. Sarah Buie's sensitive exhibition design presented John Trumbull at his best. And, finally, I thank Jack Ross Cooper for his inexhaustible patience and unstinting encouragement.

— Helen A. Cooper

Lenders to the Exhibition

The Addison Gallery of American Art, Phillips Academy, Andover, Massachusetts

Mr. John R. Bockstoce

Boston Athenaeum, Boston, Massachusetts

The Chamber of Commerce and Industry of the State of New York, New York

Mrs. Percy Chubb

Cincinnati Art Museum, Cincinnati, Ohio

The Connecticut Historical Society, Hartford, Connecticut

The Corcoran Gallery of Art, Washington, D.C.

The Dayton Art Institute, Dayton, Ohio

Fordham University Library, Bronx, New York

Mrs. Charles H. Higgins

The Historical Society of Pennsylvania, Philadelphia, Pennsylvania

Mr. Jonathan Trumbull Isham

Mr. Robert L. McNeil, Jr.

Mead Art Museum, Amherst College, Amherst, Massachusetts

The Metropolitan Museum of Art, New York

Museum of Fine Arts, Boston, Massachusetts

National Gallery of Art, Washington, D.C.

The National Portrait Gallery, Smithsonian Institution, Washington, D.C.

The New-York Historical Society, New York

The New York Public Library, Astor, Lenox and Tilden Foundations, New York

Princeton University Library, Princeton, New Jersey

Rockingham State Historic Site, New Jersey Division of Parks and Forestry, Rocky Hill, New Jersey

The Slater Memorial Museum, The Norwich Free Academy, Norwich, Connecticut

The Toledo Museum of Art, Toledo, Ohio

Virginia Museum of Fine Arts, Richmond, Virginia

Wadsworth Atheneum, Hartford, Connecticut

The White House, Washington, D.C.

The Henry Francis du Pont Winterthur Museum, Winterthur, Delaware

Yale University, New Haven, Connecticut

Notes & Abbreviations

Dimensions are given in inches, then centimeters; height precedes width.

A key to bibliographical abbreviations and manuscript collections follows. Extensive bibliographies of the Trumbull literature appear in the first edition of Sizer's *Works* (see Sizer 1967) and Jaffe 1975.

In order to make the identification of Trumbull's works accord with the artist's own designations, the wording of most titles used here follows that in the 1832 *Catalogue* published at the opening of the Trumbull Gallery at Yale or Trumbull's "Account of Paintings." (The 1832 *Catalogue* was republished in Trumbull's 1841 *Autobiography*; only the enumeration differs.)

FREQUENTLY CITED SOURCES

DAB
> *Dictionary of American Biography.* 21 vols. New York, 1943–44.

Dunlap 1834
> Dunlap, William. *A History of the Rise and Progress of the Arts of Design in the United States.* 2 vols. New York, 1834.

Jaffe 1971
> Jaffe, Irma B., "Fordham University's Trumbull Drawings: Mistaken Identities in *The Declaration of Independence* and Other Discoveries." *The American Art Journal,* 3 (Spring 1971), pp. 5–38.

Jaffe 1975
> Jaffe, Irma B., *John Trumbull: Patriot-Artist of the American Revolution.* Boston, 1975.

Morgan 1926
> Morgan, John H. *Paintings by John Trumbull at Yale University.* New Haven, 1926.

Rollin 1768
> Rollin, Charles, and J. B. L. Crevier. *The Roman History from the Foundation of Rome to the Battle of Actium.* Translated from the French. 3rd ed. 10 vols. London, 1768.

Silliman, "Notebook"
> Silliman, Benjamin. "Notebook." Unpublished reminiscences, 1857. YUL-SF. Although a typescript exists, page references here are to the original manuscript, which is divided into two separately paginated sections (I and II).

Sizer 1953
> Sizer, Theodore, ed. *The Autobiography of Colonel John Trumbull: Patriot-Artist, 1756–1843.* New Haven, 1953.

Sizer 1967
> Sizer, Theodore. *The Works of Colonel John Trumbull.* Rev. ed. New Haven, 1967 (1st ed., 1950).

Trumbull, "Account of Paintings"
> Trumbull, John. "Account of Paintings by Jno. Trumbull. Copied from an Early Book which was Ruined by Damp." YUL-JT. Divided into two sections, the first (I) works executed between 1770 and 1783; the second (II), pictures done in London, 1784. Reprinted in the *Yale University Library Gazette,* 22 (April 1948), pp. 116–23.

Trumbull 1831
> Trumbull, John. Draft of an exhibition list (for Trumbull 1832). FUL.

Trumbull 1832
> Trumbull, John. *Catalogue of Paintings by Colonel Trumbull . . . Now Exhibiting in the Gallery of Yale College. . .* , New Haven, 1832.

Trumbull 1841
> Trumbull, John. *Autobiography, Reminiscences and Letters by John Trumbull from 1756 to 1841.* New York, London, and New Haven, 1841.

MANUSCRIPT COLLECTIONS

CHS	The Connecticut Historical Society, Hartford; John Trumbull Papers
CSL	Connecticut State Library, Hartford; Jonathan Trumbull Papers
FUL	Fordham University Library, Bronx, New York; Charles Allen Munn Collection
HSP	The Historical Society of Pennsylvania, Philadelphia
LC	Library of Congress, Washington, D.C.; Trumbull Papers
MHS	Massachusetts Historical Society, Boston
NYHS	The New-York Historical Society; John Trumbull Papers
YU-B	Yale University; Beinecke Rare Book and Manuscript Library
YUL-BF	Yale University Library; Benjamin Franklin Collection
YUL-JT	Yale University Library; John Trumbull Papers
YUL-SF	Yale University Library; Silliman Family Papers

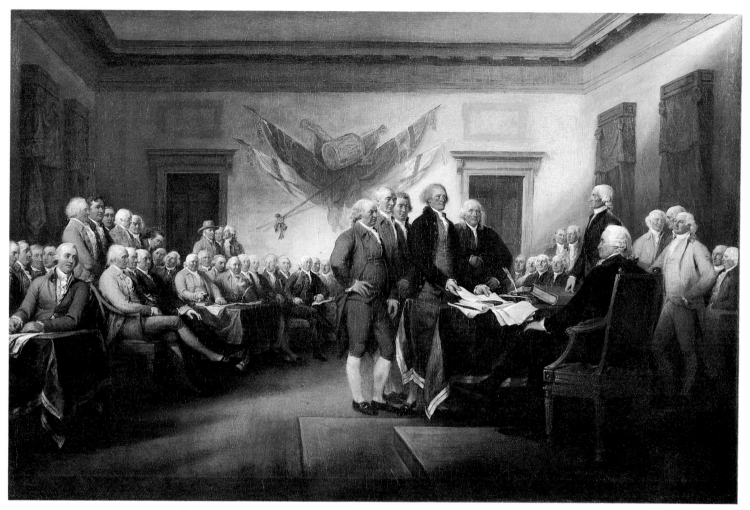

Fig. 1. The Declaration of Independence (Cat. 25).

John Trumbull: A Life

By Helen A. Cooper

1756 Born at Lebanon, Connecticut (June 6), Trumbull was the youngest of six children of Jonathan Trumbull, representative to the Connecticut General Assembly, and his wife Faith, a descendant of the Pilgrim leader John Robinson.

1761—62 At about five years of age, Trumbull fell down a flight of stairs and permanently lost the sight in his left eye. He received his early education at Nathan Tisdale's school in Lebanon, considered the best school in New England.

> I soon displayed a singular facility in acquiring knowledge, particularly of languages, so that I could read Greek at six years old. . . . My taste for drawing began to dawn early . . . and for several years the nicely sanded floors . . . were constantly scrawled with my rude attempts at drawing.[1]

1771 At the age of fifteen, he completed his studies with Master Tisdale. His father, who was now governor of Connecticut, determined on a ministerial or legal career for his son, decided to send Trumbull to his alma mater, Harvard. "I am sensible of his natural genius and inclination for limning; an art I have frequently told him, will be of no use to him."[2] Trumbull disagreed:

> The tranquillity of the arts seemed better suited to me . . . and I ventured to remonstrate with my father . . . that the expense of a college education would be inconvenient to him, and after it was finished I should still have to study some profession by which to procure a living; whereas, if he would place me under the instruction of Mr. Copley . . . the expense would probably not exceed that of a college education, and that at the end of my time I should possess a profession, and the means of supporting myself . . . but my father had not the same veneration for the fine arts that I had.[3]

1772 On his way to Cambridge, Trumbull visited John Singleton Copley in Boston.

> We found Mr. Copley dressed to receive a party of friends at dinner. I remember his dress and appearance— an elegant looking man, dressed in a fine maroon cloth, with gilt buttons— this was dazzling to my unpracticed eye!— but his paintings, the first I had ever seen deserving the name, riveted, absorbed my attention, and renewed all my desire to enter upon such a pursuit. But my destiny was fixed, and the next day I passed my examination . . . and was readily admitted to the Junior class.[4]

1 Trumbull 1841, p. 5.
2 Jonathan Trumbull, Sr. to William Kneeland, August 10, 1772, MHS, Andrew Elliot Papers.
3 Trumbull 1841, pp. 10–11.
4 Ibid., p. 11.

Trumbull tutored himself in the fine arts by studying the works which hung on the college's chamber walls, including Copley's portraits. He also searched the college library for books on the arts, finding works by Hogarth, du Fresnoy, de Piles, Le Brun, and others.[5] He also found and copied a study of perspective.[6] In his free time, he visited a French family living in Cambridge, who provided him with hours of practice in speaking French, in which he was soon fluent.

> In July, 1773, I graduated without applause, *for I was not a speaker*, and returned to **1773** Lebanon. Several circumstances prevented my forming intimate connections while in college; I was the youngest boy in my class; I had entered in an unusual way . . . and I had too little pocket money to partake in any expensive gaieties, if my timidity and awkwardness had not also prevented me from doing so. I formed . . . only one, intimate acquaintance . . . with Christopher Gore.[7]

On December 16, 1773, the Boston Tea Party took place, and the rumblings of the Revolution began.

Trumbull "caught the growing enthusiasm": **1774**

> I sought for military information; acquired what knowledge I could, soon formed a small company from among the young men of the school and the village, taught them, or more properly we taught each other, to use the musket and to march, and military exercises and studies became the favorite occupation of the day.[8]

April. Shortly after the Battle of Lexington, Trumbull was made an adjutant of the First Regiment of **1775** Connecticut under General Joseph Spencer, stationed in Roxbury. In May, the Second Continental Congress voted to put the Colonies in a state of defense. On June 17, during the Battle of Bunker Hill, Trumbull observed the conflict through field glasses from his vantage in Roxbury. In July, Washington arrived to take command of the troops. Trumbull hoped to enhance his own position, writing to his brother David that "the Justice is using his influence to get me into General Washington's family— I hope I shall be accepted."[9] As a way of bringing Trumbull to Washington's attention, his brother Joseph, who was commissary general of the entire American army, suggested that Trumbull draw a plan of the enemy's position at Boston Neck, which he knew Washington wanted. Upon seeing the plan, Washington appointed Trumbull his second aide-de-camp.

In the spring, Major General Horatio Gates appointed Trumbull a deputy adjutant-general, with the **1776** rank of colonel, to the regiment bound for Fort Ticonderoga, "the Gibraltar of America." Trumbull's duties included painting numbers on cartridge boxes and cannon carriages and reporting on the condition of the defeated and diseased American troops retreating from nearby Quebec. "I did not look into tent or hut in which I did not find either a dead or dying man."[10] His most significant military contribution to the War of Independence was a plan for strengthening and defending Fort Ticonderoga, developed with the engineer Thaddeus Kosciusko, which won assent from General Benedict Arnold. After the enemy retreated from Ticonderoga, Trumbull and General Gates went to Newtown, Pennsylvania, to join Washington— just days before the Battle of Trenton.

> In the meantime, [Trumbull] had remained without a commission. This rendered his

5 Jaffe 1975, p. 14; see also pp. 22–23, below.
6 Ibid., p. 12.
7 Trumbull 1841, p. 13.
8 Ibid., pp. 15–16.

9 JT to David Trumbull, July 16, 1776, CHS. The "Justice" was apparently a reference to Trumbull's oldest brother, Joseph; see Jaffe 1975, p. 23.
10 Trumbull 1841, p. 28.

situation peculiarly painful, and what rendered it more so was, that other and inferior officers did receive commissions, giving them rank equal to his own.[11]

Trumbull wrote to his brother:

> The Congress has been Informd, by Genl Gates, of his Design in bringing me here with him, & of the Character in which I now act— if they want a more Ceremonious Application, I must say I wish to receive nothing from them— Ceremony *I hate*. I have made it a rule never to ask Promotion in any other way than by doing my Duty with all the Attention & punctuality in my Pow'r— I shall wait a little longer at the service of my country— but not *much* longer, By God![12]

1777 Trumbull received his long-awaited commission from Congress in February, but it was dated September 1776 instead of June, the month when his work as adjutant had begun. He complained to John Hancock, president of the Congress:

> I expect, sir, to be commissioned from that date, if at all. A soldier's honor forbids the idea of giving up the least pretension to rank.[13]

His effort to rectify the terms of commission failed, and Trumbull resigned.

> When length of service, and unimpeached character, and a forwardness to serve in a quarter where success was despaired of, is rewarded by *neglect*, we have reason to complain. But . . . there was no occasion to add insult. . . . From this day . . . I lay aside my cockade and sword never to resume them until I can do it with honor.[14]

Trumbull deeply regretted the end of his military service, "for my mind was at this time full of lofty aspirations. . . . I returned to Lebanon [and] resumed my pencil."[15] He painted portraits of himself, his relatives and friends, and scenes from the Bible and ancient history (see, for example, Cats. 1, 33, 34).

1778 Distressed by his family's conviction that art was a frivolous pursuit, he went to Boston.

> There I hired the room which had been built by Mr. Smibert . . . and found in it several copies by him from celebrated pictures in Europe, which were very useful to me. . . . Mr. Copley was gone to Europe, and there remained in Boston no artist from whom I could gain oral instruction; but these copies supplied the place, and I made some progress. . . . [However] the war was a period little favorable to regular study and deliberate pursuits.[16]

1779 Trumbull joined his brothers' tea and rum business, but found such "daubing . . . without profit."[17] Disappointed in mercantile pursuits and discouraged by the American indifference to art, he resolved to go to England "to study the art of painting."[18]

1780 Although determined to pursue his art studies abroad, Trumbull declined Benjamin Franklin's offer to go to Europe as his secretary. Instead, he undertook for his family and friends the management of a financial project in Europe, the investment of American securities, and arranged to study with Benjamin West in his spare time. He may also have been involved in a secret mission from Congress

11 Dunlap 1834, I, p. 349.
12 JT to Jonathan Trumbull, Sr., August 25, 1776, CSL.
13 Trumbull 1841, p. 39.
14 JT to James Lovell, February 22, 1777, FUL.
15 Trumbull 1841, p. 49.
16 Ibid., pp. 49–51.
17 JT to David Trumbull, September 10, 1779, CHS.
18 Trumbull 1841, p. 317.

to Franklin— a scheme related to the French-Dutch-English conflict in the West Indies. Shortly after landing in Paris, he found that the business scheme had collapsed— the public securities were rendered worthless by the American defeat at Charleston, South Carolina. He left immediately for London and Benjamin West's studio.

> Mr. West asked Trumbull if he brought any specimen of his work, and being answered in the negative, told him to copy some one of his pictures and bring it to him. "Go into that room, where you will find Mr. Stuart painting, and choose something to copy." Trumbull selected one (by an old master). . . . West asked him if he knew what he had chosen, he said, no. West told him, adding, "You have made a good choice; if you can copy that, I shall think well of you." The picture was [a copy of] Raphael's "Madonna della sedia."[19]

For the next four months, Trumbull worked closely with Gilbert Stuart on joint exercises assigned by West. Despite dissimilar temperaments, the two artists became close friends.

Heedless of repeated warnings, Trumbull made no effort to conceal his political beliefs. His letters to his family were filled with anti-British sentiments.

> Tis the sword only that can give us such a peace, as our past glorious struggles have merited. The sword must finish what it has so well begun.[20]

On November 20, Trumbull was arrested and charged with treason. The London *Political Magazine* claimed the evidence to be Trumbull's "extraordinary correspondence," but Trumbull suspected that he was the victim of American Loyalists wanting revenge for the execution of Major John André, who had plotted to deliver West Point to the British.

> I had remained some time in London, with more prospect of success there than in any place on the continent, and perfectly secure under the name of an artist, till the news of the death of the unfortunate André arrived, and gave a new edge to the vengeful wishes of the American refugees. The arts they had for a long time used to no effect, now succeeded; and they had interest enough to persuade the ministry that I was a dangerous person, in the service of Dr. Franklin, &c &c. The occasion united with their wishes, and the resentment of government marked me as an expiatory sacrifice.[21]

A reporter recorded that at the trial Trumbull "conducted himself . . . with a collected fortitude, highly becoming his situation."[22] Trumbull argued that he had resigned from all military duties and had come to London to pursue the art of painting, adding,

> I am a son of the . . . governor of Connecticut. . . . I have had the honor of being an aid-du-camp [*sic*] to . . . General Washington. These two have always in their power a greater number of your friends, prisoners, than you have of theirs. . . . I am entirely in your power; and, after the hint which I have given you, treat me as you please, always remembering, that as I may be treated, so will your friends in America be treated by mine.[23]

Although Trumbull was always treated with marked civility, his appeal for release was unsuccessful. He sought the support of West and Edmund Burke. West went to King George III to vouch that Trumbull "was so entirely devoted to the study of my profession as to have left no time for political

19 Dunlap 1834, I, p. 351. Although he professed ignorance of what he chose, Trumbull had in fact seen a copy of the Raphael in Smibert's studio; see p. 25, below.
20 Quoted in Lewis Einstein, *Divided Loyalties*, London, 1933, p. 364.

21 Trumbull 1841, pp. 316–17.
22 Quoted in Jaffe 1975, p. 50.
23 Trumbull 1841, pp. 71–72.

intrigue."[24] The king assured West that Trumbull's life was safe, but declared he could do nothing to secure his release.

1781 Trumbull was imprisoned in Bridewell, Tothill Fields, for almost eight months. Horace Walpole described his activities:

> Mr. Trumbull . . . during his confinement, amused himself with painting in which he had been regularly educated. Some beautiful strokes of the above gentleman's pencil were admired in the royal academy, without an idea that they came from the gloom of prison. Ingenuity and fine taste, combined with judgement and accuracy procured him no inconsiderable share of credit in his profession.[25]

After numerous visits and letters of appeal, Burke persuaded the Privy Council to release Trumbull. On June 12, "it was done with the stipulation that I should quit the kingdom within thirty days, and remain very quiet during that time."[26]

Trumbull traveled to Amsterdam, where he received an appeal from his father to negotiate a loan for the State of Connecticut. Although the war was going well for the Americans— Cornwallis would surrender in October— Trumbull responded:

> The public credit of the United States has been injured in every part of Europe by the mismanagement of her affairs in that department . . . and consequently the people . . . are slow and fearful of advancing to our aid.[27]

1782 In late January, after a six-month voyage, delayed and rerouted by bad weather, Trumbull arrived in New York.

> I returned to Lebanon, as soon as possible, and occupied myself with closing all accounts respecting my unfortunate mercantile experiment. My reflections were painful— I had thrown away two of the most precious years of life— had encountered many dangers, and suffered many inconveniences, to no purpose. I was seized with a serious illness, which confined me to my bed, and endangered my life; and it was autumn before I had recovered strength sufficient to attempt any occupation.[28]

For the next two years, he grudgingly helped his brother David to provision the American army. But the failure of his various commercial ventures persuaded him that he had no place in the business world. The old argument between father and son concerning the proper profession was renewed.

> My father again urged the law, as the profession which in a republic leads to all emolument and distinction, and for which my early education had well prepared me. My reply was, that so far as I understood the question, law was rendered necessary by the vices of mankind— that I had already seen too much of them, willingly to devote my life to a profession which would keep me perpetually involved, either in the defense of innocence against fraud and injustice, or (what was much more revolting to an ingenuous mind) to the protection of guilt against just and merited punishment. In short, I pined for the arts, again entered into an elaborate defense of my predilection, and again dwelt upon honors paid to artists in the glorious days of Greece and Athens. My father listened patiently, and when I had finished he complimented me upon the able manner in which I had defended what to him still

24 Quoted in Trumbull 1841, p. 76.
25 Horace Walpole, *Anecdotes of Painting in England* (1760–95), 5 vols., New Haven, 1937, V, p. 112.
26 Trumbull 1841, p. 335.
27 Ibid., p. 336.
28 Ibid., pp. 87–88.

appeared to be a bad cause. "I had confirmed his opinion," he said, "that with proper study I should make a respectable lawyer; but," added he, "you must give me leave to say, that you appear to have overlooked, or forgotten, one very important point in your case." "Pray, sir," I rejoined, "what was that?" "You appear to forget, sir, that *Connecticut is not Athens.*"[29]

The Governor finally gave in and sent a letter of introduction to the Earl of Dartmouth, explaining that Trumbull wished "to improve his natural turn to the Pencil, which his Countryman the celebrated artist Mr. West considers as well worthy of cultivation."[30] **1783**

Trumbull arrived in London in January, and went immediately to West, who received him warmly. **1784** He planned to study with West for two years and to spend the following year in Rome "without which excellence in the Historical line cannot be attain'd."[31] At West's, Trumbull followed a strict regimen, waking at five to study anatomy, breakfasting at eight, then painting all day, with a lunch break at two. In the evenings, he visited friends or attended classes at the Royal Academy, where he frequently sat by the side of Thomas Lawrence.

> I am . . . a Student at the Drawing Academy, among boys, some of whom draw better than I do:— but I have the pleasure to find that my labour is not in vain, & to hear Judges of the Art declare that I have made a more rapid progress in the few months I have been here than they have before known; but 'tis a Slow and difficult study— so difficult that I am Confident no youth knowing what He had to acquire, would ever commence [to be a] painter.[32]

West introduced Trumbull into his large circle of artists, diplomats, and aristocrats and, occasionally, took him to Windsor Castle, where they met Copley for tea, sketching, and walks. However, Trumbull did not

> feel . . . at home in this Country— whether it is that I grow old, & the edge of Curiosity is worn down, I know not, but I often wish myself quietly seated . . . in Lebanon:— I . . . hope . . . to return to America as soon as I can compleat myself in my profession— but I must see Italy first:— the late War opens a new and noble field for historical painting & our Vanity will make portraiture as gainful in America as in any part of the world.[33]

Despite his loneliness and dislike of England,

> everyday confirms me in the propriety of my Choice. My improvement has hitherto exceeded my own expectations. . . . I already do something towards supporting myself & in fact, if it were not improvement rather than gain that I pursue at present, I might maintain myself very handsomely.[34]

Although he could support himself from portrait commissions,

> the great object of my wishes . . . is to take up the History of Our Country, and paint the principal Events particularly of the late War:— but this is a work which to execute with any degree of honour or profit, will require very great powers— & those powers must be attain'd before I leave Europe.[35]

29 Ibid., pp. 88–89.
30 Jonathan Trumbull, Sr. to the Earl of Dartmouth, October 13, 1783; in B. F. Stevens, ed., *Facsimilies of Manuscripts in European Archives*, Wilmington, Del., 1970, no. 2107.
31 JT to Jonathan Trumbull, Jr., March 10, 1784, YUL-JT.
32 JT to Jonathan Trumbull, Jr., September 25, 1784, YUL-JT.

33 JT to Jonathan Trumbull, Jr., March 10, 1784, YUL-JT.
34 JT to Jonathan Trumbull, Jr., March 30, July 18, 1784, YUL-JT.
35 JT to Jonathan Trumbull, Sr., March 15, 1785, CHS.

By the spring of 1784, Trumbull was "the established successor of Gilbert Stuart in West's apartments."[36]

1785 Trumbull began to "meditate seriously" on Revolutionary subject matter, deciding first upon scenes of the death of General Warren at Bunker Hill and the death of General Montgomery at Quebec.[37] He recalled having met, this same year, Thomas Jefferson, then American minister in Paris, who was visiting London.

> He had a taste for the fine arts, and highly approved my intention of preparing myself for the accomplishment of a national work. He encouraged me to persevere in this pursuit, and kindly invited me to come to Paris, to see and study the fine works there, and to make his house my home, during my stay.[38]

1786 In March, Trumbull completed *The Death of General Warren at the Battle of Bunker's Hill* (Cat. 4). West called it the "best picture" of a modern battle that had been painted.[39]

Trumbull finished *The Death of General Montgomery in the Attack on Quebec* (Cat. 7), and turned his mind to publishing prints of the two scenes, hoping thereby to make the images affordable to American purses, no less than to make a profit for himself. He began work on three other Revolutionary War battle scenes (Cats. 14, 24, 27). At the prompting of West, he also took up the subject of the British victory over the Spanish at Gibraltar— as a conciliatory gesture to the English and as a way of establishing his reputation.

In July, Trumbull accepted Jefferson's invitation to visit him in Paris, bringing along *Bunker's Hill* and *Quebec*. As Jefferson's guest, Trumbull moved in the highest intellectual, cultural, and social circles of Paris. He met the architect Charles Bulfinch, visited Jacques-Louis David at the Louvre, toured the great private collections with Houdon, and attended the gatherings of Mme. Vigée-Lebrun, where he met Maria Cosway and her husband, and "all the principal artists and connoisseurs in Paris."[40] He was overwhelmed by the art he saw, and in his diary commented on works by Raphael, Titian, Correggio, Rubens, and Van Dyck.[41] David's *Oath of the Horatii* is a "story well told, drawing pretty good, colouring cold";[42] Houdon's *Diana* is "a very beautiful figure— an honor not only to the artist, but to the country and age in which he lives."[43] He showed *Bunker's Hill* and *Quebec* to French artists and collectors. Jefferson described the reception of the works in a letter to Ezra Stiles:

> [A] countryman of yours, Mr. Trumbul [*sic*], has paid us a visit here, and brought with him two pictures which are the admiration of the Connoisseurs. His natural talents for this art seem almost unparalleled.[44]

In Paris, Trumbull began the composition of *The Declaration of Independence*, with Jefferson providing an account of the event and a sketch of the room (Cat. 26). In early September, Trumbull left Paris, "my brain half turned by the attention which had been paid to my paintings . . . and by the multitude of fine things which I had seen."[45] He then traveled through Germany and the Low Countries to find engravers for *Bunker's Hill* and *Quebec*.

36 Dunlap 1834, I, p. 356.
37 Trumbull 1841, p. 93.
38 Ibid., p. 95. The date of the meeting between Trumbull and Jefferson is in question; Jefferson's correspondence indicates they met in the spring of 1786; see Jaffe 1975, p. 96.
39 JT to David Trumbull, January 31, 1786, CHS.
40 Trumbull 1841, p. 95.
41 Ibid., pp. 100–17.
42 Ibid., p. 109.
43 Ibid., p. 102.
44 Thomas Jefferson to Ezra Stiles, September 1, 1786, in Julian P. Boyd, ed., *Papers of Thomas Jefferson*, Princeton, 1950– , X, p. 317.
45 Trumbull 1841, p. 147.

In November, Trumbull returned to London and began work on *The Declaration of Independence* (Cat. 25).

Trumbull began to paint the first version of *The Sortie Made by the Garrison of Gibraltar* (Cat. 10). Late in the year he returned to Paris, bringing with him the fully composed *Declaration,* and *Surrender of Lord Cornwallis at Yorktown* (Cat. 27) in order to paint the portrait of Jefferson into the former, and those of French officers into the latter. He again stayed with Jefferson and renewed many acquaintances.

<div style="text-align: right;">

1787

</div>

Trumbull kept abreast of American ideas and events through voluminous correspondence with his brother Jonathan. An American diplomat noted a "belief throughout the continent that the U.S. are on the brink of perdition."[46] Trumbull's attitude toward America shifted from pride and inspiration to angry pessimism.

<div style="text-align: right;">

1788

</div>

> Is it that Men were formerly wise or is it that we observe their real Character more accurately— or are we Cynical— I know not but it appears to me a very ridiculous world.— & perhaps We are not the least ridiculous objects in it.— you talking wisely of Oeconomy, republican Virtue, & national Honor,— and yet finding Folly, Luxury & Extravagance with Gauze, Ribbons & Tin:— while I rail at Vanity, & yet live by flattering it.[47]

By February, Trumbull had completed three versions of the *Sortie* in West's studio. In April, the largest version (Cat. 12) went on exhibition at Spring Gardens. Despite Walpole's approbation,[48] Trumbull had been apprehensive about the work's reception:

<div style="text-align: right;">

1789

</div>

> This, of course, was a subject to make me known & which must bring me in more immediate comparison with the Artists of the day.— it required therefore all my exertions— & there was still another spur in my sensibility that neither my Country, my Family, my own past History or works tended to give me any popularity here— with all these incentives I have labour'd for a long time past, & have now almost compleated a Picture which [in] spite of prejudice, begins to be lookd upon with pleasure & to be rank'd as one of the best modern productions of the Pencil. . . . One event of which is certain— that I shall draw upon myself a thousand criticisms in every shape, in every newspaper:— every tingling tongue of Envy will be busy in recalling all my past sins of Rebellion in America, of Spyship & Imprisonment . . . of connexions in France. . . . But "Neck or Nothing," as I translate our Family Motto, I will hazard it.[49]

He wrote to Jefferson that "success . . . gives me at once both reputation and money— if unsuccessfull I cannot lose much of either."[50] The limited success of the exhibition disappointed Trumbull because it did not give him the solid reputation that West or Copley enjoyed.

> I have perhaps staked too much on the cast of a Single die.— but it is an experiment which will decide upon my future life— for if Five Years have not been sufficient with the Slavish application which I have given to my pursuit to raise me to some notice— it is at least time enough to have wasted in a hopeless pursuit— and as this affair ends I shall either feel

46 F. L. Humphreys, ed., *Miscellaneous Works of Colonel Humphreys*, New York, 1970, p. 341.

47 JT to Jonathan Trumbull, Jr., September 25, 1784, YUL-JT.

48 See Sizer 1953, p. 151.

49 JT to Jonathan Trumbull, Jr., February 27, 1789, YUL-JT. The family motto was "Fortuna Favet Audaci"— "fortune favors the bold."

50 JT to Thomas Jefferson, May 1, 1789 in Boyd, *Papers of Thomas Jefferson*, XV, p. 84.

myself justified in pursuing my profession honorably— or in quitting it before it be too late.[51]

In the midst of this professional crisis, he received an offer from Jefferson to serve as his private secretary, but he declined, claiming both a professional and patriotic obligation to continue with his history painting.[52]

Curious about the events of the French Revolution, Trumbull took a brief trip to France in the summer.

I conceiv'd that the taking of the Bastille & the King's visit to Paris were proper subjects for painting: I found them so: I have . . . secured such materials as will enable [me] to paint the two Subjects hereafter.[53]

He was in full sympathy with the French Revolutionary cause:

while France is rising to the highest dignity of Human Nature!— this paltry degenerate race [the English] are Idolizing a mad King & a drunken prince.[54]

Trumbull left for America in October and arrived in New York in November 1789.

1790 In 1790, Trumbull fell in love with Harriet Wadsworth (Cats. 96, 105), thirteen years his junior, whom he had known from childhood. He proposed to her by letter; unable to decide between the artist and another suitor, she gave no answer. In this same year, Trumbull opened subscriptions for the engravings of *Bunker's Hill* and *Quebec*. For the next four years he traveled up and down the Eastern seaboard collecting portraits for the history paintings.

1793 The death of Harriet Wadsworth in April sent Trumbull into a period of severe depression. He was also affected by the spirit of discord in America resulting from the Reign of Terror in France and the war between Great Britain and France.

The whole American people [were converted] into violent partisans of one or the other; . . . the whole country seemed to be changed into one vast arena . . . on which the two parties, forgetting their national character, were wasting their time, their thoughts, their energy, on this foreign quarrel. . . . The discord which . . . distracted the people of America, pervaded also the very cabinet of the President, and Mr. Jefferson, the secretary of state, became the apologist of France, and was pitted against Mr. Hamilton, the secretary of the Treasury. In such a state of things, what hope remained for the arts? None— my great enterprise was blighted.[55]

He abandoned his work on the American history series.

1794 Trumbull received an offer from Chief Justice John Jay to serve as his secretary on the Jay Treaty Commission in London, organized to settle commercial and frontier questions between the Americans and the British. Although he had doubts about giving up his artistic pursuits, his family was delighted with the offer and he accepted— in part to take advantage of the opportunity to oversee the completion of the three engravings being made after the *Sortie, Bunker's Hill*, and *Quebec*.

51 JT to Jonathan Trumbull, Jr., May 6, 1789, YUL-JT.
52 Trumbull 1841, pp. 157–58.
53 JT to Jonathan Trumbull, Jr., September 7, 1789, YUL-JT. Trumbull never completed these subjects.
54 Ibid.
55 Trumbull 1841, pp. 168–69.

The Treaty agreement made, Trumbull was sent to Paris to inform James Monroe, United States **1795**
minister to France, of its terms, on condition that Monroe not divulge the information to the French
government. Having promised the French he would keep them informed, Monroe could not accept
the condition and therefore was not told the details, which angered him. As a result, Trumbull
became, unofficially, unwelcome in diplomatic circles and was regarded with suspicion by Monroe
and the French.[56]

Still in Paris awaiting further orders, Trumbull engaged in art dealing with the connoisseur Jean- **1796**
Baptiste Pierre Lebrun, buying Old Master paintings from families made destitute by the French
Revolution. He also speculated in the tobacco and brandy trade to Germany and England.

> I have reason to believe that the profit will . . . enable me with the help of my prints to do
> what I wish, cease from Rumbling, & set quietly down among my friends.[57]

The ventures were moderately successful and Trumbull cleared himself of debt.

> I begin to feel that I have pursued Butterflies and Bubbles long enough. 'Tis full time to
> meditate more serious occupation.[58]

He refused his brother's offer to join a business venture at home in America.

> You know I have passed my Life in pursuits rather brilliant than *Solid*;— it is time I should
> attend a little to considerations of a Substantial Nature:— my actual pursuits and my
> prospects promise me well, and it hardly appears to me justifiable to quit in a moment like
> the present, the advantages which I possess. . . . I expect to find all my Plates . . . finished—
> they will be printed & forwarded as soon as possible to my friends. . . . I feel it a Duty to
> compleat this Work if possible, even tho' the advantages to be derived from it should not be
> great.— It can only be done by me. (for Nature is fast removing from our View the most
> precious Materials) and I feel my Own Reputation, and, Vanity prompt me to add, the
> Honour of our Country concerned;— to say nothing of the pleasure I feel in paying
> Tribute of Gratitude and Friendship to many good Men.[59]

Trumbull was appointed a member of the commission to execute the seventh article of the Jay Treaty, **1797**
which involved the judicial settlement of claims by American and British shippers in connection with
captured ships and their cargoes. As courier to American envoys in Paris representing Rufus King,
American ambassador to England, Trumbull became involved in the "XYZ Affair," an attempt by the
French foreign minister Talleyrand to secure 250,000 dollars from the envoys in exchange for smooth
Franco-American relations.[60] Trumbull could not embark for England without permission from the
French government. Writing from Calais, he asked Talleyrand for a passport, but received no answer,
and proceeded to Paris. Talleyrand suspected that Trumbull's business partnership with Lebrun was
merely a cover for political intrigue, and pressed him for information regarding the Jay Treaty. When
Trumbull remained silent, Talleyrand refused to aid him in obtaining a passport. With the help of
Jacques-Louis David, Trumbull finally received permission to leave.

The *Gibraltar, Bunker's Hill* and *Quebec* engravings were published.

Trumbull returned to England. **1798**

56 Jaffe 1975, p. 170.
57 JT to Jonathan Trumbull, Jr., February 27, 1796, YUL-JT.
58 JT to Jonathan Trumbull, Jr., May 30, 1797, NYHS, letter
 book, 1796–1802.
59 JT to Jonathan Trumbull, Jr., May 15, 1796, YUL-JT.
60 For a discussion of Trumbull and the XYZ affair, see Jaffe
 1975, pp. 177–82.

1800 Trumbull decided to resume painting:

> seeing the uncertainty of my present Situation, I have thought it wise to resume my Pencils, & have been suffering very severe mortification from finding in how great a degree I had lost the powers I once possessed— I determined to regain them,— an Effort was necessary— and I have scarcely thought of anything else for some months.[61]

On October 1, Trumbull, age forty-four, married Sarah Hope Harvey, twenty-six, strikingly beautiful, but of dubious background. The event came as a great surprise to the painter's family and friends. Trumbull did the first of several portraits of her (see Cats. 112, 115, 118).

1801 The Trumbulls traveled to Brighton, Bath, and Wales for a belated honeymoon. During this period, Trumbull accepted full responsibility for the education and upkeep of a young boy, John Trumbull Ray:

> When I was last in America an accident befel me, to which young Men are often exposed;— I was a little too intimate with a Girl who lived at my brother's, and who had at the same time some other particular friends;— the natural consequence followed, and in due time a fine boy was born;— the number of Fellow labourers rendered it a little difficult to ascertain precisely who was the Father; but, as I was best able to pay the Bill, the Mother using her legal right, judiciously chose me;— I was absent at the time;— the Business was ill-managed,— became public. . . . But, having committed the Folly, and acquired the name of Father, I must now do the Duty of one, by providing for the education of the Child, to whoever He may belong.[62]

1803 Determined to return to the United States, Trumbull was nonetheless unsure whether the new nation would provide adequate support for a history painter.

> I feel at times not a little anxiety on the Subject of *picture making*— I have by no means money eno: to live comfortably without business of some sort— I hate your nasty Squabbling Politics— they disgust me:— I know nothing of Farming— little of Trade & I fear I shall find that my Countrymen care very little for the only thing which I pretend to understand.[63]

1804 With Trumbull's work on the Jay Treaty Commission ended, he returned to the United States. Political discord and the absence of national unity convinced him it was useless to persevere in his history series. He settled in New York and concentrated on portrait painting. In an effort to interest New Yorkers in the arts, Trumbull exhibited his collection of Old Master paintings, the first public showing in America of such pictures, and some of his own works; but the public remained apathetic. In late summer, he went to Boston, thinking to settle there.

> I soon observed that whenever I alluded to the idea of . . . pursuing my profession as a portrait painter, a cloud seemed to pass over and to chill the conversation. I could not, for a long time, account for this, but at length I learned that my old friend and fellow student, Stewart [*sic*] who having pursued that branch of the profession for more than twenty years

61 JT to Jonathan Trumbull, Jr., August 16, 1800, YUL-JT.

62 Sizer 1953, p. 333. Trumbull does not mention his illegitimate son in his *Autobiography*. Sizer discovered the information about Ray in a number of unpublished letters (YUL-JT), for which see Sizer, pp. 332–50.

63 JT to Daniel Wadsworth, September 7, 1803, YUL-JT. Wadsworth, like Benjamin Silliman, was Trumbull's nephew-in-law. Both men married daughters of Jonathan Trumbull, Jr.

. . . in Washington, had lately received an invitation to come and settle at Boston. Boston . . . did by no means offer an adequate field of success for two rival artists. I therefore immediately returned to New York.[64]

Re-established in New York, Trumbull enjoyed the undisputed position of first artist in the city. He visited New Haven, where he was introduced to Benjamin Silliman, his future nephew-in-law, then a tutor at Yale College; it was the beginning of a lifelong friendship.

1805–6 Trumbull was elected a director of the New York (later, American) Academy of the Fine Arts, a group concerned with "educating public taste." The New York art community was full of optimism during this prosperous period, and Trumbull received numerous public and private commissions. West wrote to Trumbull:

> Those two cities, New York and Philadelphia, being rivals in commerce— should they be rivals for a proud emulation in cultivating science, and the Liberal Arts, I am persuaded the[y] would in a few years under the blessing of Peace, take the lead in mental accomplishments in the civilized world— and would be the next great school that would arrive— at least those two cities would be the Athens, and Corinth in the western world.[65]

1807 The rapid rise of the arts in America and the prosperity of those on whom Trumbull depended for artistic patronage were threatened by the political and economic consequences of the Embargo Act, a complete prohibition of all international trade with American ports.

1808 During the political tumult, Trumbull left New York City, and spent time in Hartford, Connecticut, Genesee, New York, Niagara Falls, and Canada, sketching and painting throughout the journey. In the same year, he was elected vice-president of the American Academy of the Fine Arts, the first artist to serve on the Academy's board of directors. Despite his prominence in the art world, he was dismayed by the sharp decrease in portrait commissions. Concerned also about his rapidly deteriorating eyesight, he decided to go to England for treatment.

1809–12 In London, because of the impending war, anything American was unpopular. Trumbull won few portrait commissions, and fell into debt. Thomas Sully described the situation:

> I do not think this excellent Painter is duly appreciated in London. His merit is neither generally understood, nor valued . . . the English taste is in favor of strong effect, & brilliant colouring; whilst the higher excellencies of painting, which are design, and composition, are undervalued. . . . I think France would be a more favorable theatre for a display of Mr. Trumbull's powers and am surprised he has not given that country a trial.[66]

Trumbull received an additional blow when he learned that his son, John Ray, who had come to live with him as his "nephew," had joined the British army against America. Trumbull's plans to return to America were cut short by the outbreak of the War of 1812. After many appeals, the Trumbulls were permitted to move as far as Bath, where after six months, he wrote:

> I am tired of this place. . . . I hope to God our mad Government will soon conclude some arrangement which will admit of our finding our way to America— I am heartily weary of this waste of Life.[67]

64 Trumbull 1841, pp. 244–45.
65 West to JT, September 29, 1806, YUL-JT.
66 Sully to Daniel Wadsworth, June 17, 1810, CSL.
67 JT to Samuel Williams, May 5, 1814, draft of letter, YUL-JT.

Despite adverse conditions, Trumbull produced paintings on several literary and religious subjects (see Cats. 135, 157) and exhibited them at the Royal Academy.

1815 With the restoration of peace, the Trumbulls returned to the United States and settled permanently in New York. His prospects as a portrait painter appeared gloomy.

> In addition to Stuart, who had all the applications from the rich and celebrated to the east, Sully was in high and deserved reputation, commanding the demand for portraits in Philadelphia . . . and Jarvis was full of orders for private and public individuals in New York. Vanderlyn had likewise returned from . . . Europe, and the admirers of the fine arts looked with mingled delight and admiration on his "Marius" and "Ariadne." And although Allston had not yet arrived, the fame of his success had preceded him. . . . Besides these prominent men, a number of younger artists were coming forward, many of whom soon displayed skill.[68]

1816 At the opening exhibition of the American Academy in October, Trumbull, the most prominent artist in the exhibition, showed twenty works. Shortly afterward, he sold four paintings to the Academy for 10,000 dollars.[69] When they could not raise the money, he agreed to accept instead an annuity of 900 dollars a year. Money continued to be a problem and Trumbull was forced to borrow from his relatives. As he explained his predicament,

> in times like the present there is little demand for works of ornament & taste:— my profession is therefore affected more than perhaps any other.[70]

Trumbull wrote Jefferson and Adams of his hopes that the government might employ him to decorate the new U.S. Capitol with his American history scenes. He argued that

> future Artists may arise with far Superior Talents, but Time has already withdrawn almost all their Models . . . no time remains therefore for hesitation.[71]

1817 Trumbull and his wife arrived in Washington in January to await the government's decision on the commission. Jefferson wrote to Senator James Barbour on Trumbull's behalf:

> For his merit as a painter I can . . . assure you that on the continent of Europe . . . he was considered as superior to West. . . . I pretended not to be a connoisseur in the art myself, but comparing him with others of that day I thought him superior to any historical painter of the time except David.[72]

Adams, renowned for his disapproval of the arts, declined to support Trumbull's cause, although he would not take responsibility for his decision:

> Your design has my cordial approbation and best wishes. . . . Your country ought to acknowledge itself more indebted to you than to any other Artist who ever existed; and I therefore heartily wish you success. But I must beg Pardon of my Country, when I say that I See no disposition to celebrate or remember, or even Curiosity to enquire into the

68 Dunlap 1834, I, p. 375.
69 Included were *The Woman Taken in Adultery* and *The Earl of Angus Conferring Knighthood on De Wilton* (Cats. 135, 157).
70 JT to Jabez Huntington, December 12, 1816, YUL-JT.
71 JT to Thomas Jefferson, December 26, 1816, draft of letter, YUL-JT.
72 Quoted in Sizer 1953, p. 310.

Characters Actions or Events of the Revolution. I am therefore more inclined to despair, than to hope for your Success in Congress though I wish it with all my heart.[73]

On January 27, Congress passed a resolution to employ Trumbull "to compose and execute *four* paintings commemorative of the most important events of the American Revolution, to be placed when finished, in the Capitol of the United States."[74] Trumbull was to receive 8000 dollars for each painting: *The Surrender of General Burgoyne at Saratoga*, *The Surrender of Lord Cornwallis at Yorktown*, *The Declaration of Independence*, and *The Resignation of General Washington*. Trumbull wrote to Adams:

> You will be pleased to see that this Nation . . . has given a preference to two great Political & Moral Events. I hope the Example thus set will be hereafter followed, in employing the Arts, in the Service of Religion, Morality & Freedom.[75]

Trumbull was elected president of the American Academy of the Fine Arts, a position he held for nineteen years. With an economic depression in the United States, the Academy could not make the necessary payments on the Trumbull annuity. Trumbull proposed that the institution give him the use of their gallery to exhibit the large *Declaration of Independence* in return for the sum owed.

Trumbull continued with the Capitol commission. He employed Theodore Dwight, Jr. to sell members of Congress subscriptions to the proposed engraving of his *Declaration of Independence*. Not a single member subscribed. **1818**

> The utter failure . . . has given me more vexation than any accident which has befallen me for a long time; and in truth it is inexplicable.[76]

After several months of traveling and exhibiting the *Declaration* to considerable public acclaim, Trumbull arrived in Washington to wait for the Senate to pass the appropriation bill authorizing payment, afraid **1819**

> to leave the business with anyone: for everyone is too busy with their own affairs to pay any attention to me or mine, unless I worry continually. I am tired to death but see no remedy . . . but patience.[77]

He returned to New York to begin his second picture for the Rotunda, *Yorktown*.

Having met Asher B. Durand, and greatly impressed by the young engraver's extraordinary talents, he employed him to engrave the *Declaration*. **1820**

> I am the more confirmed in the opinion that European instruction is not essential to a man of Talent in that pursuit, by witnessing the very extraordinary progress making by a young Gentleman in the City, M! Durand.[78]

On April 12, Sarah Hope Harvey died at fifty years of age, just as the sixty-eight-year-old artist was completing his Capitol commission. **1824**

73 John Adams to JT, January 1, 1817, YUL-BF. For the background for Adams' letter in relation to the Capitol commission, see p. 263.

74 Trumbull 1841, p. 262. For other reports of the resolution, see pp. 263–64.

75 JT to John Adams, March 3, 1817, YUL-BF.

76 JT to David Daggett, February 19, 1818, in Trumbull 1841, p. 357.

77 JT to Sarah Trumbull, February 19, 1819, YUL-JT.

78 JT to Benjamin Silliman, February 4, 1820, YUL-JT.

I had the misfortune to lose my wife, who had been the faithful and beloved companion of all the vicissitudes of twenty-four years. She was the perfect personification of truth and sincerity.[79]

1825 Trumbull's presidency of the American Academy was perceived by many as inhibiting to the training of artists. Little effort was made to procure instructors, and students were granted access to the antique casts in the Academy's collection only during the early morning hours. Dunlap recorded an incident involving Trumbull and some young artists who wished to work and found the door to the building locked:

> On Mr. Trumbull's arrival, the director [Dunlap] mentioned the disappointment of the students. . . . The president then observed . . . "When I commenced my study of painting, there were no casts to be found in the country. I was obliged to do as well as I could. These young men should remember that the gentlemen have gone to a great expense in importing casts, and that they (the students) have no property in them. . . . They must remember that beggars are not to be choosers.[80]

Despite the charge that he retarded the progress of the arts, Trumbull admired and acknowledged talent in others. John Blake White, Washington Allston, Nathaniel Jocelyn, Samuel Waldo, and especially Thomas Cole, were among those whose ways were smoothed by Trumbull.[81]

Trumbull spent freely on objects of art; Silliman recalled that

> a fine picture, especially if of the old masters, usually tempted him successfully, and he was equally ready to encourage a young artist by purchasing pictures of merit. [Thomas] Cole met with perhaps the first instance of decided encouragement by Col Trumbull's approbation and subsequent purchase of a picture of his— being a wild scene in the Cattskills [*sic*].[82]

Several disagreements arose between Trumbull and other members of the Academy about the extent of the president's duties, often climaxing in a threat of resignation by Trumbull and ensuing pleas by the board that he reconsider his position. Samuel F. B. Morse noted that

> Colonel T—— is growing old, [but] there is no artist of education sufficiently prominent to take his place as President of the Academy of Arts.[83]

In the spring of 1825, several young artists, including Durand and Morse, met in the New-York Historical Society to consider the formation of a "Society for the Improvement in Drawing," an organization to be managed wholly for and by artists.

1826 On January 19, the planned society was formed as the National Academy of Design. In response to the establishment of this rival institution, the American Academy made a series of gestures aimed at satisfying the needs of the "young artist rebels," but to no avail: the new National Academy attracted the best of the younger artists in New York, while the American Academy struggled on with Trumbull at its head.

79 Trumbull 1841, p. 276.
80 Dunlap 1834, II, pp. 279–80.
81 Jaffe 1975, p. 220.

82 Silliman, "Notebook," I, pp. 28–29. Cole's Catskill scene is unlocated. His *Kaaterskill Falls* (Wadsworth Atheneum), commissioned by Daniel Wadsworth after a Cole in Trumbull's collection, is thought to be a replica of the lost picture.
83 Edward Lind Morse, ed., *Samuel F. B. Morse: His Letters and Journals*, 2 vols., Boston and New York, 1914, I, p. 249.

On November 28, the Capitol Rotunda opened to the public. Shortly afterward, Trumbull wrote two long letters to President John Quincy Adams, urging the construction of a building devoted to the "permanent encouragement of the Fine Arts" by the American government.[84] In his diary, Silliman noted:

> This proposal failed to be carried into effect . . . because the nation then possessed no building proper to receive and preserve such works; and because doubts then existed . . . in the minds of some gentlemen, whether Congress possessed the right of appropriating the public money to such purposes.[85]

Failing in his efforts to receive more commissions from Congress to fill the remaining four niches of the Rotunda, Trumbull

1828

> employed his pencil in making portraits of many of his friends gratuitously, and in making copies from the works of older artists, with, generally, variations to please his own taste.[86]

Silliman urged Trumbull to write an autobiography:

> Your life has covered more than half a century, of the most interesting events in history, in relation to the arts and to your own country. You have been conversant with many of the distinguished actors, and retain in vivid recollections, so many important events.[87]

Trumbull did not take up his nephew-in-law's suggestion until seven years later.

After a bout with cholera, and in difficult financial straits,

1830

> the thought occurred to me, that although the hope of a sale to the nation, or to a state, became more and more desperate from day to day, yet, in an age of speculation it might be possible, that some society might be willing to possess these paintings, on condition of pay by a life annuity. I first thought of Harvard College, my alma mater, but she was rich, and amply endowed. I then thought of Yale— although not my alma, yet she was within my native state, and poor.[88]

The artist proposed his plan for a gallery at Yale to Silliman, who, along with his brother-in-law Daniel Wadsworth, accepted the task of raising money for the annuity, which was to be 1000 dollars a year.

At the American Academy, Trumbull exhibited fifty-one works, including miniatures, history paintings, portraits, and his late religious and romantic literary "exhibition pieces." The show was not a success.

1831

> My Exhibition has by no means answered my hopes:— by shutting up (very unnecessarily) the entrance for Carriages . . . and thus leaving no access to my room except by walking past the entrance of the criminal court, the grand jury room— & the police, the Committee . . . have rendered it almost impossible *for Ladies* to come to the Room, and you know they are the main Support of exhibitions of this sort.[89]

84 The letters were read to the directors of the American Academy, who were so impressed that they ordered 500 copies published; *Letters Proposing a Plan for the Permanent Encouragement of the Fine Arts*, New York, 1827; reprint, New York, 1973.
85 Silliman, "Notebook," II, p. 3.
86 Dunlap 1834, I, p. 390.
87 Benjamin Silliman to JT, December 31, 1828; quoted in Silliman, "Notebook," I, p. 13.
88 Trumbull 1841, p. 288.
89 JT to Joseph Trumbull, August 8, 1831, YUL-JT.

Trumbull designed a new building for the Academy.

The Corporation of Yale College agreed to Trumbull's proposal for an art gallery— the first college museum in the nation. During the year, Silliman, Trumbull, and Wadsworth exchanged voluminous correspondence over the details and design of the gallery project. Wadsworth suggested that Trumbull divide his collection between two gallery branches: one in New Haven, the other in Hartford. However, because the division of Trumbull's paintings proved to be a sensitive issue, the group settled on a single Trumbull Gallery located in New Haven.[90] In the summer, Trumbull began to design the gallery, consulting with Ithiel Town and A. J. Davis. The artist planned to install a crypt beneath the gallery to serve as a tomb for himself and his wife.

> It is my wish to be interred beneath this Gallery . . . these [pictures] are my children— those whom they represent have all gone before me, let me be buried with my family. I have long lived among the dead.[91]

1832 On October 25, the Trumbull Gallery opened. Trumbull noted:

> The Gallery . . . contains fifty five pictures by my own hand painted at various periods, from my earliest essay of the Battle of Cannae, to my last composition, the Deluge.[92]

Of the collection, the *Connecticut Journal* reviewer said:

> Col. Trumbull has the hand and spirit of a painter. . . . Altogether this Gallery must be considered the most interesting collection of pictures in the country. They are American.[93]

1833 The National Academy of Design proposed a merger with the American Academy, but Trumbull refused to consider it.

1836 Trumbull resigned as president of the American Academy.

1837—40 In financial difficulty, Trumbull decided to accept Silliman's offer to retire to the professor's home in New Haven to write an autobiography. It was probably the appearance in 1834 of Dunlap's rancorous and disparaging account of Trumbull's life in *A History of the Rise and Progress of the Arts of Design* which persuaded the artist to set down his own version of his long and eventful life.

During his years at the Silliman residence, Trumbull painted several pictures, met with young artists, and lectured to college students "on the subject of pictures." Silliman recalled:

> He did not . . . in general, encourage [the artists] with any very flattering hopes of brilliant success. His pictures of the life of an artist were rather deeply shaded— for he thought that the profession of a painter afforded but an uncertain reliance.[94]

The aging artist continued to work on his reminiscences. In 1838, Faith Wadsworth Silliman wrote to her sister Maria:

> Uncle is reading again to some friends his manuscript. The Hillhouses, Skinners, Whitneys, Mrs. Pritchard, Susan, Mr. Bakewell come here Saturday evenings. Uncle reads till about

90 See pp. 91–92.
91 Quoted in Silliman, "Notebook," I, p. 40.
92 Trumbull 1841, p. 293.

93 *Connecticut Journal*, 65, November 6, 1832, p. 3.
94 Silliman, "Notebook," I, p. 20.

nine o'clock and then he furnishes grapes and champagne and we a basket of cake. They are very pleasant little meetings.[95]

Trumbull returned to New York to be near his physician. Friends observed: **1841**

> He is very frail, and has painted none for a year. He is a very agreeable man in his conversation. He has a large library . . . composed principally of French, Italian, and Spanish works. He employs himself in reading.[96]

> He walks out when the weather will admit, his eyes are better, tho he does not allow himself to use them much as all their strength is required to correct the proofs of his book which is now printing, and the interest and excitement caused by its progress will help keep his spirits and energy.[97]

The American Academy closed. Trumbull's *Autobiography*, with twenty-three plates engraved from his drawings, was published in New Haven, New York, and London. It was the first autobiography written by an American artist. Silliman noted:

> The historical facts are authentic and important. . . . As a literary performance it is lucid, vivid and attractive; an elegant simplicity without studied ornament makes it beautiful.[98]

However, the book was not a success. "The public expected more of personal anecdote," observed Silliman, adding bitterly that, by contrast, "the dark crowded pages of the books of tales, cheap and enervating to the mind, go off at the first bid."[99]

Trumbull died in New York on November 10, at the age of eighty-seven. His body was brought to **1843** New Haven by steamboat the following day. The funeral was held in the Yale College Chapel, and he was buried next to his wife in the Trumbull Gallery, beneath his full-length portrait of Washington. A memorial tablet placed in the gallery was inscribed: "To his country he gave his sword and pencil."

At the National Academy of Design, Trumbull was eulogized by S. F. B. Morse as one

> whose name and works are amongst the earliest associations of our childhood, and whose fame is interwoven, not merely with the history of the arts of design, but also with the political history of the country.[100]

Silliman concluded:

> The soldier, the artist, the man of letters and varied talents— the man of the world, the accomplished gentleman and the man of policy and diplomacy were all united in him. . . . Long may his works remain and longer still his fame.[101]

95 Faith W. Silliman to Mrs. John Barker Church, December 23, 1838, YUL-SF.

96 Sylvester Genin, quoted in Sizer 1953, p. 300.

97 Benjamin Silliman to Faith W. Silliman, May 18, 1841, YUL-SF.

98 Silliman, "Notebook," I, p. 16.

99 Ibid. and Silliman to Jabez Huntington, July 25, 1845, YUL-SF.

100 S. F. B. Morse, quoted in Thomas S. Cummings, *Historic Annals of the National Academy of Design*, Philadelphia, 1865, p. 175.

101 Silliman, "Notebook," II, pp. 2, 129.

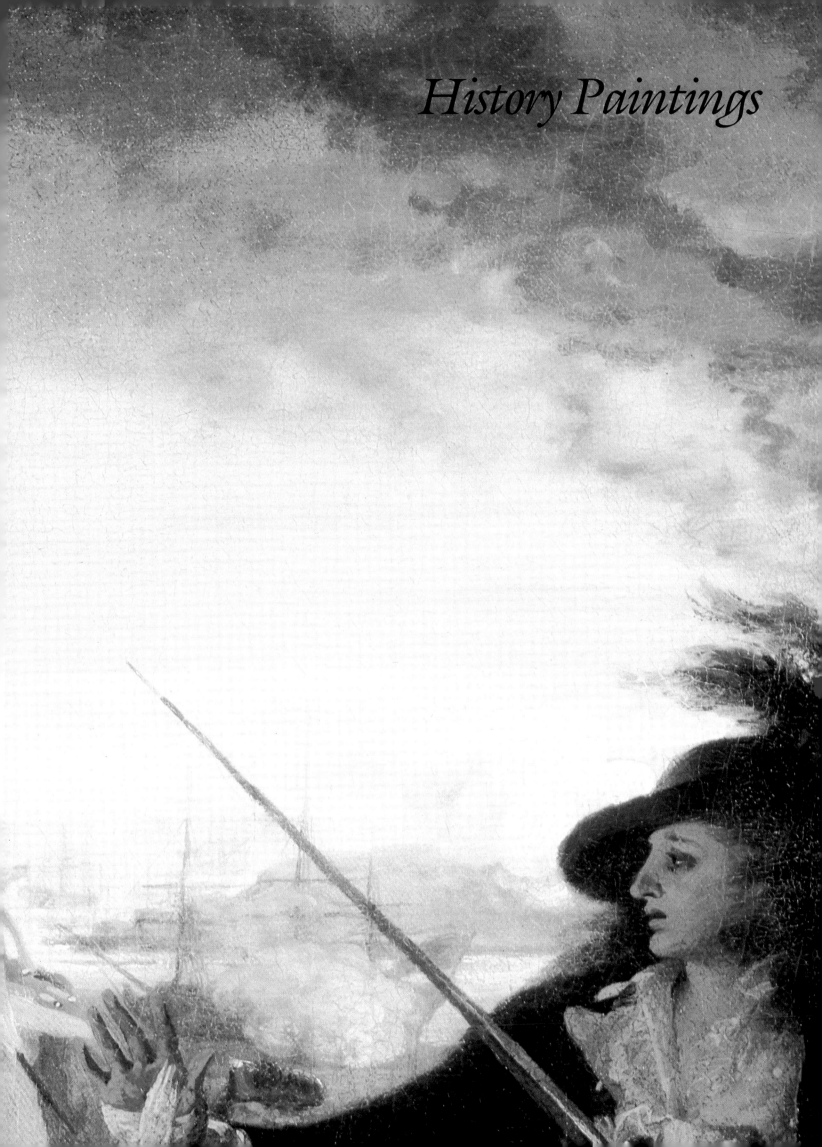

John Trumbull as History Painter

By Jules David Prown

It seems deceptively easy to place John Trumbull in the development of American art. When the major artists of the preceding generation, Benjamin West and John Singleton Copley, remained in England after the War of Independence, Trumbull and Gilbert Stuart carried forward in America the arts of history painting and portraiture, respectively, during the early years of the Republic. Trumbull's particular contribution was the application of West's and Copley's realistic innovations in history painting to American subjects. But in fact Trumbull is not so simply pigeonholed. For one thing, he was different from other American eighteenth-century artists. Almost all early American artists came from lower- or middle-class, often craft or shopkeeper, backgrounds; Trumbull was an aristocrat, the son of the governor of Connecticut. Trumbull was the first American artist to receive a college education. He was also that rarity, a one-eyed artist. And while most artists, with the notable exception of Charles Willson Peale, shied away from politics and war, Trumbull was an active officer in the War of Independence, albeit briefly, and subsequently served in various diplomatic and administrative capacities.

Trumbull also had a complex personality, striving constantly to reconcile the contradictory aspects of his life: an aristocrat who was uneasy with elegance and sophistication; a college graduate who wanted to work with his hands; an American who spent much of his life in England; an artist who stopped painting for seven years; a moralist who crept into bed with his brother's servant girl, and married an attractive, divorced English woman beneath his social station— in both cases doing his duty, supporting his illegitimate son as his "nephew" and attending faithfully to his wife even during her embarrassing bouts of intemperance and family troublemaking; a brittle, touchy man who was tender and loving with his family and a few close friends; and, as we shall see in this essay, an idealistic, creative painter who had pangs of guilt about not pursuing an activity that was more socially redeeming or, at least, profitable.

Perhaps because he was aware of these inconsistencies, Trumbull went to considerable lengths to leave his own unified and rationalized view of himself and his achievements for posterity. He wrote an *Autobiography* which recorded the ways he devoted his gifts to the service of his country through his art. For his portrait by Samuel Waldo and William Jewett (*Fig. 2*), Trumbull chose as symbolic accoutrements his sword and his brush and palette. The self-image presented in his *Autobiography* and Waldo's portrait is of the artist as patriot, uniquely equipped by talent and historical circumstance to record the great events of his time. The true measure of Trumbull's achievement is, however, not the artist's view of himself but his art.

Although Trumbull as a youth wanted to study painting with John Singleton Copley in Boston and become an artist, his father intended that he prepare for one of the learned professions, preferably the ministry, and sent him to Harvard in January 1772. In Boston Trumbull met Copley and was impressed by his elegant house on Beacon Hill, by the artist himself dressed in finery to receive dinner guests, and above all by Copley's paintings (see p. 2).

At Harvard, he saw a number of Copley portraits and copied *Rev. Edward Holyoke* (unlocated). He read extensively in the literature on the history, theory, and practice of art available in the library:

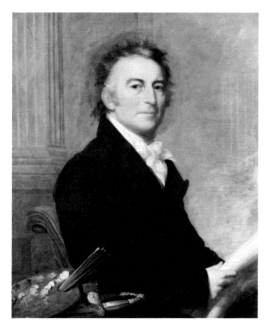

Fig. 2. Samuel Lovett Waldo and William Jewett, *Colonel John Trumbull*, c.1821. New Haven, Yale University Art Gallery; Gift of Alfred Wild Silliman and Benjamin Silliman IV.

Fig. 3. *The Death of Paulus Aemilius at the Battle of Cannae* (Cat. 1).

Hogarth's *Analysis of Beauty* (prominently displayed in his 1777 *Self-Portrait*, Cat. 33), Webb's *On Painting*, Charles du Fresnoy's *De Arte Graphica* in Dryden's translation, de Piles' *Cours de Peinture* (Trumbull mastered French through private lessons while at Harvard, an accomplishment which served him well in future years) and Walpole's *Anecdotes of Painting*. He also studied an Italian-English dictionary, Veneroni's *Italian Master*. He read history: Rollin's *Roman History*, Burnett's *History of His Own Times*, Smollett's *History of England*. He read *Ossian*, the *London Magazine*, and the *Gentleman's Magazine*. He looked at Piranesi engravings of Roman ruins; he copied plates from Kirby's *Dr. Brook Taylor's Method of Perspective Made Easy* and Le Brun's *Expression des Passions de l'Âme*; he copied a Rubens *Crucifixion* in watercolor from a print, and his copy in oil of an engraving after Antoine Coypel's *Abraham's Servant Meeting Rebekah at the Well* was praised by Copley; he made copies in both oil and watercolor of a scene of the eruption of Mt. Vesuvius that hung at Harvard in the Philosophical Chamber.[1]

Trumbull graduated in July 1773, and returned to his home in Lebanon, Connecticut. His "first attempt at composition" was *The Death of Paulus Aemilius at the Battle of Cannae* (Fig. 3) in which he borrowed figures from "various engravings . . . as suited my purpose, combining them into groups and coloring them from my own imagination."[2] His literary source was Rollin's *Roman History*.[3] The Roman consul Paulus Aemilius, mortally wounded in battle against Hannibal's Carthaginians, refused the offer of a horse on which to escape, choosing instead to continue to direct his army until the end. This scene from antiquity of the death of a military leader in battle conveys a moral lesson of courage, loyalty and devotion to duty and country; it was the thematic precursor of Trumbull's Revolutionary War paintings.

Trumbull's perception of a link between ancient and contemporary events developed during his post-Harvard days in Lebanon where, in the house of his father, the provincial governor, he was immersed in the details of current political developments. Trumbull later recalled that as America's quarrel with Britain intensified, "I caught the growing enthusiasm; the characters of Brutus, of

1 Jaffe 1975, p. 15. Unless otherwise indicated, biographical information comes from Jaffe or from Trumbull's 1841 *Autobiography*.

2 Trumbull 1841, p. 14.

3 Rollin 1768, III, pp. 472–73.

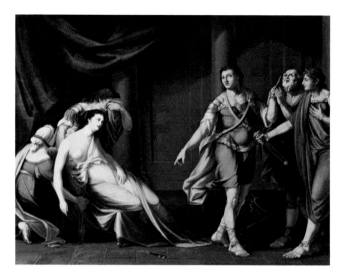

Fig. 4. Domenico Cunego (after Gavin Hamilton), *The Oath of Brutus*, 1768, engraving. London, The Trustees of the British Museum.

Fig. 5. *Brutus and His Friends at the Death of Lucretia* (Cat. 2).

Paulus Emilius, of the Scipios, were fresh in my remembrance, and their devoted patriotism always before my eye."[4]

War with England broke out at Lexington on April 19, 1775, and by May 1 the troops of the First Regiment of Connecticut were marching to Boston with young Trumbull as "adjutant" and "a sort of aid-du-camp [*sic*]" to General Joseph Spencer, a friend of his father.[5] The Connecticut troops were stationed at Roxbury, and it was from there on June 17 that Trumbull heard the firing and saw the smoke and flames of the Battle of Bunker Hill and the burning of Charlestown. This was as close as he got to personal involvement in any of the events he later depicted.

Following the British evacuation of Boston in March 1776, the Continental army, and Trumbull with it, moved to New York. General Horatio Gates, in charge of the Northern army, offered Trumbull a post as a deputy adjutant-general with the rank of colonel. Early in 1777, Trumbull became incensed when his formal commission from Congress was dated later than the date he had assumed his responsibilities. Pridefully rejecting attempts at conciliation, Trumbull left military service and resumed his artistic career in Lebanon, where he painted family portraits and several history pictures, the latter based largely or in part on engraved sources. Perhaps because of the influence of black-and-white prints, these early works are marked stylistically by strong contrasts of light and dark and an almost harsh linearity and flatness, a lack of plasticity in the modeling of individual figures. There is also a tendency to focus attention more on the rendering of details than on overall visual or pictorial coherence.

In July 1777 Trumbull began *Brutus and His Friends at the Death of Lucretia* (*Fig. 5*). The composition relied heavily on Domenico Cunego's 1768 engraving after Gavin Hamilton's *Oath of Brutus* (*Fig. 4*), except for the less active, more thoughtful central figure of Brutus, which Trumbull took from another source (see Cat. 2), and the kneeling figure of the woman on the left, taken from a 1768 mezzotint of Benjamin West's *Elisha Restoring the Shunammite's Son* (*Fig. 6*), a print which Trumbull copied in its entirety in oil shortly afterward (*Fig. 7*).[6] In *Brutus* Trumbull abandoned the compositional integration of Hamilton's design, dividing the picture into a lower diagonal "Lucretia"

4 Trumbull 1841, p. 15.
5 Ibid., p. 18. As adjutant, Trumbull's activities were for the most part bureaucratic, involving record keeping, personnel, correspondence, supplies, provisions, etc.

6 West's *Elisha* is now in the J. B. Speed Art Museum, Louisville, Kentucky.

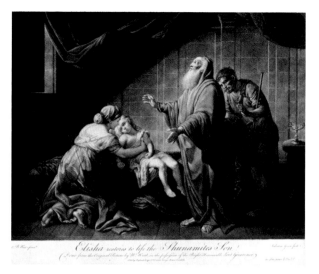

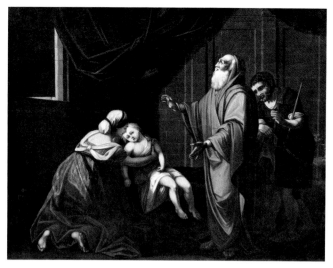

Fig. 6. Valentine Green (after Benjamin West), *Elisha Restoring the Shunammite's Son*, 1768, mezzotint. New Haven, Yale Center for British Art; Paul Mellon Collection.

Fig. 7. Elisha Restoring the Shunammite's Son, 1777. Hartford, Wadsworth Atheneum; Gift of Mrs. John T. Roberts.

group on the left and a vertical "Brutus" group on the right. Lucretia in Trumbull's version is less active, her left arm dropping into her lap instead of grasping Brutus' tunic. This scene of the swearing of an oath, an affirmation of duty and honor, like *Paulus Aemilius*, didactically presented classical virtues as moral examples to the eighteenth-century viewer.[7] A representation of revolt against corrupt authority— Brutus swears vengeance on a ruler who had transgressed against his subjects— Trumbull's painting may have had an intended resonance with the revolutionary cause of the American colonies.

Copying engravings after paintings by such leading artists as Hamilton and West, Trumbull was attempting to stay abreast of contemporary developments in European history painting as best he could. But the time lag inherent in the production of engravings,[8] plus the limited interchange between America and Europe during the war, inhibited Trumbull's progress and made his work in the Colonies inescapably retardataire. Trumbull also continued his study of Old Masters. In the following year he painted *Belisarius* (Cat. 3), taking the central figure from an engraving by Robert Strange after Salvator Rosa. The choice of subject may have reflected some bitterness at what Trumbull felt to be ingratitude on the part of his fellow-citizens for his military contributions.

Trumbull moved to Boston in June 1778, renting the former studio of the artist John Smibert. Since he could not study with Copley, who had gone to England, he improved himself by studying the Smibert copies of Van Dyck's *Cardinal Bentivoglio*, Poussin's *Continence of Scipio* and Raphael's *Madonna della Sedia* which remained in the studio. Although still sympathetic to the American cause, he was offended by the more extreme displays of patriotic fervor in Boston. His patrician sensibilities were not really attuned to an excess of egalitarianism, and he was appalled by the persecution of the remaining Tories. Trumbull's attention seems to have drifted away from art during this Boston interlude; he was plagued by doubts as to his vocation and produced fewer works than during his previous year in Lebanon. Early in 1779, he decided to visit France on a speculative commercial venture. At the urging and with the help of the influential John Temple, he also secured the option of studying art in England should the business undertaking fail. Temple obtained clearance from Lord

7 See Robert Rosenblum, *Transformations in Late Eighteenth Century Art*, Princeton, 1967, esp. chap. II, "The Exemplum Virtutis," pp. 50–106.

8 For example, William Woolett's engraving of West's important 1771 painting, *The Death of General Wolfe*, was not published until January 1, 1776.

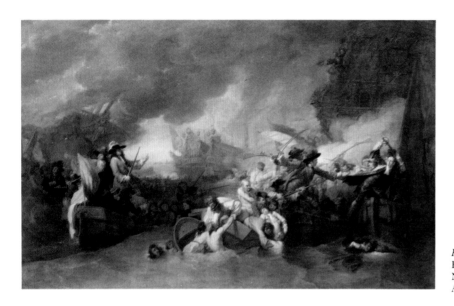

Fig. 9. (Opposite) Benjamin West, *The Death of General Wolfe*, 1771. Ottawa, The National Gallery of Canada; Gift of the Duke of Westminster.

Fig. 8. John Trumbull (in the studio of Benjamin West), *The Battle of La Hogue*, 1785. New York, The Metropolitan Museum of Art; Harris Brisbane Dick Fund.

George Germaine, English secretary of state, for Trumbull to study in London as long as he avoided any political activity. It is possible that Trumbull, with his substantial political connections in America, may have had, beneath his cover of commercial and artistic interests, a clandestine diplomatic mission. He sailed for Europe in May 1780.[9]

When Trumbull's enterprise in Paris collapsed, he continued on to London, carrying a letter of introduction from Franklin to Benjamin West. West, friend and tutor to an endless stream of young American artists, accepted Trumbull as a pupil. Told to select a picture to copy, Trumbull chose a copy of Raphael's *Madonna della Sedia;* later he copied West's copy of Correggio's *Madonna of St. Jerome* (Cat. 133). However, his artistic idyll in West's studio did not last long. When news arrived in London of the execution in New York of Major André as a British spy, Trumbull was seized and jailed. His former rank and duties in the Continental army were comparable to André's,[10] so he was a convenient target for retaliation. Fortunately, perhaps because he was not caught *in flagrante* and surely because of West's influence with King George III, Trumbull did not suffer André's fate. Seven

9 Jaffe 1975, p. 50, suggests that Trumbull may have been "involved in a scheme related to the French-Dutch-English conflict in the West Indies," but the fact that Trumbull dined in Paris with the engraver Robert Strange (Trumbull 1841, p. 65), whose engraving of *Belisarius* he had copied two years earlier, prompts a different speculation. Strange was the brother-in-law of Andrew Lumisden, private secretary to James III, "The Old Pretender," and continued to serve Prince Charles Edward in the same role until 1768. He subsequently settled in Paris. Both Lumisden and his sister, Isabella Strange, were ardent Jacobites (and Strange himself had fought under Bonnie Prince Charlie at Culloden). Years later, Sir Walter Scott told Washington Irving that among the Stuart Papers at Carlton House "he had found a memorial to [Prince] Charles, from some adherents in America, dated in 1778, proposing to set up his standard in the back settlements" (Washington Irving, *Abbotsford and Newstead Abbey*, London, 1835, p. 48). Abbé Fabroni, Rector of the University of Pisa, prior to 1806 told the Rev. Louis Dutens, librarian to the Prince Regent, that in 1775 [*sic*] he had seen letters from Americans at Boston to

Prince Charles "assuring him of their allegiance, and inviting him to put himself at their head"; see Alice Shield, *Henry Stuart, Cardinal of York, and His Times*, London, 1908, p. 214.

A further clue that Trumbull may in fact have participated in some such scheme to involve the aging and dissolute Pretender in American affairs is that subsequently in London Trumbull received a mysterious letter dated November 1780, addressed not to his lodgings "but in care of Mr. Waters" (Jaffe 1975, p. 48). Prince Charles on occasion had letters addressed to him as Mr. J. Douglas "forwarded through Mr. Waters, Banker, Paris"; see Nora K. Strange, *Jacobean Tapestry*, London, 1947[?], p. 30. For further information see Lord Mahon [Philip Henry Stanhope], *History of England*, 3rd ed., London, 1853, VI, esp. p. 122, and James Dennistoun, *Memoirs of Sir Robert Strange, Knt.*, 2 vols., London, 1855, *passim*. I am grateful to Paul Monod for information regarding the Pretender and an American connection.

10 Both had been deputy adjutants-general.

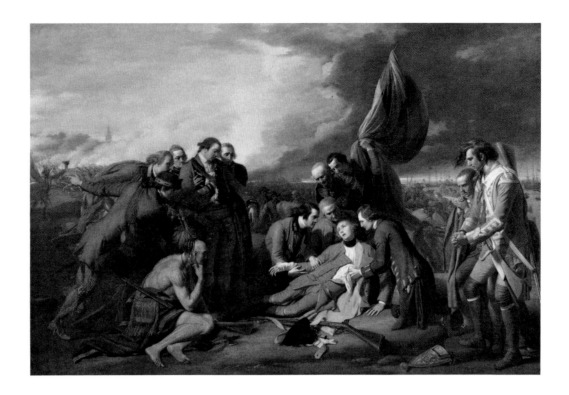

months later, in June 1781, he was released on bail— West and Copley posted half of the bond— and he returned to America.

After hostilities ceased, Trumbull came back to London in December 1783 to resume his studies with West. Although he painted some portraits, his primary aspiration was to paint history like West. In 1784 he exhibited *The Deputation from the Senate Presenting to Cincinnatus the Command of the Roman Armies* (unlocated) at the Royal Academy, incorporating a likeness of George Washington as Cincinnatus. The equation of Washington with Cincinnatus was a widely understood reference to Washington's renunciation of power at the end of the Revolutionary War, a gesture that Trumbull believed no European leader would have had the grace or confidence to make. The subject thus is linked to one that later grew in importance as Trumbull's Revolutionary War series developed, the scene of *The Resignation of General Washington* (Cat. 31). *Cincinnatus,* approximately the same size as the earlier *Brutus*, was an ambitious undertaking. But Trumbull felt that of even greater value, indeed "of inestimable importance," was the opportunity given him by Benjamin West in the summer of 1785 to paint an enlarged replica of West's own *Battle of La Hogue (Fig. 8).*[11] This "importance" may have been the confidence gained in working on a larger scale, the experience of handling numerous figures in a complex scene, the opportunity to depict a more recent, although far from contemporary, historical event, and the accumulation of compositional ideas with increased understanding of the possibilities for achieving variety through pose, gesture, light, color, texture, and incident.

Shortly after copying *La Hogue*, Trumbull painted a more traditional, Gavin Hamilton-like subject, *Priam Returning to His Family, with the Dead Body of Hector* (Cat. 153). Then, in the fall of 1785, Trumbull and Raphael West, Benjamin West's older son and Trumbull's fellow student, visited the Reverend Samuel Preston in Chevening, Kent. In Preston's library, Trumbull immersed himself in works on "the Trajan, Antonine and other Columns— the triumphal arches, bas-reliefs, &c. &., of Rome." At this time, Trumbull also made his first recorded Revolutionary War scene, a "small sketch in Indian ink, on paper, of the death of General Frazer, at Behmus's heights." On his return to West's studio after this visit, Trumbull decided firmly to paint those Revolutionary War scenes which became "the great objects of my professional life."[12]

11 Trumbull 1841, p. 92. 12 Ibid., pp. 92–93.

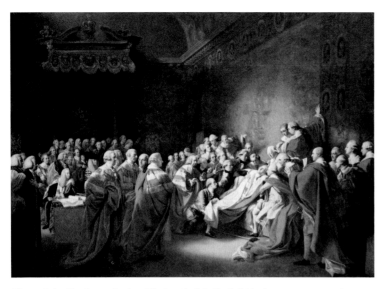

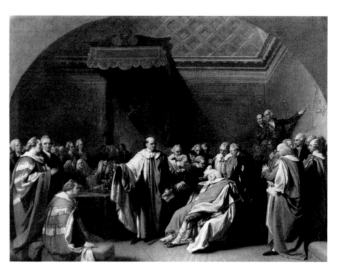

Fig. 10. John Singleton Copley, *The Death of the Earl of Chatham*, 1779–81. London, The Tate Gallery.

Fig. 11. Benjamin West, *The Death of the Earl of Chatham*, 1778. Fort Worth, Kimbell Art Museum.

The Revolutionary War series, in its several incarnations and with all of the related drawings, miniature portraits, oil sketches, engravings, and its attendant artistic and political efforts, indeed did constitute the core of Trumbull's artistic career. His dilemma, as with American artists before and after him, was that America and serious art seemed irreconcilable. To be an artist in America meant to paint portraits; to be an artist on a more ambitious level, to be a history painter, meant to abandon America, where there was little patronage, and settle in Europe as West and Copley had done. But the patriotic appeal of a series of Revolutionary War scenes, with economic possibilities ranging from Federal commissions for large paintings to the sale of engravings to a large American audience, suggested a resolution to the dilemma, a possible way to succeed as a history painter in America. Moreover, the projected series combined Trumbull's two fundamental interests— his country and his art. It reconciled his practical need to make a living with a higher aspiration toward art and morality. And, by depicting modern events, it allowed him to bring his skills as a portrait painter to bear on the grander task of history painting.

Although the Revolutionary War series became Trumbull's great life work, he did not in fact originate the scheme. As with so many developments in English history painting in the second half of the eighteenth century, the credit must go to Benjamin West. During the 1760s, West had been an artistic innovator with his factually accurate depictions of ancient history. In 1771, he made a bold leap into modern history with *The Death of General Wolfe* (Fig. 9) and the shocking realism of its contemporary dress. This was followed in 1772 by another relatively modern scene, *Penn's Treaty with the Indians*. But West, who became Painter of Historical Pictures to George III in that year, subsequently avoided scenes of contemporary history which had potential and sometimes unforeseen political implications. Discretion became the better part of artistic valor for West during the 1770s.

Copley settled in London in 1776, and took up the task of depicting contemporary history, exhibiting his first modern scene, *Watson and the Shark*, at the Royal Academy in 1778. Trumbull must have seen *Watson and the Shark* when he renewed his acquaintance with Copley in London in 1780. He certainly saw the large *Death of the Earl of Chatham* (Fig. 10) in Copley's studio, since Copley was working on it in that year. Although he presumably missed the public exhibition of the *Death of Chatham* in the spring of 1781 because of his incarceration and later deportation, Trumbull surely heard of its enthusiastic public reception.

A recently discovered oil sketch by Benjamin West for the *Death of Chatham* (Fig. 11) is closely related to Copley's earliest known compositional ideas. It accords with Horace Walpole's description

of such a sketch, and validates Walpole's observation that "West would not finish it [*Chatham*], in order not to interfere with his friend Copley."[13] The sketch proves that in 1779 West was contemplating a return to the depiction of contemporary history, although he eventually deferred to Copley, perhaps as much out of political circumspection as friendship, since West was history painter to George III and Chatham was hardly a royal favorite. West's *Chatham* sketch would presumably have been in his studio, and the projected new painting of contemporary history, although abandoned, still a topic of conversation when Trumbull first arrived.

Just as West had been the originator of the scheme to paint *Chatham*, so too he was the first to conceive of the Revolutionary War series. On June 15, 1783, half a year before Trumbull's return to England, West wrote to his former pupil, Charles Willson Peale:

> I have now a favor to ask for myself, which is, that you would procure me the drawings or small paintings of the dresses of the American Army, from the Officers down to the common Souldeir— Rifill men &c. &c. and any other charectoristic of thier Armys or camps from which I may form an exact Idea, to enable me to form a few pictures of the great events of the American contest.— To make up my mind for this work (which I propose to have engraved) it will be necessary for your assistance in procuring me the meterials (of which you will be a proper judge) so that the American armys may be charectorised from those of Europe— This work I mean to stile the American Revolution.[14]

To insure that Peale received his request, West repeated it on August 4, 1783:

> I wrote you by M.^r Vaughn my intentions of composing a set of pictures containing the great events which have affected the revolution of America; for the better enabling me to do this, I desired you to send what ever you thought would give me the most exact knowledge of the custumes of the American Armys, portraits in small (either painting or drawing) of the conspicuous charectors necessary to be introduced into such a work— I now imbrace by my friend Cap.ⁿ Falconer the Opertunity to make the same request, and that you would on his return to this country, send me (on consulting some able friend) what you might have in readyness with this plan for such an undertaking. I mean the arrangement of the subjects most expressive and most pointed, as for instance— the cause of the Quarel, the commencement of it, the carrying it on, the Battles, alliances &c. &c. &c.— to form one work, to be given in eligent engravings— call'd the American revolution— this work I mean to do at my one expence, and to imploy the first engravers in Europe to carry them into execution, not having the least dout, as the subject has engaged all the powers of Europe all will be interested in seeing the event so portraid.[15]

That West actually began work on the project is evidenced by his unfinished *The Peace Commissioners in 1782* (The Henry Francis du Pont Winterthur Museum), a representation of the Americans present— Benjamin Franklin, William Temple Franklin, John Adams, John Jay and Henry Laurens. Peale responded to West's inquiry on August 25, 1783:

> remembering an acquaintance who possessed a hunting shirt & leggens I have obtained and sent them by M.^r Wister, such our of Rifflemen usted to wear with Powder horn & shot pouch of the Indian fashion, with Wampum Belts, small Round hats of bucks tail and some times Feathers. Very often these shirts were dyed brown— yellow, pink and blue black

13 Quoted in Jules D. Prown, *John Singleton Copley*, 2 vols., Cambridge, Mass., 1966, II, pp. 280–81.

14 Lillian B. Miller, ed., *The Collected Papers of Charles Willson Peale and His Family*, microfiche ed., Millwood, N.Y., 1980, II A/12B 10–14. For a more extended consideration of this subject, see Arthur S. Marks, "Benjamin West and the American Revolution," *The American Art Journal*, 6 (November 1974), pp. 15–35.

15 Miller, *The Collected Papers of Charles Willson Peale*, II A/12C 5–7.

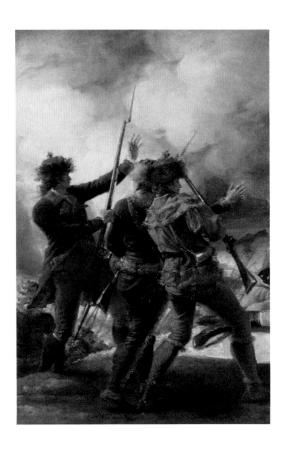

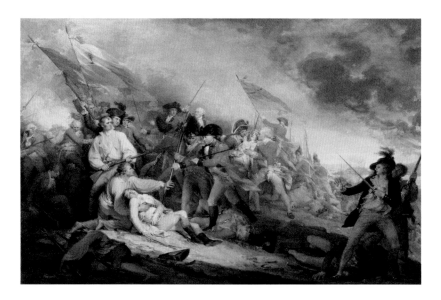

colour according to the fancy of the companies. In my next I will give you some history of the changes of the uniform of the army and all such particulars as I can judge necessary for your purpose, I will thank you when [*sic*] to write to informed me of what paintings you have on hand.

And Peale added a footnote: "A bit of fringe instead of the Ruffles on the shirt would be better."[16]

The materials Peale sent West must have arrived shortly before Trumbull's return. Trumbull would therefore have come back to find West actively involved in a Revolutionary War series—choosing topics, planning engravings, and engaged in executing the *Peace Commissioners*. During 1784, while Trumbull resumed work as pupil and apprentice, West's project stalled. Difficulty in securing cooperation from British sitters for the *Peace Commissioners* may have been one problem, but more important must have been the realization that the underlying theme— the loss of England's American colonies— was hardly a tactful subject for the king's history painter. So, as with *Chatham* and Copley, West again opted out of a possibly offensive contemporary history project and encouraged another artist, this time his young protégé Trumbull, to take it on. The costumes of the three riflemen on the left of Trumbull's *Death of General Montgomery in the Attack on Quebec* (*Fig. 12*) suggest that in addition to the concept, West turned over to Trumbull the materials he had gathered from Peale and perhaps others.

West's influence was decisive not only in launching Trumbull's Revolutionary War series, but in its execution as well. The technical training West provided, particularly as Trumbull worked on the replica of the *Battle of La Hogue*, was an essential ingredient in the development of Trumbull's manner. And West's paintings were important both as theoretical prototypes and pictorial sources. *The Death of General Wolfe*, for example, influenced Trumbull's *Death of General Warren at the Battle of Bunker's Hill* (*Figs. 13, 17*) and *Death of General Montgomery* (*Fig. 18*), especially the latter with its Canadian setting and the presence of scouts and Indians. But the primary stylistic influence on

16 Ibid., II A/12C 11–12.

Fig. 12. (Opposite, left) *The Death of General Montgomery in the Attack on Quebec* (detail of Cat. 7).

Fig. 13. (Opposite, right) *The Death of General Warren at the Battle of Bunker's Hill* (Cat. 4).

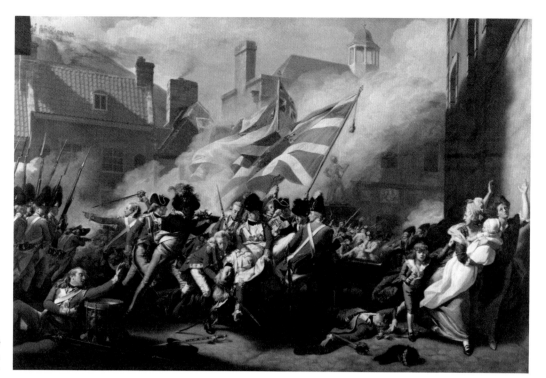

Fig. 14. John Singleton Copley, *The Death of Major Peirson*, 1782–84. London, The Tate Gallery.

Trumbull came not from West, but from Copley, who had enjoyed great popular success with his history paintings during Trumbull's impressionable early years in England. Copley's *Death of Chatham* had been a triumph in June 1781, when Trumbull was released from prison. Then, in the spring of 1784, just after Trumbull returned to London, Copley exhibited *The Death of Major Peirson* (*Fig. 14*) to even greater public acclaim. Copley, now an English artist like West, could not for political reasons contemplate undertaking the Revolutionary War series himself, and joined West in encouraging Trumbull to proceed.

Trumbull brought to his series the same seriousness of purpose with which West and Copley approached their increasingly realistic (although not reportorial) depictions of contemporary history. They saw themselves as historians preserving a visual record for posterity. In 1786, Trumbull wrote to a friend, "I am now . . . employ'd writing, in my language, the History of our country."[17] He began the first picture in the series, *Bunker's Hill*, in 1785, and completed it in March 1786. The influence of Copley's *Peirson* abounds:

> the death of a hero, a figure with a sword above his head held parallel to the ground, a fleeing group on the right, a Negro servant in a prominent pictorial role, a dead figure in the lower left, ensigns overhead, baroque diagonals and alternating bands of light and shadow, and a general sense of confusion pervaded by the smoke of battle. The soldier seizing the British bayonet to protect the moribund Warren repeats the motif in the lower left of the Rubens *Massacre of the Innocents* of the mother grasping the soldier's dagger to protect her child, suggesting that Copley may even have indicated his own source to Trumbull.[18]

17 JT to Andrew Elliot, March 4, 1786, MHS. Trumbull's father had collected documentary materials and had intended to write a history of the Revolutionary War. The project never came to fruition, but Trumbull urged his father to get the papers sorted and give them to an institu-tion like "our Yale College," where they would be useful for future historians— an early indication of the attitude that led to his own later benefaction to Yale (Jaffe 1975, p. 79).
18 Prown, *John Singleton Copley*, II, p. 309.

Trumbull's profound admiration for Rubens may have been derived from Copley; certainly the influence of Rubens is reflected in the work of both men— composition, brushwork, light and color.

Trumbull chose to begin with *Bunker's Hill* and *Quebec*, scenes of the deaths of Generals Warren and Montgomery, because, he said later, these were the earliest important events in time in the series and, as scenes of military martyrdom, they were "a just tribute of gratitude to the memory of eminent men, who had given their lives for their country."[19] More to the point may be the fact that these were active battle scenes for which West's *Wolfe* and Copley's *Peirson* were handy prototypes. In the final series of eight scenes, there is only one other battle scene, *The Death of General Mercer at the Battle of Princeton* (Cat. 14). The rest are static representations of important events— *The Declaration of Independence* (Cat. 25), *The Resignation of General Washington* (Cat. 31), and three surrenders of the British, at Trenton, Saratoga, and Yorktown (Cats. 24, 30, 27)— scenes that are more like Copley's *Death of Chatham* with its fifty-five portraits than his *Peirson* or West's *Wolfe*.[20]

One obvious attraction *Bunker's Hill* held for Trumbull as the lead-off painting in the series was the fact that it was the one event to which he had been an actual witness, although from a distance. The scene depicts the climactic moments of the battle, the death of the American General Warren juxtaposed with the death of the British Major Pitcairn, but the actual subject is moral rather than historic. The picture pays tribute to heroes giving their lives for their country, and although the lighting spotlights Warren and Pitcairn, the central figure is the British officer Major Small, who strides across the body of a fallen soldier to prevent a grenadier from bayonetting the helpless Warren. The expressions on the faces of the surrounding American soldiers and the departing officer, Lieutenant Grosvenor, and his black servant combine concern for Warren with astonishment at the magnanimity of Small. Human values, not actions, are the primary subject. And the fundamental theme is humanitarianism and generosity, the bonds that unite humans rather than the forces that set them at each other's throats. Trumbull's exemplars of morality are invariably officers like himself, not common soldiers.

Trumbull followed Copley not only in composition and theme, but also in his attempt at factual accuracy. The head wound of Warren, Lieutenant Grosvenor's bandaged hand, the topography, and seven portraits are realistic elements. The Small incident, however, although it may have been reported to Trumbull as true, does not accord with known fact.

Trumbull began *The Death of General Montgomery at the Battle of Quebec* in February 1786 with continued encouragement from both Copley and West. In *Quebec* the action is brought closer to the picture surface, heightening the dramatic intensity and the visual impact of individual figures. It is the most successful of Trumbull's history paintings. He learned his lessons well from West and Copley, and created an image of powerful dramatic intensity centered on the figure of the dying Montgomery. The aesthetic quality of the picture may well relate to the necessity forced upon Trumbull to use his imagination; most of the principal actors were dead and he did not visit the site.[21]

Thomas Jefferson, American minister to France, stopping in London, also encouraged Trumbull in his project and urged him to visit Paris. Before long, Trumbull accepted the invitation. He wanted to have his Revolutionary War pictures engraved, and arranged with Antonio di Poggi to take responsibility for the commercial arrangements as publisher, so that he could concentrate on painting. Because of the difficulty in finding an English engraver who could undertake the project promptly, Trumbull and Poggi agreed to meet in Paris to select engravers. Thus Trumbull traveled to Paris in July 1786, carrying *Bunker's Hill* and *Quebec* with him, and took up Jefferson's offer of hospitality.

Quebec is recorded as having been well advanced by early March 1786. Trumbull did not leave for

19 Trumbull 1841, p. 93.
20 Perhaps Trumbull's scenes look back ultimately to Velázquez' *Surrender at Breda* as well as ahead to David's *Tennis Court Oath*.
21 One is tempted to speculate that Trumbull would have been a better artist had he not felt so strongly the need to rely upon sources— prints for his early history paintings, Copley's compositions for his American portraits, historically correct materials and settings for his Revolutionary War series, and Old Master paintings for his later religious and mythological works.

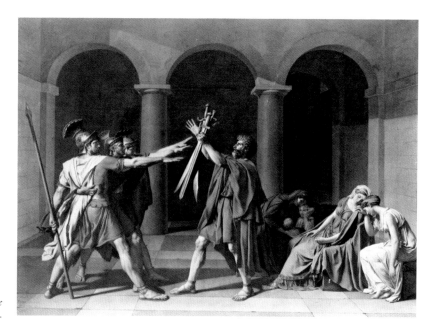

Fig. 15. Jacques-Louis David, *The Oath of the Horatii*, 1785. Paris, Musée du Louvre.

Paris until the latter part of July. In the interim, he began work on the third battle scene in his series, *The Death of General Mercer at the Battle of Princeton*. An unfinished oil sketch on canvas for *Princeton* (Cat. 15) is the same size as *Bunker's Hill* and *Quebec*. It seems reasonable to assume that Trumbull began *Princeton* on the same scale as the two earlier battle scenes. Later he apparently concluded that a smaller size would be better, perhaps more convenient for preparing the engravings. He consequently reduced the size of the subsequent oils from approximately 24 x 36 inches to 20 x 30 inches for the remaining pictures in the series, making a new version of *Princeton* in the process (see Cat. 14).

Trumbull's four-month sojourn on the Continent, in Paris and journeying through Flanders and down the Rhine, was exhilarating. He studied the work of many Old Masters. The artist who impressed him most profoundly was Rubens: "For color, composition and expression, nothing can excel a Rubens."[22] In Paris, he began to compose his next picture, *The Declaration of Independence*, with Jefferson providing both a firsthand account of the event and a rough ground plan (Cat. 26) of the room in Independence Hall where the Declaration had been signed. Jefferson and Trumbull discussed the moment to be painted (the picture depicts not the signing, but the submission to Congress of the report by the committee that drafted it), whether signers who were not present or those who were present but did not sign should be included, and also considered other possible subjects for the series, including the 1778 treaty between France and America.[23]

On August 9, 1786, Trumbull visited Jacques-Louis David's apartments in the old Louvre and was shown *The Oath of the Horatii* (*Fig. 15*). One wonders whether Trumbull's response to it was not to some extent informed by his own earlier treatment of the theme of sworn vengeance, the 1777 *Brutus*. Nearby hung David's *Belisarius Receiving Alms*, and perhaps Trumbull told David that nine years earlier, he had also painted a *Belisarius*. The following day, August 10, David returned the visit and inspected Trumbull's *Bunker's Hill* and *Quebec*. "His commendation, I fear," Trumbull wrote, "was too much dictated by politeness."[24] A question arises concerning the relationship between the three riflemen on the left of *Quebec* and the similarly, although more tightly, aligned three brothers in David's *Horatii*. It seems unlikely that two such similar compositional elements could have been arrived at simultaneously. Since Trumbull in his *Autobiography* does not mention noticing any

22 Trumbull 1841, p. 113. Perhaps Rubens served Trumbull as a role model in life as well as art, since Trumbull similarly combined art with diplomatic activities at certain times in his career.

23 Jaffe 1975, p. 122. This interior scene with figures would have related both to the *Declaration* and to the projected but unpainted *Treaty of Peace*.

24 Trumbull 1841, p. 111.

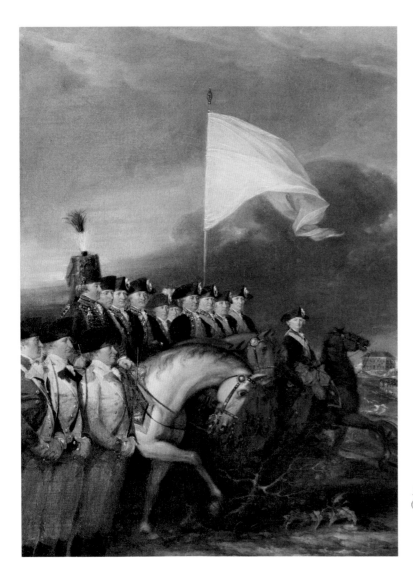

Fig. 16. The Surrender of Lord Cornwallis at Yorktown
(detail of Cat. 27).

similarities between his picture and David's, one is inclined to assume that Trumbull was influenced by David, although *Quebec* was presumably ready for the engravers when Trumbull brought it to Paris.

Trumbull returned to London in November 1786. From this point forward, perhaps as a result of the Paris trip and the stay with Jefferson, he placed greater emphasis in the series on the men who made history and on significant events rather than on scenes of action. This meant the inclusion of many more small portraits. Trumbull turned to the problem of completing the composition of the *Declaration* in order to prepare the canvas to receive portraits. As Copley had discovered with *Chatham*, the inherent compositional problems in such a subject were difficult to resolve. With the scene set in a single room and the floor establishing a flat horizontal plane, the options for posing figures were limited; it was difficult to avoid rows of heads and legs in a horizontal line. This pictorial type of small standing figures in an interior falls into the genre of the conversation piece. There was a substantial body of such work available to Trumbull in England, where the conversation piece had flourished for half a century.[25] Given the small size of Trumbull's canvases, the portraits to be included were necessarily miniatures, a mode of portraiture that he, unlike Copley, had not previously

25 Jaffe 1975, p. 109, suggests that multi-figured compositions by Johann Zoffany, such as his 1772 *Academicians of the Royal Academy*, may have been especially pertinent.

practiced. Yet Trumbull quickly developed his skill as a miniaturist, perhaps with an assist from Richard Cosway, the English miniaturist, whom he knew in Paris.[26] After his return to London, Trumbull also proceeded with *The Capture of the Hessians at Trenton* and *The Death of General Mercer*, and began *The Surrender of Lord Cornwallis at Yorktown (Fig. 16)*. By the end of 1787 Trumbull was able to return to Paris with the now fully composed *Declaration of Independence* and *Surrender of Lord Cornwallis*. He painted likenesses of Jefferson into the former and of fifteen French officers into the latter, noting that "I regard these as the best of my small portraits; they were painted from the life, in Mr. Jefferson's house."[27]

Before his first trip to Paris in 1786, Trumbull had conceived of painting a different kind of historical subject, *The Sortie Made by the Garrison of Gibraltar* (Cats. 10–13), which would have more appeal to a British audience than scenes from the War of Independence.[28] The Revolutionary War scenes "had given offence to some extra-patriotic people in England," Trumbull wrote later, and he therefore produced the *Sortie* to demonstrate that he intended to celebrate "noble and generous actions, by whomsoever performed."[29] In *Bunker's Hill*, Trumbull had in fact depicted a British victory in which the main protagonist is the British Major Small rather than the expiring American General Warren. Apparently the central message of the picture— that virtue transcended national boundaries— did not get through to an audience concerned that the scene was from a lost war. Therefore, in the *Sortie* Trumbull delivered the same universal message by depicting a British victory in which the protagonist is a Spaniard. The dying hero of *Sortie* is a young Spanish officer, Don José de Barboza, who fell in a doomed single-handed attack on the British when he was deserted by his comrades. Like Paulus Aemilius in Trumbull's earliest history painting, the gallant Spanish officer refused an offer to be removed to a place of greater safety, preferring to expire on the scene of battle.

When Trumbull started to make sketches for the *Sortie* in 1786, Copley was already at work on his mammoth *Siege of Gibraltar*, for which he had won a commission from the city of London in March 1783. West's resentment over losing that competition may have led him to encourage Trumbull to rival Copley with a similar subject. Trumbull, however, chose not to challenge Copley, with whom he was still on good terms and who continued to encourage him in the Revolutionary War series. Copley depicted the events of the final battle of September 13–14, 1782, in which the British garrison under General Elliot repulsed the Spanish "floating batteries" and broke the siege. Trumbull selected a different scene, painting the events of the night of November 26–27, 1781, when the British in a daring sortie destroyed the threatening Spanish breastworks. As in *Bunker's Hill*, Trumbull was strongly influenced compositionally by Copley's *Death of Major Peirson*.[30]

Trumbull first painted a small version of the *Sortie* (Cat. 10), which he gave to Benjamin West (suggesting that West did indeed have a special interest in the *Gibraltar* project). Discovering he had made an error in the color of the Spanish uniforms, Trumbull then made a second version, 20 x 30 inches (Cat. 11), the same size as the later Revolutionary War pictures. He then proceeded to paint the *Sortie* one-half life-size on a 6 x 9-foot canvas, the first large-scale history painting of his own composition. He exhibited this picture at Spring Gardens from April to July 1789, but, perhaps because of competition from the annual exhibition of the Royal Academy and the simultaneous opening of John Boydell's Shakespeare Gallery, it failed to attract much attention. Trumbull said he was offered 1200 guineas for the picture (an extraordinarily high sum, if accurate), but he declined,

26 I am indebted to Esther Thyssen for the suggestion of Trumbull's possible reliance on Cosway. For the similarity in style, see Cosway's miniature *Self-Portrait* (National Portrait Gallery, London) in Daphne Foskett, *British Portrait Miniatures*, London, 1968, fig. 82, opp. p. 97. Trumbull was Jefferson's confidant and go-between in the romantic interlude that took place between Jefferson and Cosway's wife, Maria Cosway, in the late summer of 1786.

27 Trumbull 1841, p. 151.

28 Trumbull later recalled that he undertook the *Sortie* in May 1787 upon being told the story of the event by Poggi (Trumbull 1841, p. 148); but extant drawings are dated a year earlier.

29 Trumbull 1841, p. 149.

30 Jaffe 1975, p. 138, has noted that Trumbull's *Sortie*, which was completed well before Copley's *Gibraltar*, influenced Copley in the design of the left-hand side of his picture.

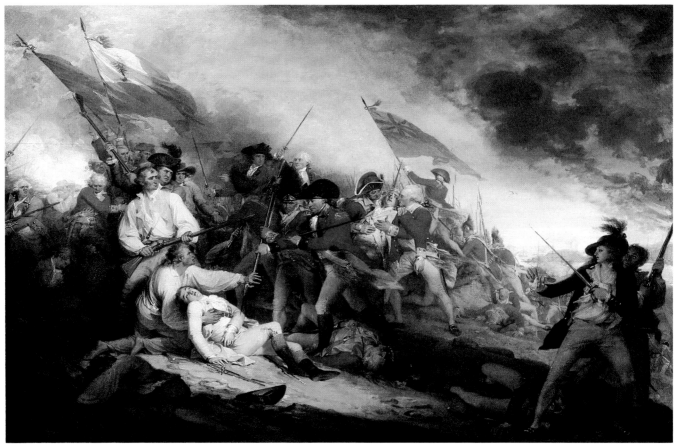

Fig. 17.

Fig. 18.

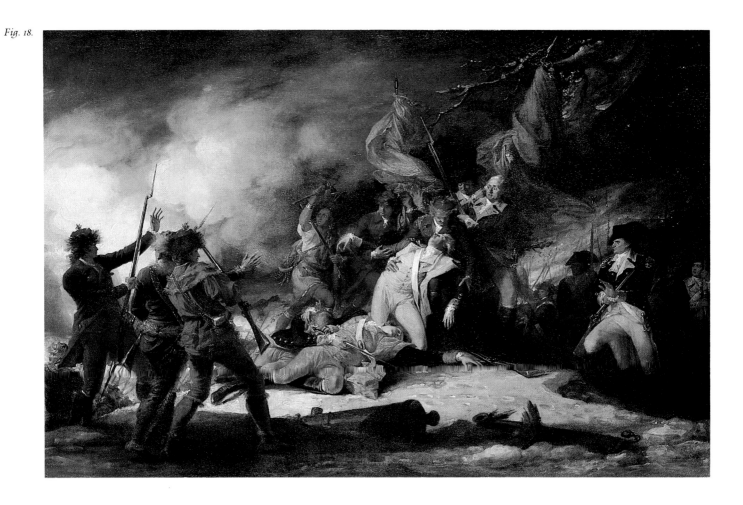

thinking, incorrectly as it turned out, that he would realize greater profit by exhibiting the picture, taking a subscription for prints, and then selling the painting later.

The time had now come, Trumbull felt, to return to America. First, he visited Paris briefly in the summer of 1789 to experience at first hand the beginnings of a revolution which he felt was the partial consequence of and parallel to the American Revolution. His decision to return to America arose from the need to secure portraits for the Revolutionary War series. The decision was not easy; Jefferson simultaneously offered him a post as private secretary in Paris, a sinecure that would have left Trumbull free to pursue his art in Europe. If he remained in Europe, he could continue as a history painter, but might well be condemned to permanent exile since there was little patronage for history painting in America. He hoped that the Revolutionary War project would find support in America, but he had to go there to find out. In America he could obtain the necessary portraits of Revolutionary War heroes before they passed from the scene; he could test American interest in subscribing to engravings of the series; and he could satisfy the moral imperative he felt as the only person both to have been involved personally in the Revolutionary War and able as a history painter to record the heroic deeds and moral achievements for posterity. Trumbull set forth his thoughts and purposes in a letter dated June 11, 1789, declining Jefferson's invitation to be his secretary:

> The greatest motives I had or have for engaging in, or for continuing my pursuit of painting, has been the wish of commemorating the great events of our country's revolution. I am fully sensible that the profession, as it is generally practiced, is frivolous, little useful to society, and unworthy of a man who has talents for more serious pursuits. But, to preserve and diffuse the memory of the noblest series of actions which have ever presented themselves in the history of man; to give the present and the future sons of oppression and misfortune, such glorious lessons of their rights, and of the spirit with which they should assert and support them, and even to transmit to their descendants, the personal resemblance of those who have been the great actors in those illustrious scenes, were objects which gave a dignity to the profession, peculiar to my situation. And some superiority also arose from my having borne personally a humble part in the great events which I was to describe. No one lives with me possessing this advantage, and no one can come after me to divide the honor of truth and authenticity, however easily I may hereafter be exceeded in elegance. Vanity was thus on the side of duty, and I flattered myself that by devoting a few years of life to this object, I did not make an absolute waste of time, or squander uselessly, talents from which my country might justly demand more valuable services; and I feel some honest pride in the prospect of accomplishing a work, such as had never been done before, and in which it was not easy that I should have a rival.[31]

The letter also indicated that Trumbull considered the exhibition of his *Sortie* as a test of how the public would respond to his work, and its completion as the last step in preparing for his great work on the Revolutionary War. He considered the small pictures he had made of Revolutionary War scenes as studies, like the oil sketches of Rubens, from which he would ultimately make large finished pictures on the half-life scale of the *Sortie*, or larger.

Trumbull arrived in New York in November 1789. He had with him the three battle scenes— *Bunker's Hill*, *Quebec* and *Princeton*— and the unfinished ceremonial scenes— the *Declaration* and the surrenders at *Trenton* and *Yorktown*, all of which awaited the portraits he now intended to secure. On January 23, 1790, in the *Gazette of the United States*, he announced his artistic project to the American

31 Trumbull 1841, pp. 157–58.

Fig. 17. The Death of General Warren at the Battle of Bunker's Hill (Cat. 4).

Fig. 18. The Death of General Montgomery in the Attack on Quebec (Cat. 7).

public, a series of thirteen subjects that would be painted and engraved— the eight that ultimately were completed (the six already begun plus *The Surrender of General Burgoyne at Saratoga*, Cat. 30, and *The Resignation of General Washington*, Cat. 31) and five other subjects: *The Treaty with France*, *The Treaty of Peace*, *The Evacuation of New York by the British*, *The President Received by the Ladies of Trenton at the Arch*, and *The Inauguration of the President*. A broadside published on April 2, 1790, added one more subject to the list, *The Battle of Eutaw Springs*.[32]

In New York, Trumbull painted Washington into *Trenton* and *Princeton* in February and March, and made a number of other portraits for the *Declaration* and *Yorktown*. Now he was ready to travel to get other portraits. During the next few years, he went north to Newport, Providence, Boston, and New Hampshire, and south to Philadelphia, Charleston, Yorktown (where he drew the site of the *Surrender*), Williamsburg, Richmond, and Fredericksburg. If the compositions were sufficiently advanced, he painted portraits directly onto the canvas; if the pictures were still in the planning stage, he painted miniature portraits on small mahogany panels. The collection at Yale includes a number of miniatures painted in Charleston in 1791 for *The Battle of Eutaw Springs*, in Philadelphia in 1792 for *The Inauguration of the President*, and others perhaps intended for *The Treaty with France* and *The Treaty of Peace*, as well as some for *Saratoga* and *The Resignation of General Washington*, which were eventually incorporated into completed pictures.[33] If the intended sitter was no longer alive, Trumbull relied on surviving portraits or, if necessary, took portraits of sons as substitute likenesses (see Cat. 106).

After initial neglect, the response to Trumbull's proposed subscription for engravings picked up when some of the distinguished national figures whose miniature portraits he painted subscribed, but then interest slackened again. By 1793, the entire project had slowed down. As political and economic problems accumulated for the new Republic, the times became less propitious for patronage of Trumbull's idealistic artistic venture. Moreover, the excesses of the French Revolution made Americans less enthusiastic about the idea of revolutions in general, even their own.

In the end, Trumbull's trip provided him with a negative answer to the question of whether America would support ventures in nationalistic history painting. In 1794, thirty-eight years old, with limited artistic prospects, Trumbull decided to pursue a different direction. He sailed for England in May as secretary to John Jay on a diplomatic mission which led to the signing of the Jay Treaty in November. Trumbull then went to Stuttgart, where Müller was engraving *Bunker's Hill*, but his interests had moved away from art. On his return to London, Trumbull was appointed to a commission adjudicating claims involving British and American shippers and imprisoned American seamen.

In 1797, Trumbull traveled to Stuttgart once more, this time to retrieve *Bunker's Hill* and Müller's completed engraved copper plate. Returning to London via Paris, he became involved in a high level diplomatic intrigue. He was eyed suspiciously by the authorities, and eventually seemed quite threatened, managing to get out of France only through the good offices of his old friend David, who accompanied him to the appropriate officials and displayed *Bunker's Hill* as proof that Trumbull was anti-British and possessed of a true revolutionary spirit. When he left Paris, Trumbull "carried the first XYZ dispatches out of France."[34]

Trumbull effectively had stopped painting for seven years, but in the wake of his unexpected marriage to Sarah Harvey in 1800 (see Cat. 112) he began to paint again. In the summer of 1804, Trumbull returned to New York. He exhibited Old Master paintings acquired in Paris along with *Sortie*, *Bunker's Hill*, *Quebec*, and his own "Old Master" exercise, the *Madonna au Corset Rouge* after

32 Jaffe 1975, p. 154. *The Treaty of Peace*, for which an ink sketch and some miniature portraits survive (see pp. 133–34 below), may have been intended to represent either the preliminary treaty of November 30, 1782 or, more likely, the final Treaty of Paris on September 3, 1783; see Sizer 1967, p. 101.

33 Of the surviving individual miniatures, the largest groups are nineteen intended for the *Inauguration*, eight for *Saratoga*, and five each for *Eutaw Springs* and the *Resignation*; this count is approximate because of uncertainty about the intended destination of some of the miniatures.

34 Jaffe 1975, p. 177.

Fig. 19. Peter the Great at the Capture of Narva, 1812. New Haven, Yale
University Art Gallery; Trumbull Collection.

Raphael (*Fig. 71*). He was elected to the board of directors of the recently founded American Academy of the Fine Arts, and became vice-president of the Academy in 1808. In that year he returned to London, in part to secure medical treatment for his bad eye and in part because, as in 1793, adverse economic conditions in America reduced patronage.[35]

In England, Trumbull painted mostly religious and literary subjects, influenced in the former by the recent triumphs of the elderly Benjamin West. Only one history painting dates from this period, *Peter the Great at the Capture of Narva* (*Fig. 19*) of 1812, which was exhibited at the British Institution in 1813. Like the earlier historical scenes, it deals with the subject of heroism and magnanimity. Peter the Great places his blood-drenched sword on a table, having put an end to his army's rapacious slaughter of innocent women and children by personally slaying a few of his own soldiers.

At the outset of the War of 1812, Trumbull was stuck in London against his wishes, and could not get back to New York until August 1815. He found the America of 1815 a different place in terms of mood and outlook from the economically depressed and politically entangled country he had left in 1808. In the wake of the War of 1812 patriotism was back in style, and with it an interest in history paintings celebrating great moments in American history. The city of Baltimore was interested in commissioning history paintings to commemorate the death of General Ross at North Point and the attack on Fort McHenry by the British ships. Trumbull visited the sites at the end of 1815 and made proposals, but the city finally decided not to pursue the project.[36] A year later, however, he had better luck in Washington with a more ambitious proposal for the Rotunda of the Capitol. In January 1817, he set up his small, as yet unfinished, *Declaration of Independence* in the hall of the House of Representatives, and also had with him *Trenton*, *Princeton*, and *Yorktown*. With uncharacteristic tact, he did not show his two best pictures, *Bunker's Hill* and *Quebec*, which were scenes of American defeats. The lobbying paid off. President Madison was authorized by the House of Representatives on January 27, 1817, to select four pictures to be painted by Trumbull for the Rotunda. He was surprised when Madison decided on large pictures— 12 x 18 feet, that is, life-size— rather than the half-scale of the earlier *Sortie* (see p. 264). Trumbull and Madison agreed upon two military scenes— the surrenders of entire British armies at Saratoga and Yorktown— and two civil scenes— *The Declaration of Independence* and *The Resignation of General Washington*. Two of these— *Saratoga* and the *Resignation*— were new pictures, long planned but uncomposed. The artist was to be paid 8000 dollars for each picture, a total of 32,000 dollars. Trumbull's career was revitalized and the sharp

35 Ibid., p. 221.
36 Trumbull 1841, p. 261.

improvement in his fortunes was echoed in his election as president of the American Academy of the Fine Arts in New York, a post to which he was re-elected annually for the next nineteen years.

When Trumbull set to work on the enlarged *Declaration*, he also revived his earlier idea of having his pictures engraved. He wisely chose a young American, Asher B. Durand, for the *Declaration*, rather than an English engraver, a decision which saved him money, gratified national sensibilities, and led to an excellent result. When the large *Declaration* was completed, Trumbull exhibited it in New York at the American Academy in October 1818, and then took it on tour to Boston (Faneuil Hall), Philadelphia (Independence Hall in the room where the original signing had taken place), and Baltimore. The tour was a success, the culmination of prolonged artistic effort, the realization of Trumbull's most profound artistic aspirations, and in fact the crowning moment of his career.

In March 1819, Trumbull began *Yorktown*, and finished it the following year. It too was taken on tour, but with less satisfactory results. Next Trumbull turned to *Saratoga*, a picture for which there was no existing preliminary sketch. In developing the composition, Trumbull was influenced by West's series of scenes from the life of Edward III done for the Audience Chamber at Windsor Castle in 1787–89 when Trumbull had worked as West's assistant.[37] The placement of Major Ebenezer Stevens leaning on a cannon in the right foreground is a prominent reminder of Trumbull's own involvement in the campaign that led to Burgoyne's surrender. It was from Stevens that Trumbull had secured a cannon in order to prove his point about the military threat of Mount Defiance to the American position.[38]

Finally, Trumbull composed and painted the *Resignation* in 1822–24 as a pendant to the *Declaration*. The completion of the *Resignation* coincided with a severe personal loss to Trumbull, the death of his wife. To get his mind off of his unhappiness, the artist took the *Resignation* on tour, but the response was disappointing.

In November 1826, in the wake of the fiftieth anniversary of the Declaration of Independence and the remarkable coincidence of the simultaneous deaths of Jefferson and Adams on July 4, all of which focused attention on the passing of the nation's founding heroes into history, Trumbull's four large pictures were installed in Bulfinch's new Capitol Rotunda. The seventy-year-old Trumbull thereupon launched an unsuccessful campaign for a commission to fill the four remaining vacant panels (these eventually were done by other artists).[39] Subsequently, Trumbull's work as a history painter consisted largely of repetitions of works already painted, notably the half-size replicas of the Revolutionary War series for the Wadsworth Atheneum in Hartford.

Trumbull carefully cultivated his image as patriot-artist during his final years, the years of the establishment of the art gallery at Yale and the writing of his *Autobiography*. Although his brief military service alone would hardly seem to validate his public use of a military title and the excessive

37 Jaffe 1975, p. 246 and fig. 176.

38 While serving under General Gates in northern New York at Fort Ticonderoga in 1776, Trumbull argued with Gates' principal officers that Mount Defiance, which overlooked the American positions, could be occupied and used by the enemy; the other officers felt that it was inaccessible, out of range, and irrelevant. Trumbull secured a cannon and demonstrated that Mount Defiance was in fact within range. Furthermore, with General Benedict Arnold and Colonel Anthony Wayne, he scaled the hill to prove that it could be occupied and fortified by the enemy. Then he drew up two memoranda detailing the alternative costs in terms of men and supplies of 1) defending Ticonderoga from the present positions, or 2) fortifying Mount Defiance. Trumbull's recommendation of the latter course was not followed. With some gratification, he noted later that when the British eventually attacked, General Burgoyne took Mount Defiance and "as I had predicted, the whole position became untenable" (Trumbull 1841, p. 34).

39 In response to some criticism "in and outside of Congress" of the four Rotunda paintings, Trumbull compiled and sent to Edward Everett on January 12, 1827 (YUL-JT), a list and account of other living American artists who had at one time or another painted history pictures: Charles Willson Peale, John Vanderlyn, Washington Allston, William Dunlap, Henry Sargent, Raphaelle Peale, Thomas Sully and Samuel F. B. Morse. All painted portraits, and Trumbull observed: "Portrait painters are many, but the difference between portrait and historical painting is almost the Same as that between a Cabinet-maker and an Architect— a man may produce exquisite cabinet work, who would be utterly incapable of combining the vast and varied Magnificence of the Capitol." He observed that among all the artists listed "you find not one instance of any attempt to record the Glory of our Country"; quoted in Sizer 1953, pp. 369–71. Obviously Trumbull felt he was the only artist qualified to paint the remaining panels.

pride he took in being one of the last surviving Revolutionary War officers, it must be said that throughout his life Trumbull's patriotism was constant; he served his country in various capacities, some of which may have been secret; and surely his extraordinary dedication to recording artistically the heroes and great events of the Revolutionary era justifies his pretensions. What Trumbull neglected to indicate openly, perhaps because it would not have gone down well in Jacksonian America, was the aristocratic bias of his patriotic values. His pictures celebrated classical virtues, and these virtues were invariably displayed by leaders— Paulus Aemilius and Brutus, George Washington and Major Small, Don José de Barboza and Peter the Great— an aristocratic officer class that transcended the barriers of time or nation.

There is a paradox here. Trumbull's aristocratic viewpoint manifests itself in the heroic subject matter of his art, the emphasis on family genealogy in his *Autobiography*, the disdain he expressed for rabble-rousers in Boston in 1778 and in Paris fifteen years after, and, in later years, as president of the American Academy of the Fine Arts, in his autocratic treatment of students. On the other hand, Trumbull was not snobbish in human relations. The resolution of the paradox, of his conflicting aristocratic instincts and democratic inclinations, resides in Trumbull's paintings. They convey his apparently fundamental conviction that American democracy would make aristocratic virtues and values the common property of all. The purpose of his Revolutionary War series was didactic, to promulgate the values of the Revolutionary generation as the heritage of all Americans. And his benefaction to Yale had the same fundamental purpose, to enlighten future generations of students in regard to the values of the past.

I

The Death of Paulus Aemilius
at the Battle of Cannae

1773

Oil on canvas, 24½ x 34¹³/₁₆ (62.2 x 88.4)

Inscribed: lower center, *Animaeq magnae Prodigum Paulum* [sic] | *Superante Poeno.*; verso (covered in relining), *Battle of Cannae.* | *John Trumbull Inc! u Px!* | *Æt.17*

Yale University Art Gallery; Trumbull Collection

An avid reader from his youth, Trumbull developed many of the tastes of his European contemporaries— including a respect for the great deeds of the past and for literature and art that instructed men's moral sensibilities. In his *Autobiography*, he recalled that among the books he "read with care" was Charles Rollin's *Roman History*, an eighteenth-century French moralizing chronicle contrasting virtuous and vicious deeds of antique figures. Trumbull referred to the story of Paulus Aemilius' death as "a passage of Roman history which I had always admired."[1]

In 216 B.C., Consul Paulus Aemilius was co-commander of the Roman army seeking to vanquish the Carthaginian forces led by Hannibal. Toward the end of the battle at Cannae, when the Romans' defeat was certain, a tribune offered the wounded Paulus Aemilius his horse so that the consul could escape death at the hands of the enemy. Knowing he was near death, Paulus Aemilius did not permit his selfless tribune to die through a "useless compassion." Instead, he urged him to ride the horse to Rome and warn the city to arm itself. The tribune fled, and one of the enemy killed the consul without knowing who he was.[2]

Trumbull wrote that *The Death of Paulus Aemilius* was "my first attempt at composition."[3] Executed at his parents' home in Lebanon, Connecticut, shortly after he graduated from Harvard, the painting was created "by selecting from various engravings such figures as suited my purpose, combining them into groups and coloring them from my own imagination."[4] Gravelot's engraving of *Hannibal after the Battle of Cannae* (Fig. 20) appears to be the principal source for the figures on the left side of the painting. Trumbull rearranged several of the Gravelot figures, however, placing the prone soldier in the right foreground of the engraving between two middle-ground pairs of soldiers from the engraving's left side. The horse offered to Paulus Aemilius derives from the engraving by F. Hayman and C. Grignion, *Pompey when Consul, passing Review and leading his Horse before the Censors*. For his colors "from imagination," Trumbull relied on a palette dominated by pinks and blues.

Both the Gravelot and Hayman/Grignion engravings appeared in the early English editions of Rollin's *Roman History*.[5] Rollin's writings, informed by his belief that "History shews by a thousand examples . . . that nothing is great and commendable but honor and probity," achieved wide popularity in the eighteenth century.[6] Because the accompanying engravings illustrated episodes important to Rollin's narratives, a number of Neoclassical artists based figures in their paintings on these images.

Trumbull also relied upon Rollin's description of the Battle of Cannae. Rollin relates how Hannibal disposed

Fig. 20. Hubert Gravelot, *Hannibal after the Battle of Cannae*, 1742. Engraving from Charles Rollin, *The Roman History*, London, 1768.

his army so that the dust raised by the wind blew into the faces of the Romans;[7] in Trumbull's painting, clouds of dust obscure the distant figures. Rollin also describes the battle in terms of sweeping masses of horses and men— but focuses on the exchange between the consul and his tribune. Trumbull's representation, with Paulus Aemilius' sacrifice as its central and largest event, is the visual equivalent of Rollin's narrative. And where Rollin had included a passage from Horace in the margin of his text, "Animaeq magnae prodigum Paulum, superante Poeno,"[8] Trumbull inscribed these words across the bottom of his canvas.

Rollin's representations of heroism had left their mark on the young artist. On the eve of the Revolutionary War, Trumbull wrote that "the characters of Brutus, of Paulus Emilius, of the Scipios, were fresh in my remembrance, and their devoted patriotism always before my eye."[9] Believing that the image of men dying for their country evoked virtue and heroism, Trumbull would often feature a soldier's death in his later history paintings.[10]

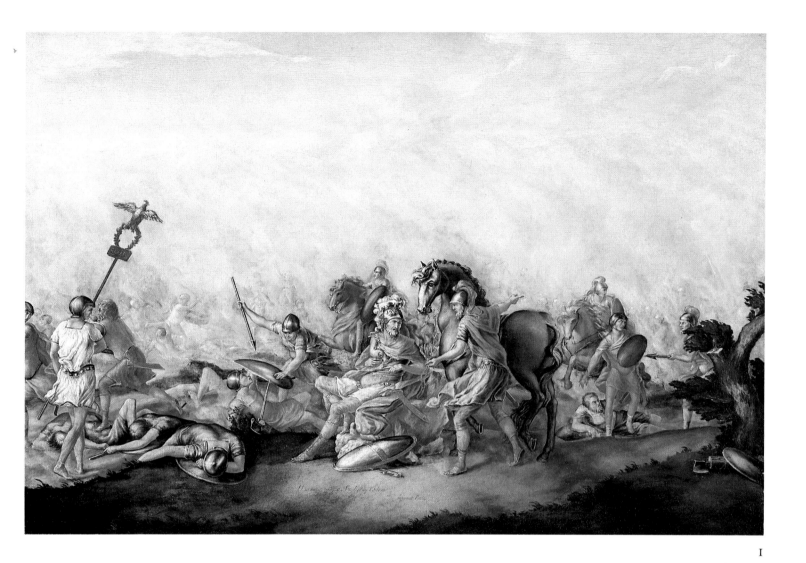

I

1 Trumbull 1841, pp. 9, 14.
2 Rollin 1768, III, p. 473.
3 Trumbull 1841, p. 60.
4 Ibid., p. 14.
5 In the third edition (1768) of *Roman History*, the Gravelot engraving faces p. 495 of volume III; the Hayman/Grignion plate is the frontispiece to the same volume.
6 From Rollin's *The Method of Teaching and Studying the Belles Lettres*, quoted in Peter Walch, "Charles Rollin and Early Neoclassicism," *The Art Bulletin*, 49 (1967), p. 126.
7 Rollin 1768, III, p. 470.
8 Ibid., p. 472: "Paulus generous of his noble life when the Carthaginians were winning"; *Odes*, I, 12, 38.
9 Trumbull 1841, p. 15.
10 Silliman, "Notebook," II, p. 112, recorded that Trumbull preserved *Paulus Aemilius* "chiefly as a maiden effort and a part of the History of American art."

Brutus and His Friends
at the Death of Lucretia

1777

Oil on canvas, 39½ x 49 (100.3 x 124.5)
Yale University Art Gallery; Gift from the Heirs of
David Trumbull Lanman

The death of Lucretia is recounted in Livy's *History of Rome* (I, 57–59). Raped by the wicked son of the unpopular King Tarquinius Superbus, the grief-stricken Lucretia received a promise of vengeance from her family, then produced a dagger from her robe and killed herself. Her cousin Lucius Junius Brutus seized the dagger and, holding the blade aloft, had his friends join him in swearing an oath against the king and his family.

In Trumbull's "Account of Paintings," he wrote that his depiction of this scene was "partly copied from a print after Gavin Hamilton, & partly original."[1] The print was Domenico Cunego's well-known engraving after Hamilton's *The Oath of Brutus* (*Fig. 23*), which shows the moment when Brutus became the leader of the revolutionary movement against Tarquinius.[2] The "partly original" aspect involved changes that Trumbull made in Hamilton's design, along with the addition of details from other engravings.

From Hamilton, Trumbull appropriated the pairs of figures flanking Brutus, but he made them less muscular. Their limbs no longer form energetic rhythms across the picture plane; Lucretia does not clutch Brutus' robe, but rests her hand in her lap. For Brutus, Trumbull evolved a different figure and rethought its compositional placement. The result was an interpretation which departed significantly from Hamilton's. Turning away from his compatriots, Trumbull's Brutus conveys the sense that his experience is an individual one.

Hamilton's painting, with the impassioned gesture of Brutus, captured the violent tone of Livy's description: Brutus' knife is "dripping with gore," as he swears to pursue the Tarquins with "whatever violence [he] may."[3] Charles Rollin's version of Brutus' oath in his *Roman History*, a book much admired by Trumbull (see Cat. 1), omits these phrases. Rollin wrote that Brutus, a descendant of one of Aeneas' followers, "received a happy education, which formed his manners to the genius of the nation. He had great endowments, as well of nature as art."[4] Like Rollin, Trumbull seems more concerned with the moral sensibility that guided Brutus.

This concern may explain Trumbull's choice of sources for the Brutus figure. Brutus' turned head and upraised eyes resemble Charles Le Brun's design for *Ravissement*, or "Rapture" (*Fig. 21*), described in editions of Le Brun as a transporting emotion— admiration or veneration for things of spiritual value.[5] It is an apposite facial expression for Brutus, now guided by motivations higher than vengeance. Brutus' posture and billowing cape derive from the figure of Virginius in Gravelot's illustration of *The Death of Virginia* (*Fig. 22*), another subject dealing with a revolt that followed a ruler's attempt to usurp a maiden's honor. The engraving illustrated the story in Rollin's *Roman History*.[6] Significantly, Gravelot's Virginius was the subject of Trumbull's earliest surviving work in oil,[7] and the specific change Trumbull made at that

Fig. 21. (Above) Charles Le Brun (after), *Le Ravissement*. Engraving from *Conference . . . sur l'Expression . . . des Passions*, Verona, 1751. Cambridge, Mass., The Houghton Library, Harvard University, Department of Printing and Graphic Arts.

Fig. 22. (Opposite, left) Hubert Gravelot, *The Death of Virginia*, 1739. Engraving from Charles Rollin, *The Roman History*, London, 1768.

Fig. 23. (Opposite, right) Domenico Cunego (after Gavin Hamilton), *The Oath of Brutus*, 1768, engraving. London, The Trustees of the British Museum.

time— turning Virginius' grasping hand into a pointing one— recurs in the *Brutus*. But, in keeping with the meditative tone of *Brutus and His Friends*, Trumbull lowered Virginius' upraised arm, repeating the pose he had used several years earlier in *St. Paul at Athens* (Cat. 132). For Lucretia's kneeling attendant, Trumbull conflated the kneeling figures from *The Death of Virginia* and from Valentine Green's mezzotint after Benjamin West's *Elisha Restoring the Shunammite's Son*, which Trumbull copied in full that same year (see *Fig. 7*).

1 Trumbull, "Account of Paintings," I, no. 29.
2 Hamilton appears to have been the first artist to represent this moment; see Robert Rosenblum, "Gavin Hamilton's 'Brutus' and Its Aftermath," *The Burlington Magazine*, 103 (1961), pp. 8–16.
3 Livy, *History of Rome* (I, 59, 1).
4 Rollin 1768, I, p. 155.
5 Le Brun's famous compendium of facial expressions was engraved and published in many editions throughout the eighteenth century. Trumbull copied ten of Le Brun's designs into his sketchbook "Early Sketches and Drawings," YU-B.
6 Rollin 1768, I, pp. 401–10. *The Death of Virginia* faces p. 406.
7 Sizer 1967, p. 94. Sizer incorrectly identifies the work as *Brutus* (Caesar's assassin) *Brandishing a Dagger* (Wadsworth Atheneum).

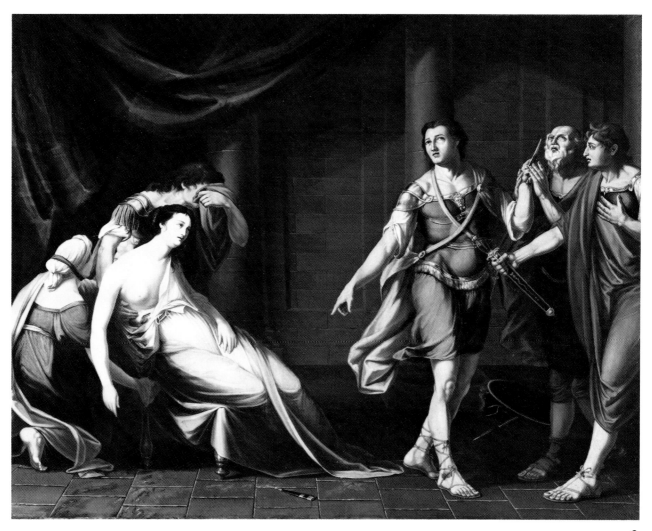

2

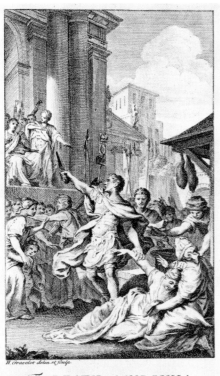

The DEATH of VIRGINIA.

Publish'd Nov.16.1739. by J.&P.Knapton.

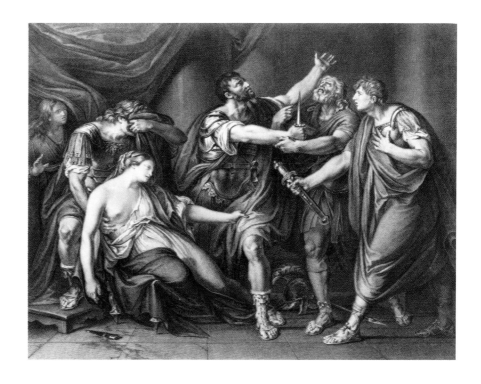

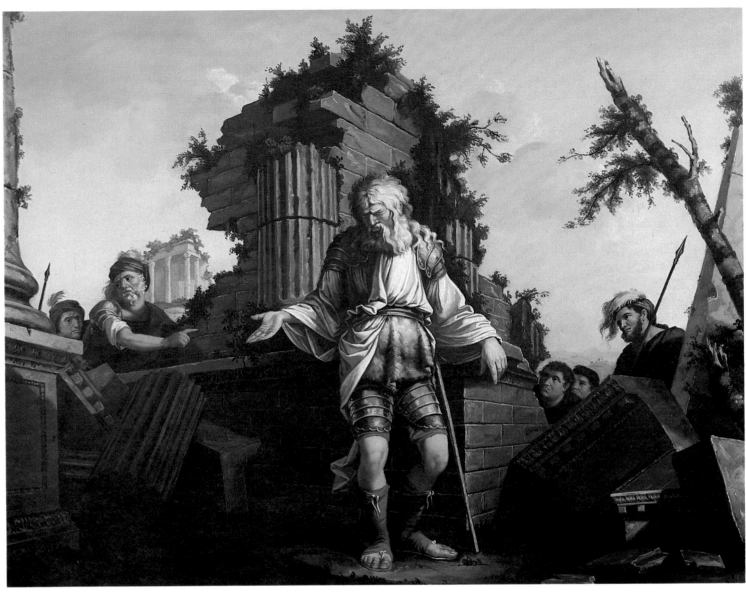

3

3
Belisarius

1778 or 1779[1]
Oil on canvas, 40 x 50 (101.6 x 127)
Wadsworth Atheneum; Gift of Mrs. Henry A. Stickney

The story of Belisarius, the commander-in-chief of Emperor Justinian's armies in the sixth century, would have been familiar to Trumbull from a variety of literary sources. As the contemporaneous historian Procopius wrote in his *Secret History*, Belisarius acquired such wealth and power that he aroused the jealousy of Empress Theodora. She persuaded her husband to deprive the general of his command, a change of fortune that revealed Belisarius' true cowardly character. He became fearful of assassination, greedy for new wealth, and inconstant to his friends.[2] By the eighteenth century, this account of Belisarius' life had been superseded by a romanticized version in which the noble general was not only stripped of power, but blinded and reduced to beggary by an ungrateful emperor.[3]

Jaffe has pointed out[4] that the theme of an unjustly treated soldier must have had special significance for Trumbull in the years immediately following the controversy over the date of his commission in the army (see p. 4). Years later, recalling his bitter feelings during this period, Trumbull wrote: "A deep and settled regret of the military career from which I had been driven, and to which there appeared to be no possibility of an honorable return, preyed upon my spirits; and the sound of a drum frequently called an involuntary tear to my eye."[5] However, Trumbull's choice of the Belisarius theme was probably motivated as much by a desire to imitate the great masters of European painting as it may have been by his personal melancholy. He noted many years later that he copied the figure of Belisarius, as well as elements in the right half of the picture, "from Strange's engraving, after Salvator Rosa" (*Fig. 24*).[6]

The changes Trumbull made when copying the engraving indicated that he wished to emphasize the pathetic aspects of the romanticized Belisarius story. By shifting from a vertical to a horizontal format, he was able to augment the background ruins. The enlarged composition allowed Trumbull to give greater prominence to the subsidiary figures, particularly the dramatically gesturing figure at the left. These changes paralleled Diderot's commentary on a *Belisarius* by Van Dyck, in which he noted that the spectator figures were crucial to the painting, because their reactions as spectators to Belisarius' condition suggested the appropriate reaction for real-life spectators of the painting.[7]

When compiling lists of his earlier works, Trumbull was uncertain as to when he had completed this painting. In his "Account of Paintings," the artist grouped it with works completed at Boston in 1778, but then noted in the margin, "I believe at Lebanon." When he wrote his *Autobiography* in 1841, he apparently changed his mind again, and gave Boston 1779 as its place and date of execution.[8] Trumbull's use of a print suggests that it may have been painted in Lebanon, since a number of his efforts there were based on prints; the majority of his Boston works seem to have been copies after paintings in Smibert's studio or portraits done from life. On the other

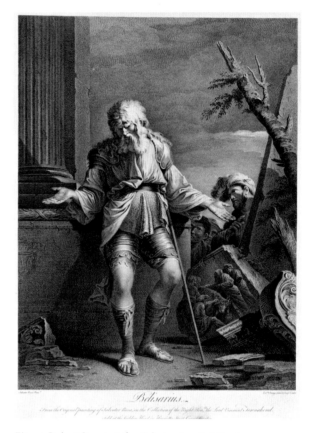

hand, Trumbull's handling of paint in this picture seems considerably more advanced than such Lebanon canvases as the *Brutus* of 1777 (Cat. 2), a change that might have resulted from the experience of studying the paintings in Smibert's Boston studio. Possibly he began the picture in Lebanon, and completed it in Boston. The broader brushstrokes and touches of pure color in Belisarius' armor and costume foreshadow the changes in Trumbull's technique after his first trip to England.

1 Trumbull's original title for this painting was *Belisarius*; see "Account of Paintings," I, no. 61, and Trumbull 1841, p. 62. Sizer referred to it by the same name in the 1950 edition of the *Works*, but in the 1967 revision he changed the title to *The Blind Belisarius*, a form never used by the artist. Jaffe likewise called it *The Blind Belisarius* in her 1975 monograph.
2 Procopius of Caesaria, *The Anecdota, or Secret History*, H. B. Dewing, trans., Cambridge, Mass., 1935, pp. 48–55.
3 Michael Fried, *Absorption and Theatricality: Painting and Beholder in the Age of Diderot*, Berkeley and Los Angeles, 1980, pp. 147–50.
4 Jaffe 1975, p. 37.
5 Trumbull 1841, p. 51.
6 Ibid., p. 62. In 1758, one year before he left for Europe, the young Benjamin West had also produced a painting after Strange's print of Rosa's *Belisarius*; see John Galt, *The Life, Studies, and Works of Benjamin West, Esq.*, London, 1820, part I, p. 83.
7 Fried, *Absorption and Theatricality*, pp. 147–50.
8 Trumbull 1841, p. 62.

4
The Death of General Warren
at the Battle of Bunker's Hill,
June 17, 1775

1786
Oil on canvas, 25 x 34 (63.5 x 86.4)
Inscribed, lower center: *Jnº Trumbull. | 1786.*
Yale University Art Gallery; Trumbull Collection

5
Study for The Death of General Warren
at the Battle of Bunker's Hill

1785
Pen and ink, wash, and pencil on paper, 9¼ x 7½
(23.5 x 19.1)
The Historical Society of Pennsylvania

6
Lieutenant Thomas Grosvenor
and His Negro Servant

c.1797
Oil on wood, 15 x 11⅝ (38.1 x 29.5)
Yale University Art Gallery; The Mabel Brady Garvan
 Collection

Trumbull began the series of scenes of the American Revolution with *The Death of General Warren at the Battle of Bunker's Hill* because he considered this battle the earliest important event in the war.[1] He had witnessed the smoke and fire of the battle through field glasses on June 17, 1775, while stationed across Boston Harbor at Roxbury.[2] The confrontation took place on Breed's Hill, when the British, then occupying Boston, attempted to claim the strategically important heights of Charlestown and Dorchester. In order to prevent the enemy from gaining this advantage, William Prescott and Israel Putnam, with 1200 men, erected fortifications on Bunker and Breed's Hill. At daybreak the British discovered the redoubt on Breed's Hill and their warships stationed on the Charles River opened fire. The bombardment was followed by two unsuccessful attacks by foot-soldiers. When 1400 fresh British troops arrived for the third assault, hand-to-hand combat resulted, and the Americans slowly had to yield their defenses. Although the British grenadiers gained the ground, they lost 1150 men, nearly three times the losses suffered by the Americans.

Bunker's Hill represents the moment when General Joseph Warren is killed by a musket ball through the head,
just as the British successfully press beyond the American fortifications. The British Major John Small is shown attempting to save Warren from being bayonetted by a grenadier, who means to avenge the death of an officer who has fallen at his feet.[3] Directly behind Small, Major John Pitcairn of the British marines falls dying into the arms of his son; at the far left of the canvas, General Putnam of Connecticut, with an upraised sword, orders the Americans to retreat. General William Howe, commander of the British forces, wearing a black hat, is seen next to the Bunker Hill flag in the center background, together with the white-haired General Henry Clinton. In the right foreground, Lieutenant Thomas Grosvenor of Connecticut, wounded in his breast and sword hand, is shown with his servant, about to retreat, as Putnam has ordered, yet transfixed by the sight of the dying General Warren.[4]

William Dunlap criticized Trumbull for his selection and handling of the scene:

> The death of Doctor Warren . . . is an incident of minor consequence compared with the repeated defeats of the veterans of Great Britain, by Prescott, Putnam and the brave undisciplined Yankee yeomen. . . . Surely one of these moments of triumph might have been chosen by an American painter for his picture. *Then* Prescott, Warren, and Putnam would have been the heroes, instead of Small, Howe and Clinton.[5]

However, Trumbull did not intend to make *Bunker's Hill* an eyewitness account of the major events of the battle. Like West, in whose London studio Trumbull first considered painting scenes of the Revolution, Trumbull's primary aim in his history paintings was to convey a moral message.[6] The focus of *Bunker's Hill* is not on the outcome of the encounter, but on the noble behavior of the participants. The artist emphasizes the incident of Major Small arresting the grenadier's bayonet in order to honor an officer whom he praised as "equally distinguished by acts of humanity and kindness to his enemies, as by bravery and fidelity to the cause he served."[7]

It is significant that the incident which became the focus of the painting does not appear in any of the known preparatory drawings. Rather, the studies show the same kind of focus on a national hero that appeared in West's *Death of General Wolfe (Fig. 9)* and Copley's *Death of Major Peirson (Fig. 14)*. The influence of the earlier paintings is also evident in the development of the composition for *Bunker's Hill*. In the first extant preparatory drawing (*Fig. 25*), executed in pencil, Trumbull adapted the motif of a dying hero surrounded by his comrades from West's *Wolfe*. In a later drawing in pen, ink, and wash (*Fig. 26*), he elaborated the costume and background details, and added at the left a pair of fleeing figures, a motif similar to that in Copley's *Peirson*. Both drawings feature the frieze-like arrangement of figures seen in *Wolfe* and *Peirson*.

In developing and clarifying his composition, Trumbull shifted figures from one side to the other. The figure of General Putnam, for example, located beneath the Patriot flag on the far right in the wash drawing, is seen brandishing a sword at the extreme left of the final painting. In a wash detail study (Cat. 5), squared for transfer, Trumbull moved the dying Warren from the right of the sheet to the left, and the pair of fleeing figures from the left to the right, the positions they would retain in the

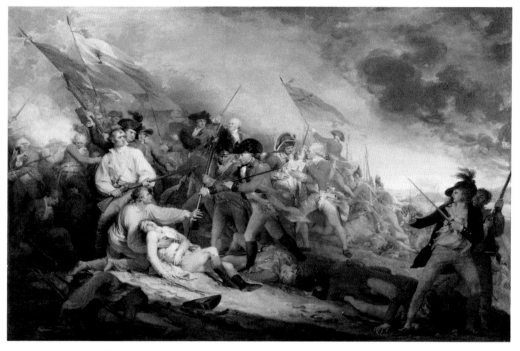

4 *Color reproduction, Fig. 17*

Fig. 25. Study for *The Death of General Warren at the Battle of Bunker's Hill*, 1785. Philadelphia, The Historical Society of Pennsylvania.

Fig. 26. Study for *The Death of General Warren at the Battle of Bunker's Hill*, 1785. Collection of Susan Silliman Pearson.

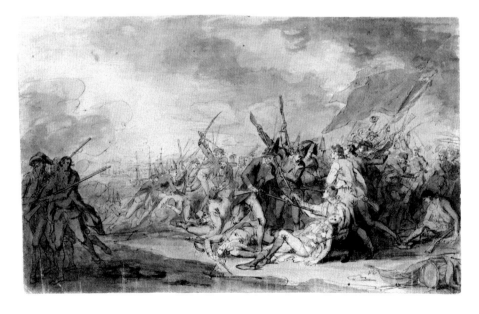

painting. Although clearly influenced by West and Copley, Trumbull attempted to go beyond them in *Bunker's Hill*. West's *Death of General Wolfe* is essentially a calm, classical scene of the death of a hero; and Copley's *Death of Major Peirson*, for all its drama, lacks the sense of split-second action provided here by such incidents as the soldier at the left who attempts to deflect with his bare hand the bayonet poised above Warren. With Small only a step away at the right, the concluding moment seems imminent. It was perhaps at this stage in the development of the composition that Trumbull envisioned changing the central focus from Warren's death to include the incident of Small's noble gesture, since in the center of this sheet, Trumbull altered the poses of the young lieutenant and his companion from fleeing figures to figures caught in an awestruck moment. In the painting Grosvenor's gesture suggests astonishment at the British officer's act of generosity.

In addition to providing a moral exemplum, Trumbull intended *Bunker's Hill* to preserve the likenesses of the principal figures involved in the event. His 1790 proposal for subscriptions to the engraving of *Bunker's Hill* identifies seven figures as portraits.[8] For the two officers slain at the battle, Warren and Major Pitcairn, Trumbull relied on portraits by other artists; Putnam, Clinton, Small and Lieutenant Pitcairn were probably painted from life.[9] Trumbull's desire for accuracy even induced him to permit another artist to work on his canvas. The American painter Archibald Robertson later recalled a conversation in which Trumbull had told him that Howe had refused to pose for *Bunker's Hill*, and that Benjamin West had "painted in the head," presumably because West knew the general.[10] A close examination of the painting reveals that Howe's portrait is probably not by Trumbull's hand. The flesh color is darker than that used for the other portraits, and the masses and highlights of Howe's face are handled in a broad, summary manner, more characteristic of an artist accustomed to painting portraits on a larger scale.

Bunker's Hill is one of Trumbull's most successful works. In 1786, working in Europe with the active encouragement of the leading American painters of his day, Trumbull was at the height of his powers. Instead of arranging his figures in the horizontal, stagelike space used by West and Copley, he decided to represent the action on the compressed space of a hilltop. The asymmetrical positioning of the figures on the sloping ground creates a dramatic sense of movement, and by placing the viewer at the bottom of the incline, Trumbull gave the scene greater immediacy. The diagonals of banners and smoke, and the alternating areas of light and shadow were devices the artist developed from Copley's *Peirson* to further heighten the drama of the death scene. Trumbull also went beyond his customary techniques of coloring, noting that "the white . . . was broken with *burnt Terra di Pisa*, to [give] a warm Orange tint;— No pure white was used in any part; and the universal Shadow was *Terra di Cassele* [*sic*]."[11] These dynamic colors attracted the attention of Sir Joshua Reynolds, who, under the mistaken impression that *Bunker's Hill* was painted by West, commented to West: "This is better colored than your works are generally."[12]

When Trumbull completed *Bunker's Hill*, in March of 1786, Benjamin West hailed it as "the *best picture* of a modern battle that has been painted . . . *no Man* living can paint such another picture of that Scene."[13] West encouraged Trumbull to have it engraved, so that the picture would be better known, and so that the artist might earn more money than he would from the sale of a single work.[14] The original canvas, however, continued to bring Trumbull great acclaim. In 1787, Goethe saw it at the engraver's workshop in Stuttgart, and wrote favorably about it to Schiller.[15] Madame de Brehan, a friend of Jefferson and Maria Cosway, so admired the figures of Grosvenor and his servant that she asked Trumbull to copy the detail as a separate painting; several years later, probably in 1797, after the painting had been engraved, Trumbull fulfilled the request (Cat. 6).[16]

The reaction of Abigail Adams to *Bunker's Hill* was perhaps the most eloquent:

> To speak of its merit, I can only say that in looking at it my whole frame contracted, my blood shivered, and I felt a faintness at my heart. [Trumbull] is the first painter who has undertaken to immortalize by his pencil those great actions, that gave birth to our nation. By this means he will not only secure his own fame, but transmit to posterity characters and actions which will command the admiration of future ages, and prevent the period which gave birth to them from ever passing away into the dark abyss of time. At the same time, he teaches mankind that it is not rank nor titles, but character alone, which interests posterity.[17]

1 Trumbull 1841, p. 93. Trumbull follows the British usage, "Bunker's Hill."
2 Trumbull 1841, p. 20.
3 For Trumbull's description of the painting, see Trumbull 1832, pp. 7–11.
4 Although Trumbull does not name them, he specifies in his 1832 *Catalogue* (see Trumbull 1841, pp. 412–13) that these two figures sustain a master-servant relationship. Silliman identifies the young officer as Thomas Grosvenor of Connecticut, who remained on the field after he was wounded, encouraging his men until retreat was ordered; see Silliman, "Notebook," II, p. 62. Sizer 1967, fig. 146, and Jaffe 1975, p. 317, identify the black man as Peter Salem, the slave who is credited with having shot the British Major Pitcairn. Historically, Peter Salem was not Thomas Grosvenor's slave (see Josiah H. Temple, *History of Framingham, Massachusetts*, Framingham, 1887, pp. 324–25); however, the prominent position of Grosvenor's black servant suggests that Trumbull may have intended him to represent the man who shot Pitcairn.
5 Dunlap 1834, I, p. 357.
6 Joseph Farington recorded the following defense made by Benjamin West of the historical inaccuracies in his own contemporary history paintings: "There was no other way of representing the death of a Hero but by an *Epic* representation of it.— It must exhibit the event in a way to excite awe, & veneration & that which may be required to give superior interest to the representation must be introduced, all that can shew the importance of the Hero. . . . A mere matter of fact will never produce this effect"; cited in Joseph Farington, *The Farington Diary*, James Greig, ed., 4 vols., London, 1922–24, IV, p. 151.
7 Trumbull 1841, pp. 412–13; Silliman, "Notebook," II, pp. 61–62.
8 See Trumbull 1841, p. 339.
9 Jaffe 1975, p. 317.
10 Quoted in William Dunlap, *Diary*, 3 vols., New York, 1931, III, p. 733.
11 Trumbull, "Account of Paintings," II, no. 28.
12 Trumbull 1841, p. 93, quoting Reynolds.
13 JT quoting West, to David Trumbull, January 31, 1786, CHS.
14 Trumbull 1841, p. 94.
15 Goethe to Schiller, August 30, 1797, in Sizer 1953, p. 184, n. 13; see also p. 94, below.
16 Jaffe 1975, p. 317.
17 Abigail Adams to Mrs. [John] Shaw, March 4, 1786, in Charles Francis Adams, ed., *Letters of Mrs. Adams, the Wife of John Adams*, Boston, 1840, pp. 324–25.

5

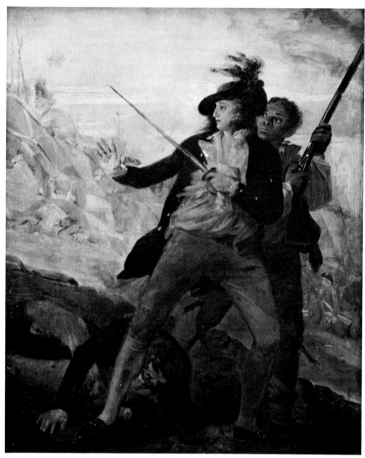

6

7
The Death of General Montgomery in the Attack on Quebec, December 31, 1775

1786
Oil on canvas, 24⅝ x 37 (62.5 x 94)
Yale University Art Gallery; Trumbull Collection

8
Study for The Death of General Montgomery in the Attack on Quebec

c.1785
Pen and ink, wash, and pencil on paper, 5½ x 8 1/16 (14 x 20.4)
Inscribed, verso (recorded before sheet laid down):
J. Trumbull | Death of Gen¹ Montgomery at Qiebec | 30ᵗʰ Dec 1775 | Painted 1786.
Fordham University Library; Charles Allen Munn Collection

9
Study for The Death of General Montgomery in the Attack on Quebec

1785
Pen and ink on paper, 7⅛ x 8⅜ (18.1 x 21.3)
Inscribed, lower left: *Sketched at Milesend Novᵣ 12ᵗʰ*
Yale University Art Gallery; Gift of the Associates in Fine Arts at Yale

The Death of General Montgomery in the Attack on Quebec, the second of Trumbull's Revolutionary War paintings, depicts the moment when Major General Richard Montgomery expires in the arms of Major Matthias Ogden. Before him lie the bodies of his two aides-de-camp, Captains Jacob Cheeseman and John MacPherson, who were killed by the cannon blast. Lieutenants John Humphries and Samuel Cooper and Lieutenant Colonel Donald Campbell surround the two central figures in a protective semicircle, while an Oneida Indian chief, Colonel "Joseph Lewis," defiantly raises his tomahawk in the direction of the shots. Three figures in the left foreground, Major Return Jonathan Meigs and Captains Samuel Ward and William Hendricks, gesture in shock at the sight of the dying general.

Trumbull considered Montgomery's effort to take Quebec— "to attack the enemy at the heart"— distinguished for its "brilliancy of conception and hardihood of attempt."[1] On the night of December 31, 1775, Montgomery attempted to enter the city during a heavy blizzard, hoping that the snow would veil the sight and sound of the marching Continentals. At first, he planned to stage a simultaneous attack on the upper and lower towns. However, one part of the army deserted, and Montgomery thought it best to attack the lower town from two directions with the force of his remaining troops. The two parties would then join and march together through the upper town. One battalion, led by Colonel Benedict Arnold, managed to take the first battery and move on to the designated site of rendezvous. However, they waited in vain for Montgomery's first battalion. The general, leading about 300 New York militiamen, determined to storm the first battery below the cliffs at Cape Diamond; but British and Canadian troops had waited silently until the American forces approached the blockhouse and then fired a blast of grapeshot from a naval cannon, killing Montgomery, MacPherson, Cheeseman, and several others.[2]

Trumbull began *Quebec* while putting the final touches on *Bunker's Hill* (Cat. 4). On March 4, 1786, he wrote to his brother Jonathan:

> my first picture of Bunker's Hill . . . almost finished— & met much approbation; the second:— of Montgomery's death before Quebec. is now far Advanc'd, & has rec'd from the few Judges who have seen it, still warmer praise.— Mʳ West & Mʳ Copley particularly encourage me to go on.[3]

In an early compositional sketch in pencil (*Fig. 27*), Trumbull worked out a generally symmetrical placement of two major groups, similar to the arrangement of the dying hero and sympathizing lords in Copley's *Death of the Earl of Chatham* (*Fig. 10*). On the right, the expiring general raises his hand in a heroic gesture as he falls into the arms of an attending figure. On the left, three figures, one of whom is on the ground in a pose mirroring that of the dying general, counterbalance the Montgomery group.

In a more advanced study (Cat. 8), executed in pen and ink and wash, and scored for transfer, Trumbull redivided the composition into three parts. He placed the limp figure of the general and his aides in the center, flanked by groups of figures on the right and left.[4] The chiaroscuro is developed into the sweeping pattern of intersecting diagonals that would appear in the painting. Trumbull frequently used this device of atmospheric diagonals in his history compositions.

Trumbull further explored the central group in a pen-and-ink study (Cat. 9), giving emphasis to the angle of Montgomery's head, so that he leans against the breast of his companion, Major Ogden. The officer, on one knee, braces the general against him and gently grasps his arm, while a second aide leans in to support Montgomery's right arm, bringing the central group together in a tight, urgent unit.

Quebec, finished in June of 1786, and *Bunker's Hill* (Cat. 4) are Trumbull's two most successful American history paintings. *Quebec's* spontaneous, fluid brushwork and brilliant palette of warm, glowing colors, conveys the excitement of the battle and the intense drama surrounding the death of Montgomery. Many years later, even the critical William Dunlap hailed the composition and col-

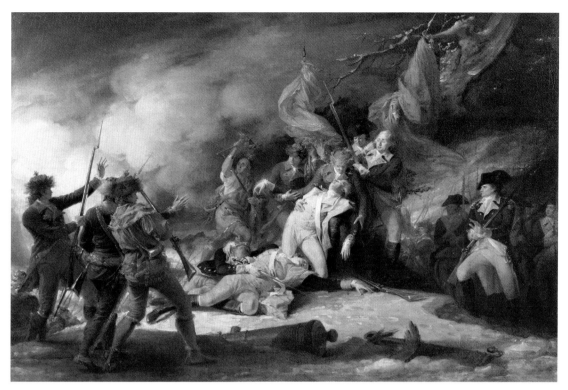

7 *Color reproduction, Fig. 18*

Fig. 27. Study for *The Death of General Montgomery in the Attack on Quebec*, 1785 or 1786. New York, Fordham University Library; Charles Allen Munn Collection.

oring of *Quebec*: "The figures are accurately drawn, and the attitudes finely diversified. The *chiara scuro* is perfect."[5]

West's *Death of General Wolfe* served as a model for *Quebec*, as the Canadian setting and the presence of scouts and an Indian in both works clearly shows. At this stage of his career, however, Trumbull was confident and ambitious enough to chart his own course. In West's painting, the dying general is in the moribund pose usually associated with the lamentation over the body of Christ.[6]

Trumbull chose a more active posture, with General Montgomery still on his knees. Equally dramatic are the comrades supporting Montgomery. They are linked to the banners and tree limbs above and the body of the fallen Captain Cheeseman in a powerful diagonal thrust that is only barely contained by the three riflemen at the left, who, as Prown points out (p. 33), resemble the three brothers in David's *Oath of the Horatii*. In style and feeling, however, the two works could not be more different:

David's is a severe Neoclassical presentation, while Trumbull's has the emotionally exuberant character of Baroque art.

When he painted *Quebec*, Trumbull was still at West's studio and had to depend on information available in England for his research on the battle. West had asked Charles Willson Peale for information (see p. 29), and Peale may have provided manuscripts or printed editions of journals or letters written by participants of the battle, or possibly, a newspaper account of two letters that Colonel Arnold wrote to General David Wooster in Montreal shortly after Montgomery's death.[7] It seems likely that Trumbull gathered facts for his rendition of the battle from Arnold's letters, or some version of them. Describing the painting in his 1832 *Catalogue*, the artist gives an account of the Canadian venture that closely resembles Arnold's reports.[8] And in the original Key that accompanied prints of the painting, Trumbull identifies twelve figures, nine of which are mentioned in Arnold's letters.[9] The real likenesses in this painting were those of Montgomery, Thompson, Cheeseman, and MacPherson; because his situation in England made it difficult to procure portraits of the men who were at Quebec, Trumbull took "the Liberty, in the Plate of Reference . . . to give to several of the Figures, the Names of those who were killed or wounded;— that this be regarded as a justifiable though imperfect tribute to their Memory."[10]

William Dunlap criticized Trumbull's *Quebec* for violating "the truth of history," not because the artist included individuals not present at the scene, but "in misrepresenting the spot where Montgomery and his brave companions fell."[11] Silliman visited Quebec in 1819 and noted:

> The place [of Montgomery's death] is immediately under Cape Diamond, and was, at that time, as it is now, a very narrow pass, between the foot of the impending precipice, and the shore. . . . The battery stood on the first gentle declivity . . . and the deaths happened on the level ground, about forty yards still farther on.[12]

In placing the scene of Montgomery's death on level ground covered by fresh snow, Trumbull was true to the historical event. However, because he was unaware of the exact topography of this site, he did not depict the cliffs at Cape Diamond.[13] He did include part of the fortress at Quebec in the left background, as well as several of the scaling ladders that Montgomery's men hoped to use to enter the citadel.

Dunlap further criticized Trumbull for choosing to "commemorate another triumph of Britain over America." Unlike West's General Wolfe, or Copley's Major Peirson, both of whom died "surrounded by friends in the moment of victory," Trumbull's "dying men . . . are nothing more than— dying men."[14] However, the artist and many of his contemporaries considered the attack on Quebec a brilliant campaign, and the men who participated in it remarkable for their bravery and persistence. Montgomery and his troops had taken Ticonderoga, St. John's, Chambly, and Montreal. Trumbull described this last effort to take Quebec in midwinter as a "gallant but desperate attempt."[15] Shortly after Montgomery's death, Congress raised a monument to him, lauding his "patriotism, conduct, enterprize and perseverance."[16] Even a member of the British Parliament, Edmund Burke, acclaimed the bravery of the American general, contrasting the humiliation of the large British army— "8,000 men starved, disgraced, and shut up within the single town of Boston"— with "the movements of the hero who in one campaign had conquered two-thirds of Canada."[17]

1 Trumbull 1841, p. 414.
2 For an eyewitness account, see Return J. Meigs, "A Journal of Occurrences," published in Kenneth Lewis Roberts, ed., *March to Quebec: Journals of the Members of Arnold's Expedition*, New York, 1938, p. 189.
3 JT to Jonathan Trumbull, Jr., March 4, 1786, YUL-JT.
4 An undated sheet of sketches for details of several paintings (see *Fig. 36*), probably contemporary with this drawing, includes two rough studies of one figure supporting another in poses that closely resemble the configuration of the central group in *Quebec*.
5 Dunlap 1834, I, p. 358. Trumbull used the same palette for *Quebec* as for *Bunker's Hill*.
6 See Jules D. Prown, *American Painting from Its Beginnings to the Armory Show*, Geneva, 1969, p. 41.
7 Benedict Arnold to General David Wooster, December 31, 1775, and January 2, 1776, as cited in Roberts, *March to Quebec*, pp. 102–6.
8 Trumbull 1832, pp. 12–13.
9 The Key was sold with the engraving by J. F. Clemens, published March 1798, by Antonio di Poggi in London; see Morgan 1926, pp. 31–33. Although Arnold's accounts do not mention Lieutenant Samuel Ward, who was captured at Quebec, Trumbull chose to honor his old friendship with Ward by depicting him as one of the "gallant officers" at the siege. The artist also included two men, Colonel "Joseph Lewis" and William Thompson, who were not present at Quebec.
10 In his 1790 proposal for subscriptions to the engraving, Trumbull described four of the likenesses in *Quebec* as portraits: Montgomery, Thompson, MacPherson, and Cheeseman (Trumbull 1841, p. 339). Antonio di Poggi's 1792 proposal for subscriptions also lists Lieutenant Colonel Campbell as a portrait; see *Proposals, by A. C. Poggi, for publishing by subscription, two prints . . .* , London, 1792, YUL-BF. The Key sold with J. T. Clemens' engraving, however, named only three figures as portraits: Montgomery, Cheeseman, and MacPherson; see Morgan 1926, p. 33. It is not known on what image Trumbull based his posthumous portrait of Montgomery. He may have seen Charles Willson Peale's miniature or small portrait, but he certainly did not make an exact copy; see Charles Coleman Sellers, *Portraits and Miniatures by Charles Willson Peale*, Philadelphia, 1952, pp. 144–45, ill. p. 305. Since Trumbull simply obscured the features through dramatic foreshortening of the tilted head, it is unclear whether or not Montgomery's face was intended to be an accurate likeness.
11 Dunlap 1834, I, p. 358. Dunlap also criticized Trumbull for not including Aaron Burr in his composition; see Dunlap, *Diary*, 3 vols., New York, 1931, III, pp. 737–38. Burr claimed that having survived the explosion that killed Montgomery, he decided to save the general's body, hoisting it to his shoulders, and "hastening from the fire of the enemy"; see Matthew L. Davis, ed., *Memoirs of Aaron Burr*, 2 vols., New York, 1836–37, I, p. iv.
12 Benjamin Silliman, *Remarks Made, on a Short Tour, between Hartford and Quebec in the Autumn of 1819*, New Haven, 1820, pp. 283–85.
13 In 1834, Trumbull painted the subject again as part of the series now in the Wadsworth Atheneum. The background of this second version includes a detailed depiction of the cliffs at Cape Diamond.
14 Dunlap 1834, I, p. 358.
15 Trumbull 1841, p. 415.
16 *The National Cyclopedia of American Biography*, I (1898), p. 101.
17 Burke is quoted in Mark M. Boatner III, *Encyclopedia of the American Revolution*, New York, 1966, p. 726.

8

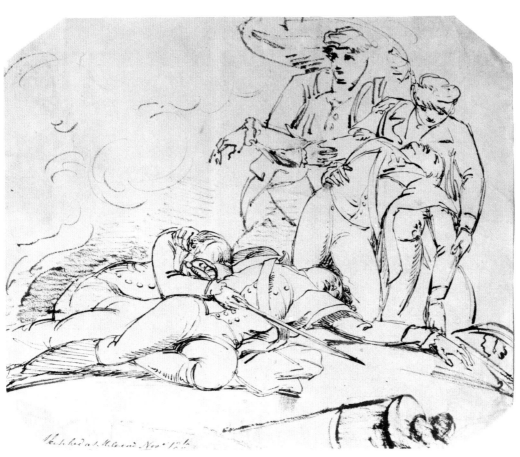

9

The Sortie
Made by the Garrison of Gibraltar

1787
Oil on canvas, 15⅛ x 22⅛ (38.4 x 56.2)
The Corcoran Gallery of Art; Museum Purchase

The Sortie
Made by the Garrison of Gibraltar

1788
Oil on canvas, 20 x 30 (50.8 x 76.2)
Cincinnati Art Museum; John J. Emery Endowment

The Sortie
Made by the Garrison of Gibraltar

1789
Oil on canvas, 70½ x 106 (179.1 x 269.2)
The Metropolitan Museum of Art; Purchase, Pauline V.
 Fullerton Bequest; Mr. and Mrs. James Walter Carter
 Gift; Mr. and Mrs. Raymond J. Horowitz Gift;
 Erving Wolf Foundation Gift; Vain and Harry Fish
 Foundation, Inc.; Gift of Hanson K. Corning, by
 exchange; and Maria DeWitt Jesup and Morris K.
 Jesup Funds

Thomas Lawrence
as the Dying Spaniard
Study for The Sortie
Made by the Garrison of Gibraltar

1789
Pen and ink, pencil, chalk, and watercolor on blue-gray
 paper, 14 x 11½ (35.6 x 29.2)
Boston Athenaeum

In a letter from London to his brother Jonathan, dated
May 24, 1786, Trumbull said that Benjamin West had
suggested he paint a picture dealing with the recent Brit-
ish victory at Gibraltar. It was, Trumbull wrote, "a subject
of the History of this Country, at once popular, sublime,
& in every respect perfect for the pencil . . . hitherto

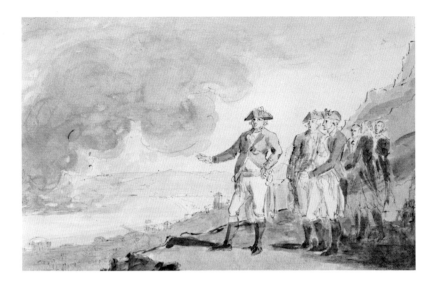

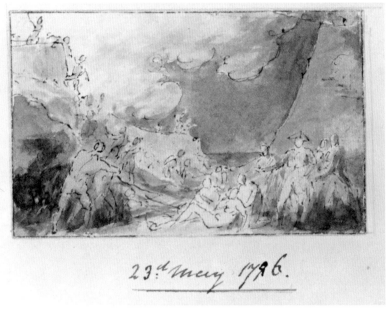

Fig. 28. (Top) *General Elliot at Gibraltar, May 20, 1786.* Hartford, The
Connecticut Historical Society.

Fig. 29. (Bottom) Study for *The Sortie Made by the Garrison of Gibraltar,* 1786.
Boston Athenaeum.

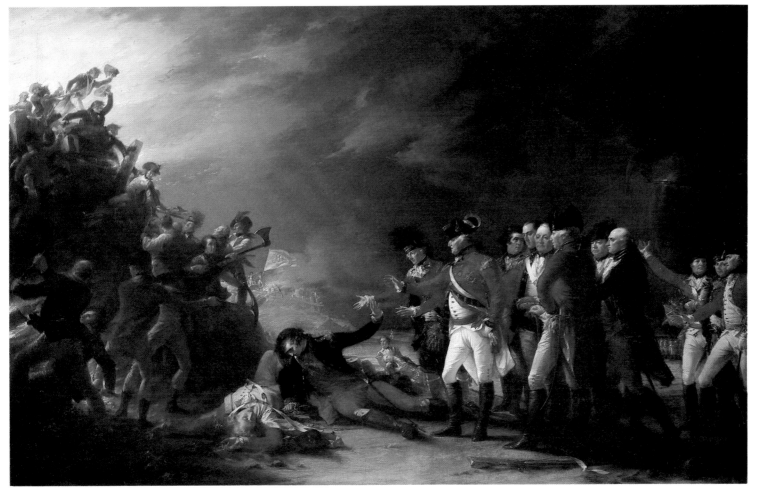

12

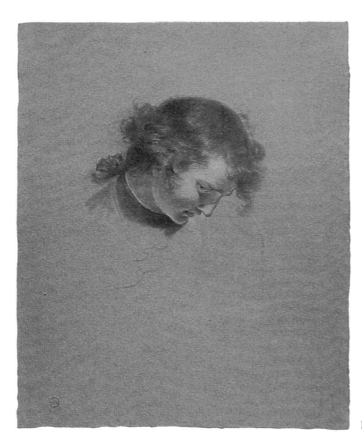

13

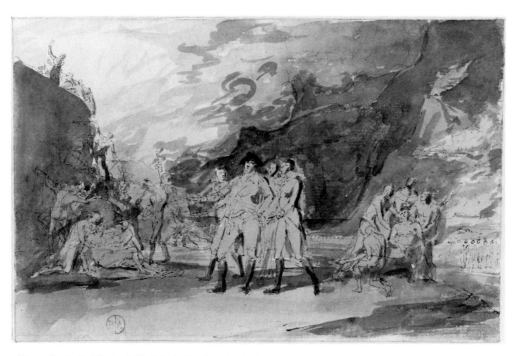

Fig. 30. Study for *The Sortie Made by the Garrison of Gibraltar,* 1786–87. Boston Athenaeum.

untouched & which alone, if properly treated is sufficient to establish my Reputation."[1]

The British "victory" was really a series of confrontations between the British troops occupying the Gibraltar garrison and the French and Spanish forces which had been besieging it both by land and sea over a period of years. The hostilities began as a result of the alliance of the two continental powers with the United States during the Revolutionary War.[2] In the end, British bravery and ingenuity won out and Gibraltar remained in British hands.

The conflict provided ample material for a history painter; the problem was choosing a particularly meaningful or visually interesting episode. Trumbull's choice, the daring sortie made by the garrison and the destruction by fire of encroaching Spanish batteries on the evening of November 26, 1781, not only followed Trumbull's preference for scenes of great personal heroism, but probably also avoided a conflict with his fellow American history painter, John Singleton Copley. Copley was then at work on a large canvas commissioned by the London Court of Common Council depicting the final siege of Gibraltar by sea. Trumbull, whose choice of a Gibraltar subject already placed him in direct competition with the older master, doubtless wished not to exacerbate matters.[3] The two earliest known drawings related to the project confirm this sequence. The first, dated May 20, 1786 on the verso (*Fig. 28*) is a compositional study depicting the siege of Gibraltar, precisely Copley's subject; the second, dated May 23, 1786 (*Fig. 29*), illustrates the sortie made by the garrison.

Trumbull's main reasons for undertaking a work dealing with an episode in recent British history are clearly alluded to in his letter to his brother. He wanted to achieve a reputation as a history painter in Britain, but he obviously thought that this recognition would not come through his planned Revolutionary War scenes. Less obvious was his probable desire to indulge Benjamin West's wish that he outdo Copley in painting a work dealing with Gibraltar. Both West and Copley had competed for the Court of Common Council commission; Copley had won, largely because he had sizeably reduced his fee. West was not happy over the decision and would have been gratified had Trumbull managed to get a fine Gibraltar work to the engraver in advance of Copley, who was known to be having great problems with his picture.[4]

According to Trumbull, the engraver Antonio di Poggi first told him about the sortie and the death of the Spanish officer Don José de Barboza, who, abandoned by his troops, charged a British column single-handedly, was mortally wounded, and died refusing the aid proffered by British officers, including the garrison commander General George Elliot. How Poggi knew these details is uncertain, since he was not a witness at Gibraltar. Immediately after hearing Poggi's account, Trumbull made a small sketch of the scene, probably the one dated May 23, 1786 (*Fig. 29*).[5] As he put it: "I was pleased with the subject, as offering, in the gallant conduct and death of the Spanish commander, a scene of deep interest to the feelings, and in the contrast of the darkness of night, with the illumination of an extensive conflagration, great splendor of effect and color."[6]

Persuaded of the pictorial potential of his subject, Trumbull proceeded to make a number of preparatory drawings, most of which he presented to the Boston Athenaeum in bound form when that institution purchased his large version of the *Sortie* in 1828.[7] From these drawings it is clear that Trumbull always conceived his composition in three parts, with the attack on the batteries at the left, the dying Barboza in the middle, and the group of British officers to the right. Only once did he deviate from this arrangement (*Fig. 30*). By shifting the

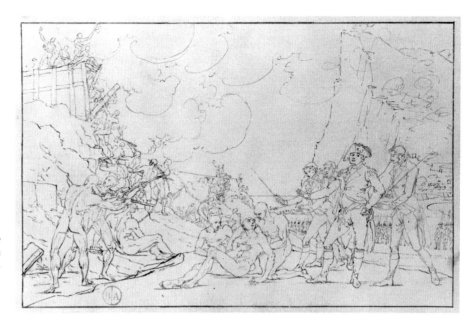

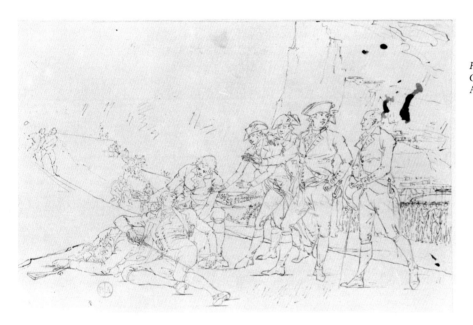

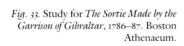

Fig. 31. Study for *The Sortie Made by the Garrison of Gibraltar*, 1786–87. Boston Athenaeum.

Fig. 32. Study for *The Sortie Made by the Garrison of Gibraltar*, 1786–87. Boston Athenaeum.

Fig. 33. Study for *The Sortie Made by the Garrison of Gibraltar*, 1786–87. Boston Athenaeum.

10

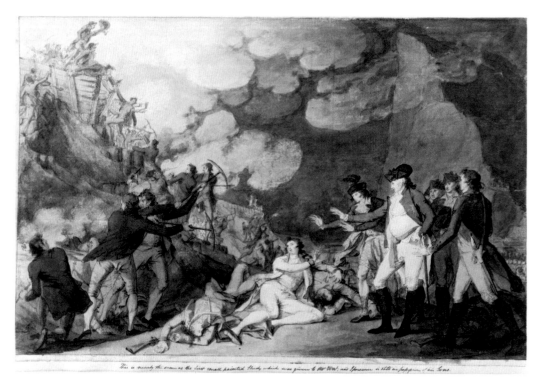

Fig. 34. Study for *The Sortie Made by the Garrison of Gibraltar*, 1786–87. Boston Athenaeum.

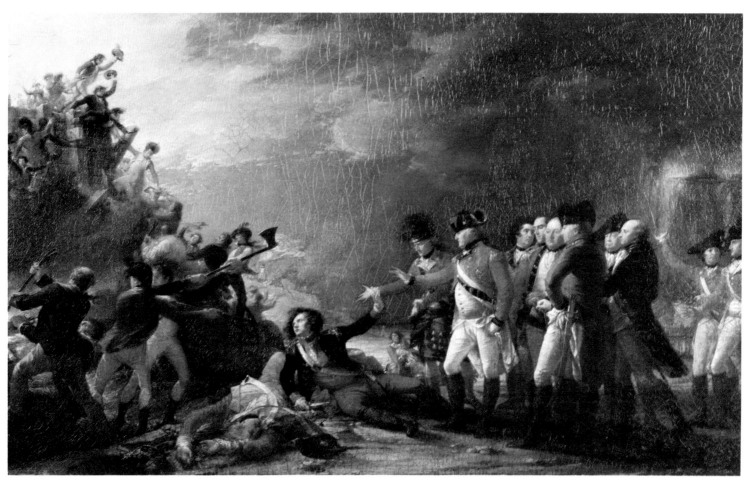

group of officers to the center, the drama of the confrontation between them and the dying Spaniard was lessened; Trumbull promptly discarded this alternative. Having worked out in detail the location of the Spanish officer (*Fig. 31*), Trumbull then turned him at right angles to the British officers (*Fig. 32*), so that his now foreshortened body cuts deep into the pictorial space. The soldier who supports Don José was dispensed with in *Fig. 33*, and the defiant refusal of aid by the expiring Spaniard begins to find expression in the dramatic gesture of his right hand.

Trumbull also made studies of the various secondary figures in the composition, which show his reliance on antique sculpture. On one sheet of studies (*Fig. 36*), also used for the *Princeton* painting, the *Dying Gaul* (viewed from the rear) appears at the upper left, while the *Borghese Warrior* appears on the verso. The latter was eventually included in the first painted version of the *Sortie* in the profile figure of the British soldier climbing the battery. Practically all of these figures, however, were first included in the full compositional study (*Fig. 34*) which, as Trumbull noted on the margin, "is nearly the same as the first small painted Study which was given to M.̲r West."

The first painted version of the *Sortie* (Cat. 10) was completed some time in 1787. In this small work, the painterly treatment of the agitated sky further emphasized the visual sense of motion Trumbull had established in the final compositional study. In later years, he claimed that it was an error in this work— he had dressed the Spaniard in white and scarlet instead of the historically accurate blue and scarlet— that prompted him to attempt another, slightly larger version.[8] It seems unlikely, however, that Trumbull would have executed another picture just to change the colors of a uniform, which he could easily have overpainted. Given the other refinements in the second version, it seems more probable that he realized that the first version was just too small and unfinished to be a real history painting. For the second version (Cat. 11), completed in 1788, he set about obtaining portraits of the officers involved in the action. Then he altered the dying Spaniard once again: this time Don José assumes an attitude of defiance as he recoils from his would-be benefactors. The group of officers to the right has become more friezelike and now includes eight rather than five figures. Two more English officers and a soldier wielding a crowbar were added as framing elements at the extreme right and left, respectively.

The second version was almost certainly intended for the engraver. Trumbull had hoped that its success would help redress the offense he thought his American subjects had given to "some extra-patriotic people in England."[9] He himself, however, "was not satisfied with all its parts" and the Spanish hero "seemed to express something approaching to ferocity"; furthermore, "several other parts appeared . . . not well balanced."[10] Without having it engraved, he sold it to Sir Francis Baring, a London financier, for the considerable sum of 500 guineas, and decided to paint a much larger version. Although he never admitted it, it was probably ambition more than aesthetic

Fig. 35. Study for *The Sortie Made by the Garrison of Gibraltar*, c.1789. Collection of Jonathan Trumbull Isham.

dissatisfaction that led him to attempt this third canvas, almost 6 x 9 feet in size.

While the third version (Cat. 12) does not seem noticeably different from the second, there are significant changes. One of these is the alteration of Don José's pose. As Trumbull worked it out in a pen-and-ink compositional sketch (*Fig. 35*), the head now falls downward, so that the entire figure echoes the *Dying Gaul*. The effect is one of poignancy rather than defiance. Trumbull carefully considered the angle of the head and facial expression— he even went so far as to seek out the handsome young painter Thomas Lawrence to pose for the Spaniard's likeness (Cat. 13), producing in the process one of his finest character studies.

Other changes in the final painted work, and perhaps also studied in detail in sketches now lost, are the deeper and less cluttered foreground, the calmer aspect of the sky,[11] the sharply foreshortened prone Redcoat next to the Spaniard (based on a center foreground figure in Copley's *Peirson; Fig. 14*), and the added figure of an officer, already suggested in the Isham sketch, at the extreme right. To convey a sense of monumental grandeur, Trumbull arranged the figures of the English officers in a manner that recalls Roman relief sculpture, as West had done in his *Agrippina Landing at Brundisium with the Ashes of Germanicus*, 1768 (Yale University Art Gallery). The execution itself— more linear, smooth and restrained than in the two preceding versions— also gave the large *Sortie* a strongly classical look.

Trumbull's decision to enlarge the scale enabled him to more clearly represent the various events. More importantly, he takes the viewer into the fray, to confront the emotionally charged death of an enemy hero and to admire the magnanimity of the British commanding officers. In this respect, the final *Sortie* is a more ambitious work than its immediate forerunners in the Anglo-American history painting tradition— West's *Death of Wolfe* (*Fig. 9*), Copley's *Death of Major Peirson* and indeed Trumbull's own *Bunker's Hill* and *Quebec*.

The large *Sortie* was completed in February 1789 and shown at a private exhibition organized by Trumbull at Spring Gardens in April of that year. The public appears to have been moderately receptive, although newspaper critics remained silent. At least one connoisseur, Horace Walpole, praised it highly; Trumbull reports that Walpole

thought it the finest picture he had ever seen painted north of the Alps.[12] Sometime afterward, Trumbull received— and declined— an offer of 1200 guineas for it. The painting remained in his possession, save for a period of about three years between 1824 and 1827, when it was with an unidentified English owner, until he sold it to the Boston Athenaeum in 1828 for 2000 dollars.

After the completion of the *Sortie*, Trumbull refrained from painting contemporary historical subjects on such a scale until 1817, when he began four Revolutionary War paintings for the Rotunda of the Capitol.

1 JT to Jonathan Trumbull, Jr., May 24, 1786, YUL-JT.
2 For a history of this protracted belligerence see John Drinkwater, *A History of the Siege of Gibraltar*, London, 1786.
3 On Copley's difficulties with his *Siege of Gibraltar*, see Jules D. Prown, *John Singleton Copley*, 2 vols., Cambridge, Mass., 1966, II, pp. 324–30.
4 That the rivalry between West and Copley was a major factor in Trumbull's decision to paint the *Sortie* is emphasized in Jaffe 1975, pp. 131–38; see also p. 35, above.
5 This sketch is the most likely candidate for being the one Trumbull described; see Trumbull 1841, p. 148.
6 Ibid.
7 Most of these are illustrated in Jean Lambert Brockway, "Trumbull's Sortie," *The Art Bulletin*, 16 (1934), pp. 5–13.
8 Trumbull 1841, pp. 148–49. For a discussion of the first version of the *Sortie*, see H. W. Williams, *Corcoran Gallery of Art Bulletin*, 16 (November 1967), pp. 15–21. At some point this work was repainted so that the costume of the dying Spaniard met the requirements of history.
9 Trumbull 1841, p. 149.
10 Ibid.
11 In the rendering of the picture as a night scene illuminated by fires, Trumbull undoubtedly saw Joseph Wright of Derby's *View of Gibraltar During the Destruction of the Spanish Floating Batteries*, exhibited at Robin's Rooms, Covent Garden, in April 1785 (Milwaukee Art Museum), in which the effects caused by the nighttime burning of the batteries at sea were very successfully exploited in a work of large size.
12 Trumbull 1841, p. 150.

14
The Death of General Mercer
at the Battle of Princeton,
January 3, 1777

For Cat. 15, *see p. 68*

c.1789–c.1831
Oil on canvas, 20⅛ x 29⅞ (51.1 x 75.9)
Yale University Art Gallery; Trumbull Collection

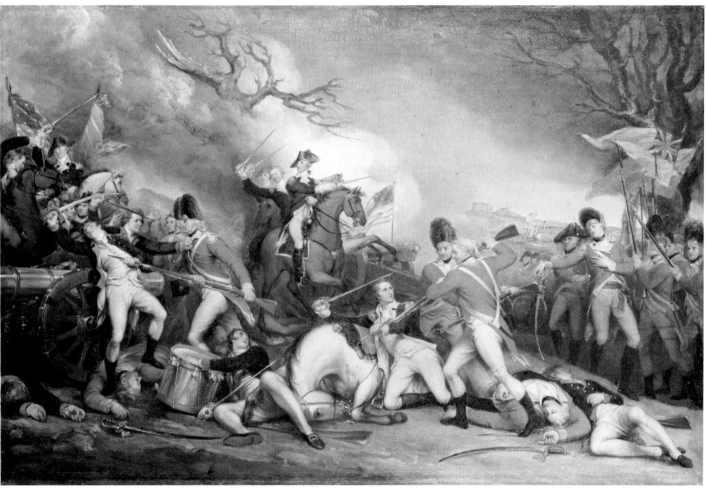

14

The Death of General Mercer at the Battle of Princeton is the third battle scene in Trumbull's Revolutionary War series to commemorate the loss of a leading general. The composition, ordered into discrete groupings of figures, represents different incidents of the battle simultaneously. In the center, General Hugh Mercer, cut off from his beleaguered men, with his horse shot out from beneath him, is mortally wounded by British grenadiers. At the left, where the struggle is most intense, Lieutenant Charles Turnbull bends backward against the cannon, recoiling from a grenadier's bayonet. The figure on a white horse at the far left is probably General Thomas Mifflin. On the right, the British Captain William Leslie, his sword dropping, presses the wound in his chest. And in the middle distance, General Washington, on a brown horse, enters the field accompanied by Doctor Benjamin Rush and others.

The Battle of Princeton was an American victory, the last conflict in Washington's campaign against the British in New Jersey. It signaled a change in the fortunes of the discouraged American Revolutionaries. Horace Walpole wrote after the ten-day offensive, "Washington . . . has shown himself both a Fabius and a Camillus. His march through our lines is allowed a prodigy of generalship."[1]

The Battle of Princeton took place shortly after the American victory at Trenton. Lord Cornwallis, hoping to take the offensive, decided to storm Washington's camp at Assumpink Creek, just north of Trenton. However, in allowing his troops to rest when they reached the far side of the creek on January 2, Cornwallis gave Washington time to slip around the British camp by night. Washington sent General Mercer's brigade to destroy a bridge at Stony Brook, to prevent the advance of a smaller British force that planned to join Cornwallis. Before Mercer

16

Study for The Death of General Mercer at the Battle of Princeton

1786
Pen and ink and pencil on paper, 11¾ x 18¾
 (29.8 x 47.6)
Inscribed, verso: *No. 2 | Princtown* [sic]
Princeton University Library

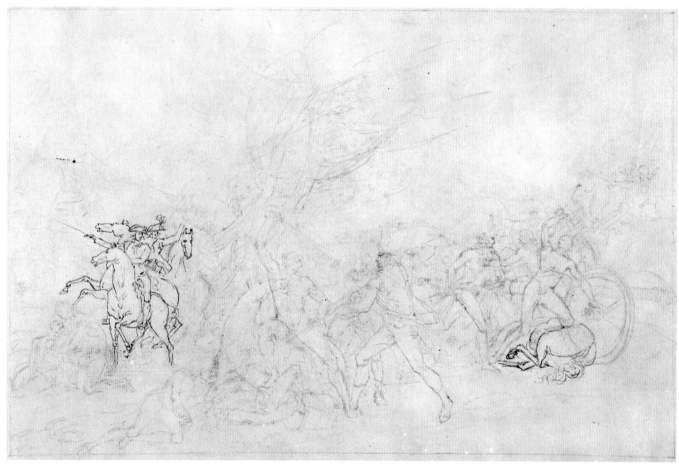

16

Fig. 36. *Figure Studies*, 1786. New Haven, Yale University Art Gallery; Trumbull Collection.

17

Study for The Death of General Mercer at the Battle of Princeton

1786
Pen and ink and pencil on paper, 11½ x 16¾
 (29.2 x 42.5)
Inscribed, verso: *No. 1.* | *Princetown*
Princeton University Library

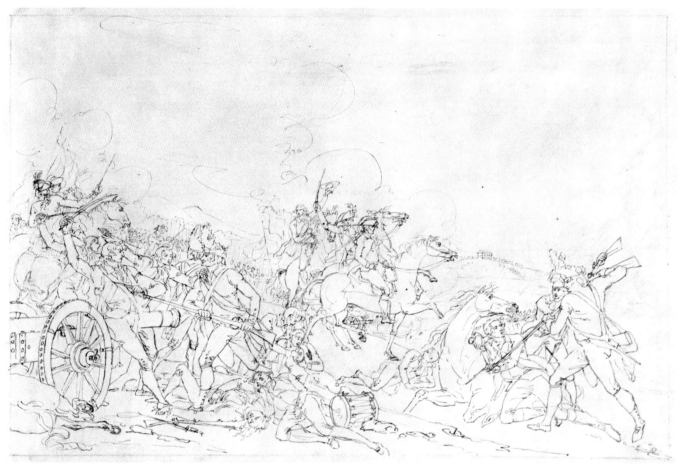

reached the bridge, he was forced to stand against a detachment of British soldiers. Armed only with slow-loading muskets, Mercer's troops did not have time to recover before the enemy was among them with bayonets. It was not until Washington rushed into the center of the conflict that the American troops rallied, and with reinforcements from General John Cadwalader's brigade, were able to disperse the British. Mercer, who had been bayonetted and clubbed by the British when he refused to beg for mercy, was taken alive from the field, but died nine days later. As a result of this battle, Cornwallis decided to remove his entire force behind the Raritan River, leaving Washington in control of most of New Jersey.[2]

Trumbull began studies for *Princeton* at London in 1786, at the same time as the studies for the first version of the *Sortie* (Cat. 10) and *Trenton* (Cat. 24). At least thirteen preparatory studies survive which document his work on the picture from the first arrangements of figure groups, to wash drawings of the entire composition, in addition to portraits of several of the battle's participants, and

topographical drawings of the site.

Trumbull "thought" with drawings; following a traditional academic method, he sought to work out the composition in several stages. Starting with quick, generalized sketches, he defined the elements, using jagged pencil lines of different intensities, and a chiaroscuro method of ink washes over pen and pencil outlines. Atmosphere played an important role from the start; broad areas of light, shadow, smoke, and haze hold the composition together and provide its source of energy.

The *Princeton* theme first appears on a sheet of random figure studies in pencil, pen, and ink (*Fig. 36*). In three separate sketches, Trumbull explores the central motif of General Mercer with his upraised sword beside his fallen horse, defending himself against the grenadiers. In this early stage, Mercer is in a standing position. Classical models were undoubtedly the visual source for the poses: the sharply twisting figure at the left drawn in pencil and reinforced in ink, evokes the *Laocoön*— in the eighteenth century considered a paradigm of heroic suffering; the

18
Study for The Death of General Mercer at the Battle of Princeton

1786
Pen and ink, pencil, and wash on paper, 4 x 6⅞
 (10.2 x 17.5)
Princeton University Library

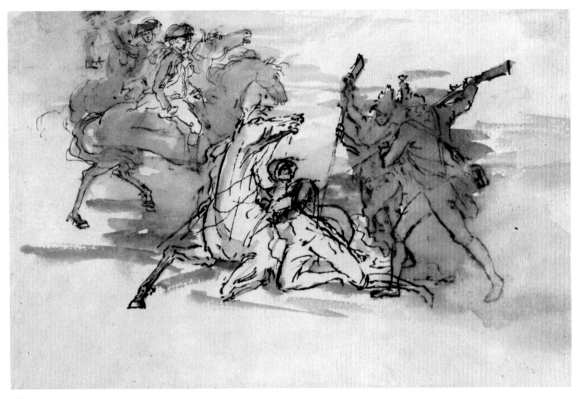

18

gesturing figure sketched in pencil on the right of the sheet is reminiscent of one of the so-called *Dioscuri*, who were viewed as ideal types for warriors.[3] Reynolds considered such quotations essential foundations on which to build a history painting.[4]

The first extant compositional drawing for *Princeton* (Cat. 16) borrows the figures at the left and center of the sheet of random studies, but retains only the left group as the Mercer group in the compositional sketch. The figures at the right reappear in the right of the composition as the group representing Lieutenant Turnbull. On the left, Trumbull introduces Washington and his aides on horseback.

Perhaps because Mercer's standing pose did not convey the hopelessness of his personal situation, Trumbull, in the next drawing (Cat. 17), shows the general sunk to his knees, leaning on his fallen horse.[5] Because Trumbull numbered this drawing "1" on the verso, it traditionally has been considered his first large study for the entire picture, with Cat. 16 being the second. The visual evidence, however, suggests the reverse: the figures of Mercer and Turnbull in Cat. 16 are transcribed exactly as they appear on the sheet of random studies, still in the heroic nudity of the ancient statues, while in Cat. 17, the figures

are clothed and Mercer is now in the pose he would retain in the painting.[6] Undoubtedly, there are several missing sheets between these two drawings, for the composition has been far advanced from Cat. 16 to Cat. 17. In a detail study of Mercer and the grenadiers (Cat. 18), Trumbull turned to the medium of washes to define the lights and darks of the scene.

Apparently displeased with the Mercer group's off-center placement in the second composition study, Trumbull returned it to the center in a third sketch (Cat. 19). Again, following his usual working method of an outline drawing followed by a wash study, Trumbull executed Cat. 20. Not all of the compositional problems were resolved, however, for the artist produced another outline sketch (Cat. 21) in which he reduced the number of figures and moved the Mercer group into the foreground. In the subsequent wash drawing (Cat. 22) he added a number of figures to the composition.

Reversing images and shifting around set groups were clearly major parts of Trumbull's working method. He moved the Washington group from the center of an earlier drawing (Cat. 17) to the right in two later ones (Cats. 19, 20), only to return it to the center in Cats. 21 and 22. Trumbull also experimented with the far right side of the

19

Study for The Death of General Mercer at the Battle of Princeton

1786
Pen and ink and pencil on paper, 12 x 19 (30.5 x 48.3)
Inscribed, verso: *No. 3. | Princtown* [sic]
Princeton University Library

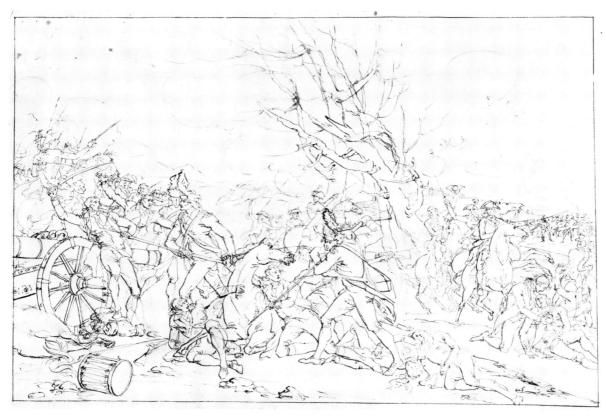

19

composition: in Cats. 19 and 20 he introduced the fallen figure, who appeared as General Warren in *Bunker's Hill* (Cat. 4), which he then shifted to the right background in the subsequent compositional drawing (Cat. 21). To fill the resulting void he also appropriated the idea of a pair of fleeing soldiers from a sketch for *Bunker's Hill* (*Fig. 26*).[7] As part of his effort to tighten the composition in Cat. 21, he brought together the fallen swordsman next to Mercer's horse and the drum, two hitherto discrete elements. This motif was retained in the last extant sketch for *Princeton* (Cat. 22), where Trumbull also introduced the line of British grenadiers on the right.[8]

Trumbull made further changes in *Princeton*'s composition when he began his first version of the painting (Cat. 15). Each group of figures was tightened, and the separate incidents were brought closer together. The large, leafless tree, which had been at the center of most of the preliminary drawings, was shifted to the left, creating a diagonal sweep across the canvas similar to that in *Bunker's Hill*. On the right, Trumbull added the death of the British Captain Leslie, which had not been part of any of the previous studies. Perhaps, as in *Bunker's Hill*, he wished to depict dying officers from both sides. This same brotherhood of rank existed at the battle, for Doctor Benjamin Rush

vainly sought to save the lives of both Mercer and Leslie.

Trumbull must have considered Washington's entrance of central importance to his representation of the battle, for in the final painting it took on even greater prominence. Indeed, one of Trumbull's reasons for abandoning work on the first painting of *Princeton* was that "the position of [Mercer's] horse did not please him."[9] By lowering the horse's head in the final canvas, he allowed Washington to dominate the composition. As Silliman later observed, Trumbull wished his picture to commemorate the commander-in-chief's noble disregard for personal safety, which on this occasion gave the American army a crucial victory.[10] Trumbull must have decided that Washington's action was more deserving of the central position than Mercer's death, particularly as this was his only opportunity in the American Revolution series for showing Washington in a scene of conflict.

The dates at which Trumbull was at work on the different stages of *Princeton* are not as well documented as those for some of the other history paintings. Although he recalled in his *Autobiography* that he "made studies upon paper" in the summer of 1787, two of the drawings are dated May 11 and 18, 1786, respectively (Cats. 20, 22).[11] Moreover, certain motifs in the drawings are similar

15
The Death of General Mercer
at the Battle of Princeton
(*unfinished version*)

c.1786–88
Oil over black chalk on canvas, 26 x 37 (66 x 94)
Yale University Art Gallery; Trumbull Collection

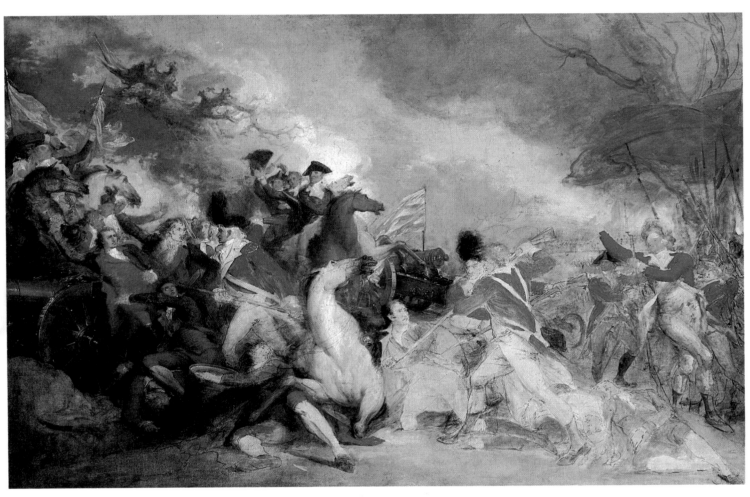

15

20

Study for The Death of General Mercer at the Battle of Princeton

1786
Pen and ink and wash on paper, 12 x 18¼ (30.5 x 46.4)
Inscribed, verso: *No. 4. | Death of Genl Mercer at*
 Princeton—Jany 1777 | J. Trumbull—10ᵗʰ May 1786.
Princeton University Library

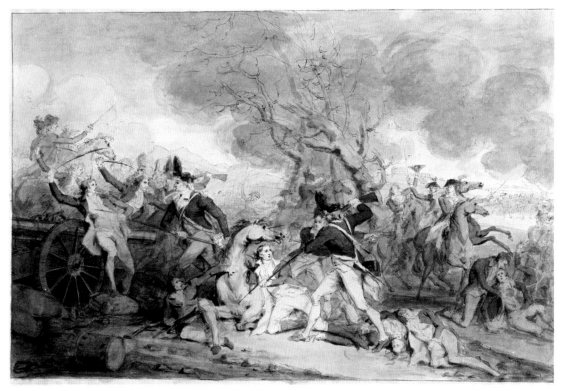

20

to ones in *Bunker's Hill*, completed in early 1786. The bayonetting soldiers in the wash study of the Mercer group (Cat. 18) were probably derived from the analogous figures in *Bunker's Hill*.

An even closer relationship exists between *Princeton* and the first version of *The Sortie Made by the Garrison of Gibraltar* (Cat. 10). The artist seems to have traded motifs between these two compositions: a group of one figure supporting another, at the lower left in the first outline study (Cat. 16) and in four other *Princeton* drawings (Cat. 17, in the center, and at the far right in Cats. 19, 20, 21) also appeared in several sketches for *Gibraltar*. Eventually, Trumbull must have found this motif more appropriate for *Gibraltar*, for it turns up in the center background of both the Cincinnati and New York versions (Cats. 11, 12), whereas it was never included in the *Princeton* paintings.

A precise dating of the two oil versions of *Princeton* is difficult. The studies seem to follow one another in close succession, with the last surviving drawing in the series dated May 18, 1786. The differences in composition between the last drawing and the first painting of *Princeton* may be due to a temporary halt in the work during the summer of 1786, which Trumbull devoted to traveling on the Continent and to completing the first version of the

Sortie. Although it is not known precisely when he began work on the first *Princeton*, he stopped when it was determined that the size of the canvas was too large for the engraver to copy,[12] probably shortly after Müller was engaged to engrave *Bunker's Hill* in 1788. The second version of *Princeton* was laid out before Trumbull's return to America in November of 1789.[13] Less than three months later, the picture was sufficiently advanced to permit the artist to paint Washington's portrait into it.[14] Moreover, in a broadside dated April 2, 1790, Trumbull announced to potential subscribers to the engravings that *Princeton* was among those history paintings that were "considerably advanced."[15]

It is also difficult to determine exactly when Trumbull finished work on the second canvas. He took a miniature of Thomas Mifflin at Philadelphia in May or June of 1790 (see Cat. 76). His drawing of the battle site, made at Princeton in December of 1790 (Cat. 23), seems to have been done after he had already painted in the same generalized background buildings that appeared in his London studies.[16] On his return from South Carolina in April of 1791, he did a portrait drawing of Hugh Mercer's son (Cat. 106), which he used as the basis for his representation of the general.[17] Apparently he did not paint Mercer's

21

Study for The Death of General Mercer at the Battle of Princeton

1786
Pen and ink and pencil on paper, 12 x 18½ (30.5 x 47)
Inscribed, verso: *No. 5. Princetown*
Princeton University Library

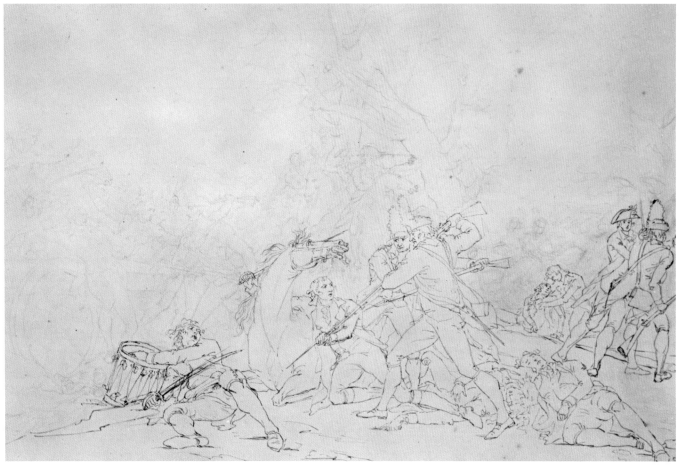

21

portrait into the canvas until 1827, for he wrote to the son on December 4 of that year: "My success in your portrait . . . has convinced me that . . . with the aid of the Optician I can still execute such small work, as well as formerly, and I shall therefore devote myself without interruption to finishing the entire Series of small paintings . . . begun Forty years ago."[18] The painting must have been completed by 1831, when the artist described it in the draft of an exhibition list as "Composed & begun in London 1787— finished recently in America."[19]

For John Trumbull, as for other artists of his generation, returning from Europe to the relatively thin artistic culture of the United States was a highly problematic venture. Gilbert Stuart, who had fully matured as an artist over a long period of time in England and Ireland, and who limited himself to portraiture, was exceptional in that he continued to produce work of real distinction in this country. More usual, however, were the painters like

Washington Allston, John Vanderlyn, and Trumbull, whose work suffered an almost catastrophic decline in quality soon after their return. The reasons for this may be summarized as the absence of the stimulus provided by a community of serious and accomplished artists, a general lack of Old Master paintings to serve as exemplars, and a far less discriminating audience. In Trumbull's case, the two versions of the *Battle of Princeton* provide ready evidence of his retrogression as a painter. In the first painting, done shortly after *Bunker's Hill* and *Quebec*, Trumbull's energetic composition was heightened by the same dramatic distribution of light and shadow which he had used in the other two pictures. The colors are handled brilliantly, particularly in the Turnbull group and in Mercer's dying horse. In the second version the light has become harsher and more uniform, giving each incident equal value with the others. As a result, Trumbull's colors, particularly the reds and whites, have lost their luminos-

22

Study for The Death of General Mercer
at the Battle of Princeton

1786
Pen and ink and wash on paper, 11¾ x 18¾ (29.8 x 47.6)
Inscribed, verso: *Death of Gen.l Mercer at Princeton
Jan.y 2d 1777 | J. Trumbull— 18ᵗʰ May 1786*
Princeton University Library

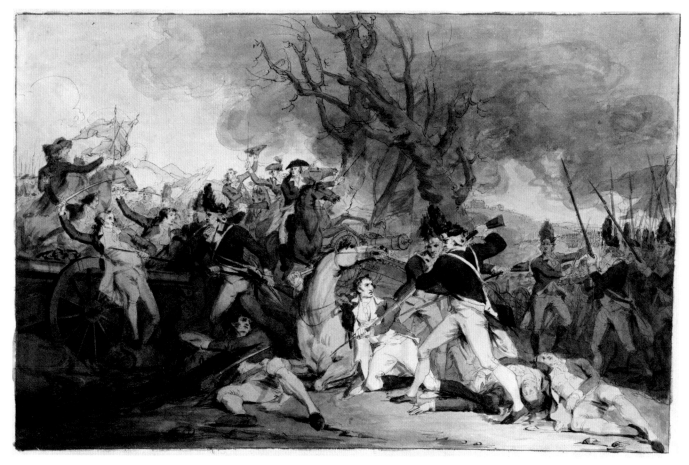

22

ity, and the representations of battle smoke and flags have become opaque and flat. The canvas also suffers from the piecemeal manner in which it was painted. The second version is much less a unified battle scene than it is a series of carefully arranged episodes. Those portions of the second canvas that were executed in the 1790s, such as the figures of Washington and probably Mifflin, are technically superior and anatomically more correct than such later foreground figures as the dead soldier under Turnbull or the grenadier bayonetting Mercer, which may not have been finished until the 1820s.

Despite its shortcomings, Trumbull held the finished version of *Princeton* in high regard. When Benjamin Silliman asked him, hypothetically, which of the paintings in the Trumbull Gallery he would save first from destruction, Trumbull replied: "I would save this painting of the battle of Princeton."[20] Perhaps Trumbull's lifelong idolization of Washington led him to choose a less aesthetic-

cally successful picture, but the only one in which he celebrated Washington's heroism in battle.

1 Horace Walpole to Sir Horace Mann, April 3, 1777, in W. S. Lewis, Warren Hunting Smith, and George L. Lamb, eds., *Horace Walpole's Correspondence with Sir Horace Mann*, 11 vols., New Haven, 1954–71, VIII, p. 287.
2 A standard history of the battle is Alfred Hoyt Bill, *The Campaign of Princeton, 1776–1777*, Princeton, 1948.
3 Casts and engravings after these statues were available to Trumbull when he was a student at the Royal Academy in 1784; see Giuseppe Baretti, *A Guide Through the Royal Academy*, London, 1781, and Francis Haskell and Nicholas Penny, *Taste and the Antique: The Lure of Classical Sculpture 1500–1900*, New Haven and London, 1981, pp. 136–40, 243–47.
4 Sir Joshua Reynolds, *Discourses on Art*, Robert R. Wark, ed., New Haven, 1975, pp. 99–100.
5 Jaffe 1975, p. 151, suggests that Trumbull took the motif of a tangle of figures around a thrashing horse from Benjamin West's *Edward the Black Prince Crossing the Somme*. However, West was at work

College and Village of Princeton

1790
Pen and ink and wash on paper, 2¾ x 4½ (7 x 11.4)
Inscribed, verso: *The College & Village of Trenton as seen |
 from the Field on which was fought the Battle | of the 2ᵈ
 Jany 1777. | Drawn Dec. 10ᵗʰ, 1790 by | J. Trumbull*
Rockingham State Historic Site, New Jersey Division of
 Parks and Forestry

23

on this picture until 1788, and since two of the drawings for
Princeton are dated "1786," it is difficult to determine whether
Trumbull saw West's studies, or one artist borrowed from the
other, or if they both drew on a common source for a similar
compositional problem.

6 Six of the compositional drawings at the Princeton University
 Library (Cats. 16, 17, 19, 20, 21, 22) were numbered sequentially by
 Trumbull at a later time, which may explain why the order of the
 first two was reversed. Sizer 1967, pp. 143–46, accepts Trumbull's
 numbering.

7 The motif may have originated with the group of fleeing figures
 in Copley's *Peirson*; see Jaffe 1975, p. 151.

8 Jaffe, ibid., suggests that the fallen swordsman who leans on a
 drum may be based on a similar motif in Copley's *Peirson*. The line
 of grenadiers may also be derived from this source.

9 Silliman, "Notebook," II, p. 70. The unfinished version of *Prince-
 ton* has sometimes been referred to as a preliminary sketch, but
 both Silliman's recollections and the detailed underpainting on
 the canvas refute this idea. Silliman also notes that Trumbull
 placed the unfinished work in the gallery "as a study for young
 artists."

10 Ibid., II, p. 82.

11 Trumbull made the same mistake in dating his first studies for the
 Sortie to 1787; see Trumbull 1841, p. 148.

12 Silliman, "Notebook," II, p. 70; see also p. 32, above, where
 Prown points out that the first *Princeton* canvas is identical in size
 to *Bunker's Hill* and *Quebec*, and hence must have immediately
 followed them.

13 The detail of Captain Leslie's sword hanging from his wrist by a
 leather thong, which appears only in the second painting, was
 added to the picture after the British artist Robert Sherr Porter
 described this detail to Trumbull during a visit to Trumbull's
 London studio; see Silliman, "Notebook," II, p. 84.

14 Trumbull 1841, p. 164, and John C. Fitzpatrick, ed., *The Diaries of
 George Washington*, 4 vols., Boston and New York, 1925, IV, pp. 86,
 93, 106, and 136.

15 *Proposals by John Trumbull, for Publishing by Subscription Two Prints
 from Original Pictures painted by himself*, New York, April 2, 1790,
 YUL-JT.

16 Howard C. Rice, Jr., "Lost Horizon: The Princeton Skyline in
 1790, drawn by John Trumbull," *The Princeton University Library
 Chronicle*, 29 (Winter 1968), pp. 124–26.

17 JT to Harriet Wadsworth, April 27, 1791, YUL-JT.

18 JT to Hugh Mercer, December 4, 1827, NYHS.

19 Trumbull 1831, no. 8.

20 Silliman, "Notebook," II, p. 86.

24

The Capture of the Hessians at Trenton, December 26, 1776

1786–1828
Oil on canvas, 21¼ x 31⅛ (54 x 79.1)
Yale University Art Gallery; Trumbull Collection

The Capture of the Hessians at Trenton focuses on the magnanimity of the victorious Americans toward a fallen enemy officer. In the center, General Washington, attended by two aides, Captain Tench Tilghman and Lieutenant Colonel Robert Harrison, directs Major William Stephens Smith to care for the mortally wounded Hessian Colonel Johann Gottlieb Rall.

> [I] composed the picture, for the express purpose of giving a lesson to all living and future soldiers in the service of [their] country, to show mercy and kindness to a fallen enemy— their enemy no longer when wounded and in their power.[1]

In secondary roles, at the right, General Nathanael Greene on a white horse looks down on Captain William Washington, who has been wounded in the right hand; in the left middle distance, Lieutenant James Monroe lies badly wounded on the ground, supported by a comrade.[2]

Trenton commemorates an important American victory. On December 25, 1776, Washington resolved to put an end to the long series of military defeats that had demoralized American troops by launching a surprise attack on the Hessians at Trenton. After crossing the Delaware on a stormy night, the Continentals besieged the town with cannons and bayonets. The Germans, caught on the morning after Christmas celebrations, were unable to organize a resistance; the ensuing battle lasted only forty-five minutes. Colonel Rall, the Hessian commander, was mortally wounded, and 1000 of his troops taken prisoner, while only three Americans were injured.[3]

In his *Autobiography*, Trumbull implies that he began the studies for *Trenton* simultaneously with those for *Princeton* (Cat. 14) and *Yorktown* (Cat. 27).[4] Accounts of the battle state that Washington and Rall were on King Street in Trenton at about the same time, although they did not meet. In an early sketch of the composition, Trumbull adheres to this report, placing the two officers at some distance from one another (*Fig. 37*).

In the painting, Trumbull shifted Washington from the side of the scene to the center, making him the focal point of the picture. The tripartite structure of the composition not only draws attention to the action of the hero, it also creates a mood of stability and calm. As in his other history paintings, Trumbull opted for dignity and multiplicity of incident over visual interest and drama. In the early sketch, the horsemen led by Washington create a diagonal thrust to the right of the composition and the figure of Rall is backed by dramatically rearing horses. The flag, bunched into a complex and potentially beautiful form in the drawing, becomes in the painting a flat, less interesting shape. Moreover, where there are only seven figures in the foreground and middle ground in the sketch, in the finished work their number has expanded to twenty-three. Trumbull apparently decided that the importance of the occasion required him to present as many

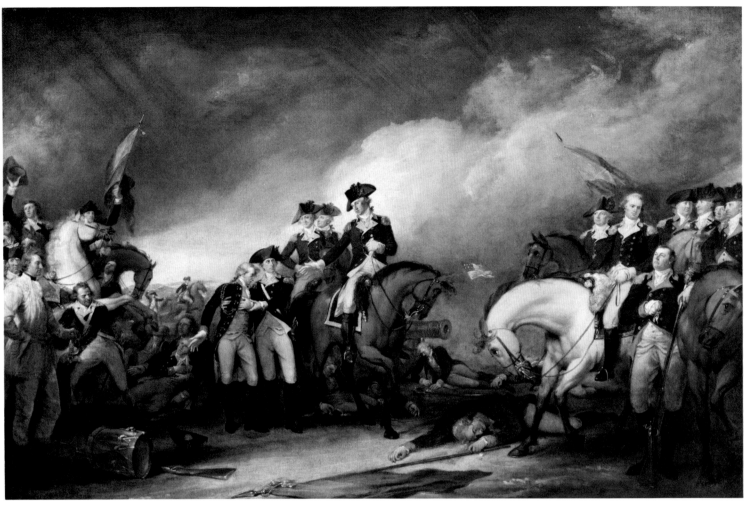

24

historical personages as possible. In effect the artist has been replaced by the visual historian.

Trenton shares a number of motifs with *Princeton* and *Gibraltar*: in the right center background the wounded Hessian on the ground between the two horses is derived from the *Dying Gaul*, which Trumbull had sketched on a sheet of drawings for *Princeton* (*Fig. 36*) and had also used in studies for *Gibraltar* (*Fig. 31*); on the left, the fallen Monroe supported by his companion is similar to the group which appears in studies for both *Princeton* and *Gibraltar*.

By 1789, when Trumbull returned to America, *Trenton* was sufficiently advanced to receive portraits. Over the next two years, the artist traveled to New York, Fredericksburg, and other Eastern seaboard towns, taking likenesses for the history paintings. It was during one of these trips that Trumbull probably executed the drawing of Arthur St. Clair (Cat. 104), a general who participated in the battles of Trenton and Princeton.[5] Two of the American officers depicted in *Trenton* had died before Trumbull returned to America: Nathanael Greene (see Cat. 46) and

Tench Tilghman. The artist copied the former from Charles Willson Peale's 1783 portrait, and may have portrayed the latter from memory.[6]

Anxious to secure Washington's portrait for *Trenton*, *Princeton*, and *Yorktown*, Trumbull made arrangements (probably through his brother Jonathan), to dine with the president. After meeting the artist and seeing his paintings, Washington agreed to several sittings over a period of two months, and one day even exercised on horseback at the artist's request.[7] In both *Princeton* and *Trenton*, Charles Willson Peale noted that "Washington [is] placed in an amiable point of view," displaying noble bravery in the former, and "magnanimous kindness" in the latter.[8] According to Benjamin Silliman, "Col. Trumbull remarked . . . that Washington's face varied extremely in its expression in different circumstances. In this case [*Trenton*], he is looking down from his horse with an expression of deep sympathy and concern. The artist when painting his portrait desired Gen! Washington to place himself as nearly as possible in the position which he occupied at that moment."[9]

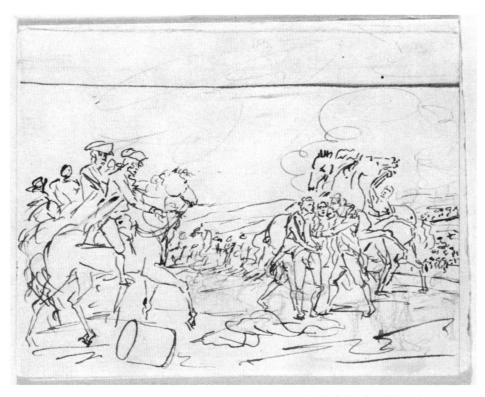

Fig. 37. Study for *The Capture of the Hessians at Trenton*, 1787 or 1788. New York, Fordham University Library; Charles Allen Munn Collection.

Although by 1790, the composition of *Trenton* was "considerably advanced," it underwent several changes before its completion in 1828.[10] Benjamin Silliman recorded the origin of one alteration: "The horses of Gen Washington & Greene standing near to & looking at each other are bowing their heads and curvetting as they are reined in. The artist remarked to me that 'some critics might say— these horses are making bows at each other & so I placed a dead Hessian on the ground between them that the horses might have something to snort at.' "[11] In spite of these changes, or in part because of them, *Trenton* drew sharp criticism. When Dunlap visited the Trumbull Gallery in 1834, he remarked: "All that is good in this picture was painted in 1789 and shortly after. What is good is very good, but unfortunately the artist undertook, in afterlife, to finish it, and every touch is a blot. To look at the hands and compare them to the heads, excites astonishment. Washington's head and Smith's are jewels— the hands are very bad."[12]

1 Trumbull 1841, p. 420.
2 "He [Monroe] was dangerously wounded by a ball which passed through his lungs," Trumbull told Silliman in the 1830s, and "that fortunate ball . . . made him president of the United States"; see Silliman, "Notebook," II, p. 74.
3 See William S. Stryker, *The Battles of Trenton and Princeton*, Boston, 1898, reprint Spartanburg, S.C., 1967, pp. 1–196.
4 Trumbull 1841, p. 148. In Trumbull 1831, no. 7, he described the painting as "composed in London 1786 & 7— finished in America in 1828."
5 Sizer 1967, fig. 165, identifies the figure on horseback at the right of *Trenton* as Major John Sullivan, but the portrait more closely resembles St. Clair.
6 Jaffe 1975, p. 320; see Cat. 46.
7 John C. Fitzpatrick, ed., *The Diaries of George Washington*, 4 vols., Boston and New York, 1925, IV, p. 93.
8 Charles Willson Peale, "Diary," 1817, p. 11, Library of the American Philosophical Society, Philadelphia.
9 Silliman, "Notebook," II, pp. 73–74.
10 *Proposals by John Trumbull, for Publishing by Subscription Two Prints from Original Pictures painted by himself*, New York, April 2, 1790, YUL-JT; see also Jaffe 1975, p. 320.
11 Silliman, "Notebook," II, p. 74. The figure itself bears witness to its introduction at a late date; it is poorly drawn and unconvincing anatomically, the work of Trumbull's declining years.
12 Dunlap 1834, I, p. 392.

25

The Declaration of Independence, July 4, 1776

1787–1820
Oil on canvas, 21⅛ x 31⅛ (53.7 x 79.1)
Yale University Art Gallery; Trumbull Collection

26

Thomas Jefferson,
Plan of Assembly Room
John Trumbull, First Idea
of the Declaration of Independence

1786
Pen and ink and pencil on paper, 6¹⁵/₁₆ x 9¹/₁₆ (17.6 x 23)
Inscribed: lower left, *done by Mr. Jefferson— Paris 1786: to
 convey | an Idea of the Room in which congress | sat, at the
 Declaration of Independence | on the ground floor of the
 old state house in | Philadelphia— lefthand at entering ;*
 along vertical fold at center, *first Idea of Declaration of
 Independence | Paris Sept. 1786.*
Yale University Art Gallery; Gift of Mr. Ernest A.
 Bigelow

The Declaration of Independence is without doubt the best
known of Trumbull's works. Trumbull himself consid-
ered it to be of such importance that in 1817, when he won
the commission from Congress to decorate the Capitol
Rotunda with four life-size paintings of scenes from the
Revolutionary War, he chose to begin with a copy of the
Declaration. At the time, the sixty-one-year-old artist
wrote to President James Madison:

> I have been constantly occupied with the Declaration
> of Independence, feeling the uncertainty of life &
> Health, & considering that Subject as most
> interesting to the Nation, as well as most decisive of
> my own Reputation. . . . The universal interest which
> my Country feels & ever will feel in this Event will in
> some degree attach to the painting which will
> preserve the resemblance of Forty Seven of those
> Patriots to whom we owe this memorable Act and all
> its glorious consequences.[1]

Although the scene was described by Trumbull himself
as portraying the events of July 4, he actually represents
the moment on June 28 when the committee appointed to
draw up the document submitted Thomas Jefferson's
draft for the consideration of Congress. In the center of
the composition, Jefferson presents the document to John
Hancock, then president of Congress, and the first signer
of the Declaration. Jefferson is surrounded by the other
members of the drafting committee: John Adams, Roger

Sherman, Robert Livingston, and Benjamin Franklin. In
the background, forty-eight congressmen are clustered in
groups of varying size, most with their heads turned
attentively to the action of the committee.

Although this painting became one of Trumbull's most
important works, he did not include the *Declaration* in his
original plan for a series of history paintings.[2] In fact,
there is no mention of the subject in Trumbull's letters
until 1786, when he visited Thomas Jefferson in Paris.
Greatly impressed with Trumbull's plans to execute a set
of American history paintings, Jefferson had invited the
artist to stay with him at his home, the Hôtel de Lan-
geac.[3] There, "I began the composition of the Declaration
of Independence, with the assistance of his information
and advice."[4]

It seems likely that Jefferson, chief author of the docu-
ment, might have suggested the topic to Trumbull as a
possible addition to his history series. Apparently, the
two Americans discussed the subject in some detail, with
Jefferson providing a firsthand account of the event and a
rough floorplan of the Assembly Room in the Pennsylva-
nia State House at Philadelphia where Congress had con-
vened (Cat. 26). As Trumbull's inscription indicates, the
sketch was intended "to convey an Idea of the Room in
which congress sat." It is not an architecturally accurate
description of the interior. The drawing indicates an en-
trance near the north end of the west wall instead of the
double door at the center of the wall that actually served
as an entrance. Jefferson also added an additional window
on the north wall.

On the opposite side of Jefferson's floor plan, Trum-
bull sketched his first idea for the composition, using the
interior recollected by Jefferson. The committee stands in
the center of the room, looking toward John Hancock,
who is seated behind a table to the right. In the final
composition, the committee is closer to the viewer and
faces right. Jefferson stands at the edge of the desk as he
hands the document to Hancock.

In all of his compositional sketches, Trumbull chose to
have the whole committee present the document rather
than a single spokesman, which would have been histori-
cally accurate. In the catalogue for an early exhibition of
the *Declaration* at Yale College, Trumbull, speaking in the
third person, states:

> In order to give some variety to his composition, he
> found it necessary to depart from the usual practice of
> reporting an act, and has made the whole committee
> of five advance to the table of the president, to make
> their report, instead of having the chairman rise in his
> place for the purpose: the silence and solemnity of the
> scene, offered such real difficulties to a picturesque
> and agreeable composition, as to justify, in his
> opinion, this departure from custom, and perhaps
> fact.[5]

Trumbull consulted with John Adams and Jefferson over
several questions regarding the particular moment to be
portrayed, and the individuals to be represented.

> Should he regard the fact of having been actually
> present in the room on the 4th of July, indispensable?
> Should he admit those only who were in favor of, and
> reject those who were opposed to the act? Where a
> person was dead, and no authentic portrait could be
> obtained, should he admit ideal heads?[6]

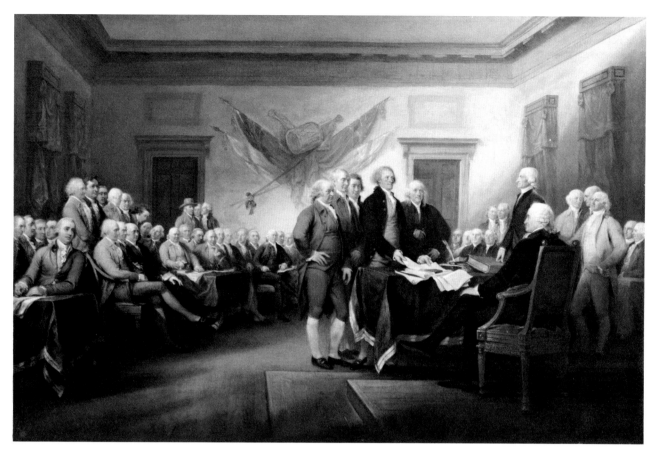

25 *Color reproduction, Fig. 1*

Adams and Jefferson, as Trumbull later recalled, advised him that

> with regard to the characters to be introduced, the signatures of the original act . . . ought to be the general guide. That portraits ought, however, to be admitted, of those who were opposed to, and of course did not sign, as well as of those who voted in favor of the declaration, and did sign it, particularly John Dickinson, of Delaware, author of the Farmer's Letters, who was the most eloquent and powerful opposer of the measure . . . that where any one was dead, he should be careful to copy the finest portrait that could be obtained; but that in case of death, where no portrait could be obtained, (and there were many such instances, for, anterior to the Revolution, the arts had been very little attended to, except in one or two cities,) he should by no means admit any ideal representation, lest, it being known that some such were to be found in the painting, a doubt of the truth of others should be excited in the minds of posterity; and that in short, absolute authenticity should be attempted, as far as it could be obtained.[7]

Trumbull seems to have followed this advice in most respects, including the accurate rendering of contemporary costumes. "In fact," he writes, "nothing has been neglected by the artist, that was in his power, to render this a faithful memorial of the great event."[8]

Nevertheless, because Trumbull based his representation of the Assembly Room on Jefferson's recollections, the interior was inaccurate. As noted above, Jefferson made errors in his floor plan, particularly in the placement of the doors. The trophy of banners on the rear wall may have been added at Jefferson's direction, since it appears in Trumbull's first sketch for the picture. Trumbull knew that such a trophy was not present in the Assembly Room in 1776: he wrote that he "took the liberty of embellishing the background by suspending upon the wall, military flags and trophies: such had been taken from the enemy at St. John's, Chambly, &c. and probably were actually placed in the hall."[9] He also gave the room a Doric cornice, and covered the windows with elaborate draperies instead of the venetian blinds that were actually in place. It is now known that the Assembly Room was furnished with Windsor chairs, but Trumbull provided the members of Congress with elegant mahogany armchairs, placing Hancock in an upholstered and gilded version. These additions may have been intended to elevate the character of the proceedings of a provincial assembly in the eyes of a European audience. Trumbull may even have copied furnishings he had seen in Jefferson's Paris house; in his first sketch he showed Hancock in an oval-back Louis XVI armchair, which was probably based on a French model.[10]

After returning to London in November of 1786, Trumbull continued to work on the *Declaration*. He

planned the composition in sketches, within the boxlike space recollected by Jefferson. In a sketch (*Fig. 38*), he placed the corner of the room at the picture's center. In a later drawing, he changed the angle of view (*Fig. 39*) so that the rear wall is parallel to the picture plane. This more symmetrical design is used in the Yale painting and imparts a sense of stability to the scene.

By the summer of 1787, Trumbull had "arranged carefully the composition . . . and prepared it for receiving the portraits, as I might meet with the distinguished men, who were present at that illustrious scene."[11] As Jaffe notes, radiographs show that Trumbull painted in the background of his composition, leaving space for faces and figures. Once the portrait was in, he would paint and repaint the area around it to make the figure fit the pocket.[12] Trumbull painted some of the portraits directly onto the canvas.[13] For others, he executed preparatory pencil drawings, such as *Stephen Hopkins* (Cat. 109), or miniature portraits on mahogany.

Both Benjamin Franklin and John Adams were painted directly onto the canvas during the summer of 1787. "Mr. Adams took leave of the court of St. James," Trumbull wrote, "and preparatory to the voyage to America, had the powder combed out of his hair. Its color and natural curl were beautiful, and I took that opportunity to paint his portrait in the small Declaration of Independence."[14] In Paris he painted Jefferson's portrait from life onto the canvas, and regarded this as one of the best among his small portraits.[15]

In 1790, Trumbull returned to America and traveled up and down the East coast, collecting portraits for his history paintings. During the next few years, he went to Boston, where he painted John Hancock and Samuel Adams; to Charleston, where he painted Edward Rutledge, and to Newport, Providence, New Hampshire, Philadelphia, and Yorktown. In a letter to Jefferson, Trumbull related the success of his efforts:

> The picture will contain Portraits of at least Forty Seven Members:— for the faithful resemblance of Thirty Six I am responsible, as they were done by myself from the Life, being all who survived in the year 1791. of the remainder, Nine are from pictures done by others:— One Gen! Whipple of New Hampshire is from Memory: and one M.^r Ben: Harrison of Virginia is from description, aided by memory.[16]

Trumbull added Harrison's face in December 1817. The last portrait to be added was that of Thomas Nelson, Jr., in 1819. Trumbull completed his first version of the *Declaration of Independence* by the following year.[17]

After the artistic adventurousness and compositional daring of the early battle scenes, *The Declaration of Independence*, which also depicts an event of enormous national interest and historical significance, seems static and repetitive. Given the nature of the assembly and Trumbull's determination to record the likenesses of as many members as possible, he was faced with a difficult problem. The artist could not avoid painting rows of heads with portraits of forty-eight members of the Congress, most of them sitting quietly in their seats. The central event itself, Jefferson handing his draft of the Declaration to Hancock, is devoid of action and without pictorial drama. The individual portraits are sometimes very fine,

as is that of Jefferson, but in many cases years passed before Trumbull took a likeness, so that it was painted when his skills as a portraitist had begun to decline. Despite these difficulties, his determination resulted in a national icon.

In January of 1817, Trumbull had set up the nearly finished painting in the hall of the House of Representatives, together with its Key, as part of a proposal to decorate the Capitol Rotunda with a series of history paintings.[18] He originally intended to produce half life-size figures for the Capitol series, but President Madison preferred life-size ones. The artist set to work on the commission by ordering the 12 x 18-foot canvas for the *Declaration*. By the end of the year, he had laid in the figures and the lights and darks.[19] This version of the *Declaration* is a direct copy of the Yale painting, except that it omits one of the forty-eight congressmen, Thomas Nelson, Jr.

When Trumbull completed the large painting in 1818, he exhibited it at the American Academy of the Fine Arts in New York. Between October 5 and November 7, 6375 visitors paid 25 cents to see it. During a one-day benefit for the Deaf and Dumb Institute, 1328 persons came to view the painting. After the New York City exhibition, the *Declaration* toured Boston, Philadelphia (at Independence Hall in the room where the original signing took place), and Baltimore, and arrived in Washington on February 16, 1819, when it was submitted to Congress.[20] The tour was a tremendous success— the high point of Trumbull's career. He chose a young American, Asher B. Durand, to engrave the *Declaration*, and began a campaign to sell subscriptions. However, the campaign was not as successful as the exhibition tour. By 1823, when the print was completed, only 275 subscriptions had been sold.[21]

The Capitol version of the *Declaration* drew harsh judgments from several factions. John Vanderlyn and William Dunlap, envious of Trumbull's comfortable commission, severely criticized the "poor touch and coloring" and the "violations of truth" in the paintings.[22] One anonymous critic, who signed himself "Detector," wrote a biting commentary on the historical inaccuracies of the *Declaration*:

> It is not my intention to examine the merits of this production as a specimen of the arts. It may, perhaps, be a *very pretty picture*, but is certainly no representation of the Declaration of Independence. . . .
> To make the "national painting" . . . subservient to a display of the likeness of any American, however distinguished, who was not both a member of Congress and present in that body when Independence was declared, is . . . ridiculous.[23]

Trumbull responded by describing the considerable difficulties in obtaining completely accurate information:

> The journals of Congress are silent; it would be dangerous to trust the memory of any one— and the only prudent resource was to take as a general guide the signatures to the original instrument, although it was well known to Mr. Jefferson and Mr. Trumbull then as it is now to the sagacious "Detector" that there were on that instrument the names of several gentlemen who were not actually present on the 4th of July; and also, that several gentlemen were then present who never subscribed.[24]

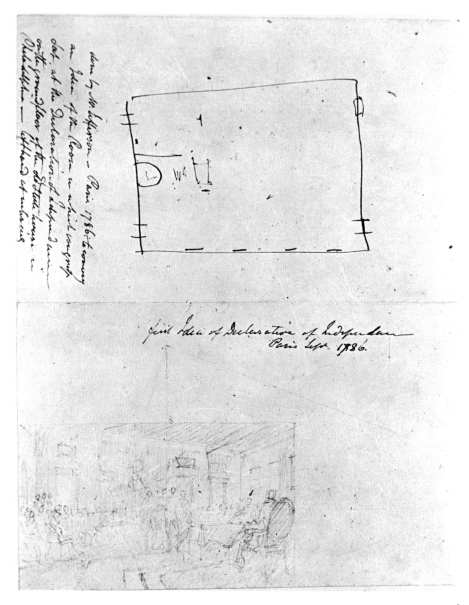

26

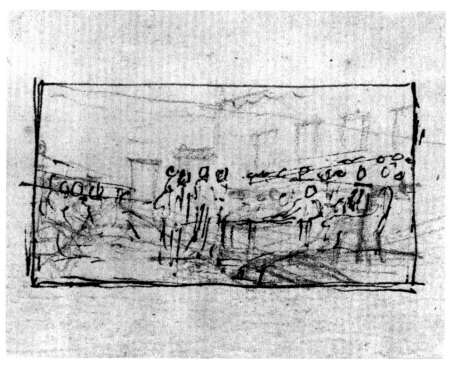

Fig. 38. Study for *The Declaration of Independence*, detail, 1786 or 1787. Philadelphia, The Historical Society of Pennsylvania.

Fig. 39. Study for *The Declaration of Independence*, 1786 or 1787. Philadelphia, The Historical Society of Pennsylvania.

Several members of Congress criticized Trumbull for exhibiting the Capitol paintings for profit before giving them to the nation.[25] Furthermore, some congressmen were disappointed in the paintings as works of art. In 1828, Representative John Randolph, a member of the committee that had supported Trumbull's commission ten years earlier, declared that he

> hardly ever passed through that avenue [the Rotunda] to this Hall . . . without feeling ashamed of the state of the Arts in this country; and, as the pieces of the great masters of the Arts have, among the *cognoscenti*, acquired a sort of *nom de guerre*, so ought, in his opinion, the picture of the Declaration of Independence to be called the *Shin-piece*, for surely never was there before such a collection of legs submitted to the eyes of man.[26]

In 1832, Trumbull installed the first version of the *Declaration* in the newly built Trumbull Gallery at Yale College. Shortly after, he began a third version of the subject, intended to hang in the Trumbull Gallery planned for Hartford. The Wadsworth version of the *Declaration* (*Fig. 39a*) differs from the two earlier paintings. For unknown reasons, Trumbull deleted the portrait of Josiah Bartlett, the third figure from the left in the original version. He also provided a more accurate representation of the Assembly Room, placing a single door in the center of the rear wall, and showing molded plaster walls and a dentil cornice. Although no criticism of his original depiction of the room is recorded, it is possible that Trumbull heard

negative comments regarding the historical accuracy of the Rotunda picture when it was exhibited in Philadelphia in 1817. At about the same time, Joseph Sansom made a drawing from memory of the Assembly Room interior, which Trumbull may have owned and used to paint the background of the Wadsworth *Declaration*.[27] Perhaps he had not been aware of the inaccuracies of Jefferson's floor plan until after the Rotunda picture was publicly exhibited, although he must have visited the Pennsylvania State House in 1790.[28] It is possible that the opportunity to correct inaccuracies gave the artist an added incentive to return to this theme for a third and final time.

1 JT to James Madison, autograph copy, December 26, 1817, YUL-JT.

2 In a letter to his brother Jonathan, Trumbull listed the events he had in mind for the series: the Battle of Bunker's Hill, Trenton, Saratoga, and Yorktown; JT to Jonathan Trumbull, Jr., September 13, 1785, YUL-JT.

3 See Marie Kimball, *Jefferson: The Scene of Europe 1784–1789*, New York, 1950, pp. 117–18.

4 Trumbull 1841, p. 96.

5 Trumbull 1832, p. 15.

6 Ibid., p. 14.

7 Ibid. There were fifty-six signers of the Declaration of Independence. Trumbull represented forty-three. For those omitted, as well as the variations between the Yale and Wadsworth Atheneum versions, see Jaffe 1975, p. 319.

8 Trumbull 1841, p. 418.

9 Ibid.

10 For a complete history of the Assembly Room interior, see Penelope Hartshorne Batcheler, "Independence Hall: Its Appearance Restored," in *Building Early America: Contributions toward the*

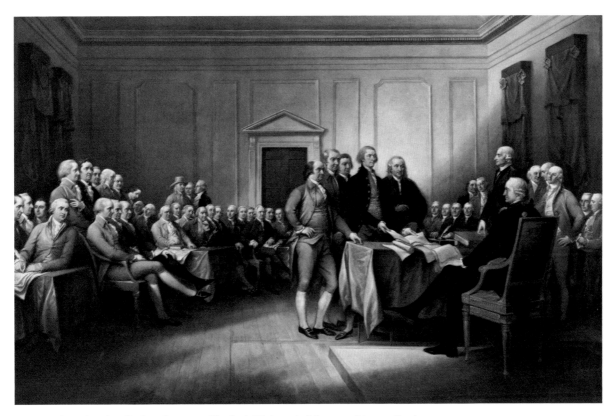

Fig. 39a. *The Declaration of Independence*, 1832. Hartford, Wadsworth Atheneum; Museum Purchase.

History of a Great Industry, Charles E. Peterson, ed., Radnor, Pa., 1976, pp. 298–318. The use of Windsor chairs in the State House is discussed in Jane B. Kolter and Lynne A. Leopold-Sharp, eds., *The Branded Windsor Furniture of Independence National Historical Park*, Philadelphia, 1981, p. 6. The Lewis Walpole Library, Yale University, owns a set of Philadelphia-made chairs which exhibit turnings and backs similar to the unusual "cabriole" armchairs Trumbull placed in the interior, although no example identical to Trumbull's chairs is known. A complete view of one of these chairs is possible by combining the partial views seen in both the *Declaration* and the *Resignation* (Cat. 31), in which identical chairs were represented.

11 Trumbull 1841, p. 146.

12 Jaffe 1975, p. 107.

13 In a letter to Robert Treat Paine, February 22, 1837, YUL-JT, Trumbull makes clear that he painted portraits from life into his history paintings: "The Portrait of your Grandfather was painted by me in Boston in 1791— and as I had then the original picture with me for the purpose, I painted Saml Adams, Mr. Paine & others in the original work— without any separate sketch or Study."

14 Trumbull 1841, pp. 146–47.

15 Ibid., p. 151.

16 JT to Jefferson, December 28, 1817, Letterbook, YUL-JT. This statement is not completely accurate. As Jaffe 1975, p. 319, notes, Hopkins' portrait was painted posthumously from a likeness of his son. Eight other signers had died by 1791, and had to be represented by portraits taken after other artists: Franklin, Hewes, Hooper, Hopkinson, Livingston, Lynch, Middleton, and Stockton. Although George Walton and John Dickinson were both alive in 1791, Jaffe believes Trumbull copied their portraits from other sources: the former, from a portrait by an artist named Edwards (Charles Tait to JT, July 31, 1817, HSP); the latter, possibly after the engraving by James Smither; see Jaffe 1975, pp. 116–18.

17 Ibid., p. 318. The total number of portraits actually came to forty-eight; the five non-signers Trumbull depicted were George Clin-

ton, John Dickinson, Robert Livingston, Thomas Willing, and Charles Thomson.

18 For the commission and Trumbull's lobbying efforts, see pp. 262–64. Trumbull's original Key for the *Declaration* is lost. The earliest known Key is the "Durand" Key, published by Asher B. Durand in 1823. Based on the Yale painting, it shows forty-eight heads. In an essay on Fordham University's Trumbull drawings, Jaffe (1971, pp. 6–14) suggests that the Durand Key misidentifies three of the individuals represented: Stephen Hopkins, George Clinton, and John Dickinson.

19 Trumbull 1841, p. 262; see Jaffe 1975, p. 236.

20 Jaffe 1975, p. 242; accounts of expenses and receipts for the exhibition of the Rotunda paintings are in manuscript form in account books for 1821–24, YUL-JT and NYHS.

21 Jaffe 1975, p. 241. This was a bitter disappointment to Trumbull since he had relied upon the subscriptions to the series of engravings for a steady income.

22 Dunlap 1834, I, p. 376; John Vanderlyn to Thomas Sully, August 6, 1820, Boston Public Library.

23 *Washington National Advocate*, October 20, 1818, reprinted in *The Portfolio*, 7 (1819), pp. 84–86.

24 *New York Daily Advertiser*, October 22, 1818, reprinted in ibid., pp. 86–87.

25 *Annals of the Congress of the United States* (1855), 15th Congress, Second Session, February 8, 1819, pp. 1142ff.

26 Ibid., 20th Congress, Second Session (1828), January 9, 1828, I. p. 942. In fact, very few legs are visible in the painting. Garry Wills, *Inventing America*, New York, 1979, p. 347, suggests that Randolph's gibe refers not to the number of legs in the painting, but to the fact that the participants are shown in stockings and knee britches which accentuate their calves; at a time when figures in historical scenes were traditionally presented in classical garb, Trumbull's representation of contemporary dress made this "a decidedly bourgeois picture of a heroic deed."

27 Reproduced in Jaffe 1975, fig. 72.

28 Irma B. Jaffe, *John Trumbull: Five Paintings of the Revolution*, Hartford, Conn., 1975, pp. 23–24.

27
The Surrender of Lord Cornwallis at Yorktown, October 19, 1781

1787–c.1828
Oil on canvas, 20⅞ x 30⅝ (53 x 77.8)
Yale University Art Gallery; Trumbull Collection

28
Count Deuxponts
Study for The Surrender of Lord Cornwallis at Yorktown

c.1787
Pen and ink and pencil on paper, 9 x 7³⁄₁₆ (22.9 x 18.3)
Yale University Art Gallery; Gift of the Associates in
 Fine Arts at Yale University

29
Landscape study for
The Surrender of Lord Cornwallis at Yorktown

1791
Pen and ink and wash on three cards, 2¹⁵⁄₁₆ x 13⅝
 (7.4 x 34.5)
Inscribed, verso: *York Town in Virginia April 23ᵈ 1791.* |
 as seen from the point at which the | *British Army*
 enterd between the two lines of | *the Allied Troops of*
 America & France at the Surrender | *in 81.—*
 distance from the advancd works 270 yᵈˢ
Fordham University Library; Charles Allen Munn
 Collection

The Surrender of Lord Cornwallis at Yorktown depicts the
moment when the principal officers of the British army,
colors cased and marching to a tune appropriately entitled
"The World Turned Upside Down," came out of York-
town to lay down their arms— a gesture that signaled the
end of the Revolutionary War. In the center of the com-
position, Major General Benjamin Lincoln, Washington's
second-in-command, accepts the official surrender from
Cornwallis' deputy, standing at the head of the British
and German soldiers. The defeated forces pass between
two lines of victorious troops: the Americans drawn up
on the right of the road, the French facing them on the
left. The leader of each army stands slightly forward of the
ranks, General Rochambeau on the left balancing the
slightly larger and more prominent figure of General
Washington on the right.
 According to historical accounts of the event, General
Cornwallis had feigned illness on the occasion and passed

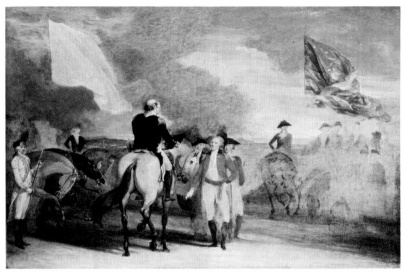

Fig. 40. Study for *The Surrender of Lord Cornwallis at Yorktown*, 1787. The Detroit
Institute of Arts; Gift of Dexter M. Ferry Jr.

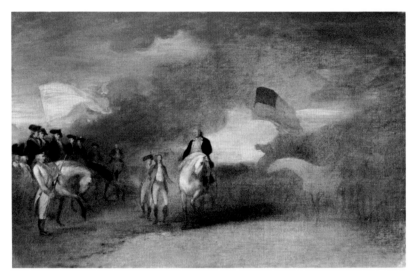

Fig. 41. Study for *The Surrender of Lord Cornwallis at Yorktown*, 1787. The Detroit
Institute of Arts; Gift of Dexter M. Ferry Jr.

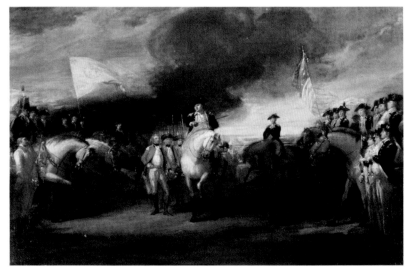

Fig. 42. Study for *The Surrender of Lord Cornwallis at Yorktown*, 1787. Private Collection.

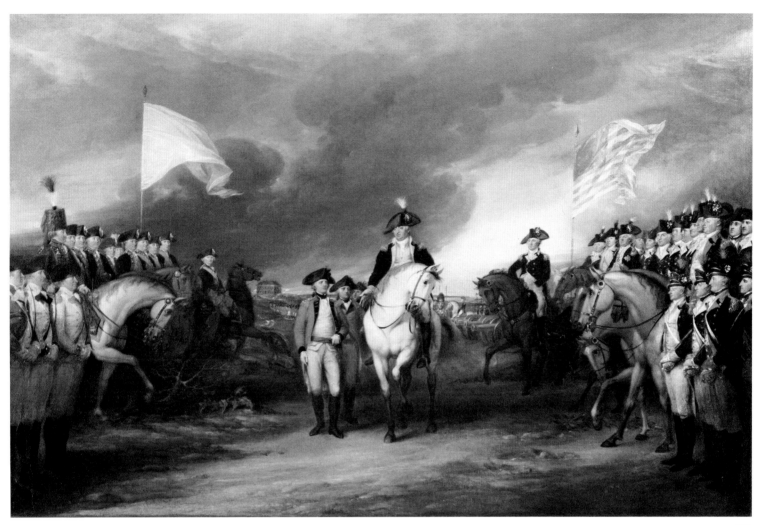

27

the responsibility for surrender to his assistant, General Charles O'Hara. O'Hara had intended to surrender to the Comte de Rochambeau, general-in-chief of the French forces, but the French leader passed him on to Washington, who, recognizing the snub, directed O'Hara to Major General Lincoln. Lincoln accepted O'Hara's sword and handed it back to him.[1]

Trumbull had included a painting depicting the surrender at Yorktown in his original plan for the series of history paintings. He began studies for the composition in 1786 while working on *Princeton* (Cat. 14) and *Trenton* (Cat. 24). Unlike these works, *Yorktown* did not readily lend itself to dynamic or theatrical arrangement.

> The scene was altogether one of utter formality—The ground was level— military etiquette was to be scrupulously observed, and yet the portraits of the principal officers of three proud nations must be preserved, without interrupting the general regularity of the scene. I drew it over and over again, and at last . . . resolved upon the present arrangement.[2]

Trumbull's strict adherence to the formality of the occasion resulted in a static, rigid composition, with rows of portrait heads stretching out in a straight line on either side.

Although few of the drawings survive, three oil sketches give some indication of the problems Trumbull faced in arranging the composition. In an early sketch (*Fig. 40*), the central group occupies the foreground, somewhat in front of the other figures. This arrangement shows General Lincoln from the rear, hatless, his bald pate clearly visible. Apparently displeased with this undignified position, Trumbull turned the figure around in his next sketch (*Fig. 41*), and set the general and his horse further back in space. Since the artist considered portraiture more important than narrative in the commemoration of a historical event, this composition satisfied his purpose: "The principal officers of the three nations are brought near together, so as to admit of distinct portraits."[3] A more developed sketch of this arrangement (*Fig. 42*) closely resembles the final painting, although the faces are not yet portraits, and the French uniforms are red rather than blue.

In September of 1787, Trumbull wrote to Thomas Jefferson that he could not come to Paris until he had settled the composition of *Yorktown*. He wanted to have the painting advanced to the stage where it could receive portraits in order not to lose time when he reached France.[4] In February of the following year, he wrote from Paris to his brother Jonathan:

> I have been in this capital of dissipation and nonsense near six weeks for the purpose of getting the portraits of the French Officers who were at York Town, and have happily been so successful as to find all whom I wished in town. I have almost finished them, and shall return to London in a few days— they are Rochambeau, De Grasse, De Barras, Viomenil, Chattellux [*sic*], St. Simon, the young Viomenil, Chiozy [*sic*], Lauzun, de Custine, de Laval, Deux ponts, Pherson [*sic*], & Dumas— besides the Marquis La Fayette.[5]

These likenesses, which Trumbull regarded as "the best of my small portraits," were painted directly onto the canvas

in Jefferson's house.[6] At this time, he also made an outline sketch of a French officer's uniform, carefully marked with color notations (Cat. 28), which served as his guide in recreating the French army's attire.

When the artist returned to America in 1789, he was pleased to find "all the world assembled" in New York for a congressional session. At this time, he took the likenesses of several of the Americans who were present at Yorktown, including a portrait of Washington on horseback.[7] In his concern for authentic detail, Trumbull traveled to Yorktown in April of 1791 to sketch the site of the surrender (Cat. 29). This drawing accords almost exactly with the terrain in the final composition, showing a distant glimpse of the York River, and Chesapeake Bay. Apparently, Trumbull was less concerned with the historical accuracy of the flags in his painting, since the American flag behind Washington displays thirteen stars and fourteen stripes.[8]

In 1817, Trumbull carried the "far advanced" Yorktown to Washington, D.C., as a sample of what he might produce if Congress awarded him the Capitol commission.[9] Trumbull continued to work on the Yale *Yorktown* while he executed the larger version for the Capitol, completing the latter in 1820. The Yale version occupied him for almost another decade.

1 See Donald Barr Chidsey, *Victory at Yorktown*, New York, 1962, p. 154.
2 Trumbull 1841, p. 148.
3 Ibid., p. 429.
4 JT to Thomas Jefferson, September 17, 1787, in Julian Boyd, ed., *Papers of Thomas Jefferson*, Princeton, 1950– , XII, p. 139.
5 JT to Jonathan Trumbull, Jr., February 6, 1788, NYHS.
6 Trumbull 1841, p. 151.
7 Ibid., p. 164; John C. Fitzpatrick, ed., *The Diaries of George Washington*, 4 vols., Boston and New York, 1925, IV, p. 93.
8 There is no apparent logic to Trumbull's use of the American flag in his history paintings. He included a flag with alternating red and white stripes and a blue canton in both *Princeton* and *Trenton*, although these battles took place half a year before Congress officially adopted this flag on June 17, 1777. Moreover, Trumbull followed no consistent number or arrangement of stars and stripes in any of his representations of the flag. For further discussion, see Sizer 1967, pp. 141–42.
9 JT to Thomas Jefferson, December 26, 1816, YUL-JT.

silver or gold on the
colour of the edging & cuffs

silver small & 3 large

large —

3 Large

3 large

3 Small

Drawpoints.

Light Blue with yellow
& yellow edging - white lining
white Buttons. & Epaulette

Fleur de Lys - Colour of the Cuff

Laval White — white Lappells — Black cuffs & edging
white buttons & Epaulettes. —

Custine White — white Lappells — Green Cuffs & Edging
yellow buttons & Epaulette —

all White cross White. without clasps. —
& yellow Gorgets with 3 fleurs de lis silver. & yellow
swords. except D.P. yellow & white.

Vests single row of Buttons — skirts & pocket flaps
3 small buttons. — plain & no edging.

28

29

The Surrender of General Burgoyne at Saratoga, October 16, 1777

c.1822–32
Oil on canvas, 21¼ x 31⅛ (54 x 79.1)
Yale University Art Gallery; Trumbull Collection

Trumbull depicts the moment when the British General John Burgoyne, attended by General William Phillips, and followed by other officers, offers his sword in surrender to General Horatio Gates, who refuses it, gesturing the generals toward the tent to take refreshments. A number of the principal officers of the American army, headed by Colonel Daniel Morgan, are assembled at the right, while the British troops are indistinctly seen crossing the meadows in the background.

Trumbull's rendition of the event closely accords with historical fact. On October 17, 1777, Burgoyne rode out of camp to meet Gates for dinner and to sign the articles of surrender. At first, Gates did not allow American soldiers to witness the event, but when the British regulars marched away, the Continentals lined the road, and struck up "Yankee Doodle," whereupon Gates and Burgoyne came out to watch. At this point, Burgoyne handed over his sword, and Gates handed it back, according to military custom.[1]

Trumbull had planned *The Surrender of General Burgoyne at Saratoga* as early as 1785 as part of his Revolutionary War series (see p. 80, n. 2). However, he did not actually begin the Yale picture until at least 1822, after having produced the large version for the Capitol Rotunda. He completed the Yale version by 1832, in time for the opening of the Trumbull gallery.[2] The artist considered *Saratoga* an especially appropriate subject with which to decorate the Capitol of the United States: the surrender, which occurred shortly after two fierce engagements between British and American troops, marked the turning point in the Revolutionary War. After this victory, the French government regarded American prospects for independence with greater optimism, and officially recognized the American Republic. The French troops and weapons which bolstered American forces at Yorktown allowed them to win the battle that ended the war.

The only surviving compositional study for the work, a brief outline sketch, dated 1791, suggests that Trumbull planned the subject while at work on *Yorktown*. In both paintings, Trumbull settled on a tripartite composition, although he attempted to effect smoother transitions between the groups of figures in *Saratoga*. At the center, General Gates extends both arms, visually drawing in the other gesturing generals. Jaffe suggests that in arranging the composition, Trumbull was influenced by West's series on the life of Edward III, painted in 1787–89 when Trumbull worked as West's assistant.[3]

Dunlap criticized *Saratoga* for its enervated composition and figure style, suggesting that the lack of vitality was evidence of the artist's advancing years.[4] By comparing the heads of Colonel Morgan and Major Ebenezer Stevens (the figure at the right edge of the canvas) with the original miniatures from which they were adapted (Cats. 73, 48), the deterioration in Trumbull's abilities becomes evident. The artist had collected most of the portraits in the painting from life (see Cats. 47, 48, 49, 50, 72, 75, 82, 107, 108), and was so intent on depicting those involved in the event that the heads are sometimes disproportionately large in relation to the bodies, or incorrectly attached. The head of the figure with his left hand on the cannon, for example, does not fit the torso below it. Moreover, Trumbull's interest in portrait heads resulted in an uninventive arrangement of figures at the right, where they are simply lined up to give each face equal emphasis. However, *Saratoga* is unique for its richly colored landscape background. In September 1791, Trumbull had sketched a landscape panorama of the surrender scene (*Fig. 43*), which bears the notation on the back: "Saratoga seen from the / rising ground nigh the Church, on which / was Gen. Gates' Marquee," that is similar to the topographical sketches he executed for other history paintings. In the final painting the landscape bears little resemblance to the sketch. Perhaps reflecting the interest he developed in landscape painting around 1800, and the impact in the 1820s of Thomas Cole's autumn scenery, Trumbull places the figures in a friezelike arrangement against a background of trees in autumn foliage.

1 See Rupert Furneaux, *Saratoga: The Decisive Battle*, London, 1971, pp. 268–72. In the painting's title, Trumbull erroneously gave October 16 as the date of Burgoyne's surrender.
2 In 1831 he exhibited the still-unfinished painting at the American Academy; see Trumbull 1831, no. 9.
3 Jaffe 1975, p. 246.
4 Dunlap 1834, I, p. 378.

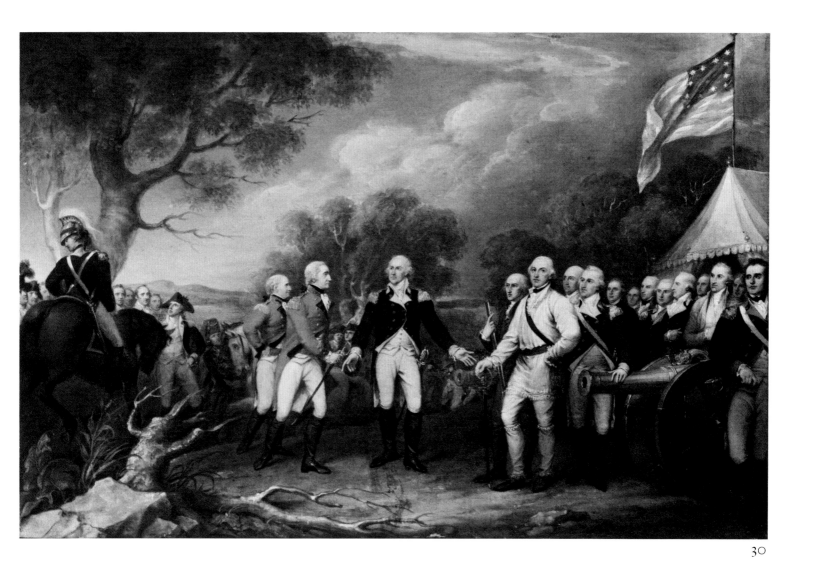

Fig. 43. Landscape study for *The Surrender of General Burgoyne at Saratoga*, 1791. New York, Fordham University Library; Charles Allen Munn Collection.

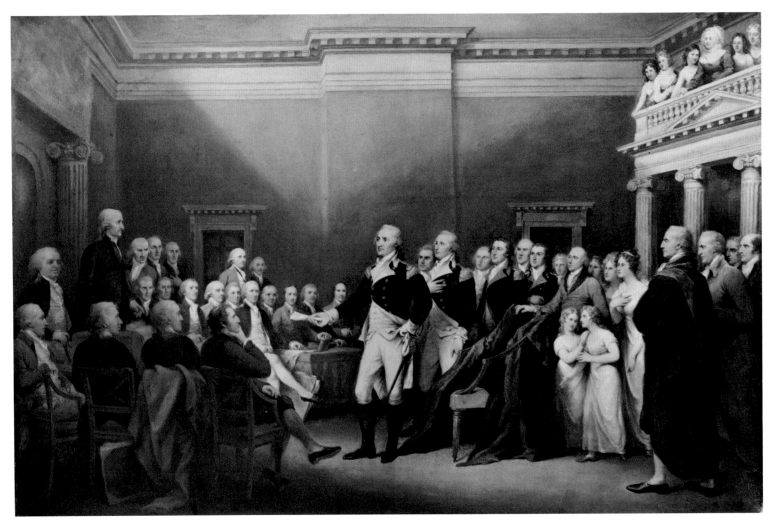

31

Fig. 44. The Resignation of General Washington, 1822–24. Washington, D.C., Architect of the Capitol.

Fig. 45. Study of the State House at Annapolis (recto), 1822. New Haven, Yale University Art Gallery; Gift of the Associates in Fine Arts at Yale.

Fig. 46. Study of the State House at Annapolis (verso), 1822. New Haven, Yale University Art Gallery; Gift of the Associates in Fine Arts at Yale.

The Resignation of General Washington, December 23, 1783

1824–28
Oil on canvas, 20 x 30 (50.8 x 76.2)
Yale University Art Gallery; Trumbull Collection

The Resignation of General Washington represents the moment at the conclusion of the Revolutionary War when the commander-in-chief returned his commission to Congress. As both a scene with Congress in session and a solemn moment in American history, the artist selected this subject to complement *The Declaration of Independence*.[1] Like *Saratoga*, the *Resignation* was part of Trumbull's 1790 proposal, but was not executed until 1822–24 as a Rotunda picture (*Fig. 44*). The smaller version at Yale was probably begun after Trumbull had completed the larger canvas, for in 1828 he wrote, "I have nearly finished my small copy of the Resignation of Washington."[2]

As with the *Declaration*, Trumbull wished the *Resignation* to be a faithful record of the event. Because he did not take up the subject until 1822, however, he encountered difficulties in composing a historically accurate picture. The *Journal of Congress* supplied him with the names of those persons who were present at the Annapolis State House on December 23, 1783, but Trumbull could find life portraits of only a few of these men. He copied the figure of Washington from his own 1792 portrait of the general (Cat. 42).[3] At least seven of the miniature portraits he had taken between 1790 and 1793 were of participants in this scene; he also seems to have based the figures of the two women at the left of the balcony group on his miniatures of Harriet Chew and Harriet Wadsworth (Cats. 55, 96), although neither woman was present at the event.[4] In 1822, Trumbull sent a printed letter to members of Congress, asking them to seek out portraits of their predecessors.[5] The artist's quest for likenesses was unsuccessful, however, for a contemporary pamphlet describing the Rotunda picture noted that "a few *ideal* heads have been admitted" to the painting.[6] He also introduced several persons who were not in Annapolis at the time, including Martha Washington and her granddaughters, and James Madison. Trumbull explained to Madison, "that I may have all the Virginia Presidents, I have taken the liberty . . . of placing you among the Spectators— It is a Painter's licence, which I think the occasion may well justify."[7]

Trumbull exercised further license in his representation of the Senate Chamber. Perhaps to avoid the inaccuracies that had crept into the *Declaration*, he visited the Annapolis State House in 1822, making both an overall sketch of the interior and a detailed study of the Ionic capital and frieze over the president's chair (*Figs. 45, 46*). Although the drawing clearly shows the mantel and the large portrait that hung above it, in both versions of the painting Trumbull chose to omit these details. He also left out the windows flanking the niche behind the president, and made the niche itself more shallow. In the Rotunda version, moreover, he transferred the half-round frieze with oak leaves in relief from the niche to the visitor's gallery at right. Trumbull used the same mahogany armchairs in this scene as in the *Declaration*, possibly as a means of reinforcing the thematic connections between the two paintings. None of the furniture used in

1783 survived at Annapolis by the time of Trumbull's visit, and he chose not to copy the furniture John Shaw had made for the room in 1796.[8]

Trumbull undoubtedly simplified the architecture to minimize distraction from the figure of Washington. The artist considered the general's resignation "one of the highest moral lessons ever given to the world."[9] Describing the event in his catalogue of the Yale collection, Trumbull wrote:

> What a dazzling temptation was here to earthly ambition! Beloved by the military, venerated by the people, who was there to oppose the victorious chief, if he had chosen to retain that power which he had so long held with universal approbation? The Caesars— the Cromwells— the Napoleons— yielded to the charm of earthly ambition, and betrayed their country; but Washington aspired to loftier, imperishable glory,—to that glory which virtue alone can give, and which no power, no effort, no time, can ever take away or diminish.[10]

By focusing on the moment when Washington actually returned the commission to the president of Congress, Trumbull created a clear parallel to his depiction of Jefferson presenting the Declaration of Independence to John Hancock.[11] But whereas he represented Jefferson as the leader of a group, Trumbull seems to have emphasized the fact that Washington acted as an individual. He isolated the general at the picture's center, against the bare chimney breast, and directed the room's reflected light toward his head. The cloak on the chair behind Washington suggests a king's robes draped on a throne, a royal emblem on which Washington has turned his back.

The Resignation of General Washington was even less successful than the Rotunda version of the *Declaration*. As in his earliest work, the artist here had difficulty in rendering space convincingly. The figures behind Washington, although they diminish in size, do not recede into the background. The anatomy, especially in the figures of the women, is uncertain. Even in the portraits, at which the artist had once distinguished himself, there is evidence of awkwardness and insecurity. One senator called the *Resignation* a "solemn daubing," and asked, "What do you see in this picture? Why, a man looking like a little ensign, with a roll of paper in his hand, like an old newspaper, appearing as if he was saying, 'Here, take it.' "[12] Trumbull, however, had attempted to create a scene that would reflect both the solemnity of the event, and his personal admiration for Washington. The two standing figures at the right, wrapped in long cloaks, were probably quoted from the figures in parliamentary robes at the left of Copley's *Death of the Earl of Chatham (Fig. 10)*, thus giving a greater sense of ceremony to the scene. Trumbull visually reinforced the *Resignation*'s thematic continuities with the *Declaration*: he took from the earlier work the overall composition of the room, and the group of seated and standing figures in the left background. He also attempted to improve on the controversial aspects of the *Declaration* (see Cat. 25): he later commented to Silliman that "he had taken care to cover as many legs as possible from view."[13]

1 Jaffe 1975, p. 263.
2 JT to Alexander Robinson, March 2, 1828, NYHS.
3 Jaffe 1975, p. 323.

4 Because he did not begin the *Resignation* until the 1820s, Trumbull may have copied his 1793 miniatures of the two women as a means of ensuring that the costume details would be more contemporary to the time of the event. The other miniatures which probably served as models for the *Resignation* are those of Thomas Mifflin, Martha Washington, Eleanor Parke Custis, Jacob Read, Brigadier General William Smallwood, General Otho Williams, and Arthur Lee (Cats. 76, 53, 51, 83, 71, 86, 80).
5 JT, printed form letter, Washington, D.C., April 15, 1822, YUL-BF.
6 *General Washington*, Pamphlet, p. 3, YUL-BF.
7 JT to James Madison, October 1, 1823, Letterbook, YUL-JT.
8 For a history of the Annapolis State House, see Morris L. Radoff, *The State House at Annapolis*, Annapolis, 1972, p. 30.
9 Trumbull 1841, p. 263.
10 Trumbull 1832, p. 26.
11 Jaffe 1975, p. 246.
12 Senator Holmes of Maine, cited in Lillian B. Miller, *Patrons and Patriotism: The Encouragement of the Fine Arts in the United States 1790–1860*, Chicago, 1966, p. 47.
13 Silliman, "Notebook," II, p. 104.

The Death of General Warren at the Battle of Bunker's Hill

1834
Oil on canvas, 72½ x 108¹¹/₁₆ (184.2 x 276.1)
Wadsworth Atheneum; Purchased of the heirs of the
 artist's estate

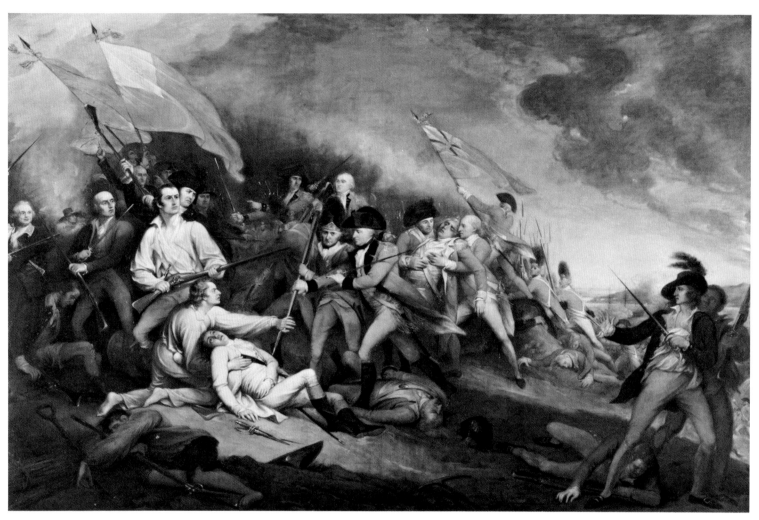

32

Although Trumbull considered the Rotunda commission the crowning achievement of his career, it was also the cause of considerable disappointment. The artist had envisioned the Rotunda as a Hall of the Revolution, with eight large-scale history paintings that would fit into Bulfinch's design of eight equal-sized niches. The final commission, however, was for only four paintings.[1]

Trumbull's hopes for creating a complete series in monumental size were revived early in 1831. In the course of the discussions surrounding the establishment of the Trumbull Gallery at Yale, Daniel Wadsworth offered to donate the property and much of the funding for a second Trumbull Gallery to be built in Hartford. Trumbull favored the plan, intending to divide his works between the two galleries, except for the small history paintings, which would go to Yale. The Hartford gallery would

receive half-life-size copies of the Yale paintings "as an equivalent for the originals."[2] Wadsworth tentatively agreed. By September 1831, the enthusiastic artist had completed copies of *Trenton* and *Princeton*, with plans to finish the other six subjects of the Revolution as soon as possible. Negotiations for a second Trumbull Gallery broke down when Wadsworth proposed that the original history paintings be periodically exchanged between the New Haven and Hartford galleries, believing, as Silliman said, that "the fresh productions of the early skill of the artist were superior to the enlarged copies painted in the evening of life."[3] Trumbull was adamant in rejecting the proposal:

This plan of exchanging is subversive of the first
principle by which I have been actuated in the whole

negotiation, I mean, the *desire to preserve* the Labor of my Life, as far as possible:— the repeated packing & unpacking, transportation by Land or Water— hanging & unhanging, would unavoidably in a few repetitions occasion irreparable injury; and when I am gone, who is to attempt repairs in the small pictures— I myself could not now repair the small heads in the Declaration & in Yorktown; *and no one else ever can*. I regard these things as inestimable— and not to be exposed to unnecessary hazard.[4]

Thus the plan for the Hartford Trumbull Gallery failed. Hoping that one of the states might purchase a complete set of the history series, the artist continued working, completing the *Declaration* in 1832 and *Bunker's Hill* and *Quebec* in 1834. "In my estimation," he wrote, "[they] are better than those in the Capitol."[5] He exhibited the five works at the American Academy in New York in 1835, and planned to go to New Haven to copy the remaining three without delay. But he was almost eighty years old and in poor health. The effort required to finish three more huge paintings proved too great; although he continued to talk about finishing the series until the end of his life, it was never completed. The paintings finally found a permanent home after Trumbull's death, when in 1844 Wadsworth purchased them for 4000 dollars from Benjamin Silliman, executor of Trumbull's estate, and installed them in the newly founded Wadsworth Atheneum.

The Hartford version of *Bunker's Hill* exemplifies the dramatic change that took place in Trumbull's abilities during the second half of his career. In 1786, in full command of his artistic energies, he produced the Yale canvas (Cat. 4) in Benjamin West's studio, spurred on by the encouragement and interest of the American community in England. The Wadsworth *Bunker's Hill* was completed in New York almost half a century later, when the artist was seventy-eight and there was little interest in history paintings. Like his late religious and literary canvases, this work exhibits none of the rich handling of paint that distinguished Trumbull's earlier history paintings. *Bunker's Hill* is so thinly painted that the preliminary grid used to lay out the composition has become visible, and passages like the yellow flag at the left are not advanced beyond the stage of an outline filled with a flat area of color. Certain details are awkwardly drawn, such as the figure of Captain Knowlton, who stands behind General Warren, and the hands of the Pitcairn group. The dark outlines of the forms, and the red, black and ochre palette, which is similar to that used in other of his late works, create heavy shadows, with none of the atmospheric quality of the earlier pictures.

Although Trumbull intended it to be a replica, the Wadsworth *Bunker's Hill* is not an exact copy of the Yale picture. The expressions on the faces of Colonel Putnam, Captain Knowlton, and Major Small are less dramatic. Trumbull introduced other changes in the second version that also weakened its general impact. He represented Warren and Pitcairn as dead rather than dying men, which removes the scene's overall stirring and pathetic effect. This change also places greater emphasis on these figures and less on Major Small, whose prominence in the earlier canvas had been criticized. Trumbull further clarified some details in the later version— for example, he separated the clergyman's gesture of loading his rifle from the cluster of guns and flags behind Captain Knowlton, altered the pose of the figure between General Putnam and Knowlton, and turned the figure's indistinct features into a clear portrait.

1 Trumbull's involvement with Bulfinch and the details of the Rotunda commission are discussed, pp. 266–69. Disagreement in the Congress over what subjects would be appropriate to fill the remaining four spaces was so great that the niches remained empty until the 1840s.
2 Silliman, "Notebook," II, p. 18.
3 Ibid., pp. 19–20.
4 JT to Benjamin Silliman, November 30, 1831, YUL-JT.
5 JT to Ithiel Town, February 15, 1840; quoted in Sizer 1953, p. 283, n. 3.

Trumbull's Portraits

"His talent shows itself particularly in the character portraits brought out in bold strokes"
— Goethe on *Bunker's Hill*[1]

By Oswaldo Rodriguez Roque

John Trumbull's portraits present to the student of his art a puzzling assortment of the beautiful, the acceptable, and the downright ugly. Although the quality of the portraits generally relates to that in the other genres of his painting, it is especially in his portraiture that the contradictions and ambivalences of his highly complex personality are revealed. If Trumbull doubted the worthiness of his career, as we know he did, then it was portraiture that bore the brunt of his uncertainty. If he proved willing to short-cut his working methods and compromise his standards, as we also know he did, then it was his portraiture that suffered most. Conversely, when inspiration took hold of him and he believed strongly in what he was doing, then, as Goethe perceptively noted, his talent showed itself particularly in the portraits.

The origins of Trumbull's problems with portraiture may be traced to his earliest experience as a would-be artist. Having wanted to study with John Singleton Copley, then the leading American painter, Trumbull instead was forced by his family to attend Harvard College. This had the unintended effect, however, of putting him in close proximity to the master and his works. Through a friend of his brother's, Trumbull managed to see Copley as soon as he could:

> We found Mr. Copley dressed to receive a party of friends at dinner. I remember his dress
> and appearance— an elegant looking man, dressed in a fine maroon cloth, with gilt
> buttons— this was dazzling to my unpracticed eye!— but his paintings, the first I had ever
> seen deserving the name, riveted, absorbed my attention, and renewed all my desire to
> enter upon such a pursuit.[2]

Here, then, was tangible evidence, in the form of portraits, that an artist could produce works of great beauty, as well as achieve wealth, status, and respectability. Yet at the same time, the classical education Trumbull was receiving at Harvard and, in particular, the treatises on painting by de Piles, du Fresnoy, and others which he was reading on his own told him that portraiture was the lowest branch of the art of painting.[3] For the time being, however, the young Trumbull did not attempt to pass judgment on the genre— at least we have no record that he did so. His list of pictures painted before he departed for Europe in 1780 records quite a number of portraits executed during his Cambridge years and shortly thereafter, an indication that in this period, when painting did not actually provide his daily bread, he did not scoff at portraiture.[4] Still, by the time of his graduation from Harvard in 1773, Trumbull must have been vaguely aware that success in the manner of Copley would not necessarily satisfy his artistic ambitions. He certainly would have come to this realization after 1774, when Copley left for England largely because he desired to become something more than a colonial portrait painter.

1 Goethe to Schiller, August 30, 1797, in Sizer 1953, p. 184, n. 13.
2 Trumbull 1841, p. 11.

3 For the treatises read by Trumbull while a student at Harvard, see pp. 22–23, above, and Sizer 1953, p. 12, n. 35.
4 See the large number of pre-1780 portraits listed in Trumbull 1841, pp. 59–62.

By 1775, another crucial experience for Trumbull in his development as a painter— one which, like his confrontation with the painting treatises, did not cause him any great immediate concern— was absorbing his attention. He had joined the Revolutionary army and had rapidly risen to the position of aide-de-camp to General Washington. The lesson here was, in effect, that he could abandon his chosen career at will and succeed at another. As it happened, his military service was a short one and by 1777 he was back in Lebanon trying to teach himself how to paint. In June 1778, he moved to Boston, renting the studio— with all its paraphernalia of casts, engravings, and copies— of the deceased painter John Smibert. Thus, by the time he left for England in 1780, Trumbull had learned two lessons which, as far as his work as a portraitist went, he would have been better off not learning: that he might not necessarily wish to be a portrait painter; and that, if circumstances required it, he could give up painting and do something else. Although no written records attest to these responses, they can be confirmed retrospectively, for the actions he took later in life and the attitudes toward his art that caused him so much grief are better understood as products of his formative years.

Leaving aside the larger issues, however, what was Trumbull's actual achievement as a portraitist in the years between 1770 and 1780? Briefly, it was that by dint of effort and persistence, and without formal training, he assimilated to a very large degree Copley's mature American style. One need only compare two *Self-Portraits*, that of 1774 (*Fig. 47*) and that of 1777 (*Fig. 49*), to realize how fully he had done so. Linearity, strong coloring, simplicity of composition, careful execution, and an overriding emphasis on verisimilitude— all hallmarks of Copley's works— characterize the later portrait, as they also characterize the more ambitious double-portrait of his aging parents (Cat. 35) and the charming group portrait of Jonathan Trumbull, Jr. with his wife and daughter (Cat. 34). What is peculiarly Trumbull in these works, aside from an all-too-obvious preference for painting large eyes and other anatomical awkwardnesses, is a certain plainness in the way fabrics, furniture and other accessories are represented. Trumbull shunned the rich patterned damasks, fancy lace, wigs, pets, and jewelry— the emblems of social pretension— that are so intimately linked with Copley's portraits. In this respect, it is interesting that in his *Self-Portrait* of 1777 Trumbull, well-born, well-educated and definitely an aristocrat, chose to represent himself not as Copley had done in his 1769 *Self-Portrait*

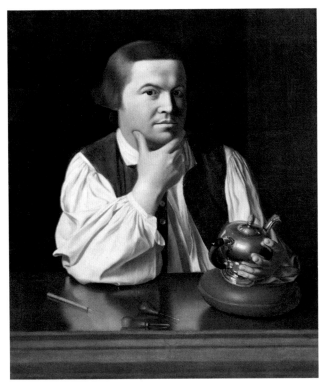

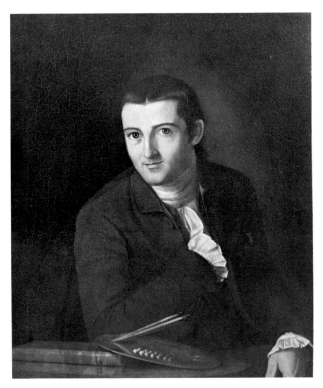

Fig. 48. John Singleton Copley, *Paul Revere*, 1768–70. Boston, Museum of Fine Arts; Gift of Joseph W., William B., Edward H. R. Revere.

Fig. 49. Self-Portrait (Cat. 33).

(The Henry Francis du Pont Winterthur Museum) but as Copley had portrayed the silversmiths Paul Revere (*Fig. 48*) and Nathaniel Hurd: dressed in simple garb and leaning upon a table on which rest the tools of the sitter's trade.[5] A strong Puritanical attitude was already exercising its influence upon Trumbull's approach to portraiture. Deeply ingrained in his personality, it did not diminish with time.

Trumbull expected his sojourn in England in 1780 to provide the opportunity for a long overdue apprenticeship in the studio of a recognized professional. Instead, his stay there proved to be an unhappy one. Four months after placing himself under Benjamin West, he was carted off to jail on suspicion of being a spy. By the end of January 1782, he was back in Connecticut, contemplating once again the future of his career. Only one important work, a full-length portrait of *George Washington*, painted from memory in London, resulted from his trip to England (*Fig. 51*). It was a significant accomplishment: compared to his one previous full-length depiction of a military man, the 1777 portrait of *Major General Jabez Huntington* (*Fig. 50*), the Washington portrait is a far more assured performance. Although still careful and restrained, the execution here is looser, recession in space more convincing, and the wooden quality observable in the faces of his earlier sitters has given way to a softer modeling. More significantly, Washington's pose, as well as the entire composition of the work, reflect a knowledge of the latest conventions in British portraiture.[6] Shortly after it was painted, the work was engraved by Valentine Green in London and became the first representation of Washington to circulate widely in Europe. It put Trumbull before the public eye.

5 This perceptive comparison is made in Jaffe 1975, p. 17.
6 The elongation of the figure as well as its placement in the foreground of a landscape recall Gainsborough. The device of portraying a military hero with a horse and groom behind him, especially a black groom wearing a turban, was also popular in British portraiture at this time. The formal aspects of this work are fully discussed in John Caldwell and Oswaldo Rodriguez Roque, *American Paintings in the Metropolitan Museum of Art, Volume I: Painters Born by 1815* (forthcoming).

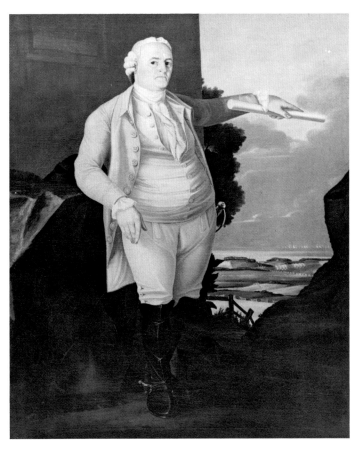

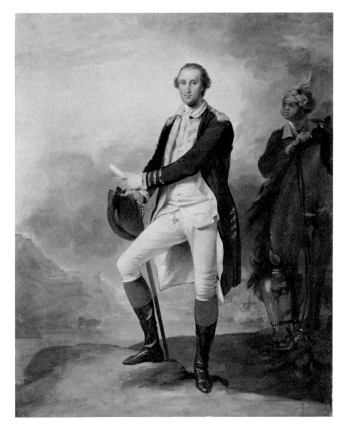

Fig. 51. George Washington, 1780. New York, The Metropolitan Museum of Art; Bequest of Charles Allen Munn.

Fig. 50. Major General Jabez Huntington, 1777. Hartford, Museum of Connecticut History, Connecticut State Library.

The next two years of Trumbull's stay in America are relatively silent ones. The country was still technically at war with England and in a fairly depressed economic state. Trumbull worked as an agent for his brother in the military supply business. It is thought that he painted some portraits at this time, but the extent of his activity has never been determined. With the signing of the articles of peace between Britain and America, "an end was thus put to all further desultory pursuits"; he realized that "it was now necessary to determine upon a future occupation for life."[7] He opted for painting once again and in December of 1783 set sail for London.

The years Trumbull spent between 1784 and 1789 in England and on the Continent were marked by quick progress and great achievement. He painted in West's studio by day and in the evening attended classes at the Royal Academy. In spite of his proximity to West, Trumbull (like Gilbert Stuart) did not at this point attempt to emulate his teacher's style. His first portrait commission after arriving in England came from an old friend of the Trumbull family, Colonel Jeremiah Wadsworth of Hartford. Trumbull fulfilled it as well as he could and with obvious care, which is probably why the picture appears rather hard-edged and belabored (Cat. 38). In portraying a moment of informal and affectionate communication between a father and his son, Trumbull paid his respects to the popular English conversation-piece tradition; in terms of its execution, however, *Jeremiah Wadsworth and His Son Daniel Wadsworth* is something of a retrogression to Copley's colonial manner. The artist took it to Sir Joshua Reynolds, then the leading portraitist in London, and was told "in a quick sharp tone, 'that coat is bad, sir, very bad; it is not cloth— it is tin, bent tin.'"[8] The criticism jarred Trumbull and caused him to adopt a looser style in works such as the 1784 group portrait of *Sir John Temple and Family* (Fig. 52) or the outdoor portrait of *Mrs. John Barker Church, Son Philip, and Servant* (c.1785,

7 Trumbull 1841, p. 88.
8 Ibid., p. 92.

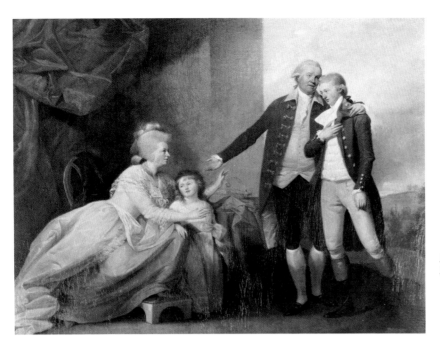

Fig. 52. Sir John Temple and Family, 1784. Collection of Mr. and Mrs. Albert L. Key.

Collection of Mrs. Amy Olney Johnson). The looser execution in these works, however, is not that of a painter familiar with handling a loaded brush and controlling its action on the canvas. Consequently, the portraits appear rather thinly and timidly painted for pictures that so clearly attempt to emulate painterly English portraiture *à la* Reynolds. Interestingly enough, all these works are small in scale, something that may have been due to West's influence or to Trumbull's own preference for the small format. In later years, he would do his best work on small canvases— although he would repeatedly go against his own inclination and West's advice and attempt large-scale pictures.[9]

If one were to judge from the quality of the portraits Trumbull produced in 1784, it would be difficult to perceive any great dissatisfactions with portrait painting. It is clear, however, that during this year Trumbull developed a strong distaste for portraiture. Early in 1785 he wrote to his brother:

> the difficulties & labour of my profession begin to wear off as I acquire more practise & knowledge,— but portraits continue to be insupportable to me.— I wish to rise above the necessity of painting them & there is a line, untrodden in any eminent degree but by one man, which offers me a more easy & elegant support if I can acquire the necessary powers of execution; tis but a few days since the Idea started in my mind— I shall try what can be done. & when I have made my experiment I will let you know its success.— If I do succeed it makes me master of my time. & disengages me from all the trumpery & caprice & nonsense of mere copying faces— & places me the servant not of Vanity but Virtue.[10]

By "virtue" Trumbull meant history painting of a certain type, that is, history painting that commemorated heroic events of the recent past and immortalized them for posterity. This was the type of picture that had been pioneered in England by West and brought to maturity by Copley. Trumbull saw himself as particularly suited to work within this relatively new Anglo-American mode and quickly conceived of an ambitious plan to make his mark. Although he was studying with West, it was Copley's achievement that exercised his imagination and it was Copley to whom he referred as

9 In a letter to Benjamin West, dated August 30, 1790 (YUL-JT), Trumbull tells his teacher about the large portrait of Washington he is painting for New York City: "I have been tempted to disobey one of your injunctions & to attempt a large Portrait of him." In his *Autobiography* (1841, p. 139), Trumbull also noted: "The reflection here occurs to me, that there is in nature, in the law of optics, an insurmount-

able difficulty in rendering a large work equal to a small; in small, the eye is near its object, and without change of place can compare the parts with the whole; not so in large,— while at work, the eye must be almost equally near the surface, but can form no judgment of the relation of the parts to the whole, without removing to a distance."

10 JT to Jonathan Trumbull, Jr., January 18, 1785. YUL-JT.

the man who practiced history painting to an "eminent degree." In May of 1784 Copley had put on exhibition his monumental *Death of Major Peirson* (*Fig. 14*) before an eagerly awaiting public. Admission cost one shilling and Copley realized a handsome profit. In addition, the work was to be engraved, raising the prospect of still greater profitability, or, as Trumbull put it, of increased "elegant support" for its author. Clearly, Trumbull was under the spell of this enormous success and it was no coincidence that his first essay in the historical genre, *The Death of General Warren at the Battle of Bunker's Hill* (Cat. 4), visually quotes a number of elements in Copley's work.[11]

That Trumbull chose to follow Copley's example in the painting of historical works, as opposed to West's, had the predictable consequence of involving him in portraiture more than ever before. Copley's history paintings, grounded in specificity, included actual portraits of the participants; they are inconceivable without his background as a portraitist accustomed to producing accurate likenesses and lifelike details. Trumbull's choice of historical subjects now forced him to become as proficient a portraitist as Copley, lest the quality of his history paintings not meet Copley's standards:

> the great object of my wishes . . . is to take up the History of Our Country, and paint the principal Events particularly of the late War:— but this is a work which to execute with any degree of honour or profit, will require very great powers— & those powers must be attained before I leave Europe.[12]

The period of great development in portrait painting now began for Trumbull. The fact that his work in portraiture directly contributed to an endeavor which he perceived to be noble and virtuous transformed an activity associated with vanity and caprice into something worthwhile and deserving serious study.[13] Naturally, his growing proficiency in portraiture also manifested itself in portraits that had nothing to do with his history paintings. Hence the impressive quality of the full-length, life-size portrait of *Patrick Tracy* (*Fig. 53*), and the astonishing mastery evident in the small portrait of *Thomas Jefferson* painted for Maria Cosway (Cat. 40). Ironically enough, Trumbull's progress in portraiture in its purest form, that is, in capturing a likeness, far outpaced his progress in pictorial composition. It is not surprising, then, that to Goethe the remarkable thing about *Bunker's Hill* was the outstanding quality of the portraits and not, for example, the quality of the composition or the coloring. For the great German poet, familiar with continental history painting, but probably not yet acquainted with the relatively recent Anglo-American tradition, it would have been the emphasis on realism, particularly in details of costume and in the veracity of the likenesses, which would have impressed him as novel.

It is not always easy to divine an artist's state of mind and it is especially risky to do so when dealing with a figure as full of personal contradictions as Trumbull. Nevertheless, in order to understand what occurred in his subsequent career as a portrait painter some measure must be taken of his general outlook regarding both painting and portrait painting as it crystallized in London in the years between 1784 and 1789. No better summary of his thinking exists than in his letter to Thomas Jefferson of June 11, 1789, where he justifies his decision to continue his career as an artist:

> The greatest motive I had or have for engaging in, or for continuing my pursuit of painting, has been the wish of commemorating the great events of our country's revolution. I am fully sensible that the profession, as it is generally practiced, is frivolous, little useful to society, and unworthy of a man who has talents for more serious pursuits. But, to preserve and diffuse the memory of the noblest series of actions which have ever presented themselves in the history of man; to give to the present and the future sons of oppression and misfortune, such glorious lessons of their rights, and of the spirit with which they

11 See Cat. 4, and Jules D. Prown, *John Singleton Copley*, 2 vols., Cambridge, Mass., 1966, II, p. 309.
12 JT to Jonathan Trumbull, Jr., November 23, 1784, CHS.

13 Trumbull was much concerned with questions of virtue at this time, especially of virtuous republican behavior. In this he was more in accord with recent developments in French painting than in English painting; see Jaffe 1975, pp. 65–66.

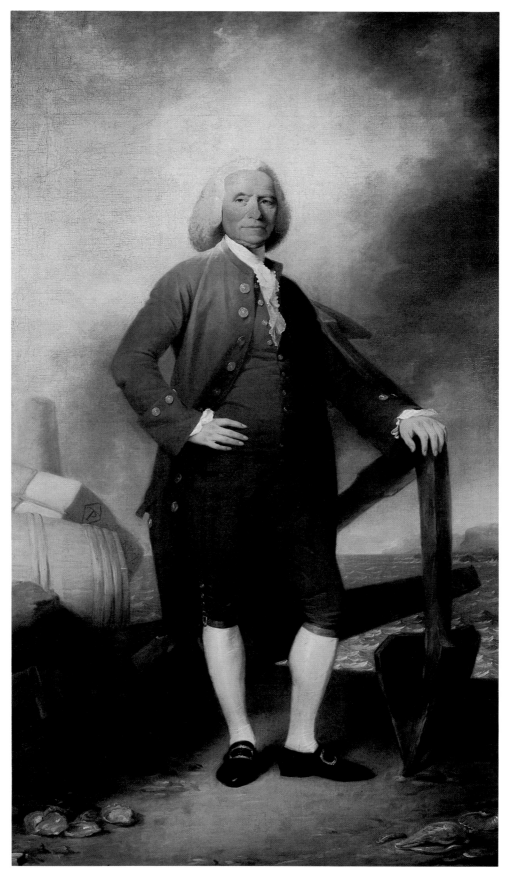

Fig. 53. Patrick Tracy (Cat. 39).

should assert and support them, *and even to transmit to their descendants, the personal resemblance* [author's italics] of those who have been the great actors in those illustrious scenes, were objects which gave a dignity to the profession, peculiar to my situation.[14]

It would appear that Trumbull, just a few months before returning to America, had arrived at the conclusion that painting was an occupation much in need of redemption. We do not know why he felt this way, only that he did. Needless to say, this was not the attitude of a committed painter, but rather of someone maintaining a certain aloofness from his own actions and, ultimately, of someone capable of pursuing another career. It was not, in any case, the kind of attitude that would permit him to survive the enormous indifference he was to encounter in America toward his projected series of history paintings. America patronized portraiture generously, but in Trumbull's morality portraiture was only justifiable as an adjunct to history painting. For our age, which has amply demonstrated its high regard for portraits of quality in record auction prices, this attitude seems strange indeed. In his time, however, Trumbull's outlook was not an uncommon one. It was shared, for instance, by Washington Allston who, upon seeing Trumbull's *Sortie Made by the Garrison of Gibraltar* (Cat. 12), wrote to a friend:

> I have no idea of a painter's laboring up to fame. When he ceases to obtain reputation without it, he becomes a mechanic. Trumbull is no portrait painter. By this picture alone he has gained credit.[15]

Allston, too, perceived that a successful historical work, although full of portraits, removed an artist from the ranks of mere portrait painters and lifted him to a more exalted plane.

Trumbull arrived in New York in November of 1789. His avowed purpose was the collecting of likenesses, topographical information, architectural data, and other visual material for his projected series of Revolutionary War paintings. For the most part he adhered to his plan. In terms of portraiture, the result was a wonderful series of small works (Cats. 46–100), executed in oil on mahogany, which are certainly the most beautiful and sophisticated portraits painted in this country between the departure of Copley and the arrival of Gilbert Stuart late in 1793. Done in the small scale of miniatures, and often thought of as such, they are not really miniatures in medium or in artistic intent. Rather, they are serious attempts to document the character as well as the likeness of the important personalities who were to figure in his history paintings. Unlike miniatures, they are not decorative or precious and were not intended to be worn as personal adornment. Moreover, they are painted in the loose, ductile manner and in the colors of the full-scale portraiture then fashionable in London. Trumbull's "miniatures," for the most part, are comparable in quality to Stuart's portraits of 1794–1800 and thus raise the possibility that, if he had only wanted to, Trumbull might have made as good a portrait painter as Stuart.

Trumbull's other major activity in the years 1789–94 was the painting of full-scale finished portraits. Among these are the full-length portraits of *General Washington* and *George Clinton* painted for the city of New York (*Fig. 54*), a smaller portrait of the president painted for his family (Cat. 41), and the impressive life-size portrait of Washington now at Yale (Cat. 42). These are all excellent works executed in light colors and composed in a similar way. The key influence here seems to have been the portraits by Van Dyck that Trumbull had seen in Europe and, in particular, the portrait of *Charles I* he had greatly admired in the Louvre.[16] Other portraits, such as those of *John Adams* (Cat. 44) and *Lemuel Hopkins* (Cat. 45), are very competent but less satisfying. In the representation of Hopkins,

14 JT to Thomas Jefferson, June 11, 1789, quoted in Trumbull 1841, pp. 157–58.
15 See Jared B. Flagg, *The Life and Letters of Washington Allston*, New York, 1892, pp. 45–46. Sizer 1953, p. 148, n. 273, interprets this statement as a negative comment upon the portraits painted by Trumbull in his *Sortie*. In view of Allston's admiration for the picture, however, it makes more sense to interpret the phrase "Trumbull is no portrait painter" to mean, "Trumbull is no longer just a portrait painter," rather than "Trumbull is unable to paint portraits." The latter interpretation also seems inconceivable in view of the wonderful execution of the portraits in the *Sortie*.
16 For Trumbull's use of the Van Dyck portrait, see Cat. 41.

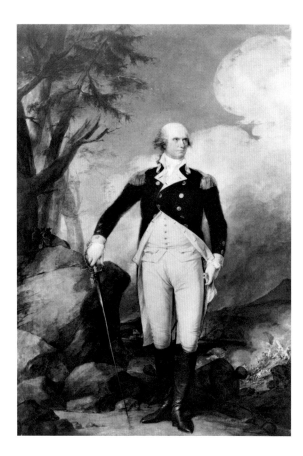

Fig. 54. George Clinton, 1791. Art Commission of the City of New York.

with bulging eyes and a half-crazed look, one feels Trumbull edging close to real sympathy for the human aspects of portrait painting. Unfortunately, this was but a passing moment in his career. The conclusion is unavoidable that what quality there is in these works exists as a by-product of his concern with history painting and that, in the case of the full-length portraits, the superior quality is present because Trumbull in fact regarded these pictures as history painting.[17]

Nearly all Trumbull scholars are in agreement that his greatest works were produced in the years between 1784, when he came to England for the second time, and 1794, when he arrived for his third sojourn. The artist himself, however, does not seem to have realized that this was the case. His views and opinions, held with the conviction of absolute moral certainty, clearly interfered with any objective evaluation of his own output. Hence, what seems to us most surprising— that in 1794 he abandoned his artistic career at the peak of his powers in order to become a diplomat (see p. 10)— appeared to him as an entirely rational course of action. In his letter to Jefferson of June 1789, he had more or less reviewed his position:

> My future movements depend entirely on my reception in America, and as that shall be
> cordial or cold, I am to decide whether to abandon my country or my profession. I think I
> shall determine without much hesitation; for although I am secure of a kind reception in
> any quarter of the globe, if I will follow the general example of my profession by flattering
> the pride or apologizing for the vices of men, yet the ease, perhaps even elegance, which
> would be the fruit of such conduct, would compensate but poorly for the contempt which I
> should feel for myself.[18]

Trumbull's reception in America had not been cold— in a short space of time he had received numerous commissions. But his project for the Revolutionary War pictures had met with little real

17 This is clear from the many full-size military portraits Trum-
bull treated as history paintings in the list of American
historical painters he included in a letter of January 12, 1827,

to Edward Everett (YUL-JT), at that time a congressman
from Massachusetts; quoted in Sizer 1953, pp. 369–71.
18 Trumbull 1841, p. 160.

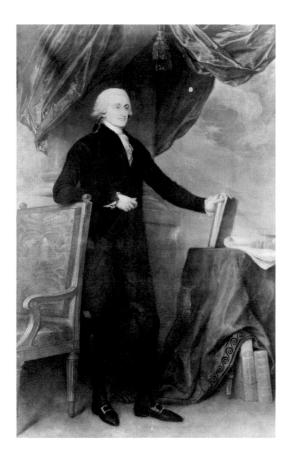

Fig. 55. John Jay, 1805. Art Commission of
the City of New York.

enthusiasm and he had obtained no governmental backing for it. At the time, he had considered remaining in America but giving up painting and pursuing another career. Now, in 1794, Trumbull gave up both his country and his profession in order to embark on an important diplomatic mission. As far as his history painting went, it would have been preferable if he had remained in America, modified his standard of living, as well as his resolve not to paint portraits, and worked on the histories as time permitted. But perhaps this imposes a modern outlook on Trumbull's situation. Needless to say, he gave up neither his gentlemanly ways nor his convictions about painting. Eventually, both his lifestyle and philosophy about art would make him an odious figure to an entire generation of younger American painters.

During his decade of diplomatic service Trumbull painted little. What few works he did produce are, with the exception of appealing portraits of his wife (Cats. 112, 115), invariably disappointing. By about 1800, when he painted the portrait of *Maurice Swabey* (The New-York Historical Society), his portraiture had largely lost the grace and colorfulness that characterized his American works of 1790–94. The qualities that we now associate with Trumbull's mature portraits— a limited palette with a heavy reliance on reds and yellows, a frequent and overly generous use of black, an inability to render flesh tones, and a general stiffness— began to manifest themselves at this time. Henceforth, he departed from this portrait style only infrequently. After his return to New York in 1804 and during the next four years, when he virtually established himself as the official portrait painter to the city, this was his predominant style.

Whether Trumbull would have returned to America, and necessarily to portrait painting, had he been able to continue working as a diplomat is debatable. As he made clear, he resented the fact that his government service had been brought to an end because his Federalist views were out of tune with the Democratic administration in Washington.[19] He points out, in fact, as an example of his integrity, that he had preferred the lowly life of a portrait painter in America to sacrificing his political

19 Ibid., p. 242.

principles.[20] It is clear, then, that his return to portraiture in 1804 was a reluctant and completely unenthusiastic enterprise. Originally he had intended to work in Boston, a Federalist stronghold, but being advised that Gilbert Stuart was about to move there he decided to remain in New York (see pp.12–13). This was probably a wise decision. Politically and socially New York was being polarized by the tragic outcome of the Aaron Burr-Alexander Hamilton duel. City Hall was in the hands of the Federalists and Trumbull was the logical choice for the many portraits the city either required or commissioned in order to provide patronage for him. His first commissions were full-length portraits of New York's leading Federalists, John Jay (*Fig. 55*) and the late Alexander Hamilton. Where once Trumbull might have conceived of them as historical portraits and thus exercised his best efforts on their execution, now he despaired of ever again being a real history painter, so that the works became just portraits. This, at least, is what the viewer who today comes upon them in the Governor's Room of the New York City Hall is forced to conclude, observing the surprising differences between these two portraits and the full-length ones of *Washington* and *Clinton* which Trumbull had painted for the city fourteen years before. Where the older portraits are colorful, elegant and authoritative, the portraits of *Jay* and *Hamilton*, probably intended to hang as pendants, are dull, boring, and present distasteful likenesses of the subjects. Both are virtually monochromatic performances in browns, yellows and reds, with an all-too-predominant use of black. Clearly, they were quickly and somewhat sloppily painted with none of the regard for specific detail that characterizes the *Washington* and *Clinton* portraits. They are, in short, formula portraits of the type Benjamin West occasionally turned out during his mature years.

In the smaller works Trumbull painted for the city, as well as for its merchant aristocracy, he generally applied the same formula. From time to time, as in the portrait of *Mrs. Robert Lenox* (Cat. 116), a quiet colorism of significant appeal crept in. However, if such a work needed to be copied, Trumbull reverted to his formula— as was the case with the copy of the portrait of *Mrs. Robert Lenox* now in the New-York Historical Society. Yet it is clear from the few truly outstanding portraits painted in this period that his powers had not declined as much as his interest. Consider the painting of *Mrs. Thomas Sully* (Cat. 120), commissioned in 1806 by her husband, the Philadelphia portraitist, in order to observe Trumbull's working methods. It is a well-executed work, with an effective color scheme that endows the sitter with an air of romance and feminine allure. In its rendering of character and thoughtful conception, it contrasts pointedly with the portraits of *Mrs. John Murray* (Cat. 121) and *Mrs. Stephen Minot* (Museum of Fine Arts, Boston). Both are interesting for their recollections of European styles— in the former, Dutch seventeenth-century portraiture, in the latter, French Neo-classical portraiture— yet both are perfunctorily painted according to Trumbull's formula.

In December 1808, after four years of nearly constant portrait painting, Trumbull sailed for England once again. This trip, which lasted until 1815, was an unmitigated disaster. Not having painted for fourteen years, the fire had gone out of his technique. He now fell completely under the spell of Benjamin West's proto-Romantic religious painting, and works in this genre increasingly occupied his attention. With history painting replaced by religious subject matter, and with West rather than Copley as his guiding light, nothing in the "higher" branch of painting contributed to any improvement in Trumbull's portraiture. When he returned to New York in 1815, he resumed his old ways, the only difference being that a younger generation of highly competent portrait painters and a changing political climate had now begun to challenge his near-monopoly in this area. That Trumbull was still the favored painter of the New York Federalist upper class, however, was amply demonstrated by his election to the presidency of the American Academy of the Fine Arts. In this position, which he used largely for his own advancement, he eventually alienated most younger members of the New York art world, among them portraitists such as Henry Inman, Charles

20 Sizer 1953, p. 237, n. 2.

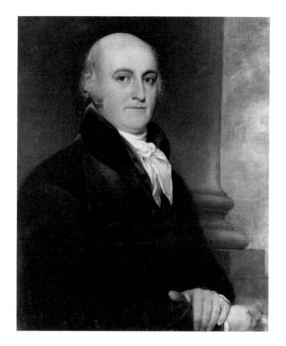

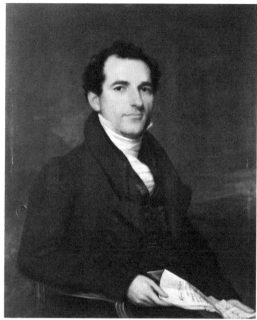

Cromwell Ingham, and Samuel F. B. Morse, all of whom in 1826 bolted Trumbull's Academy and founded the artist-run National Academy of Design.

Trumbull's art had a relatively limited impact on most of the artists of the following generation in New York. In portraiture, however, there are suggestive parallels between his portrait style as he practiced it after 1804 and the style adopted about 1821 by the prolific portrait-painting partnership of Samuel Lovett Waldo and William Jewett. Waldo was vice-president of the American Academy of the Fine Arts during a large part of Trumbull's tenure and had, like Trumbull, been exposed to West's late works. More importantly, he and Jewett were interested in fast production and must have noticed that adopting a formula, as Trumbull had, greatly expedited the work. Eventually, they came to rely on a waist-length format and on a color scheme of reds and blacks for the majority of their male portraits. That this formula derived from Trumbull's late portraits is clear from a comparison of Trumbull's *Richard Varick (Fig. 56)* with Waldo and Jewett's *Henry La Tourett de Groot (Fig. 57)*, or Trumbull's *Rev. Jonathan Mayhew Wainwright* (c.1822, New Britain Museum of American Art) with Waldo and Jewett's *Rev. Gardiner Spring* (c.1825, formerly The Metropolitan Museum of Art). The same generally applied to their portraits of women. Insofar as Waldo and Jewett were probably the key figures in establishing a formularized portrait style that was frequently followed by other artists (such as the young William Sidney Mount and Charles Cromwell Ingham) and that is clearly recognizable as a New York style, Trumbull's New York portraits were not without influence. They may, in fact, have been far more influential than either his Revolutionary War pictures or his religious paintings. In this respect it is significant that in the opinion of many talented American artists and critics of the next few decades, the great redeeming feature of Trumbull's Revolutionary War paintings in the Capitol Rotunda was the verisimilitude of the portraits.[21]

21 See, for example, John Neal's comment on the Rotunda pictures: "they are among the greatest and unaccountable failures of the age . . . valuable only as a collection of tolerably well-arranged portraits"; quoted in Harold E. Dickson, ed., *Observations on American Art: Selections from the Writings of John Neal, 1793–1876*, State College, Pa., 1943, p. 28. Morse made a similar remark: "They [the younger artists in Morse's circle] regarded Trumbull's four pictures [in the Capitol] as works of great intrinsic value because of the portraits"; quoted in S. I. Prime, *The Life of Samuel F. B. Morse, LL.D.*, New York, 1875, p. 599. C. E. Lester, in noting Trumbull's importance as the preserver of the great episodes in American history and of the likenesses of their participants, wrote: "We have had artists perhaps who surpassed Trumbull in genius. West was a greater painter. Stuart and Copely [*sic*] executed better portraits, and Allston improved in a higher field of Art. But to no one of them does the country owe so much as to Trumbull"; C. E. Lester, *The Artists of America*, New York, 1846, p. 171.

Early Portraits

33
Self-Portrait

1777
Oil on canvas, 29¾ x 23¾ (75.6 x 60.3)
Inscribed on stretcher (covered in relining, 1908):
 John Trumbull ipse pinxit aestat 21
Museum of Fine Arts, Boston; Bequest of George Nixon
 Black

This is one of two *Self-Portraits* Trumbull is known to have executed during the 1770s.[1] In the first, a bust dating to about 1774, his sole purpose seems to have been the recording of his features; the oval format focuses attention on the face (*Fig. 47*). In executing this second portrait at the age of twenty-one, however, Trumbull turned the mere delineation of his features into a pronouncement of his new self-definition as an artist. The palette with brushes and copy of Hogarth's *Analysis of Beauty*,[2] which are carefully arranged on the table before him, represent Trumbull's zealous decision, following his military resignation, to return to the study of painting.[3]

Art was still a rare profession in the Colonies and Trumbull faced his father's continuous disapproval of his aspirations (see pp. 2 and 6–7). Undaunted, Trumbull painted extensively from 1777 to 1778 at his parents' home in Lebanon, producing both historical subjects and several portraits of family members which reveal the strong influence of John Singleton Copley (see Cats. 35, 37). Trumbull's deep admiration for Copley is also evident in this *Self-Portrait*, with its spare, focused composition and dramatic light, as well as the smooth glow of the table-top in the foreground. However, the prominence of

Hogarth's *Analysis* suggests that Trumbull also wished to ally himself with European traditions. The division of his palette into tones recalls Hogarth's principle of color classification: in the *Analysis*, Hogarth had identified five original hues and arranged them into seven value gradations, the pure color being number four in the series;[4] Trumbull's palette imitates the seven-step organization, but places the pure color at the extreme end of the scale, omitting the black section entirely.[5]

As in most of Trumbull's early portraits, the eyes are large and staring and the forms somewhat awkwardly rendered, indicating his lack of professional training. Yet the intensity of the gaze conveys a sense of earnestness which is heightened by the knowing smile and rather animated pose. Leaning forward, his right arm aligned with the paint brushes below, Trumbull projects confidence in himself and enthusiasm with the pursuit he is following.

1 This portrait is listed in Trumbull's "Account of Paintings," I, no. 28, as: "Portrait of myself, headsize, July 1777. given to Miss Tyler." The identity of Miss Tyler is not known.
2 Although simply labeled "Hogarth," a book of that size by the English artist could only have been his theoretical *Analysis of Beauty*, first published in 1753.
3 Trumbull 1841, p. 49.
4 See William Hogarth, *The Analysis of Beauty*, London, 1753, p. 116.
5 The major part of the *Analysis of Beauty* is devoted to discussion of stylistic principles, prominent among which were animation, variety, and the serpentine "line of beauty." Although these features appear to a certain extent in Trumbull's 1777–78 works, he seems to have derived them primarily through the imitation of Copley's composition and poses.

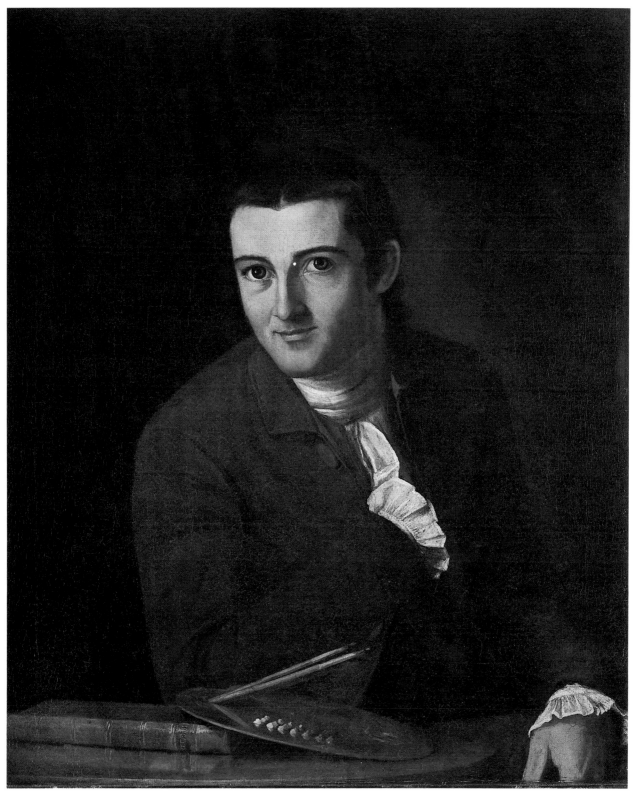

33

Mr. and Mrs. Jonathan Trumbull, Jr. and Their Daughter Faith

1777
Oil on canvas, 38½ x 48⅛ (97.8 x 122.2)
Yale University Art Gallery; Gift of Miss Henrietta
 Hubbard

Of the early portraits which Trumbull executed at home in Lebanon, Connecticut, perhaps the most ambitious is this depiction of his brother's family. Executed in 1777, it represents Trumbull's first attempt at group portraiture.[1]

In his design Trumbull clearly displayed the deep admiration he felt for the work of Copley.[2] Copley's influence is apparent in the dark background and raking light that Trumbull used to dramatize the forms; the shallow space with drapery hanging to one side was also a standard feature of portraits by Copley and other colonial artists. Jonathan Trumbull's pose echoes that of Isaac Winslow in Copley's *Mr. and Mrs. Isaac Winslow* of 1774 (*Fig. 58*) and the Chippendale chair, polished table, book, and fruit basket are also found in numerous Copley portraits. But whereas Copley usually varied the directions of his sitters' glances, Trumbull here has all three family members gazing at the viewer. The figures have a quiet presence, intensified by the hard, somewhat linear handling of form (similar to the style of Trumbull's fellow Connecticut artist Ralph Earl) which is characteristic of Trumbull's style prior to his study in London.

Trumbull also expanded upon Copley's single- or double-portrait format by including in his painting the Trumbulls' daughter Faith.[3] Although a few family portraits can be found among the works of other colonial artists, the type was not common in eighteenth-century American art.[4]

In the portrait Trumbull reinforced the sense of the familial bond by placing the sitters' hands within a central triangle, and Jonathan Trumbull's extended arm seems to shield his wife protectively. Further reference to the family may be found in the basket of fruit, a traditional symbol of fertility which appeared often in eighteenth-century portraits of women.[5] It is likely that the Trumbulls, whose first child died in infancy, expected more children.[6]

Trumbull had a deep affection for his brother's family. Jonathan, an aspiring politician,[7] was probably the artist's most important correspondent during his many years in England, and Faith remained a special favorite throughout his life.[8]

1 The portrait was begun on April 21, 1777, and subsequently sold for 42 pounds; see Trumbull's "Account of Paintings," I, no. 27.
2 For Trumbull's description of his meeting with Copley, see p. 94.
3 Copley seems to have avoided portraits of entire families until after his move to England in 1774.
4 An early example of family portraiture is John Smibert's 1729 *Dean Berkeley and His Entourage* (Yale University Art Gallery); the type was emulated by American artists such as Robert Feke, in his *Isaac Royall and Family* of 1741 (Harvard University).
5 Copley's use of fruit to represent fertility is discussed by William H. Gerdts and Russell Burke, *American Still-Life Painting*, New York, 1971, p. 22.
6 Jonathan Trumbull III was born in December 1767, and died in 1768. At the time this portrait was begun, Eunice Backus Trumbull was in fact pregnant with her third child, Mary, who was born the following December. This baby also died in infancy, but the Trumbulls' last two children, Harriet and Maria, survived.
7 For Jonathan Trumbull, Jr.'s career, see Cat. 91.
8 For other portraits of Jonathan and Faith, see Cats. 91, 97, and 111.

Fig. 58. John Singleton Copley, *Mr. and Mrs. Isaac Winslow*, 1774. Boston, Museum of Fine Arts; M. and M. Karolik Collection.

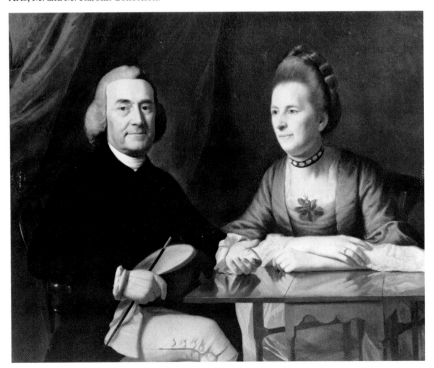

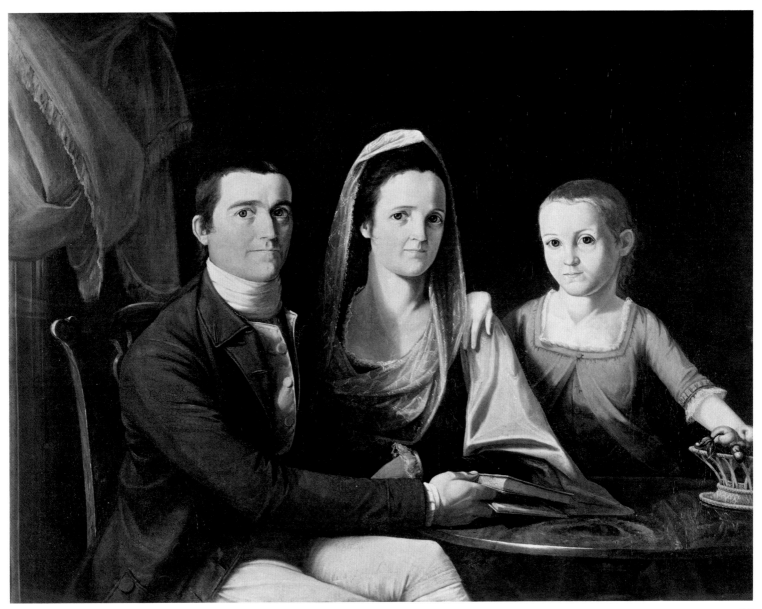

34

Governor
and Mrs. Jonathan Trumbull, Sr.

1778
Oil on canvas, 40 x 50 (101.6 x 127)
Inscribed, lower left: *IT 1778*
The Connecticut Historical Society

During the 1770s Trumbull painted several portraits of his father, Jonathan Trumbull (1710–1785) and his mother, Faith Robinson Trumbull (1718–1780). Perhaps the finest is this life-size double-portrait of 1778, prominent for its realism and sensitive characterization.[1]

Like his painting of his brother's family, executed the year before (Cat. 34), the portrait of his parents has a crispness of line and rather flat rendition of form which indicates Trumbull's lack of formal training at this time. As in the earlier portrait, the strong influence of John Singleton Copley is evident, both compositionally and in the use of distinctive chiaroscuro to accentuate facial features. Jules Prown has compared the portrait to Copley's *Mr. and Mrs. Thomas Mifflin* (*Fig. 59*) in the treatment of two seated figures, the setting, and the reflection of objects on the polished table— pictorial motifs which Trumbull may have seen at Copley's studio in Boston in 1773.[2]

An unusual feature of the painting is its allusions to ancient Roman art. Faith Trumbull's mantle and gathered veil resemble costumes found in antique statuary; the quiet, sober forms of husband and wife, framed by a classicizing pilaster and column, recall Roman funerary portraiture.[3] Trumbull's incorporation of such motifs may have been inspired by current intellectual ideas. The resurgence of classical studies in eighteenth-century Europe had spread quickly to the Colonies, and as a boy Trumbull developed an early love for Greek and Roman literature.[4] By the time he attended Harvard College in 1772–73, its library was filled with illustrated books on antique history and culture, which the students were encouraged to read for both scholarly and moral edification.[5] As early as 1773, Trumbull had drawn upon several European engravings in composing his Roman battle scene, *The Death of Paulus Aemilius* (Cat. 1).[6]

It was partly through book engravings that Trumbull gained familiarity with ancient art. He found another important source in reproductive engravings of paintings by classicizing European artists such as Raphael and Poussin; the high admiration bestowed upon these works in Trumbull's time was in large part due to their embodiment of the antique spirit.

The most prominent classical reference in Trumbull's portrait, the veil worn by his mother, with its delicately patterned material, peaked at the top, probably derives its Roman design from Raphael and Poussin.[7] Trumbull had first used such a veil for the figure of Eunice Trumbull in the portrait of his brother's family (Cat. 34). Veils were not a common feature of colonial dress, and had only occasionally appeared in eighteenth-century English portraits.[8] Trumbull's deliberate use of classicizing veils reveals his concern with antique precedent. The references to antiquity found in Mrs. Trumbull's costume and the surrounding architecture, as well as the classical calm which pervades the whole composition, serve to strengthen the gravity and directness of the couple's presence.

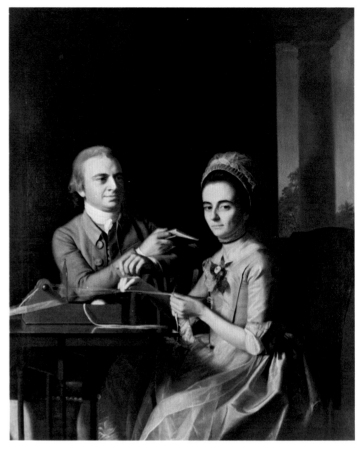

Fig. 59. John Singleton Copley, *Mr. and Mrs. Thomas Mifflin*, 1773. Philadelphia, The Historical Society of Pennsylvania.

1 The painting is listed in "Account of Paintings," I, no. 32, under the heading "Lebanon 1777": "Portraits of my parents— 4.2 by 3.4— sold to my brother £42 (paper)— (now in possession of my brother David 1818)." In his *Autobiography* (1841, p. 61) Trumbull included the information that the painting was "on a half length cloth reversed; my father dressed in a blue damask night gown." For the later miniatures of Trumbull's parents, see Cats. 92 and 98.
2 Jules D. Prown, "Paintings, Drawings and Watercolors," in Charles F. Montgomery and Patricia E. Kane, eds., *American Art 1750–1800: Towards Independence*, New Haven, 1976, p. 97.
3 See Brown University, Department of Art, *The Classical Spirit in American Portraiture*, exh. cat., Providence, R.I., 1976, p. 14.
4 Trumbull 1841, p. 9.
5 *The Classical Spirit in American Portraiture*, p. 9.
6 Another example of Trumbull's early incorporation of classical elements can be found in the 1777 portrait of *Major General Jabez Huntington* (*Fig. 50*), where the Connecticut officer stands in a pose which echoes imperial Roman iconography (*The Classical Spirit in American Portraiture*, p. 34). Trumbull must have enhanced his knowledge of ancient art while staying in John Smibert's former studio in Boston from 1778 to 1779; Smibert had amassed a large collection of plaster casts and engravings of ancient art, which had become well known in Boston and provided inspiration for several colonial artists, including Charles Willson Peale, Mather Brown, and Samuel King (ibid., p. 12).
7 Trumbull's admiration for these two artists is revealed in his report that while in Boston he studied Smibert's copies of Poussin's *Continence of Scipio* and Raphael's *Madonna della Sedia*; Trumbull 1841, p. 50.
8 Sir Joshua Reynolds and George Romney each painted a few portraits of women wearing veils; however, the decoratively lightweight, ungathered appearance of these headpieces differs significantly from the sculptural folds of Trumbull's Romanizing veils.

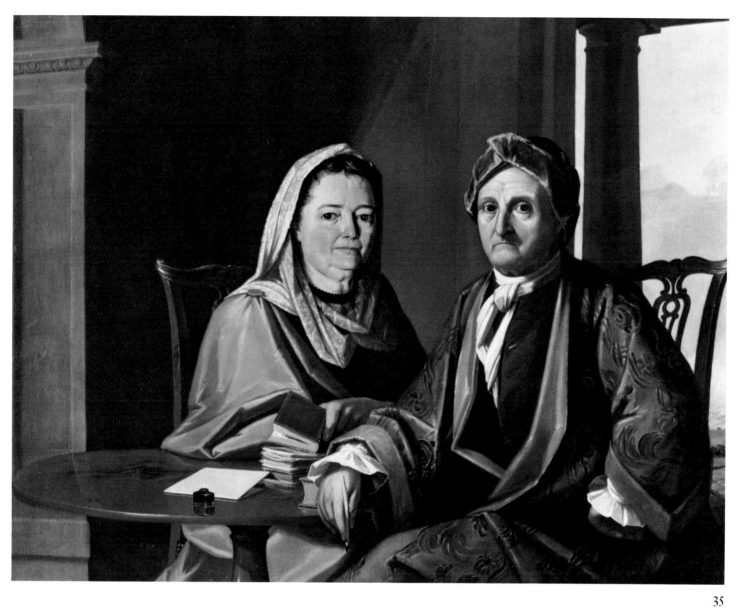

35

Roger Alden

1778
Oil on wood, 14½ x 11¾ (36.8 x 29.8)
Inscribed, lower left: *JT:* | *1778.*
Private collection

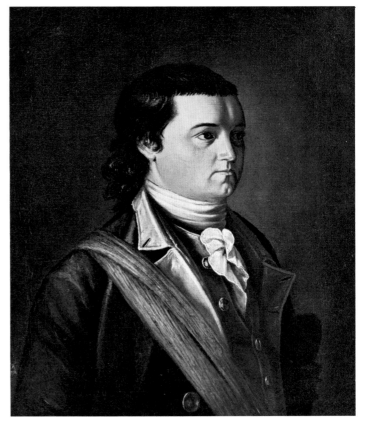

36

Trumbull described Roger Alden (1748–1836) as one of his "very particular friends" from Lebanon, Connecticut.[1] Having graduated from Yale in 1773, Alden joined the local military company that Trumbull had recently organized, in which "the young men of the school and the village . . . taught each other, to use the musket and to march."[2] Alden continued to serve in the Revolutionary army until 1780, rising to the position of brigade major in July 1777. After the war, he acted as deputy secretary in the Continental Congress, and later as military storekeeper and postmaster at West Point.[3]

Trumbull's portrait of Alden dates to 1778, the year after he had been appointed brigade major.[4] His coat is most likely a military uniform, although the red sash draped over his shoulder seems to be a later addition by another hand.[5] The emphasis on outline and rather flat, patchy modeling are typical of Trumbull's early portraits. Sharply cast light accentuates Alden's face against the somber background,[6] focusing attention on the serious, earnest expression of the thirty-year-old officer. The portrait is one of the few Trumbull executed of non-family members during this first period of his career.

1 Trumbull 1841, p. 16.
2 Ibid., pp. 15–16.
3 Theodore Sizer, unpublished notes, Yale University Art Gallery.
4 The portrait is listed in the "Account of Paintings," I, no. 34, among Trumbull's Lebanon works; in his *Autobiography* (1841, p. 61), it is cited as "Portrait of Major Roger Alden, small head— not bad."
5 Sizer, unpublished notes. The striated, thick pigment of the sash is uncharacteristic of Trumbull's execution.
6 As with most of Trumbull's early portraits, such illumination derives from the work of John Singleton Copley.

37
Joseph Trumbull

1778
Oil on canvas, 49⅛ x 40¾ (124.8 x 103.5)
Private collection

Trumbull painted this portrait from memory, a few months after his brother died at the age of forty-one. The oldest son of Governor Jonathan Trumbull, Joseph served as representative to the Connecticut General Assembly for thirteen years; in 1774 he was chosen to be Roger Sherman's alternate at the Continental Congress. Appointed commissary general by Washington during the Revolutionary War, Joseph Trumbull took charge of supplying food for the entire Continental army.[1] The two brothers were especially close. It was Joseph who sought to bring the young artist to Washington's attention in the early days of the war (see p. 3).

Trumbull was still living in Smibert's rooms and educating himself by copying prints when he executed this painting. He aimed high; the full-length portrait was the most ambitious composition he had yet attempted. Its format, pose, setting, costume, and accoutrements all reveal Trumbull's study of Copley's portraits of Boston gentlemen. At this early date, Trumbull was not yet in full control of his technique. The colors are unmodulated, the chair skewed, the composition slightly off balance, the perspective not quite right. The stiff, linear handling is similar to that of Trumbull's double-portrait of his parents (Cat. 35), which dates from the same year. Joseph's brooding expression gives this posthumous portrait its intensity of emotion.

Pleased with his work, Trumbull wrote to his brother David: "I have begun our Broʳ Jos:— and succeed much better than I expected. . . . I must take a Copy for myself, & then will send home that which shall be the best resemblance."[2] A second version, which Trumbull painted for his widowed sister-in-law, is now in the Connecticut Historical Society.[3]

1 George Washington wrote: "Few armies, if any, have been better and more plentifully supplied than the troops under Mr. Trumbull's care"; see *DAB*, XIX, p. 19.
2 JT to David Trumbull, October 29, 1778, CHS.
3 In the list of pictures executed before 1780 included in the *Autobiography* (1841, pp. 59–61), Trumbull identified no. 52 as "Portrait of my eldest brother Joseph, *from memory*, after his death; half length, size of life.— These at Boston"; and no. 56 as "Copy of 52, for his widow, my sister-in-law." On stylistic grounds, Sizer 1967, p. 76, identified the second work as the portrait now on permanent loan to the Connecticut Historical Society; reproduced in Jaffe 1975, fig. 31.

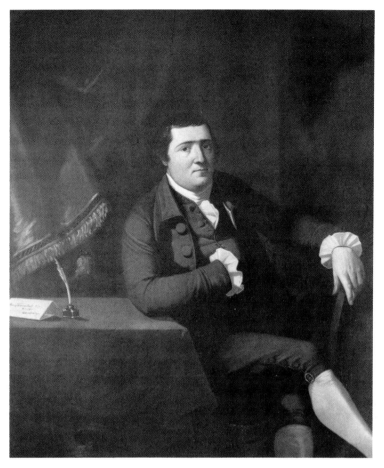

37

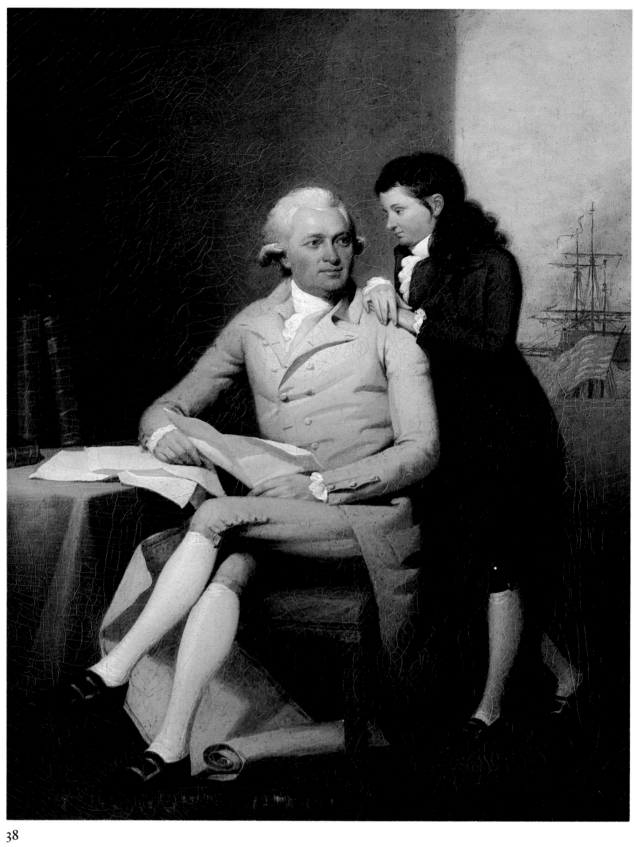

38

Jeremiah Wadsworth and His Son Daniel Wadsworth

1784
Oil on canvas, 36¼ x 28½ (92.1 x 72.4)
Wadsworth Atheneum; Gift of Faneuil Adams

In January of 1784 Trumbull made his second trip to London, where he resumed his studies with Benjamin West. An old friend of the Trumbull family, Jeremiah Wadsworth of Hartford, also arrived in England that year. As commissary to the French troops in America, Wadsworth had been obliged to personally submit a report in Paris and was continuing to travel in Europe for business purposes before returning to Connecticut.[1] Accompanying Wadsworth was his thirteen-year-old son Daniel, who would later become the founder of the Wadsworth Atheneum and an important patron of Trumbull.[2] While in London in 1784, the father and son posed for this portrait, which was among the earliest of the young artist's commissioned works.[3]

The immediate change produced in Trumbull's style by firsthand exposure to European art is apparent in the Wadsworth portrait. In contrast to the rigid pattern of position and gaze which characterizes the sitters of Trumbull's American works, the poses of Wadsworth and his son display animation and variety. A new kind of coloristic subtlety appears in the cool tonality— especially the pearl gray of Wadsworth's suit— which dominates the work, a tonality found frequently in contemporary English painting.[4] The sense of psychological exchange between the two figures, as well as their casual poses and full-length presentation on a small scale, relate the work to the "conversation piece," a popular genre of English family portraiture which also informed Trumbull's 1784 painting of *Sir John Temple and Family* (Fig. 52).[5] Allusions to the grand tradition of English portraiture, epitomized in the work of Sir Joshua Reynolds, can also be seen, as in the elaborately strewn papers and background view of ships which represent Wadsworth's commercial occupation.

It was from Reynolds himself that Trumbull received commentary on this painting memorable enough to record in his *Autobiography* almost sixty years later:

> I had the vanity . . . to take [the portrait] to show to Sir Joshua Reynolds; the moment he saw it, he said, in a quick sharp tone, "that coat is bad, sir, very bad; it is not cloth— it is tin, bent tin." The criticism was but too true, but its severity wounded my pride, and I answered, (taking up the picture,) "I did not bring this thing to you, Sir Joshua, merely to be told that it is bad; I was conscious of that, and how could it be otherwise, considering the short time I have studied; I had a hope, sir that you would kindly have pointed out to me, how to correct my errors." I bowed and withdrew and was cautious not again to expose my imperfect works to the criticism of Sir Joshua.[6]

1 See *DAB*, XIX, pp. 309–10; and Richard Saunders with Helen Raye, *Daniel Wadsworth: Patron of the Arts*, exh. cat., Wadsworth Atheneum, Hartford, 1981, p. 11.
2 Because of Daniel's poor health and eye injuries, his father had brought him to Europe to be examined by French physicians. In a subsequent letter, Jeremiah wrote: "I took him with me to France, the voyage mended his health which had never been good after his fall & his right eye grew stronger but was too weak to be of much use"; quoted in Saunders, *Daniel Wadsworth*, p. 11, n. 2.
3 In a letter to his brother Jonathan (July 18, 1784, YUL-JT), Trumbull wrote: "I have receiv'd from Wadsworth & Church— the first fruits of my profession.— W. gave me for the little picture which you will see. fifteen Guineas & C. for two smaller ones. the same sum". The painting is listed under "Pictures done in London 1784" in Trumbull's "Account of Paintings," II, no. 6: "small portraits Col? Wadsworth & Son— 15 Guineas."
4 See, for example, *William Atherton and His Wife, Lucy*, 1743–44, by Arthur Devis (Walker Art Gallery, Liverpool) and *The Hon. Mrs. Thomas Graham*, 1777, by Thomas Gainsborough (National Gallery of Scotland, Edinburgh).
5 An excellent discussion of conversation pieces is found in Ellen G. D'Oench, *The Conversation Piece: Arthur Devis & His Contemporaries*, exh. cat., Yale Center for British Art, New Haven, 1980, chap. II.
6 Trumbull 1841, pp. 91–92.

39
Patrick Tracy

1784–86
Oil on canvas, 91½ x 52⅝ (232.4 x 133.7)
National Gallery of Art; Gift of Patrick T. Jackson

Patrick Tracy (1711–1789) was an entrepreneur. Born in Ireland, he immigrated with his family as a boy to Newburyport, Massachusetts. He learned the skills of navigation on numerous voyages to the West Indies and eventually became a master mariner, shipowner, and powerful merchant. Part owner of several privateers, he contributed considerable amounts of time and money to the Revolutionary forces and served on the committee that advised delegates from Massachusetts to the Continental Congress in Philadelphia. At the time this portrait was painted, Tracy was one of the leading citizens of Newburyport, having been appointed justice of the peace there in 1772. The brick mansion he built as a wedding gift to his son Nathaniel now serves as the town's public library. He died in Newburyport at 78 years of age. His estate was valued at slightly more than 3739 pounds, a considerable sum for the time.[1]

Although in the late nineteenth and early twentieth centuries this portrait was attributed to John Singleton Copley, the ascription to Trumbull was established by Theodore Sizer when he realized that it was probably the picture listed in Trumbull's "Account of Paintings" as: "Whole length of Mr. P. Tracy (father of Nat) leaning on an Anchor— head copied— recd 20 guineas."[2] Some years later, a note was found, written by one of Tracy's descendants, listing the portrait as by Trumbull, dating it 1786, and giving its price as 20 guineas.[3] The portrait's attribution to Trumbull is now universally accepted.

As Trumbull's "Account of Paintings" entry makes clear, he did not paint *Patrick Tracy* from life, but from another work, very probably a miniature. Tracy's son Nathaniel was in England in 1784 and 1785, and it must have been he who commissioned this work from Trumbull and who provided the likeness the artist copied.[4] He must also have told Trumbull about his father's activities as a seaman and a merchant, allusions to which are important elements of this ambitious work.

Although paintings on the scale of *Patrick Tracy* often gave Trumbull considerable trouble, in this case the artist managed to produce a highly accomplished portrait in the fashionable English Rococo style of Joshua Reynolds and Thomas Gainsborough. The latter master's influence, in particular, is evident in the frontality and unaffectedness of Tracy's pose, as well as in the inclusion of a large anchor to denote his association with the sea. Gainsborough's portrait of *Augustus John, Earl of Bristol* (National Trust, Ickworth, Sussex), engraved in 1773, helped to popularize this iconography in portraits of naval officers. In his portrait of *Midshipman Augustus Brine* (1782, The Metropolitan Museum of Art), Copley had included a similar device, though not too prominently visible. Here, Trumbull has modified the traditional usage somewhat, making it appropriate to a portrait of a merchant by also including a barrel and other bales of goods; one package is stamped with the shipper's monogram.

Despite a number of anatomical awkwardnesses— Tracy's left arm does not seem to be connected to the

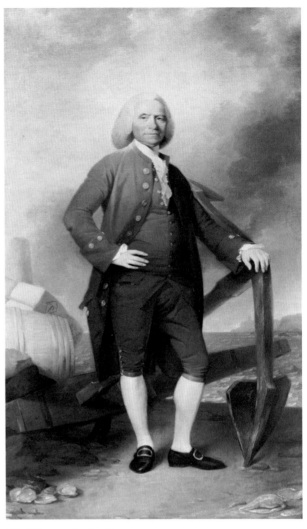

39 *Color reproduction, Fig. 53*

shoulder, his body below the waist is excessively long, the right arm appears shorter than the left— this work must be counted among Trumbull's most successful full-length portraits. The delineation of character in the head is forceful, details throughout are carefully observed and the balance of colors, especially the use of blues and grays, produces a pleasing overall effect. Many of these qualities also characterize Trumbull's major full-length portraits painted in America after his return from England: *George Washington* and *George Clinton* (*Fig. 54*), painted for the city of New York in 1790 and 1791, respectively, and *General George Washington at the Battle of Trenton*, 1792 (Cat. 42). The portrait of Patrick Tracy thus may be regarded as the forerunner to this distinguished series of works.

1 For biographical information see John T. Currier, *Ould Newbury*, Boston, 1891, pp. 545–51, and Thomas Amory Lee, "The Tracy Family of Newburyport," *Essex Institute Historical Collections*, 57 (January 1921), pp. 57–59.
2 Trumbull, "Account of Paintings," II, no. 15.
3 See the copy of the letter by Helen E. Jackson to William P. Campbell, December 18, 1964, Yale University Art Gallery Files. She writes that in a notebook kept by her father-in-law she had located the following reference to the portrait: "Patrick Tracy. Painted by John Trumbull. 20 gn. 1786."
4 Nathaniel Tracy also commissioned a small full-length portrait of himself (unlocated); see "Account of Paintings," II, no. 16.

1788

Oil on wood, 4⅜ x 2¾ (11.1 x 7)
Gift of the Government of Italy to the White House, on
loan to the National Portrait Gallery

In the winter of 1787–88, Trumbull was a guest in Jefferson's home in Paris, where he painted Jefferson's portrait directly into *The Declaration of Independence* (Cat. 25). He regarded it as among the best of his small portraits.[1] A year earlier, in Paris, Trumbull had introduced Jefferson to the celebrated English artists, Richard Cosway and his beautiful wife Maria. Shortly thereafter, Mrs. Cosway and Jefferson became romantically involved.[2] When both Mrs. Cosway and Trumbull were back in England, she saw Jefferson's portrait in the *Declaration* and wrote to him: ". . . will you give Mr. Trumbull leave to Make a Coppy of a certain portrait he painted at Paris?"[3] Apparently she had already approached Trumbull herself. The artist had been acting as intermediary in the correspondence between Jefferson and Mrs. Cosway. Trumbull, writing to Jefferson about Mrs. Cosway's crossness at the infrequency of his letters, reported: "She is angry, yet she teases me every day for a copy of your little portrait, that she may scold *it* no doubt."[4] When Trumbull did not produce the copy quickly enough, Mrs. Cosway complained to Jefferson: "I cannot announce the portrait of a friend of mine in my Study yet, Trumbull puts me out of all patience. I allways thought painting slow work, 'tis dreadfull now."[5] Upon the portrait's completion that summer, she told Jefferson: "Wish me joy for I possess your Picture. Trumbull has procured this happiness which I shall be ever gratfull for."[6] The portrait remained with Mrs. Cosway throughout her life; she never saw Jefferson again after their initial meeting in Paris.[7]

The portrait, showing the American minister at age forty-five, is remarkable for its fresh and fluid brushwork. Trumbull changed the plain appearance Jefferson had in the *Declaration*, adding a more elaborate shirt ruff and wig— a more suitable image for a diplomat— which may have been inspired by Mather Brown's portrait of Jefferson (*Fig. 60*), which Trumbull saw in March of 1788 in John Adams' London home.[8]

Mrs. Cosway's was the first of three small portraits of Jefferson taken from the *Declaration*. The second (The Metropolitan Museum of Art) was executed for Angelica Church, another mutual friend of Trumbull and Jefferson; she wrote Jefferson, "Mr. Trumbull has given [Mrs. Cosway and myself] each a picture of you. Mrs. Cosway's is a better likeness than mine."[9] The third (The Thomas Jefferson Memorial Foundation) was given by Trumbull to Jefferson's eldest daughter Martha. These three portraits, of which the Cosway version is the finest, are among the earliest of Trumbull's small portraits on panel, most of which were executed in America between 1790 and 1794.

40

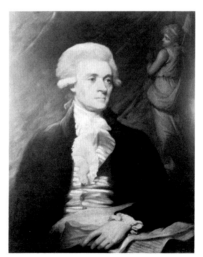

Fig. 60. Mather Brown, *Thomas Jefferson*, 1786. Collection of Charles Francis Adams.

1 Trumbull 1841, p. 151.

2 See Helen Duprey Bullock, *My Head and My Heart: A Little History of Thomas Jefferson and Maria Cosway*, New York, 1945.

3 Maria Cosway to Thomas Jefferson, March 6, 1788, in Julian P. Boyd, ed., *Papers of Thomas Jefferson*, Princeton, 1950– , XII, p. 645.

4 JT to Thomas Jefferson, March 6, 1788, in ibid., p. 647.

5 Maria Cosway to Thomas Jefferson, April 29, 1788, ibid., XIII, pp. 115–16.

6 Maria Cosway to Thomas Jefferson, August 19, 1788, ibid., p. 525.

7 Mrs. Cosway took the portrait with her to Lodi, Italy, where in 1812 she founded a college for young girls. Elizabeth Cometti brought the portrait to the public's attention in 1952; see "Maria Cosway's Rediscovered Miniature of Jefferson," *The William and Mary Quarterly*, 9 (April 1952), pp. 152–55. The portrait was given to the United States by the government of Italy during President Ford's administration.

8 William Howard Adams, ed., *The Eye of Jefferson*, exh. cat., National Gallery of Art, Washington, D.C., 1976, p. 140.

9 Angelica Church to Thomas Jefferson, July 21, 1788, in Boyd, *Papers of Thomas Jefferson*, XIII, p. 391.

41

Washington at Verplanck's Point
New York, 1782,
Reviewing the French Troops
after the Victory at Yorktown

1790
Oil on canvas, 30 x 20⅛ (76.2 x 51.1)
Inscribed, lower right: *J. Trumbull | 1790*
The Henry Francis du Pont Winterthur Museum

The circumstances surrounding the creation of this portrait are elucidated by Trumbull in a letter to Martha Washington's granddaughter Elizabeth Parke Custis.

> In the summer of 1790 I painted a small whole length portrait of General Washington, standing by a White Horse and leaning the right arm on the Saddle & holding the bridge reins— in this picture every part of the Dress, the Horse & horse furniture, were carefully painted from the real objects:— the background represents the encampment of the American Army at Verplanck's point on the North River in 1782— and the reception there which I saw of the French Army returning from the capture of Yorktown— a glimpse of the North River, Stony Point, & the Highlands where the French troops crossed are seen in the distance. . . . My name is inscribed on the bottom of the picture . . . with the date 1790:— It was presented by me to Mrs. Washington in evidence of my profound and affectionate respect.[1]

Verplanck's Point was a site of great importance to the Americans, for the ferry which connected it to Stony Point across the river served as a key point of communication between the northern and southern Colonies. Both Washington and the French had twice led their armies through this crossing. The British made several attempts to overtake Verplanck's Point, but their efforts were successfully thwarted by the Americans, who retained control of the area throughout most of the war. In this portrait, Washington stands on a hill, removed from the events below. On the lower plain, his troops can be seen in a double row, flanking the entering French army; two mounted officers, probably Washington and the French General Rochambeau, occupy the middle ground.[2] Trumbull was particularly pleased with the portrait of Washington, writing to Benjamin West that it was "thought very like."[3]

While working on the portrait, Trumbull received a commission to paint another portrait of Washington for the New York City Hall in a size slightly larger than life. Instead of proceeding with both works at the same time, Trumbull appears to have finished the small portrait first and then gone on to the large one. In spite of a formal request from the government of the city of New York, Washington evidently did not sit for the large portrait, perhaps making it inevitable that the city's painting— with the exception of the background— became an almost exact copy of the smaller one. Perhaps for this reason, too, the small portrait is a more animated and spirited work than the large one.[4]

In choosing to represent Washington in an informal pose, the arm draped over the saddle and another at his

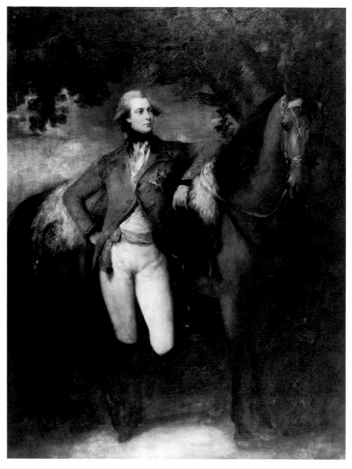

Fig. 61. Thomas Gainsborough, *George, Prince of Wales*, 1782. Waddesdon Manor, England (National Trust, copyright reserved).

waist, Trumbull again took his cue from contemporary British portraiture. The pose was common enough in portraits of esquires and gentlemen at leisure, as in Joseph Wright of Derby's *Mr. and Mrs. Thomas Coltman* (c.1769–73),[5] but it was probably Gainsborough's use of a similar composition in portraits of worthies that attracted Trumbull's attention (e.g., *Colonel St. Leger*, Buckingham Palace, and *George, Prince of Wales*, Waddesdon Manor, Buckinghamshire [*Fig. 61*], both of which were exhibited at the Royal Academy in 1782).

Although in his account Trumbull would have us believe that Washington's horse was painted from life, the stylized curve of the animal's neck and its left leg raised to its mouth suggest that he copied it from an engraving of Van Dyck's famous *King Charles I* (Louvre), a work Trumbull had much admired while visiting Versailles in 1786.[6]

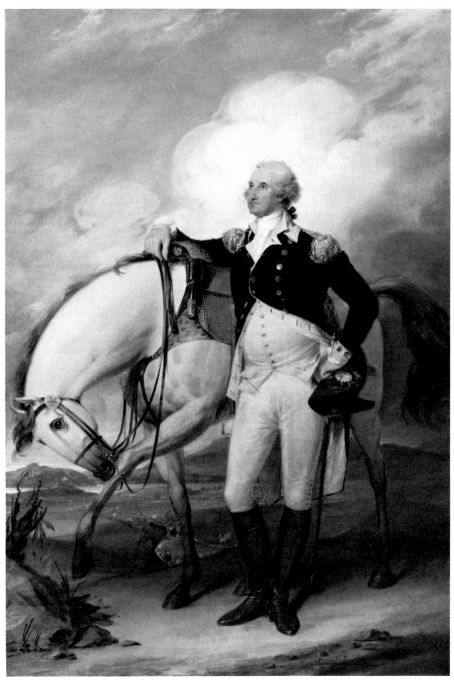

41

1 JT to Elizabeth Parke Custis, May 1, 1829, The Henry Francis du Pont Winterthur Museum. Mrs. Custis inherited the painting from Martha Washington in 1802. George Washington Parke Custis described Trumbull's working method: "The painter had *standings* as well as sittings— the white charger, fully caparisoned, having been led out and held by a groom, while the chief was placed by the artist by the side of the horse, the right arm resting on the saddle. In this novel mode the relative positions of the man and horse were sketched out and afterwards transferred to the canvas"; see George Washington Parke Custis, *Recollections and Private Memoirs of Washington*, New York, 1860, quoted in Edgar P. Richardson, "A Penetrating Characterization of Washington by John Trumbull," *Winterthur Portfolio*, 3 (1967), p. 10.

2 In his *Mémoires*, Rochambeau recounted the meeting of the French and American troops: "The general [Washington], wishing to show his respect for France and his gratitude for its generous acts, had us pass between two ranks of his troops, clothed, equipped, and armed for the first time since the Revolution, partly in materials and arms brought from France, partly from English stores taken with the army of Cornwallis and which the French army had generously given over to the American army. General Washington had his drums beat the French march during this entire review, and the two armies rejoined each other with the liveliest signs of mutual pleasure"; quoted in translation by Richardson, "A Penetrating Characterization of Washington," p. 9.

3 JT to Benjamin West, August 30, 1790, YUL-JT.

4 Jaffe 1975, p. 315, points out that Washington's diary does not register any further sittings for Trumbull after July 19, 1790, the date of the city's formal request for his portrait. This implies that the large work was not at all painted from life, but is a copy.

5 Reproduced in W. Gaunt, *The Great Century of British Painting*, London, 1971, fig. xiv.

6 Trumbull 1841, p. 112: "Saw here the whole length portrait of King Charles I, engraved by Strange— the most perfect and loveliest of Vandyck's portraits that has come to my view." The relationship of Trumbull's *General Washington* to the Van Dyck portrait is discussed by Leo Steinberg, "The Glorious Company," in Jean Lipman and Richard Marshall, *Art About Art*, exh. cat., Whitney Museum of American Art, New York, 1978, pp. 8–9.

General George Washington at the Battle of Trenton

1792

Oil on canvas, 92½ x 63 (235 x 160)
Yale University Art Gallery; Gift of the Society of the
 Cincinnati in Connecticut

After his success with the portraits of *George Washington* and *George Clinton* (*Fig. 54*) he had painted for the New York City Hall in 1790 and 1791, Trumbull was generally recognized as America's most accomplished painter of public portraits then working. It was logical, therefore, that when in 1792 the city of Charleston, South Carolina, decided to obtain a large portrait of Washington for its city hall, the commission went to Trumbull. Since all decisions regarding the time and place represented in the work, as well as its color, composition, and other details, were left up to him, he conceived of an ambitious scheme to make of this portrait a veritable history painting representing a moment of overriding importance in the American Revolutionary War. Consequently, the picture has more in common with his Revolutionary War historical paintings than with any of his previous portraits of Washington. He painted it in Philadelphia, then the seat of national government, in 1792, during Washington's presidency.

As Trumbull made clear in his *Autobiography*, his aim here was to give Washington's military character "in the most sublime moment of its exertion— the evening previous to the battle of Princeton; when viewing the vast superiority of his approaching enemy, and the impossibility of again crossing the Delaware, or retreating down the river, he conceives the plan of returning by a night march into the county from which he had just been driven, thus cutting off the enemy's communication, and destroying his depot of stores and provisions at Brunswick." Trumbull further noted: "I told the President my object; he entered into it warmly, and, as the work advanced, we talked of the scene, its dangers, its almost desperation. He *looked* the scene again, and I happily transferred to the canvass, the lofty expression of his animated countenance, the high resolve to conquer or to perish."[1]

That Washington should have been moved by the memory of these events is not only plausible, but appropriate; Trumbull had cleverly chosen to depict the critical moment of his career as a general as well as of the course of the war. In later years, Trumbull frequently commented upon the portrait's historical and psychological authenticity. For him this was Washington the general at his most heroic, most noble, most inspired— a judgment shared by most students of American art.[2]

If in previous portraits of Washington Trumbull almost completely relied on established English models for military portraiture, in this work he employed the pictorial formulas he had developed in his Revolutionary War battle pictures and in the last version of *The Sortie Made by the Garrison of Gibraltar* (Cat. 12). The strong diagonals, the superimposition of forms upon one another in an almost cluttered fashion, the agitated horse and turbulent sky, all relate to West's proto-Romantic battle paintings of the 1780s (*The Battle of Crecy* and *Edward III Crossing*

the Somme, both 1788, Collection of Her Majesty The Queen), but they more directly descend from Trumbull's own *Capture of the Hessians at Trenton* (Cat. 24) and *The Death of General Mercer at the Battle of Princeton* (Cat. 14). Both these works were completed at a much later date than the Washington portrait, but their composition and details had been determined long before the artist began the portrait. By contrast, the figure of Washington relates to the classically derived principal figures in the final version of the *Sortie*. Whether inspired by the Apollo Belvedere or by a more ordinary Roman statue of a worthy in the *ad locutio* pose, his stance and gesture evoke the noble grandeur associated with classical sculpture in the late eighteenth century. It is also possible that the placement of Washington in relief against a horse viewed from the side was inspired by one of the marble groups in the procession frieze of the Parthenon. The entire frieze was illustrated by Stuart and Revett in their *Antiquities of Athens*, with this particular plate published in June 1789, while Trumbull was still in London (*Fig. 62*).[3]

As with Trumbull's earlier history paintings, and in keeping with the tradition of Anglo-American history painting in general, the carefully planned composition in this work is complemented by historically accurate details. As Silliman reports, Trumbull assured him that here Washington's "person, his spy glass— his dress— his arms & all the appendages even to his hat & gloves are faithful copies of the originals."[4]

Because it was so obviously a portrait laden with the trappings of history painting, the city of Charleston decided that it was not suitable. In their resolution of May 7, 1791, the city council had noted its wish that Trumbull's portrait of Washington should be "the most lasting testimony of their attachment to his person" and should "commemorate his arrival in the metropolis of this State."[5] They had something more amiable in mind than a military portrait-*cum*-battle scene. The city's representative in this transaction, William Loughton Smith (Cat. 81), told this to Trumbull in clear terms: "the city would be better satisfied with a more matter-of-fact likeness, such as they had recently seen him— calm, tranquil, peaceful."[6] Because Trumbull liked the portrait so much and probably because he reasoned that at some future date it would be properly appreciated, he kept it and obliged Charleston by producing another portrait more to its liking. Eventually, when the Society of the Cincinnati in Connecticut dissolved, some of its members provided Yale with the funds— 500 dollars— to purchase the work from the artist in 1806.

1 Trumbull 1841, pp. 166–67.
2 Ibid., p. 166: Trumbull calls it "the best certainly of those which I painted, and the best, in my estimation, which exists, in his heroic military character." At one time, he told Benjamin Silliman: "You may assure your young men, that they here see *the George Washington* of the Revolution, exactly as he appeared at the head of the armies, when he was in the meridian of life. . . . there is no other portrait existing which does justice to his military appearance and character"; see Silliman, "Notebook," II, pp. 46–47.
3 Jaffe 1975, p. 158, notes that the positions of the groom and horse are in the style of the famous ancient equestrian group, the *Dioscuri*.
4 Silliman, "Notebook," II, p. 47.
5 Quoted in Anna Wells Rutledge, *Catalogue of Painting and Sculpture in the Council Chamber, City Hall, Charleston, S.C.*, Charleston, 1943, p. 31.
6 Trumbull 1841, p. 167.

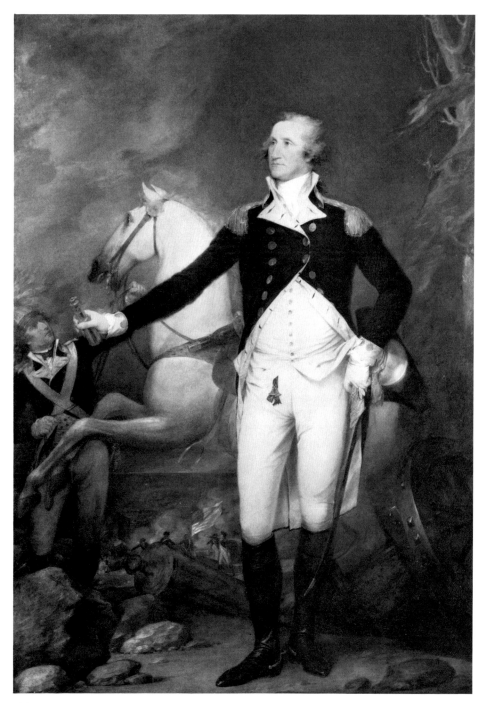

42 *Color reproduction, Frontispiece*

Fig. 62. Parthenon Frieze, 1789. Engraving from James Stuart and Nicholas Revett,
The Antiquities of Athens, London, 1762–94.

43
Alexander Hamilton

1792

Oil on canvas, 86¼ x 57½ (219.1 x 146.1)
The Chamber of Commerce and Industry of the State of
 New York

In December of 1791, a committee of five New York mer-
chants commissioned Trumbull to paint this full-length
portrait of the first secretary of the treasury, Alexander
Hamilton (1757–1804).[1] Hamilton probably sat for Trum-
bull early in 1792, when the artist was visiting Philadelphia
to take likenesses for his history paintings. The bust-
length portrait Trumbull completed at that time[2] was
probably the model for both the New York merchants'
picture and his depiction of Hamilton in *The Surrender of
Lord Cornwallis at Yorktown* (Cat. 27), in which Hamilton
appears at the far left of the group of standing American
officers. The full-length portrait was completed by July 3,
1792, when it was exhibited at New York's City Hall.[3]

In painting this portrait, Trumbull had to reconcile the
somewhat contradictory wishes of the donors and the
sitter. The merchants commissioned a large-scale picture,
to be "placed in one of our public buildings."[4] Hamilton,
on the other hand, wished to "appear unconnected with
any incident of my political life. The simple representation
of their fellow Citizen and friend will best accord with my
feelings."[5] To create the sense of dignity appropriate to a
life-size public portrait, the artist relied on the traditional
props of a column, background architecture, and a robe
thrown over a chair, all of which were quoted from Eu-
ropean grand manner portraiture.[6] At the same time,
Trumbull avoided the elaborate trappings and overtly
political symbols suitable for a man who was Washing-
ton's military secretary, a Cabinet officer, and the power-
ful leader of the Federalist party. The delicate color
scheme and subdued highlights on such details as the
brass upholstery tacks, Hamilton's seals and watch fob,

and the silver inkstand further suggested a private, unof-
ficial atmosphere. The importance of the artist's restraint
is evident when this painting is compared to another full-
length portrait of the same year, *General George Washing-
ton at the Battle of Trenton* (Cat. 42), in which strong
colors and brilliant highlights reinforce the effect of pub-
lic grandeur. Trumbull's sympathetic portrayal of Hamil-
ton suggests the respect he felt for the Federalist leader,
whose fatal duel with Aaron Burr in 1804 the artist called
"that unhappy event which deprived the United States of
two of their most distinguished citizens."[7]

1 See Gulian Verplanck et al. to Alexander Hamilton, December 29,
 1791, LC, Alexander Hamilton Papers.
2 Trumbull 1832, p. 30, states that the Hamilton portrait at Yale was
 "copied in 1832 from an original, painted at Washington in 1792,
 now in possession of Gov. Wolcott." Noting that the city of
 Washington was not planned until 1791, Sizer 1967, p. 36, deter-
 mined that a bust-length life portrait of Hamilton was done at
 Philadelphia (which was the capital of the United States in 1792),
 and tentatively identified it as the painting now in the National
 Gallery of Art, Washington, D.C. The immediacy and freshness
 of the National Gallery portrait suggests that it was done from
 life; however, this painting descended in the family of John Jay.
 No portrait of Hamilton by Trumbull can now be identified as
 having been the property of the Wolcott family. The head of the
 Chamber of Commerce portrait is definitely of the same type as
 the National Gallery portrait, although whether the latter picture
 was the model for the full-length or whether the full-length was
 also done from life cannot be determined with certainty.
3 Reported in the *New York Daily Advertiser*, July 4, 1792.
4 Gulian Verplanck to Alexander Hamilton, December 29, 1791, LC,
 Alexander Hamilton Papers.
5 Alexander Hamilton to Gulian Verplanck et al., January 15, 1792,
 LC, Alexander Hamilton Papers.
6 Such devices, found for example in the portraits painted by Hy-
 acinthe Rigaud for the French court, were similarly quoted by
 Gilbert Stuart in the "Lansdowne" *George Washington* of 1796,
 which became a prototype for official portraits of American states-
 men; see Richard J. Boyle, "The Pennsylvania Academy of the
 Fine Arts, its founding and early years," *Antiques*, 121 (March
 1982), p. 674.
7 Trumbull 1841, p. 244.

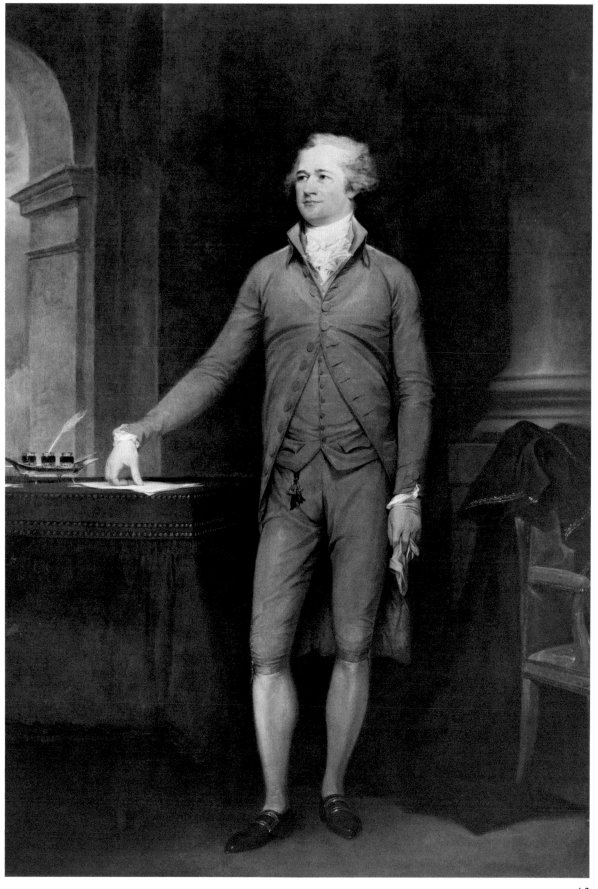

43

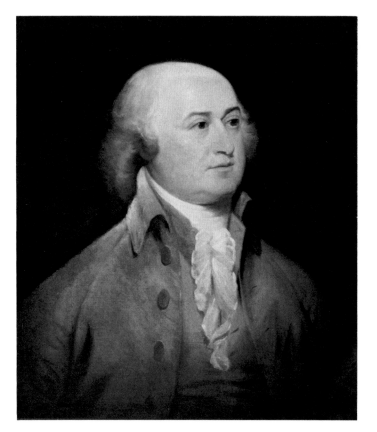

44

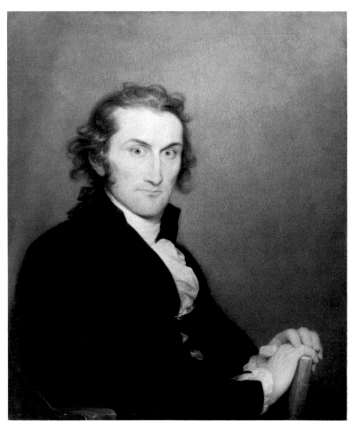

45

John Adams

c.1793
Oil on canvas, 30 x 25 (76.2 x 63.5)
The National Portrait Gallery

Adams (1735–1826) and Trumbull crossed paths many times during the course of their long careers. When the young artist stopped in Paris in 1780 on his first trip to London, he later recalled that Adams, then commissioner to France, was one of the few people he knew.[1] In 1785, when Adams was minister to England, Trumbull visited his London home several times; however, the artist thought there was "too much of constraint, too much of the great and the wise to admit any thing sporting, familiar— or relaxing."[2] Trumbull painted Adams' portrait directly into the first version of *The Declaration of Independence* (Cat. 25) prior to Adams' departure from England in 1787; six years later in Philadelphia, when Adams was vice-president, Trumbull painted a miniature of him as well (Cat. 68).

There are three portraits of Adams dating to c.1793, one probably painted from life, the other two replicas, but it is not certain which version is the first. The National Portrait Gallery painting descended through the sitter's family;[3] John Jay, Adams' fellow commissioner in the 1783 peace negotiations with England, owned another, and Andrew Cragie gave a third to Harvard in 1794.

In this portrait Trumbull omits all attributes or setting. Instead, through lighting, and a limited palette of rich browns and creams, he focuses attention on Adams' face, thus subtly suggesting a leader who is beyond possessions or place and is known instead for the quality of his mind.

1 Trumbull 1841, p. 65.
2 JT to Jonathan Trumbull, Jr., August 2, 1785, YUL-JT.
3 See Andrew Oliver, as quoted in *Antiques*, 91 (April 1967), p. 475.

Lemuel Hopkins

1793
Oil on canvas, 30¼ x 24¼ (76.8 x 61.6)
Inscribed, lower right: *J. Trumbull.* | *1793.*
Yale University Art Gallery; Gift of Miss Elizabeth Sill

This portrait of *Lemuel Hopkins* (1750–1801) owes much of its impact to the sitter's bizarre appearance, which was further impressed in the public's mind by his fame as both an innovative physician and an amateur poet. Hopkins was the only doctor among a group of politically conservative satirists known as the "Connecticut Wits." As members of the professional establishment in Connecticut, the Wits were critical of the new American political system, which gave power to people who lacked wealth or education. They attacked popular politics in such poems as "The Anarchiad" of 1786–87, of which Hopkins was the principal author.[1] His poetry, however, was never considered outstanding; one critic remarked that his poems were "somewhat like his personal appearance and manners— singular and eccentric."[2] Hopkins was equally well known as an unorthodox doctor, and he turned his poetry against tradition in such satires on medicine as "Epitaph on a Patient Killed by a Cancer Quack." Because of a childhood predisposition to tuberculosis, Hopkins specialized in treating that disease, rejecting such time-honored cures as asses' milk in favor of fresh air and a healthy diet.[3]

The portrait shows Hopkins at the age of forty-three. Trumbull presumably painted it in Hartford, where his miniature of Hopkins was done in the same year, probably at the same time (Cat. 94). In the painting, Trumbull shows Hopkins seated in a green Windsor chair, an unusual prop in the artist's portraits.[4] The forward thrust of Hopkins' pose gives the portrait great immediacy, which Trumbull has heightened by using light, fluid brushstrokes in the hair and costume details. The strong representation of Hopkins' eccentric personality suggests that Trumbull found him a congenial subject, possibly because the doctor had been Harriet Wadsworth's personal physician, had attended Governor Trumbull in his last illness, and was an early critic of the political upheavals in France.

1 See Cat. 94.
2 Charles W. Everest, *The Poets of Connecticut*, Hartford, 1843, p. 52.
3 See *DAB*, IX, p. 215.
4 While at Hartford in 1793, Trumbull also painted a half-length portrait of Hopkins' fellow-Wit John Trumbull, the artist's second cousin, in which he showed him holding the same leather-bound book as Hopkins, and seated in an identical Windsor chair. This portrait is now in the Detroit Institute of Arts.

Portrait Miniatures

Trumbull took seriously the accurate recording of the likenesses of those figures who had been present at the great events of the Revolutionary War. After he returned from London in 1789, he spent five years traveling up and down the eastern coast of the United States, taking "heads" from life, mainly of statesmen and military officers, for his series of history paintings (see p. 38 for a discussion of the proposed series). Most of these portraits— for executed and unexecuted paintings— were included in the artist's gift to Yale. Arranged five to a tablet when they were exhibited in the Trumbull Gallery in 1832, they remain in their original frames.

Trumbull referred to these portraits as "miniatures," but except for their small size they bear no relation to traditional eighteenth-century portrait miniatures, which were meant to be used as decoration or ornament. The latter were produced in gouache or watercolor on ivory, using a fine stipple technique. Trumbull's miniatures were created as studies for his own use. Executed in oil on mahogany, their brushwork is fluid and painterly, with impastos and transparent glazes that produce contrasting textures. Outstanding for their spontaneity, sensitivity of characterization, and coloristic brilliance, these small works are among the most successful achievements of Trumbull's career.

Biographical information on the sitters is taken either from the appropriate entry in the DAB *or from material in the Yale University Art Gallery Files.*

46
Nathanael Greene

1792

Oil on mahogany, 4 x 3⅛ (10.2 x 7.9)
Inscribed on paper attached to verso: *Nath! Green Esq!* | *[——] Maj! Gen! in the American | Service. during the War of | their independence:— & | [——] commander of those | Armies in the Southern | department.— | Painted by J. Trumbull | in Phil? 1792. from the only | original picture remaining.*
Yale University Art Gallery; Trumbull Collection

47
William Hull

1790

Oil on mahogany, 4 x 3⅛ (10.2 x 7.9)
Inscribed on paper attached to verso: *William Hull, Esq! | Captain in the American | army at the taking of Gen! | Burgoyne— & afterwards | Colonel to the close of the | war | Painted at Boston | 6 N? 1790. by J. Trumbull.*
Yale University Art Gallery; Trumbull Collection

48
Ebenezer Stevens

1790

Oil on mahogany, 3⅞ x 3¼ (9.8 x 8.3)
Inscribed on paper attached to verso: *William* [sic] *Stevens, Esq^r— | Commander of the American | Artillery at the capture of | Gen! Burgoyne— [——] | Colonel to the close of the War. | Painted at New York | 1790. by John Trumbull.*
Yale University Art Gallery; Trumbull Collection

49
Thomas Youngs Seymour

1793

Oil on mahogany, 3⅞ x 3⅛ (9.8 x 7.9)
Inscribed on paper attached to verso: *[——] Tho? Seymour | AEt. 35— | Capt. of Dragoons | at the surrender of | Gen! Burgoyne. | painted by | J. Trumbull at | Hartford. 1793.*
Yale University Art Gallery; Trumbull Collection

50
John Brooks

1790

Oil on mahogany, 3⅞ x 3⅛ (9.8 x 7.9)
Inscribed on paper attached to verso: *John Brooks, Esq! | Colonel of a Regiment in | [——] American Service [——] | during the War of their | independence— and present | at the capture of General | Burgoyne. | Painted by J. Trumbull | at Boston— Oct! 1790.*
Yale University Art Gallery; Trumbull Collection

The five men depicted here in miniatures were military officers during the Revolutionary War.

Nathanael Greene (1742–1786) served as a deputy to the Rhode Island Assembly, and became a brigadier general in the Continental army at the outbreak of the Revolutionary War. He was promoted to the rank of major general in 1776, fighting in two of the battles which Trumbull intended to paint: *The Battle of Eutaw Springs* (unexecuted) and *The Capture of the Hessians at Trenton* (Cat. 24), where Greene appears at right on the light-colored horse. In 1786, when Trumbull heard of Greene's death, he wrote his brother about the urgency of painting those people he wanted to include in his history paintings, now conscious "of the precariousness as well as the value of many other lives."[1] The "original picture" to which Trumbull refers in his inscription is Charles Willson Peale's 1783 portrait of Greene, now at Independence Hall, Philadelphia.

William Hull (1753–1825) served almost continuously throughout the Revolutionary War, fighting in such important battles as Trenton, Princeton, and Saratoga. His valor earned him the commendation of General Washington and Congress, as well as a series of promotions which brought him to the rank of lieutenant colonel. In the *Surrender of General Burgoyne* (Cat. 30), Hull stands to the immediate right of the tree.

Ebenezer Stevens (1751–1823), born in Boston, participated in the Boston Tea Party. He fought in New York in the battles of Ticonderoga, Stillwater and Saratoga, and accompanied Lafayette to Virginia, where he served as part-time commander of the artillery during the siege at Yorktown. After the war, Stevens was a merchant in New York and commanded the artillery of New York City during the War of 1812. In the *Surrender of General Burgoyne* Stevens leans on the cannon at the far right of the painting. Sizer has suggested that he also appears in the background of the *Surrender of Lord Cornwallis*,[2] although the face of this distant figure on horseback seems too generalized to identify with certainty.

Thomas Youngs Seymour (1757–1811) became a lieutenant of the Second Continental Dragoons in 1777, during his senior year at Yale College. After General Burgoyne's surrender, Seymour was appointed to escort the captive British officer to Boston. Among the positions he held after his resignation from the army were commander of the Connecticut governor's Horse Guard, Connecticut state attorney, and representative to the Connecticut General Assembly. In the *Surrender of General Burgoyne*, Seymour is mounted on the black horse at the left.

John Brooks (1752–1825) fought as captain of the Reading Minute Men in the Battle of Concord and commanded the Eighth Massachusetts Regiment as lieutenant colonel. He became a leading physician after the war. In the *Surrender of General Burgoyne*, Brooks stands to the right of center with his hand on a cannon.

1 JT to Jonathan Trumbull, Jr., December 27, 1786, YUL-JT.
2 Sizer 1967, p. 68.

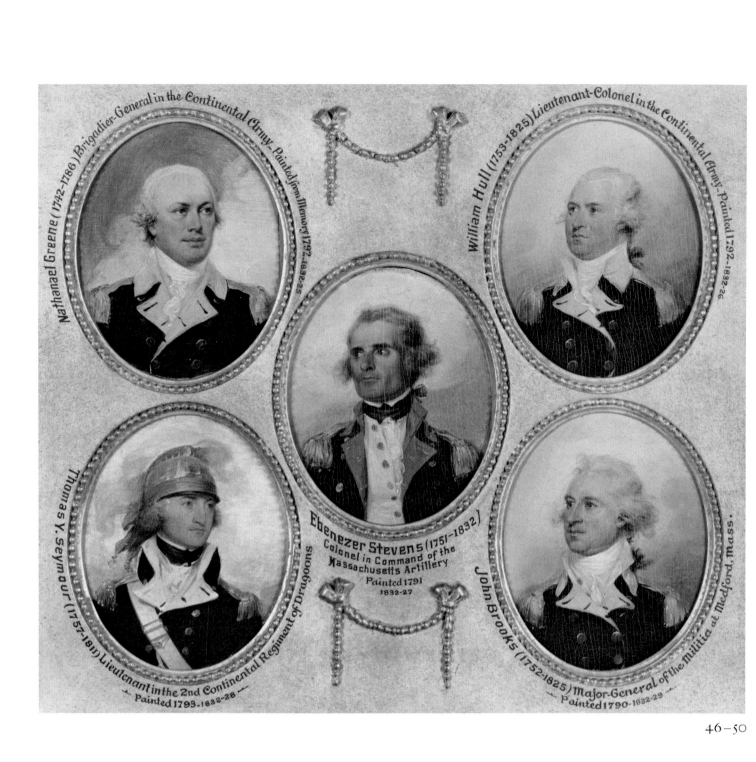

Nathanael Greene (1742-1786) Brigadier-General in the Continental Army. Painted from Memory 1792. 1832-25

William Hull (1753-1825) Lieutenant-Colonel in the Continental Army. Painted 1792. 1832-26

Thomas Y. Seymour (1757-1811) Lieutenant in the 2nd Continental Regiment of Dragoons. Painted 1793. 1832-28

Ebenezer Stevens (1751-1832) Colonel in Command of the Massachusetts Artillery. Painted 1791 1832-27

John Brooks (1752-1825) Major-General of the Militia at Medford, Mass. Painted 1790. 1832-29

46–50

51

Eleanor (Nelly) Parke Custis

1792

Oil on mahogany, 3⅞ x 3¼ (9.8 x 8.3)
Inscribed on paper attached to verso: *Eleanor Custis |
 Grand daugter* [sic] *| of Mr.s Washington | Painted. 1792 |
 by J. Trumbull | at Philadelphia*
Yale University Art Gallery; Trumbull Collection

52

Cornelia Schuyler

1792

Oil on mahogany, 3⅞ x 3⅜ (9.8 x 8.6)
Inscribed on paper attached to verso: *Cornelia Schuyler |
 daughter of | Gen.! Schuyler. | Painted at Phil.a | 1792
 by J. Trumbull*
Yale University Art Gallery; Trumbull Collection

53

Mrs. George Washington

1792

Oil on mahogany, 3⅞ x 3¼ (9.8 x 8.3)
Inscribed on paper attached to verso: *Martha Washington
 | Wife of | George Washington | President of the U.S. | of
 America. | Painted in Phil.a | 1792. by J. Trumbull.*
Yale University Art Gallery; Trumbull Collection

54

Sophia Chew

1793

Oil on mahogany, 4 x 3¼ (10.2 x 8.3)
Inscribed on paper attached to verso: *Sophia Chew |
 daughter of | Benj.a Chew Esq.r of | Philadelphia | Painted
 by | J. Trumbull 1793. | at Phil.a*
Yale University Art Gallery; Trumbull Collection

55

Harriet Chew

1793

Oil on mahogany, 4 x 3¼ (10.2 x 8.3)
Inscribed on paper attached to verso: *Harriet Chew. |
 daughter of | Benj.a Chew Esq. of | Philadelphia | Painted
 by | J. Trumbull 1793. | at Phil.a*
Yale University Art Gallery; Trumbull Collection

The subjects of two of the miniatures in this tablet appear in *The Resignation of General Washington* (Cat. 31). Martha Dandridge Custis (1732–1802) was one of the wealthiest women in Virginia upon the death of her husband, Daniel Parke Custis, in 1757. She married the then Colonel George Washington two years later. During her husband's two terms as president, she was a gracious first lady, but preferred a private life and welcomed their retirement to Mount Vernon. She is the central figure in the balcony in the *Resignation*.

Nelly Custis (1779–1832) was the daughter of Martha Washington's last surviving child by her first marriage. Miss Custis, who was thirteen years old at the time Trumbull painted this miniature, was raised in George Washington's household after her father's death. She later married Lawrence Lewis, the son of George Washington's sister. She stands to the left of Martha Washington in the *Resignation*.

Harriet Chew (1775–1861) may be the dark-haired woman with an open collar standing at the far left in the balcony. Although the remaining two miniatures of Cornelia Schuyler (1776–1808) and Sophia Chew (1769–1841) may have been used for the *Resignation*, precise identification is difficult.

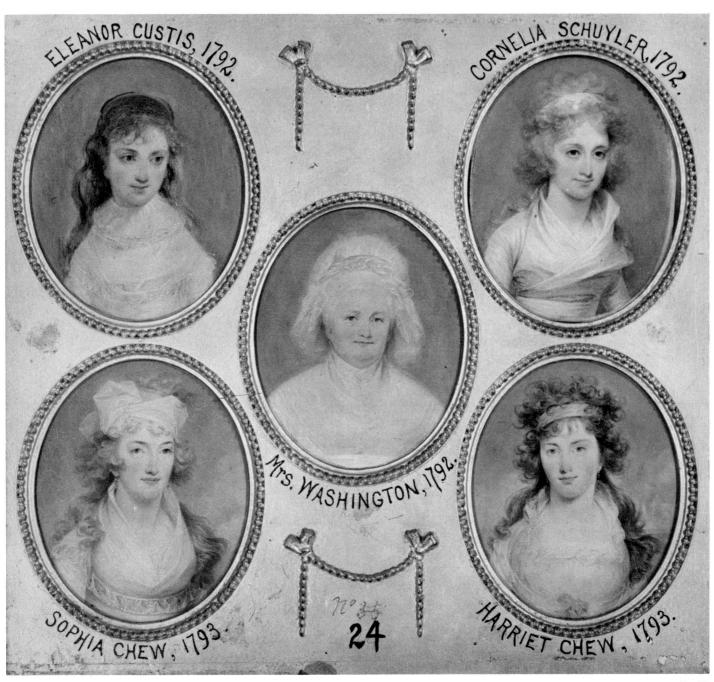

ELEANOR CUSTIS, 1792.

CORNELIA SCHUYLER, 1792.

Mrs. WASHINGTON, 1792.

SOPHIA CHEW, 1793.

HARRIET CHEW, 1793.

24

51–55

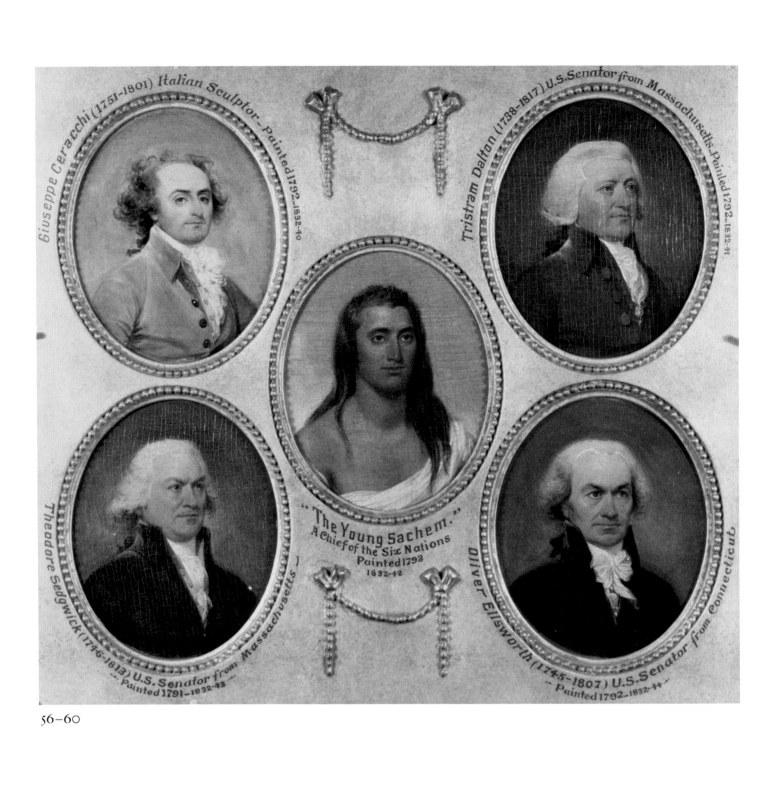

Giuseppe Ceracchi (1751–1801) Italian Sculptor – Painted 1792–1832–40

Tristram Dalton (1738–1817) U.S. Senator from Massachusetts–Painted 1792–1832–41

Theodore Sedgwick (1746–1813) U.S. Senator from Massachusetts – Painted 1791–1832–43

"The Young Sachem."
A Chief of the Six Nations
Painted 1792
1832–42

Oliver Ellsworth (1745–1807) U.S. Senator from Connecticut – Painted 1792–1832–44

56–60

56
Giuseppe Ceracchi

1792

Oil on mahogany, 3⅞ x 3 (9.8 x 7.6)
Inscribed on paper attached to verso: *Sign.ʳ Cerrachi.* |
of Rome— | *Philadelphia* | *1792. painted by* | *John*
Trumbull.
Yale University Art Gallery; Trumbull Collection

57
Tristram Dalton

1792

Oil on mahogany, 4 x 3¼ (10.2 x 8.3)
Inscribed on paper attached to verso: *Tristram Dalton*
Esq.ʳ | *Senator in the Congress of* | *the United States from*
the | *State of Massachusetts* | *& present at the*
inauguration | *of the first President.* | *Painted in*
Philadelphia | *by J. Trumbull. 1792.*
Yale University Art Gallery; Trumbull Collection

58
"The Young Sachem,"
A Chief of the Six Nations

1792

Oil on mahogany, 4 x 3¼ (10.2 x 8.3)
Inscribed on paper attached to verso: *The Young Sachem* |
a young Chief of the | *Six Nations.* | *Painted in Philadel.ᵃ* |
by J. Trumbull | *1792.*
Yale University Art Gallery; Trumbull Collection

59
Theodore Sedgwick

1792

Oil on mahogany, 3⅞ x 3¼ (9.8 x 8.3)
Inscribed on paper attached to verso: *Theodore Sedgwick*
Esq. | *Representative from the* | *State of Massachusetts*
in the | *Congress of the UStates.&* | *present at the*
inauguration | *of the first President* | *Painted in*
Philadelphia | *by J. Trumbull 1792.*
Yale University Art Gallery; Trumbull Collection

60
Oliver Ellsworth

1792

Oil on mahogany, 3¾ x 3⅛ (9.5 x 7.9)
Inscribed on paper attached to verso: *Oliver Ellsworth*
Esq.ʳ | *Senator in the Congress* | *of the United States of* |
America. from the | *State of Connecticut* | *present at the*
inaugu- | *-ration of the first* | *President.* | *Painted at*
Philad.ᵃ | *by J. Trumbull. 1792.*
Yale University Art Gallery; Trumbull Collection

Trumbull made three of the miniatures in this set as
portrait studies for his planned *Inauguration of the Presi-*
dent (see also Cats. 61, 62, 64, 65): Theodore Sedgwick
(1746–1813) was a Congressman from Massachusetts; Tris-
tram Dalton (1738–1817) was a Massachusetts Senator;
Oliver Ellsworth (1745–1807), one of the most distin-
guished Connecticut politicians of his time, was also serv-
ing as a United States Senator.

Giuseppe Ceracchi (1751–1801), a fervent revolutionary,
came to America in 1791, hoping to receive a commission
for a sculpture depicting Liberty. While waiting for Con-
gress to reply to his proposal, Ceracchi executed terracotta
busts and medallions of the leading political figures, in-
cluding Washington, Adams, Madison, and Hamilton.
Only a few of these studies were ever carved in marble,
and Trumbull later sought unsuccessfully to recover the
originals, which Ceracchi had taken back to Europe after
his project was voted down. Ceracchi also modeled a bust
of Trumbull, perhaps at the same time that Trumbull
painted his miniature.[1]

"The Young Sachem," an unidentified Indian chief,
was a deputy from the Six Nations, a confederation of
Iroquois tribes, who conferred with Congress in 1792.
John Morgan suggested that Trumbull made this portrait
in preparation for his proposed *Murder of Jane McCrea.*[2]

1 JT to Mr. Irvins, February 24, 1818, YUL-JT.
2 Morgan 1926, p. 74.

61
Rufus King

1792

Oil on mahogany, 4 x 3¼ (10.2 x 8.3)

Inscribed on paper attached to verso: *Rufus King Esq.* | *Senator in the Congress* | *of the United States of* | *America:* *from the* | *State of New York: present* | *at the inauguration* *of the* | *first President.* | *Painted in Phil.ª by* | *J. Trumbull* *1792.*

Yale University Art Gallery; Trumbull Collection

62
Fisher Ames

1792

Oil on mahogany, 3⅞ x 3⅛ (9.8 x 7.9)

Inscribed on paper attached to verso: *Fisher Ames, Esq.* | *Representative in Congress* | *of the United States of* *America* | *from the State of* | *Massachusetts.* | *& present at* *the inaugu.* | *= ration of the first* | *President.* | *Painted by* *J Trumbull* | *Phil.ª 1792.*

Yale University Art Gallery; Trumbull Collection

63
"The Infant,"
Chief of the Seneca Indians

1792

Oil on mahogany, 4 x 3¼ (10.2 x 8.3)

Inscribed on paper attached to verso: *The Infant.* | *a Chief* *of the Six Nations.* | *Six feet. four inches high* | *wearing his* *beard as in* | *the picture.* | *in his War Dress.* | *Painted by* *J. Trumbull* | *in Philadelphia 1792.*

Yale University Art Gallery; Trumbull Collection

64
John Langdon

1792

Oil on mahogany, 3⅞ x 3¼ (9.8 x 8.3)

Inscribed on paper attached to verso: *John Langdon Esq.* | *Senator in the Congress of* | *the United States. from the* | *state of New Hampshire* | *present at the inauguration* | *of the first President* | *painted in Philadelphia* | *by* *J. Trumbull 1792.*

Yale University Art Gallery; Trumbull Collection

65
John Brown

1792

Oil on mahogany, 3⅞ x 3¼ (9.8 x 8.3)

Inscribed on paper attached to verso: *John Brown Esq.* *representative in Congress* | *of the United States of* *America* | *from the state of Virginia* | *after from Kentucky.* | *present at the inauguration* | *of the first president* | *Painted by J. Trumbull* | *Phil.ª 1792.*

Yale University Art Gallery; Trumbull Collection

Four of the miniatures in this series are portrait studies for Trumbull's proposed painting of *The Inauguration of the President*.

Rufus King (1755–1827) and Trumbull began their life-long friendship in Boston in 1778, when they both belonged to a group of recent Harvard graduates who met to discuss literature and politics. King served as a delegate to the Massachusetts general court (1783–85), was an outstanding speaker in Congress (1784–87), and a senator from New York (1789–96). In 1796, he was appointed minister to England, a post he held until 1803.

A graduate of Harvard, Fisher Ames (1758–1808) acquired a reputation as a powerful speaker at the Massachusetts ratifying convention of 1787. He was a representative of Dedham in the general court of Massachusetts in 1788, and a member of Congress from 1789 to 1797.

During the Revolutionary War, John Langdon (1741–1819) secured supplies for New Hampshire, built ships for the government, financed General Stuart's expedition against Burgoyne, and led New Hampshire troops in the Rhode Island campaign. In 1783, Langdon had hosted Trumbull in Portsmouth while the young artist waited for his ship to sail to England. When Trumbull painted this miniature, Langdon was president *pro tempore* of the Senate.

John Brown (1757–1837) served under Lafayette in the Revolutionary War and studied law under Jefferson. Born in Virginia, he moved to Kentucky in 1782. He represented the Kentucky district of Virginia in the Virginia legislature in 1787 and in Congress in 1789, becoming a central figure in Kentucky's achievement of statehood in 1792. Brown then served as a senator from Kentucky until 1802.

In 1787, Trumbull drew several composition studies for an unexecuted painting depicting the murder of Jane McCrea by Indians at Fort Edwards in 1777.[1] Morgan has suggested that this miniature of "The Infant," Chief of the Seneca Indians, was made in preparation for that work.[2]

1 The drawings are at Fordham University Library in the Charles Allen Munn Collection, and at the Bennington Museum in Bennington, Vermont.
2 Morgan 1926, p. 74.

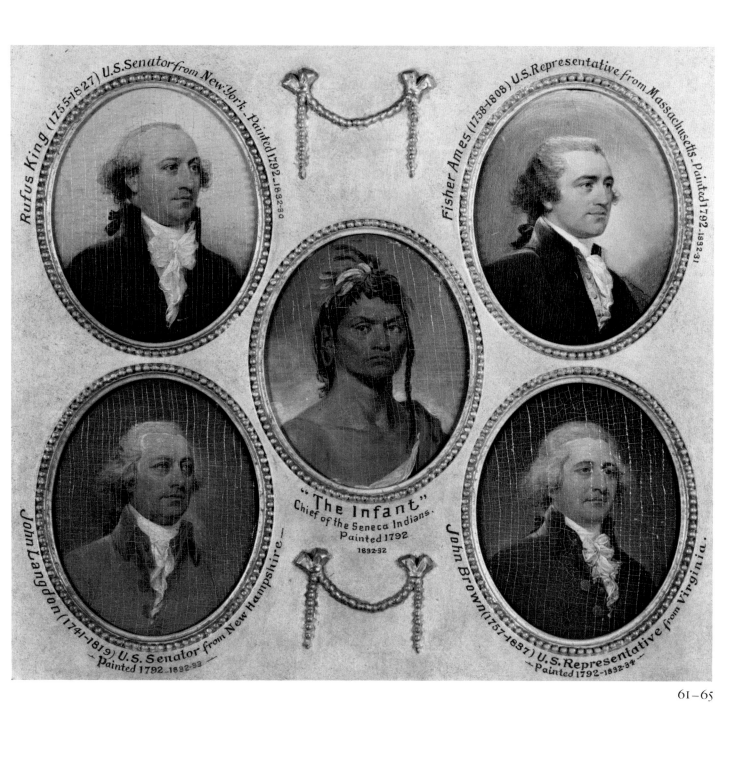

Rufus King (1755-1827) U.S. Senator from New York - Painted 1792 -1832-30

Fisher Ames (1758-1808) U.S. Representative from Massachusetts - Painted 1792 -1832-31

"The Infant"
Chief of the Seneca Indians.
Painted 1792
1832-32

John Langdon (1741-1819) U.S. Senator from New Hampshire — Painted 1792 -1832-33

John Brown (1757-1837) U.S. Representative from Virginia. U.S. Representative from Virginia. Painted 1792 -1832-34

61-65

66
Henry Laurens

1791

Oil on mahogany, 3⅝ x 3 (9.2 x 7.6)

Inscribed on paper attached to verso: *Henry Laurens Esq.*
| President of Congress in | 1799— confin'd in the | Tower
of London 1780 & 1. | & of the commissioners on the | part
of America at the | Treaty with G Britain 1783 | Painted by
J. Trumbull | in Charleston S° Carolina | 1791.

Yale University Art Gallery; Trumbull Collection

67
John Jay

1793

Oil on mahogany, 4 x 3¼ (10.2 x 8.3)

Inscribed on paper attached to verso: *John Jay, Esq. |*
Chief Justice of the Uni | ted States of America. & one | of
her ministers at the | conclusion of peace | with G Britain
in 1783 | Painted by J. Trumbull at Phil.ª 1793.

Yale University Art Gallery; Trumbull Collection

68
John Adams

1793

Oil on mahogany, 3⅞ x 3¼ (9.8 x 8.3)

Inscribed on paper attached to verso: *John Adams. | first*
Vice President of | the United States of America | & one of
her Ministers at | the conclusion of peace | with G Britain
in 1783. | Painted by J. Trumbull | at Philadelphia 1793.

Yale University Art Gallery; Trumbull Collection

69
George Hammond

1793

Oil on mahogany, 3⅞ x 3⅛ (9.8 x 7.9)

Inscribed on paper attached to verso: *George Hammond*
Esq. | first Minister Plenip. | of G. Britain to America | &
Sec.ʳʸ to the commission | for concluding Peace | between the
two countries | in 1783 | Painted in Phil.ª | by J. Trumbull
1793.

Yale University Art Gallery; Trumbull Collection

70
William Temple Franklin

1790

Oil on mahogany, 3⅝ x 3⅛ (9.2 x 7.9)

Inscribed on paper attached to verso: *Wᵐ Temple Franlin*
[sic], | Grandson of Doct.ʳ Franklin | & Se[cy] of the
American | commissioners at the treaty | with G Britain
1783. | Painted in Phil.ª | 1790 by J. Trumbull.

Yale University Art Gallery; Trumbull Collection

The five miniatures in this tablet were done in preparation
for a painting (never executed) commemorating *The
Treaty of Peace* (see *Fig. 63*). Shortly after publicly an-
nouncing his plans for the subject in 1790, Trumbull began
to take portraits of the prominent figures involved in the
negotiations.

Henry Laurens (1724–1792), a leading merchant and
planter from Charleston, South Carolina, became active
in provincial politics as hostilities with the British arose
during the 1760s. After the outbreak of war, he was elected
to Congress, and later served as an unofficial minister to
England.

One of the most active statesmen of his age, John Jay
(1756–1843) served as a member of Congress, delegate to
the Constitutional Convention, minister to Spain, and
governor of New York. The year after this portrait was
painted, Jay asked Trumbull to serve as his secretary dur-
ing negotiations for the Jay Treaty (see p. 10). Trumbull's
miniature of Jay may also have been done in preparation
for the unexecuted *Inauguration of the President.*

Trumbull's first portrait of John Adams (1735–1826)
was painted directly into the unfinished *Declaration of
Independence* (see Cat. 25). When the artist began to pre-
pare for *The Treaty of Peace*, he may have found it necessary
to take a likeness of Adams in the formal attire of an
American minister. In contrast to Adams' portrait in the
Declaration, where the hair is natural, in this miniature
Adams wears a wig (see also Cat. 44).

George Hammond (1763–1853) began a distinguished
diplomatic career as the secretary to the British delegation
at the Treaty of Peace. Trumbull painted Hammond's
likeness while the latter was in America, serving as minis-
ter to the United States (1791–95).

William Temple Franklin (c.1760–1823), the illegiti-
mate child of Benjamin Franklin's son, William Franklin,
was adopted by his grandfather and later served as his
secretary in Paris.

Fig. 63. Study for *The Treaty of Peace*, c.1790. Philadelphia, The Historical
Society of Pennsylvania.

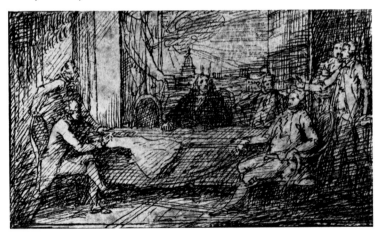

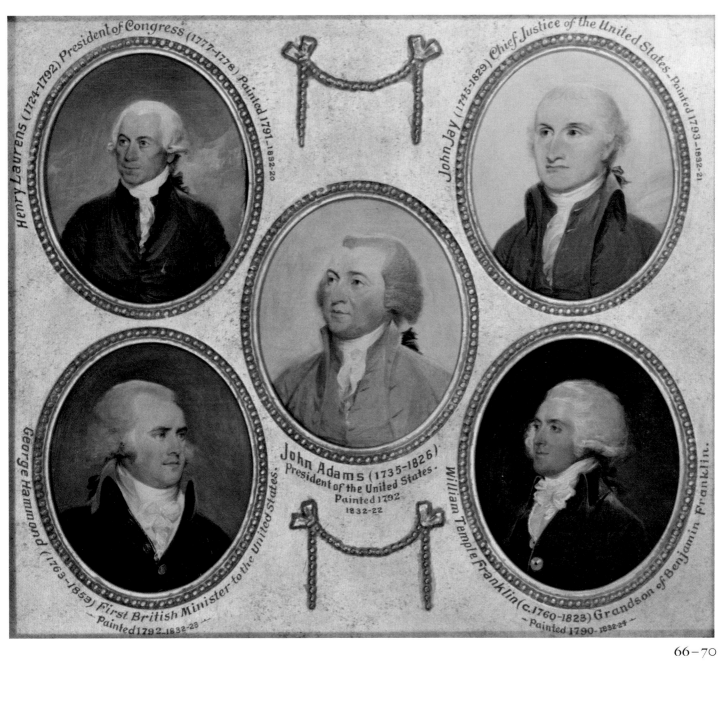

Henry Laurens (1724–1792) President of Congress (1777–1778) Painted 1791 · 1832-20

John Jay (1745–1829) Chief Justice of the United States · Painted 1793 · 1832-21

George Hammond (1763–1853) First British Minister to the United States · Painted 1792 · 1832-23

John Adams (1735–1826) President of the United States · Painted 1792 · 1832-22

William Temple Franklin (c.1760–1823) Grandson of Benjamin Franklin · Painted 1790 · 1832-24

66–70

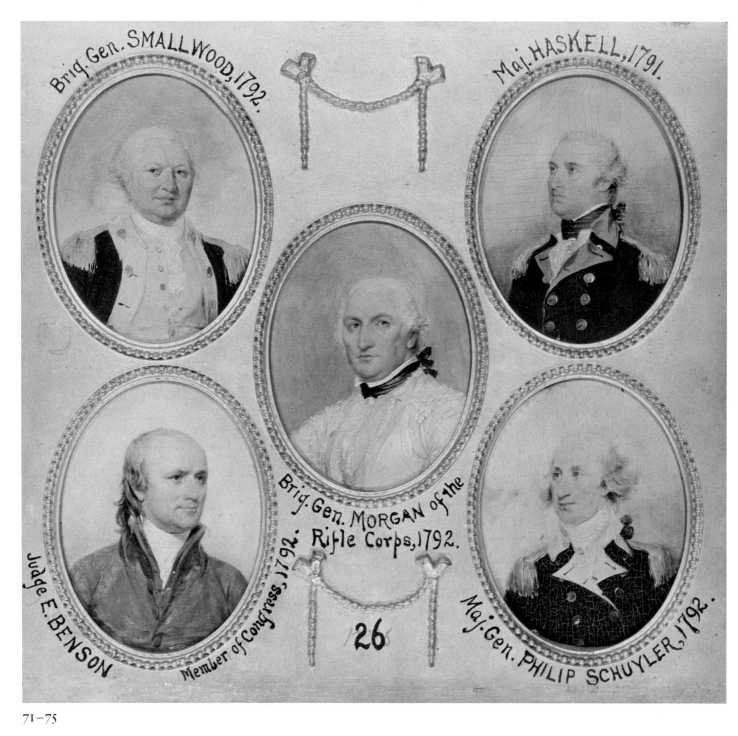

71–75

71
William Smallwood

1792

Oil on mahogany, 3⅞ x 3 (9.8 x 7.6)
Inscribed on paper attached to verso: *Brig.! Gen!*
Smallwood | of the American Army | present at the
resignati- | = on of Gen! Washington | Painted at Phil.? |
1792. by J. Trumbull | from an original by | M.? C. W.
Peale.
Yale University Art Gallery; Trumbull Collection

72
Elnathan Haskell

1791

Oil on mahogany, 4 x 3 (10.2 x 7.6)
Inscribed on paper attached to verso: *Major Haskell | of*
the American Army | present at the capture | of Gen!
Burgoyne | Painted by J. Trumbull | at Charleston S.?
Carolina | 1791
Yale University Art Gallery; Trumbull Collection

73
Daniel Morgan

1792

Oil on mahogany, 3¾ x 2¾ (9.5 x 7)
Inscribed on paper attached to verso: *Brig.!r Gen! Morgan.*
| of the American Riflemen | distinguish'd at the Cow
Pens. | & present at the capture | of Gen! Burgoyne. |
Painted at Phil.? | 1792. by J. Trumbull | from an original
by M.? | C W. Peale
Yale University Art Gallery; Trumbull Collection

74
Egbert Benson

1792

Oil on mahogany, 3¾ x 3⅛ (9.5 x 7.9)
Inscribed on paper attached to verso: *Egbert Benson Esq.! |*
Representative in the | Congress of the United | States of
America from | the State of New York | & present at the
inaugu- | = ration of the first | President. | Painted by
J. Trumbull | at Phil.? 1792.
Yale University Art Gallery; Trumbull Collection

75
Philip John Schuyler

1792

Oil on mahogany, 3¾ x 3⅛ (9.5 x 7.9)
Inscribed on paper attached to verso: *Philip Schuyler Esq.!*
| Maj.! Gen! in the Ameri- | -can service:— sometime
commanding in the No. | department. & present | at the
capture of Gen! | Burgoyne. | Painted by J. Trumbull | at
Phil.? 1792.
Yale University Art Gallery; Trumbull Collection

William Smallwood (1732–1792) was a delegate in the
Maryland Assembly before he commanded the highly
regarded Maryland troops in the Revolutionary War.
After the war, he served four terms as governor of Mary-
land. In *The Resignation of General Washington* (Cat. 31),
Smallwood is the third figure to the right of Washington.
The Peale portrait to which Trumbull refers in his inscrip-
tion, now at Independence National Historical Park,
Philadelphia, was painted c.1781–82.

Elnathan Haskell (1755–1825) was a first lieutenant and
adjutant in the Fourteenth Massachusetts Regiment. He
later served as General Howe's aide-de-camp. Haskell is
the seventh figure from the right in *The Surrender of
General Burgoyne at Saratoga* (Cat. 30).

Daniel Morgan (1736–1802) was born in New Jersey
and moved to Virginia early in 1754. He served as an
officer in the Continental army, and later, as commander
of the Virginia militia, aided in suppressing the Whiskey
Rebellion. Between 1797 and 1799, Morgan served as a
member of the House of Representatives from Virginia.
In *The Surrender of General Burgoyne at Saratoga*, Morgan
is the figure in white to the right of center. Although
Trumbull's inscription says that he painted this miniature
in 1792 "from an original by M.? C. W. Peale," the only
known Peale portrait of Morgan dates from c.1794, and
does not resemble Trumbull's miniature.[1] Perhaps Trum-
bull knew an earlier, unlocated portrait of Morgan by
Peale.

A lawyer from New York, Egbert Benson (1746–1833)
actively promoted the Revolutionary cause and the for-
mation of the Union. He represented New York in the
first two Congresses, and was an influential justice in the
New York Supreme Court. Benson later became the first
president of the New-York Historical Society. This mini-
ature was a study for the proposed *Inauguration of the
President.*

Philip John Schuyler (1733–1804) first served as a cap-
tain and then major in the French and Indian War. In the
Continental army, he was chosen as one of four major
generals. Trumbull first met Schuyler in Albany while
traveling to Ticonderoga with General Gates in 1776.
Trumbull painted two miniatures of Schuyler in Philadel-
phia in 1792; the other is at the New-York Historical
Society. Schuyler is the third figure from the right in the
Surrender of General Burgoyne.

1 See Charles Coleman Sellers, *Portraits and Miniatures by Charles
Willson Peale*, Philadelphia, 1952, p. 146.

76
Thomas Mifflin

1790

Oil on mahogany, 3⅝ x 3 (9.2 x 7.6)
Inscribed on paper attached to verso: *Thomas Mifflin | President of Congress | at the resignation of | Gen. Washington in 1783.— Governor | of Pennsylvania. | Painted at Phil*ª | *1790 by J. Trumbull*
Yale University Art Gallery; Trumbull Collection

77
Samuel Livermore

1792

Oil on mahogany, 3¾ x 3⅛ (9.5 x 7.9)
Yale University Art Gallery; Trumbull Collection

78
Laurence Manning

1791

Oil on mahogany, 4 x 3 (10.2 x 7.6)
Inscribed on paper attached to verso: *Captain Manning | of Lee's Legion in the | American Service. | distinguished by his | gallantry at the Battle | of Eutaw Springs under | Gen! Greene. | Painted at Charleston | So. Carolina 1791. | by J. Trumbull*
Yale University Art Gallery; Trumbull Collection

79
Richard Butler

1790

Oil on mahogany, 3¾ x 2⅞ (9.5 x 7.3)
Inscribed on paper attached to verso: *Richard Butler. Esq*! *| Lieu*! *Col*ª *of a Rifle Corps in | War of the American Revolu | = tion:— present at the capture | of Gen*! *Burgoyne. | afterwards a Maj*! *Gen*ˡ *& killed in the Battle of the | 4*.*ᵗʰ Nov. 1792 near the Miami | Villages.— | Painted by J. Trumbull | at Phil*ª *1790.*
Yale University Art Gallery; Trumbull Collection

80
Arthur Lee

1790

Oil on mahogany, 3⅞ x 3⅛ (9.8 x 7.9)
Inscribed on paper attached to verso: *Arthur Lee Esq*! *of | Alexandria Virginia. | One of the Commissioners of | the United States of America | at their first Treaty with | France. | Painted at New York in | 1790— by J. Trumbull*
Yale University Art Gallery; Trumbull Collection

Thomas Mifflin (1744–1800), one of the leading men of colonial Pennsylvania, was later to become a governor of the state and a member of the legislature. During the Revolutionary War, he served with Trumbull as an aide-de-camp to General Washington, although Mifflin's involvement with the faction that sought to replace Washington with Horatio Gates undoubtedly created cool relations with the artist. Mifflin was serving as the president of Congress at the time when Washington resigned his commission as commander-in-chief. Trumbull probably used this miniature for his two depictions of Mifflin; he appears mounted on a white horse at the far left of *The Death of General Mercer at the Battle of Princeton* (Cat. 14); and is seated in the president's chair at the left in *The Resignation of General Washington* (Cat. 31).

Samuel Livermore (1732–1803) was elected to Congress from New Hampshire in 1789, and was in that office when Trumbull painted his portrait, possibly in preparation for the never-executed *Inauguration of the President*. The Yale miniature is a replica of the one taken from life (The Currier Gallery of Art).

Laurence Manning (1756–1804) settled in South Carolina after the war, and became an adjutant-general in the state militia. Trumbull probably took this miniature for his proposed history painting, *The Battle of Eutaw Springs*.[1]

Richard Butler (1743–1791) began his military career as an Indian agent in western Pennsylvania. He joined the Continental army after the outbreak of war in 1775, participating in the battles of Saratoga and Yorktown. He later became a government commissioner for negotiations with a number of eastern tribes, including the Iroquois, Chippewa, Ottawa, and Shawnee. During a campaign against hostile tribes in the Ohio country, Butler was mortally wounded, only one year after Trumbull painted this portrait.

With the growth of resistance to British policies, Arthur Lee (1740–1792) became involved with politics, publishing a series of letters in English newspapers opposing Parliamentary actions toward America. These letters earned him a widespread reputation as a patriot and, in 1775, he was asked by the Continental Congress to become a confidential correspondent in London. He was active during the conflict as an unofficial envoy for the American cause, negotiating several treaties with foreign powers. Trumbull portrayed Lee among the members of Congress in *The Resignation of General Washington* (Cat. 31), where he is seated seventh to the left of Washington. This miniature may also have been intended for the unexecuted *Treaty of Peace*.

1 Morgan 1926, p. 71.

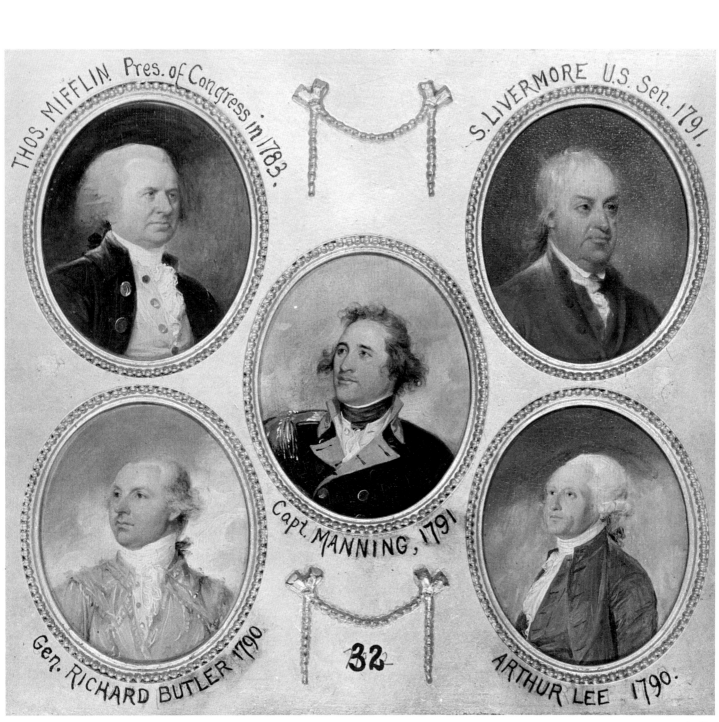

76–80

81
William Loughton Smith

1792

Oil on mahogany, 3¾ x 3 (9.5 x 7.6)
Inscribed on paper attached to verso: *William Smith Esq.* | *Representative in the* | *Congress of the United* | *States of America from* | *the State of South Carolina* | *& present at the inaugu* | *ration of the first President.* | *Painted by J. Trumbull* | *Phil.ª 1792*
Yale University Art Gallery; Gift of Herbert L. Pratt

82
Rufus Putnam

1790

Oil on mahogany, 3⅞ x 3¼ (9.8 x 8.3)
Inscribed on paper attached to verso: *Rufus Putnam Esq.* | *Colonel of a Regiment in* | *the Service of the United* | *States of America. during* | *the War of their Independence* | *& present at the capture of* | *Gen. Burgoyne.* | *Painted at New York* | *1790. by J. Trumbull*
Yale University Art Gallery; Trumbull Collection

83
Jacob Read

1793

Oil on mahogany, 3⅝ x 3¹/₁₆ (9.2 x 7.8)
Inscribed on paper attached to verso: *Jacob Reed* [sic], *Esq.* | *Member of Congress from* | *S.º Carolina. in 1783. and* | *present at the resignation* | *of Gen! Washington at* | *the close of the War of* | *the Revolution in America* | *Painted at Charleston* | *S.º Carolina. 1793* | *by J. Trumbull*
Yale University Art Gallery; Trumbull Collection

84
Ralph Izard

1793

Oil on mahogany, 3¾ x 2⅞ (9.5 x 7.3)
Inscribed on paper attached to verso: *Ralph Izard, Esq.* | *Senator in the Congress of* | *the United States of America* | *from the State of S.º Carolina* | *& present at the inaugu-* | *-ration of the first President* | *Painted at Phil.ª* | *179[—]* | *by J. Trumbull*
Yale University Art Gallery; Trumbull Collection

85
John Faucheraud Grimké

1791

Oil on mahogany, 3⅝ x 3 (9.2 x 7.6)
Inscribed on paper attached to verso: *Col.º Grimké — of* | *the American Artillery* | *at the seige of Savannah* | *Painted in Charleston* | *S.º Carolina 1791* | *by J Trumbull*
Yale University Art Gallery; Trumbull Collection

William Loughton Smith (c.1758–1812), a lawyer and planter from South Carolina, served five terms in Congress and acted as Charleston's agent in 1792 when that city commissioned Trumbull to paint a full-length portrait of Washington (Cat. 42). Although he was personally pleased with the artist's effort, "he thought the city would be better satisfied with a more matter-of-fact likeness,"[1] leading Trumbull to execute another portrait. Trumbull painted this miniature of Smith for the proposed painting of *The Inauguration of the President*.

Rufus Putnam (1783–1824) engineered the construction of many fortifications during the Revolutionary War, notably at Dorchester Heights during the winter of 1775–76 to force the British evacuation of Boston. After the conclusion of the war, Putnam superintended the Ohio Company, and in 1790, Washington appointed him judge of the Northwest Territory. Putnam is the third figure from the left in the rightmost group in *The Surrender of General Burgoyne at Saratoga* (Cat. 30).

During the Revolutionary War, Jacob Read (1752–1816) served as a captain in the Charleston, South Carolina, militia. He was a member of the Continental Congress between 1783 and 1786. In 1787, he was elected speaker of the South Carolina House of Representatives, serving in that body until 1794. Read stands in the left doorway in *The Resignation of General Washington* (Cat. 31).

Born into a wealthy South Carolina planter family, Ralph Izard (1742–1804) opened negotiations with the Duchy of Tuscany to secure funds for the United States during the Revolutionary War. During the sessions of the Third Congress, Izard was president *pro tempore* of the Senate. He was a close friend of Washington, and Trumbull painted this miniature for his proposed *Inauguration of the President*.

John Faucheraud Grimké (1752–1819) was born in South Carolina of French and German parents. Before he was made a prisoner of the British at the surrender of Charleston in 1780, he had risen to the rank of deputy adjutant-general for South Carolina and Georgia. After the war, Grimké became a noted jurist, serving as judge of the South Carolina Superior Court and later as its senior associate. This miniature may have been intended as a study for the unexecuted *Siege of Savannah*.

1 Trumbull 1841, p. 167.

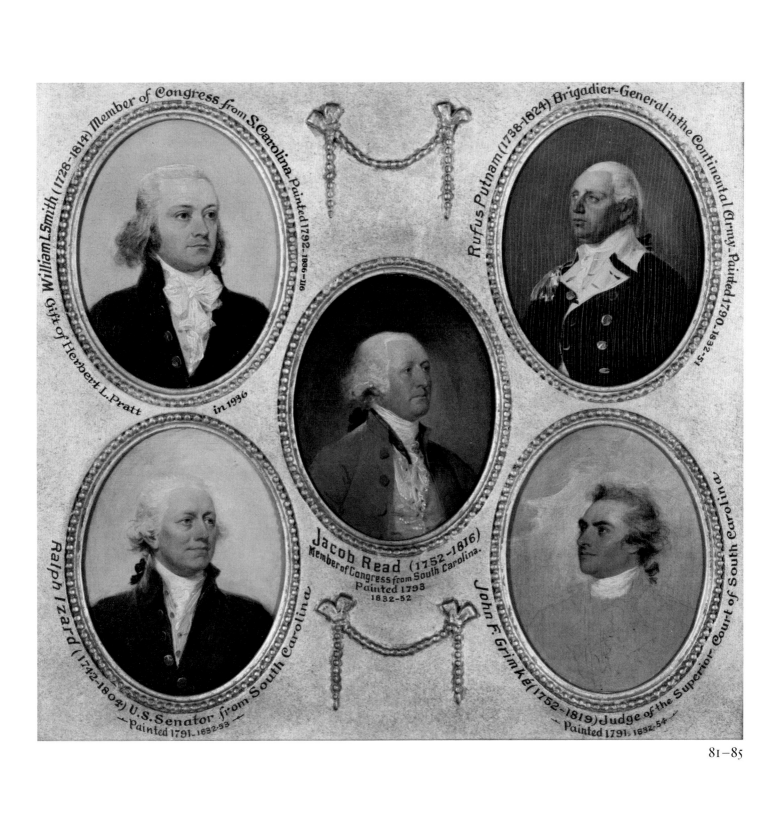

William L.Smith (1728–1814) Member of Congress from S.Carolina. Painted 1792. 1836–116 Gift of Herbert L.Pratt in 1936

Rufus Putnam (1738–1824) Brigadier-General in the Continental Army. Painted 1790. 1832–51

Jacob Read (1752–1816) Member of Congress from South Carolina. Painted 1793 1832–52

Ralph Izard (1742–1804) U.S. Senator from South Carolina. Painted 1791. 1832–53

John F. Grimké (1752–1819) Judge of the Superior Court of South Carolina. Painted 1791. 1832–54

81–85

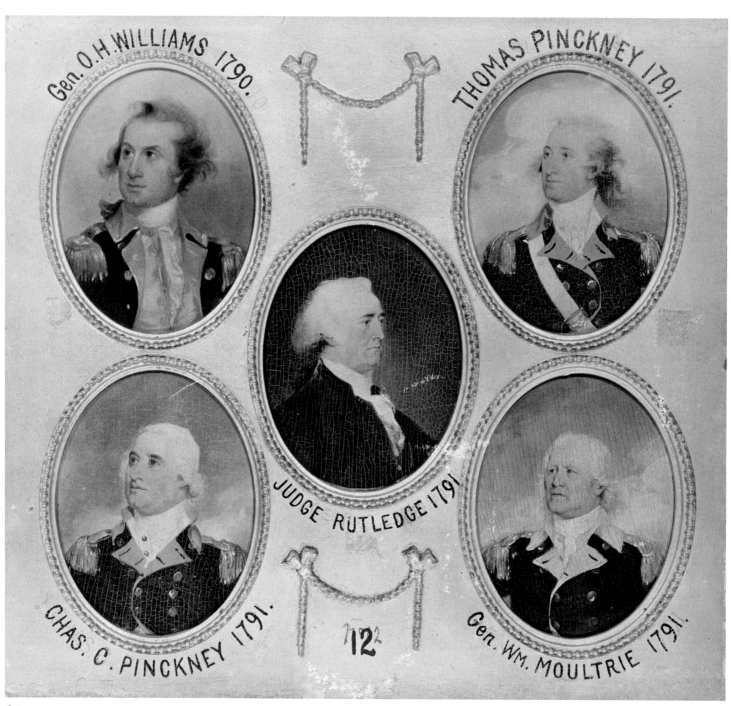

86–90

86
Otho Holland Williams
(*George W. Flagg after John Trumbull*)

1842
Oil on mahogany, 3⅞ x 3 (9.8 x 7.6)
Yale University Art Gallery; Trumbull Collection

87
Thomas Pinckney

1791
Oil on mahogany, 3¾ x 3⅛ (9.5 x 7.9)
Inscribed on paper attached to verso: *Thomas Pinckney |
[——] | [——] at the attack | of Savannah Aide- |
de-Camp to G[——] | the Battle of [——] | Painted at
Charleston | S.º Carolina 1791 | by J Trumbull*
Yale University Art Gallery; Trumbull Collection

88
John Rutledge

1791
Oil on mahogany, 3¾ x 3⅛ (9.5 x 7.9)
Inscribed on paper attached to verso: *John Rutledge Esq.ʳ |
Governor of the State | of S.º Carolina during | the
American Revolution | Painted at Charleston |
S.º Carolina 1791 | by J. Trumbull.*
Yale University Art Gallery; Trumbull Collection

89
Charles Cotesworth Pinckney

1791
Oil on mahogany, 3¾ x 3 (9.5 x 7.6)
Inscribed on paper attached to verso: *Charles Cotesworth
Pinckney | Colonel of a Regiment [——] | [——] | at the
Attack of | Savannah [——] | Painted by J Trumbull |
Charleston [——] Carolina | [——]*
Yale University Art Gallery; Trumbull Collection

90
William Moultrie

1791
Oil on mahogany panel, 4 x 3 (10.2 x 7.6)
Inscribed on paper attached to verso: *William Moultrie
Esq.ʳ | commanded at Sullivan's | Island— Charleston—
against | the attack of S.ʳ Peter Parker. | 1776—
afterwards a | Brig.ʳ Gen.ˡ during the War. | Painted at
Charleston S.º Carolina. 1791. | by J. Trumbull.*
Yale University Art Gallery; Trumbull Collection

Otho Holland Williams (1749–1794) was adjutant-general
under General Nathanael Greene in the Revolutionary
War. In *The Resignation of General Washington* (Cat. 31),
Williams is the fourth figure to the right of Washington.
The original of this miniature was painted by Trumbull
in Philadelphia in 1790; however, he later removed the
painting from its tablet and sold it to Robert Gilmor of
Baltimore. Benjamin Silliman, first curator of the Trum-
bull Gallery, borrowed the miniature from Gilmor and,
with Trumbull's approval, had it copied by George Flagg
to complete the tablet.

The inscriptions on the remaining four miniatures
suggest that, in addition to the fourteen history paintings
Trumbull included in the lists he announced in 1790 (see
pp. 37–38), he considered painting at least two other Rev-
olutionary War scenes, *The Siege of Savannah* (Thomas
Pinckney, Charles C. Pinckney) and *The Attack on Charles-
ton* (Rutledge, Moultrie), neither of which was ever
executed.

Thomas Pinckney (1750–1828), the younger brother of
Charles Cotesworth Pinckney, was special aide to Count
d'Estaing at Savannah. During the siege at Charleston in
1779, he was sent to speed the arrival of relief troops, and
escaped capture when that city fell. The Yale miniature is
one of three that Trumbull painted of him in South Car-
olina in 1791.

John Rutledge (1739–1800) was elected governor of
South Carolina in 1779 on the eve of the British invasion
of Charleston. Despite his efforts to gather militia, the
city surrendered the following year. In 1781, Rutledge was
responsible for raising an army and supplies, and for
restoring civil government. He sat in the state House of
Representatives from 1784 to 1790 and was elected chief
justice of South Carolina in 1791.

Charles Cotesworth Pinckney (1746–1825) served as
aide-de-camp to Washington in the Revolutionary War,
before being commissioned brigadier general in 1783. Al-
though later appointed minister to France, that country
refused to recognize him. A candidate for vice-president
in 1800 and for president in the next two elections, Pinck-
ney served as president general of the Society of the
Cincinnati, an organization formed in 1783 by the officers
of the American Revolutionary army.

As brigadier general, William Moultrie (1730–1805)
commanded the 1780 defense of Charleston during the
Revolutionary War. When the city fell, he was captured
and held for almost two years. He served in the South
Carolina House of Representatives, and was later elected
lieutenant governor and then governor of the state.

91

Jonathan Trumbull, Jr.

1793

Oil on mahogany, 4 x 3⅛ (10.2 x 7.9)

Inscribed on paper attached to verso: *Jonathan Trumbull Esq.! | Representative in the | Congress of the United | States of America from | the State of Connecticut | & present at the inau = | =guration of the first | President. | Painted by his Brother | J. Trumbull. at | Phil.? 1793*

Yale University Art Gallery; Trumbull Collection

92

Jonathan Trumbull, Sr.

1793

Oil on mahogany, 4 x 3¼ (10.2 x 8.3)

Inscribed on paper attached to verso: *Jonathan Trumbull | Governor of the State of | Connecticut. during the | Revolution of America. | by the choice of the People | died 1785. Aged 75. | Painted by J. Trumbull | his youngest Son at Lebanon | in Connecticut 1793.—from | a picture done from the life | by him in 1783.*

Yale University Art Gallery; Trumbull Collection

93

"Good Peter,"
Chief of the Oneida Indians

1792

Oil on mahogany, 4⅛ x 3¼ (10.5 x 8.3)

Inscribed on paper attached to verso: *Good Peter | a Chief of the Six Nations | and Great Orator. as well | as Warrior. aged 75. | Painted by J. Trumbull | in Philadelphia. 1792.*

Yale University Art Gallery; Trumbull Collection

94

Lemuel Hopkins

1793

Oil on mahogany, 3⅞ x 3¼ (9.8 x 8.3)

Inscribed on paper attached to verso: *Lemuel Hopkins | M.D.— | of Hartford in Connect. | AEt: 44.—principal | Author of the Anarchiad. | Painted by | J. Trumbull | Dec.! 1793*

Yale University Art Gallery; Trumbull Collection

95

John Trumbull

1794

Oil on mahogany, 3⅞ x 3¼ (9.8 x 8.3)

Inscribed on paper attached to verso: *John Trumbull | Author of M.!Fingal | [——] | Painted by | J. Trumbull, son | of Gov.! Trumbull | Jan.! 1794.*

Yale University Art Gallery; Trumbull Collection

Jonathan Trumbull, Jr. (1740–1809), brother of the artist, acted as paymaster of the Continental army's Northern Division and served as General Washington's military secretary from 1781 to the end of the war. After serving in the Connecticut legislature, the first three congresses under the new constitution, and the Senate, Trumbull became lieutenant governor of Connecticut, and then, upon the death of Governor Oliver Wolcott, chief executive of the state. Trumbull painted the portrait of his brother directly into *The Surrender of Lord Cornwallis at Yorktown* (Cat. 27) in 1786 or 1787 while in London— he is the fifth figure from the left of the rightmost group. The miniature, showing Jonathan in civilian dress, was painted five or six years later during his second term as a representative in Congress.

Jonathan Trumbull, Sr. (1710–1785), the artist's father, began his career with the intention of entering the ministry, but established himself in commerce instead. In 1766, he suffered a severe financial reversal. He had pursued politics since 1733, and became governor of Connecticut in 1769. During the Revolutionary War, he supervised the distribution of supplies to the American troops, making an invaluable contribution to the war effort. The 1783 portrait to which Trumbull refers in his inscription is unlocated.

Morgan has suggested that Trumbull painted the miniature of "Good Peter" as a study for the proposed *Murder of Jane McCrea*.[1]

John Trumbull (1751–1831), a second cousin of the artist, was tutored by his mother as a child, passing his entrance examination to Yale College at the age of seven. He wrote poetry throughout college and published a satire on collegiate instruction after he graduated. He also studied and practiced law. His most popular poetic work, *M'Fingal*, dealt with the ineptness of the British during the Revolutionary War (see also Cat. 45, n. 4).

For Lemuel Hopkins, see Cat. 45.

1 Morgan 1926, p. 74.

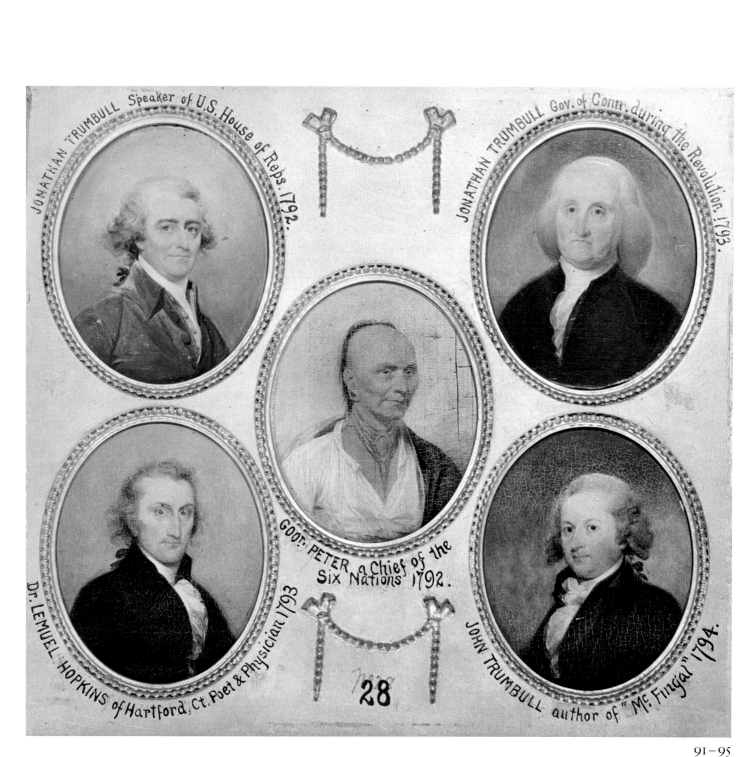

JONATHAN TRUMBULL Speaker of U.S. House of Reps. 1792.

JONATHAN TRUMBULL Gov. of Conn. during the Revolution. 1793.

Dr. LEMUEL HOPKINS of Hartford, Ct. Poet & Physician 1793.

GODT. PETER a Chief of the Six Nations 1792.

JOHN TRUMBULL author of "Mc Fingal" 1794.

28

91–95

96

Harriet Wadsworth

1793

Oil on mahogany, 3⅞ x 2⅞ (9.8 x 7.3)
Inscribed on paper attached to verso: *Miss H. Wadsworth | died at Bermuda | April 1793. | painted from memory | by J. Trumbull | July of the same year.*
Yale University Art Gallery; Trumbull Collection

97

Faith Trumbull

1791

Oil on mahogany, 3⅝ x 3 (9.2 x 7.6)
Inscribed on paper attached to verso: *Faith Trumbull | eldest daughter of | Jonᵃ Trumbull Esqʳ | of Lebanon | Painted at Hartford | 1791. By her Uncle | John Trumbull*
Yale University Art Gallery; Trumbull Collection

98

Mrs. Jonathan Trumbull, Sr.

1793

Oil on mahogany, 3⅞ x 2⅞ (9.8 x 7.3)
Inscribed on paper attached to verso: *Faith Trumbull | wife of Govʳ Trumbull. | died at Lebanon | May 1780. aged 62. | Painted at Lebanon | by her youngest Son | J. Trumbull 1793. | copied from one done by him | from life in 1779.*
Yale University Art Gallery; Trumbull Collection

99

Catherine Wadsworth

1792

Oil on mahogany, 3⅞ x 3 (9.8 x 7.6)
Inscribed on paper attached to verso: *Catharine Wadsworth | daughter of | Jere: Wadsworth, Esqʳ | of Hartford. Connecticut | Painted at Philᵃ | 1792 by J. Trumbull*
Yale University Art Gallery; Trumbull Collection

100

Julia Seymour

1792

Oil on mahogany, 3⅞ x 3 (9.8 x 7.6)
Inscribed on paper attached to verso: *Julia Seymour | daughter of | Thoˢ Seymour Esqʳ of | Hartford. Connecticut | Painted at Lebanon | by J. Trumbull | 1792.*
Yale University Art Gallery; Trumbull Collection

Four of the miniatures in this tablet are of women in Trumbull's family. Harriet Wadsworth (1769–1793), the daughter of Jeremiah Wadsworth (see Cat. 38), and Trumbull were cousins and childhood friends. In 1790, he proposed marriage to her, but she had another suitor and could not decide between the two. Trumbull may have based the second woman from the left in the balcony of *The Resignation of General Washington* (Cat. 31) on this miniature portrait.

Trumbull first painted his niece Faith (1769–1846) as part of a group portrait with her parents in 1777 (Cat. 34). The artist was very fond of her. As early as 1789, he declared his wish to bequeath half of his estate to her, and the rest to be divided equally among his remaining nieces and nephews.[1] In 1794, Faith married Daniel Wadsworth, a Hartford collector who would become one of Trumbull's most important patrons.

Faith Robinson Trumbull (1718–1780), the artist's mother, was born in Duxbury, Massachusetts, daughter of the Reverend John Robinson. She married Jonathan Trumbull in Lebanon, Connecticut, in 1735; they had six children over the next twenty-one years, John Trumbull being the youngest. The miniature's prototype, referred to in the inscription, is unlocated.

Catherine Wadsworth (1774–1841) was the wife of General Nathaniel Terry, a prominent Hartford lawyer. When Trumbull wrote his *Autobiography*, Mrs. Terry owned the double-portrait Trumbull had painted in England of her father and brother Daniel (Cat. 38).

Trumbull painted Julia Seymour (1769–1843) two years before her marriage to Captain John Chenevard in 1794. She was the younger sister of Captain Thomas Youngs Seymour (Cat. 49).

1 JT to Benjamin West, October 8, 1789, YUL-JT.

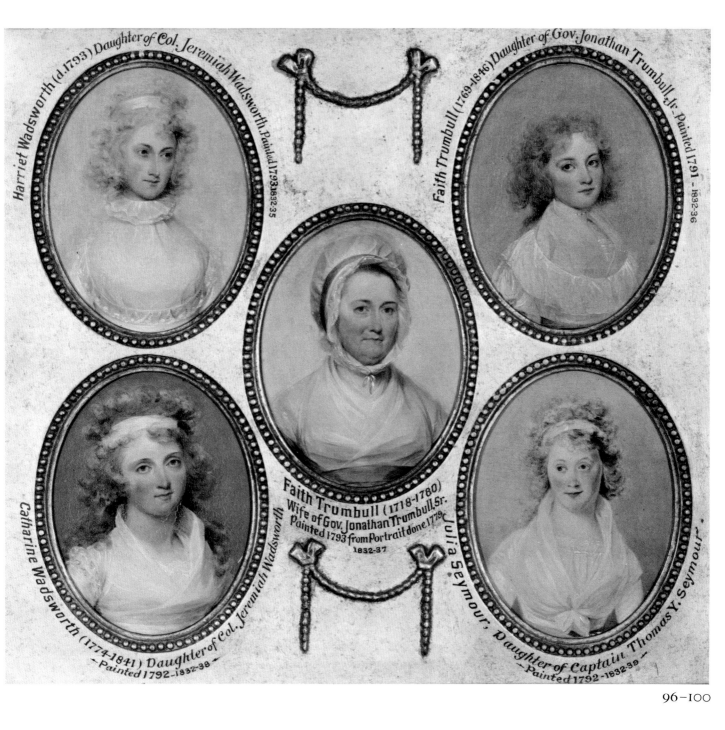

Harriet Wadsworth (d.1793) Daughter of Col. Jeremiah Wadsworth. Painted 1793 1832-35

Faith Trumbull (1769-1846) Daughter of Gov. Jonathan Trumbull, Jr. Painted 1791 - 1832-36

Faith Trumbull (1718-1780) Wife of Gov. Jonathan Trumbull, Sr. Painted 1793 from Portrait done 1779. 1832-37

Catharine Wadsworth (1774-1841) Daughter of Col. Jeremiah Wadsworth - Painted 1792 - 1832-38

Julia Seymour, Daughter of Captain Thomas Y. Seymour. - Painted 1792 - 1832-39

96-100

Portrait Drawings

Trumbull is considered the most gifted draftsman of late eighteenth-century America.[1] While his fame justifiably rests on his history paintings, he would have been assured of a place in the history of American art on the basis of his small, realistic pencil portraits, and his vigorous chalk figure studies (see Cats. 125–31). Trumbull made most of the pencil portraits in preparation for his history series, often adding precise notes on the verso of the sheet about the sitter's coloring or costume. Executed on heavy laid paper with a finely pointed, hard pencil that caused little shadow, the outlines are rapid, essential and dynamic. Instead of creating flat Neoclassical shapes, he employs a broken contour line that suggests light and atmosphere. Delicate cross-hatching is used for subtle shading, with slightly darker lines for emphasis.

In these studies, Trumbull uses drawings in a way different from that of his predecessors, most notably Copley. Whereas Copley's portrait studies for his history paintings, executed in chalk, are gently modeled, almost painterly in effect, and concerned more with pose than with individual features, Trumbull's portraits, executed in the sparer medium of pencil, are carefully linear, and capture a sense of personality.

1 See Theodore E. Stebbins, Jr., *American Master Drawings and Watercolors*, New York, 1976, pp. 36–42.

Captain Blodget

c.1786
Pencil on card, 4½ x 2⅞ (11.4 x 7.3)
Inscribed, verso: *Capt L Blodget | Princeton | [——] 17.*
Yale University Art Gallery; Gift of Mrs. Winchester
 Bennett

Although Trumbull's inscription on the verso of this drawing reads "L. Blodget," the portrait is probably of Captain Samuel Blodget, Jr. (1757–1814) of the New Hampshire militia, which fought at the Battle of Princeton.[1] Originally, the artist may have intended to represent Blodget in *The Death of General Mercer at the Battle of Princeton* (see Cat. 14), but none of the surviving studies shows a figure in his pose. It is possible that Trumbull took Blodget's portrait in London when planning the painting and decided later not to include it. Sizer dated the drawing to 1786 on the basis of a small portrait of Blodget "in a Rifle dress" that Trumbull painted that year at London,[2] after Blodget had retired from the army and became a merchant in the East India trade.

 1 *DAB*, II, pp. 380–81.
 2 Sizer 1967, p. 21; see also Trumbull, "Account of Paintings," II, no. 29.

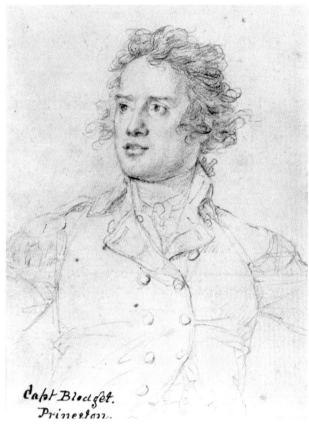

101

Major Winthrop Sargent

1790
Pencil on paper, 4⅝ x 2⅞ (11.7 x 7.3)
The National Portrait Gallery

During the War of Independence, Sargent (1753–1820) fought with Washington in the battles of Trenton and Princeton. After the war, Sargent was appointed surveyor in the new Northwest Territory in 1786, and negotiated the purchase and colonization of the Ohio Valley lands. In 1791, Arthur St. Clair, governor of the Northwest Territory, appointed Sargent adjutant-general in command of the territorial militia, and when Washington made St. Clair general-in-chief of the army, Sargent was named acting governor. His efficiency led to his appointment as governor of the Mississippi Territory in 1798. Sargent's administration created friction with certain factions, and President Jefferson refused to reappoint him in 1801.[1]

 1 *DAB*, XVI, pp. 368–69.

102

103

Hopothle Mico

1790

Pencil on paper, 4⅞ x 3⅞ (12.4 x 9.8)

Inscribed, verso: *Hopothle Mico or | the Talasee King |
 N York July 1790*

Fordham University Library; Charles Allen Munn
 Collection

The subject of this drawing is the Creek chief called "the
Good Child King," who negotiated a treaty between the
Creek Nation and the United States.[1] The military coat
and the silver gorget, customary gifts from the American
government to Indian allies, make it likely that the sitter
was part of the delegation which signed the treaty in the
summer of 1790. In his *Autobiography*, Trumbull noted
that he had been impressed by the dignity of the Indian
delegates, and was able to make sketches of some "by
stealth," since they were suspicious of his ability to trans-
form a two-dimensional surface into a three-dimensional
representation.[2] Trumbull's exceptional ability in his por-
trait drawings to capture a sense of personality is evident
in this study. Using short delicate strokes of varying de-
grees of darkness, and a minimum of shading, he succeeds
in conveying both the strength and the pathos of the
Creek chieftain.

1 Jaffe 1971, pp. 14–19.
2 Trumbull 1841, pp. 164–65.

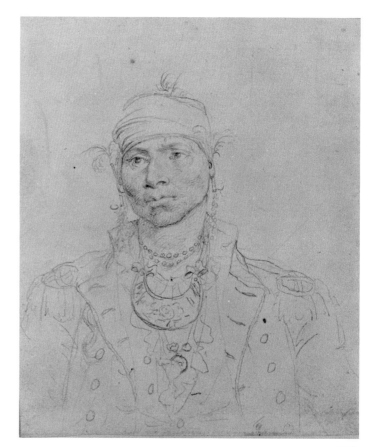

103

104
Major General Arthur St. Clair

1790

Pencil on paper, 4⅞ x 3⅞ (12.4 x 9.8)

Inscribed, verso: *Genl Arthur St Clair | N York August 1790*

The Metropolitan Museum of Art; Gift of Robert W. De Forest

St. Clair (1737–1818) married a niece of Governor James Bowdoin of Pennsylvania in 1760. With the money he received from Bowdoin's estate, St. Clair became the largest resident property owner in western Pennsylvania. He was appointed an agent of the colonial government before the Revolutionary War, and during the fighting served as brigadier general at the battles of Trenton and Princeton. St. Clair may be the black-hatted figure on horseback beneath the flag at the right in *Trenton* (Cat. 24).[1] As governor of the Northwest Territory, St. Clair was commanded to erect a chain of military posts to secure the area against the Indians, but because of poor planning and inexperience, the venture failed miserably. His attempts to postpone Ohio's achievement of statehood antagonized the local Jeffersonians, and Jefferson removed him from office in 1802. In 1812, he published a defense of his campaign against the Indians. He died penniless.[2]

1 Sizer 1967, fig. 165, identifies this figure in *Trenton* as Major John Sullivan, but the portrait seems to more closely resemble St. Clair.
2 *DAB*, XVI, pp. 293–95.

105
Harriet Wadsworth

1790 or 1791

Pencil on paper, 4½ x 3⅞ (11.4 x 9.8)

Wadsworth Atheneum

This likeness is identical to Trumbull's miniature of Harriet Wadsworth, which he executed in 1793 (Cat. 96), and may have been done in preparation for it. Since Trumbull's drawings of this type were done from life, the present study was probably made in 1791, the last year in which the artist saw Harriet.

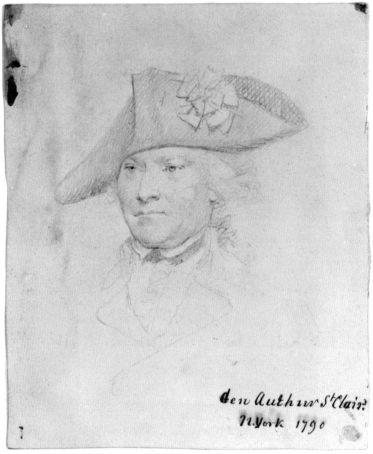

104

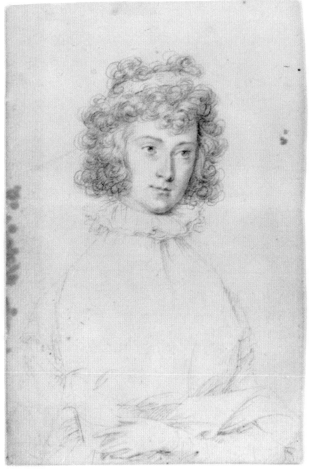

105

106

General Hugh Mercer

1791

Pencil on paper, 4^{15}/$_{16}$ x 3^{1}/$_{8}$ (12.5 x 7.9)

Inscribed, verso: *From his son Fredricksburg 1791 | Genl Mercer | Genl Mercer | from— Fredricksburg | April 26th 1791 | Skin ruddy— | Auburn hair and blue eyes | Aged 42 or 3*

The Metropolitan Museum of Art; Gift of Robert W. De Forest

Mercer (c.1725–1777) was killed in the Battle of Princeton, having been knocked down and bayonetted in the Americans' encounter with the British. Planning to feature the late general in the *Battle of Princeton* (Cat. 14), Trumbull traveled to Fredricksburg, Virginia, in 1791 to sketch Mercer's son Hugh. In the description on the verso, Trumbull mistakenly noted that the father was "aged 42 or 43." The general was born about 1725, and was fifty-two or fifty-three at the time of his death.[1]

1 See Theodore Sizer, "Sketches by Trumbull," *The Metropolitan Museum of Art Bulletin*, 6 (1948), p. 261.

107

Major Lithgow

1791

Pencil on card, 4^{5}/$_{8}$ x 2^{7}/$_{8}$ (11.7 x 7.3)

Inscribed, verso: *Majr Lithgow | Blue & White | Black Stock | Boston 10th July [——] '91.*

Yale University Art Gallery; Gift of Mrs. Winchester Bennett

William Lithgow (1750–1796) served as captain of the Massachusetts militia in 1776 and became major of the Massachusetts regiment in 1777. After being wounded at Saratoga in 1779, he resigned from the army. The words "Blue & White" written on the verso must refer to the intended colors of Lithgow's clothing in the painting, while the words "Black Stock" probably refer to a sort of wide neck scarf. The basic format of the drawing is almost exactly repeated in the portrait of Lithgow at the extreme left in *The Surrender of General Burgoyne at Saratoga* (Cat. 30). Although the chin has been raised somewhat and a large black cockaded hat has been added, the same three-quarter view is employed. But in terms of nuance and subtlety of expression, the drawing emerges as more successful than the painting, for which it was intended.

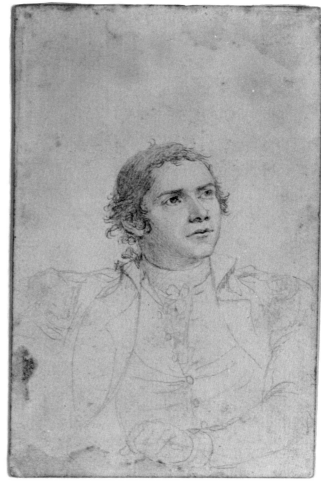

106

107

Rev. Enos Hitchcock

1791

Pencil on card, 2¹⁵⁄₁₆ x 4⅝ (7.5 x 11.7)

Inscribed: bottom, in later hand, *Rev.ᵈ W* [sic] *Hitchcock. | surrender of Burgoyne*; verso, *Rev.ᵈ W* [sic] *Hitchcock | at the surrender of | Burgoyne— | very light & florid complexion— Dark blue Eyes light flaxen hair— | Sept— 1791*

Yale University Art Gallery; Gift of Mrs. Winchester Bennett

From 1775 on, Hitchcock (1744–1803) served as chaplain of the Third Continental Infantry in the Revolutionary War. During this time, he was affiliated with the Second Church of Beverly, Massachusetts, having been ordained there in 1771. In 1783, Hitchcock became pastor of the Benevolent Congregational Church of Providence, and remained with that church until his death.[1] Trumbull made this drawing for later use in *The Surrender of General Burgoyne at Saratoga* (Cat. 30), where Hitchcock is the ninth man from the right. Using light cross-hatching and stumping to give texture to Hitchcock's fleshy cheeks, chin, and nose, Trumbull captures the individuality of the robust chaplain who served with General Horatio Gates at Saratoga.

1 *DAB*, IX, pp. 72–73.

108

Stephen Hopkins

1791
Pencil on paper, 5 x 3⅛ (12.7 x 7.9)
Inscribed: bottom, in later hand, *Jnº* [sic] *Hopkins | July 4
 1776*; verso, *Gov. Hopkins | Congress 1776-July 4th |
 Bright dark eye | Brown complexion | Grey Hair |
 Providence 3 Sept 1791 | from his Son Rufus Hopkins Esq.*
Fordham University Library; Charles Allen Munn
 Collection

Raised as a farmer, Hopkins (1707–1785) was elected pres-
ident of the Scituate, Rhode Island, town council in 1735.
After moving to Providence in 1742, he became a member
of the General Assembly and the Rhode Island superior
court, serving as its chief justice in 1751. He lost the elec-
tion for governor to William Green in 1754. Hopkins met
with success the following year, and was re-elected almost
every year thereafter until 1768. During this time, Hop-
kins became a leading supporter of the Revolutionary
cause in Rhode Island. He was active in the First and
Second Continental Congresses, and was a signer of the
Declaration.[1] He appears as the eighth seated man from
the left in *The Declaration of Independence* (Cat. 25).

1 *DAB*, IX, pp. 219–20.

109

110
Brigadier General Anthony Wayne

c.1791
Pencil on card, 4³/₁₆ x 2¹³/₁₆ (10.6 x 7.1)
Fordham University Library; Charles Allen Munn
 Collection

"Mad Anthony" Wayne (1745–1796), who acquired his
nickname from his impetuous acts of bravery, first met
Trumbull when they were both stationed at Ticonderoga
in 1776. Together they tested Trumbull's assertion that the
terrain surrounding the fort left the Americans vulnerable
to enemy attacks. Wayne went on to direct an important
American victory at Stony Point, New York, where he
took 1500 British prisoners; he was also instrumental in
foiling Benedict Arnold's plan to surrender West Point.[1]
Trumbull probably did this portrait at Philadelphia in
1791–92, when Wayne was in residence as a congressman
from Georgia. This sketch later served as the basis for
Wayne's portrait in *The Surrender of Lord Cornwallis at
Yorktown* (Cat. 27), in which he appears as the fifth figure
from the right in the front row of mounted American
officers.

1 *DAB*, XIX, pp. 563–64.

110

111
Faith Trumbull Wadsworth

c.1794
Pencil on card, 4½ x 2¾ (11.4 x 7)
Yale University Art Gallery; Gift of Mrs. George H.
 Gray

In this drawing, Trumbull shows his niece in a different
pose from that in the miniature of 1791 (Cat. 97); the
drawing may have been done at the time of her marriage
to Daniel Wadsworth in 1794.[1]

1 Sizer 1967, p. 72.

111

Late Portraits

112
Sarah Trumbull in a White Dress

c.1800
Oil on canvas, 23¾ x 20½ (60.3 x 52.1)
Collection of Mrs. Charles H. Higgins

This was probably Trumbull's first portrait of his wife, painted soon after their marriage on October 1, 1800.[1] It may have been the portrait Trumbull sent to America in 1803 as preparation for the couple's imminent arrival; Trumbull wrote from England to his brother-in-law William Williams, "I shall . . . have the pleasure of showing you your new sister whose Portrait you are pleased with"; and to Daniel Wadsworth, "I am glad you like the picture— but hope you will like the original better."[2]

Little is known of Sarah Hope Harvey's background. Born near London on April 1, 1774,[3] she seems to have had a quiet and rather lonely upbringing. Trumbull wrote to his brother Jonathan in 1801:

> She lost her mother at a very early time, before she remembers, and remained for several years in the Country under the Care of a good notable Woman, who regarded reading, writing & Housewifery, as the essentials of Female education. At 15 or 16, she came to Town & spent some years in the Family of a considerable Merch[t], whose wife had been the intimate friend of her mother. Here also, the business of the Family & Economy were regarded as the principal objects of attention. . . . She has no near relations living, of her blood; and in this Country still more than ours, other ties are feeble. No attachments therefore bind her strongly here and when the time arrives for leaving the country, I trust she will leave it with little regret, & soon become a good American. You will not therefore expect to see a modern fine Lady.[4]

Trumbull's family apparently had no prior knowledge of his relationship with Sarah Harvey, for she is not mentioned in the correspondence before their marriage.[5] The cautionary note in Trumbull's letter to Jonathan suggests that he was a little apprehensive about his wife's reception in America; sending a portrait ahead of time was therefore an important step in her introduction.

Sarah Trumbull in a White Dress would have clearly revealed to Trumbull's family the sweetness and beauty of his new wife. More than a simple likeness, however, the painting carries an important symbolic message; with her left hand grasping the white material and her right displaying a cross upon her breast, Sarah suggests both her innocence and the holiness of Christian matrimony.[6] Religious associations are also implicit in the placement of Sarah's hands, which recalls the traditional image of divine enlightenment typified by "Conversion" in the Hertel edition of Ripa's *Iconologia* (Fig. 64).[7]

Sarah may have been married when Trumbull met her.[8] Trumbull's silence concerning their courtship, as well as his rather abbreviated account of her past, suggest that their relationship may originally have been adulter-

Fig. 64. Gottfried Eichler, *Conversio*. Engraving from Cesare Ripa, *Iconologia*, ed. J. G. Hertel, Augsburg, 1758–60.

ous (see Cat. 135), which would certainly have met with disapproval in the Trumbull family. In presenting Sarah with the attributes of Christian piety, Trumbull perhaps wished to dispel any doubts the family may have had about the virtue of his new wife. With this "wedding" portrait Trumbull began his frequent practice of painting Sarah with allegorical references.

1 The couple were married by the Reverend Ralph Worsley in the parish church of St. Mary's, Hendon. Present were Trumbull's friends Rufus King and Christopher Gore, as well as one Elizabeth Holbrook, apparently a friend of Sarah Hope Harvey; see Jaffe 1975, p. 190.
2 Quoted in Jaffe 1975, p. 312; JT to William Williams, July 16, 1803, NYHS; JT to Daniel Wadsworth, September 7, 1803, YUL-JT.
3 See the Trumbull memorandum quoted in Sizer 1953, p. 352. Sarah's birthdate is somewhat questionable, however, for at her death, the *New-York American* reported in an obituary (April 12, 1824) that she was fifty-one years old (Sizer 1953, p. 365), which would set her birthdate at 1773.
4 JT to Jonathan Trumbull, Jr., May 1, 1801, quoted in Jaffe 1975, p. 191.
5 The circumstances of the couple's introduction and courtship are unknown; see Jaffe 1975, pp. 194–95.
6 Trumbull has drawn his symbolism from common features of feminine apparel; necklaces with pendant crosses and Sarah's white, high-waisted gown were fashionable at the beginning of the nineteenth century.
7 Although it is uncertain whether Trumbull ever saw the 1758–60 Hertel edition of Cesare Ripa's *Iconologia*, from which this illustration is drawn, he would have been familiar with the pose through its common appearance in Christian painting since the Renaissance.
8 On the basis of the letter Trumbull wrote to his brother-in-law William Williams (above, n. 2), in which he states that Sarah's maiden name was Hope, Sizer 1953, p. 354, and Jaffe 1975, p. 195, have concluded that she was previously married to a man named Harvey.

112

1802–4

Oil on canvas, 30½ x 25½ (77.5 x 64.8)
Yale University Art Gallery; Trumbull Collection

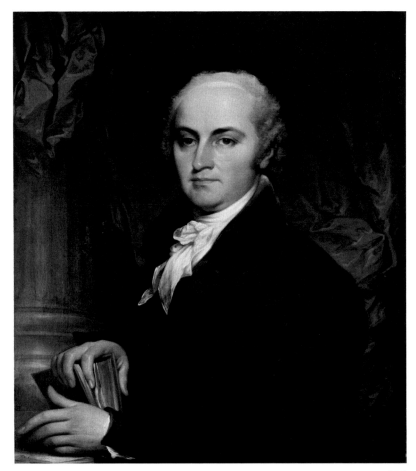

Christopher Gore was painted at London, one of several portraits that Trumbull executed after a seven-year break from painting.[1] He prepared two versions of this picture, giving one to the sitter (now in the Massachusetts Historical Society) and retaining the one now at Yale for himself. William Dunlap noted that the style of these portraits was "altogether different and much less happy than that he had formerly adopted."[2] *Christopher Gore* does lack the direct, psychological approach to his sitters that Trumbull had shown in such portraits of the early 1790s as *Lemuel Hopkins* (Cat. 45). Instead, the Gore portrait has a formal, pyramidal composition, and a tone of aristocratic aloofness from the viewer. Apart from the richly painted passages in the red curtain and Gore's white shirt front, the picture as a whole is a smooth, unemotional image. Its somber red and black color scheme and air of reserve indicate that Trumbull was following the formula for male portraits currently popular among English artists.

Trumbull's decision to adopt the Neoclassical style for this portrait may have been influenced by its appropriateness to his subject. Christopher Gore, after serving with Trumbull on the Jay Treaty Commission, returned to his native Massachusetts, where he served as governor, and later as a United States Senator. Like Trumbull, he subscribed to the Federalist doctrine that those with superior education and social status were best qualified to rule, and he despised the younger politicians who competed for what he termed "Place and Distinction" with the rise of political parties.[3] Trumbull's image of an imperturbable Gore, whose distance from the viewer is reinforced by the barrier created by his left arm, seems entirely consistent with the sitter's political philosophy. Moreover, the sense of Gore's social distinction and sophistication, which Trumbull alluded to by such props as the book, the background column and curtain, were appropriate to a man who served as an overseer and fellow of Harvard College, a president of the Massachusetts Historical Society, and a fellow of the American Academy of the Fine Arts. Such an official presentation, however, prevented Trumbull from making any indication in the picture of his warm feelings toward Gore, whom he called his "only intimate acquaintance" from college, and who was later to give away Sarah Harvey at Trumbull's wedding. "In after life," Trumbull recalled in his *Autobiography*, "it pleased Providence to bring us frequently into near and intimate associations in important affairs."[4]

1 A date of 1800 is recorded in Trumbull 1832, no. 30. However, during recent conservation Wynne Beebe discovered that the canvas bears a textile stamp for 1802, making this the earliest possible date that Trumbull could have worked on it. The painting must have been completed before Trumbull returned to America in April of 1804.
2 Dunlap 1834, I, p. 370.
3 Christopher Gore to Rufus King, October 5, 1812, cited in Charles R. King, ed., *The Life and Correspondence of Rufus King, Senator from New York*, 6 vols., New York, 1894–1900, V, p. 282.
4 Trumbull 1841, p. 13.

114
Self-Portrait

c.1802

Oil on canvas, 30 x 25 (76.2 x 63.5)
Yale University Art Gallery;
 Gift of Marshall Hill Clyde, Jr., in honor of the
 exhibition

The sense of accomplishment and purpose which Trumbull had gained by middle age emerges clearly in this dignified self-portrait as a gentleman, patriot, and artist. Trumbull presents himself in the grand manner tradition, sitting erect before a dramatic curtain and sky. Benjamin Silliman's description of Trumbull as an "elegant, graceful gentleman," conservative and dignified,[1] finds clear expression in this *Self-Portrait*. The sword hilt under his hand and the palette with brushes are emblems of the artist's dual service to America as an officer of the Revolution and visual recorder of its events; from this time on, the "sword and pencil" would serve as Trumbull's self-defining attributes.[2]

Stylistically, the *Self-Portrait* resembles Trumbull's portraits from the first decade of the nineteenth century, such as *Christopher Gore* (Cat. 113). During these years Trumbull's life changed significantly, as he developed new plans and aspirations for the future. His marriage to Sarah Hope Harvey in 1800 coincided with his return to painting after a hiatus of several years, and new thematic possibilities were beginning to take shape in his mind. Perhaps this *Self-Portrait* affirms Trumbull's renewed commitment to art, just as his 1777 *Self-Portrait* (Cat. 33) had defined his early ambitions. As a sequel to the 1777 *Self-Portrait*, it also represents the confidence which Trumbull had gained in maturity; while in the earlier work the young artist is seen leaning eagerly toward his theoretical manual and carefully arranged palette, in the later painting he sits back assuredly, his palette— now much used— resting behind him.[3]

It is likely that Trumbull executed this work before he and Sarah left England in 1804, for it seems to be a pendant to *Sarah Trumbull with a Spaniel* (Cat. 115). The two portraits have mirror compositions and identical dimensions, and seem to present complementary themes as well: Sarah Trumbull is represented with the attributes of marital faithfulness, while the artist is shown with the objects of his professional accomplishments. The execution of Trumbull's *Self-Portrait* is, however, somewhat different from that of *Sarah Trumbull with a Spaniel*; his face displays a complexity of modeling and glazing which the portrait of his wife lacks. Nevertheless, this contrast does not exclude the possibility that Trumbull painted the two portraits at the same time, for the subtle execution of the *Self-Portrait* is found in the 1802–4 *Christopher Gore* portrait. The limited facial modeling and rather patchy "blush" in Sarah Trumbull's portrait probably derives from the artist's wish to portray his wife with an idealized, pink-and-white complexion.

1 Silliman, "Notebook," I, pp. 6, 19.
2 A palette with brushes and a sword appear in the portrait of Trumbull executed by Waldo and Jewett about 1821 (*Fig. 2*). On the memorial plaque marking Trumbull's tomb, Benjamin Silliman had inscribed: "Col. John Trumbull, Patriot and Artist . . . To his Country he gave his SWORD and his PENCIL"; see Sizer

1953, p. 380. In this *Self-Portrait*, the large sheet of creased paper beneath the palette may also represent Trumbull's work in architectural design.
3 In this later *Self-Portrait*, Trumbull did not find it necessary to display the careful organization of his palette, for it contains only summary indications of color daubs. The portrait by Waldo and Jewett, however, clearly reveals the distribution of paint on Trumbull's palette, and markedly contrasts to the Hogarthian palette appearing in the 1777 *Self-Portrait*. For a discussion of Trumbull's mature technique, see Sizer 1967, pp. 133–37.

115
Sarah Trumbull with a Spaniel

c.1802

Oil on canvas, 30 x 25 (76.2 x 63.5)
Yale University Art Gallery;
 Gift of Marshall Hill Clyde, Jr., in honor of the
 exhibition

While Trumbull's first portrait of his wife symbolized the sanctity of Christian marriage, *Sarah Trumbull with a Spaniel* concerns enduring marital faithfulness. Sharing with its predecessor a combination of allegory and admiring depiction, this work seems to form a pendant to Trumbull's *Self-Portrait* of c.1802. Sarah Trumbull stands before a dark green curtain which dramatizes the elegant lines of her white form, accentuated by touches of red. She is dressed in the height of fashion and projects an air of beauty and poise. Resting her hand upon the dog, a traditional symbol of faith, Sarah also expresses commitment to her husband and the mutual trust which characterizes their union.[1] She places her left arm across her breast, which brings her sparkling wedding ring into a direct line with the spaniel's upturned head and gaze, emphasizing the dog's symbolic function in this portrait.

1 The image of a dog had been used since the Renaissance to symbolize marital faithfulness, especially in representations of women; see James Hall, *Dictionary of Subjects and Symbols in Art*, London, 1974, p. 105. It was a popular feature of late eighteenth-century English portraiture, although usually not so prominently symbolic as in Trumbull's painting; see, for example, Gainsborough's 1776 portrait of *Lady Caroline Alicia Brisco* (Kenwood, Iveagh Bequest).

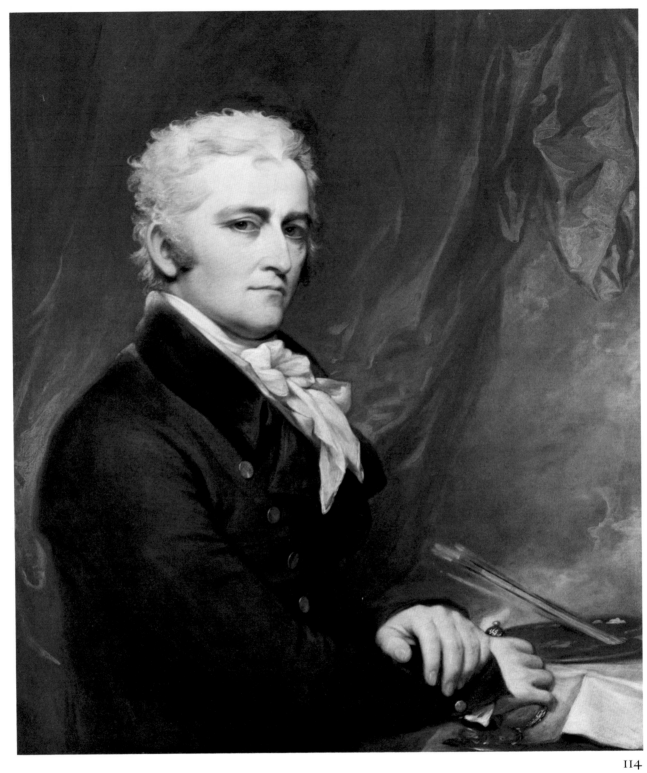

114

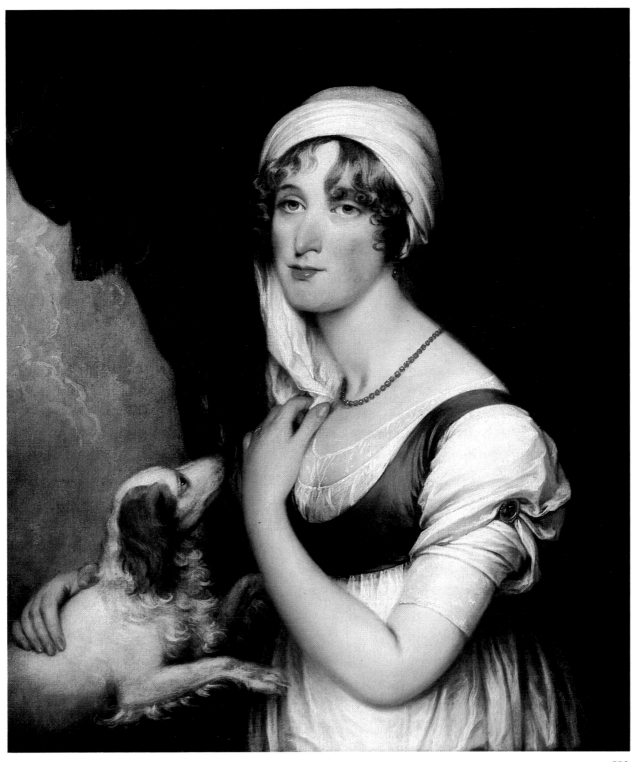

115

116

Mrs. Robert Lenox

1805
Oil on canvas, 36 x 28 (91.4 x 71.1)
The New York Public Library; Astor, Lenox and Tilden
 Foundations

117

Robert Lenox

1805
Oil on canvas, 37 x 28 (94 x 71.1)
The New York Public Library; Astor, Lenox and Tilden
 Foundations

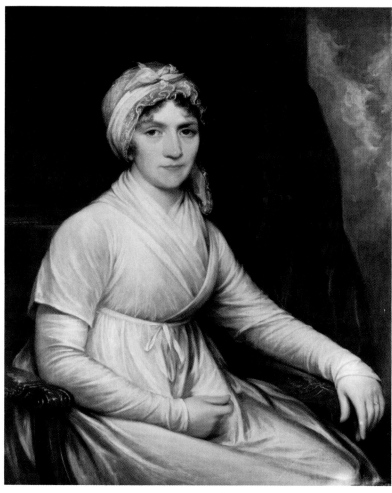

116

On returning to America in 1804, Trumbull made his living painting portraits of members of the merchant and aristocratic families of New York. He charged 500 dollars for a full-length, 100 dollars for a bust; in 1805–6 alone he executed more than thirty half-length portraits at 250 dollars apiece.[1] His half-length portraits of Mr. and Mrs. Robert Lenox are among the finest of these bread-and-butter commissions. Robert Lenox, born in Scotland in 1759, was a merchant who speculated in real estate. A trustee of the College of New Jersey, and later president of the New York Chamber of Commerce, he was one of the five richest men in New York by the time he died in 1839. He married Rachel Carmer (1763–1843) in 1783. Their son James, a noted bibliophile and historian, founded the New York Public Library.[2]

Following a format he used for most of his half-length portraits, Trumbull depicted the middle-aged husband and wife as a matched pair, to be displayed facing each other on one wall, or on either side of a door or fireplace. This traditional composition, which has its roots in Rembrandt's and Hals' portraits of the prosperous merchants of the Dutch bourgeoisie, was adopted by English portrait artists and later by Copley and Stuart. Trumbull balanced the symmetrical images with a set of visual devices which reveal correspondences and differences in the sitters' personalities. Robert Lenox is painted in the warm, dark tones that Trumbull often used in his portraits of men, while Mrs. Lenox sits against a background of cool greens and grays. Her white dress contrasts with her husband's black suit. He sits upright, she leans back in a soft French Empire chair.[3] Lenox is portrayed as a man of intellectual vigor, seated at his desk with books and pen at hand; Mrs. Lenox, dressed in modest "at home" attire, waits before an open window in calm and thoughtful repose.

To modern viewers the portrait of Rachel Lenox stands out as one of Trumbull's most sensitive and appealing images, suggesting that the sitter must have been a lady of considerable charm and intelligence. Benjamin West also singled out this portrait, but had even greater praise for that of Robert Lenox. After Trumbull sent the pair to be exhibited in London in 1806, his former teacher wrote to him:

> At your request I went to see the Portraits you painted of M.ʳ and M.ʳˢ Lenox— and I think it but just to say, that I found the art the[y] contained much superior to any of the Portraits you painted of your friends while hear— in particular that of Mr. Lenox:— were the accompaning parts in that picture a little more subdued, to give a triumph to the head— that picture would then stand the competition with some of the finest Portraits of the times.[4]

1 JT to Joseph Elgar, December 10, 1828, Henry E. Huntington Library and Art Gallery, San Marino, California. An entry dated December 10, 1805, in one of Trumbull's account books (YUL-JT) records: "Robert Lenox, pay for | two portraits . . . 250."
2 For further information on the Lenox family, see *DAB*, XI, pp. 172–73.
3 Stuart used a similar chair in several of his portraits; see, for example, *Mrs. John Tayloe*, painted at Washington, D.C., in 1804, reproduced in Lawrence Park, *Gilbert Stuart*, 4 vols., New York, 1926, IV, fig. 823. Trumbull's matched portraits of himself and his wife (Cats. 114, 115) follow a similar format and color scheme.
4 West to JT, September 29, 1806, YUL-JT.

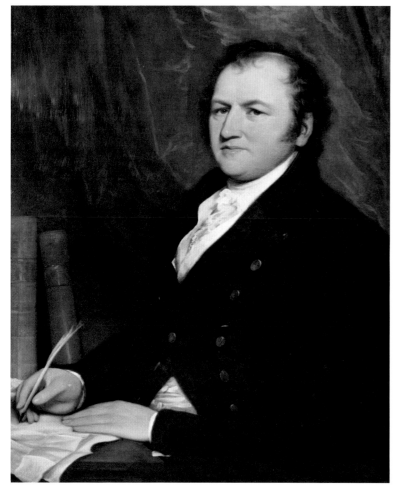

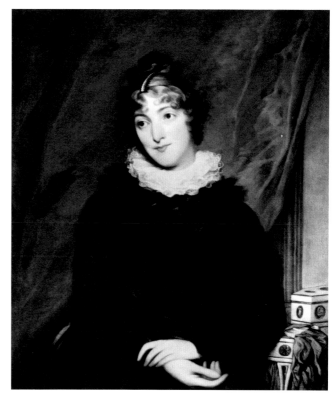

118

117

118
Mrs. John (Sarah Hope Harvey) Trumbull

c.1805
Oil on canvas, 29¹⁵/₁₆ x 25¹/₁₆ (76 x 63.7)
The Henry Francis du Pont Winterthur Museum

In this portrait Trumbull again presents his wife as a beautiful, fashionable lady. Sarah Trumbull is dressed for the outdoors, in a fur and lace collar, her gloves lying on the table. The more subdued colors of her garments suggest that she is a little older than in the other two portraits (Cats. 112, 115). It is likely that this painting was executed shortly after the Trumbulls' arrival in America in 1804.[1]

The portrait is a more straightforward rendering than the earlier works, containing no symbolic objects or allegories. However, Trumbull has attempted to portray a fuller image of his wife than mere description of her features would allow by showing her seated next to a sewing box and table. Sarah's dressmaking skills were an object of great pride to Trumbull, who wrote to his brother Jonathan in 1801: "while she has read as much as most women, She has acquired knowledge of other kinds here little attended to: there are few things relating to the House in Town or Country which She does not pretty well know & no article of her own dress, except Shoes, which she cannot & does not make."[2]

Trumbull sometimes included representative objects, such as a book, in his portraits of men, and in his *Self-Portrait* (Cat. 114) he is seen with his palette and the hilt of his sword. Trumbull's portraits of women, however, are generally devoid of such references, which lends added distinction to this image of Sarah Trumbull with the accoutrements of her skill.

1 Like most of Trumbull's other portraits of his wife, this one is difficult to date precisely. Sizer dated it 1800 because of the similarity between Sarah's comb and that worn by Mrs. Rufus King in her portrait of 1800 (Sizer 1967, p. 158). However, Jaffe 1975, p. 312, observed that Trumbull's 1803 packing list included only one painting of Sarah Trumbull, which was probably *Sarah Trumbull with a Spaniel* (c.1802), the *White Dress* portrait (c.1800) having been sent to America (see Cat. 112). It therefore seems that the Winterthur portrait was executed after the couple's return to the United States in 1804. Sarah Trumbull's slightly older appearance in this portrait strengthens the argument for its later date. Furthermore, her layered lace collar seems to have been fashionable somewhat later in the first decade of the nineteenth century.
2 JT to Jonathan Trumbull, Jr., May 1, 1801, quoted in Jaffe 1975, p. 191. Mrs. Trumbull was apparently also an occasional painter. The records of the American Academy disclose that she exhibited two pieces: in 1816, *Fruit and Flowers*, and in 1817, *Flowers*; see Mary Bartlet Cowdrey, *American Academy of Fine Arts and American Art Union*, 2 vols., New York, 1953, I, p. 86, n. 27.

The Vernet Family

1806

Oil on canvas, 40 x 50⅛ (101.6 x 127.3)
Yale University Art Gallery; Gift of the Associates in
 Fine Arts at Yale

During the first decade of the nineteenth century, Trumbull supported himself largely by painting portraits. Receiving many commissions from political leaders and other public figures, he also found considerable demand for portraiture among private citizens of the growing middle class. One of the more important of these latter commissions was a group portrait of the *Vernet Family*.[1] John Vernet, French by birth, had acquired a considerable fortune in Caribbean Islands trade when he moved to Connecticut for "retired leisure at Norwich."[2] There he met and married Anne Brown, a native of Norwich, and settled down to raise a family. The conspicuousness of Vernet's wealth in the town was evidenced by the new house he built in 1809 "at a cost and in a style of elegance beyond what had been previously exhibited at Norwich."[3]

In 1806 Trumbull was engaged to paint both the group portrait and a smaller bust of John Vernet.[4] In executing the *Vernet Family*, the artist drew upon stylistic features of European portraiture. The active brushwork and animation of line and gesture form a strong contrast to the more contained, sober forms in Trumbull's earlier American works. In addition, by alluding to the grand tradition of English portraiture with the column and background landscape, Trumbull was able to convey the social and economic prominence of this Norwich family.

The background view also reveals Trumbull's increasing involvement with naturalistic landscape painting, for it depicts the local scenery of Norwich, with the falls of the Yantic visible on the left. While in Norwich, Trumbull had made several drawings of the surrounding landscape,[5] which appear to be records of his observations, and provided him with a model for depicting the foliage and rocky terrain; one, labeled "View of Norwich Falls from the grounds of M Vernet," roughly corresponds to the upper right portion of the *Vernet Family* landscape, suggesting Trumbull's wish to obtain an appropriate view for his portrait.[6]

The *Vernet Family* forms an interesting contrast to one of Trumbull's few other family portraits, *Mr. and Mrs. Jonathan Trumbull, Jr. and Their Daughter Faith* of 1777 (Cat. 34). In the earlier portrait Mr. and Mrs. Trumbull, with their interlocking poses and similar garment colors, form a complementary pair somewhat removed from their daughter; in the *Vernet Family*, it is the mother and baby that appear most firmly united in the solid vertical which dominates the center of the painting. At the same time, there is a marked difference in execution between the sharp, clear delineation of John Vernet's features and the generalized, somewhat idealized treatment of Mrs. Vernet and the two children.

1 The portrait depicts John Vernet (1764–1827), his wife Anne Brown Vernet, and their two sons, John Gil Vernet (1803–1819), and Peter Croise Vernet (1805–1840).
2 Francis Manwaring Caulkins, *History of Norwich, Connecticut*, Hartford, 1874, p. 537.
3 Ibid. Caulkins reports (pp. 513, 537) that in 1811 Vernet met with sudden financial disaster and was forced to sell the house; the family subsequently moved to Wilkes-Barre, Pennsylvania.
4 John Trumbull, "Account Book," YUL-JT. The group portrait is referred to under the heading "Cash— Norwich": "Nov. 4ᵗʰ Recᵈ of Jesse Brown Esqʳ | in full for a Family | picture of J. Vernet | his wife & two children | Cash— 300." The single bust (now in the collection of Mrs. W. V. Ingham) may be the item referred to under a New York heading for earlier in 1806: "Feb. 9th cash from J. Trumbull to pay in adᶠᵗ on [?] Jesse Brown for J. Vernet's picture 120." Sizer 1967, p. 78, also records an unlocated pencil drawing of John and Anne Brown Vernet.
5 John Trumbull sketchbook, "More Recent Sketches," nos. 4, 6, 8, 9, 11, 12, YU-B.
6 No. 8 in "More Recent Sketches." Beneath the drawing Trumbull recorded the dimensions of the frame for the *Vernet Family* portrait. Trumbull's continuing interest in the Norwich landscape is evident from the three versions of the *Falls of the Yantic* which he painted soon afterward; see Cats. 144–46.

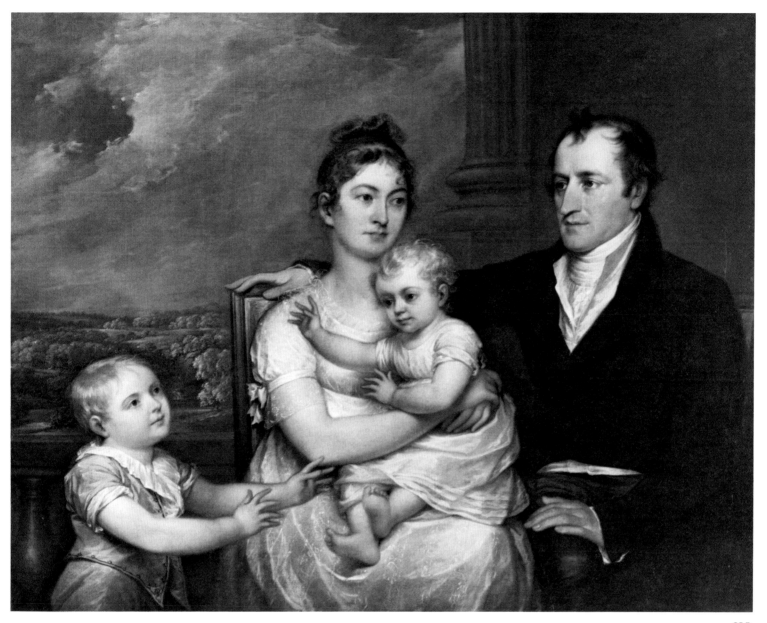

119

Mrs. Thomas Sully

1806
Oil on canvas, 28¼ x 23¼ (71.8 x 59.1)
Mead Art Museum, Amherst College; Bequest of
 Herbert L. Pratt

In 1806 Thomas Sully and his wife, Sarah, moved to New York, where the young portrait painter intended to establish a studio. Having received a 1000-dollar loan from a generous patron, Sully used 100 dollars to commission a portrait of Sarah from Trumbull, "that he might see his mode of painting, and have a specimen from his pencil."[1]

The portrait represents something of a departure for Trumbull in its simplicity of composition, color, and form. As in *Mrs. Stephen Minot* of the same date (Museum of Fine Arts, Boston), the artist completely eliminated background detail, directing full attention to Mrs. Sully's face and the elegant contour of her neck and shoulder; the restrained palette is almost entirely given over to shades of brown, white, and gray. Such reductiveness and linearity seems closer to current Neoclassical trends[2] than to the more traditional grand manner mode that Trumbull usually followed,[3] although in this work he has still retained a subtly blurred line which softens the figure's silhouette.

It is uncertain how much Sully actually learned from his experience of watching Trumbull paint; Dunlap wrote that he "probably learned to imitate the neatness with which palette and pencils and oils and varnishes were used and preserved,"[4] a suggestion that seems to be corroborated by Sully's stress on cleanliness and organization in the opening section of his *Hints to Young Painters*.[5] More important, perhaps, was the younger artist's general admiration for Trumbull, of whom he wrote in 1810: "I do not think this excellent Painter is duly appreciated in London. . . . His last performance in the Exhibitions was far superior to any other work placed there."[6] In *Hints to Young Painters*, Trumbull was one of the authorities whose methods Sully described and recommended.[7]

1 Dunlap 1834, II, p. 111. Thomas and Sarah Annis Sully had married in 1805; Sarah was at that time the widow of Lawrence Sully, Thomas' brother, who had died in 1803. In 1806 Thomas Abthorpe Cooper arranged for Sully to come to New York and loaned him 1000 dollars to begin work there as an independent portraitist; see also Edward Biddle and Mantle Fielding, *The Life and Works of Thomas Sully*, Philadelphia, 1921, pp. 7–9.
2 Compare, for example, John Vanderlyn's portrait of *Theodosia Burr*, 1802–3 (Yale University Art Gallery). Mrs. Sully's high-waisted white chemise also reflects the popularity of French Neoclassical fashions after 1800.
3 For an example of Trumbull's more typical compositions, see *Mrs. Robert Lenox* (Cat. 116), in which the figure sits on a chair before a gathered curtain and background sky.
4 Dunlap 1834, II, p. 111. Dunlap, as usual, embellished this speculation with an editorial deprecation of Trumbull's capabilities.
5 Jaffe 1975, p. 211. See Thomas Sully, *Hints to Young Painters and the Process of Portrait Painting*, Philadelphia, 1873, pp. 10–15.
6 Sully to Daniel Wadsworth, June 17, 1810, CSL.
7 Sully, *Hints to Young Painters*, pp. 44, 49. Stylistically, Sully's work seems to be related to that of a variety of contemporary portraitists, including Trumbull, although his most important influence was probably Sir Thomas Lawrence, with whom he studied in 1809–10; see Biddle and Fielding, *The Life and Works of Thomas Sully*, pp. 12, 15.

Mrs. John Murray

c.1806
Oil on canvas, 30 x 24 (76.2 x 61)
The Metropolitan Museum of Art; Morris K. Jesup
 Fund

Mrs. John Murray, the former Hannah Lindley, was born in 1746. Little is known about her. Her husband, an established New York merchant and importer, was one of the wealthiest businessmen in the city and a public-spirited citizen. He supported many charities, backed the patriot cause during the Revolutionary War, and between 1798 and 1808 was president of the New York Chamber of Commerce. The Murrays are remembered today in the name of the Manhattan neighborhood of Murray Hill, once the site of the Murrays' country house. Among their seven children was the early New York collector and art patron John R. Murray.[1] Mrs. Murray died on May 22, 1835, "a truly Christian lady."[2]

This work, among the better ones produced by Trumbull in the 1804–8 period, has long been considered a pendant to Trumbull's portrait of *John Murray*, also at the Metropolitan Museum of Art.[3] Given the more accomplished execution and ambitious composition of *Mrs. John Murray*, and the lack of complementary features between the two, it appears certain that the female portrait was conceived by Trumbull as an independent work.

Although we do not know the extent of Trumbull's acquaintance with Mr. and Mrs. John Murray, it is probable that he knew them fairly well. When Trumbull sailed for London in 1808 he left his household goods and books stored in sixty-five boxes and trunks in Murray's warehouse. The New-York Historical Society possesses correspondence between the two men regarding these boxes and trunks, and the large version of *The Sortie Made by the Garrison of Gibraltar*. Perhaps because of their acquaintance, Mrs. Murray is here portrayed by Trumbull as a genial and engaging person rather than as a sour and forbidding matron, his more usual way of representing older women at this time. For the same reason, he may have attempted to give Mrs. Murray's picture the qualities of Old Master portraits. In particular, the use of yellows and browns, the sitter's pose, and her fur stole recall Dutch seventeenth-century portraiture formulas as employed, for example, in Ferdinand Bol's *Elisabeth Bas*, c.1641 (Rijksmuseum, Amsterdam). According to Sizer, Trumbull's portrait was painted in New York about 1806.[4]

1 Albert TenEyck Gardner and Stuart P. Feld, *American Paintings. A Catalogue of the Collection of the Metropolitan Museum of Art, I: Painters born by 1815*, Greenwich, Conn., 1965, pp. 106–7, give biographical data on the sitter and her husband.
2 Sarah S. Murray, *A Short History of the Descendants of John Murray*, New York, 1894, pp. 23–24.
3 The two works came to the museum as a pair, but wrongly identified as Mr. and Mrs. Robert Murray. A comparison of the likeness in the portrait of *John Murray* painted by Daniel Huntington for the New York Chamber of Commerce with the Metropolitan's painting, however, established that it was of John, and not Robert, Murray. The identification of the other portrait in the pair as Mrs. John Murray followed from this. The possibility exists, therefore, that the present portrait portrays another member of the Murray family and not Mrs. John Murray; see Gardner and Feld, *American Paintings*, p. 106.
4 Sizer 1967, p. 55, and fig. 47. In terms of style, it is virtually certain that it was painted between 1804 and 1808.

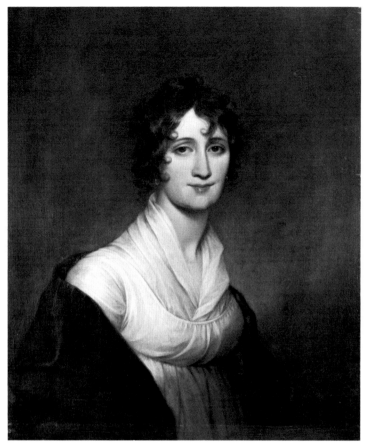

120

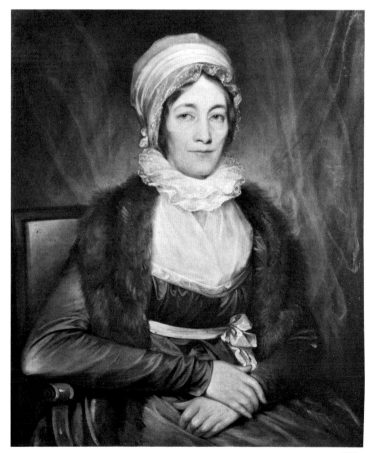

121

122
Sarah Trumbull on Her Deathbed

1824

Oil on canvas, 19⅝ x 24⅛ (49.8 x 61.3)
Yale University Art Gallery; Gift of Joseph Lanman
 Richards

The dramatic portrayal of Sarah Trumbull's death culminated a series of portraits which Trumbull executed of his wife throughout their twenty-four-year marriage. Mrs. Trumbull was fifty-one years old when she died and had been in poor health for some time before. Long-standing emotional strains probably contributed to her illness; Trumbull had written to her in 1819: "Keep your Spirits I beseech you, and believe, as I truly do, that Providence has much good in store for you who have always strove to do good to others, while you have suffered so much."[1]

Although the exact nature of Sarah Trumbull's sufferings is unknown, Trumbull's frequent letters of encouragement suggest that she was chronically lonely and unhappy. An orphan from early childhood, she had no close family ties in her native England[2] and Trumbull's relatives seem to have treated her with an aloofness occasionally breaking into open hostility, which may have been due to her questionable past (see Cat. 112).[3] References by a few contemporaries, especially later in the 1810s, imply that she was also an alcoholic.[4] Her persistent concern for the welfare of Trumbull's illegitimate son,[5] however, suggests a compassion confirmed by Benjamin Silliman, who wrote that in times of family sickness she could be an "angel of mercy."[6] Trumbull certainly regarded his wife with a consistent reverence and devotion which found perhaps greatest expression in this deathbed portrait of her.

The moribund subject of the painting is reflected in its dark background and restrained palette, with Mrs. Trumbull appearing almost as an apparition, her thin, veinous hands extended eerily into space. Lifelike, however, is the roseate complexion of her fingers and face, her red, parted lips, and the animation of her rapt gaze. The focus of Sarah Trumbull's attention lies beyond the upper right corner, from which streams in the painting's only light, revealing diagonal streaks of color in the curtains and illuminating the chest and right side of the dying woman's body. Whatever Sarah sees has caused her to start up slightly from her pillow, as she opens her arms in a gesture of reception. But only her head and shoulders rise; her back and lower torso are almost indistinguishable from the shadowy bedclothes which envelop them, and receive none of the rounded modeling of her shoulder, face and chest. As the lower part of the dying woman's body thus recedes, her head and arms seem to reach toward the mysterious light; her face, flush with life, is transfixed by what must be an otherworldly emanation.

The expression of divine presence through light had been an integral aspect of Christian thought and art since the Middle Ages. Its specific association with salvation evolved during the seventeenth century, when light, in the form of symbolic rays or actual illumination, often appeared in tomb sculpture as the representation of spiritual rebirth.[7]

The events of the deathbed scene itself, long an important part of Christian ritual, were given renewed attention in the early decades of the nineteenth century. A popular theme in literature— for example, John Warton's *Deathbed Scenes and Pastoral Conversations* (London, 1828), the Christian deathbed also became a more common subject in art, particularly in funeral monuments.[8] Women were often the subject of such representations, perhaps an early sign of the close association between femininity and spirituality in the nineteenth-century mind.[9]

English church monuments in the early decades of the 1800s included many portrayals of dying women at the moment of spiritual illumination.[10] John Flaxman was an important initiator of this trend, with his relief plaques of wraithlike women attended by angels.[11] More corporeal representations appeared in the works of Francis Chantrey, whose *Monument to Elizabeth Digby* (Worcester Cathedral) included a poem on the tomb chest describing the saved woman's enlightenment: "As nearer death she drew, and her firm mind / Through the dim passage mark'd the light behind."[12] These words could apply equally well to the dying Sarah Trumbull, as she strains toward the light which emanates from above, illuminating her flushed and animated face and leaving her unneeded body obscured in shadow.

In a letter of 1800, Trumbull articulated his emotional response to one of these monuments, a sculpture of a dying woman by Joseph Nollekens (*Fig. 65*) which he had just seen:

> It is to the memory of a Lady who died in childbed of her first child & consists of a lovely young woman expiring, looking up with humble hope upon the Figure of Religion, which stooping over her, supports her and points to Heaven.— while the last feelings of human sensibility are expressed by her feebly grasping the little hand of her Infant, who lies dead upon her Bosom.— I have seen nothing ancient or modern that addresses so irresistably the finest feelings of the heart.[13]

Jaffe suggests that the sentiments evoked by this monument may have influenced Trumbull's later conception of his deathbed portrait.[14] His painting, however, displays a much greater sense of agitation and immediacy, for it is still fundamentally a portrait, serving only indirectly as a memorial image.[15] Trumbull had earlier imbued representations of his wife with allegorical or symbolic meaning (see Cats. 112, 115), so perhaps the symbolic light and spiritual awakening depicted in *Sarah Trumbull on Her Deathbed* may be regarded as "attributes" of salvation, presenting a final statement of her Christian purity.[16]

Trumbull's strong religious beliefs found expression in the many paintings of biblical subjects and characters which he executed throughout his life. That he shared the general concern with the deathbed's Christian "lesson" is revealed in an exchange of letters between Trumbull and his nephew, Jonathan G. W. Trumbull, after the death of Trumbull's brother David. Jonathan recounted the last moments of his father's life, when "At this hour, when life was quivering on his lips, & the soul at the moment of departure, those very lips uttered a pathetic prayer, & expressed a supreme love to the 'Saviour of men, his blessed Redeemer.'"[17] Trumbull responded: "You have . . . received the most impressive lesson which can be given to Man— the death bed . . . teaches most powerfully the truth which all acknowledge, but few feel, of the fleeting

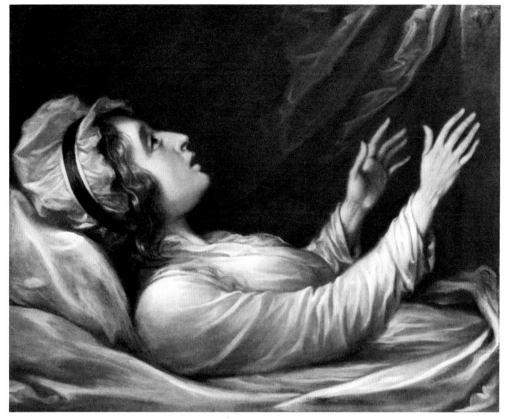

122

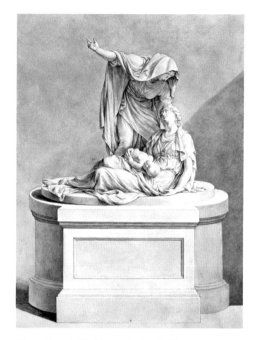

Fig. 65. Joseph Nollekens, *Design for Monument to Mrs. Howard,* c.1789. London, Victoria and Albert Museum.

nature of our own life.— You have seen the death of a Christian, & you appear to have viewed the awful Scene as a Christian should."[18]

Trumbull painted several death scenes in the course of his life; four of his contemporary history paintings focus on an expiring hero (see Cats. 4, 7, 10, 14). These deaths, however, founded on the example of academic classicism, were intended to convey moral precepts to the public. *Sarah Trumbull on Her Deathbed,* with its close-up view and dramatic isolation of the figure, reveals a more private, emotional side of the artist; in portraying the death of his "dearest friend,"[19] Trumbull expressed his basic belief in the promise of Christian salvation.

1 JT to Sarah Trumbull, January 18, 1819, NYHS. There is some question concerning Sarah Trumbull's age at her death; see Cat. 112, n. 3.

2 See Cat. 112 for Trumbull's description of her background.

3 The most serious occurrence of such animosity may have been at a family gathering in 1806, which prompted Trumbull to write a severely reproachful letter to his niece, Faith, in defense of his wife; JT to Faith Wadsworth, December 13, 1806, YUL-JT.

4 See Sizer 1967, p. 362, and Jaffe 1975, pp. 195–96.

5 It was Sarah Trumbull who persuaded her husband to support John Trumbull Ray's education, and the young man wrote many solicitous letters to his "Aunt" Trumbull; YUL-JT; Jaffe 1975, pp. 197–98.

6 Silliman, "Notebook," I, p. 31. For more facts and speculations on Sarah Trumbull's obscure biography, see Jaffe 1975, pp. 190–248, and Sizer 1953, pp. 350–65.

7 A well-known example is Bernini's monument to *The Blessed*

Lodovica Albertoni (S. Francesco a Ripa, Rome), where the dying woman is shown pierced by the light of divine salvation, symbolized by light emanating from concealed windows above; see Rudolph Wittkower, *Gian Lorenzo Bernini,* London, 1966, p. 258.

8 See Nicholas Penny, *Church Monuments in Romantic England,* New Haven, 1977, pp. 80, 88.

9 Ibid., pp. 89, 107. For an extensive discussion of the nineteenth-century relationship between women and religion in America, see Ann Douglas, *The Feminization of American Culture,* New York, 1977.

10 See Penny, *Church Monuments in Romantic England,* pp. 65–107.

11 Ibid., p. 80. Flaxman was also an important figure in the early development of the "maternal affection" theme, which may have influenced Trumbull's *Maternal Tenderness* (Cat. 158).

12 Penny, *Church Monuments in Romantic England,* p. 88.

13 JT to Charles Bulfinch, June 12, 1800, NYHS.

14 Jaffe 1975, p. 313.

15 Although funerary portraiture had been practiced since the fourteenth century (see Anton Pigler, "Portraying the Dead," *Acta Historiae Artium Academiae Scientiarum Hungaricae,* 4 [1956], pp. 1–74), specifically Christian paintings of a dying individual's contact with the divine spirit at death seem to have been more rare, especially before 1824. No direct precedent for Trumbull's representation has been discovered.

16 In preparing an inscription for his wife's gravestone, Trumbull repeated the message of his painting: "Sarah . . . left this painful and wearisome life in the humble hope of enjoying through the Divine Mercy of the merits of the blessed Redeemer a happy immortality"; see Sizer 1953, p. 352.

17 Jonathan G. W. Trumbull to JT, January 22, 1822, YUL-JT.

18 JT to Jonathan G. W. Trumbull, March 12, 1822, YUL-JT.

19 In letters to his wife, Trumbull frequently used the greeting of "My dearest friend," or "My best friend"; see, for example, JT to Sarah Trumbull, December 11, 1818, YUL-JT.

123
Benjamin Silliman

1825

Oil on wood, 19¼ x 15¾ (48.9 x 40)
The National Portrait Gallery; Gift of Alice Silliman Hawkes

Benjamin Silliman (1779–1864) was one of the most influential teachers of science in nineteenth-century America. A full professor by the age of twenty-three, and the first professor of chemistry and natural history at Yale College, Silliman was ultimately responsible for the college's establishment of the first graduate science program in the country; former students later implemented comparable programs at such universities as Cornell and Johns Hopkins. Silliman's widely read *American Journal of Science and the Arts* provided a forum for scholarly discussion. Most important for directing popular interest toward the sciences were his remarkably successful classroom and public lectures, which featured entertaining demonstrations of chemical principles.[1]

Silliman first met Trumbull in New Haven in 1804. He observed the artist and his brother Jonathan, who was then governor of Connecticut, engaging "in little sallies of wit [which] was pleasing to me, who had regarded them only as grave dignified men."[2] Silliman married Jonathan's daughter Harriet in 1809, and his friendship with the artist deepened.

Silliman recorded that Trumbull painted his portrait— at the artist's request— in 1825 in New York City. "Our sittings were at 6 a.m. for 1½ hours when I breakfasted with the Artist."[3] After breakfast, Silliman went to sit for Samuel F. B. Morse, a former Yale student who was commissioned to do a portrait of the eminent scientist by the Yale College graduating class of 1824. "Col. Trumbull painted very rapidly— Mr. Morse was less rapid and both were very agreeable companions."[4]

On the basis of Silliman's youthful appearance, the National Portrait Gallery painting has previously been dated to about 1805.[5] However, the identical high-collared jacket, shirt ruff and receding hairline in the 1825 Morse portrait (*Fig. 66*) suggests that the two portraits are exactly contemporary. Because Silliman wrote that the Trumbull portrait had "beautiful hands,"[6] Sizer believed that there were two Trumbull portraits of Silliman, one unlocated.[7] Writing about the painting more than thirty years after its execution, Silliman may have been remembering instead the hands in the Morse portrait; the provenance of the National Portrait Gallery painting shows that it was in the collection of Angelica Schuyler Church, granddaughter of the original owner, Silliman's daughter Maria Trumbull Church.[8]

Silliman recalled that when the portrait was painted, he was "just rising from a depressed state of health," and that it had a "delicate languor" which he himself felt. He considered it "an elegant work of art . . . [but] it was never regarded as a striking likeness."[9] The soft outlines and generalized forms recall the style of Trumbull's religious subjects from the 1820s.

Silliman returned the friendship that the elder Trumbull had shown him. He presented the faculty of Yale College with Trumbull's proposal to give his paintings to Yale in return for a lifetime annuity, and raised the funds

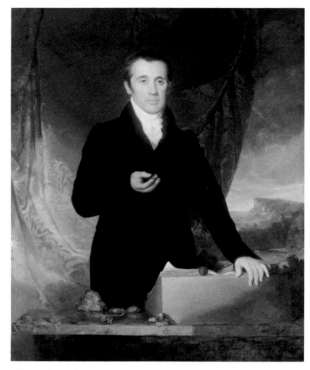

Fig. 66. Samuel F. B. Morse, *Benjamin Silliman*, 1825. New Haven, Yale University Art Gallery; Gift of Bartlett Arkell to Silliman College.

for the construction of the first Trumbull Gallery in 1832; he also acted as the collection's first curator. In 1837, the Sillimans invited the aging, long-widowed artist to move from his boarding house in New York to their home on Hillhouse Avenue in New Haven. There, with the professor's encouragement, Trumbull completed his *Autobiography*, which he had begun at Silliman's suggestion several years earlier.[10] In his own unpublished autobiography, Silliman, who was the executor of Trumbull's estate, soberly recalled that "my acquaintance with [Trumbull] ceased only with his life."[11] To the professor, the 1825 portrait was an "interesting remembrance of our eminent friend and artist."[12]

1 Leonard G. Wilson, ed., *Benjamin Silliman and his Circle: Studies on the Influence of Benjamin Silliman on Science in America*, New York, 1979, pp. 1–10.
2 Silliman, "Notebook," I, p. 6.
3 "Extracts from a record left by Benjamin Silliman— Given by Miss Maria Trumbull Dana from original in her possession. Miss Dana thinks the original was written about 1856," p. 4, YUL-SF.
4 Ibid., p. 4
5 Sizer 1967, p. 66.
6 "Extracts," p. 4.
7 Sizer 1967, p. 66.
8 Alice Silliman Hawkes, who gave the painting to the National Portrait Gallery, purchased it from her cousin Angelica Schuyler Church between 1915 and 1920 (Alice Silliman Hawkes to Theodore Sizer, February 11, 1950, Yale University Art Gallery Files). See also "Extracts," p. 4: "[The 1825 portrait] is now in the possesion of my eldest daughter, Maria T. Church."
9 Ibid., p. 4.
10 Jaffe 1975, p. 284
11 Silliman, "Notebook," I, p. 7.
12 "Extracts," p. 4.

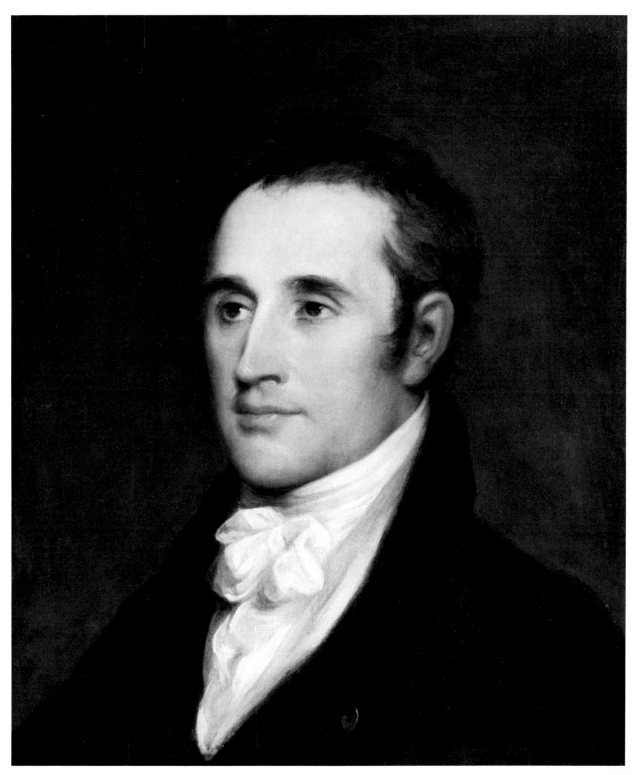

123

Asher B. Durand

1826
Oil on wood, 25¼ x 20¾ (64.1 x 52.7)
The New-York Historical Society

Trumbull first met the young Asher B. Durand (1796–1886) during his search for an artist to engrave *The Declaration of Independence*. Although Trumbull had originally chosen the Englishman James Heath, noting that American engravers were unfamiliar with "artistic" subjects,[1] Heath's fee of 7000 dollars and the inconvenience of having the job done abroad led Trumbull to reconsider. After seeing some of Durand's work in 1820, he wrote to Benjamin Silliman, "European instruction is not essential to a man of Talent . . . witnessing the very extraordinary progress making by . . . Mr. Durand— who has lately engraved several heads from portraits painted here, which would not dishonor the first-living Artists in Europe."[2] Trumbull was delighted to sign a contract with Durand for only 3000 dollars. Moreover, as the work progressed during the next three years, Trumbull was able to promote the project with appeals to patriotism. In a letter to Thomas Jefferson, he observed that Durand was "Native of this Country, who has acquired his Skill in this Country— and has demonstrated in this work, that Talent & Industry may carry whoever possess them, far toward the perfection of this art, without the aid of foreign instruction. . . . The work will be completely American, & I hope will be thought in some degree worthy of the glorious Scene which it commemorates."[3] Ironically, the finished engraving never brought Trumbull the financial security he had hoped, whereas it gave Durand immediate renown and launched his successful career as an engraver.[4]

According to Durand's son, Trumbull's portrait of the young artist was painted in 1826, three years after the *Declaration* engraving had been completed.[5] In January of that year, Durand had become a founding member of the National Academy of Design. Although it might seem uncharacteristic of Trumbull to do a portrait of someone who had challenged his leadership of the American Academy (see p. 16), John Durand maintained that relations between his father and Trumbull were "intimate," noting that Durand "always . . . spoke gratefully of the eminent painter who thus started him in life."[6] The painting itself is similar to other portraits painted by Trumbull in the mid-1820s, such as *Benjamin Silliman* of 1825 (Cat. 123). The broad handling of the paint and the use of wood panel instead of canvas seems to be characteristic of Trumbull's work at this time.[7]

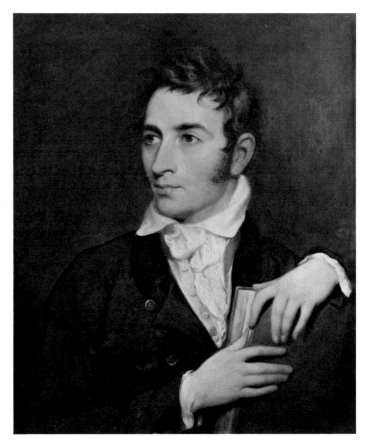

124

1 Gordon Hendricks, "Durand, Maverick and the *Declaration*," *The American Art Journal*, 3 (Spring 1971), pp. 62–63.
2 JT to Benjamin Silliman, February 4, 1820, YUL-JT.
3 JT to Thomas Jefferson, June 29, 1823, NYHS.
4 Wayne Craven, "Asher B. Durand's Career as an Engraver," *The American Art Journal*, 3 (Spring 1971), p. 44.
5 John Durand, *The Life and Times of A. B. Durand*, New York, 1894, p. 209.
6 Ibid., pp. 26–27.
7 Trumbull painted at least eighteen large-scale portraits on wood; of these, at least fourteen were definitely executed after 1820.

Figure Drawings

Trumbull's drawing skills developed in a conventional eighteenth-century pattern. Beginning by copying from two-dimensional works such as prints, he graduated to the more difficult task of representing three dimensions in two, first from plaster casts after antique sculpture, and then from the model. Nowhere in Trumbull's work is drawing as an artistic discipline more evident than in the academic figure studies represented here.

The figure drawings Trumbull produced during 1780, his first year abroad, were probably based on figures in drawing books and engravings. *Studies of Male Torsos* (Cat. 125), which he made in prison, suggests the same precise linear depiction of the idealized human body that eighteenth-century anatomy books presented. When Trumbull returned to London in 1784 to study with West, his formal training as an artist began in earnest. He attended the regular evening drawing sessions of the Royal Academy (see p. 7), copying casts of antique sculptures to create finished chalk studies such as *Meleager* (Cat. 126). Modeling and shadows are achieved through energetic cross-hatched and parallel lines, with contours carefully outlined and reworked. Drawing after casts was intended to instill in the art student a noble heroic attitude toward the human body and, indeed, a number of figures in Trumbull's later history paintings would be depicted in postures taken directly from the Academy's antique casts (see, for example, Cat. 12).

Trumbull's skills as a draftsman began to mature at about the same time he was developing a painterly freedom in his oils. The drawing style became softer, yet precise and bathed in light. Executed in black and white chalk, over pencil, on blue laid paper, these later life studies (Cats. 127–31) are less typical of the London Royal Academy than of Paris and the French Academy. Trumbull had several opportunities to participate in the French Academy's life classes, having visited the city in 1786 (when he commented that the drawing quarters for students drawing from life were much smaller than those in London),[1] and again in 1787, 1789, 1795–96, and 1797.

The French origin of Trumbull's post-1784 figure studies is suggested in a number of ways. According to the tenets of the French Academy, a history painter had to begin with life studies that emphasized modeling in light and shade, and the muscular figure caught in motion. Three of the five studies shown here display these principles: a seated male nude twists sharply in space (Cat. 129); a standing figure pulls on a rope, his muscles tense, as wind seemingly blows through his hair (Cat. 127); another male figure stretched out on the ground pulls himself up as he reaches dramatically forward (Cat. 128).[2] Because the Academy expected students to borrow figure types from great art of the past in their subsequent history paintings, its models often assumed poses from well-known antique and Renaissance sculptures.[3] The artist thus developed a repertoire of poses and gestures.

The two reclining female nudes (Cats. 130, 131) differ noticeably in intent from the previous three studies. They are less concerned with the body in motion and so would have been less useful as preparations for history paintings. (They are also unlikely postures for a battle or presentation scene.). Trumbull systematically explored the front and back views of the body. The front-view *Reclining*

Female Figure is a sensuous depiction of a sleeping model whose inner languor contrasts with the interplay of shadows and glistening surfaces. The *Reclining Female Figure* seen from the back suggests the growing Neoclassical fashion for precise contours. Yet at the same time, Trumbull retained in both studies a sense of considerable softness, as if the figure were seen through an atmospherical veil.[4] The delicately shaded drawing style was consonant with a renewed romantic inclination in French art.

All five of these drawings are so much more accomplished technically than the *Meleager*, with delicate lights and shadows and more assured contours, that they suggest a later date of execution. The "Grecian" hairstyle in Cat. 130 indicates a date as late as the Directory, as does the technique of stumped chalk, which recalls Trumbull's contemporary, Pierre Paul Prud'hon. Trumbull spent some ten months in France in 1795–96 engaged in various business activities (see p. 11) and the drawings probably date to that period.

These exceptional chalk studies, together with the fine pencil portraits (Cats. 101–11) which Trumbull executed as studies for his American history series, reveal a drawing style of fluency and subtlety.

1 Trumbull 1841, p. 104.
2 Jaffe 1975, p. 329, notes that the pose of this figure is strikingly similar to one by Copley in a study for *The Siege of Gibraltar*.
3 See James Henry Rubin, *Eighteenth Century French Life Drawing*, exh. cat., The Art Museum, Princeton University, 1977, esp. pp. 17–37.
4 The figure's pose is almost a mirror image of Velázquez' *Rokeby Venus* (National Gallery, London), a painting that was in the Alba Collection in Madrid from 1688 to 1802. Exactly how the Velázquez figure came to be used as a pose for a life study in Paris is not clear.

125
Studies of Male Torsos

1780
Black and white chalks on blue paper, 13⅜ x 11⁹/₁₆
 (34 x 29.4)
Inscribed: left, *Tothill Fields | 28th Nov. 1780 | J Trumbull*;
 right, *Tothill Fields Academy | Nov 29th | J Trumbull*
Fordham University Library; Charles Allen Munn
 Collection

126
Meleager

1784
Black and white chalks on blue paper, 19½ x 12
 (49.5 x 30.5)
Fordham University Library; Charles Allen Munn
 Collection

127
Male Figure

c.1795
Black and white chalks with black crayon on blue paper,
 22¼ x 14 (56.5 x 35.5)
Collection of Mrs. Percy Chubb

128
Male Figure

c.1795
Black and white chalks with black crayon on blue paper,
 14 x 22½ (35.6 x 57.2)
Fordham University Library; Charles Allen Munn
 Collection

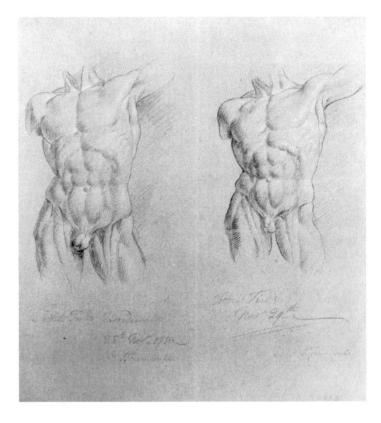

125

126

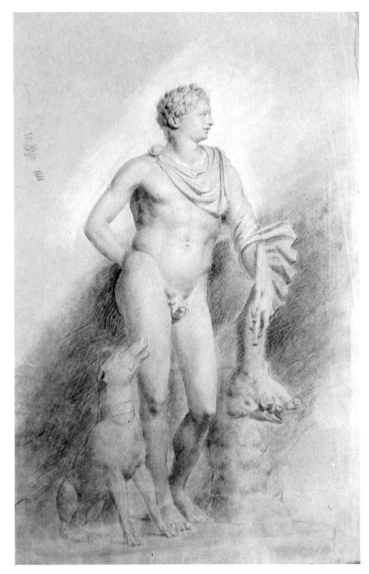

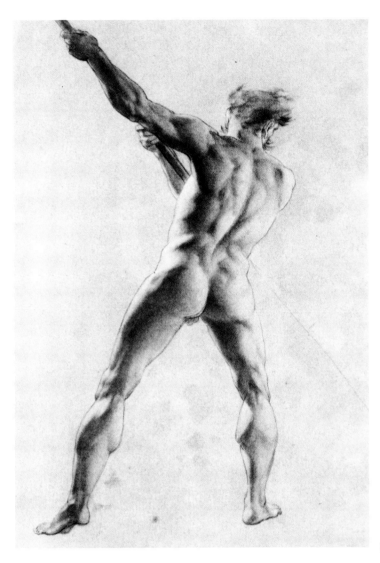

127

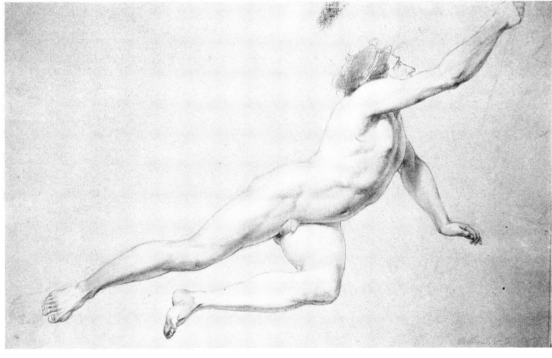

128

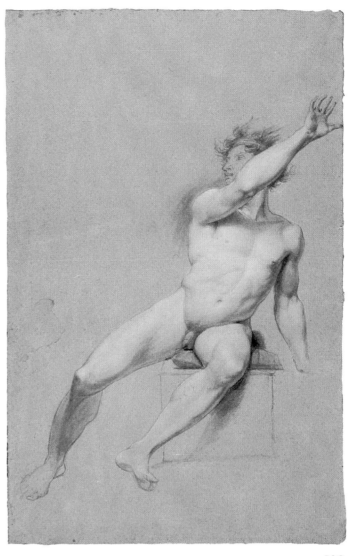

129

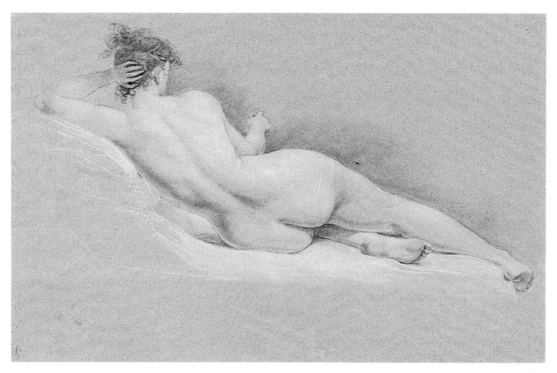

130

129
Seated Male Figure

c.1795
Black and white chalks with black crayon on blue paper,
 22 x 13⅞ (55.9 x 35.2)
Yale University Art Gallery; Gift of Gifford A. Cochran,
 B.A. 1929

130
Reclining Female Figure

c.1795
Black and white chalks with black crayon on blue paper,
 14 x 22½ (35.6 x 57.1)
Yale University Art Gallery; Gift of the Associates in
 Fine Arts at Yale

131
Reclining Female Figure

c.1795
Black and white chalks with black crayon on blue paper,
 13⅞ x 22¼ (35.2 x 56.5)
Yale University Art Gallery; Gift of the Associates in
 Fine Arts at Yale

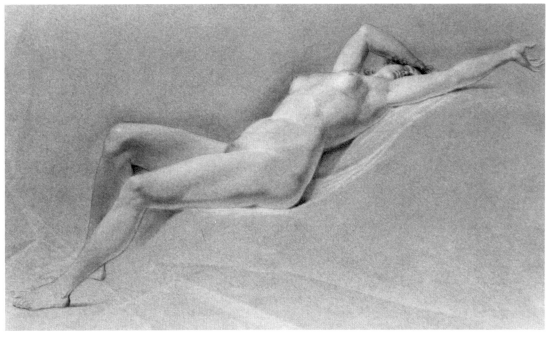

131

Religious Paintings

Trumbull's Religious Paintings
Themes and Variations

There is no country in the whole world in which the Christian religion retains a greater influence over the souls of men than in America

—Alexis de Tocqueville[1]

By Patricia Mullan Burnham

It is a provocative paradox that John Trumbull's most intensely religious works were, to all outward appearances, secular. The Revolutionary War series which engaged his labors for so many years was replete with spiritual significance for him. Born a Congregationalist and educated according to Puritan principles, Trumbull learned early to equate historical circumstance with the workings of divine providence. To him, it seemed as if the God who had so bountifully given America to the colonists granted them the gift of political independence a century and a half later. Political independence was not solely an act of national self-determination, but was connected in the Puritan mind with a particular concept of freedom. The only kind of resistance to civil authority sanctioned by Puritan orthodoxy was rebellion against tyranny. Thus, to the colonial peoples, especially devout Congregationalists like the Trumbulls, the American War of Independence possessed religious as well as political legitimacy.[2] Victories in battle were interpreted as divinely inspired, and defeats as divine chastisements; military leaders were looked upon as saints no less than as heroes.

As self-proclaimed "graphic historiographer"[3] of the Revolution, John Trumbull thought of his role as prophetic as well as journalistic. As he once wrote to a family member, he hoped to

> be spared to complete the work, for the accomplishment of which I seem to have been sent, & continued here.— that is— to shew to posterity the wonderful things which it pleased God to do for our Fathers.— for it was not their own wisdom, nor the strength of their own right hand, which founded & reared the mighty fabric under which we live.[4]

The art that was the fruit of this destiny included the eight small history paintings at Yale, the five half-size copies at the Wadsworth Atheneum, the four major panels for the Capitol Rotunda in Washington, D.C., and numerous other works relating to the war and its principal actors, especially George Washington. The commander-in-chief was held in the greatest esteem by his countrymen, not least the Trumbull family of Connecticut. The legends and myths that grew up about him became a kind of Protestant version of a Catholic hagiography.[5] When Washington was made general of

1 Alexis de Tocqueville, *Democracy in America*, Henry Reeves, trans., New York, 1839, I, p. 303.
2 See Sydney E. Ahlstrom, *A Religious History of the American People*, 2 vols., Garden City, N.Y., 1975, I, pp. 438–39, 453.
3 Trumbull used this term to refer to himself in Trumbull 1832, p. 3.
4 JT to Jonathan G. W. Trumbull, December 1, 1835, YUL-JT.
5 See, for example, the enumeration of relics and other hagiographical references to Washington in Silliman, "Notebook," II, pp. 51–54: "At Alexandria is the church in which he worshipped— the pew in which he sat. . . . In the museum . . . are the head and hoofs of his favorite war horse— the embroidered white silk mantle in which, when a babe, he was offered to God in baptism. . . . When Genl Washington's remains were removed from the early tomb it was said at the time . . . that the features were so little changed that they were recognized by those who had known him when living. . . . At Fredericksburg where he spent his early youth and where I passed some weeks in 1836 . . . they related many anecdotes of his childhood & youth but none that were marked by sin & folly."

Overleaf: detail of Cat. 137

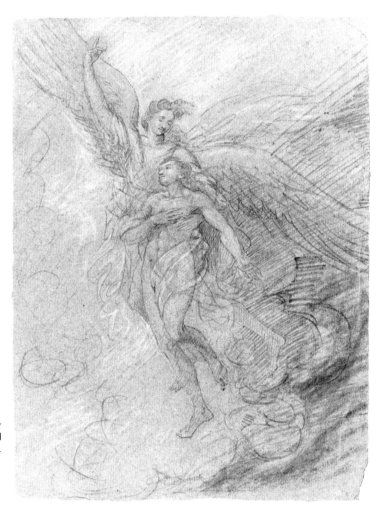

Fig. 67. The Apotheosis of Washington, c.1800. New York, Columbia University; Avery Architectural and Fine Arts Library.

the American army, Governor Trumbull congratulated him with sentiments that linked piety and patriotism:

> May the God of the armies of Israel shower down the blessings of his divine providence on you, give you wisdom and fortitude, cover your head in the day of battle.[6]

John Trumbull, who had served as the general's second aide-de-camp for a short period during the early part of the war, maintained a lifelong devotion to his memory. As Benjamin Silliman, his nephew-in-law, friend and confidant, wrote in 1857,

> His admiration of Washington amounted indeed to enthusiasm towards that great man; it appeared in the highest admiration of all the traits of his character, and in a warm feeling of personal attachment an affection truly filial.[7]

At his death, Trumbull was buried, according to his wishes, beneath his portrait of Washington in the Trumbull Gallery at Yale.[8]

Trumbull executed about sixteen portraits of Washington, as well as an allegorical drawing, *The Apotheosis of Washington* (Fig. 67).[9] The most interesting of Trumbull's characterizations of

6 Isaac William Stuart, *Life of Jonathan Trumbull, Sen., Governor of Connecticut*, Boston, 1859, p. 200.
7 Silliman, "Notebook," I, p. 25.
8 See Benjamin Silliman to C. Edwards Lester, March 17, 1846, YUL-JT, in which Silliman stated, "He [i.e., Trumbull] said to me— Place me at the foot of my great Master."
9 For the portraits, see the listing in Sizer 1967, pp. 81–84. The

Apotheosis of Washington theme, as it proliferated in the years after his death in 1799, is discussed in Phoebe Lloyd Jacobs, "John James Barralet and the Apotheosis of George Washington," *Winterthur Portfolio*, 12 (1977), pp. 115–37; and Patricia A. Anderson, *Promoted to Glory: The Apotheosis of George Washington*, exh. cat., Smith College Museum of Art, Northampton, Mass., 1980.

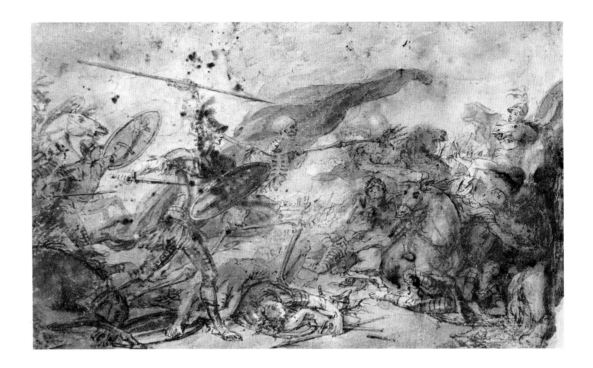

Washington is his *Joshua at the Battle of Ai—Attended by Death* (Cat. 159), the preparatory drawing for which (*Fig. 68*) was produced in 1786, at that special moment when history and religion were one. Although the subject is biblical, Trumbull's immediate source was Reverend Timothy Dwight's epic poem of 1785, *The Conquest of Canaan*. The poem, dedicated to George Washington, was an allegory of the American Revolutionary War, in which the exploits of Joshua were compared with the military victories of the American rebels; many claimed that Joshua was meant to represent Washington himself.

The parallels Dwight constructed between Old Testament Israel and the American experiment constitute a peculiar form of American typological thinking— a Puritan notion prevalent since the founding of the New England colonies. The perception of Old Testament figures and events as prefigurations of the New Testament is fundamental to Christian thought. But the use of the Old Testament to prefigure episodes in the contemporary secular sphere was a Puritan innovation.[10]

The Joshua/Washington story was an unusual choice of subject for a young, aspiring artist living in England in 1786, where the idea was originally conceived; it was a provincial choice for such a cosmopolitan context, American both in its literary source and in its use of scriptural parallels. Perhaps it provided a way for Trumbull to cling to his American identity while pursuing his chosen profession in an alien land. By this time, he was engaged in the beginning stages of his sketches for the Revolutionary War series. In the pull between referring to the war allegorically, as in *Joshua*, or representing the events of the war literally, the latter conclusively won out. The Revolutionary War series occupied much of his labor from then on, whereas the allegorical *Joshua* drawing was not worked up into a finished oil until almost fifty years later.

Joshua is unique in Trumbull's oeuvre in its combination of literary, religious, and historical/political references. Never again would he conceive of a subject in such richly allusive terms, although his Puritan love for multiple meanings would never be abandoned completely. It is at once a testament to a moment in his own lifetime, when his Puritan sensibility was still intact, and to a particular moment in the national psyche. After 1786, Trumbull firmly separated his subject categories into

10 See especially Sacvan Bercovitch, *The Puritan Origins of the American Self*, New Haven, 1975, pp. 35–36: "In its original form, typology was a hermeneutical mode connecting the Old Testament to the New in terms of the life of Jesus," but Puritan typology "translates secular history, whether of individuals, or of communities, into spiritual biography." See also Ursula Brumm, *American Thought and Religious Typology*, New Brunswick, N.J., 1970, p. 46.

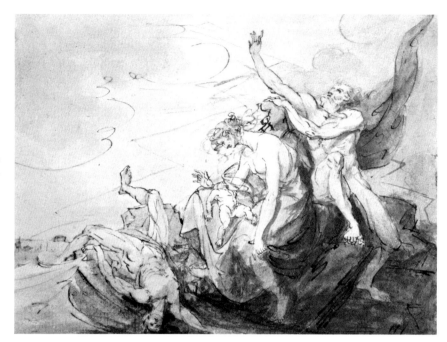

Fig. 68. (Opposite) Study for *Joshua at the Battle of Ai— Attended by Death* (Cat. 160).

Fig. 69. Study for *The Last Family Who Perished in the Deluge* (Cat. 138).

contemporary history paintings and traditional religious themes. Puritan typology gave way to pure history; Protestant spirituality espoused Catholic art.

In view of the religious content in his historical paintings, it is hardly surprising that Trumbull also painted purely religious subjects: almost fifty finished oils in all, counting copies, replicas, and variants (of which about half are extant), and over thirty assorted drawings and sketches. In sheer volume, Trumbull's religious paintings outnumber everything except his portraits, and date from his adolescence through his old age. Because they span a period of almost seventy years, they exhibit a more varied range of style than do the other genres in which Trumbull worked, and reveal him to have been in the vanguard of English history painting, a term that included scriptural subjects. Trumbull's religious works were part of the renascence of religious art in England that began with Thornhill and Hogarth early in the eighteenth century and reached its apogee in Benjamin West.[11] These works were exhibited at the Royal Academy and the British Institution in London, and were the mainstay of the American Academy of the Fine Arts exhibitions in New York City for two decades. Of the seven pictures Trumbull contributed to the British Institution exhibitions, three were religious in subject. In this country, they commanded high prices on a par with their British counterparts. In short, they were valued by him and by society as serious and worthy works of art.

Why, then, have Trumbull's religious works been systematically neglected for so long? To begin with, in Trumbull's own lifetime, figural religious painting went out of fashion. Madonnas and Holy Families did not suit Jacksonian America; the wonder is that they were tolerated even in the Federalist era. Eventually, scholarly taste also changed. Art historians and critics considered landscapes and genre scenes the art most expressive of nineteenth-century America. To compound matters, many of Trumbull's religious works were openly, even blatantly, derivative. This not only raised the issue of "foreign" influence during the nationalistic decades of the mid-nineteenth century, but later became a special problem in its own right, when originality came to be considered a necessary condition for artistic merit. There is also the issue of quality: many of Trumbull's religious canvases are uneven, particularly those done in his later years. From the perspective of the present, however, it is help-

11 The evolution of religious painting in England and West's contribution to it are discussed by Jerry Don Meyer in "The Religious Paintings of Benjamin West: A Study in Late Eighteenth and Early Nineteenth Century Moral Senti- ment," Ph.D. diss., New York University, 1973, and John Dillenberger, *Benjamin West: The Context of his Life's Work, with Particular Attention to Paintings with Religious Subject Matter*, San Antonio, Texas, 1977.

ful to view the artist holistically, more aware of the context in which he worked and open to his multiple intentions.

The question then becomes: What were Trumbull's intentions in making so many religious pictures? His personal piety has already been mentioned as a factor, especially with regard to the American history paintings. His religious affiliation changed over the years— from Congregationalism as a youth and young adult, to Anglicanism when he married and, if Benjamin Silliman is to be believed, to an interest in Unitarianism in his later years.[12] Silliman vividly describes him as "a punctual attendant on our family prayers, and tears would sometimes flow down his checks when certain passages of the bible were read, for he had great sensibility both moral and physical."[13] His commitment to basic Christian principles was thus a constant in his life, whatever denominational form it took. But it is evident that this is not the only explanation for his interest in religious subject matter as a basis for art.

From the beginning, Trumbull came to liken religious themes to high art. A checklist he drew up cites a *Crucifixion* (unlocated), executed while he was still a teenager.[14] While an undergraduate at Harvard, he copied another *Crucifixion* (unlocated) in watercolor from an engraving after Rubens, and copied in oil *Abraham's Servant Meeting Rebekah at the Well* from an engraving after Coypel. He copied a mezzotint after West's *Elisha Restoring the Shunammite's Son* (*Figs. 7, 6*) three years before he actually met West in London.[15] When he visited John Smibert's old studio in Boston after his military service, one of the paintings that he admired there was Smibert's copy of Raphael's *Madonna della Sedia* (unlocated).[16]

Trumbull arrived in London in 1780, just after George III had commissioned Benjamin West to undertake a massive project at Windsor Castle, the painting and installation of over thirty canvases "for the purpose of displaying a pictorial illustration of the history of revealed religion."[17] Only recently, the Duke of Rutland had paid Sir Joshua Reynolds the extraordinary sum of 1200 pounds for his painting of the *Nativity*, the preparatory work for a stained-glass window at Oxford.[18] (In his *Discourses*, Sir Joshua had recommended "the capital subjects of Scripture history" as subject matter for art, "which, besides their general notoriety, become venerable by their connection with our religion."[19]) Furthermore, there was the example of Renaissance and Baroque masterpieces, many of which were religious in nature. The great collections were being formed in England, and the auction houses and art dealers were busy filling country seats with European religious art. Among the first tasks assigned to Trumbull by his teacher, Benjamin West, was to copy copies of masterpieces, such as Raphael's *Madonna della Sedia*.[20] Most of Trumbull's first visit to England was taken up by his seven-month imprisonment, but the one painting he worked on in prison was religious (Cat. 133), a copy of West's copy of Correggio's *Madonna of St. Jerome*.[21] The implication was clear: painting great religious subjects, worthy in itself, also led to prosperity and artistic renown.

The first original religious conceptions that Trumbull worked out on his own date from his second visit to England, the *Joshua* drawing of 1786, and *The Last Family Who Perished in the Deluge*, dating to the same year (*Fig. 69*). In terms of subject matter, the *Deluge* was less original than *Joshua*, and was in fact beginning to be a popular theme. The subject enjoyed a certain preference among romanticized religious subjects in English art, although the most famous examples by John Martin and Girodet-Trioson came considerably later (see Cat. 138). Trumbull's interpretation of the subject was also Romantic. He focused on the fate of the last family to perish in the flood, no doubt influenced by the current interest in the sublime in England.

12 Silliman, "Notebook," I, p. 33.
13 Ibid.
14 Trumbull, "Account of Paintings," I, no. 5.
15 Ibid., I, nos. 7, 19, 30.
16 Trumbull 1841, pp. 49–50.
17 John Galt, *The Life of Benjamin West* (1816–20), reprint, Gainesville, Fla., 1960, part II, p. 53.

18 Ellis Waterhouse, *Reynolds*, London, 1973, p. 30.
19 Sir Joshua Reynolds, *Discourses on Art*, Robert R. Wark, ed., New Haven, 1975, p. 58.
20 Trumbull 1841, pp. 66–67.
21 Ibid., pp. 67–68.

Trumbull abandoned the drawing as he had the *Joshua* drawing, only to pick it up again in 1838. The two 1786 drawings are good examples of Trumbull's achievement at the beginning of his London career. *Joshua* and the *Deluge* illustrate his efforts to translate biblical stories with which everyone was familiar into stark dramas that would capture the public taste for pictures depicting highly wrought emotional states. Formally, they document his experiments with figure styles, as well as with compositional organization. The two finished paintings (Cats. 137, 159), executed late in life, disclose his continuing interest in color harmony, multiple glazes, and painterly effects. Together, this sequence of drawings and paintings of Old Testament themes constitutes an ambitious effort in the field of religious art between the 1780s and the 1840s.

The key religious work of John Trumbull's third English sojourn (1794–1804) is the *Madonna au Corset Rouge* (*Madonna and Child with St. John the Baptist*), 1801 (*Fig. 71*), a copy of Raphael's *La Belle Jardinière* at the Louvre.[22] Copies were the means by which admired masterworks became known, especially in the New World. In addition, ambitious artists often copied in order to demonstrate their mastery of technique to peers and potential patrons. Trumbull's decision to copy *La Belle Jardinière* was pivotal in his development for several reasons: it was a formal declaration of his esteem for Raphael and the Renaissance tradition; it announced a set of themes— Madonna and Child, the Holy Family— that would claim his attention for years to come; and it was a practical source of motifs for several spin-off works that were thought of and exhibited as originals. The *Madonna au Corset Rouge* represented a surprising departure from the type of religious art exemplified by *Joshua* and the *Deluge*, revealing Trumbull's interest in New Testament themes, in Renaissance instead of contemporary prototypes, and in devotional qualities rather than narrative content.

Trumbull married Sarah Hope Harvey in 1800, the year before he painted the *Madonna au Corset Rouge*. They wed with the earnest but unfulfilled hope of starting their own family. The sudden proliferation of Madonnas in his art at that time would seem to be expressive of his tender regard for his wife, and of his hope for progeny. (He even went so far as to substitute Sarah's likeness for the face of Raphael's Virgin in the *Madonna au Corset Rouge*.) It was apparently during this period that Trumbull also came to embrace Anglicanism, a less austerely patriarchal sect than the Congregationalism in which he had been reared. He seems to have been attracted to a more "feminized" spirituality, one that encouraged as well as judged, loved as well as punished. Trumbull even referred to his paintings as his "children."[23]

An interest in family subjects was widespread in late eighteenth-century England, a phenomenon which reflected developments in the sociology of the family.[24] The very definition of a child changed under the somewhat contradictory influences of Enlightenment pedagogical principles and the theories of Jean-Jacques Rousseau. The rationalist philosophers viewed the child as a *tabula rasa*; Rousseau saw the child as fundamentally good. To both groups, however, childhood was a separate and enviable phase of the life cycle and a special time of innocence. This is perhaps best expressed by Reynolds' *The Age of Innocence*, 1788 (National Gallery, London), in which a sweet-faced, sentimentalized young girl personifies Innocence. The effects of such tendencies on art were readily seen in the renewed interest in the family as subject matter, whether sacred or secular.[25] It is significant that the frontispiece to the New Testament part of Macklin's *Bible*, published in 1800, was not a Crucifixion or a Resurrection scene, but an engraving after Reynolds' *Holy Family*.[26]

22 It was actually a copy of a copy of *La Belle Jardinière*; see Jaffe 1975, p. 201.

23 See Trumbull's comment, quoted in Silliman, "Notebook," I, p. 40: "It is my wish to be interred beneath the Gallery. . . . These [paintings] are my Children."

24 For references, see Cat. 158, n. 11.

25 The mother-child relationship and associated motifs as they occur in Reynolds and are developed by Trumbull will be discussed at greater length in my doctoral dissertation on the religious paintings of John Trumbull, now in progress.

26 For the Macklin *Bible*, see the definitive studies by T. S. R. Boase, "Macklin and Bowyer," *Journal of the Warburg and Courtauld Institutes*, 26 (1963), pp. 148–77, and "Biblical Illustration in Nineteenth Century English Art," *Journal of the Warburg and Courtauld Institutes*, 29 (1966), pp. 349–67.

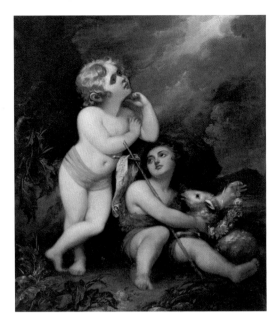

Fig. 70. *Infant Savior and St. John*, 1801. Hartford, Wadsworth Atheneum; Bequest of Daniel Wadsworth.

Fig. 71. (Opposite, left) *Madonna au Corset Rouge (Madonna and Child with St. John the Baptist)*, 1802. New Haven, Yale University Art Gallery; Trumbull Collection.

Fig. 72. (Opposite, right) *Holy Family*, 1802–6. New Haven, Yale University Art Gallery; Trumbull Collection.

Trumbull's *Holy Family*, 1802–6 (*Fig. 72*), is thematically connected with the burgeoning interest in family subjects, and is one of the pictorial offspring of the *Madonna au Corset Rouge*. Trumbull copied the Madonna and children directly from the *Madonna au Corset Rouge*, and added the figures of Joseph, Zachariah, and Elizabeth— a willowy young woman whose elongated body is more related to the contemporaneous figural vocabulary. This kind of pastiche had a long history in Trumbull's work. In his *Autobiography*, he described composing one of his earliest works, *The Death of Paulus Aemilius* (Cat. 1) by selecting figures from various engravings and combining them into groups.[27] Even as late as 1800, when he had been a professional artist for some years, Trumbull followed a similar practice in this painting: borrowing the Madonna and children from Raphael, the male characters probably from a northern Baroque prototype, and Elizabeth perhaps from a contemporary source. When William Dunlap saw the painting at the Trumbull Gallery many years later, he excoriated it as being "without originality of thought," although he conceded that it was "beautifully painted."[28] Trumbull would have been surprised at such a criticism. The practice of borrowing was common and had even gained the sanction of Sir Joshua. In his Sixth Discourse, Reynolds stated that

> he, who borrows an idea from an antient, or even from a modern artist not his contemporary, and so accommodates it to his own work, that it makes a part of it, with no seam or joining appearing, can hardly be charged with plagiarism: poets practise this kind of borrowing, without reserve.[29]

Trumbull no doubt felt that he was continuing a tradition of associative borrowing established by Reynolds.

Another descendant of the *Madonna au Corset Rouge* composed according to the principles of selective borrowing is *Infant Savior and St. John*, 1801 (*Fig. 70*), in which the Christ Child is derived from Raphael but the infant Baptist is adapted from Murillo's child saints.[30] Trumbull's choice of Murillo as a model is interesting in that the Spanish artist was considered inferior to the great painters

27 Trumbull 1841, p. 14.
28 Dunlap 1834, I, p. 393.
29 Reynolds, *Discourses*, ed. cit., p. 86.

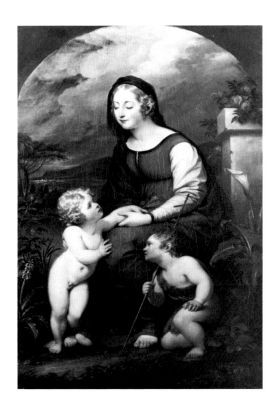
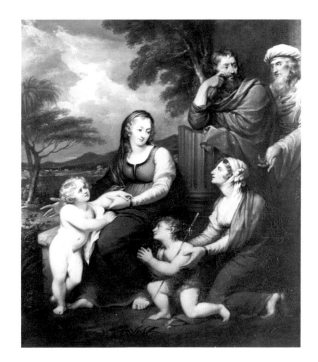

of the Italian Renaissance. He was not among the artists recommended by Reynolds in his *Discourses*, and Sir Thomas Lawrence is on record as having disliked his work.[31] English collectors, however, began to acquire Murillos toward the end of the eighteenth century. The Bryan Collection, for example, auctioned in 1798, contained a variety of Madonna and Holy Family pictures, including six by Murillo; the catalogue stated that Murillo was to be admired for his "simplicity and truth."[32] In addition, the tenderness of Murillo's Madonnas and children would have appealed to the taste for the sentimental on the part of English buyers. The collection which Trumbull acquired and sold in 1797 also included a Murillo, *St. John with the Lamb* (unlocated).[33]

The children who form a conventional part of Madonna imagery seem to have had a special attraction for Trumbull, possibly again for personal as well as artistic reasons. In 1792, he apparently fathered an illegitimate son in Connecticut, who would have been only slightly older than the young boys he painted in these pictures.[34] Shortly after his marriage in 1800, at his bride's prompting, Trumbull made contact with the boy's natural mother and sought to make provision for him. These factors, coupled with his acknowledged yearning to have a child by his wife, lend a secondary meaning and a touching poignancy to the child pictures of his third English period.

When Trumbull returned to London in 1808 for the fourth and last time, his aged mentor, Benjamin West, was already embarked on "an event which formed an era in the history of the arts," the series of vast scriptural narratives, which he had begun some years before.[35] Of these, *Christ Healing the Sick in the Temple* of 1811 (*Fig. 73*; the Tate Gallery picture is damaged; reproduced here is

30 In 1800, Trumbull painted *St. John and the Lamb* (Yale University Art Gallery), which he subsequently described as being "from memory of an exquisite picture by Murillo" (Trumbull 1832, p. 29). Possibly Trumbull meant a Murillo such as *Infant Baptist* (National Gallery of Ireland, Dublin). The infant Baptist in the 1801 picture, which features both Christ and St. John, is a variation of the 1800 *St. John and the Lamb*.

31 See Francis Haskell, *Rediscoveries in Art*, Ithaca, N.Y., 1976, p. 70.

32 From the catalogue, *Auction of Mr. Bryan's Collection by Peter Coxe, Burrell and Foster*, London, 1789, p. 2, YUL-JT.

33 The Murillo is mentioned in *A Catalogue of a Most Superb and Distinguished Collection of Italian, French, Flemish, and Dutch Pictures—A Selection Formed with Peculiar Taste and Judgment by John Trumbull, Esq.*, London, 1797, YUL-JT. For a discussion of Trumbull's art dealings, see Jaffe 1975, pp. 172–75.

34 For Trumbull's illegitimate son, see p. 12, and Sizer 1953, pp. 332–50.

35 Galt, *The Life of Benjamin West*, part II, p. 186.

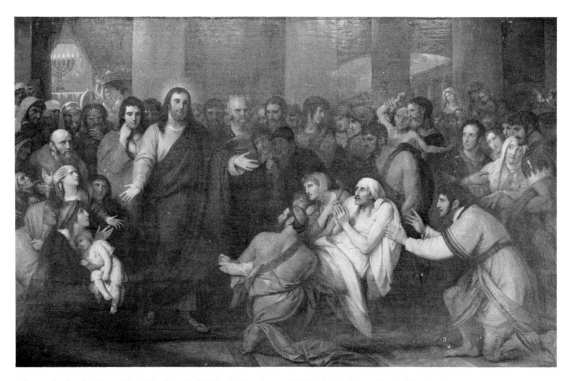

Fig. 73. Benjamin West, *Christ Healing the Sick in the Temple*, 1815. Philadelphia, Pennsylvania Hospital.

the 1815 version) was probably the most popular. Dismissed from his Windsor Castle commission in 1801 and thrown on his own resources at a vulnerable age in life, West rallied bravely and succeeded in making bold and dramatic artistic statements and attracting patrons for them. The first version of *Christ Healing the Sick* had its own exhibition at the British Institution in 1811, where it was besieged by viewers and netted almost 10,000 pounds in receipts. In these late paintings West discovered how to dramatize scriptural events by adroit orchestration of the emotions of a large cast of characters. Neither the artistic nor the financial lessons were lost on Trumbull.

The *Woman Taken in Adultery*, 1811 (*Fig. 76*), and *Our Savior and Little Children*, 1812 (*Fig. 74*), Trumbull's scriptural narratives done in emulation of West's, were cited by Dunlap as "the best pictures painted by the artist at this period."[36] For large-scale canvases obviously intended to be major statements by the artist, they are surprisingly derivative in style. During his three previous English visits, Trumbull's style had not been predominantly Westian, despite the fact that he had worked closely with West. Why, then, when he was a practicing artist of many years' standing, now in his mid-fifties, did he associate himself with West in such an obvious way? It is worth noting that even Washington Allston, who also resided in London at this time and ordinarily took a more independent course, imitated West's style in his oil study for *Christ Healing the Sick*, 1813 (Worcester Art Museum). It is almost as if they thought of these late works by West as moral exemplars no less than as pictorial prototypes governing how a scriptural episode ought best to be painted. Trumbull priced these paintings higher than any of his works, except for the *Sortie* and the Revolutionary War pictures commissioned for the Capitol Rotunda. At one point, *The Woman Taken in Adultery* and *Our Savior and Little Children* were sold to the American Academy of the Fine Arts in New York for 3500 dollars apiece, which was the same price promised to Washington Allston by the Pennsylvania

36 Dunlap 1834, I, p. 374.

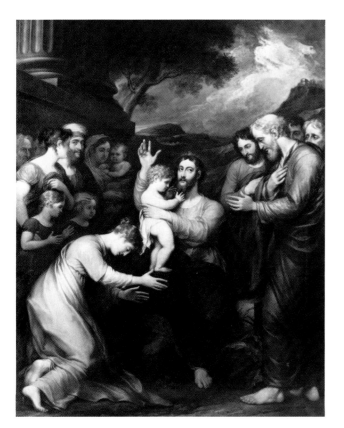

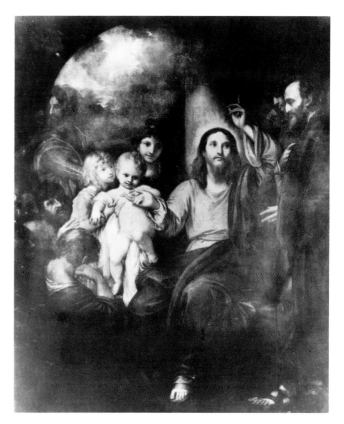

Fig. 74. Our Savior and Little Children (or *Suffer Little Children*), 1812. New Haven, Yale University Art Gallery; Trumbull Collection.

Fig. 75. Benjamin West, *Suffer the Little Children*, 1792. London, The Governors of the Thomas Coram Foundation for Children.

Academy of the Fine Arts for his *Dead Man Revived by Touching the Bones of Elisha*.[37] When the American Academy was forced to default on payment, the two large paintings were sent to the Boston Athenaeum, priced at 2500 dollars apiece.[38] Such prices indicate the high value Trumbull placed on these particular works.

Thematically, *Our Savior and Little Children* was the logical end-point of all the infant saint pictures of the previous decades. It spiritualized the secular penchant for sentimental child subjects by pointing to the religious basis for them. The motif had a distinguished history in the English religious art produced in the circle of Benjamin West, who first attempted the subject in his *Christ Blessing Little Children* of c.1781 (Royal Academy, London), and on several occasions thereafter. The last of West's essays on this theme was *Christ Teacheth to be Humble*, 1810 (recently, London art market), which Trumbull would have seen at the Royal Academy the same year. Thus, the thematic precedent for Trumbull was set.

West's *Suffer the Little Children (Fig. 75)* was influential from a stylistic point of view. The figure of Christ, a constant in West's long series of biblical narratives, derived principally from the Bolognese masters and late Raphael. Trumbull took over the physical type in *Our Savior and Little Children*— in fact, the whole painting is a pastiche of the West. William Dunlap actually preferred Trumbull's Christ to West's, calling it "the best large historical figure by this painter."[39] Trumbull's child figure in *Our Savior and Little Children* is quite different, however, from the naturalistic children of West, and is obviously descended from the plump, curly-haired idealized infant saints of Raphael, as in the *Madonna del Cardellino*.

37 See Elizabeth Johns, "Washington Allston's *Dead Man Revived*," *The Art Bulletin*, 61 (1979), p. 96.

38 Jaffe 1975, pp. 268–69, discusses the Academy default. The 2500-dollar price is recorded in the archives of the Boston Athenaeum.

39 Dunlap 1834, I, p. 374.

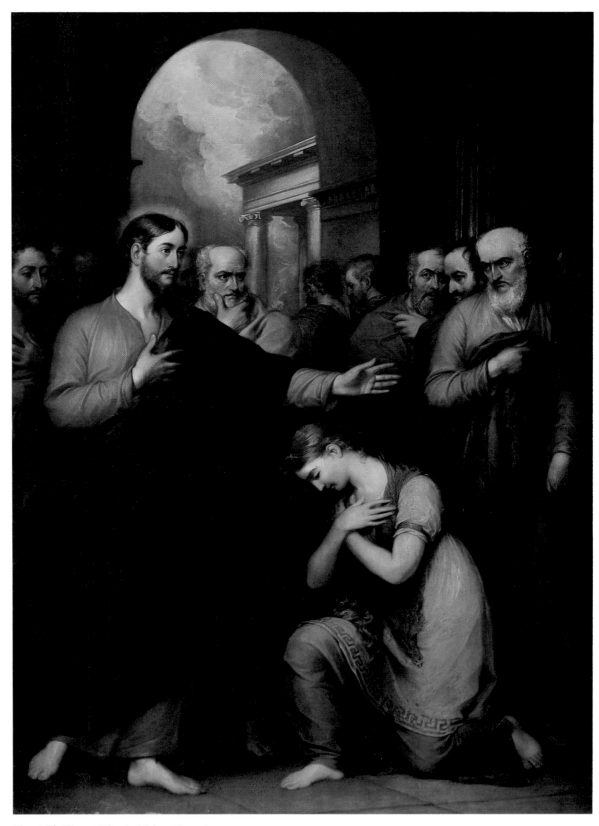

Fig. 76. The Woman Taken in Adultery (Cat. 135).

Trumbull also looked to West in his attempts to characterize the Apostles in *Our Savior and Little Children* and the scribes and Pharisees in *The Woman Taken in Adultery*. In the latter, especially, the intensity of feeling and specificity of emotion rival West's in *Christ Healing the Sick*. In his Academy discourse delivered in December 1811, West had set forth his ideas concerning dramatic truth and psychological realism:

> The first thing they [the students] must impress upon their minds, and ingraft upon every shoot of their fancy, is that of the appropriate character, by which the subject they are about to treat, is distinguished from all other subjects. On this foundation, all the points of refined art which are, in the truest sense, intellectual, invariably rest; for without justness of character, the works of the pencil can have but little value, and can never entitle the artist to the praise of a self-governed genius, or of possessing that philosophical precision of judgment, which is the source of excellence in the superior walk of his profession.[40]

Trumbull evidently took to heart the twin concepts of "justness of character" and "philosophical precision of judgment."

For the lower part of the pose of the mother in *Our Savior and Little Children*, Trumbull used the Magdalen in Correggio's *Madonna of St. Jerome*, a borrowing which did not escape the critical eye of William Dunlap.[41] On the other hand, the pose of the adulteress in *The Woman Taken in Adultery* is supposedly based on Sarah Trumbull. The faces of both the mother in *Our Savior and Little Children* and the adulteress are copied directly from the character type of "Veneration" in Le Brun's *Expression des Passions*.[42] There is a certain contradiction in Trumbull's use of a standardized model for expression in order to attain the end of psychological realism advanced by West.

Trumbull left England for the last time in 1815. Despite the exposure his major religious pictures had enjoyed at the British Institution and the Royal Academy, they remained unsold. West, too, had difficulty selling his religious pictures after his great success of 1811. For Trumbull's fellow-American, Washington Allston, the search for patrons was also a continual struggle, but his quest was more successful than Trumbull's.[43] Even portrait commissions were hard to come by in the late days of the War of 1812, and the Trumbulls suffered financial hardship. It is conceivable that Trumbull's past as a so-called spy may have told against him. The colonel and his wife repaired to New York City, where in 1816 the best of his religious pictures, including *Infant Savior and St. John*, *Our Savior and Little Children*, and *The Woman Taken in Adultery*, were exhibited at the American Academy of the Fine Arts. They still did not sell, but nevertheless were influential in inaugurating an era of religious painting in America. Over the next fourteen years, America saw a proliferation of religious art by young and aspiring artists, as well as by established ones.[44]

Trumbull, however, turned away from religious themes. In 1817, he had finally won the commis-

40 Benjamin West, *A Discourse Delivered to the Students of the Royal Academy, Dec. 10, 1792*, London, 1793.

41 See Dunlap 1834, I, p. 374: "The most striking defect is the palpable imitation of the Magdalen in Correggio's St. Jerome, which the artist had copied (from West's copy) in the winter of 1800–01 and the utter failure in the attempt." For Trumbull's *St. Jerome, at Parma*, see Cat. 133.

42 Trumbull copied "Veneration" and other character heads from Le Brun in the 1770s in "Early Sketches and Drawings," YU-B. See also Cat. 2.

43 The *Annals of the Fine Arts* listed Allston as one of the principal history painters (which included religious subjects) in England in 1816; see William H. Gerdts, *"A Man of Genius": The Art of Washington Allston*, exh. cat., Museum of Fine Arts, Boston, 1979, p. 109.

44 Washington Allston, also recently returned from London, continued work on his *Belshazzar's Feast*, and completed several major religious works during this period. Even William Dunlap seems to have specialized in religious subjects for a time, taking them on tour throughout the country between 1822 and 1828. The most spectacular tour was conducted by Rembrandt Peale in his *Moral Allegory (Court of Death)* in 1820 (The Detroit Institute of Arts). Henry Sargent followed suit with *Christ Entering Jerusalem* and *Christ Crucified* (unlocated). Even the young William Sidney Mount began his career with two religious subjects, *Christ Raising the Daughter of Jairus*, 1828 (The Museums at Stony Brook, New York), and *Saul and the Witch of Endor*, 1828 (National Museum of American Art). Thomas Cole also began his career in the 1820s with religio-historical landscapes such as *Saint John the Baptist Preaching in the Wilderness*, 1827 (Wadsworth Atheneum), and *Expulsion from the Garden of Eden*, 1827–28 (Museum of Fine Arts, Boston).

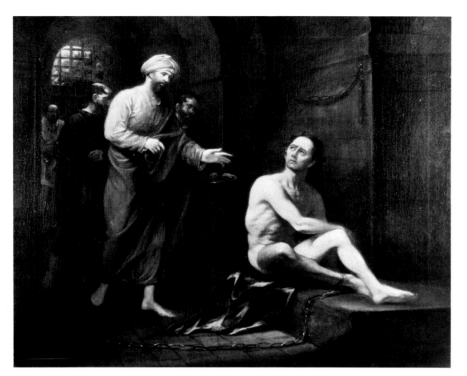

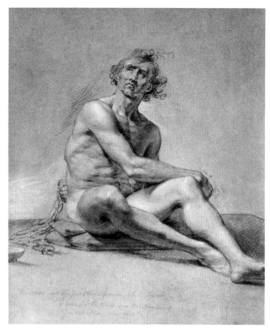

Fig. 77. "I Was in Prison and Ye Came unto Me," c.1834. New Haven, Yale University Art Gallery; Trumbull Collection.

Fig. 78. Study for "I Was in Prison and Ye Came unto Me," c.1784–85. New Haven, Yale University Library; Benjamin Franklin Collection.

sion to paint the Revolutionary War scenes for the Capitol Rotunda. A decade passed before they were successfully installed and Trumbull once again took up religious subjects. By this time, Sarah was dead and he was again plagued with financial woes. Furthermore, there were problems at the American Academy of the Fine Arts, resulting in the formation of the rival National Academy of Design in 1826 (see p. 16). The following year Trumbull exhibited accomplished copies of Old Master religious works at the American Academy, in the hope that what he considered to be his superior technical ability and elevated subject matter would once again prevail. Among the religious works exhibited was *Preparation for the Entombment of the Savior*, 1827 (Cat. 136), a variation on a painting by Annibale Carracci. Despite the competence of the copy and the renown of the source, it did not sell. In 1831, at the age of seventy-five, Trumbull made over to Yale College a substantial number of his works, including many of his religious paintings.[45]

Trumbull was productive until his death in 1843. The last decade of his life was a period of sustained artistic effort divided between a third version of the American history series for Daniel Wadsworth and a series of religious subjects. Even at this late date, he undertook several major copies: Titian's *Christ Crowned with Thorns* (Wadsworth Atheneum); Raphael's *Transfiguration* (Yale University Art Gallery); and Domenichino's *Last Communion of St. Jerome* (Yale University Art Gallery). Trumbull believed that the *Transfiguration* and *Last Communion*, along with Correggio's *Madonna of St. Jerome*, "were allowed by all connoisseurs to be . . . the three finest paintings in existence."[46] It was important to him, therefore, that copies of all three be represented in the Trumbull Gallery. He had copied the *St. Jerome* early in his career (Cat. 133); it now remained for him to do likewise with the *Transfiguration* and *Last Communion*. He also did several original compositions, including yet another, different *Holy Family*, 1839–40 (Yale University Art Gallery).

45 The terms are spelled out in Trumbull 1841, pp. 288–94; see also Jaffe 1975, pp. 276–80.
46 Trumbull 1832, p. 17.

Among the paintings of Trumbull's old age is "*I Was in Prison and Ye Came unto Me*" (*Fig. 77*). Although flawed technically in figural drawing and application of paint, the picture contains interesting autobiographical elements woven into the scriptural story to create a web of rich associated meanings. The subject may have been chosen *in memoriam* to Trumbull's friend, the artist Gilbert Stuart, who had died in 1828. "*I Was in Prison*" can be viewed as a reflection on his own prison experience in London in 1780–81, with a courtly reference to the friend who had, indeed, visited him during his incarceration.[47] (In 1840, Trumbull gave to the Pilgrim Society of Plymouth the portrait of himself that was partly painted by Stuart, *John Trumbull in Prison*, 1781.[48]) Trumbull habitually quoted Scripture, as is well known from records of conversation, written correspondence, and his *Autobiography*. It would have been a natural impulse for him to have looked to the works of mercy enumerated in Matthew 25 as a metaphor for his own imprisonment and for the solicitude of his friend Stuart. Trumbull based the figure of the prisoner on a life drawing he made in London, decades earlier, probably in 1784–85, when he was taking classes in the Royal Academy (*Fig. 78*).

The prison theme was a popular one at the time, as Lorenz Eitner has pointed out, with many prison pictures reflecting contemporary attempts to reform prison conditions.[49] Trumbull's painting, however, emphasized the religious character of the scene; it is neither an indictment of prison conditions nor a Romantic study of the psychology of prisoners. "*I Was in Prison*" remains an interesting work of Trumbull's old age because of its fusion of sentiment, personal experience, and religious belief.

In 1843, Trumbull died. He was laid to rest beside Sarah in a tomb beneath the Trumbull Gallery, near the paintings he called his "children," and beneath his portrait of George Washington, as he had wished. In the funeral sermon preached by Dr. Eleazar Thompson Fitch of Yale College, the text chosen was from Genesis 25:8–10:

> Then Abraham gave up the ghost, and died in a good old age, an old man and full of years;
> and was gathered to his people. . . . The field which Abraham purchased of the sons of
> Heth: there was Abraham buried, and Sarah his wife.[50]

The funeral was simple and old-fashioned, like Trumbull himself, the analogy made between the great biblical patriarch and the painter fully in the typological mode.

More died with Trumbull than his earthly presence. His death signified the end of an era, that of religious painting in the grand style in America. The conjunction of the deaths of both Trumbull and Washington Allston in the same year spelled the end of large figural narratives from Scripture as a dominant form of religious expression. There was a shift from the traditional kind of religious art learned in England to something more indigenous. With the development of an American landscape school, the wilderness itself became "a fitting place to speak of God."[51]

47 Jane Dillenberger first mentioned to me the possibility that the prisoner might be Trumbull.

48 Trumbull wrote to the Pilgrim Society in 1840: "You are aware that I was arrested and committed to prison in London in the year 1780, and liberated in June 1781. As soon as I was at liberty, my friend Stewart [*sic*] who died lately in Boston, and who was then a student with Mr. West, painted the *face* of the portrait. I painted the other parts." Cited in *Proceedings of the Massachusetts Historical Society*, 47 (February 1914), p. 271.

49 Lorenz Eitner, "Cages, Prisons, and Captives in Eighteenth-Century Art," in *Images of Romanticism: Verbal and Visual Affinities*, Karl Kroeber and William Walling, eds., New Haven, 1978, pp. 13–38.

50 Silliman, "Notebook," I, p. 42.

51 Thomas Cole, "Essay on American Scenery, 1835," in *American Art 1700–1960: Sources and Documents*, John W. McCoubrey, ed., Englewood Cliffs, N.J., 1965, p. 100.

St. Paul Preaching at Athens

1774

Pen and ink and pencil on paper, 10⅝ x 8½ (27 x 21.6)
Inscribed, verso: *Jn.ᵒ Trumbull— Lebanon | 1774*
Fordham University Library; Charles Allen Munn
 Collection

This pen drawing of St. Paul at Athens was executed by
the eighteen-year-old artist before he had received any
formal instruction.[1] Drawing manuals circulating in
England and America during the eighteenth century pre-
sented a late Baroque idea of antiquity, with allegorical
figures shown nude or with ample drapery falling in com-
plex folds, drawn in careful outline, with shadows me-
ticulously applied by complex cross-hatching. *St. Paul
Preaching*, done shortly after Trumbull graduated from
Harvard, is like an engraving in one of these manuals. A
self-consciously ancient and noble scene, it is undoubtedly
a pastiche, combining details from different engraved
sources— such as the leaning figure seen from the rear at
the far left, based on the *Hercules Farnese*, which Trumbull
might have known from the engraving in Hogarth's *Anal-
ysis of Beauty*, and the architectural background and an-
tique pedestal in the foreground. Without knowing how
to create a space deep enough for his figures and props,
Trumbull layered them, thus adopting one of the implicit
assumptions of the drawing manuals— that composition
was merely a collection of details.[2] It is perhaps not
surprising that he never completed the laborious cross-
hatched shading of the semicircular stoa in the back-
ground, for amateur books rarely told how to produce a
fully shaded composition.

 1 When the drawing was sold at auction in 1896 the catalogue
 described the work as from the "engraving of Raphael's great
 work"; see Stan V. Henkels, *Catalogue of the Very Important Studies
 and Sketches Made by Col! John Trumbull*, Philadelphia, December
 17, 1896, no. 102. It does not appear to be after any known Raphael
 composition.
 2 See Diana Strazdes, "The Amateur Aesthetic and the Draughts-
 man in Early America," *Archives of American Art Journal*, 19 (1979)
 pp. 20–21.

132

St. Jerome, at Parma

1780–81

Oil on canvas, 31½ x 23⅝ (80 x 60)
Yale University Art Gallery; Trumbull Collection

St. Jerome, at Parma is the earliest extant religious picture
painted by Trumbull in England under the tutelage of
Benjamin West. It has achieved considerable notoriety
among Trumbull's works because it was painted by him
while he was in prison in England on charges of spying.[1]
Even the redoubtable Horace Walpole took note of the
fact that the young American painter kept up his profes-
sional training under conditions of duress.[2]
 Trumbull arrived in London in July 1780, and imme-
diately began to work under the direction of West, copy-
ing a copy of Raphael's *Madonna della Sedia* (both copies
are unlocated). He next took up the challenge of copying
West's copy of Correggio's *Madonna of St. Jerome*, "one of
the three finest paintings in existence."[3] Before he could
complete the copy, however, Trumbull was arrested as an
American spy and remanded to prison, where he lan-
guished for seven months. Fortunately, the terms of his
incarceration were mild, and he was permitted to do some
painting in his room. The West/Correggio copy is the
only painting we know with certainty that he executed
during this time. (He also produced some chalk studies,
for example, Cat. 125. *John Trumbull in Prison*, 1781, painted
partly by him and partly by Gilbert Stuart, was apparently
done after his release.[4])
 St. Jerome was a student copy done early in Trumbull's
career to the exacting requirements of West. It was per-
force a literal copy, in contrast to his embellished copies,
adaptations, or paraphrases and is among the most accom-
plished copies that he attempted during his lifetime. Wil-
liam Dunlap considered it as "equal to his master's [e.g.
West's], and certainly one of the gems of the art."[5] Trum-
bull was especially proud of having made the copy with-
out the help of transfer devices. He had first achieved this
feat, to West's astonishment, in copying the *Madonna della
Sedia*. "Do you expect to get a correct outline by your eye
only?" West had asked. When he viewed the result, he is
recorded by Trumbull as having stated categorically, "I
have now no hesitation to say that nature intended you
for a painter."[6] The achievement was all the more impres-
sive in that the *St. Jerome* was a more complex work than
the Raphael, containing several more figures in compli-
cated poses and in different spatial planes, more landscape
elements, and atmospheric perspective. A comparison
with the original Correggio (Galeria Nazionale, Parma)
indicates that the young American followed the intricacies
of Correggio's line and the subtlety of his colors (as inter-
preted by West) surprisingly well for a novice.
 That in 1781 Trumbull knew only West's copy of the
Correggio was a technicality the artist did not always
remember in his published references to the painting.[7]
However, Trumbull felt strongly that West's copy was a
superior effort. He even preferred it to copies of the
Correggio made by Annibale Carracci and Anton Ra-
phael Mengs, both of which he had seen in private collec-
tions in England.[8] He made this judgment ultimately on
the basis of comparison with the original, which he was
finally able to view when it was at the Louvre in 1797.[9]

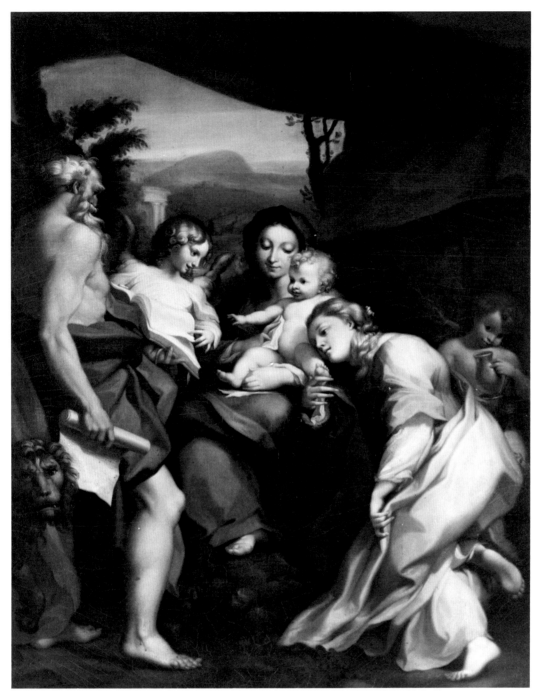

133

Only three years before he went abroad in 1780, Trumbull had copied an engraving of West's *Elisha Restoring the Shunammite's Son* (Figs. 7, 6). Without the palette or the painting technique of the original to guide him, Trumbull could only reproduce the basic figure style and the composition; the coloring is harsh, bright, and unmediated. Such was the common fate of aspiring artists in colonial America; they could learn some of the elementary principles of draftsmanship, perspective, and composition by themselves, but the complexities of paint application could only be mastered by formal instruction or apprenticeship. The degree of Trumbull's advancement is apparent when his copy of the *St. Jerome* is compared with his earlier copy of *Elisha*. The creaminess of the paint application, in particular, attests to lessons quickly and thoroughly learned in the studio of Benjamin West.

1 The traditional ascription of the painting to the months in prison stems from Trumbull himself, 1841, p. 77.
2 See p. 5.
3 Trumbull 1832, p. 17.
4 See p. 193.
5 Dunlap 1834, I, p. 355.
6 Trumbull 1841, p. 67.
7 Trumbull 1831, no. 3, merely lists the title as "Copy of Correggio's most admired picture— the St. Jerome of Parma." However, Trumbull 1832, p. 17, mentions West in a footnote.
8 Trumbull 1841, p. 68.
9 Ibid. Correggio's *Madonna of St. Jerome*, originally at Parma, was part of the booty that Napoleon shipped to France in 1796. The painting was later returned.

Madonna and Child
with Sts. Joseph and John

c.1786

Pen and ink on paper, 8¹⁵⁄₁₆ x 7¼ (22.7 x 18.4)

Fordham University Library; Charles Allen Munn
 Collection

Trumbull's drawing style here has a freedom that is considerably advanced over the carefully contained forms in the two pen-and-ink studies of 1784 for *Priam Returning to His Family, with the Dead Body of Hector* (Cats. 154, 155). Using a combination of short, delicate wiry strokes for the outlines of the four figures, the bench and the cradle, and longer energetic cross-hatched lines that cut across the forms to describe the shadows surrounding the Madonna, Trumbull communicates the sense of having quickly recorded an image before him.[1] In all likelihood, the drawing was executed during Trumbull's trip to Paris, in the summer of 1786, when he visited the major public and private art collections, making careful notes[2] and an occasional sketch of the art he saw. A pencil notation (not in Trumbull's hand) on the verso of this sheet identifies the woman seen in the upper area as "Mlle Rosamond," an artist actually named Mlle. Rosemont or Carreaux de Rozemont, whom Trumbull knew.[3] The same combination of short lively strokes to outline form, and cross-hatched lines for shading is used to create the profile portrait of the young French woman.

Trumbull often used a sketch executed years earlier as the basis for a later oil. Thus the figures of the Madonna and Child became the basis for *Maternal Tenderness* (Cat. 158), begun twenty-three years later.

1 The painting on which the drawing is probably based is thus far unidentified.
2 See Trumbull 1841, pp. 102–17.
3 See Yvon Bizardel, "L'Expérience d'un peintre américain au XVIIIᵉ siècle: John Trumbull," *Gazette des Beaux-Arts*, 60 (1962), p. 432.

134

The Woman Taken in Adultery

1811
Oil on canvas, 94³/₁₆ x 67⅛ (239.2 x 170.5)
Yale University Art Gallery; Trumbull Collection

In this painting, a beautiful young woman attired in glowing silks kneels in grateful supplication before the commanding figure of Christ. He does not return her gaze, but looks over her head into the crowd. Consternation fills the faces of the woman's accusers as they reflect on Christ's judgment on them and prepare to move away.

When the painting was exhibited at the Trumbull Gallery in 1832, the following passage from John 8:3–9 was quoted in the catalogue:

> And the Scribes and Pharisees brought unto him a woman taken in adultery; and when they had set her in the midst, they say to him, Master, this woman was taken in adultery, in the very act: Now Moses in the law commanded us, that such should be stoned; but what sayest thou?— This they said, tempting him, that they might have whereof to accuse him.— So when they continued asking him, he lifted himself up and said unto them: *He that is without sin among you, let him first cast a stone at her.*— And they which heard, being convicted by their own conscience, went out one by one.[1]

Thus Trumbull made clear by word as well as image that he had chosen to depict the moment when Christ excoriated the scribes and Pharisees.[2] It was a traditional choice, but the subject and this particular moment in it may also have had personal associations for the artist.

An aura of mystery had surrounded Trumbull's marriage to Sarah Hope Harvey ever since it had taken place in 1800. Among the many rumors circulated about her was one that reached William Dunlap, to the effect that Sarah had met and fallen in love with Trumbull while she was married to someone else.[3] Perhaps Trumbull seized the opportunity provided by the biblical episode to protest his wife's innocence. When Silliman discussed the painting in his memoir of Trumbull, he made reference to Trumbull's singular interpretation of the scriptural passage: "The artist . . . felt at liberty to take this view of the history which did not necessarily decide that she was guilty."[4] Most biblical exegesis, on the other hand, presumes the guilt of the woman but focuses instead on the universal condition of sinfulness which afflicts her accusers as well. Trumbull's idiosyncratic reading might be taken as a veiled allusion to his wife's innocence.

Furthermore, Trumbull appears to have used his wife as the model for the pose of the adulteress. Silliman recorded an incident which he stated had been described to him by the artist:

> Mrs. Trumbull who was present kneeled to pick up her scissors. She was just in the attitude which his subject required and begging her to remain kneeling as she was, he hastened to transfer her to his canvas thus placing the woman whom he loved in the position of the accused.[5]

Trumbull did not use Sarah's facial features, however, but adapted Le Brun's character head of *Veneration* (*Fig. 79*)

Veneration

Fig. 79. Charles Le Brun (after), *Veneration*. Engraving from *The Compleat Drawing-Master*, London, 1766. New Haven, Yale Center for British Art; Paul Mellon Collection.

for the face of the woman taken in adultery. His purported use of his wife as a model was a daring gesture, given the gossip regarding Sarah, although it was probably not widely known, except to family members such as Silliman.

The scale and style of Trumbull's painting were imitative of Benjamin West's magisterial scriptural narratives dating from the first two decades of the nineteenth century, such as *Suffer the Little Children (Fig. 75)* and *Christ Healing the Sick in the Temple (Fig. 73)*. *Woman Taken in Adultery* borrows elements from both West paintings. The stance of Trumbull's Christ figure— in all but the right arm and inclination of the head— as well as the orange-red tunic are based on *Christ Healing*; from *Suffer the Little Children* he took the vertical format, close-up figures, and background arch. The palette, although it followed standard eighteenth-century theory and practice in most respects, was richer and more painterly than West's. The building in the distance gleams with touches of silver and gray. Specks of blue and orange are visible in the variegated section of sky and cloud. The principle of uniting color opposites was thought to lead to "Harmony & Brilliance of Colour,"[6] as Trumbull explained in a memo to himself on color advice given to him by West. He utilized the standard opposites of red and a dark bottle-green in the robes of Christ, repeating the pattern in the lighter values in the standing figure on the right. The lavender and gold of the woman's dress are also opposites which, when combined, "will at once reduce the Glitter of the yellow & give Modesty united with Clearness."[7] The red-gold of the woman's hair and a copper-colored scarf over her shoulder are subtle additions which enrich and harmonize the basic color scheme.

The subject was not popular in English art, although one other version was on exhibition with Trumbull's at the British Institution in 1812. It was not a subject which Benjamin West took up. Macklin's *Bible* of 1800 featured an engraving after a painting by William Artaud, *The Woman Accused of Adultery*, c.1791 (The Art Institute of Chicago). This painting and the engraving after it, while not influential on Trumbull stylistically, perhaps encouraged him to try his hand at the same subject. A deeper inspiration, however, may have been the whispers about his wife, Sarah.

1 Trumbull 1832, no. 18, p. 29.
2 Jonathan Richardson recommended this particular moment in the story in *An Essay on the Theory of Painting*, 2nd ed., London, 1725, pp. 53–55.
3 William Dunlap, *Diary*, 3 vols., New York, 1931, III, pp. 800-1, also pp. 738–39. Theodore Sizer discusses the issue in "Who Was the Colonel's Lady?" *The New-York Historical Society Quarterly*, 36 (1952), pp. 410–29, reprinted in Sizer 1953, pp. 350–65. See also Cat. 112.
4 Silliman, "Notebook," II, p. 124.
5 Ibid.
6 Cited in Sizer 1967, p. 135.
7 Ibid.

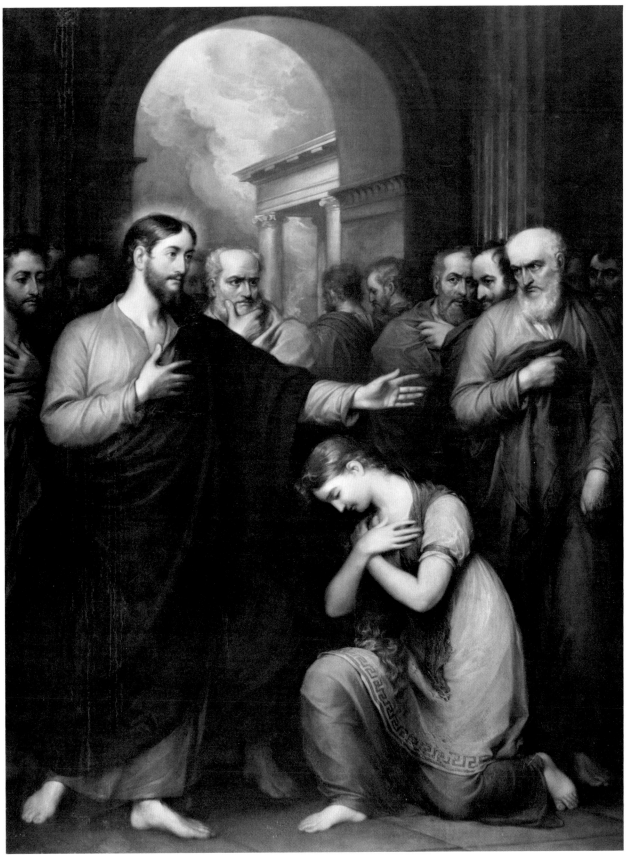

135 *Color reproduction, Fig. 76*

Preparation for the Entombment of the Savior

1827
Oil on wood, 24 x 17¹³/₁₆ (61 x 45.2)
Yale University Art Gallery; Trumbull Collection

Trumbull based the figures of both the Madonna and the Christ on Annibale Carracci's *Pietà* (*Fig. 80*), then in Naples, which he would have known from reproductive engravings.[1] More precisely, Trumbull's Madonna resembles the Virgin in a copy of the Carracci (*Fig. 81*) known to have been in England during the years when Trumbull was there.[2] Trumbull chose to imitate the gentler mien of the Madonna in the English copy than the more severe Virgin of the original Carracci, although he included the tender gesture of her fingertips curled around Christ's face, which was missing from the English copy.

The additions Trumbull made to the essential Carracci image reveal much about his working methods and what he deemed desirable in a religious painting. He left out the angels and added a number of other figures— a woman at the right holding Christ's hand, probably Mary Magdalen, and two mourning women standing at the left— placing them in a landscape background. These additions not only altered the visual field of the painting but its emotional significance: the timeless image of the *pietà* became a historiated *tableau vivant*. The standing woman at the left added a particularly contemporary note in figural style (especially the elongated neck), hair fashion, and costume design.

Such a direct use of a source raises the question of how original Trumbull's composition was. The *Entombment* was not designated as a copy or even as being "after" Carracci when it was exhibited at the American Academy of the Fine Arts in New York City over the years or at the Boston Athenaeum in 1828, although other works of Trumbull's were occasionally so classified.[3] In the 1832 catalogue for the Trumbull Gallery however, both the *Entombment* and another work were footnoted as being "not properly original compositions— nor yet copies, but reminiscences of paintings seen in Europe many years since."[4] Perhaps William Dunlap characterized it best when he called it "a copy with intended amendments."[5] The elegiac quality of the *Entombment* is not entirely the work of the original creator of the image, Carracci. Trumbull seems to have invested it with a meditative sense poignantly appropriate for a man approaching his seventy-first year who had recently lost his wife.

Fig. 80. Annibale Carracci, *Pietà*, c.1599–1600. Museo e Gallerie Nazionali di Capodimonte.

Fig. 81. Anonymous (after Annibale Carracci), *Pietà*, c.1660. Hampton Court, Collection of Her Majesty Queen Elizabeth II (copyright reserved).

1 Trumbull 1831, no. 28, gave 1827 as the date for the painting. Sizer 1967, p. 110, unaccountably dates the work in 1826. The *Entombment* was first exhibited at the American Academy in 1827.
2 The copy, presently at Hampton Court, is documented as having been at Kensington Palace in 1818, and was most probably purchased by George III. Michael Levey, *The Later Italian Pictures*, London, 1964, no. 438, p. 73, is of the opinion that it was painted c.1660 by a northern, possibly Flemish artist.
3 See, for example, Trumbull 1832, no. 9, *Madonna au Corset Rouge*, listed as being "a favorite composition of Raphael," and no. 19, *St. John and the Lamb*, as "from memory of an exquisite picture by Murillo." See also Cat. 133, n. 7.
4 Trumbull 1832, p. 7.
5 Dunlap 1834, I, p. 392.

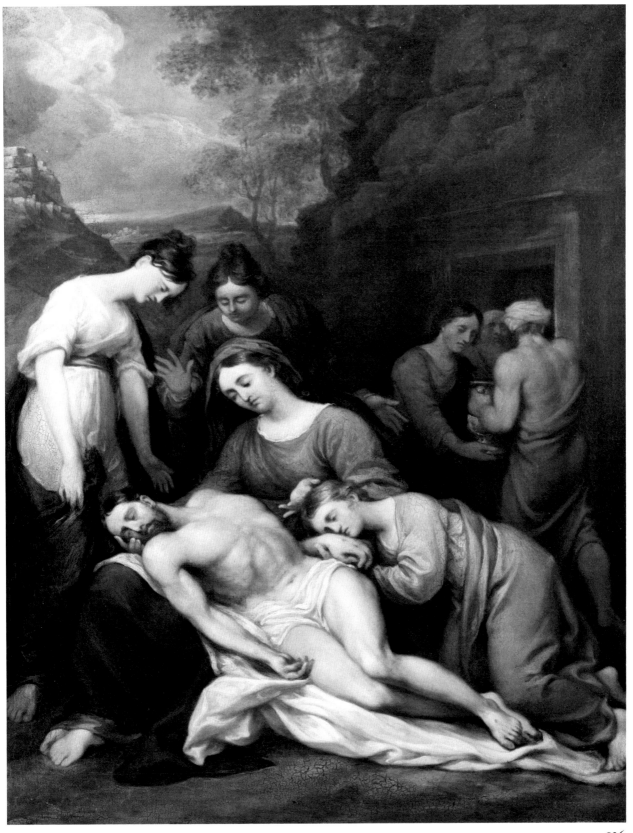

136

137
The Last Family
Who Perished in the Deluge

1838–39
Oil on canvas, 42 x 50⅞ (104.1 x 129.2)
Yale University Art Gallery; Trumbull Collection

138
Study for The Last Family
Who Perished in the Deluge

c.1786
Pen and ink and wash on paper, 4⅝ x 5½ (11.7 x 14)
Inscribed, verso, in another hand: *original of the "Deluge"*
 | *painted at 80 years of age | sketch, about 1786.*
Fordham University Library; Charles Allen Munn
 Collection

An infant exhausted by cold, wet, and hunger, lies
dead in the lap of its mother, whose whole soul is
engrossed, and all her faculties so absorbed in the
contemplation of this calamity, that she is insensible
to the horrors of the scene which surrounds her, and
does not even see that her husband is just dashed from
the rock (their last and only place of refuge) by a
violent surge, and is perishing at her feet. The father
throws up his eyes and hand to heaven, saying—
"Heavenly Father! oh, smite us at once with thy
lightning, and put an end to this lingering misery!"[1]

With these impassioned words, John Trumbull described
The Last Family Who Perished in the Deluge. The subject
was one that had long interested him. When he first visited
the Louvre in 1786, he saw and admired Nicholas Poussin's
Deluge as "a very fine work."[2] Unlike Poussin's painting,
however, which features numerous small figures sur-
rounded by landscape elements, Trumbull's painting fo-
cuses on four figures. Using the scriptural account of the
Flood merely as a point of departure, Trumbull elabo-
rated a story about the plight of the last family to perish.
His interpretation emphasizes emotion— the feelings of
the victims who are about to succumb to a terrifying death
and, by extension, the feelings of the viewers who are
stimulated to react.

As early as 1757, Edmund Burke had defined the mod-
ern concept of the sublime, which presaged the explora-
tion of emotion in English Romantic art:

> Whatever is fitted in any sort to excite the ideas of
> pain and danger, that is to say, whatever is in any sort
> terrible, or is conversant about terrible objects, or
> operated in a manner analogous to terror, is a source
> of the *sublime*; that is, it is productive of the strongest
> emotion which the mind is capable of feeling.[3]

The dead infant, the grieving mother, the desperate
father, and dying husband— especially when contrasted

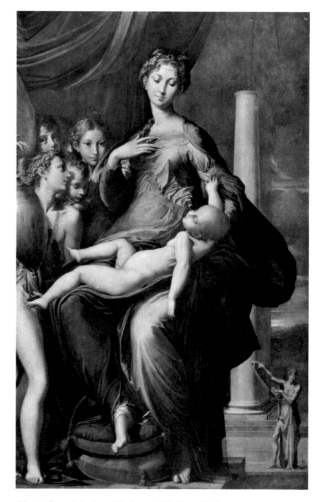

Fig. 82. Parmigianino, *Madonna of the Long Neck,* c.1535.
Florence, Galleria degli Uffizi.

with the serene security of the ark in the distance— were
Trumbull's means of producing "the strongest emotion"
in the hearts of his viewers.

By the late 1830s, the subject of the Flood was among
the most popular of romanticized scriptural incidents. As
early as 1785, Trumbull's friend and fellow-artist, Maria
Cosway, exhibited a painting entitled *The Deluge* at the
Royal Academy. Benjamin West painted *The Abating of
the Waters after the Deluge* in 1791.[4] Philippe de Louther-
berg's *Deluge* (c.1790, Victoria and Albert Museum) was
engraved for Macklin's *Bible* in 1800. Turner's *Deluge*
(Tate Gallery) was exhibited at the Royal Academy in
1813. Joshua Shaw's *Deluge* (The Metropolitan Museum of
Art; previously attributed to Washington Allston) ap-
peared at the British Institution the same year. Perhaps
the best-known was Girodet-Trioson's painting of 1806
(Louvre). In 1826, by which time Trumbull was living in
New York City, the English painter John Martin exhibited
a painting called *The Deluge* at the British Institution. A
mezzotint made from it in 1828 caused considerable com-
ment in the New York press when it was published.[5]

Trumbull's painting is based on a drawing he did
almost fifty years earlier.[6] The painting was not begun
until 1838, when the artist was in his early eighties. Perhaps

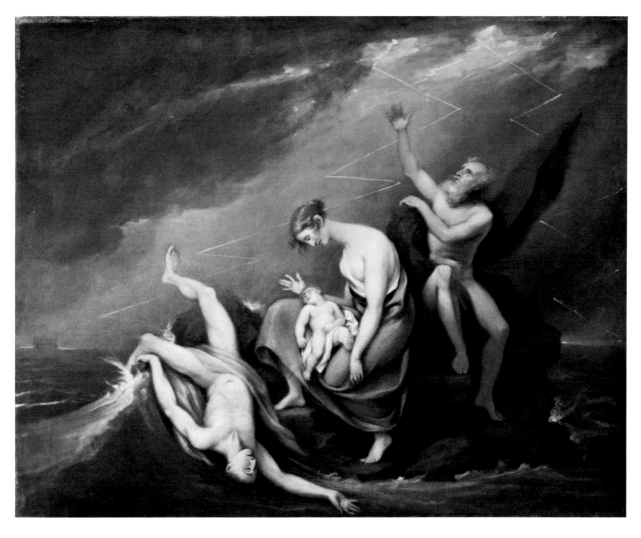

137

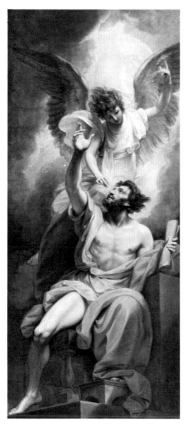

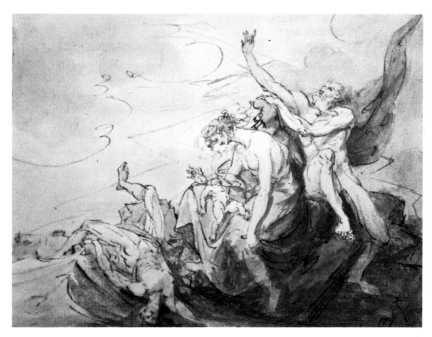

138

Fig. 83. Benjamin West, *The Call of the Prophet Isaiah*, 1784.
Greenville, S.C., Bob Jones University.

the continued popularity of the subject encouraged Trumbull to return to it. Benjamin Silliman recalled that it was "painted in my house 1838–9."[7] By this time, all of Trumbull's unsold paintings had been donated by him to Yale College, and a new gallery to house them had recently been completed. Silliman explained how Trumbull came to paint new works so late in life: "There were four unoccupied spaces in the upper part of the room which the artist volunteered to fill with pictures not in the contract."[8] Trumbull completed the painting from his fifty-year-old drawing in slightly over a year.

A comparison reveals only minor differences between the drawing and the finished oil. The proportion of figures to background is somewhat smaller in the painting; the man's cape on the right, which reaches to the edge of the drawing, does not quite complete the diagonal in the painting. The position of the drowning husband's head and that of the dead baby are less contorted in the later version. In the final effort, the mother's neck is attenuated, which occasioned a rare criticism from Silliman about the "undue length of the neck."[9] Most interesting is the effort to cover up nudity in the painted version, which was perhaps a response to adverse public reaction to nudity in other paintings by Trumbull.[10] The baby, exposed in the drawing, is draped in the painting; the breasts of the mother, completely revealed in the drawing, are partly wrapped in the painting. Even so, Silliman complained that "the principal figures are more nude than the occasion requires."[11]

With a 90-degree shift in position, the mother, with her attenuated limbs, long torso and small head, and with the baby sliding off her lap, is immediately suggestive of Parmigianino's *Madonna of the Long Neck* (*Fig. 82*), a painting Trumbull would have known through engrav-ings. In pose, drawing style and characterization, the grandfather is a more expressive version of the prophet in West's *The Call of the Prophet Isaiah* (*Fig. 83*) of 1782.

Trumbull's lonely epic of the diluvian world expressed the excitement and terror of a tale of physical destruction in Burkean terms. Yet the grandfather's plea to the heavens for mercy points to an awareness of the moral implications of the scriptural story beyond the taste for sublime effects.

1 Trumbull 1841, p. 439.
2 Ibid., p. 116.
3 Edmund Burke, *A Philosophical Enquiry into the Origins of Our Ideas of the Sublime and the Beautiful*, London, 1773, pp. 58–59.
4 West executed the painting (unlocated), for which a number of studies survive, for the Royal Chapel at Windsor Castle. He also depicted other aspects of the Flood theme, known only from studies.
5 See, for example, *The Atlas*, November 1, 1828, p. 1; July 25, 1829, p. 3; September 19, 1829, p. 3.
6 Sizer 1953, p. 289, no. 27, and 1967, p. 106, assigned a date of 1781 to the drawing. However, in the first edition of his monograph, Sizer (1950, p. 80) gives 1786 as the date, "signed and dated." Jaffe 1971, p. 25, gives a date of c.1786, on the basis of the penciled notation on the verso of the drawing. Jaffe also bases her opinion on the stylistic similarity which she perceives between this drawing and the *Joshua* drawing (Cat. 160), which is securely dated to December 15, 1786. The later date is also supported by a consideration of Trumbull's biographical circumstances. Very few works date to 1780–81 because of his imprisonment; only some drawings (Cat. 125) and his copy of West's copy of the Correggio (Cat. 133) are known to have been done in prison.
7 Silliman, "Notebook," II, p. 116.
8 Ibid., p. 98.
9 Ibid., p. 99.
10 When Trumbull exhibited his *Infant Savior and St. John*, 1801 (Wadsworth Atheneum), at the Boston Athenaeum in 1828, it was criticized for its nudity; see JT to Warren Dutton, May 27, 1829, Huntington Library, San Marino, Ca.
11 Silliman, "Notebook," II, p. 116.

Landscapes

Revolution in the Landscape
John Trumbull and Picturesque Painting

By Bryan Wolf

One of the curious ironies in the history of American art concerns the bond which links John Trumbull to Thomas Cole, founder of an American landscape school. It was Trumbull who first made Cole known to a large public after seeing the works of the fledgling landscapist in the window of a New York framemaker in 1825. Elated at his discovery, Trumbull rushed to inform his acquaintance William Dunlap that he had found a painter who "has done what I have all my life attemped in vain."[1] Together with Asher B. Durand, Trumbull and Dunlap returned to the frame shop and purchased the three canvases displayed for 25 dollars each (Trumbull, as "discoverer," was granted the first choice). Not long thereafter, Trumbull brought Cole to the attention of Robert Gilmor, a wealthy Baltimore merchant whose patronage helped launch Cole upon his early career.

Trumbull's assessment of Cole's work is more than hyperbole. The admiration of the older man for the young artist reveals a sensitivity to landscape painting that extends beyond the conventions of eighteenth-century theory. Trumbull generally subscribed to the teachings of Joshua Reynolds and his American successor as president of the Royal Academy, Benjamin West, both of whom ranked history painting above landscape and other subject matter. Trumbull nonetheless experimented throughout his career with a wide range of non-historical modes: genre scenes, miniatures, portraits, and panoramas. His landscapes, which predate Cole's by almost two decades, belong to the first "New York period" of his life, 1804 to 1808. During this period, Trumbull practiced primarily as a portraitist. He hoped to establish himself as the premier painter of the new Republic. As for landscape, his engagement tended to be serious but sporadic.

But his professional ambitions were frustrated while in New York by external causes: the collapse of Anglo-American commerce in the years preceding the War of 1812 led to a decline in portrait commissions; strained relations between his family and his British-born wife created deep personal tensions; and Trumbull's eyesight began to deteriorate beyond the ability of his New York physicians to control (he had already lost most of his vision in one eye in a childhood accident). Seeking renewed patronage and better medical attention, Trumbull left New York for London in 1808 with his wife Sarah. His departure marks the end of his brief landscape career in America. Though he took with him two large panoramas of Niagara Falls composed during the previous year, he was unable to find a market for his American scenery in England. When Trumbull eventually returned to New York in 1815, he did not resume his efforts at landscape composition. His taste for landscapes (at least his own) was apparently exhausted. It would take painters like Thomas Cole and a new generation of American artists to achieve on canvas what Trumbull had earlier "attempted in vain."

Trumbull's landscapes of 1804–8 may be divided into two categories. Those in the first and more traditional group revolve around ideas of the "picturesque" popular in England in the second half of the eighteenth century. They are public works, conventional in their composition and usually

1 Dunlap 1834, II, pp. 359–60.

Fig. 84. Landscape (Cat. 139).

depicting well-known places. They represent the first sustained effort at landscape painting by an American artist. The second group of paintings is more private: the works record locations outside the orbit of the average American, and accord with none of the conventions traditionally associated with the picturesque. They are revolutionary works, radical in their composition and antithetical to the prevailing formula for landscape composition. They bear more resemblance to the sublime and Romantic canvases of the early Thomas Cole than to the pastoral traditions of late eighteenth-century British painting. And they suggest in their very newness that Trumbull and Cole might be closer bedfellows than we normally are accustomed to think.

To understand the significance of Trumbull's brief but abortive career as a landscapist, we must first note the conventions of picturesque painting from which his work derives. The picturesque, as a product of the eighteenth century, is more than a theory of landscape composition. It is a mode of epistemology, an effort to define the very way in which nature is perceived. The picturesque represents an attempt to validate new modes of aesthetic and imaginative experience outside the ken of traditional Enlightenment discourse.[2] It supplies eighteenth-century aesthetics with a term missing in Edmund Burke's famous polarization of experience into the opposing camps of the sublime and the beautiful. In contrast to the terror and limitlessness of the former, and the closed perfection of the latter, the picturesque provides an artistic middle ground between the two based on an appreciation of diversity and local change. It refers in general to landscape composition characterized by asymmetry, irregularity, surprise, and variety; it derives its principles largely from the works of Claude Lorrain and other seventeenth-century landscape artists. Different theorists of the picturesque stressed different aspects. William Gilpin focused on the wildness and irregularity intrinsic to nature in a state prior to cultivation; Uvedale Price emphasized the complexity and aesthetic surprise essential to true landscape vision; and Richard Payne Knight not only tidied up the loose categories

2 For a thoughtful discussion of the picturesque that includes extensive bibliographic information, see Martin Price, "The Picturesque Moment," in *From Sensibility to Romanticism: Essays Presented to Frederick A. Pottle*, Frederick W. Hilles and Harold Bloom, eds., New York, 1965, pp. 259–92; see also John Barrell, *The Dark Side of the Landscape*, Cambridge, 1980, pp. 1–33, 167.

Fig. 85. Niagara Falls from an Upper Bank on the British Side (Cat. 148).

Fig. 86. (Opposite) Frederic E. Church, *Niagara Falls*, 1857. Washington, D.C., The Corcoran Gallery of Art.

provided by Gilpin and Price, but added to them the viewer's own "association of ideas," a formulation that rendered the picturesque as much a state of mind as a description of nature.[3]

The qualities normally associated with the picturesque— an emphasis on broken lines, irregular surfaces, variegated textures, and complex tonal values— carry with them important social and cultural implications. Unlike earlier landscape theory, the picturesque values the spontaneous and the accidental. It combines an emphasis on novelty and discontinuous states of being with a celebration of the capacity to frame: to take a random view of nature and compose it according to recognizable aesthetic conventions. The picturesque thus assimilates the strange and uncanny into traditional and familiar form. It employs its conventions in an effort to establish interpretative control over its material. The picturesque may be described as an aesthetic of accommodation. It allowed the eighteenth century to extend its ideological commitment to society, culture, and the processes of civilization-making without abandoning a taste for the "natural" and spontaneous. Like the sublime, the picturesque sanctions new modes of experience within a traditional way of seeing. It introduces a new flexibility to Enlightenment thinking, and in the process consolidates alternative modes of perception under the aegis of already established principles. What better way to tame an unfamiliar social landscape than to render it a form of Claudian pastoral?

Historically the picturesque may be understood as an effort to rescue Enlightenment thought from the barrage of new and contradictory experiences associated with the early stages of the Industrial Revolution. Through an insistence on accommodation— a willingness to entertain disparate modes of experience within a single frame of reference— it takes the aesthetic sting out of social revolution. The picturesque assures the viewer that all change, like all variety, is a natural part of the landscape, and can be safely accommodated within the governing— framing— conventions of society.

This tension between variety and accommodation lies at the heart of the picturesque and animates those canvases Trumbull composed according to its conventions. In *Landscape* (*Fig. 84*), Trumbull relies on the conventions of Claudian landscape to frame and enclose an antique view. His composition contrasts a series of gently sloping diagonals receding in fanlike fashion from the left

3 William Gilpin, *Observations, Relative Chiefly to Picturesque Beauty, Made in the Year 1772, on Several Parts of England: Particularly the Mountains and Lakes of Cumberland, and Westmoreland*, London, 1786; Uvedale Price, *Essays on the Picturesque*, London, 1794; and Richard Payne Knight, *An Analytical Inquiry into the Principles of Taste*, London, 1805. Trumbull was familiar with the ideas of the sublime, beau-tiful and picturesque as formulated by Burke, Gilpin and Price. He knew Burke personally, and it is more than likely that he inspected Burke's volume published in 1757. Uvedale Price sent a copy of his book to George Washington via Benjamin West; Trumbull delivered it to the president. Washington thanked Price for the gift of the book in a letter of 1799; see Jaffe 1975, p. 220.

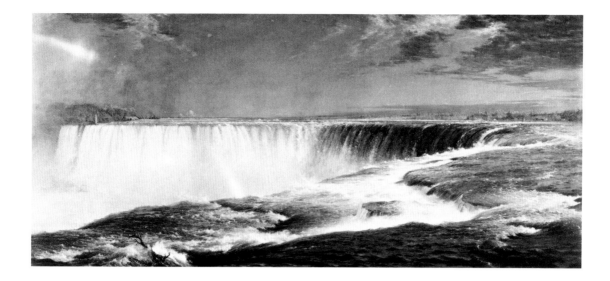

foreground with the essentially horizontal/vertical disposition of space in the painting as a whole. By flattening the sky and horizon and juxtaposing the middle-ground hills with the foreground vantage point, Trumbull creates a stagelike setting that locks in the rearward recession with an asymmetric but stable grid of rectangular elements. The contrast between diagonal forms and rectilinear framing not only enlivens the composition, but submits the diversity and variety of the landscape to the composing powers of a framing (and conventional) eye.

Though Trumbull would later liberate his diagonal spaces in the historical canvases of the American Revolution (one may in fact measure the vicissitudes of his career by the freedom or restraint accorded to his diagonal forms), his Niagara Falls landscapes of 1807–8 maintain the rigid and relatively restrained quality of the earlier *Landscape*. Whether or not his two views of the falls from the British side were intended as pendant pieces, they present complementary views of Niagara from above and below.

In *Niagara Falls from an Upper Bank on the British Side* (*Fig. 85*), Trumbull employs a rectilinear format to create a large expanse of sky punctuated only by the vertical intrusion of the foreground trees. The white mushroom cap of mist and spray emerging from the falls parallels in its shape the crowns of the flanking trees. The spume and tree crowns form a series of floating capitals that seem to hover over the flattened landscape below. The energy of the falls is thus effectively bound by the vertically placed tree trunks at either end of the canvas and the horizontal mass of sky, spume and leaves above the shallow stretch of land. Trumbull's Niagara River, in turn, seems to conspire against its own tumultuous descent. It meanders formulaically over two-thirds of the foreground plane before plunging to the basin below, and reemerges in the left distance as a calm and navigable body of water. What prospect we actually gain of the falls is confined to two rectangular bands of white and to the larger plumage of spray that defines the spectacle of Niagara more by its effects than by its actual presence to the beholder.

Niagara Falls from an Upper Bank is meant to reassure its viewer that man is in control. The subordination of diagonal to rectilinear forms, the domestication of the landscape through the presence of three tourists and an observer, the framing of falls by lateral clusters of trees, the predominance of sky over water and land— all of these elements establish Niagara as a visual backdrop against which the drama of human design is played. Nature is everywhere rendered to human scale: it is neither too powerful to be violating nor too unfamiliar to be threatening. Even the spume of mist and spray rises skyward in an assertion of rational or subliminating energies over material force. Unlike Frederic Church, whose stunning image of Niagara Falls half a century later (*Fig. 86*) ruptures the conventions of the picturesque in an effort to translate physical energy into an emblem of national power, Trumbull seeks in his canvas a national symbol that subordinates *natural*

forces to *social* ends. His Niagara differs from Church's as culture differs from nature. He is not interested in the falls *per se*, but in the process of socialization by which natural wealth is translated into *human* abundance, and both then come to be associated with an emerging national destiny.

In *Niagara Falls below the Great Cascade on the British Side* (Cat. 149), Trumbull again conventionalizes the viewer's experience of the falls. The immediacy of Table Rock and Horseshoe Falls is counterpointed against the dark walls of promontory and cascade framing either side of the canvas. Trumbull pays close attention to the interaction of viewer and falls: the umbrella on the right underscores the soggy nature of the location, while the gesticulations of the spectators to the left attest to the sheer spectacle of Niagara. These instances of dramatic contact between viewer and vista exist as foils for the imaginative control exercised over the scene by the promenaders and painting party in the foreground. Trumbull's small figures declare man's authority over the scene. Through the recurrent testimony of spectators nature's power is reduced to an object of national display.

Trumbull thus modifies and adapts the conventions of the picturesque to his own ideological ends: he emphasizes the rationality of nature over its potential wildness; he plays down the spontaneous and unaccounted in the landscape in order to stress instead its harmony and integration; and he relies upon the familiarity of the picturesque *as a convention* to domesticate and safeguard the natural world. By rendering Niagara according to the conventions of the picturesque, Trumbull subjects the falls to the ordering power of the mind. The picturesque has become in Trumbull's hands a tool for the rationalization of the landscape.

It also becomes an instrument of national design. Trumbull harnesses the conventions of the picturesque in the service of an incipient American nationalism. Since the earliest days of European exploration, Niagara had been recognized as one of the wonders of the New World. Trumbull's decision not only to paint the falls, but to include in *Niagara Falls below the Great Cascade* a dramatic if awkward rainbow spanning two-thirds of the foreground represents his effort to yoke together an image of national power with one of providential design. Trumbull's rainbow is more than an objective study of light and mist. It is a traditional emblem of covenant between God and his people. It consecrates man's control over the landscape with the seal of divine approval, and stands as a reminder of a special relation between God and this new nation. It is visible proof that "westward the course of empire lies."

Trumbull was heir to a tradition of New England providential thinking which linked the destiny of the New World to the salvation of mankind. As Sacvan Bercovitch has noted, New Englanders have always been prone to invest their own local history with the weight of biblical prophecy.[4] John Trumbull was no exception. His vision, like that of many of his contemporaries, was relatively secular when compared with that of his father and ancestors, but he still retained their faith in a national destiny sanctioned by divine judgment and directed toward universal ends. His rainbow combines scientific observation with emblematic habits of mind and, in the context of Niagara, weds spiritual purpose with national imagery. Trumbull is thus not only one of the first serious painters of an American landscape, but an early exponent of what later historians will term an "American national religion."

This same combination of history and eschatology recurs in the works of a wide range of American painters, among them Edward Hicks, a Quaker minister and self-taught artist of the antebellum period. Though Hicks is separated from Trumbull by time and temperament, he shares with the patrician Yankee painter a millennial vision of American history. Hicks' many versions of *The Peaceable Kingdom* (Fig. 87) juxtapose a foreground of messianic dimensions (disparate animals and an innocent child) against a background associated with a distinctly American scene, whether Penn's treaty with the Indians, the Natural Bridge of Virginia, or Niagara Falls. Though Hicks' paintings bear the imprint of his private religious faith, they share with Trumbull's more secular

4 Sacvan Bercovitch, *The Puritan Origins of the American Self*,
New Haven, 1975, pp. 72–108.

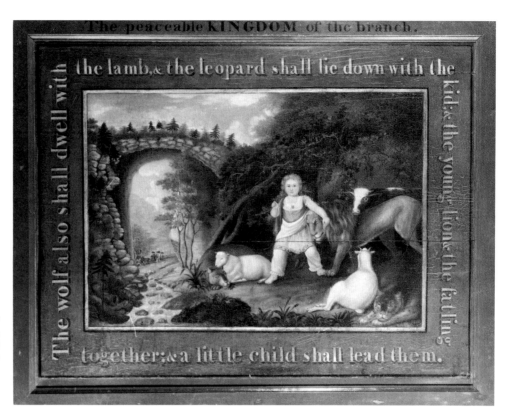

The peaceable KINGDOM of the branch.

the lamb, & the leopard shall lie down with the

The wolf also shall dwell with

kid;& the young lion& the fatling

together:&a little child shall lead them.

Fig. 87. Edward Hicks, *The Peaceable Kingdom of the Branch*, c.1825. New Haven, Yale University Art Gallery; Gift of Robert W. Carle.

depiction of Niagara a conjunction of national with spiritual destinies, and an insistence that the significance of the former can only be understood within the light of the latter.

Trumbull's prominent narrative devices may be understood as efforts to control the interpretive range of his works. His rainbow, like his promenading tourists, provides the viewer with a series of quasi-emblematic forms which restrict the significance of the falls to those social and moral ends that Trumbull desires. They limit the viewer's interpretation of a scene that might otherwise turn into a chaos of visual sensations. In terms of picturesque theory, Trumbull's imagery of rainbows, frames, painter-figures and tourists provides Niagara with a pre-selected series of associations. The painter effectively interprets his own work by placing before the viewer a visual key, a gallery of images which circumscribe the open-ended potential for meaning within the scene and substitute instead those *specific* associations by which the painter stories an otherwise "unstoried" nature.

Trumbull's desire not only to depict Niagara Falls, but to police his own interpretation, links him to his early friend— and at a later point, political foe— Thomas Jefferson. In *Notes on the State of Virginia*, Jefferson subordinates his description of the Virginia landscape to the prevailing conventions of the sublime and beautiful. In the process he transforms a study in American geography into a moral sermon not unlike Trumbull's vision of Niagara Falls. Jefferson's account contrasts the turbulent and undirected energies of the sublime with the resolving unities of the beautiful. He employs the latter as Trumbull does the picturesque: to rationalize an otherwise unruly landscape. The sublime for Jefferson represents a threat to a nature harmoniously perceived. Jefferson discovers in the geologic history of the Shenandoah Valley the outlines of a cataclysmic past: a "disrupture and avulsion" of the landscape "by the most powerful agents of nature." Unwilling to accept this sublime disharmony as nature's final word, Jefferson imposes order upon the landscape by shifting the perspective from which it is observed. He distances the viewer from the "tumult" of the foreground scene, placing him at a point above the river valley. The resultant overview resolves the turbulence of the Shenandoah Valley world and allows Jefferson to substitute, in his description, the conventions of the beautiful (smoothness, serenity and proportion) for the imagery of the sublime (violence, power and conflict).

But the distant finishing which nature has given to the picture is of a very different character. It is a true contrast to the fore-ground. It is as placid and delightful, as that is wild and tremendous. For the mountain being cloven asunder, she presents to our eye, through the cleft, a small catch of smooth blue horizon, at an infinite distance in the plain country, inviting you, as it were, from the riot and tumult roaring around, to pass through the breach and participate of the calm below. Here the eye ultimately composes itself; and that way too the road happens actually to lead.[5]

In passing from the "riot and tumult roaring around" to the deeper "calm below," the viewer subsumes the conventions of the sublime into the "distance" and "calm" of the beautiful. The convulsions of nature are assimilated into the model of a painting (note the language: "picture," "finishing," "foreground") as Jefferson employs visual strategies similar to the picturesque to domesticate an otherwise menacing scene. What is threatened is not just the geologic stability of the Shenandoah Valley, but the very assumptions of Jefferson's Enlightenment world. It is essential to Jefferson and his generation that order, efficiency and equilibrium, what Jefferson called an "oeconomy of means," predominate in the disposition of nature's forces. The sublime history of the Shenandoah Valley threatens this rational order, and Jefferson restores nature to its necessary harmony by *recomposing* his otherwise untidy landscape through the combined effort of eye and road.[6] The language of the beautiful absorbs the sublime, and disorder is reconstituted into a larger serenity. Jefferson thus employs the conventions of the beautiful to repair a potential breach in his own epistemological etiquette.

In a parallel manner, Trumbull pursues the picturesque not solely for aesthetic reasons, but as a means of affirming his culture's faith in its own social and epistemological assumptions. In *Niagara Falls below the Great Cascade*, Trumbull elevates the viewer's vantage point from the foot of the basin to a point midway up the falls. This choice, like Jefferson's "finishing" prospect, dissipates the emotional impact of encountering the falls from below. Niagara is placed at a distance, and the viewer is spared the effects of a lowered and radically foreshortened vantage. Like Jefferson's naturalist-observer, with his composing "eye," Trumbull's viewer is invited to acknowledge the power and potential "disrupture" of the scene before him as a first step in a larger visual motion toward order and control. The threat of chaos and disorder is safely suppressed and the natural world is again interpreted according to the mediations of familiar conventions. In both Trumbull and Jefferson, an aesthetic of power is subordinated to one premised upon rational social control.

But it is not always so with Trumbull. The self-policing aesthetic occasionally breaks down in his canvases, leading in certain works to a different and ideologically more radical vision. In 1806, Trumbull traveled to Norwich, Connecticut, to paint a portrait of the John Vernet family (Cat. 119). In the left background of the painting, he includes a view of Norwich Falls generalized according to the conventions of eighteenth-century landscape backdrops. Though Norwich Falls may have held particular significance for the Vernet family, the presence of the falls in Trumbull's portrait suggests the painter's recurrent concern with such scenes (the majority of Trumbull's surviving landscape compositions focus on cascades and falls). As a private interest presumably separate from his commercial painting, Trumbull produced simultaneously with the Vernet portrait several sketches and three oils (only two of which survive today) depicting the falls of the Yantic at Norwich (*Figs. 88, 89*).

Both of the Norwich canvases reveal a sense of composition very different from the picturesque treatment of Niagara. The landscape is neither domesticated nor framed according to the pastoraliz-

5 Thomas Jefferson, *Notes on the State of Virginia* (1788), reprinted in *The Portable Thomas Jefferson*, Merrill D. Peterson, ed., New York, 1975, pp. 48–49.

6 The presence of an actual "road" confirms for Jefferson what the "eye" has already achieved. It guarantees that harmony is as much a fact of nature as it is a product of human thought.

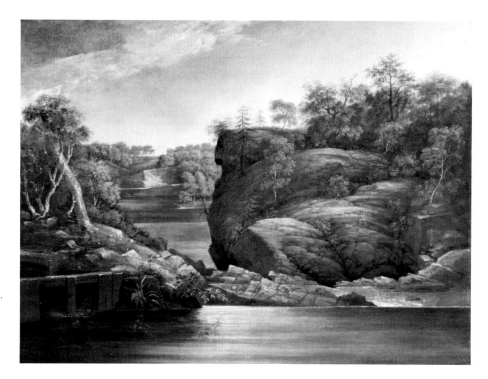

Fig. 88. Norwich Falls (or The Falls of the Yantic at Norwich) (Cat. 145).

Fig. 89. The Falls of the Yantic at Norwich (Cat. 144).

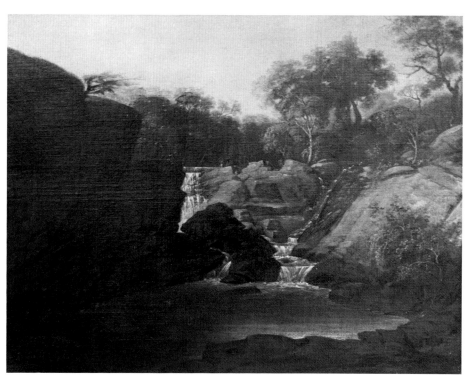

ing conventions of the picturesque. Instead the landscape is thrust dramatically against the canvas. A bold series of parallel planes divides the space into flattened segments, unlike the gentle spatial recession characteristic of the Niagara series. Where these latter paintings depend for their resolution on an aesthetic of accommodation— the ability to integrate disparate natural and social forces into a single landscape— the Norwich pictures are constituted in moments of visual aggression and confrontation. In *Norwich Falls* (*Fig. 88*) the cleavage of granite cliffs bifurcates the canvas laterally. The foreground walls of rock play against the vacant spaces before and behind. In the Slater Museum version (*Fig. 89*) massed promontories to the right and left flank the falls, while sealing off the background through a combination of foliage and rock formations.

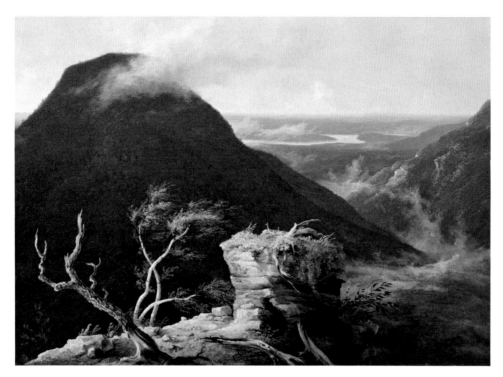

The result in each canvas is a planimetrically arranged space in which both eye and river seek to breach the walls of granite. Like Jefferson's Blue Ridge sublime, Trumbull's Norwich Falls paintings are characterized by a sense of *impediment* and the ensuing struggle for release. The closure created by the foreground promontory in the Yale version is reinforced by the carefully articulated forms of individual rocks and the virtual absence of the falls themselves. What we see instead is a limited breach in the rocks which circumscribes the viewer's vision and allows only a narrow prospect of the valley beyond. The background vista does not so much recede as *rise*, emphasizing in its uniformity and flatness the wall-like presence of the foreground rocks. In the Slater version, foreground and background planes again combine to form a single visual wall. The massing of rocks to the left partially blocks our perception of the falls, and the curve of the landscape encloses the foreground basin in a sealed and claustrophobic space.

We are no longer in the realm of the picturesque. The landscape is not so much mediated as blocked, and the passage of water is defined everywhere by its impediments. Unlike Jefferson's moral geography, where the beautiful exists to resolve the tension of the sublime, Trumbull offers us no moment of release parallel to Jefferson's "finishing" prospect. Even the breach of the enclosing rock forms in the Yale version serves more to *focus* the sense of tension in the painting than to alleviate it. The diminutive human forms which Trumbull places above the falls in the Slater version do not humanize the landscape or represent within themselves, as they do in the Niagara series, an assertion of picturesque conventions. They lack the physical stature and foreground placement of their Niagara counterparts. They are set instead against a landscape they neither control nor seem capable of translating to social ends. The socialization essential to the aesthetics of the picturesque— the transformation of nature into culture— is lacking entirely in the Norwich canvases.

What we have instead is a proto-Romantic landscape. Trumbull marshalls his space in a manner anticipatory of Cole. The Norwich canvases share with the early landscapes of Thomas Cole a massing of forms into parallel planes, a visual sense of confrontation rather than integration, and an underlying tension between enclosing and releasing forces. In *Sunny Morning on the Hudson River* (*Fig. 90*), Cole deploys the landscape according to the conventions of the Romantic sublime. The canvas is divided into a foreground at eye level with the viewer, a middle ground that seems to threaten the

foreground space through its scale and power, and a background accessible only after a visionary detour around the dark middle-ground mountain. The painting directs the viewer through composition and color to the distant background, but it establishes obstacles of scale and mass along the way: the middle plane threatens the viewer's progress by the manner in which it crops and intersects his vision. The drama of the painting lies in the tension between containing and visionary energies. Though Trumbull's Norwich canvases lack the precise articulation of Cole's landscapes— Trumbull's planes are less distinctly grouped and their interaction more problematic— he nonetheless reaches in his Norwich compositions toward a sublime disposition of space characteristic of a later generation of Romantic painters. The energies are confrontational rather than integrational, the paintings turn visually on moments of release rather than accommodation, and the landscape harbors a *wildness* that is the opposite of the pastoralized vistas of picturesque composition.

Trumbull's revolution in landscape painting is difficult to assess. Scarcely half a dozen landscape paintings survive on which to base a judgment, and his direct influence on later painters like Cole is probably minimal (though it is possible that Cole saw Trumbull's Norwich canvases in the early 1820s in New York). What the Norwich canvases reveal is a sensibility at war with itself and inwardly attuned— despite its eighteenth-century affinities— to the new forces of Jacksonian society. Cole's canvases represent at a cultural level a democratization of the landscape. Their unpopulated (or minimally populated) spaces belong to no privileged group; they express in their sublime dynamics the energies of an age impatient with earlier conventions. They reveal in their planimetric composition a sense of discontinuity with the past that distinguishes them from the modulated flow of picturesque space, and in the predominance of nature they reverse the previous generation's insistence on the *social* dimension grounding all culture.

Trumbull clearly was no Romantic. His paintings of Niagara make abundantly clear his commitment to a culture construed as the endpoint of natural processes. The falls without the iconography of rainbows and promenaders is simply inconceivable for Trumbull. His Niagara, unlike that of a later generation of Romantic painters, is characterized by control rather than wildness. But the Norwich canvases attest to an alternative moment in Trumbull's conception of the landscape. They reveal an openness to nature as more than a social construct, a willingness to entertain novelty as well as convention, and an awareness of the discontinuity and breakdown of authority characteristic of sublime art. Though the Norwich canvases seem more private works than the Niagara paintings, they suggest that Trumbull may have been *more* than the eighteenth-century gentleman he liked to present himself as: deep in that revolutionary heart lay a conflict that required the wildness of nature, rather than the events of history, for its tropes.

Landscape

c.1783

Oil on wood, 12 x 18 (30.5 x 45.7)

The Dayton Art Institute; Gift of Mr. I. Austin Kelly III, in memory of his great-great-grandfather, Ironton Austin Kelly, founder of Ironton, Ohio

In this composition, inspired by classical interpretations of the Roman campagna, Trumbull depicts a gently spreading vista with streams, roads, copses, buildings, and rocks. Colored light enters the scene from the left, illuminating the foliage and glistening on the tops of boulders and building walls. The pinkish sky and the long shadows suggest sunset, but the mood is timeless; neither does the topography depict a specific site.[1]

Trumbull described the Dayton *Landscape* as the "companion" to another oil which he painted "from a print after Salvator Rosa."[2] Writing more than sixty years after the event, he listed the *Landscape* among works "executed before my first voyage to Europe" in 1780.[3] However, the painting is unlike any other known work he did before his trip.[4] Its composition, details and subject matter link it more closely to the group of classical subjects Trumbull composed after his return: temples, lakes, bridges, open vistas, bizarre rocks, ruins, and figures in classical drapery occur in dated drawings of 1783–84, some of which appear to be derived from prints or paintings of classicizing landscapes.[5] By this time Trumbull had already been exposed to the English landscape tradition and would have been familiar with the works of Claude, Rosa, and their followers.

1 Trumbull referred to the painting as "landscape, sunset; composition"; Trumbull 1841, p. 62.
2 Sizer 1967, p. 113. The painting supposedly based on the print after Rosa (Collection of Mrs. Edwin Keiffer) cannot be related to a known Rosa work.
3 Trumbull 1841, pp. 59, 63.
4 Sizer dated the painting to 1778 because its size corresponds to a canvas Trumbull bought in 1778; see Theodore Sizer, "An Early Check List of the Paintings of John Trumbull," *Yale University Library Gazette*, 22 (April 1948), p. 7. The Dayton *Landscape*, however, is painted on panel
5 See, for example, the sketchbook, "Early Sketches and Drawings," pp. 143, 145, 147, 149, 150, 151, YU-B.

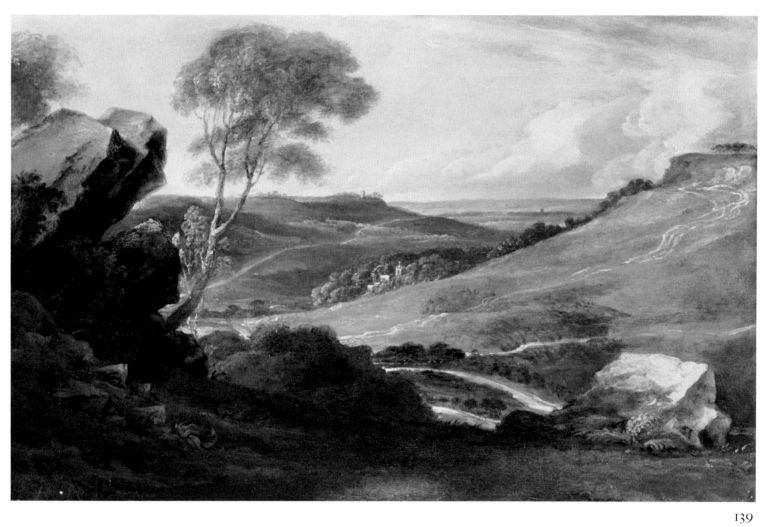

139

Cohoes Falls

1791
Pen and ink and wash on paper, 3 x 4½ (7.6 x 11.4)
Inscribed, verso: *The Cohoes Falls | 12 miles from Albany |
on the Mohawk River | 27th Sept 1791 | J Trumbull*
The Addison Gallery of American Art, Phillips Academy

Cohoes Falls records a site on the Mohawk River, near
Albany, New York. This pen-and-ink drawing is carefully
composed according to the picturesque formula: a shaded
foreground and two trees on either side frame the view of
the cascade. A startling compositional device, but typical
for Trumbull, is the isolated barren tree in the center
which interrupts the view and introduces a strong diago-
nal force into the otherwise stable composition. The bar-
ren tree placed in the center of a composition was one of
the artist's favorite motifs, appearing as early as 1783 (*Fig.
91*). It is found in several drawings for *Princeton* (see, for

example, Cats. 19, 22), and in *View on the West Mountain
near Hartford* (Cat. 142). Although *Cohoes Falls* and *Land-
scape with Dead Tree* share the general treatment of the
foreground and the tree motif, a significant development
took place in Trumbull's conception of landscape be-
tween 1783 and 1791. In the earlier drawing Trumbull
applied the motifs of picturesque composition to an imag-
inary landscape, while in *Cohoes Falls*, the motifs were
used to aid the artist in the visual organization of actual
topographical facts. By 1791, Trumbull was undoubtedly
familiar with the works of Richard Wilson,[1] who applied
elements of the classical landscape to the painting of actual
sites in England. Trumbull's interest in the American
landscape may have evolved from his concern with histor-
ical truth, for most of the topographical sketches for the
history series are contemporary with *Cohoes Falls* (see
Cats. 23, 29).

1 Jaffe 1975, pp. 218–19.

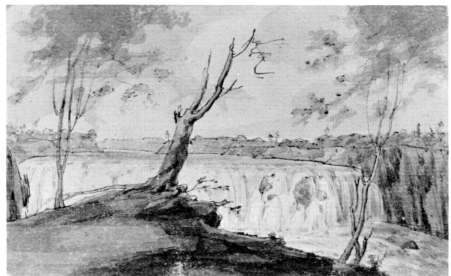

140

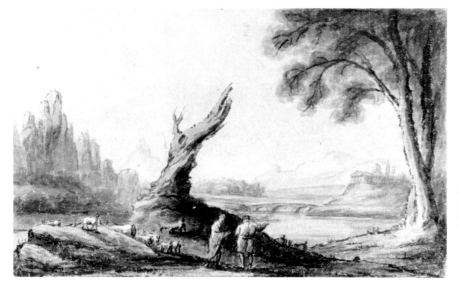

Fig. 91. Landscape with Dead Tree, 1783.
Cambridge, Mass., Fogg Art Museum,
Harvard University; Bequest of
Stephen Bleeker Luce.

The Great Falls
of the Connecticut River at Walpole

1791

Pen and ink and wash on paper, 2¹⁵⁄₁₆ x 4¹¹⁄₁₆ (7.5 x 11.9)

Inscribed, verso: *the great falls of Connecticut River | at Walpole 110 Miles above | Hartford. | Oct.º 1ˢᵗ 1791 | Jnº Trumbull*

Fordham University Library; Charles Allen Munn Collection

Waterfalls became Trumbull's favorite landscape subject. *The Great Falls of the Connecticut River at Walpole*, and the preceding drawing, *Cohoes Falls* (Cat. 140), are among the earliest works he executed of this theme.[1] The double focus on the falls and the timber bridge combines the demands of contemporary landscape conventions with Trumbull's personal interest in the site. Elements of picturesque composition are found not only in the water cascade, but also in the pairs of pines which embrace the view, and the heavy, shadowy boulders of the foreground, which act as repoussoirs. The drawing, which was in Silliman's collection, was described at its sale as "a view of the first cantilever bridge erected in this country."[2] Trumbull's fascination with the new and sophisticated structure is clear from his careful delineation. Such subjects were conscientiously avoided by later landscape artists, who searched for sites unspoiled by technology.

1 Later are two sketches of Passaic Falls, New Jersey (1804), two sketches of Canojaharie Bridge in New York with waterfalls (1807), two drawings of Montmorency Falls (1807) on the St. Lawrence River in Quebec, eight drawings of Niagara Falls (two dated 1808) and three drawings of unidentified waterfalls, in "More Recent Sketches," YU-B.

2 Stan V. Henkels, *Catalogue of the Very Important Collection of Studies and Sketches Made by Col. John Trumbull*, Philadelphia, December 17, 1896, no. 60. The bridge crossed the Connecticut River between Bellows Falls, Vermont, and Walpole, New Hampshire.

141

142

View on the West Mountain
near Hartford

c.1791

Oil on canvas, mounted on wood, 19 x 24⅞ (48.3 x 63.2)
Yale University Art Gallery; Bequest of Miss Marian
 Cruger Coffin in memory of Mrs. Julian Coffin
 (Alice Church)

143

Study for View on the West Mountain
near Hartford

1791

Pen and ink and wash on card, 2¹⁵⁄₁₆ x 4⁹⁄₁₆ (7.5 x 11.6)
Inscribed, verso: *View on the West Mountain | near
 Hartford | May— 1791*
Yale University Art Gallery; Gift of the Associates in Fine
Arts at Yale

In this painting Trumbull depicts a specific topographical
site within the idiom of idyllic landscapes. The painting
and its study show the land which later became part of
Daniel Wadsworth's estate, Monte Video.[1]

In the drawing, the major outlines of forms are quickly
sketched in brown ink, with only the essential indications
of contour depicted. Gray and gray-black washes of vary-
ing saturations suggest the foliage of the trees at left, the
general structure of the tree trunks and land masses, shad-
ows, and the sky.[2] In the later painting these composi-
tional elements are reinforced. Applying thick, white
highlights in the foreground to create a sense of texture,
and using grayish blues for the valley, pinks and yellows
to illuminate the clouds, Trumbull suggests a time of day
near sunset. He adds the seated figure at rest, gazing over
the beautiful valley, and the slowly moving herd of cattle
and sheep to create a picture in the tradition of arcadian
views. The painting has a careful compositional structure
which incorporates many of the conventions of contem-
porary picturesque theory— a valley, distant mountains,
the lake in the middle ground, a broken terrain, and a
river— irregularity and variety being essential to pictur-
esque beauty.[3]

But not all of Trumbull's encounters with the land-
scape on West Mountain were based on purely aesthetic

considerations. In a letter written from London to Jere-
miah Wadsworth, Trumbull indicated that he intended to
act as agent for the sale of the land on West Mountain to
William Beckford, the English man of letters and re-
nowned landscape gardener.[4]

> West Mountain . . . [is] a place more calculated to
> make a delightful and magnificent country residence,
> like what He has here than any thing I had ever met
> with either in America or Europe. He was struck with
> the description and desired to know how much it
> might cost an Acre and whether it could be bought.
> . . . Ascertain as near as you can the Sum at which at
> least 8 or 10,000 acres could be bought: to comprehend
> the Lake & the Mountains south and north of it, to
> the precipice on the Farmington river side, and the
> Road on the East.[5]

The confidence with which Trumbull described the site
shows his great familiarity with it. The spontaneity, scale,
and inner consistency of the drawing indicate that it may
have been done on the site, while the changes introduced
into the finished oil speak for a later execution in the
studio.

The creation of the country estate, Monte Video, may
have been Trumbull's idea. It was he who first perceived
the picturesque possibilities of its topography, and
brought it to the Wadsworths' attention.[6] The cultivation
of country estates and popularity of landscape painting
were contemporary and interrelated developments in
eighteenth-century England, and Trumbull's like interest
in West Mountain suggests a conscious effort to transplant
the tradition to America.

1 This land was incorporated into Talcott Mountain State Park in
 1965. The painting has been incorrectly entitled *Monte Video*. But
 when Trumbull exhibited it at the American Academy of the Fine
 Arts in New York in 1816 (no. 168) it was listed as "A View on the
 West Mountain near Hartford," and in 1824 (no. 45) as "Land-
 scape near Hartford."
2 This technique of drawing outlines in ink and then filling in with
 washes is one which Trumbull used earlier in more finished land-
 scapes made in 1781 on a return voyage from England to America;
 see, for example, *Shakespeare Cliff, Dover*, Jaffe 1975, fig. 36.
3 For a discussion of picturesque theory, see pp. 207-8.
4 William Beckford (1759–1844) of Fonthill Abbey, Wiltshire, was
 also a connoisseur, collector, and author.
5 JT to Jeremiah Wadsworth, September 20, 1798, YUL-JT.
6 Monte Video inspired a number of nineteenth-century images.
 See, for example, the engravings in Benjamin Silliman, *Remarks,
 Made on a Short Tour, between Hartford and Quebec, in the Autumn
 of 1819*, New Haven, 1820, frontispiece and figure facing p. 16;
 watercolor drawings by Daniel Wadsworth, CHS (the engravings
 in Silliman's *Remarks* were based on Daniel Wadsworth's draw-
 ings); and Thomas Cole, *Monte Video*, 1828, Wadsworth Athe-
 neum, which was commissioned by Wadsworth.

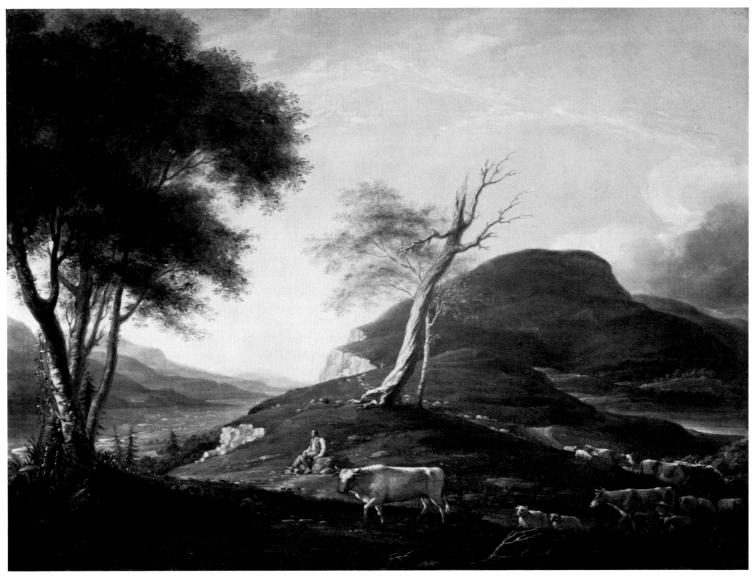

142

143

144
The Falls of the Yantic at Norwich

c.1806

Oil on canvas, 25 x 31 (63.5 x 78.7)
The Slater Memorial Museum, The Norwich Free
 Academy

145
Norwich Falls (*or* The Falls of the Yantic at Norwich)

c.1806

Oil on canvas, 27 x 36 (68.6 x 91.4)
Yale University Art Gallery; The Mabel Brady Garvan
 Collection

146
Norwich Falls

c.1806

Pen and wash on paper, 10⅛ x 15¾ (25.7 x 40)
Fordham University Library; Charles Allen Munn
 Collection

It was probably through the commission to paint the Vernet family portrait (Cat. 119) that Trumbull became acquainted with Norwich Falls and environs. He made at least six pencil sketches, one pen-and-ink drawing, and three oil paintings (two of which are known) related to the site.[1] The background of *The Vernet Family* presents another view.

In *The Falls of the Yantic* (Cat. 144) Trumbull did not focus on the greatest of the cascades,[2] but chose instead a view where the water trickles from several levels until it collects in a pool. Nevertheless he emphasized the picturesque qualities of the site by the inclusion of three spectator figures. In the middle ground above the falls a solitary figure under a tree and a couple with a parasol overlook the spectacle.

In the Yale version (Cat. 145) Trumbull shows none of the cascades, but focuses instead on the rock formation and the calm pools of water characteristic of the region. The painting's orderly and confined spatial composition is enlivened by vertical and diagonal surface patterns, the center cliff intersecting the slope of the rocky bank in the foreground being the most prominent. The entire composition implies the violence of natural effects, without actually representing the waterfalls.[3] Although the geological facts may have interested him, Trumbull was also undoubtedly aware of the local legend that the cliff in the center was that from which the last of the Mohicans threw himself. One critic has suggested that in this context the cliff may be construed as a monumental tombstone symbolizing the clash of two cultures.[4]

The rock is also the subject of the pen and wash drawing (Cat. 146), but here Trumbull shows its opposite side, where the rocks have fissured to create the dark chasm. Possibly this drawing is related to the composition of the third oil version (unlocated) of Norwich Falls. As in his sketches for the history paintings, Trumbull executed the wash drawing to define the light values in the subsequent oil.[5]

The two Norwich oils and the drawing are related to pencil drawings in Trumbull's sketchbook.[6] These drawings show the artist's initially picturesque concepts of the site. In the more finished works, however, Trumbull concentrated on the elements of untouched nature, thus anticipating the interior woodland scenes by later landscape painters of the Hudson River School.

1 Trumbull, "More Recent Sketches," pp. 4, 6, 8, 9, 11, 12, YU-B. The sketches are dated August 1806. Trumbull exhibited two of the three oil landscapes in 1809 at the Royal Academy; see Jaffe 1975, p. 328. In 1835 Trumbull appraised his three versions of Norwich Falls for a total of 500 dollars; handwritten note, YUL-JT.
2 The largest cascades occurred below the buildings of the Paper Mills at Norwich Falls, which was the subject of two pencil sketches by Trumbull; see "More Recent Sketches," pp. 4, 6.
3 Angela Miller, "The Falls of the Yantic at Norwich," unpublished paper, Yale University, Department of the History of Art, 1979, p. 2.
4 Paul Shepard, Jr., "They Painted What They Saw," *Landscape*, 3 (Summer 1953), p. 9. The subject of Indians was of some interest to Trumbull. He executed a number of portraits of Indians (see Cats. 58, 63, 93, 103), possibly in preparation for his painting of *The Murder of Jane McCrea* (unexecuted); see Morgan 1926, p. 74. Trumbull's sketches for this painting are the earliest compositions known of the subject; see Jaffe 1971, pp. 21–24.
5 See, for example, the series of drawings for the *Battle of Princeton* (Cats. 18, 22) and also the pen-and-ink drawing for *View on the West Mountain* (Cat. 143).
6 "More Recent Sketches," pp. 9, 11, 12. *The Falls of the Yantic* (Cat. 145) is closest to p. 9; Cat. 144 corresponds to p. 12 of "More Recent Sketches." The landscape background of *The Vernet Family* (Cat. 119) is based on p. 8.

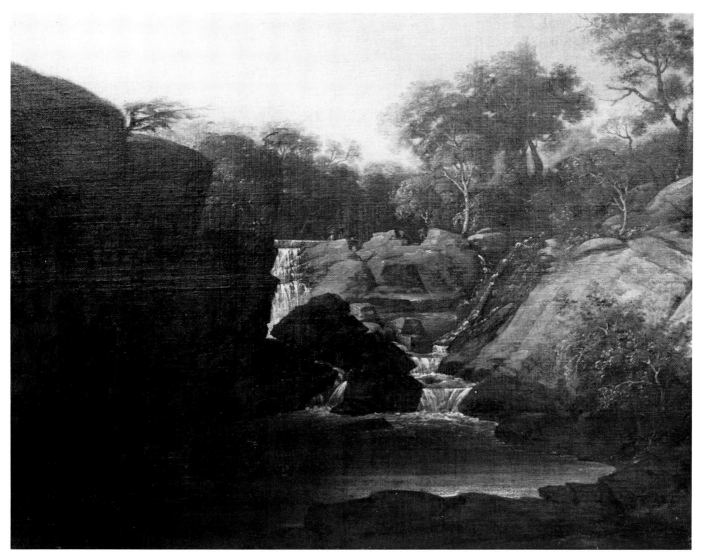

144

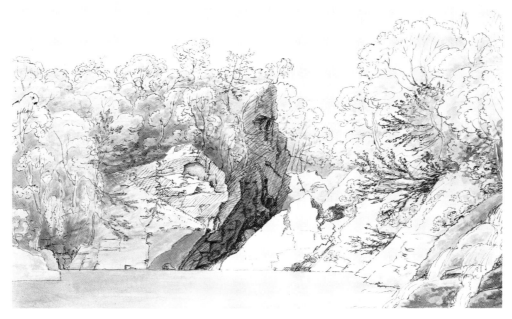

146

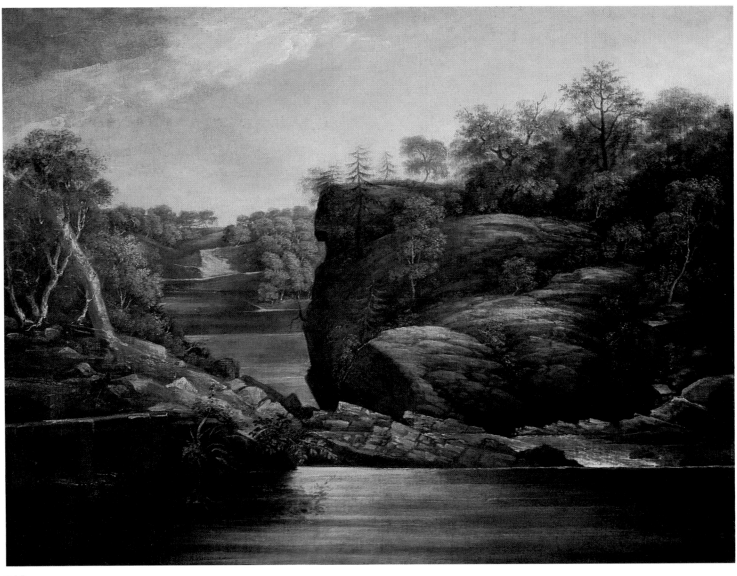

145

147
View of the Falls of Niagara from under Table Rock

c.1808
Oil on canvas, 29 x 168 (73.7 x 426.7)
The New-York Historical Society

148
Niagara Falls from an Upper Bank on the British Side

1807 or 1808
Oil on canvas, 24⅜ x 36⅝ (61.9 x 93)
Wadsworth Atheneum; Bequest of Daniel Wadsworth

149
Niagara Falls below the Great Cascade on the British Side

1807 or 1808
Oil on canvas, 24⁷/₁₆ x 36⅜ (62.1 x 92.4)
Wadsworth Atheneum; Bequest of Daniel Wadsworth

150
Niagara Falls

1807 or 1808
Pencil on paper, 5¾ x 18⅛ (14.6 x 46)
Beinecke Rare Book and Manuscript Library, Yale
 University

On November 11, 1808, Trumbull wrote to his friend and banker Samuel Williams of his plans to visit London:

> I shall also bring with me two panorama Views of the falls of Niagara, Surrounding Objects— The Scene is magnificent & novel.— I have copied it with all the fidelity in my power, and am not without a hope that it will at once excite and in some measure gratify the public curiosity.— I will thank you to mention to . . . some of your . . . opulent friends who have a taste for the fine Arts, that I have prepared such views and that they will soon be in London.[1]

The next month he shipped two rolled-up panoramic views of Niagara (Cat. 147, *Fig. 92*), two smaller paintings (Cats. 148, 149), and two canvases with the outlines of the falls sketched in ink (unlocated).[2] Like Trumbull's pro-

jected series of prints after his history paintings, and his plan to open a gallery of Old Master paintings (p. 12), the Niagara scenes were part of an attempt to make his art appeal to a wider market. And like so many of his other business ventures, the scheme failed.

Trumbull made the two 14-foot-long studies in preparation for a huge, circular panorama painting of the type then all the rage in Europe and America. Although the project was never realized, the paintings of Niagara remain of interest to historians as among the earliest surviving examples of American landscape painting. Their panoramic format recalls an important and nearly forgotten aspect of popular culture; the subject was painted at a time when Niagara was beginning to be regarded as a national icon. Their style reveals Trumbull's position as an artist at the opening of the nineteenth century, looking at the American landscape with eyes trained in the conventions of eighteenth-century British painting.

Panoramas were already exciting a great deal of interest in Britain by the 1780s and 1790s. In 1794, the Scottish landscape painter Robert Barker had opened a permanent establishment to exhibit panorama paintings in Leicester Square.[3] This round structure, 90 feet in diameter, was designed for lighting effects: the visitor entered through a darkened passage that opened up to a raised platform, from which he could view the 360-degree painting lit from above. In order to make the illusion more effective, the platform kept visitors at a sufficient distance from the painting's surface to blur any evidence of individual brushstrokes and hide all the apparatus supporting the canvas. At a time when plays were still performed in fully lit theaters, the effect of passing from darkness into a blaze of light, to be suddenly surrounded by an enormous painting, must have been spectacular. The panorama soon became a popular form of entertainment, a predecessor in many ways of today's wide-screen movies. The most popular subjects were city views, battle epics, and depictions of natural disasters. Barker's idea proved such a success that before long London had a rival panorama and imitators opened establishments in New York (1795), Munich (1800), and Paris (1800). King George III, Napoleon, and Benjamin Silliman were among the many enthusiasts.[4]

Academic artists became interested in the possibilities of the panoramic format as a new art form. Sir Joshua Reynolds is said to have become quite an admirer of Barker's panorama. Trumbull's teacher, Benjamin West, frequently visited panorama establishments, and may have shared his enthusiasm with his pupils; an advertisement appearing in the London *World* in 1790 claimed that West had allowed Barker "freely to make use of his name, in asserting Mr. Barker's idea and mode of description to be the greatest improvement to the art of painting that has ever yet been discovered."[5] The German architect Karl Friedrich Schinkel executed a number of panoramas in the early nineteenth century, and the influential British landscape painter Thomas Girtin was at work on a 360-degree view of Paris at the time of his death in 1802. Legend has it that Jacques-Louis David took a group of pupils to the panorama establishment in Paris and was moved to exclaim: "Truly gentlemen, it is here one must come to study nature!"[6]

By the time Trumbull returned to the United States and established himself as a portrait painter in New York in 1804, American enthusiasm for panoramas was in full swing. The success of the first American panorama, a view

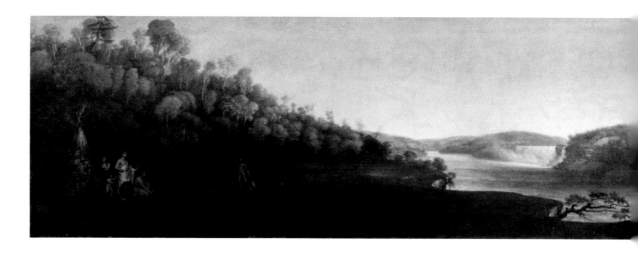

of London painted by the emigré British landscapist William Winstanley in 1795, gave rise to a series of large paintings by rival artists shown in public halls around New York.[7] Although not all of these works were completely circular, they did incorporate the novel idea of depicting more scenery than the viewer could take in at once without turning his head. Around the turn of the century, American entrepreneurs began to import panoramas from England, and to send the canvases on extended tours of American cities.[8] At first, American audiences preferred exotic images of European battles and foreign ports. Although views of Charleston and Boston figured among the earliest American panoramas, it was not until the 1830s and 1840s that native scenes— Nantucket whaling, battles from the Revolutionary War, and countless "mile-long" panoramas of the Mississippi— enjoyed much popularity.[9]

American panoramas were probably less sophisticated than the ones Trumbull would have seen in London. In New York, panoramas were considered purely theatrical entertainment— a respectable alternative to attending a stage play— and appealed to the same audiences that patronized the displays of orreries, waxworks, lantern shows, and other "exhibitions for the curious" that flourished in lower Manhattan. Exhibitors of panoramas charged admission to their buildings, sold program pamphlets, and often provided live musical entertainment.[10]

In this atmosphere of spectacle and freak show, it is little wonder that the panorama was not considered as high an art form as it was in England. Most American painters of panoramas made their living producing signs and stage sets, and had no pretensions to edifying the public with their work. Besides Trumbull, the only American artist of any stature ever to attempt a panorama was John Vanderlyn, who actually completed a circular oil painting of Versailles and its gardens in 1818. The careful perspective and sensitive handling of this work were a cut above those of the average panorama, but the painting met with little popular or financial success.[11] Trumbull probably regarded his own panorama as a commercial undertaking, like portraiture, and of a different rank altogether from his history painting.

Given the prevailing interest in natural oddities and exotica, Trumbull's choice of Niagara Falls was perfect. This was the era of fascination with the picturesque and the sublime. In the first decade of the century, most people looked on the falls not only as a romantic reminder of the presence of God in nature, but also as sheer spectacle. As early as 1782 (just after Trumbull's first visit), London audiences had thrilled to a display of the "Cataract of Niagara in North America," which included sound effects and waterworks.[12] Paintings and prints of the falls sold well on both sides of the Atlantic. In 1800 the American-born and English-trained artist Ralph Earle exhibited a "stupendous view of the Falls of Niagara" in New York and subsequently at Peale's museum in the Philadelphia State House, where it was held over an extra week by popular demand.[13] Vanderlyn traveled to the falls the next year, and painted several views on site (now in the Kingston Museum, New York, and the Museum of Fine Arts, Boston). Two of these views were engraved in 1805 (Fig. 93), and several pirate editions were made. Trumbull probably knew at least one of them. They are the first images that depict the falls in a wide, horizontal format, which may derive from the conventions of panoramic painting.[14]

By the time of Vanderlyn's visit, the falls were also taking on importance as a national symbol. In the same years during which the cult of Washington gained popularity, images of Niagara were turning up in allegorical poems and in prints, such as the 1801 mezzotint which juxtaposed a personification of America holding a flag decorated with an eagle, a picture of Washington's tomb, and the falls in the background.[15] Aware of the growing power of the image, Trumbull was the first artist to think of "exciting and gratifying the public curiosity" by combining the "magnificent and novel," and increasingly topical, subject of Niagara with the popular format of the panorama.

Trumbull made two trips to Niagara in 1807 and 1808. Drawings from both trips survive in one of his sketchbooks.[16] The four surviving oil paintings seem to be based on sketches from the second trip, which the artist took with his wife in the autumn of 1808. Trumbull had probably already decided to return to England by the time of this second visit, and may have planned the sketches with paintings for a British market in mind.[17] The sketches fill the horizontal format of the book's double-page spread, and are covered with careful notes about color, scale and proportion (see Cat. 150). The use of measurements in terms of segments of a circle suggests that the artist may have employed a surveyor's alidade.[18]

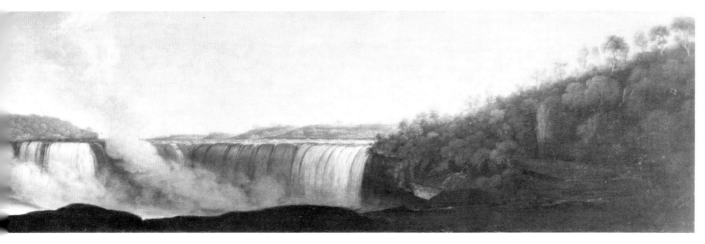

147

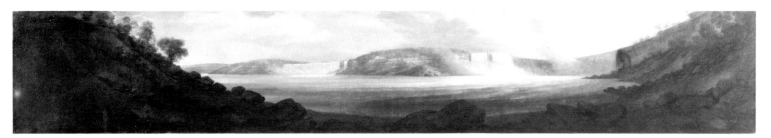

Fig. 92. Niagara Falls Two Miles Below Chippewa, c.1808. The New-York Historical Society.

Trumbull condensed the views of his expansive sketches to fit the proportions of a standard-size canvas for the Wadsworth paintings, which he probably intended to sell as separate works rather than as studies for the panorama. In doing so, he altered the scene to fit contemporary ideas of the picturesque. In *Niagara Falls from an Upper Bank* (Cat. 148), the deep space pulls the viewer's eye back into the distance and distracts from the falls themselves; Niagara becomes a genteel backdrop to the foreground scene, where two British soldiers and their ladies stroll in a conventional landscape, and practically ignore the view around them. Only the figure of the artist (perhaps a self-portrait) sketching beneath a tree at the right takes notice of the spectacle, and serves to direct the viewer's attention back to the subject of the painting. Artists included this type of group as a standard *staffage* element in most seventeenth- and eighteenth-century landscape views in order to give a sense of scale and to introduce a human element. Since none of the people in Trumbull's Niagara scenes appear in the sketches that the artist made on site, we can assume that he probably brushed them in for the same reasons, turning a scene of unbound nature into a picture of polite society.

The painting of *Niagara Falls below the Great Cascade* (Cat. 149) evokes a more immediate sensation of nature, as Trumbull's expressive, nervous brushwork conveys the different textures of rock, water, spray, and clouds. By choosing a viewpoint up under the cascade of water, Trumbull suggests some of the scale and power of the falls. But this view, too, is arranged according to classical traditions of composition, with the cascade of water on the right neatly balancing the cliff at the left. As in the other small canvas, the foreground figures here recall those used in earlier depictions of the falls. Trumbull inserted a personal note in the group at the right: the artist sketching is probably a self-portrait, and the figures looking on represent his wife and the servant who accompanied the Trumbulls on their visit to Niagara. The servant holds a parasol which could be the one Trumbull bought for his wife on the way to the falls and recorded in his account book.[19]

In his long views, Trumbull distorted his perspective to fit the panoramic format, although the strange, "bulging" effect may have something to do with his use of optical devices, with his desire to show a view which would "read" correctly when enlarged to fill a curved wall, or with his impaired eyesight. These big paintings are executed on a small scale: nature appears even tamer and more distanced than it does in the drawings and smaller paintings. Following a composition traditional for both classical landscapes and for stage sets, Trumbull arranged the landscape elements into symmetrical *coulisses*, or banks, and pushed the falls back into the exact center of each canvas. In keeping with the illusionistic requirements of the panorama, the touch of the artist's hand is less evident here than in his other paintings of the falls. The total effect works to subdue a scene which would take on high drama in the hands of the later artists of the Hudson River School. Trumbull's ordered calm, delicate handling, and blushing skies place him firmly in the eighteenth-century topographical tradition of the British artist Richard Wilson.

To increase the panorama's appeal to a British audience, Trumbull added a group of Indians to the foreground of *View of the Falls of Niagara from under Table Rock* (Cat. 147). While actual Indians still lived near the

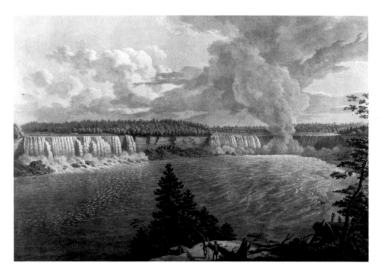

Fig. 93. J. Merigot (after John Vanderlyn), *A Distant View of the Falls of Niagara*, 1804, engraving. Peebles Island, Waterford, New York, New York State Parks, Recreation and Historic Preservation Bureau of Historic Sites.

falls at the time Trumbull visited, the figures in the painting are probably an invention. Since the eighteenth century, artists had included similar groups in depictions of Niagara; the Indians filled the role of picturesque foreground figures and also added to the exotic "Americanness" of the scene. Hardly savages, Trumbull's Indians are well-mannered stage figures. Their poses recall those of the Indians in the backgrounds of Benjamin West's portrait of *Colonel Guy Johnson* and *Penn's Treaty with the Indians*, which in turn derive ultimately from classical sculpture.[20]

Upon arriving in London in 1808, Trumbull apparently approached Robert Barker with a proposition to commission a full, 360-degree panorama, based on his two long paintings, to be exhibited in Barker's establishment in Leicester Square. According to Dunlap, Trumbull then asked West to intervene in order to influence Barker's decision, but to no avail.[21] Barker may have thought that the two long views, both of which show the same landscape but from slightly different angles, were unsuited for a circular painting. Or, as Sizer has suggested, the political climate that preceded the War of 1812 may have made such an obviously American subject unpopular in England.[22] Trumbull had no luck in finding English buyers for any of his Niagara paintings; he sent the panoramas and the smaller canvases back to America in 1813.[23]

After the failure of the London venture, Trumbull seems to have given up the idea of the panorama. Instead of trying to interest an American showman in his scheme, he exhibited his long paintings at the American Academy of the Fine Arts in its opening exhibition of 1816 and again in 1822 and 1823. The two smaller paintings were shown, along with a group of landscapes including *The Falls at Norwich*, in 1824.[24] Trumbull eventually sold the panoramic views to his friend David Hosack, who displayed them in the long picture gallery of his house in Hyde Park, New York. Daniel Wadsworth paid 400 dollars for the two smaller views in 1828.[25]

By the time Trumbull sold his last Niagara paintings, popular interest in the subject was stronger than ever.

William Dunlap achieved great success in 1828 with his performance of *A Trip to Niagara*, in which a narrator read a poem while an enormous painting unrolled behind him.[26] The next year Thomas Cole traveled to the falls, and many other artists followed. American audiences finally got a taste of Niagara in the round in 1831, when the English entrepreneur Robert Burford (the inheritor of Barker's operation) prepared a full panorama of the falls that eventually traveled to New York and Boston. In the pamphlet accompanying the exhibition, Burford expounded on the appropriateness of the subject for a panoramic format— "The scene combines every thing that is essential to constitute the sublime, the terrific, and the picturesque"[27] — and never acknowledged that Trumbull had anticipated the project twenty-five years before.

1 JT to Samuel Williams, November 11, 1808, YUL-JT.
2 For the shipping records, see the notebooks labeled "Inventories: 1803 to America, 1808 in America to London, 1813 returning to America" in the NYHS.
3 The information which follows on Barker and the development of the panorama in Europe is taken from Richard D. Altick, *The Shows of London*, Cambridge, Mass., 1978; Germain Bapst, *Essai sur l'Histoire des Panoramas. . .* , Paris, 1891; Heinz Buddemeier, *Panorama, Diorama, Photographie*, Munich, 1970; Richard Carl Wickman, "An Evaluation of the Employment of Panoramic Scenery in the Nineteenth Century Theater," Ph.D. diss., Ohio State University, 1961.
4 Napoleon appointed a committee to investigate using panoramas as a means of public propaganda; see "Séance du 28 Fructidor, An 8," reprinted in Buddemeier, *Panorama*, pp. 164–70. In a journal entry dated June 14, 1805, Silliman noted: "I am fond of Panorama paintings, especially of battles. Their magnitude— the consequent distinctness of the objects, and the circular form which they are made to assume, corresponding with the real horizon, all tend to give me the strongest impression of the reality of the scene"; see Benjamin Silliman, "Journal of London," II, pp. 82–83, YUL-SF.
5 Advertisement quoted in Altick, *The Shows of London*, p. 132.
6 Quoted in John Francis McDermott, *The Lost Panoramas of the Mississippi*, Chicago, 1958, p. 5.
7 For Winstanley's career, see Dunlap 1834, I, p. 394. His painting may have been based on engravings after Barker's panorama of London. For more information on the panorama in America, see McDermott, *The Lost Panoramas*, and Lee Parry, "Landscape Theater in America," *Art in America*, 59 (November-December 1971), pp. 52–61. Several historians have suggested that the panoramic format may have helped pave the way for the "full-length landscapes" of Church and the Hudson River School; see Wolfgang Born, *American Landscape Painting*, New Haven, 1948, pp. 75–117, and James T. Callow, *Kindred Spirits: Knickerbocker Writers and American Artists, 1807–1855*, Chapel Hill, N.C. 1967, pp. 145–46. Most recently, Barbara Novak has connected the panorama with Albert Bierstadt's "operatic landscape" in *Nature and Culture*, New York, 1980, pp. 19–26, 70–71.
8 George C. D. Odell, *Annals of the New York Stage*, 15 vols., New York, 1927–49, II, pp. 239, 303, 304, 371, other volumes *passim*. By 1825 there were permanent structures for exhibiting panoramas in Boston, Philadelphia, and New Orleans.
9 In Boston, the Scottish-born artist Robert Salmon displayed a semicircular painting of the *Battle of Algiers* in the rotunda of the Quincy Market in 1829; pieces of that painting are now preserved at the Museum of Fine Arts, Boston, and the Art Museum in New Britain, Connecticut. On the whaling panorama, see Elton W. Hall, "Panoramic Views of Whaling by Benjamin Russell," in *Art & Commerce: American Prints of the Nineteenth Century*, Charlottesville, Va., 1978, pp. 25–49. The New Bedford Whaling Museum owns the remnants of Russell's panorama painting. For Mississippi panoramas, see McDermott, *The Lost Panoramas*, and Lisa Lyons, "Panorama of the Monumental Grandeur of the Mississippi Valley," *Design Quarterly*, no. 101/102 (July 1977), pp. 32–36.
10 For other references to panoramas and theatrical entertainment in New York, see Rita Susswein Gottesman, ed., *The Arts and Crafts*

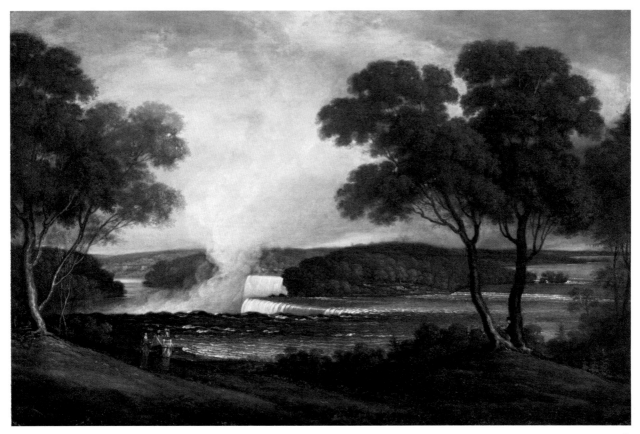

148

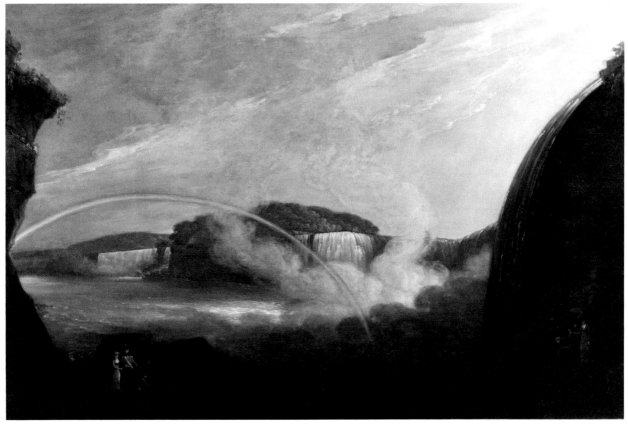

149

150

in New York: Advertisements and News Items from New York City Newspapers, 3 vols., New York, 1936–65, passim.

11 Vanderlyn's painting is now in the Metropolitan Museum of Art, New York; see Theodore Bolton, "Vanderlyn and American Panoramania," Art News, 55 (November 1956), pp. 42–45, 52; and Albert TenEyck Gardner, John Vanderlyn's Panoramic View of the Palace and Gardens of Versailles, New York, 1956. Natalie Spassky kindly made photographs of the Vanderlyn panorama available for the preparation of this entry.

12 The London performance is described in Altick, The Shows of London, pp. 121–23. For a thorough treatment of the theme of Niagara in art, literature, and intellectual history, see Elizabeth McKinsey, Niagara Falls: Icon of the American Sublime (in preparation). Professor McKinsey graciously made her manuscript available, and also offered important suggestions on panoramic views.

13 The artist was probably Ralph Earle the Elder; see the advertisement from the New York Daily Advertiser, March 18, 1800, reprinted in Gottesman, The Arts and Crafts in New York, III, p. 4; also the notice of the exhibition in the Philadelphia Federal Gazette, April 28, 1800.

14 For the Vanderlyn prints, see Kenneth Lindsay, "John Vanderlyn in Retrospect," The American Art Journal, 7 (November 1975), pp. 79–90. Elizabeth McKinsey, Niagara Falls, first suggested relating Vanderlyn's prints to panoramic composition.

15 The print, now in the collection of the New York Public Library, is reproduced in Joshua C. Taylor, America as Art, exh. cat., National Collection of Fine Arts, Washington, D.C., 1976, p. 14.

16 In "More Recent Sketches," YU-B.

17 Jaffe 1975, p. 328.

18 Ibid., p. 219. In the sketchbook, no. 17 roughly corresponds to Cat. 148; no. 28, to Vanderlyn's print; no. 29 depicts the same scene as in Cat. 149.

19 Earlier depictions of Niagara are reproduced in McKinsey, Niagara Falls, and in Three Centuries of Niagara Falls, exh. cat., Al-
bright-Knox Art Gallery, Buffalo, New York, 1964. The reference to the parasol is from Trumbull's account book for 1807–8, YUL-JT.

20 McKinsey, Niagara Falls, discusses the meaning of the Indian to Americans in the early nineteenth century. See also Elwood Parry, The Image of the Indian and the Black Man in American Art, 1590–1900, New York, 1974, pp. 36, 53; and Ruthven Todd, "The Imaginary Indian in Europe," Art In America, 60 (July-August 1972), pp. 40–47.

21 Dunlap 1834, I, pp. 372–73. Dunlap's source for this account was the American artist Alexander Robertson; see William Dunlap, Diary, 3 vols., New York, 1931, III, p. 684.

22 Sizer 1967, p. 120.

23 See the shipping records cited above, n. 2.

24 American Academy of the Fine Arts, Exhibition Record: 1816–1852, New York, 1953, pp. 355, 357, 358. It is not known which of his three versions of The Falls at Norwich was exhibited. In addition to Trumbull's paintings, the opening exhibition of the Academy included five other views of Niagara— four by Alexander Robertson, and one by his brother, Archibald.

25 A note on the back of a letter from Trumbull's patron Wolcott Huntington, dated November 19, 1823, records the prices Trumbull asked for the paintings (he eventually sold them for less): "2 Falls of Niagara, 500. 2 Panoramas, do., 600" (from information in the curatorial files at the New-York Historical Society). For the sale to Hosack, see T. B. Thorpe, "New-York Artists Fifty Years Ago," Appleton's Journal, 7 (May 18, 1872), pp. 572–74. Wadsworth's purchase is recorded in a letter from Trumbull to Daniel Wadsworth, dated May 9, 1828, in the curatorial files at the Wadsworth Atheneum.

26 Callow, Kindred Spirits, p. 148.

27 William Burford, Description of a View of the Falls of Niagara, Now Exhibiting at the Panorama, Broadway, corner of Prince and Mercer Streets, New York, pamphlet in the collection of the New-York Historical Society.

The Power of Imagination
Trumbull's Works on Literary Themes

By Martin Price

The age of John Trumbull was as revolutionary in its literature as in its politics and painting. It was an age, first of all, that secularized those religious themes an earlier time had explored with baroque and pious wit. It sought to revive a classical lucidity of form, and it stressed the moral nature that all men shared. That moral nature could ground itself in rational intuition where before it had sought revelation, but increasingly in the eighteenth century the rational was replaced by the work of feelings. It was upon their imaginative constructions that society might be seen to rest; upon shared feelings was built a vast structure of loyalties and beliefs. We can see this process recognized and asserted in Wordsworth's lines about his epic theme. Just as Milton, in *Paradise Lost*, had set a vision of spiritual heroism against traditional powers of outward combat, so Wordsworth set his own subject against Milton's:

> I must tread on shadowy ground, must sink
> Deep— and, aloft ascending, breathe in worlds
> To which the heaven of heavens is but a veil.
> All strength— all terror, single or in bands,
> That ever was put forth in personal form—
> Jehovah— with his thunder, and the choir
> Of shouting Angels, and the empyreal thrones—
> I pass them unalarmed. Not Chaos, not
> The darkest pit of lowest Erebus,
> Nor aught of blinder vacancy, scooped out
> By help of dreams— can breed such fear and awe
> As fall upon us often when we look
> Into our Minds, into the Mind of Man—
> My haunt, and the main region of my song.
>
> —*The Recluse*, ii, 781–94

Wordsworth has internalized the old heroic subject; his new theme is the powers of mind by which man creates a self and a world. Where Milton had sought in a retelling of scriptural myth to "justify the ways of God to man" and Alexander Pope in a discursive and philosophical poem to "vindicate the ways of God to man," Wordsworth wrote an account of the emergence of a poet's mind, showing "All gratulant, if rightly understood."

　　We can see this process of secularization in two of John Trumbull's works, one an early drawing, the other a comparatively late painting. There is reason to believe that Trumbull remained a man of some piety throughout his life, but such piety as could accommodate itself to a considerable range of doctrines. Very early in his *Autobiography*, he tells of his mischievous attempt as a boy to induce the Indian chief Zachary to return to the drink he had solemnly abjured. "John," the old Indian exclaims,

Fig. 94. "And Look thro' Nature, up to Nature's God"
(Cat. 151).

"you do not know what you are doing. You are serving the devil, boy! . . . *John, while you live, never again tempt any man to break a good resolution.*" What follows is interesting: "Socrates never uttered a more valuable precept— Demosthenes could not have given it in more solemn tones of eloquence. I was thunderstruck. My parents were deeply affected; they looked at each other, at me, and at the venerable old Indian, with deep feelings of awe and respect."[1] What must strike us is not simply that a reformed Mohegan chief is shown veneration but that he is likened to classical figures. While Zachary speaks of the devil, Trumbull speaks not of martyrs or angels but of classical sages.

Benjamin Silliman tells us that Trumbull "received a religious education, & imbibed a reverence for the Bible, which seems never to have deserted him" in his "communion with the world of art and fashion."[2] There was, however, a critical moment in 1793 when Trumbull's religious views seem inextricably tied to the political. The contretemps took place at Thomas Jefferson's house. Trumbull had earlier vexed Senator William Branch Giles of Virginia, and on this occasion Giles began to tease him about "the puritan ancestry and character of New England." Trumbull found himself made a source of "amusement to a rather freethinking dinner party," with Jefferson "nodding approbation of Mr. Giles." When finally Giles delivered himself of "a broad and unqualified avowal of atheism," Trumbull spoke his scorn and left the company. "From this time my acquaintance with Mr. Jefferson became cold and distant."[3] First, there was the regional or sectional note that personal resentment took in Giles. Even more, Trumbull found in this company an ideological divisiveness, condoning the Reign of Terror and the worship of Reason by which France justified her political murders. This divisiveness seemed to him to blight hope for the arts, and particularly for his contribution to them, in America.

We learn from Silliman that Trumbull's "complexion was *Unitarian*, and this . . . was his leaning in the later years of his life," but near the close "he expressed his entire reliance upon Christ for salvation."[4] As Trumbull took part in family prayers in the Silliman household, "tears would

1 Trumbull 1841, p. 8.
2 Silliman, "Notebook," I, p. 32.
3 Trumbull 1841, pp. 170–72.
4 Silliman, "Notebook," I, p. 33.

sometimes flow down his cheeks when certain passages of the bible were read, for he had great sensibility."[5] It is against this mixed pattern that I should like to set two secularized works.

The first (*Fig. 94*) is a drawing for a lost painting, to which Trumbull in effect assigned as a title a line drawn from Alexander Pope's *Essay on Man* (1734): "And look thro' Nature, up to Nature's God." That line gains greater import from its context in the poem. In this, the last of four epistles, Pope presents Virtue as the only point where human bliss stands still; and he sets it in opposition to learning and wealth, to all the instrumentalities of worldliness:

> See! the sole bliss Heav'n could on all bestow;
> Which who but feels can taste, but thinks can know:
> Yet poor with fortune, and with learning blind,
> The bad must miss; the good, untaught, will find;
> Slave to no sect, who takes no private road,
> But looks thro' Nature, up to Nature's God.
>
> —IV, 327–32[6]

Pope celebrates the good man's spontaneous wisdom in contrast with the partisan spirit and institutional dogma that can sophisticate or lose that vision. The figure in Trumbull's drawing is dressed in a garment that might equally suggest the monk's habit or the philosopher's toga, and his foot rests with scorn upon a volume of Thomas Hobbes. Hobbes was the chief proponent in seventeenth-century England of the Epicurean philosophy that refused to look beyond nature but instead saw all that was natural, human, or supposedly divine as the creation not of mind but of chance, not of spirit but matter. In contrast, there is the third Earl of Shaftesbury's figure of Theocles in *The Moralists: A Rhapsody* (1790). Theocles looks with rapture on the magnificent order of nature and through it to the ordering power of mind or God. Shaftesbury was himself distrustful of institutional religion and insisted upon the greater value of a free response, at once aesthetic and moral, to the sublimity of nature or to the beauty of man's benevolence. He appealed to the classical dignity of Apollo rather than the tormented figure of the crucified Christ; for Shaftesbury (who called himself a theist) believed that man's sentiments could be trusted if he were freed of superstitious fears and the malice to which they often gave rise. Pope in a similar vein could stress the primacy of moral goodness:

> For Modes of Faith, let graceless zealots fight;
> His can't be wrong whose life is in the right.
>
> —III, 305–6[7]

Trumbull's drawing shows a reverence that looks for God's order and meaning in nature rather than in theological system or creed. Trumbull's own faith seems to have tolerated various emphases. We can see it reaching the limits of its tolerance in the unpleasant encounter of 1793; but he shows no signs of hardening thereafter into a narrow orthodoxy.

The other secularized work of Trumbull's is the painting entitled *Maternal Tenderness* (*Fig. 95*). The sketch upon which it may be based shows a Madonna seated on what (except for its width) seems a throne or chair much like that in Raphael's *Madonna della Sedia*, which Trumbull may first have encountered in John Smibert's copy and later painted from the copy in West's studio in 1780.[8] Trumbull painted a number of religious pictures, but for this secularized painting we have his telling comment, as recorded by Silliman: "A young and lovely mother nursing her infant child is the most beautiful object in nature" (see Cat. 158). The tribute to Trumbull's "sensibility" is relevant here.

In a work which helped to create the vogue for "sensibility," *Tristram Shandy* (1759–67), Laurence

5 Ibid., I, p. 32.
6 *The Twickenham Edition of the Poems of Alexander Pope*, John Butt et al., eds., 11 vols., New Haven, 1950–67, III, p. 160.
7 Ibid., p. 124.
8 Trumbull 1841, pp. 50, 67.

Fig. 95. Maternal Tenderness (Cat. 158).

Sterne had celebrated the sheer artistry of feeling as it flowed into unpremeditated gesture or unstudied eloquence, its free and intense expression surpassing all the efforts of deliberate art. Edmund Burke's influential treatise on the sublime and the beautiful (1757) discussed a higher and more exalted kind of feeling.[9] Burke's sublime existed at the margin of the visible; it was attained precisely as the visual was threatened or transcended, through obscurity or brilliance, through suggestions of the illimitable or the terrifying. It was not so much Burke as his followers who saw the sublime as an experience that called up man's own transcendent powers. One could claim for man those powers traditionally ascribed to God, as when William Blake asserts that "He who sees the Infinite in all things sees God. . . . therefore God becomes as we are, that we may be as he is" (*There Is No Natural Religion*, 1788). This is the recognition that man must be instinct with divinity if he is to perceive the divine. The two works of Trumbull I have cited stress the goodness of the natural and the implicit presence of the divine within it. Their secularization marks an approach to the divine not at the expense of the world but in and through this world. The Madonna is, whatever else, first of all a mother, and it is maternal affection that makes every mother in some degree a madonna.

If this seems a great weight of meaning to bring to Trumbull's secularized works, I should like to turn to two heroic subjects, one drawn from Homer and the other from Ossian. The scene from Homer is *Priam Returning to His Family, with the Dead Body of Hector*, painted in 1785 (*Fig. 96*). Here again we may see a religious subject displaced into the human. Hector's body, centrally placed as a strong diagonal, recalls traditional treatments of the lowering of Christ's body in the Descent from the Cross or in the Entombment. (Trumbull was to copy such an *Entombment* after Annibale Carracci as late as 1826; Cat. 136.) In this secularization he had as models the practice of Benjamin West in *The Death of General Wolfe* (*Fig. 9*) and of John Singleton Copley in *The Death of the Earl of Chatham* (*Fig. 10*) and *The Death of Major Peirson* (*Fig. 14*); not only had they used traditional religious poses

9 Edmund Burke, *A philosophical enquiry into the origin of our ideas of the sublime and beautiful*, J. T. Boulton, ed., London and New York, 1958.

Fig. 96. *Priam Returning to His Family, with the Dead Body of Hector* (Cat. 153).

for secular heroism in modern dress, but they helped to transmit examples of Poussin and Rubens to the young Trumbull. He was to be much impressed by Charles Le Brun's *Massacre of the Innocents* ("*terribly* fine; maternal horror and distress are too wonderfully represented") and by a copy of Rubens' *Massacre* ("touched by himself— a wonderful composition").[10] The full sense of what Rubens could mean, and I think it highly relevant to the *Priam*, is made clear in Trumbull's account of *The Family of Lot Departing from Sodom (Fig. 97)*:

> Lot and his family leaving Sodom— the tender regret, the pity, the reluctance, with which the good old man quits the place where he has so long lived, his eyes cast up to heaven, as if praying that even yet his countrymen might be spared, is wonderfully expressed. The amiable, the heavenly manner of the angel who hastily leads him forward, pointing to happier and more virtuous scenes; the trembling hesitation of the wife, who is even urged forward, by another heavenly comforter; the beauty and resignation of one of the daughters, and the meretricious carelessness of the other; the heavens filled with ministers of the divine vengeance, urging on the tempest of lightning and fire upon the devoted city, forms altogether a scene, the most sublime in imagination, the most perfect in expression, and most splendid in coloring, that I have ever seen from this great man![11]

The studies for *Priam* (Cats. 154, 155) show a denser grouping of figures than the painting finally admits. The somewhat staccato gestures of the women's arms, reminiscent of treatments of the Massacre of the Innocents, give way to a more beautiful and controlled play of gesture in the painting. The clarity of the scene is heightened by the two massive Doric (or Tuscan) columns which frame Hector's body and divide the picture into three sections. The outer sections are comparable in width but contrasting in effect. The left section has a large area of open space and light, its recession to the more distant buildings controlled by the three crossing spears. The right section is largely in shadow, from which the three figures of women emerge into brilliant light. Pope discussed this scene in a note to his translation, praising Homer's distinction between the three women: "Andromache speaks like a tender Wife, Hecuba like a fond Mother, and Helen mourns with a Sorrow rising from Self-accusation."[12]

10 Trumbull 1841, pp. 103, 117.
11 Ibid., pp. 113–14.

12 John Butt et al., *Poems of Alexander Pope*, VIII, p. 574, n. 906.

Fig. 97. Peter Paul Rubens, *The Family of Lot Departing from Sodom*, 1625. Paris, Musée du Louvre.

Perhaps most moving is the gesture of Priam. As Pope says of the poem, Homer "judiciously makes Priam to be silent in the general Lamentation; he has already borne a sufficient Share in these Sorrows, in the Tent of Achilles."[13] Pope's words remind us that the more common illustrations of Book XXIV are the scene of Priam kneeling before Achilles or the mourning of Andromache over the reclining body of Hector. The latter was painted by Gavin Hamilton in 1761 and by Jacques-Louis David in 1783. Of the David, Trumbull notes, "a picture of much merit, with some defects; the style of the drapery is too little, too much cut up; the expression well and the drawing pretty good."[14] Trumbull has neglected these scenes of greater pathos. Instead the desolate father seems to offer the body of his heroic son with pride as well as grief. The women in turn receive it with gestures whose beauty is shaped by moral strength.

The painting from Ossian, *Lamderg and Gelchossa* (*Fig. 99*), is one of at least two that Trumbull painted of the subject. The strange career of the blind bard, Ossian, is one of the most fascinating literary events of Trumbull's age. James MacPherson seems to have made a serious effort to collect fragments of oral literature that still survived in the Highlands of Scotland. He claimed more than oral sources, but he could never produce the manuscripts from which he professed to have translated the epic works, most notably *Fingal* and *Temora*. But the great initial success of MacPherson's forgery has much to do with the changing conception of poetry, and particularly epic poetry, in the age. "Pope's response to Homer," a modern editor observes, "is complex. He sees Homer as guide, mentor, and model, not only in the mazes of poetry but to an extent in the mazes of life itself."[15] Pope amplifies Homer in terms that summon to mind the epic tradition that has interpreted and transformed Homer through the intervening centuries. Pope's Homer was the latest in a series of new epic poems, commentaries, and translations that served to keep Homer's works alive in later times. To keep them alive is often to sacrifice archaeological exactness, to elide details which cannot easily survive the time-bound customs of ancient Greece. Some details are retained but explained in the notes, often by analogy with similar customs— for example, forms of address— in other texts like the Bible or Milton's *Paradise Lost*.

Such a way of treating Homer stressed the similarity of his concerns to those of modern men. Thomas Jefferson "felt that the behavior of Homeric heroes was a guide to the actions of the Indians

13 Ibid.
14 Trumbull 1841, p. 104.

15 John Butt et al., *Poems of Alexander Pope*, VII, p. clxiv.

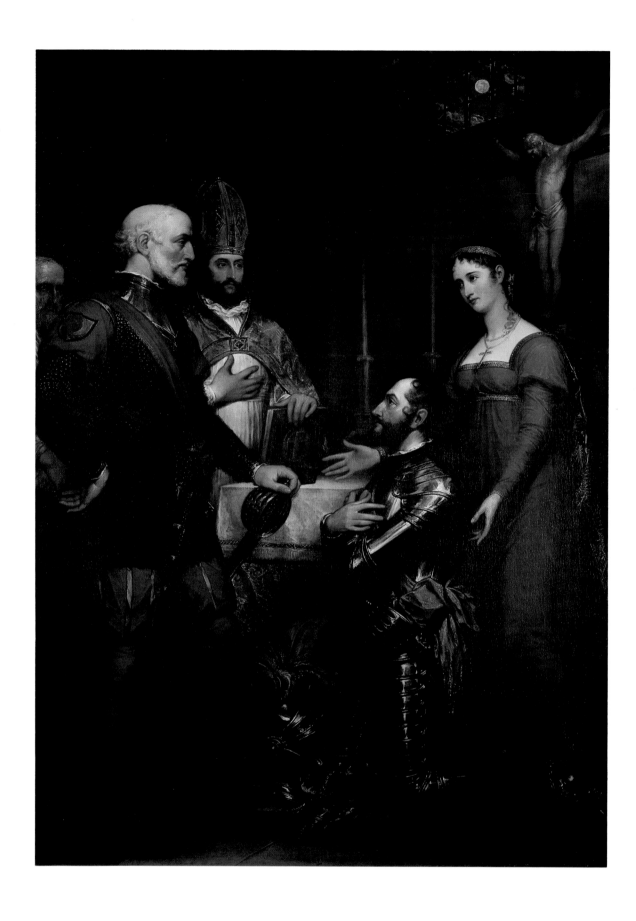

152
Unidentified subject

c.1782
Pen and ink and wash on paper, 5⅛ x 8⅟₁₆ (13 x 20.5)
Fordham University Library; Charles Allen Munn
 Collection

The similarity of this undated wash drawing to the pre-
vious drawing, "And Look thro' Nature" (Cat. 151)— its
concentration on lights and darks, technical use of the
medium, and size of the sheet— suggest it can reasonably
be dated to 1782 as well. The Silliman sale catalogue
describes the drawing as *Subject unknown. Prisoners starv-
ing to death.*[1] Sizer and Jaffe believed the scene to be a
prison ship.[2] The half-naked emaciated men, their heads
shaved, listening to one whose full head of hair and
healthier mien imply he is a more recent arrival, are per-
haps the inmates of an insane asylum. In any event, the
drawing's even, careful execution, with no reworked pas-
sages, and its dramatic chiaroscuro, suggest it was taken
from another visual source, possibly an engraving.

1 Stan V. Henkels, *Catalogue of the Very Important Collection of
 Studies and Sketches Made by Col. John Trumbull*, Philadelphia,
 December 17, 1896, no. 126.
2 Sizer 1965, p. 99; Jaffe 1971, p. 32.

152

153

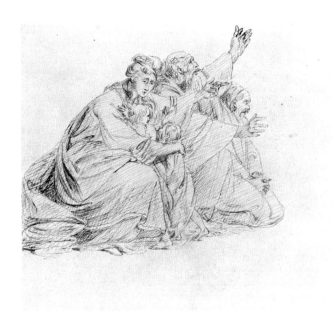

154

155

153

Priam Returning to His Family, with the Dead Body of Hector

1785

Oil on canvas, 24¾ x 36¾ (62.9 x 93.3)
Virginia Museum of Fine Arts

154

Study for Priam Returning to His Family, with the Dead Body of Hector

1784

Pen and ink on paper, 5⅞ x 7⅛ (14.9 x 18.1)
Inscribed, verso: *Jnᵒ Trumbull | London 20ᵗʰ December 1784*
Fordham University Library; Charles Allen Munn
 Collection

155

Study for Priam Returning to His Family, with the Dead Body of Hector

1784

Pen and ink on paper, 5¹³/₁₆ x 6½ (14.8 x 16.5)
Inscribed, verso: *Jnᵒ Trumbull | London Dec 22ᵈ 1784*
Collection of Jonathan Trumbull Isham

Priam represents one of the final moments from the *Iliad* (XXIV, 708)— King Priam returns to Troy from Achilles' camp with the body of his son Hector. Upon seeing Hector's body, his wife Andromache, his mother Hecuba, and his fellow Trojans "were held in sorrow passing endurance."

Scenes from the *Iliad* were popular in the late eighteenth century, and among the frequently treated subjects were "Priam in the tent of Achilles" and "Andromache mourning Hector," both of which Trumbull treated in drawings.[1] Representations of Priam's return, however, appear to have been rare.

The *Iliad*'s final book largely concerns the treatment of Hector's body. Dragged from a chariot by Achilles, but kept from disfigurement "under the golden aegis" of Apollo (XXIV, 20), Hector's body was washed and anointed with oil before it was brought home to receive the proper rites of burial. Trumbull's depiction also focuses on the body of the hero: the columns of the portico align with Hector's head and feet to lock the body into its central position. The drama of the scene is further heightened by the concentrated spotlighting of the principal figures.

Trumbull spent three months in West's studio executing this composition of many figures, for which he used

models.[2] The central group— a lifeless man borne under the shoulders and at the feet by attendants— may be derived from West's *Devout Men Taking the Body of St. Stephen* (Fig. 102).[3]

The influence of West's drawing style is also evident in the cross-hatched and parallel penstrokes, and boldly drawn profiles in two studies for groups of figures on either side of Hector (Cats. 154, 155). Trumbull redesigned these groups when he placed them into his composition, making them responsive to other parts of the painting. Hecuba, the woman who appears in profile in the Fordham drawing, turns toward Priam; the hands of the old man and mother in the Isham drawing have been brought near the hand of a soldier, creating a rhythmic pattern with their varied gestures.[4]

In *Priam*, the influence of West's methods of coloring to give "the Effect of Air or Atmosphere," and of glazing to produce "an astonishing degree of Union, & Brilliance"[5] are apparent, as is West's use of gesture to communicate emotion. When *Priam* was exhibited at the Royal Academy in 1786, one reviewer wrote that it was "a considerable advance on [Trumbull's] picture of last year; the colouring is more brilliant, and we think we foresee much improvement of this young artist in *character*, which will greatly assist his pencil."[6]

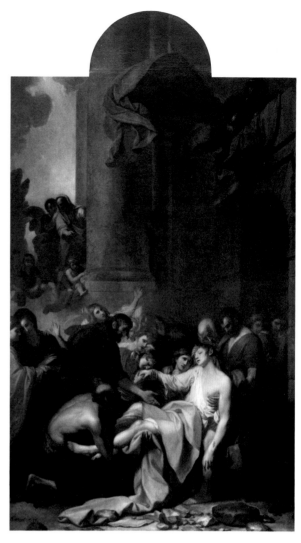

Fig. 102. Benjamin West, *Devout Men Taking the Body of St. Stephen*, 1776. London, St. Stephen, Walbrook.

1 For the *Iliad* scenes, see Dora Wiebenson, "Subjects from Homer's Iliad in Neoclassical Art," *The Art Bulletin*, 46 (1964), pp. 23–38. Trumbull's drawing of *Priam in the Tent of Achilles*, dated 1785, is reproduced in Jaffe 1975, fig. 52, collection of Mrs. Percy Chubb; the *Andromache* drawing, after Jacques-Louis David, YUL-BF, dates from 1786.

2 Trumbull, "Account of Paintings," II, no. 26: "in Models & frame [this painting] cost me Ten Guineas."

3 Dorinda Evans, *Benjamin West and His American Students*, exh. cat., The National Portrait Gallery, Washington, D.C., 1980, p. 87. The group also resembles a relief on the Column of Trajan which Trumbull would have known from the Bartoli engravings, a volume of which he owned. A preliminary pencil sketch by Trumbull for the central group, including Priam, appears on the verso of his study for *Sir John Temple and Family* of 1784, YUL-BF.

4 The figure of the child who gestures toward his mother's face is reminiscent of the child in Angelica Kauffmann's *Andromache and Hecuba Weeping over the Ashes of Hector* (location unknown). An engraving after the Kauffmann is illustrated in Robert Rosenblum, *Transformations in Late Eighteenth Century Art*, Princeton, 1967, no. 38.

5 Trumbull made these remarks in a record of a conversation with Benjamin West, quoted in Sizer 1967, p. 135.

6 *Miscellanies Relating to the Arts. Collected from the Artist's Repository and Drawing Magazine*, part II, 4, London, 1786, p. 25. The author remembers incorrectly when he refers to Trumbull's picture of the previous year; Trumbull exhibited three portraits at the Royal Academy in 1785.

156
Scene from Ossian's "Fingal": Lamderg and Gelchossa

c.1792

Oil on canvas, mounted on wood, 11^{15}/$_{16}$ x 14
 (30.3 x 35.6)

Inscribed on paper attached to verso: *You will find the Subject of the picture in | the 5th book of Fingal, the episode of Lamderg and | Gelchossa "What blood, my Love" she trembling | said "what blood runs down my warrior's side | "It's Ullin's blood" the chief replied. "Thou fairer | than the Snow. Gelchossa let me rest here a while." | the mighty Lamderg died. | I hope you will like the picture & am | Dc Sir | faithfully yours | Jno Trumbull*

The Toledo Museum of Art; Gift of Florence Scott
 Libbey

In a small but important group of paintings, Trumbull based his subject matter on contemporary poetry. The earliest such work known is *Lamderg and Gelchossa*, probably executed in 1792.[1]

Its source was *Fingal*, an epic which the Scottish poet James MacPherson claimed to have translated from ancient Gaelic texts. Supposedly recording the narrations of a third-century bard named Ossian, *Fingal* is one of several poems written by MacPherson in the early 1760s and published in 1765 as *The Works of Ossian*.

In *Fingal*, the old, blind Ossian recounts events of past days when his tribe— of which he and his nephew are the only survivors— was in its glory. Most of the poem's narration is concerned with various battles between tribes, interspersed with digressive ballads and stories. "Lamderg and Gelchossa" is one such diversion, recounted by a bard in a "song of old": the warrior Lamderg returns from battle to discover that his wife, Gelchossa, has been carried off by his enemy Ullin. Lamderg fights with Ullin on the hill of Cromla, and although victorious, he dies shortly afterward in the arms of his wife. Gelchossa, overcome with grief, also dies, and a tomb is erected over all three— Ullin, Lamderg, and Gelchossa.

As his letter attached to the reverse of the painting indicates, Trumbull chose the moment just before Lamderg's death, when Gelchossa discovers his fatal wound.[2] While stressing the dramatic interaction of the hero and the heroine, Trumbull also conveyed the narrative sequence of events by including the slain Ullin lying to the right. The blood which frightens Gelchossa is visible beneath Lamderg's elbow, and other details, such as the weaponry, reveal that Trumbull followed the text closely. The strong slope of the landscape alludes to the poem's hilltop setting.

Warren Dutton, a Boston collector who acquired the painting in 1817, wrote that it was executed in 1792.[3] If this date is correct, *Lamderg and Gelchossa* represents a considerable departure from Trumbull's main preoccupation of the early 1790s, his patriotic historical paintings; it was not until late in the following decade that he would turn his most serious attention to themes of English poetry.

Also striking, given the painting's early date, is its dramatic landscape setting. Throughout the poem, there is a proto-Romantic use of natural description and metaphor to evoke the mood of the narrative; in his painting Trumbull captured this mood in the rocky terrain and wild, desolate mountain peaks, somber and earth-toned in the middle ground, cool and bleak in the distant view. A powerful tree rises behind the hero, while the isolated, red wildflowers symbolize the tragic ending of the story. In the turbulent clouds may be found a depiction of the poetic simile: "Gelchossa saw the silent chief [Lamderg] as a wreath of mist ascending the hill."[4]

This sensitivity to the evocative potential of nature reveals Trumbull's changing attitude toward landscape. While his early landscapes were non-dramatic and of even mood (see Cats. 139, 142), the illustrative setting of *Lamderg and Gelchossa* plays an essential role in the work's dramatic message, looking forward to Trumbull's innovations of the following decade, when landscape would take on an independent, expressive character.[5]

Trumbull is the first known American artist to paint a scene from *Ossian*. His interest in the poem dates to 1772, when he withdrew a copy of it from the Harvard College Library;[6] *Ossian* had become enormously popular in America as well as Europe during the 1770s, and Trumbull's association with the "Connecticut Wits" was probably influential, for this group of poets produced several works in imitation of *Ossian*. Among them was *M'Fingal*, a 1775 satire written by Trumbull's cousin John Trumbull, which the artist seems to have particularly admired.[7]

As with several of Trumbull's works whose original conceptions date to the 1780s (see Cats. 137, 158, 159), it was most likely in Europe during this decade that he first thought of painting a scene from *Ossian*. Artistic illustration of contemporary literature had become increasingly popular in the later eighteenth century in England, although such paintings were still in the minority at Royal Academy exhibitions.

A few Ossianic subjects had begun to appear in English art in the early 1770s, by artists such as Alexander Runciman, James Barry, and Angelica Kauffmann.[8] German and Danish artists soon followed; some of the dramatic Ossianic paintings by Nicolai Abilgaard had been published as engravings by the time Trumbull was in Europe.[9] Trumbull's friends Thomas Jefferson and the artist Maria Cosway, with whom he frequently associated while visiting Paris in the mid-1780s, may have encouraged him to depict *Ossian*, for both were avid admirers of the poems.[10]

Nevertheless, in the late eighteenth century, *Ossian* was still a relatively rare subject for European artists,[11] and the "Lamderg and Gelchossa" episode may have been painted only once before.[12] Trumbull's selection was therefore highly adventurous. The composition appears to have been largely of his own invention, although the background reveals some similarity to Angelica Kauffmann's 1772 *Trenmor and Inibaca*, which Trumbull may have known from the prints by Burke or Ogborne (*Fig. 103*).[13]

Trumbull's and Kauffmann's works are also related by their depiction of a rare scene of emotional tenderness; most other artists and illustrators of the poem concentrated on dramatic images of Ossian singing and Fingal's perilous adventures.[14] The marital love between Lamderg and Gelchossa is suggested in Trumbull's painting by their interlocked poses and overlapped legs,[15] and by focusing on the approaching death of the husband— rather than the battle of the warrior— Trumbull emphasized the

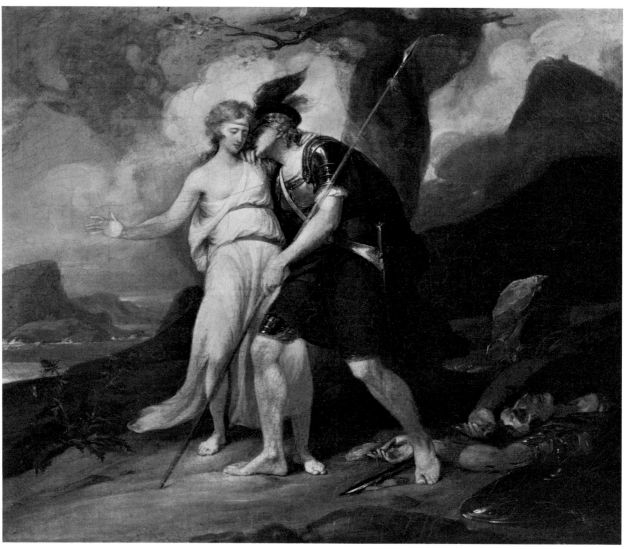

story's sentimentality. This was an unusual mood for him; perhaps it was his ardent courtship of Harriet Wadsworth during the early 1790s which prompted such a romantic expression.

In 1809 Trumbull executed another version of *Lamderg and Gelchossa* which, in contrast to his earlier work, was intended as an important exhibition piece (*Fig. 104*).[16] In keeping with his general move at this time toward larger scale, Trumbull painted the second work in monumental proportions, concentrating on the heroic presentation of the central figures. This new format, however, eliminated much of the surrounding landscape and thereby diminished the expressive role of nature which animated the earlier work. Perhaps this was why Dutton, an important patron of the Romantic artist Washington Allston, chose the first version of *Lamderg and Gelchossa* over the second.

1 Trumbull did, however, execute several drawings on various literary subjects during the 1780s; see, for example, Cat. 151.

2 Trumbull misquotes Ossian. The text should read: "What blood, my love, the soft-haired woman said."

3 Dutton's inscription is on the back of the panel: "Boston Nov 14th 1817 | This picture was painted by John Trumbull Esquire at | Lebanon, Connecticut, in the Summer of the year 1792— | Warren Dutton." Two other fragmentary inscriptions, possibly in Trumbull's hand, are also attached to the back of the work; on the stretcher are the words "Scene from Ossian | Painted by Trumbull | [illegible; may be "Lebanon"]," and on the frame is a statement that Hubbard Dutton posed for the figure of Lamderg. The identity of Hubbard Dutton has not been determined.

4 James MacPherson, *The Works of Ossian, The Son of Fingal*, 2 vols., London, 1765, I, p. 102.

5 The early nineteenth-century landscapes included three versions of *The Falls of the Yantic at Norwich* (Cats. 144–46); for whose proto-Romantic tendencies see pp. 212–15. The imaginary, poetically illustrative landscape of *Lamderg and Gelchossa*— despite its forward-looking characteristics— still remains distinct from these later views. In 1811, Trumbull would again attempt to recreate a poet's landscape setting in *The Lady of the Lake* (Yale University Art Gallery), a work somewhat similar to *Lamderg and Gelchossa* but lacking its expressive force. Among other illustrations of *Ossian*, certain artists went beyond Trumbull in exploiting the dramatic role of landscape in the poem; see Henry Okun, "Ossian in Painting," *Journal of the Warburg and Courtauld Institutes*, 30 (1967), p. 336.

6 Millard F. Rogers, Jr., "John Trumbull's 'Scene from Ossian's

Fig. 103. Thomas Burke (after Angelica Kauffmann), *Trenmor and Inibaca*, 1772, mezzotint. New York, The Metropolitan Museum of Art; Gift of Georgiana W. Sargent in memory of John Osborne Sargent.

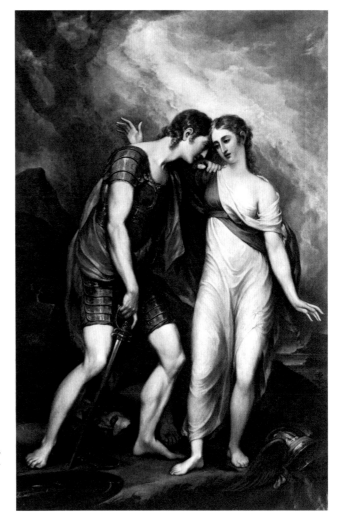

Fig. 104. *Lamderg and Gelchossa*, 1809. New Haven, Yale University Art Gallery; Trumbull Collection.

Fingal,'" *The Art Quarterly*, 22 (1959), p. 171.

7 For Trumbull's miniature of his cousin, see Cat. 95.

8 Both Runciman and Barry were followers of Henry Fuseli, whose advocacy of literary themes, especially those of a sublime or impassioned nature, probably influenced their selection of Ossianic subjects.

9 Abilgaard's Ossianic paintings were engraved by the Dane Johan Frederik Clemens, who also completed the engraving of Trumbull's *Death of General Montgomery in the Attack on Quebec*.

10 Jefferson wrote a letter to James MacPherson in 1773, in which he praised *Ossian* and requested a copy of the "originals," as well as books for learning Gaelic; see Frederic I. Carpenter, "The Vogue of Ossian in America: A Study in Taste," *American Literature*, 2 (1931), p. 407. Cosway, one of the most prolific painters of contemporary literary subjects in the later eighteenth century, was also a pioneer in the depiction of Ossianic themes, exhibiting *Althan Stood in the Wood Alone* at the Royal Academy in 1783.

11 See Okun, "Ossian in Painting," pp. 327–56.

12 Alexander Runciman, decorating the house of Sir James Clerk in Scotland in 1772, painted scenes of *Ossian* on the ceiling of the great hall; one represented "Gelchossa mourning over Lamderg." These paintings were destroyed in a fire of 1899; Okun, "Ossian in Painting," p. 331.

13 The similarity between Trumbull's and Kauffmann's paintings was observed by Okun, "Ossian in Painting," p. 335. For informa-

tion on engravings of *Trenmor and Inibaca*, see Halla Hohl and Hélène Toussait, *Ossian und die Kunst um 1800*, exh. cat., Kunsthalle, Hamburg, 1974, p. 58. Trumbull's costumes are similar to those depicted by other painters of Ossianic subjects, as well as those found in contemporary book illustrations.

14 Okun, "Ossian in Painting," p. 355.

15 For the symbolism of the "slung-leg" posture, see Leo Steinberg, "Michelangelo's Florentine *Pietà*: The Missing Leg," *The Art Bulletin*, 50 (1968), pp. 343–53. Its connection to *Lamderg and Gelchossa* was noted by Jaffe 1975, p. 325.

16 In addition to its first appearance at the British Institution in 1810, the large *Lamderg and Gelchossa* (94¼ x 58⅛ inches) was exhibited for sale at the American Academy of the Fine Arts in 1816, 1818–24, and in Trumbull's one-man exhibition at the American Academy in 1831. He valued it at 1500 dollars in 1816; see Jaffe 1975, p. 325. It is possible that Trumbull also executed other scenes from *Ossian*. A "small picture from Ossian" was included in Trumbull's 1803 and 1805 lists of objects shipped from England to America (NYHS; YUL-JT), as well as his 1816 schedule of property (Jaffe, p. 325). Dunlap 1834, II, p. 462, referred to "small Sketches of Lambderg and Golchossa [*sic*]" in the collection of Dr. David Hosack, a friend and patron of Trumbull. When the 1792 *Lamderg and Gelchossa* was exhibited at the Boston Athenaeum in 1827, the public was not "enthusiastic"; see Mabel Munson Swan, *The Athenaeum Gallery 1827–1873*, Boston, 1940, p. 22.

The Earl of Angus
Conferring Knighthood on De Wilton

1810

Oil on canvas, 94½ x 66¹¹/₁₆ (240 x 169.4)
Inscribed, lower left: *Jn. Trumbull | 1810*
Yale University Art Gallery; Trumbull Collection

After his return to London in 1809, Trumbull painted three exhibition pictures with specific literary subjects: the large version of *Lamderg and Gelchossa* of 1809 (*Fig. 104*), *The Lady of the Lake* of 1810 (perhaps the Yale University Art Gallery version) and *The Earl of Angus*. The latter two paintings, which both had subjects taken from Sir Walter Scott, were exhibited in London in 1811.

The Earl of Angus is based on an incident from Scott's poem *Marmion* (1808). The poem recounted events leading up to a 1513 battle in which rebellious Scottish forces were decisively defeated by the English, led by Lord Marmion. The fictitious Scottish hero, Ralph De Wilton, had been in hiding for several years, having been falsely accused of treason. On the eve of the conflict, he acquired proof of his innocence. Lady Clare, who had remained constant to De Wilton in his period of disgrace, rejoined him at this time. The Scottish Earl of Angus knighted De Wilton, who was then able to vindicate his personal honor at a battle where his countrymen suffered defeat.

Trumbull clearly had great ambitions for these literary pictures. Since their themes would have been considered "historical" subjects by his contemporaries,[1] the artist may have selected Scott's newly popular poems as a means of establishing himself as a history painter in London. Watercolor painters had already used Scott's early poems as subjects for their works,[2] but Trumbull was one of the first painters in oil to produce large exhibition canvases of such themes.[3] As a scene taken from Britain's medieval past, *The Earl of Angus* also represented a new direction in Trumbull's work, since his previous historical compositions had either been classical or contemporary subjects. It seems likely that he was attempting to emulate the recent achievements of such leading British history painters as West, Reynolds, and William Hamilton, who had produced medieval scenes for John Boydell's Shakespeare Gallery and Robert Bowyer's Historic Gallery. Begun in 1785 and 1792, respectively, these projects were intended "to establish an English School of Historical Painting" by commissioning paintings of Shakespearean subjects and scenes from England's past.[4] Trumbull's pioneering choice of Scott may have been a way for a patriotic American to cater to the vogue for British history and simultaneously challenge England's greatness by glorifying Scottish heroes.

Trumbull's ambition to establish himself as a history painter seems to have affected the style of his literary paintings of this period. He had not taken up the challenge of a large figure composition since completing the third version of the *Sortie* in 1789 (Cat. 12). In contrast to the Baroque poses and groupings of the *Sortie*, *The Earl of Angus* represents a solemn moment, with the figures in somewhat understated poses. This change in style may have been due to the influence of such Boydell and Bow-

yer gallery paintings as Benjamin West's *Prince John's Submission to Richard I* (*Fig. 105*), in which figures in typical theatrical poses were arranged in a shallow, stage-like space. These paintings had an important influence on Trumbull's work, for in 1811 he used a similar composition in *The Woman Taken in Adultery* (Cat. 135). Instead of depicting a particularly dramatic incident, Trumbull seems to have been more interested in creating a medieval "atmosphere." Along with Hamilton, Mather Brown, and other Shakespeare Gallery artists, he apparently did not share the intense interest in historical accuracy that Benjamin West had required in his own scenes from the English past.[5] Benjamin Silliman later reported: "All the articles of armor and costume . . . were copied faithfully from authentic originals preserved in the Tower and other guarded repositories."[6] But Trumbull's painting was not an authentic image of Scotland in 1513. De Wilton's armor is appropriate to the early sixteenth century, but Lady Clare's dress is a typical eighteenth-century fantasy of how "medieval" costume looked.[7] Moreover, Trumbull seems to have made a self-conscious reference to Rubens in the warm gold, brown, and red colors, and in the painterly touches in the satins and armor.[8]

Ultimately, *The Earl of Angus* is an unsuccessful picture. The static grouping of the figures, and the emphasis on trappings and details give it a weak effect when compared to the artist's earlier history paintings. Nevertheless, some of his contemporaries appreciated Trumbull's efforts to produce a large-scale history painting. Silliman called it "large and splendid," and noted, "in costume— action and moral effect . . . [it is] grand and imposing."[9]

1 When discussing *The Earl of Angus* and *Lamderg and Gelchossa*, Benjamin Silliman ("Notebook," II, p. 122) commented: "They are . . . historical as well as poetical & pictorial." See also Sir Joshua Reynolds, *Discourses on Art*, San Marino, 1959, pp. 50–52.
2 Jane Bayard, *Works of Splendor and Imagination: The Exhibition Watercolor, 1770–1870*, exh. cat., Yale Center for British Art, New Haven, 1981, p. 11.
3 The exhibition catalogues from the Royal Academy for the years 1808–12 list twelve paintings of subjects from Scott out of several thousand paintings that were exhibited during those years.
4 The best history of Boydell's enterprise is Winifred H. Friedman, *Boydell's Shakespeare Gallery*, New York, 1976; for the Bowyer Gallery, see Roy Strong, *Recreating the Past: British History and the Victorian Painter*, London, 1978, p. 21.
5 See Strong, *Recreating the Past*, pp. 24–28.
6 Silliman, "Notebook," II, p. 122.
7 An early sixteenth-century suit of English armor, similar to that worn by De Wilton, is illustrated in Claude Blair, *European Armor: circa 1066 to circa 1700*, London, 1958, p. 132. For a discussion of the fanciful reconstructions of medieval costumes which appeared in eighteenth-century history paintings, see Strong, *Recreating the Past*, pp. 23–24.
8 Trumbull repeatedly praised the paintings by Rubens that he saw in Europe; he called the Maria de' Medici cycle "the Empire of Color, Allegory, and Composition," adding that his opportunity to see it was "almost [the] greatest pleasure I ever received from the arts"; Trumbull 1841, pp. 108–9.
9 Silliman, "Notebook," II, p. 119. When exhibited in the Trumbull Gallery in 1832, *The Earl of Angus* was hung as a pendant to the large *Lamderg and Gelchossa*, although they do not seem to have been painted as a pair.

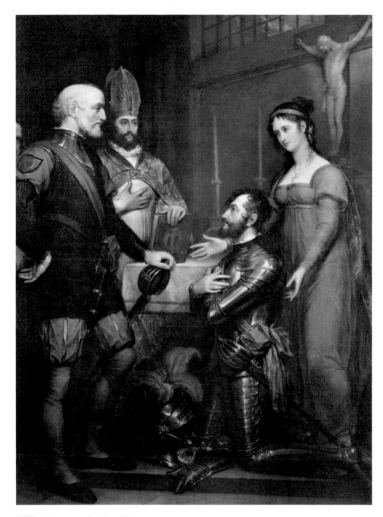

157 *Color reproduction, Fig. 98*

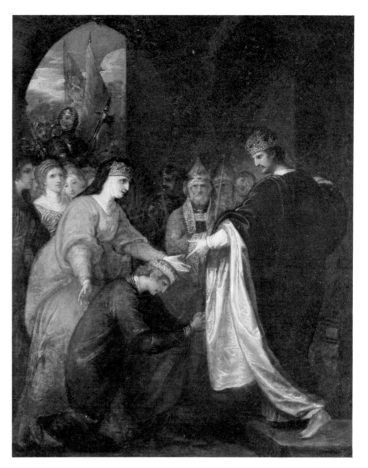

Fig. 105. Benjamin West, *Prince John's Submission to Richard I*, 1795. Unlocated.

Maternal Tenderness

1809–after 1815
Oil on canvas, 24⅜ x 20³/₁₆ (61.9 x 51.3)
Yale University Art Gallery; Trumbull Collection

In the catalogue for his 1832 bequest to the Gallery of Yale College, Trumbull listed this work as "Maternal Tenderness. London, 1809."[1] It had not, however, been completed until after the artist's return to America in 1815,[2] and was only first exhibited at the American Academy in 1825, under the title of *Maternal Affection*.[3]

Two early drawings seem to have provided the source for Trumbull's composition. While in Paris in 1786, the artist had executed an animated pen sketch of the *Madonna and Child with Sts. Joseph and John* (Cat. 134). The position of the Virgin's arms and torso, as well as the baby's gesture of grasping his foot, are echoed in *Maternal Tenderness*. A smaller tondo drawing, which also probably dates to 1786,[4] isolates the mother and child and introduces the feathery hairstyle, ledge and cushion which appear in the painting (*Fig. 106*). It is likely that the larger sketch was copied from a painting Trumbull saw in the course of his extensive viewings of public and private collections in Paris;[5] perhaps the circular drawing represents Trumbull's own development of the image.[6]

For Trumbull to use studies executed several decades before in his later American paintings was not unusual; both the *Deluge* (1838–39; Cat. 137) and *Joshua at the Battle of Ai* (1839–40; Cat. 159) are based on drawings of the 1780s, attesting to the enduring influence of his European experience.[7]

Benjamin Silliman quoted Trumbull as saying that "a young and lovely mother nursing her infant child is the most beautiful object in nature."[8] *Maternal Tenderness* is the only extant painting by Trumbull to depict this subject, although the mother-and-child theme is substantially represented in his oeuvre. Trumbull executed at least seventeen paintings, as well as numerous drawings, of Mary and the baby Jesus. His preoccupation with maternal love can also been seen in other religious paintings, such as the *Deluge*.

Although *Maternal Tenderness* may be a portrait, as Silliman suggested,[9] Trumbull always referred to it either by this title or *Maternal Affection*, implying that he intended it above all as an allegorical representation. The knowing, rather adult expression on the baby's face recalls depictions of Jesus, and the work's pictorial precedent lies in a long tradition of Virgin and Child paintings originating in the fifteenth century, in which the Virgin supports the Child on an altarlike ledge within a timeless setting. In this respect, Trumbull's image seems also to correspond to the nursing Madonna theme, which in fact had been the subject of his original sketch. By thus presenting his secular allegory in a Christian guise, Trumbull has elevated "maternal tenderness" to the realm of the sacred.[10]

Trumbull was among the first to represent motherhood allegorically. Artistic representations of domestic life had become popular in the eighteenth century, when changing social attitudes resulted in an increased attention to children and the family. The emphasis which came to be placed on the woman's role as bearer and nurturer of the young was manifested in painting by the development of the "happy mother" image toward the end of the century.[11] These depictions of mothers delighting in the company of their children appear in the works of portraitists such as Sir Joshua Reynolds, who stressed the psychological and physical bond between mother and child.[12]

It was in the first decade of the nineteenth century that "maternal affection" became allegorized. Three works bearing this title were exhibited at the Royal Academy between 1807 and 1811. Trumbull had returned to England in 1809, the same year he began his own mother-and-child painting; perhaps its title and allegorical theme were inspired by these English depictions.[13]

In representing a *nursing* mother, however, Trumbull intensified the bond between her and her child. This would have been immediately acknowledged by a society which had, by the turn of the nineteenth century, come to reject the use of wet-nurses in favor of maternal breast-feeding, which was felt to both better nourish the child and stimulate mutual affection between child and mother.[14] Nursing mothers had appeared in genre scenes at the turn of the century and earlier,[15] but the importance of nursing for "maternal tenderness" is stressed by the religious ambience of Trumbull's allegory.

Maternal Tenderness is both pictorially and thematically European. It was the first allegorical representation of motherhood to appear at the American Academy.[16] For Trumbull, the meaning of the work was probably quite personal; Silliman wrote that the painting "may be considered as the embodiment and artistic expression of the moral and social as well as pictorial impressions of the artist."[17] Trumbull's unhappy relationship with his illegitimate son, born in 1792,[18] as well as the disappointment of having had no children with Sarah, may have intensified his preoccupation with maternal love. *Maternal Tenderness* was first exhibited just one year after Sarah Trumbull's death; perhaps it was as a memorial to his wife that Trumbull presented an almost iconic glorification of mother and child.[19]

1 Trumbull 1832, p. 35.

2 In the draft copy of Trumbull's 1831 exhibition list for the American Academy, he recorded *Maternal Tenderness* as having been "composed in London— 1809— finished in America"; Trumbull 1831, no. 21.

3 In 1826 and 1827, two Trumbull paintings entitled *Maternal Affection* were listed in the American Academy exhibition catalogues, but only one appeared in 1828 and 1831; see Mary Bartlett Cowdrey, *American Academy of Fine Arts and American Art-Union*, 2 vols., New York, 1953, II, pp. 358–59. In the 1831 catalogue, however, there was a painting listed as "Mother & Child. New York, 1827"; this was probably the second *Maternal Affection* listed in 1826 and 1827. The whereabouts of this second mother-and-child painting is unknown.

4 This drawing has also been dated to 1786 because the other sketches on the same piece of paper can be identified as copies of paintings Trumbull saw while visiting Paris in 1786. They include Regnault's *Education of Achilles by the Centaur Chiron* of 1782 (Louvre), David's *Andromache Mourning Over the Body of Hector*, 1783 (École des Beaux-Arts, Paris), and Vigée-Lebrun's as yet unfinished *Madame Vigée-Lebrun and Her Daughter* (Louvre). The Regnault (which in his sketch Trumbull labeled "Renaud") and the David (labeled "David 183") were at the time of Trumbull's visit *morceaux de réception* in the collection of the French Academy; see André Fontain, *Les Collections de l'Académie Royale de Peinture et de Sculpture*, Paris, 1910, pp. 197–98. Trumbull described both paintings in his diary account of a trip to the "Gallery of the Academy at the Louvre," on August 6, 1786, Trumbull 1841, p. 104. The Vigée-Lebrun portrait he mentioned in his diary four days later; ibid., p. 111.

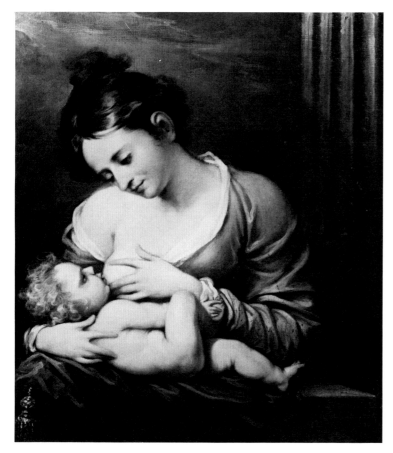

Fig. 106. *Mother and Child*, c.1786. New Haven, Yale University Library; Benjamin Franklin Collection.

158

5 Trumbull gave lively and detailed accounts of these activities in his diary, later transcribed to the *Autobiography*, 1841, pp. 99–119.

6 It is possible, of course, that the reverse might also be the case. All three of the other drawings on the page with the tondo mother and child were copies of paintings which Trumbull saw (see n. 4), and the tondo drawing shares with the others a similar technique of execution; all were sketched rapidly in pencil, then traced over and slightly corrected in ink; this suggests that the tondo drawing may be a copy as well.

7 Another idea for *Maternal Tenderness* may have come from an illustration of a fashionably dressed woman nursing a baby which appeared in Maria Cosway's *The Progress of Female Virtue*, a book of engravings published in 1800, a copy of which Trumbull owned (the copy is now in the Yale University Art Gallery). It is also possible that Trumbull and Cosway were drawing on the same source. Perhaps the emblematic quality of Cosway's domestic image influenced Trumbull's development of a secular allegory on the theme.

8 Silliman, "Notebook," II, p. 97.

9 Ibid., p. 112.

10 Trumbull's analogy between the secular and sacred mother and child is suggested in a letter to Benjamin Silliman, May 19, 1822, NYHS: "I shall be happy to fulfil my promise of the Portrait:— When Harriet is well and happy and at leisure I shall be delighted to see her and the babe they will form a most pleasing Subject— I think the Madonnas of Italy are among the most interesting and beautiful of their pictures." It is not known whether or not Trumbull ever executed this portrait of Harriet Silliman with her baby.

11 See Carol Duncan, "Happy Mothers and Other New Ideas in French Art," *The Art Bulletin*, 55 (1973), pp. 570–83. Many social historians have written on the subject of changing domestic values; see, for example, Phillipe Ariès, *Centuries of Childhood*, New York, 1962, esp. pp. 339–64, and Lawrence Stone, *The Family, Sex and Marriage in England 1500–1800*, New York, 1977, pp. 236, 266–69, and 405–80. Stone believes that in America attitudes toward family life paralleled those in England. For the philosophers' view of childhood in the late eighteenth century, see p. 185, above.

12 See, for example, Reynolds' portraits of *Georgiana, Duchess of Devonshire and her Daughter, Lady Georgiana Cavendish* (Devon-

shire Collection, Chatsworth) and *Lady Cockburn and her Three Eldest Sons* (National Gallery, London).

13 The "maternal affection" works include R. Cockburn's painting exhibited in 1807 (no. 738), Archer James Oliver's, 1808 (no. 20), and a relief plaque by John Flaxman of 1811 (no. 929); see *The Exhibition of the Royal Academy*, London, 1807, 1808, 1811. Oliver's *Maternal Affection* was also exhibited at the British Institution in 1809. The two paintings are unlocated today. Flaxman's relief may be that at the University College London; see Margaret Whitney and Rupert Gunnis, *The Collection of Models by John Flaxman, R.A. at the University College London*, London, 1967, p. 28; drawings of the same description as the London plaque are located in the collections of the Stanford University Museum and Art Gallery and Christopher Powney of Kent (Yale Center for British Art Photo Archives). They bear no visual similarity to Trumbull's painting, although Flaxman's general interest in the theme of maternal love, manifest in his work at the turn of the nineteenth century, may have been an indirect influence on Trumbull. Trumbull undoubtedly saw Flaxman's 1811 *Maternal Affection*, for the former's *Lady of the Lake* (Yale University Art Gallery) appeared in the same Royal Academy exhibition.

14 Stone, *The Family*, pp. 430–31.

15 See Duncan, "Happy Mothers."

16 A few works depicting mothers and children had appeared prior to 1825 at the American Academy, but none with an allegorical title. An examination of American Academy catalogues between 1816 and 1850 reveals that the subject in general seems to have been rare in this country before mid-century; see the various issues of *Catalogue of Painting, Busts, Drawings, Models and Engravings, exhibited at the American Academy of Arts*, New York.

17 Silliman, "Notebook," II, p. 112.

18 Letters exchanged between Trumbull and his son during the first quarter of the nineteenth century reveal increasing tension and bitterness on Trumbull's part. He disapproved of Ray's impulsive behavior, his continual requests for money, and especially his enlistment with the British in the War of 1812. See Sizer 1953, pp. 332–50.

19 All the rest of Trumbull's extant allegorical paintings are in fact paintings of his wife (see Cats. 112, 115), which suggests that this was a mode of representation reserved especially for her.

159

Joshua at the Battle of Ai—
Attended by Death

1839–40

Oil on canvas, 40¼ x 50⅜ (102.2 x 128)
Yale University Art Gallery; Trumbull Collection

160

Study for Joshua at the Battle of Ai—
Attended by Death

1786

Pen and ink and wash on paper, 4⅜ x 7 (11.1 x 17.8)
Inscribed, verso: *O er the pale rear tremendous Joshua*
 hung | Their gloomy knell his voice terrific rung | From
 glowing Eyeballs flashd his wrath severe | Grim Death
 before him hurld his murderous spear | Conquest of
 Canaan | Book 6. line 645. | Dec. 15ᵗʰ 1786 | Jnᵒ Trumbull
Fordham University Library; Charles Allen Munn
 Collection

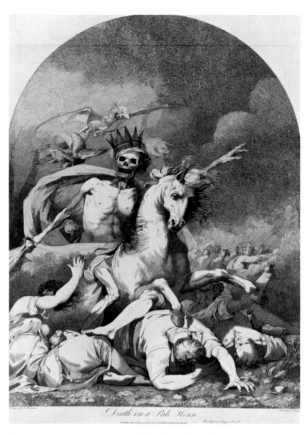

Fig. 107. Joseph Haynes (after John Hamilton Mortimer), *Death on a Pale Horse*, 1784, etching. New Haven, Yale Center for British Art; Paul Mellon Collection.

In this painting, Joshua, one of the great warriors of the Old Testament, strides into battle against the inhabitants of Ai as an instrument of divine wrath. The figure of Death accompanies him, lance poised for attack. Terrified enemy soldiers scatter in confusion at the right. Others are trampled underfoot as Joshua and Death relentlessly pursue the foe. Even the elements join in the tumult of battle— a lightning bolt surges from the heavens and storm clouds echo the turbulence below.

Although the story derives from Joshua 8, Trumbull took his main inspiration, including the personification of Death, from a literary work, *The Conquest of Canaan*, the first epic poem written in America. The author, Timothy Dwight (1752–1817), was a Congregationalist minister who served as army chaplain under General Israel Putnam during the Revolutionary War. Dwight began the poem as early as 1771, rewrote it at several military camps throughout the war, and finally published it in 1785.[1] A year later, while in London, Trumbull made a preparatory drawing (Cat. 160), on the back of which he inscribed lines from the poem.[2]

The Conquest of Canaan, which was dedicated to George Washington, embodied the religiously based patriotic attitudes of the Revolutionary era. The Canaan of the title was an allegorical representation of the United States; the biblical battles were allusions to the battles of the Revolutionary War. Furthermore, it is thought that Joshua himself was meant to be George Washington, although Dwight later disavowed this connection.[3]

Dwight's and Trumbull's paths crossed many times over the years. Both served their country during the Revolutionary War, were devoted to the memory of Washington, and became members of the prestigious Society of the Cincinnati, the organization of Revolutionary War

officers. Each was active in the formation and encouragement of the arts in a new republic. Dwight became a leading figure in the "Connecticut Wits," a group of poets that included John Trumbull (cousin of the painter), Joel Barlow, and David Humphrey, among others. Trumbull served for many years as president of the American Academy of the Fine Arts. Each was as conservative in politics as in religion, lending support to the Federalist cause. Reverend Dwight became president of Yale College in 1795, a position he held until his death in 1817. Trumbull painted Dwight's portrait twice, in 1807 and posthumously in 1817, at the request of the graduating seniors of Yale College (both paintings are now in the Yale University Art Gallery). In 1836, Trumbull wrote to Benjamin Silliman that he had "found courage to commence a picture . . . as a just tribute to the memory of that great & good man," Timothy Dwight.[4] Silliman recalls that the painting was completed in his house in New Haven in 1839 or 1840,[5] when Trumbull was eighty-three years old.

In addition to the literary source, Trumbull had recourse to a number of pictorial models, among them the well-known 1784 etching after John Hamilton Mortimer's drawing of 1775, *Death on a Pale Horse* (*Fig. 107*), which provided the image of the slain soldier under the skeleton's left foot, and Benjamin West's early drawing of *Death on the Pale Horse*, 1783 (*Fig. 108*),[6] which provided the overall model of the melee. The rushing horses (which were not mentioned in Dwight's poem) were derived from both these sources. The contorted figure on the ground at

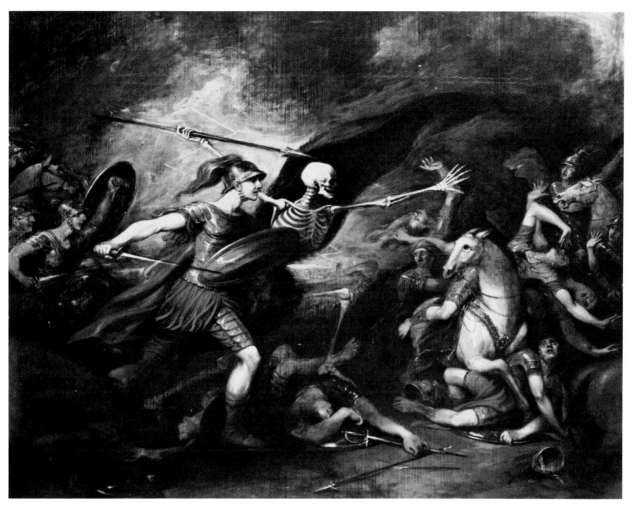

159

Fig. 108. Benjamin West, *Death on a Pale Horse*, 1783 (retouched 1803). London, Royal Academy of Arts.

160

Fig. 109. Francesco Faraone Aquila (after Raphael), *The Expulsion of Heliodorus*, detail, engraving. London, The Trustees of the British Museum.

right, however, is partly derived from Raphael's *Expulsion of Heliodorus*, of which Trumbull owned a print (*Fig. 109*).[7] For the figure of Death, a literary invention of Dwight's, Trumbull took the partly fleshed figure in Mortimer and West, but dematerialized and unhorsed it— in Trumbull's painting, Death strides in tandem with Joshua. The twinning of Joshua and Death in this manner recalls the arrangement of Joshua and his fellow-soldier in Poussin's *Victory of Joshua over the Amalekites* (Hermitage, Leningrad). Although Trumbull seems to have taken the slashing diagonal composition from West's drawing, the action of Trumbull's painting is generally more friezelike. Despite the dynamic character of such compositional devices as Death's bright red cloak, the characters act out their parts as if on a shallow stage.

Fifty years separated the drawing and the finished oil. The dramatic story recounted in the poem appealed to the imagination of the romantic young artist in 1786. After a period of five decades, Trumbull found the rich combination of American allegory, scriptural parallel, and hom-

age to an esteemed friend sufficiently compelling to return to in his old age.

1 The literary origin of Trumbull's *Joshua* was first noted by Jaffe 1975, p. 326.
2 The verses are also quoted in Trumbull 1841, no. 51, pp. 438–39, where the word "fatal" is substituted for "murderous."
3 See Kenneth Silverman, *Timothy Dwight*, New York, 1969, pp. 24, 30–41.
4 JT to Benjamin Silliman, June 21, 1836, YUL-JT.
5 Silliman, "Notebook," II, p. 117.
6 The definitive study of Mortimer's drawing is Norman Ziff, "Mortimer's Death on a Pale Horse," *The Burlington Magazine*, 112 (1970), pp. 531–35. West's several versions of *Death on the Pale Horse* are discussed by Jerry Don Meyer in "The Religious Paintings of Benjamin West: A Study in Late Eighteenth and Early Nineteenth Century Moral Sentiment," Ph.D. diss., New York University, 1973, pp. 180–84; and Grose Evans, *Benjamin West and the Taste of His Times*, Carbondale, Ill., 1959, pp. 64–65.
7 See Stan V. Henkels, *Catalogue of the Very Important Collection of Studies and Sketches Made by Col. John Trumbull*, Philadelphia, December 17, 1896, no. 237.

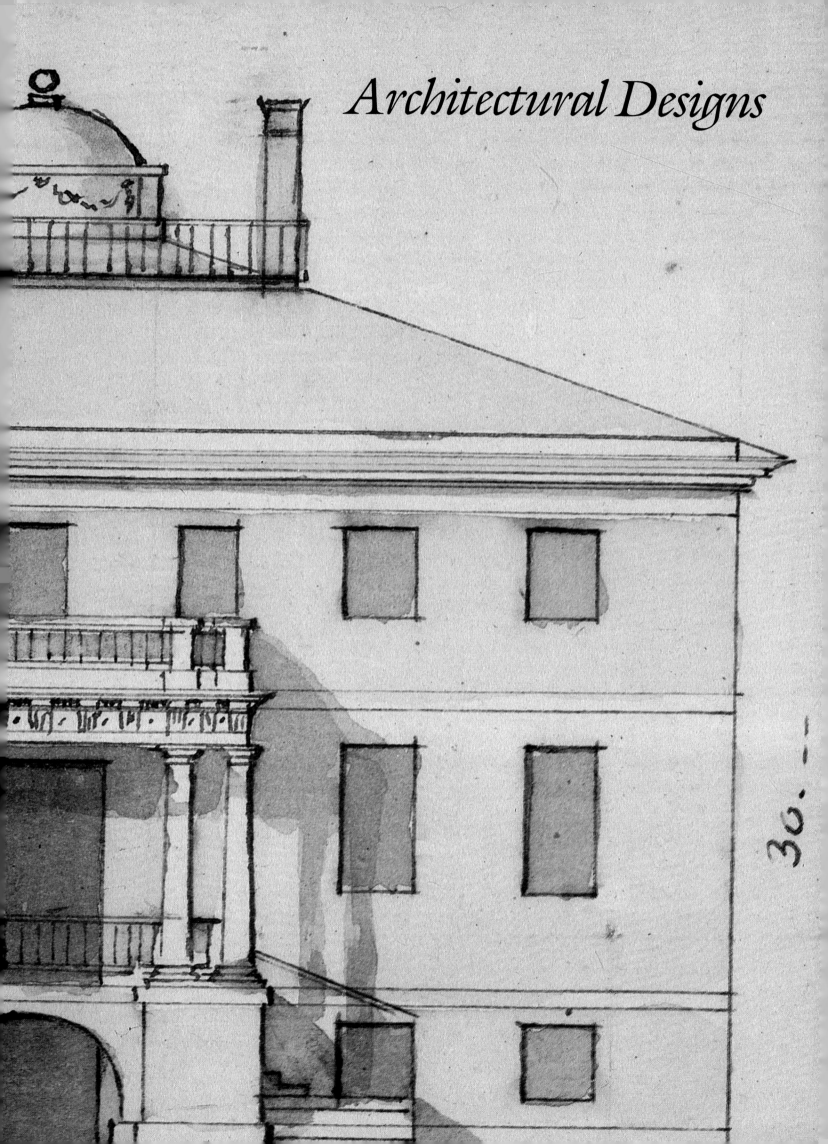

30.--

John Trumbull and the U.S. Capitol

Reconsidering the Evidence

By Egon Verheyen

The year 1817 brought to the painter-patriot John Trumbull the fulfillment of a long-cherished hope: the contract for four paintings depicting events of the Revolutionary War for the United States Capitol (*Fig. 110*).[1] The commission was awarded at a time when the repairs of the Capitol, burned by the British in August 1814 (*Fig. 111*), had not yet been completed and when work on the center section had not even begun. A rotunda had been planned for that section by Benjamin Latrobe, but early in 1817 it was uncertain whether Latrobe's plan would be realized.[2] In this situation, it is not surprising that Trumbull devoted his time not only to the commissioned paintings, but also, and with the same intensity, to questions of architecture. Edmund Burke had long before advised Trumbull to study architecture.[3]

Much has been said about the circumstances which led to the commission and Trumbull's involvement in the design of the Rotunda;[4] but much has remained unsaid. It is the purpose of this essay to re-evaluate the evidence in order to gain a better understanding of the artist and the complexities of his major commission.

In his *Autobiography*, Trumbull recalled that

> Congress was in session, and my friend, Judge Nicholson, advised me to go on [from Baltimore] to Washington, and there offer my great, but long suspended, project of national paintings of subjects from the Revolution. The Judge went with me, introduced me to his friends in both houses, and the plan was favorably received. Several gentlemen, (particularly Mr. Timothy Pitkin, of the house of representatives,) were zealous to see my plan executed in its full extent. Some of the studies were put up in the hall of the house; and in one of the debates on the subject, Mr. John Randolph was ardently eloquent in his commendation of the work, and insisted that I should be employed to execute the whole. The result was, that a resolution finally passed both houses, giving authority to the president, "to employ me to compose and execute four paintings, commemorative of the most important events of the American revolution, to be placed, when finished, in the Capitol of the United States."[5]

This essay is derived from a chapter in my book in preparation, *Embellishing the Temple of Liberty. The Decoration of the United States Capitol, 1793–1850*. Some of the source material which can only be mentioned or alluded to here will be given there in detail.

1 Text of the contract in Trumbull 1841, pp. 263–65.
2 Benjamin Latrobe to Rufus King, March 27, 1816, in Edward C. Carter II, ed., *The Papers of Benjamin Henry Latrobe*, microtext ed., Clifton, N.J., 1976, microfiche 221, frame F9.
3 Trumbull 1841, pp. 90–91, recounting the advice Burke had given him in 1784: "You are aware that architecture is the eldest sister, that painting and sculpture are the youngest, and subservient to her; you must also be aware that you belong to a young nation, which will soon want public buildings; these must be erected before the decorations of painting and sculpture will be required. I would therefore strongly advise you to study architecture thoroughly and scientifically, in order to qualify yourself to superintend the erection of these national buildings— decorate them also, if you will."
4 Jaffe 1975, pp. 234–63, with further literature.
5 Trumbull 1841, pp. 261–62.

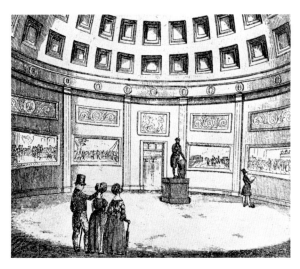

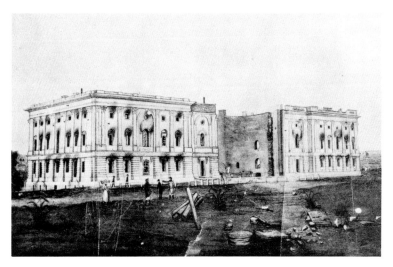

Fig. 110. *Interior of the Rotunda with Paintings by John Trumbull.* Engraving from Philip Maas, *Public Buildings and Statuary of the Government . . .* , Washington, D.C., 1840.

Fig. 111. William Strickland (after George Munger), *View of the Capitol after the Burning by the British,* detail, c.1814, aquatint. Washington, D.C., Library of Congress.

This statement raises questions because Trumbull singles out two men, Representatives Pitkin and Randolph, as the principal supporters of his project. He does not mention any senator, yet it is known from congressional records that the resolution to commission paintings from Trumbull was initiated in the Senate. To mention Pitkin may have been a tribute to the representative of Trumbull's own state, Connecticut. To include Randolph, however, can only be interpreted as an attempt to remind the representative from Virginia, whose later criticism of Trumbull's paintings had hurt the painter both personally and professionally, of his original support for Trumbull's project. The defensive mood in Trumbull's account should not be overlooked.[6] Trumbull's recollections were written in 1841. Like all autobiographies, the point of view is by necessity personal, subjective. Information need not be wrong, yet the mental process that determines which material is included and which omitted may in the end create a sequence of events which does not correspond to what the historian can and must reconstruct with a less biased attitude. Taking Trumbull's account at face value, one must conclude that he needed only the proper introduction to members of Congress to obtain the commission for the four Capitol paintings. But if it was indeed such an easy undertaking, why did Trumbull wait until 1816 to ask for government patronage? Congress had moved to Washington in 1800 and Trumbull himself had been working on paintings devoted to the American Revolution since the 1780s. Even more enigmatic is why he chose that moment to apply— no funds for construction, let alone decoration of the building were available. Work on the center section of the Capitol had not yet begun, and Trumbull was absolutely correct in calling the Capitol a ruin.[7] Although his paintings would eventually decorate the Rotunda, no such scheme was under consideration in 1816.

The documented events of late 1816 and early 1817, rather than confirm Trumbull's assertions, reveal above all the obstacles he had to overcome and how he tried to accomplish his goals. He had two objectives: one was financial security, the other was his desire to celebrate great events of the American Revolution. He was aided by friends who provided introductions and the necessary

6 The best summary of the controversy between Trumbull and Randolph is found in Morgan 1926, pp. 79–82; see also John F. Weir, *John Trumbull: A Brief Sketch of His Life*, New York, 1901, p. 36, and Jaffe 1975, p. 260, for Greenough's reference to Randolph's "unscrupulous sarcasm."

7 Quoted in a letter from Rufus King to Christopher Gore, January 17, 1817, in Charles R. King, *The Life and Correspondence of Rufus King, Senator from New York,* 6 vols., New York, 1894–1900, VI, pp. 45–46.

contacts without which a commission could not be obtained. This help was essential because large-size historical paintings excluded private patronage. If Trumbull wanted to be successful, he had to emphasize the content of his paintings and its historical significance, rather than the works' artistic value. Yet even with government patronage, the success of the enterprise depended on the scenes chosen. Trumbull could not count on any widespread interest in Revolutionary scenes which stressed national unity at a time when the political situation was described as "little short of a Civil War."[8] Trumbull himself claimed, as Silliman wrote in his biographical sketch, that

> the patriotic ardor of that [Revolutionary] period had, in a great measure died out, and the pursuit of wealth and the spirit of party reigned in its stead. His feelings became at times so intense that he expressed regret that he had given his earliest efforts as a soldier and his mature labors as an artist to promote and to perpetuate the memory of that great event.[9]

The first attempt to mobilize Congress on Trumbull's behalf was carried out by John S. Cogdell, a South Carolina lawyer, himself an amateur painter and sculptor, as well as a patron of Allston, Vanderlyn, Powers, and Sully. Trumbull and Cogdell had met in New York in November 1816. Cogdell wrote to Trumbull and informed him that after his return to Charleston, he had mailed a long letter to Mr. Gales— the editor of the *National Intelligencer*— "with this strict injunction: 'first read: & if you do not object then forward them for publication.'"[10] Gales promised to publish it as soon as Congress met again. The letter was published on December 2, 1816, and signed "Correggio." Cogdell-Correggio pointed out some of the day's most pressing political issues and then made an impassioned plea: Congress should encourage and patronize the arts so that the aid of foreign artists would not be required; paintings of "glorious, matchless achievements" would serve as examples for all nations; the Declaration of Independence was a topic to be remembered above all others; and Trumbull was the best artist to carry out the task.

There can be no doubt that it was this appeal— and not only the suggestion of Judge Nicholson— which prompted Trumbull to go to Washington. He arrived there early in January, at the latest, bringing with him the history paintings and portraits he had made in previous years. He showed these works to as many members of Congress as were interested in seeing them. Trumbull also approached Senator James Barbour of Virginia for patronage, as we learn from a letter by Barbour to Jefferson, written on January 9, 1817:

> Colonel Trumbull the celebrated painter is on a visit to this city— bringing with him several specimens of historical paintings. The Subjects he has selected are of a character which impart the highest interest to an American bosom. The wish of the Colo. is to be employed in his line in embellishing the Capitol with some of those pieces executed on a scale commensurate with the building. A direct application has been made to me to patronize the views of Colo. Trumbull and as a recommendation it has been stated that while you were abroad you became so well acquainted with this Gentleman and impressed so favorably with his character both as a man and as an artist as to dispense to him many acts of kindness.[11]

Trumbull's lobbying was successful. He informed Judge Nicholson in Baltimore that Senator Barbour would present a resolution in the Senate to commission him to paint a large version of *The Declaration of Independence*.[12] The resolution had hardly been introduced when, at the suggestion of Senator Robert Goldsborough, it was turned over to a committee for further consideration, "for the

8 Christopher Gore to Rufus King, August 20, 1815, ibid., V, pp. 485–86.
9 Silliman, "Notebook," I, pp. 24–25.
10 John S. Cogdell to JT, December 15, 1816, YUL-JT.
11 James Barbour to Thomas Jefferson, January 9, 1817, LC, Jefferson Papers.

12 JT to Judge Nicholson, January 13, 1817, YUL-JT. For the resolution, see *Annals of the Congress of the United States* (1854), 14th Congress, Second Session, January 13, 1817, p. 64.

purpose of selecting two additional scenes from the period of the Revolution to be subjects of paintings, which, together with the *Declaration of Independence* when completed, are to be deposited in the Capitol of the United States."[13]

The purpose of Senator Goldsborough's resolution was to man the committee with Trumbull's friends, who in cooperation with the artist could draw up a recommendation in line with the artist's own inclinations. Trumbull's proposal to the Senate committee is recorded in a draft of a letter written to confirm a conversation but never mailed. He points out that his artistic career had been interrupted for the long period he had served on the Jay Treaty Commission, during which time younger artists had "risen into reputation." Then he continues:

> The declaration of Independence, with portraits of most of those eminent Statesmen, who laid the foundations of our Nation, will surely be thought no improper ornament for the Hall of the Senate or the Representatives. The Surrender of Saratoga and of Yorktown, and the other memorials of those Heroes who either cemented those foundations with their blood, or who lived to aid in the Superstructure, cannot I trust fail to interest the feelings of every one who loves this Country; or to stimulate Youth to the imitation of such glorious examples. While Posterity will be delighted and proud to see these monuments of patriotism of their Ancestors; and the declaration of Independence will be to them what Runnimede would be to Englishmen, had any contemporary Artist lived to convey to them the Scene and the Actors in that great Event.[14]

Trumbull had sacrificed the prime of his artistic life while serving on a commission which netted millions of dollars for the United States. Now he wanted his share of the profit. The commission for *The Declaration of Independence*— even if this were the only painting ordered from him— would provide him a reasonable income and at the same time assure his fame over that of the younger painters, who might be better artists but who had not lived through the events depicted nor known the people who had shaped the country's political course.

Trumbull also expressed his conviction that he was the only living artist familiar with both the Revolutionary events and the major protagonists in letters to two former presidents, John Adams and Thomas Jefferson.[15] Trumbull had known both men for some forty years.[16] Approaching them, however, was not only an attempt to enlist two friends in his cause, but was also designed to obtain bipartisan support, to secure a Northern and a Southern statesman around whom members of Congress could rally. The reactions of Adams and Jefferson were as different as their political creeds, as distinguished as their attitudes toward the arts. Adams wished Trumbull "success . . . with all [his] heart," but otherwise showed himself disinterested in the project. There is no indication that Adams had written any letters on Trumbull's behalf. Jefferson, on the other hand, felt "that they [the paintings] should be retained in this country as monuments of the taste as well as of the great revolutionary scenes of our country."[17] Moreover, Jefferson, in response to Barbour's letter of January 9, 1817, had asked the senator to support Trumbull's proposal.[18] However, this request could not have

13 Ibid., January 15, 1817, pp. 67–68.
14 LC. According to a note, which Trumbull added on the last page of this letter, it was composed in December 1816 but never mailed. Similar letters were sent on December 26, 1816, to John Adams and Thomas Jefferson (see n. 15), but these do not contain the specific suggestions of the unmailed version. This could only have been written in January 1817 in an effort to explain to members of the Senate committee which "two additional scenes" should be selected.
15 Letters to both men were written on December 26, 1816. The Jefferson letter (LC, Jefferson Papers) is reprinted in Sizer 1953, p. 309; the letter to Adams is unlocated.
16 On Jefferson's role in the design of *The Declaration of Inde-*

pendence see Cat. 26 and Jaffe 1975, pp. 97–122.
17 John Adams to JT, January 1, 1817, YUL-BF, quoted above, p. 14. Jefferson's reply is lost but his sentiment is recorded in a letter to Senator Barbour: Thomas Jefferson to James Barbour, January 19, 1817, in Sizer 1953, p. 310. Trumbull's reply to Jefferson's letter is dated March 3, 1817, YUL-BF, Sizer 1953, pp. 310–11.
18 Jefferson's letter to Barbour of January 19 (above, n. 17) was not written in response to Trumbull's request for Jefferson's support. Sizer 1953, p. 310 and, following him, Jaffe 1975, p. 235, imply such a connection.

had any impact on the discussion in Congress since the issue was decided in the Senate only one day after Jefferson's letter was mailed.

The Senate debated the recommendation of the committee on January 20; on the following day, the *National Intelligencer* reported that

> the Senate afterwards took up the Joint Resolution for Authorizing a Painting to be executed from Col. Trumbull's design of the *Declaration of Independence*. On this bill there was a debate, Mr. Barbour being its principal supporter. The resolve was so amended as to authorize the execution of four pictures of the principal events of our Revolutionary History; and, thus amended, was ordered to be engrossed and read a third time.

The Senate resolution was sent to the House, whose committee accepted it without amendments. This action set the stage for the debate of January 27, 1817, which resulted in the commission of four paintings from Trumbull.[19]

On January 28, the *National Intelligencer* briefly reported this debate. The newspaper stated that the size of each painting would be 12 x 18 feet, the figures as large as life. The subjects mentioned were *The Declaration of Independence, The Surrender of General Burgoyne at Saratoga,* and *The Surrender of Lord Cornwallis at Yorktown,* as well as *The Resignation of General Washington.* The brief report went on to say:

> Judging from the one or two of these Paintings, on small scale, now exhibited in the Hall of Representatives, these great historical Paintings, when executed, will do credit to the artist and to his country.

It should be noted that Congress authorized the president to employ Trumbull without specifying the topics of the paintings. Thus the final decision about the subject matter and the size was left to the painter and the president. Trumbull, recalling these events without, however, speaking of the congressional debate, attributes the decision about the size of the paintings to Madison, but claims that the choice of the subjects was his.

> "What would you have for the fourth [painting]?" "Sir," I replied, "I have thought that one of the highest moral lessons ever given to the world, was that presented by the conduct of the commander-in-chief, in resigning his power and commission as he did, when the army, perhaps, would have been unanimously with him, and few of the people disposed to resist his retaining the power which he had used with such happy success, and such irreproachable moderation. I would recommend, then, the resignation of Washington." After a momentary silent reflection, the president said, "I believe you are right; it was a glorious action."[20]

In light of the report in the *National Intelligencer*, however, Trumbull's claim seems exaggerated. The painter had made his influence felt between the time of the initial resolution and the final debate in the Senate on January 20. During this short time, he had successfully suggested the addition of *The Surrender of Lord Cornwallis* and *The Surrender of General Burgoyne* to *The Declaration of Independence.* Before the final House debate on January 27, Trumbull— or someone else— must have suggested *The Resignation of General Washington,* so that in the meeting with the president no new proposals were in fact made. Instead, the congressional consensus (as reported in the *National Intelligencer*) was accepted. Congress could have determined the topics but chose not to do so. Leaving the decision about the paintings to the president created an advantage for Trumbull. It allowed him to explain to the president, as he had previously to the Senate committee, the real extent of his project. As early as 1790, he had planned a series of fourteen Revolutionary War scenes,[21] and in January 1817 was still

19 *Annals of the Congress of the United States* (1854), 14th Congress, Second Session, January 27, 1817, pp. 761–63.
20 Trumbull 1841, p. 263.

21 The prospectus Trumbull published in 1790 for a Revolutionary War series lists thirteen scenes; another was added shortly after (see pp. 37–38).

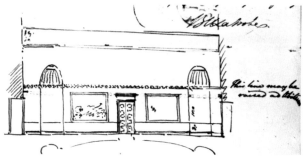

Fig. 112. Benjamin Latrobe to John Trumbull, July 11, 1817, detail. New Haven, Yale University Library; Yale University Archives.

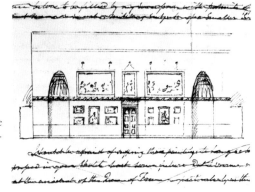

Fig. 113. John Trumbull to Benjamin Latrobe (detail of Cat. 161).

thinking on a grand scale. He may not have said so publicly, but in private he did, as we learn from Senator Barbour's letter to Jefferson of January 9 (quoted above), and from a letter by Rufus King to Christopher Gore, written on January 17, 1817:

> His object is to adorn the Capitol with pictures which shall perpetuate the great events & the glories of the Revolution, as the Ducal Palace of Venice, and the State House at Amsterdam, by the talents of the great Painters of the day, have commemorated those of these Republics.[22]

Considering that within a week, the Senate had agreed to commission four rather than only one painting, Trumbull must have felt confident that even more paintings would be ordered from him. Indeed, on February 28, 1817, Representative Ward from New York proposed that Trumbull execute a fifth painting, depicting the capture of Major André.[23]

Trumbull must have known that large paintings could not be placed in either the Senate Chamber or the House of Representatives. The most advantageous place would have been the still unbuilt Rotunda, and there can be little doubt that Trumbull wanted his paintings displayed there. Only this room would give them prominence.[24] This focus on the Rotunda explains his deep interest in the architectural design of the room, as is evident from his correspondence with Latrobe and Bulfinch, to which we will now turn.

The first correspondence between Latrobe and Trumbull took place on January 22, 1817, when the architect congratulated the painter on the favorable vote in the Senate and expressed his pleasure

22 Rufus King to Christopher Gore, January 17, 1817, in King, *The Life and Correspondence of Rufus King*, VI, pp. 45–46; see also Trumbull 1841, pp. 261–62, where Trumbull mentions Representative Pitkin as supporting the project "in its full extent."

23 *Annals of the Congress of the United States* (1854), 14th Congress, Second Session, February 28, 1817, p. 1041. This suggestion was "laid on the table," but no further action was taken.

24 Trumbull's letters written in connection with the various exhibitions of his paintings before he took them to Washington mention again and again his pleasure or dislike of the arrangements made for their temporary display. The need for proper exhibition space was also mentioned by "Correggio" in his letter to the *National Intelligencer* of December 2, 1816.

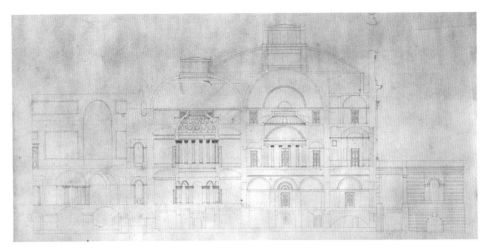

Fig. 114. Benjamin Latrobe, *Section through the North Wing of the Capitol*, detail, October 1817. Washington, D.C., Library of Congress.

that Trumbull's paintings would be hung on his walls.[25] In July 1817, Trumbull and Latrobe began to exchange letters in which they explored a mutually satisfactory solution for the installation of the paintings. These letters show the architect eager to save his design, which anticipated the display of sculpture, yet willing to accommodate the painter's need. The painter, on the other hand, was anxious to see his paintings become the dominant decoration of the room. Latrobe suggested curved stretchers and frames for the paintings and a reduction of their width (*Fig. 112*), because he did not want to reduce the width of the wall between the paintings and the niches of the Rotunda.[26] Trumbull rejected this idea, favoring the placement of the paintings above the impost, with the lower parts of the wall left free for additional paintings (*Fig. 113*).[27] Trumbull's counterproposal was unacceptable to Latrobe, who argued that the high position of the paintings would make them difficult to see— they would be too distant from the viewer and the angle would cause glare.[28] However, he reconsidered his earlier request that Trumbull reduce the width of the paintings and was now willing to provide spaces large enough for them and high enough above ground to avoid damage by curious spectators. The final arrangement was recorded by Latrobe in a drawing of the north wing of the Capitol (*Fig. 114*).

Trumbull's claim that he could not change the width of the paintings and Latrobe's original insistence that he could not reduce the wall space between the picture and the niche was not a controversy over a few inches of space, but touched upon the basic issue of the predominance of architecture over its decoration. In Latrobe's proposal, the paintings were recessed, that is, they were absorbed by the walls. Such an arrangement was essential if the circular ground plan, echoed in the semicircular niches, was to be maintained. His suggestion to stretch the paintings on concave frames must be seen in this light. Trumbull, however, argued from a different point of view. For him, the architecture was primarily the support for his four paintings and those which would follow in later years. On November 20, 1817, before the compromise between Latrobe and Trumbull could be carried out, Latrobe resigned as architect of the Capitol. On December 4, 1817, Charles Bulfinch, the architect of the State House in Boston, was appointed his successor. Bulfinch's foremost task was the construction of the center part of the Capitol "on a scale," as President Monroe put it, "adequate to national purpose."[29] Each of the parties involved had a different concept of "national purpose." Members of

25 Benjamin Latrobe to JT, January 22, 1817, YUL-JT. Jaffe 1975, p. 248, implies that as early as January 1817 the Rotunda had been selected for Trumbull's paintings.

26 Benjamin Latrobe to JT, July 11, 1817, YUL-JT; Sizer 1953, p. 312.

27 JT to Benjamin Latrobe, September 25, 1817, draft of letter, NYHS.

28 Benjamin Latrobe to JT, October 10, 1817, YUL-JT.

29 President Monroe in his first "Annual Message," December 2, 1817, in *Documentary History of the Construction and Development of the United States Capitol Building and Grounds*, Washington, D.C., 1904, p. 199.

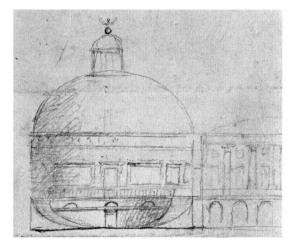

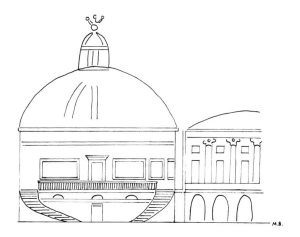

Fig. 115. *Section through the Capitol Rotunda* (Cat. 162).

Fig. 116. *Schematic Reconstruction of the Sketch of Trumbull's Proposal for the Interior of the Rotunda.* Drawn by Mary Bahr.

Congress wanted more committee rooms and were willing to abandon altogether the idea of preserving the Rotunda. Trumbull wanted the Rotunda for his paintings, Bulfinch for a large staircase. It is against this background that we must evaluate the correspondence between Trumbull and Bulfinch.

Bulfinch expressed his preference in a letter to Trumbull, now lost, on January 19, 1818. The content of this letter can be reconstructed from Trumbull's reply, written on January 25, 1818.[30] Bulfinch planned a large staircase modeled after the one in New York's City Hall and a separate gallery for Trumbull's paintings. Such a proposal directly threatened Trumbull's idea of using the Rotunda for the installation of his paintings. Trumbull took the initiative and sent to Bulfinch some drawings proposing a different architectural solution.[31] The drawings are lost but the carefully executed drafts were later incorporated by Trumbull in a book of his architectural designs. Of these drawings, the elevation is the most important one (*Fig. 115*). It amounts to a revision of Latrobe's proposal of October 1817 (*Fig. 114*). Instead of an external staircase, Trumbull would have created four internal ones, two each starting at the eastern and western entrance to the Capitol and ascending to the doors connecting the Rotunda with the House and Senate wings. Had this design been executed, the floor of the Rotunda would have "floated" like an island, being removed from the walls of the room by 9 feet. The horizontal alignment of the upper part of the doors and the picture frames, combined with the line created by the 5-foot-high railing, emphasized the friezelike character of the painted decoration, which was echoed in the intended but unspecified sculptural decoration of the frieze.

If one renders Trumbull's sketch in a schematic drawing (*Fig. 116*), the reason for eliminating the large niches in Latrobe's design becomes obvious. Trumbull needed all the space for the proposed installation of his paintings. In the right section of the Rotunda part of the sketch, three paintings are indicated, diminishing in width to signify foreshortening. If three paintings could be hung on the walls between two doors, then the Rotunda could be decorated with twelve Revolutionary War scenes. This conclusion is supported by the numbers Trumbull entered at the bottom of his sketch,

30 JT to Charles Bulfinch, January 25, 1818, Letterbook, YUL-JT and LC; Trumbull 1841, pp. 265–66.

31 JT to Charles Bulfinch, January 28, 1818, Letterbook, YUL-JT and LC; Trumbull 1841, pp. 266–72. Bulfinch acknowledged this letter two and a half months later: Charles Bulfinch to JT, April 17, 1818, LC. Trumbull claimed that Bulfinch's reply had been lost (Trumbull 1841, p. 265; Sizer 1953, p. 261, mentions the letter). Trumbull, in turn, replied briefly in July, congratulating Bulfinch on having saved the "grand central room"; JT to Charles Bulfinch, July 25, 1818, Letterbook, YUL-JT and LC; Trumbull 1841, pp. 272–73.

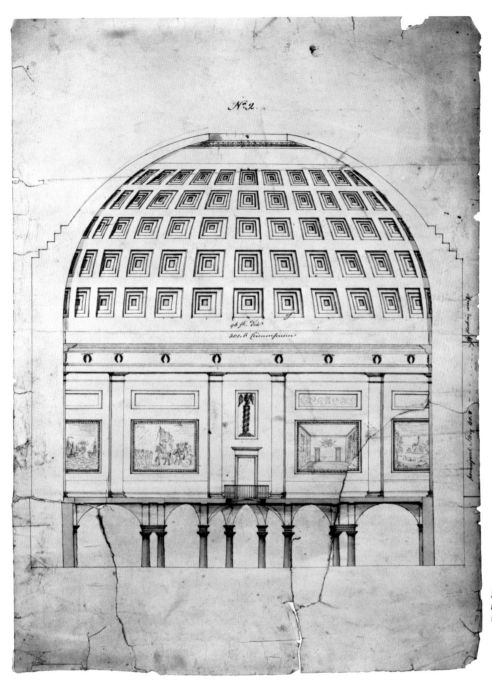

Fig. 117. Charles Bulfinch, *Plan No. 2 Showing the Interior of the Rotunda*, February-March 1818. Washington, D.C., Library of Congress.

where he figured out whether there was indeed sufficient space for twelve paintings.[32] Trumbull had seized the opportunity which Bulfinch had provided by asking his advice in architectural matters to propose his own design for the interior of the Rotunda. Although only four paintings had been

32 Trumbull assumed the diameter of the Rotunda to be about 90 feet. To obtain an approximate figure for the circumference of the Rotunda, he multiplied this figure by 3, rather than 3.14. The result was 270 feet of uninterrupted wall space. In the left column of figures, he subtracted from this number 48 feet— the space needed for the four doors and their frames, which he calculated at 12 feet each. This simple calculation is carried out in the left column:

 270 (circumference of the Rotunda)
 48 (4 x 12 feet for the doors and their frames)
 ———
 222 (space available for paintings)

The number 12 placed in front of 222 indicates that Trumbull planned to divide 222 by 12, but he did not carry out this calculation. The right column of figures can be read as follows:

 222 (space available for paintings)
 111 (space available for paintings in one half of the Rotunda)
 55.6 (space available in one quarter of the Rotunda, that is, between two doors)

This figure (55.6 instead of 55.5) is then divided by 3 (the number of paintings he wanted to place there), resulting in 18.6 (instead of 18.5). Since the paintings were to be 18 feet wide, Trumbull assured himself that he could indeed hang twelve pictures in the Rotunda. His method of calculation assures us of a weakness in his mathematical skills.

commissioned, Trumbull hoped that more would follow. Anticipating such an event, he prepared the Rotunda for twelve. Only if this arrangement is understood, does the following passage from Trumbull's letter of January 28, 1818 (which included the lost original drawing), reveal its full meaning:

> I want not a Column nor a Capital; plain solid walls, embellished only by four splendid doorcasings of white marble & elegant workmanship:— a Fascia of white marble running around the Room, with an ornament somewhat like that which surmounts the Basement story on the outside:— and a Frieze crowning the Top of the wall, where either now or at some future time Basso-Relievos may be introduced:— these are all the decorations which I propose, except the paintings.[33]

It has been suggested that Trumbull's letter persuaded Bulfinch to "retain the Rotunda."[34] This is only partly correct. It must not be overlooked that Bulfinch presented the plan submitted by Trumbull together with two of his own to the congressional committee and a barely interested president. The choice was theirs. What Bulfinch had realized was that only a plan following the principles of Latrobe's design could have any hope of approval. Of Bulfinch's plans, one has been preserved in the Library of Congress (*Fig. 117*).[35] Pilasters were introduced which subdivided the wall space into four smaller bays for the doors and eight larger ones for the paintings. Above the paintings and doors were to be relief panels. The larger ones over the paintings were filled with a floral pattern, those over the north and south doors contained the fasces, a well-understood symbol of the Union. The frieze above the pilasters carried wreaths. Bulfinch's proposal was a compromise; it maintained the basic forms of Latrobe's plan but introduced those architectural elements which— for obvious reasons— Trumbull did not want in the Rotunda. The compartmentalization stressed the individual paintings, rather than consider each of them as part of a frieze, and destroyed any hope of hanging more than eight in this room. Bulfinch's design also eliminated the circular staircase and thus the special presence which the installation of the paintings— separated from the spectator by almost 10 feet— would have created. With the physical gap and the frieze effect Trumbull planned, the spectator would have been surrounded by historical scenes, viewing the painting in a space and atmosphere like that experienced by spectators of panoramas.[36]

An element of irony accompanied the selection of Bulfinch's plan over Trumbull's. Throughout his life, as Silliman wrote, Trumbull's "admiration of Washington amounted indeed to enthusiasm towards that great man."[37] When in 1800 Congress passed a resolution to erect a monument to Washington in the Capitol, Trumbull objected to this plan, recommending instead a design submitted by Benjamin West to his friend Christopher Gore. West had proposed a large pyramidal structure which "should not be shut up within an Apartment but should stand a conspicious and imposing Feature of the Federal City, durable as the Earth on which it Stands."[38] Now, in 1817, the idea of erecting a monument to Washington was debated once again, and the ground floor of the Rotunda was selected as the most appropriate location. Trumbull considered the plan "poetical, grand and captivating,"[39] despite the fact that it destroyed his own imposing design for the Rotunda. Was Trumbull's admiration for Washington so overpowering that he was willing to sacrifice his own design for the building and decoration of the Rotunda? After all, if Trumbull could not succeed as architect, he still could succeed as painter.

When Bulfinch prepared his drawing of the interior of the Rotunda, he incorporated four sketches of paintings, two of them given only partially (*Fig. 117*). A similar drawing of the other half of the room

33 JT to Charles Bulfinch, January 28, 1818, Letterbook, YUL-JT and LC; see also Trumbull 1841, p. 271.

34 Jaffe 1975, p. 251.

35 Charles A. Place, *Charles Bulfinch: Architect and Citizen*, New York, 1968, p. 257. Place does not discuss the drawing.

36 In 1808, Trumbull made panoramic views of Niagara Falls, which he took with him to London (see Cat. 147).

37 Silliman, "Notebook," I, p. 25.

38 JT to Christopher Gore, February 28, 1800, MHS, Sedgwick Papers.

39 Trumbull 1841, p. 277.

Fig. 118. Balthasar Frederic Leizelt (after Richard Paton), *Combat mémorable entre le Pearson et Paul Jones*, 1781, engraving. Washington, D.C., Library of Congress.

might have existed and contained further scenes. Of the two fully visible scenes, one depicts the room (without the figures) of Trumbull's *Declaration of Independence*. The others do not relate to any of Trumbull's known compositions. Do these sketches represent Trumbull's ideas, or at least suggestions for paintings to be added to the four specified in the contract? When Bulfinch received from Trumbull his proposal for the interior of the Rotunda, emphasizing the friezelike arrangement of the paintings, it might have contained these sketches, which Trumbull did not include— and did not need to include— in the draft he kept. It is also possible that Trumbull availed himself of the services of Theodore Dwight, Jr., who brought Trumbull's drawings to Bulfinch and who might have explained the painter's intentions.

It can be argued that these sketches represent lost drawings by Trumbull. However, Bulfinch, on his own, may have added scenes to make clearer the decorative features of his proposed design for the Rotunda. He either followed Trumbull's ideas— as in *The Declaration of Independence*— or composed Revolutionary War scenes with borrowed motifs.

The partially visible painting at the left of Bulfinch's drawing is obviously a rendering of a naval battle. None of the events selected by Trumbull in 1790 provides a clue. However, the sketch shows striking similarities to Balthasar Leizelt's engraving depicting the battle of the warships *Serapis* and *Bon Homme Richard*, that is, the battle between Captain Richard Pearson and Commander John Paul Jones (*Fig. 118*).[40]

A print may also be the source for the "half-painting" next to *The Declaration of Independence*. The only distinct features of the sketch are a tree with one or more figures below it and some buildings on a hill. Comparable features appear in Bernard Romans' rendering of the Battle of Charlestown (*Fig. 119*).[41]

Finally, the full painting sketched in on the right recalls the composition of *The Surrender of Lord Cornwallis*, but the differences far outweigh the similarities. A group of mounted soldiers following a large American flag is contrasted with a group of soldiers on foot; no fighting is taking place. Could this sketch relate to the rallying of the troops by Washington at the Battle of Monmouth?[42]

The issue of identifying the scenes and attributing them to Bulfinch or Trumbull is a complex one. If the identifications proposed here can be accepted as a working hypothesis, we will know seven

40 Library of Congress, *An Album of American Battle Art 1755–1918*, Washington, D.C., 1947, pp. 37–40.

41 Ibid., p. 27. A similar engraving was produced by Robert Aitken.

42 So far I have not yet located a print which can be related to this sketch in the same way the other engravings could be linked.

Fig. 119. Bernard Romans, *An Exact View of the Late Battle at Charlestown*, engraving. The New York Public Library, Astor, Lenox and Tilden Foundations; I. N. Phelps Stokes Collection, Art, Prints and Photographs Division.

of the eight scenes proposed in 1817 when the design of the Rotunda was under consideration. The eighth painting may have been *The Treaty of Peace*; but this suggestion cannot be ascertained.

In November 1826, the four paintings commissioned in 1817 were completed and installed in the Rotunda and President Adams came to see them.[43] In his *Memoirs*, Adams described the state of the decoration of the Capitol, his admiration for Persico, his dislike of the reliefs in the Rotunda, and his indifference toward Trumbull's *Declaration of Independence*.[44] He also recorded the old painter looking at his paintings and gazing at the four empty niches which he always had hoped to fill with four more of his paintings. At that time, Trumbull was seventy years old. He was made to believe or believed that another commission was forthcoming, and, as he had done in 1817, tried to convince members of Congress to support his application.[45] Then he had invited them to see the paintings; now he placed under the large empty niches in the Rotunda "his small pictures of the deaths of Warren and Montgomery, and two others, bare sketches, one of the death of Mercer at Princeton, and the fourth, another battle."[46] Trumbull had no intention of designing new subjects; he could only envision translating sketches made three decades earlier into large paintings. There is undoubtedly a tragic element in the image of old Trumbull with his sketches in the Rotunda. Yet Trumbull did not perceive the differences which existed between these earlier works and the large-size paintings he had just completed. In fact, he considered the large paintings superior to the earlier works.[47] Moreover, he still hoped that his historical panorama would be realized, and insisted that he was the only history painter qualified for the task.[48]

In his *Autobiography*, Trumbull omits any reference to all the difficulties he had to overcome to obtain the commission. This is not a willful falsification of history, but rather evidence of his unwillingness to see the realities of the day. He lived in a world of his own and was, as Silliman put it,

> a relic of a gone by age. Between the peace of 1783 and his death in 1843 two generations had arisen and he was, to the greater number of them, like one who only lingered on the shores of time or had perchance returned from another world.[49]

The four empty niches in the Rotunda, which Trumbull wanted to fill with four more paintings, remained empty for another quarter century.

43 Jaffe 1975, p. 257, with reference to Trumbull's miscellaneous notes of November-December 1826, NYHS.
44 See Charles Francis Adams, *Memoirs of John Quincy Adams*, 12 vols., Philadelphia, 1874–77, IV, p. 128.
45 See Jaffe 1975, pp. 259–63.
46 Adams, *Memoirs of John Quincy Adams*, VII, p. 188. Judging from Trumbull's existing works, the unnamed fourth scene could only have been *The Capture of the Hessians at Trenton*.
47 Ibid., IV, p. 128.
48 JT to Edward Everett, January 12, 1827, YUL-JT; Sizer 1953, pp. 368–71.
49 Silliman, "Notebook," I, p. 25.

Capitol Drawings

September 25, 1817
The New-York Historical Society

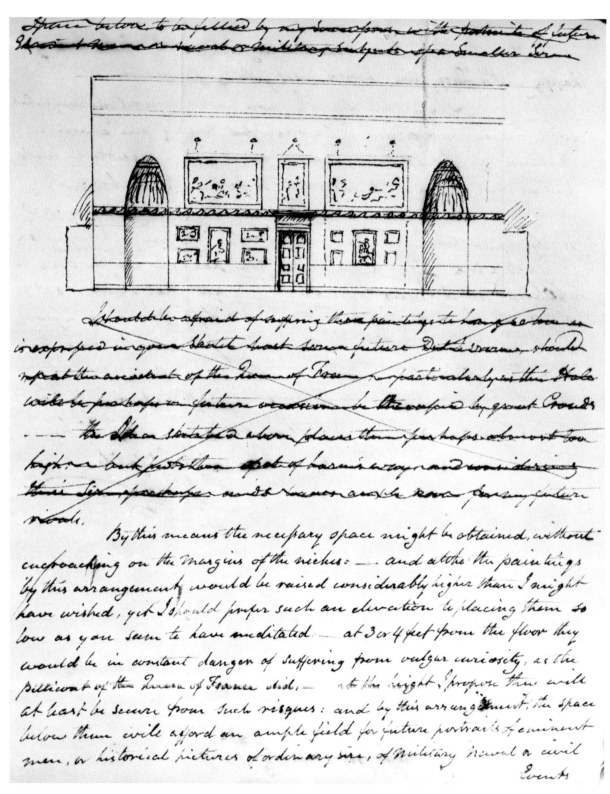

161

162
Section through the Capitol Rotunda

1818
Pencil on paper, 7⅛ x 5½ (18.1 x 14)
The New-York Historical Society

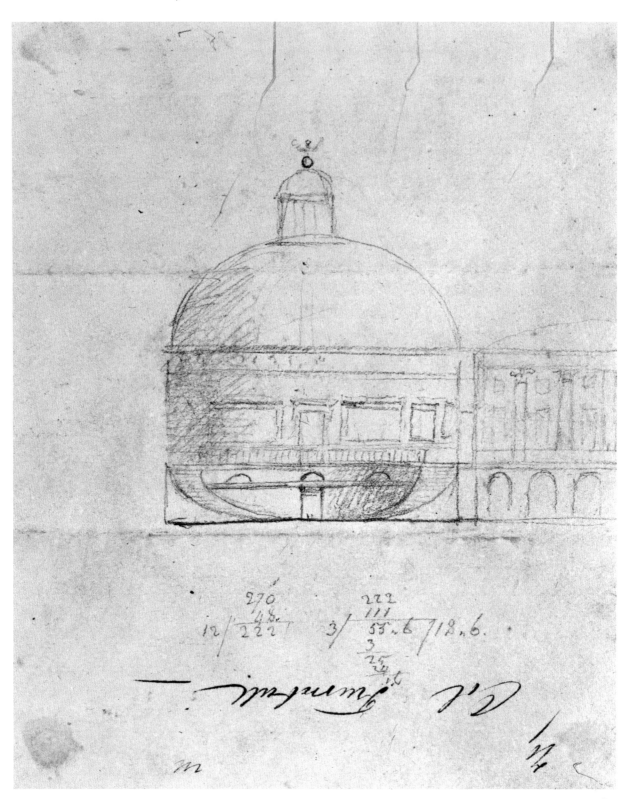

162

163

Plan for the Basement
of the Capitol Rotunda

1818
Pen and ink and wash on paper, 10¼ x 14¼ (26 x 36.2)
The New-York Historical Society

The groundplan for the basement of the Rotunda of the
Capitol was submitted by Trumbull to Bulfinch to explain
his description of the proposed features for the center
section of the Capitol. The careful rendering of this draw-
ing allows us to reconstruct the style of the final version
of the elevation drawing which is preserved only as a draft
(Cat. 162).

The outer circle marks the exterior walls of the Ro-
tunda. Between it and the wall marked by the next circle,
the staircase was to be installed, ascending from both the
east and the west entrance and creating below it wedge-
shaped storage areas for coal and fuel. Below the highest
point of the staircase, i.e., at the entrance to the Senate
and House wings, a passage to the furnace in the center of
the basement was planned. The third circular wall created
the inner wall of a 3-foot-wide circular passage which
could be entered from the east and west (at the bottom of
the staircase; see the door in the elevation drawing) and
the north and south (via the passage to the furnace). From
this circular passage six record rooms could be entered;
the rooms received a limited amount of light from the
semicircular windows visible in the elevation drawing.
The two inner circular walls and the strong walls separat-
ing the record rooms were needed as support for the floor
of the Rotunda.

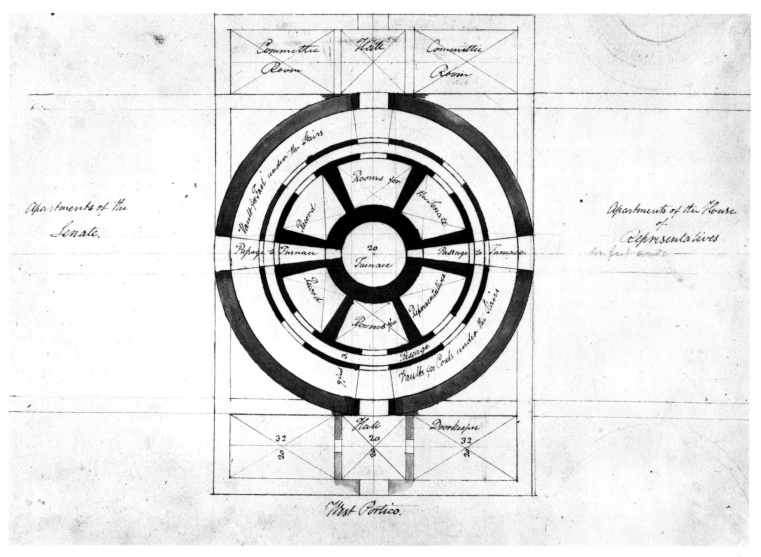

Committee
Room

Hall

Committee
Room

Apartments of the
Senate.

Vault for Fuel under the Stairs

Rooms for
Record

Rooms for
the Senate

Passage to Furnace

20
Furnace

Passage to Furnace

Record

Representatives

Rooms for

Representatives

Passage

Vaults for Coals under the Stairs

Apartments of the House
of
Representatives

Hall

Doorkeeper

32

20

20

32

West Portico.

163

Other Architectural Drawings

In the eighteenth century, an interest in architecture was the sign of a well-educated person. Books of engravings after antique buildings, reprints of the works of Vitruvius and Palladio, collections of contemporary English and French plans, and practical builders' guides made a wealth of material available to those who enjoyed sketching imaginary plans. Thomas Jefferson and his niece Maria Randolph were among the most notable American amateur architects; Harvard-educated Charles Bulfinch, the first native-born professional architect to practice in the United States, began his career in the tradition of the gentleman-amateur. Before the advent of professional architectural training in this country, amateur architects had many opportunities to realize their plans. A physician designed the White House; the president of the Bank of Philadelphia drew up plans for the bank's new quarters built in 1804.[1]

Trumbull had dabbled in architecture for some time before Edmund Burke counseled him in London: "You belong to a young nation, which will soon want public

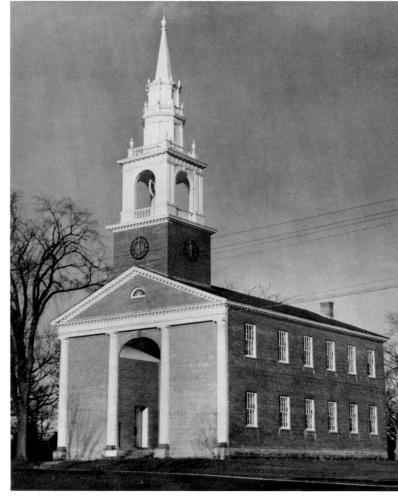

Fig. 121. Meetinghouse at Lebanon, built 1804–6, subsequently restored.

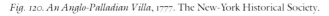

Fig. 120. An Anglo-Palladian Villa, 1777. The New-York Historical Society.

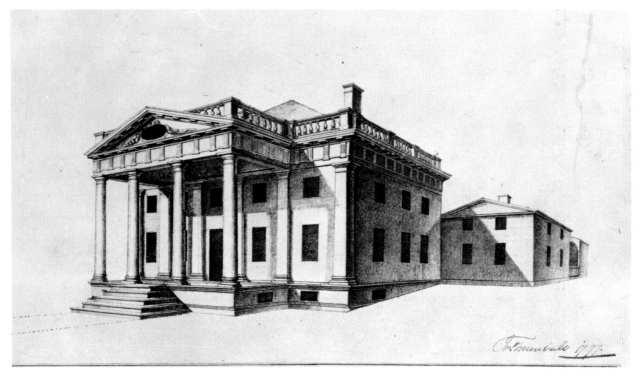

buildings. . . . I would therefore strongly advise you to study architecture thoroughly and scientifically."[2] Trumbull's interest probably went back to his student days at Harvard, where he spent hours in the library poring over volumes of Piranesi's views of Rome.[3] His first architectural drawing, a perspective view of a villa, dated 1777 (*Fig. 120*), shows the influence of the English Palladian designs that an amateur could have studied in eighteenth-century anthologies of drawings by William Chambers, Colen Campbell, and other English architects. Most of Trumbull's subsequent architectural studies follow the schematic format of plan and elevation presented in books. He rarely made a working drawing, or depicted a building in a natural setting. Both his drawings and his realized buildings have the stark, two-dimensional quality characteristic of the work of an amateur who conceives buildings as drawings on paper instead of as physical structures in space.[4]

Although he did not follow Burke's advice, Trumbull continued to pursue architecture as a hobby throughout his career. While in England, he sketched several plans during his months in prison. At home in Lebanon in the early 1790s, and again in London, Trumbull made increasingly elaborate drawings of houses both actual and imaginary. He also received several commissions for buildings. At the request of Yale's treasurer James Hillhouse in 1792, Trumbull drew up plans for the future expansion of the college which, although not followed to the letter, did establish the pattern for the later Brick Row along College Street. In 1804, he designed a handsome meeting house which still stands at Lebanon (*Fig. 121*). He also drew plans for the first home of the American Academy of the Fine Arts (1831), and with the advice of Ithiel Town and Alexander Jackson Davis, designed the Trumbull Gallery built at Yale in 1832 (*Fig. 122*).[5] But most of Trumbull's architectural efforts were devoted to imaginary plans for houses. Toward the end of his life he spent many evenings in New Haven devising architectural schemes with the young Town, who was to become one of the most prominent architects in America.[6]

Trumbull's architectural drawings present models of decorum, more rational than the actual world and more elegant than provincial American architects and builders could hope to realize. There is no crowding in Trumbull's houses and no irregularity in his designs. With his strictly symmetrical plans and his restrained use of classical ornament, Trumbull created a world in which everything had its place.

Fig. 122. *Trumbull Gallery*, photograph, c.1861.
New Haven, Yale University Library; Yale University Archives.

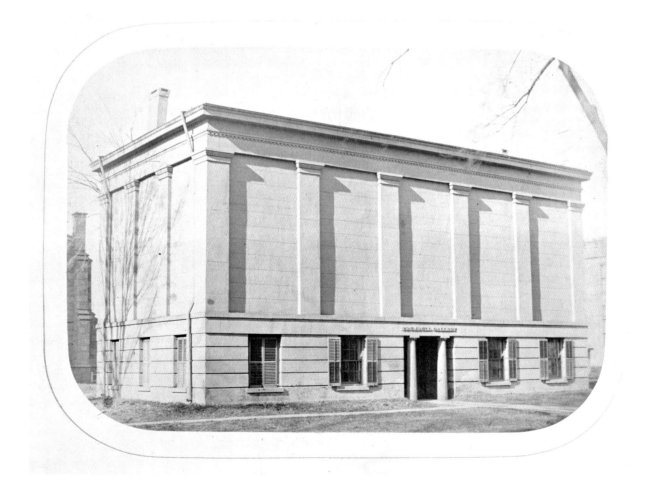

164
Elevation and Plan
of a Residence

1790–94
Pen and ink, wash, and pencil on blue paper, 6¼ x 8¼
(15.9 x 21)
Inscribed, bottom: *Lebanon 1790 to 94*
Yale University Art Gallery; Gift of the Associates in Fine
Arts at Yale

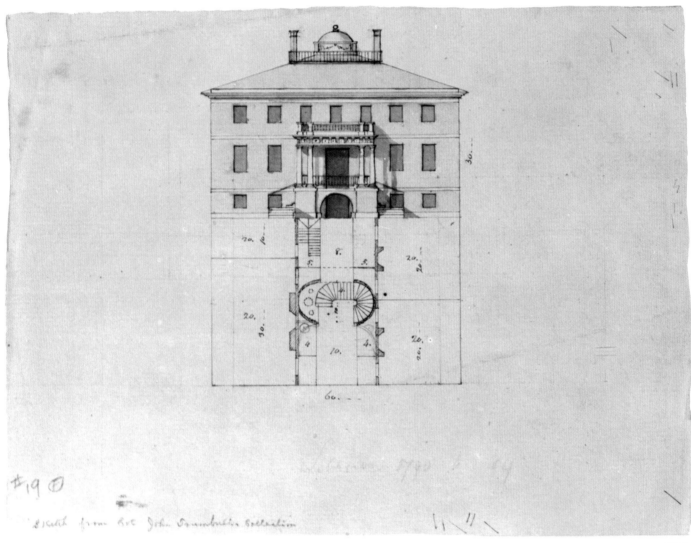

164

Trumbull's architectural taste stood in marked contrast to the picturesque movement gaining popularity in England when he visited in the 1790s. The best-known example of the new trend in design was Strawberry Hill, a country house in fanciful Gothic-Moorish style built outside London between 1748 and 1763. Its owner, Horace Walpole, had hoped that the irregular design of his house and the grounds dotted with artificial ruins would provide a suitable setting for romantic reverie. The conservative Trumbull preferred a severe vocabulary of classical ornament, symmetrically disposed (Cats. 165, 168). His use of urns, domes, niches, and pediments recalls the settings of Benjamin West's history paintings; like West, Trumbull intended his knowledge of classical "grammar" to bespeak his erudition.

Trumbull's house plans reveal his passion for strict social order (Cat. 164). He placed a strong emphasis on such ceremonial spaces as grand stairways, halls, and

Two Interior Views

c.1800
Pen and ink and wash on paper, 4½ x 8¾ (11.4 x 22.2)
The New-York Historical Society

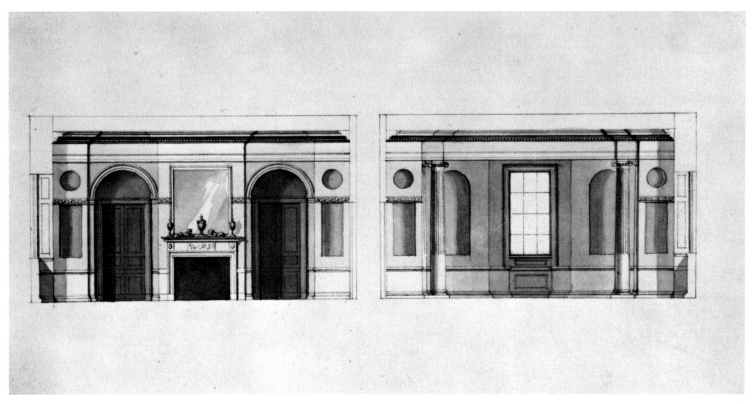

receiving rooms. A visitor to the artist's house (Cat. 166) would have little opportunity to wander from the strictly planned path leading from entrance to staircase to hall to exhibition room. Since each function is isolated within its own separately demarcated space, we sense that there would be no eating allowed in the gallery, no painting in the drawing room, no dancing in the dining room.

Trumbull's penchant for separating functions is especially evident in his plans for Yale College (Cats. 167, 169). At the time he made his drawings, the typical American campus consisted of a field with buildings constructed more or less randomly as the need arose. Yale College had two buildings: Connecticut Hall, containing dormitories, classrooms, and a refectory; and a chapel which housed the college library on its upper floor.[7] Trumbull proposed remodeling Connecticut Hall with a flat roof to replace the Colonial gambrel and dormers that he considered "an inconvenient and expensive Gothicism," and building a new dormitory, echoing the design of the older

structure, on the other side of the chapel. Future construction would extend the college buildings in a row, fronting on an open square to be divided by broad brick paths lined with elms.

While classrooms, libraries, and chapels were to be arranged in a strictly rational fashion, all the college's practical functions were removed to the wooded land behind the new quadrangle. The landscape plan he recommended was surprisingly informal. Trumbull noted on the drawing: "Behind the buildings, the walks may be irregular and winding, beginning behind the two Chapels and corresponding to the two broad ones in their front— the planting also may be irregular." Here, out of view of the more formal educational buildings, Trumbull hid the privies and the dining hall behind picturesque plantings. "The Temples of Cloacina (which it is too much the custom of New England to place conspicuously), I would wish to have concealed as much as possible, by planting a variety of shrubs, such as Laburnums, Lilacs, Roses,

Plans for an Artist's House

c.1800
Pen and ink and wash on paper, 8⅞ x 10¾ (22.5 x 27.3)
Pen and ink and wash on paper, 9 x 9¼ (22.9 x 23.5)
The New-York Historical Society

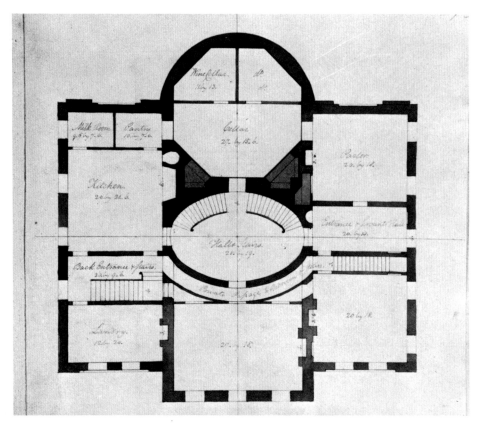

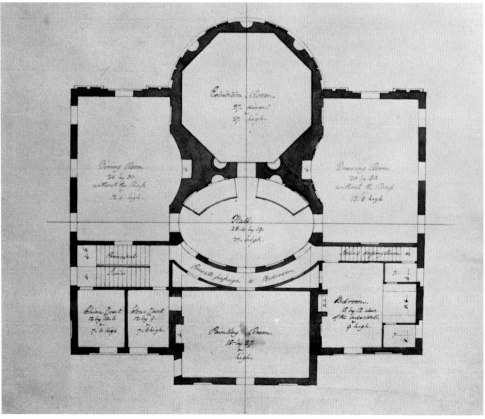

Landscape Plan for Yale College

c.1792
Pen and ink and wash on paper, 13 x 15¹³⁄₁₆ (33 x 40.2)
Inscribed, far right: *J. T.*
Architectural Archives Collection, Yale University
 Archives, Yale University Library

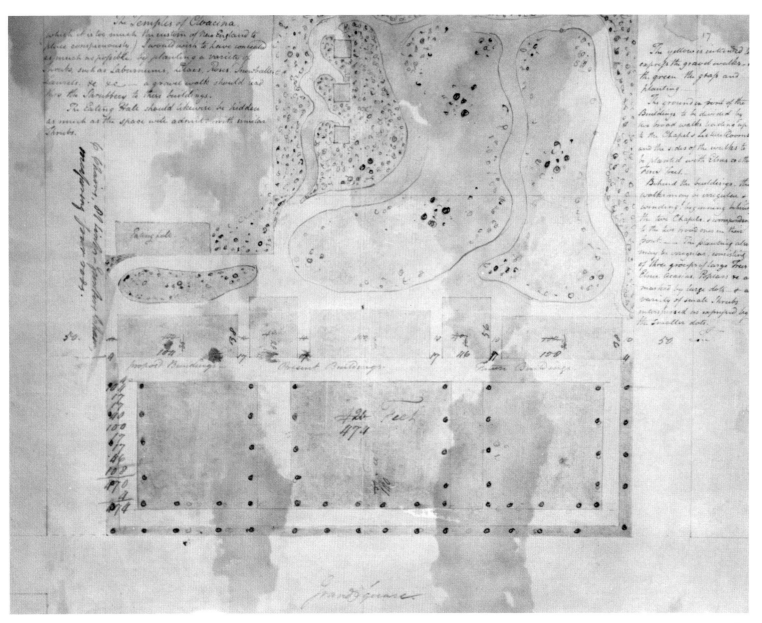

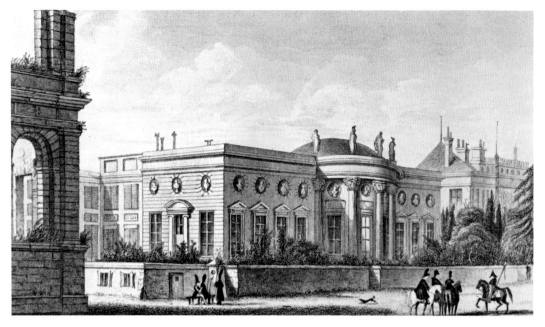

Fig. 123. Antoine Rousseau, *Hôtel de Salm*, Paris, 1784. Engraving from A. C. Pugin, *Paris and Its Environs*, London, 1829–31.

Snowballs, Laurels, &c. . . . a gravel walk should lead thro the shrubbery to those buildings. The Eating Hall should likewise be hidden as much as the space will admit with similar shrubs."[8]

In his designs for houses Trumbull followed less picturesque ideals. In addition to studying the work of English Palladian architects, he was inspired by contemporary French Neoclassical architecture. He owned several prints of the Hôtel de Salm, a townhouse just being completed when he visited Paris with Jefferson and Bulfinch in 1786 (*Fig. 123*). At that time, Jefferson had written to a friend: "While in Paris I was violently smitten with the Hôtel de Salm and used to go to the Tuilleries almost daily to look at it."[9] Along with the innovative designs of Claude-Nicolas Ledoux, this building, with its smooth facade and clearly defined volumes, became the prototype for a new architectural aesthetic based on Roman precedents. It influenced Jefferson's designs for Monticello, Bulfinch's James Swan House (1796), and the work of later English architects, including Soane and Latrobe at the beginning of the nineteenth century. Trumbull repeated the hôtel's drumlike, projecting front, low dome, and flat niches in several of his studies for houses (Cat. 168), and its simple masses informed many of the others. The style and format of a large group of Trumbull's architectural renderings are similar to the drawings of French-inspired houses by the English architects Samuel and Jeffry Wyatt that were reproduced in the volumes of *The New Vitruvius Britannicus*, a compendium published in 1802.[10]

Other Trumbull drawings, especially the studies he did at Lebanon in the 1790s, show him tempering the severe geometries of French Neoclassicism with the more delicate ornament typical of the English architect-decorators Charles and Robert Adam that formed the basis for the Federal style in American architecture at the turn of the nineteenth century. The Adam brothers and their American followers emphasized shallow relief and linear surface patterns over volumes, and oval and polygonal plans over circles and squares. We can see this refined taste at work in the unusually shaped rooms Trumbull proposed for his artist's house (Cat. 166) and in his predilection for cupolas and spiral staircases (Cats. 164, 170). The spindly railings, Palladian windows, and ornamental wreaths that Trumbull included in the houses designed at Lebanon are all characteristic of the American Federal style, and presage the work of Samuel McIntire and Bulfinch.[11] But unlike later American architects working with Adamesque ornament, Trumbull handled decorative elements with unusual restraint. By the time he designed the Trumbull Gallery in 1832, he had abandoned even this limited use of ornament for a severe and rather awkward version of the Greek Revival style that Town and Davis advocated. Conceived like a temple but laid out like a warehouse, this structure combined an emblematic reference to antiquity with Trumbull's own ideal of functional and economical design.[12]

The starkness and strict order of Trumbull's architecture reveal the cast of his mind: in his unrealized plans we can see the effort to create environments of order, decorum and refinement, and to transplant classical learning and European rationalism to American soil.

1 On the tradition of the gentleman-amateur architect in America, see William H. Pierson, *American Buildings and Their Architects: The Colonial and Neo-Classical Styles*, Garden City, New York, 1970, pp. 211–12, and Harold Kirker, *The Architecture of Charles Bulfinch*, Cambridge, Mass., 1969, pp. 5, 13.

2 The full quotation appears on p. 260, n. 3. According to Trumbull's *Autobiography* (1841, p. 90), his father had written to Burke, "expressive of his gratitude for the kindness shown to his son when in prison, and commending me to his future protection."

3 On Trumbull's reading at Harvard, see pp. 22–23.

4 On characteristics of drawings by American amateur architects, see David Gebhard and Deborah Nevins, *Two Hundred Years of American Architectural Drawing*, New York, 1977, pp. 30–31.

Three Elevations
of Three-story Buildings

c.1800

Pen and ink, wash, and pencil on paper, 6 x 9 (15.2 x 22.9)
Pen and ink and wash on paper, 6 x 9 (15.2 x 22.9)
Pen and ink and wash on paper, 6 x 9 (15.2 x 22.9)
The New-York Historical Society

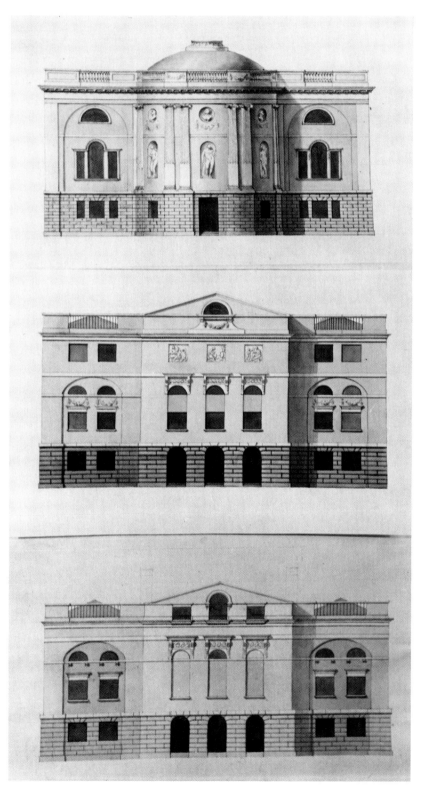

168

Plan for the Development
of Yale College

1792
Pen and ink and pencil on paper, 13 x 30¼ (33 x 76.8)
Beinecke Rare Book and Manuscript Library, Yale
 University

Buildings which may be erected hereafter.

The face of this Building
to be same as the Chapel.
Lower Story to be divided
to recitation Rooms & the
upper ones thrown into
one Room the whole size of
the Building — for a Library.
the present library might
converted into an Apparatus
Lecture Room of natural &
experimental Philosophy.

Plan of the two Bed Rooms — shewing
manner of conducting the
... of the Chimnies — proportion of
... Bed &c — I would wish
... for fire to be brought out of the
... of the way marked by the dotted lines
the Chimnies may thus narrow in front.

This Building to be the same in
size & accommodation as the one now proposed.

Probably but a few Years will elapse
before the Building now determined on, will
be found too small to accommodate the Scholars.
it is therefore submitted to the Corporation whether
in placing the present, they ought not to carry
their views forward to a time when other
Buildings will be necessary: —— if
the present Building be placed at an Angle with
the existing one, it will preclude the Possibility
of reconciling the Whole University to any
degree of Elegance or Uniformity, — while at
the present time it is questionable whether it
offers more accommodation than the Plan here
proposed — & is certainly less agreeable to the Eye.

But an arrangement similar to that
meditated above — would unite Utility
with Ornament. — & would admit of being
pursued gradually. & whether partially or
compleatly executed, would be in all its stages
handsome. —— The very nature
& form of the Ground seems to point it out, & in...
it would be difficult to find in America or
in Europe a situation where such an ...

The following Table will shew the
proposed Plan of a College to be much more
Oeconomical than the Old.

	New Plan	Old	
Number of inner Doors to a floor	12	24	
Number of Windows to a Floor	20	30	10

In the whole Building therefore
there will be less than in the Old —— 48 Doors. &
40 Windows
notwithstanding which I believe the four young
gentlemen will be much better & more agreeably
lodg'd in one of these Apartments than in two of the
old Rooms. ——

There is no doubt also that the Gambrel Roof
is more expensive than the additional height of wall
and a flat Roof — & the Dormin Windows with their
Roofs & casings, are expensive at first, always
leaky, & very soon out of Repair. — besides that
the rooms under such a Roof are very inconvenient.

On the whole I trust that the Corporation
will indulge a time not far distant, when
New Haven shall become another Oxford. &
will make their present decisions with a view to
future Embellishments — anticipating that happy
Period, when the Arts of Peace shall succeed in the
Esteem of the World to those of Devastation. which
have so long falsely engross'd the Applause of Mankind.

170

Garret Floor Plan, Two Sections through a Four-story House

c.1800
Pen and ink and wash on paper, 8¼ x 14¼ (21 x 36.2)
The New-York Historical Society

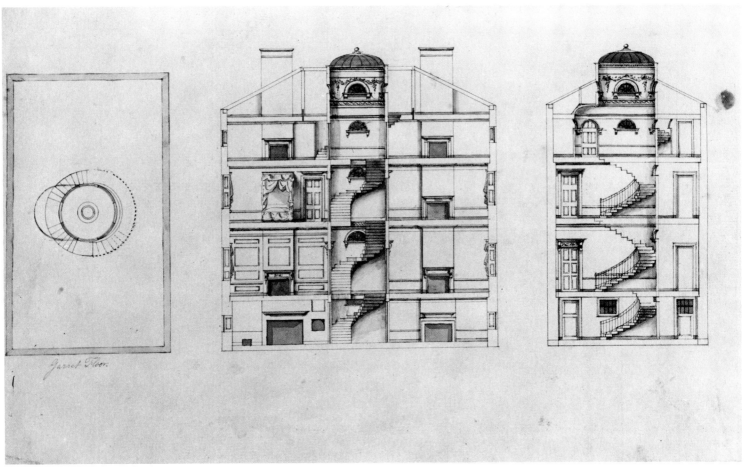

170

5 Sizer 1967, pp. 127–29, gives a complete list of Trumbull's known architectural drawings and buildings; for reproductions, see his figs. 253–62, Jaffe 1975, figs. 196–99, and Gebhard and Nevins, *Two Hundred Years*, pp. 48, 100–1. Most of Trumbull's drawings of houses are collected in an album, assembled by him for Alexander Jackson Davis, now at the New-York Historical Society.

6 Jaffe 1975, p. 286. Trumbull was also credited with encouraging Davis to become an architect; see Alan Gowans, *Images of American Living*, Philadelphia, 1964, pp. 310–11.

7 On American campus architecture, see Pierson, *American Buildings*, pp. 318–19. On architecture at Yale, see Joshua L. Chamberlain, ed., *Yale University*, Boston, 1900, pp. 55–75. For a discussion of Trumbull's plan, see Brooks Mather Kelly, *Yale: A History*, New Haven, 1974, p. 103.

8 Trumbull's idea of surrounding a geometrically arranged campus with winding paths and picturesque plantings predates the French architect J. J. Ramée's plans for Union College, Schenectady, New York of 1812 (illustrated in Pierson, *American Buildings*, fig. 238).

Trumbull's euphemistic "Temples of Cloacina" probably refers to the *Cloacus Maximus*, the great sewer of Rome.

9 Jefferson's letter to the Comtesse de Tessé is quoted in Pierson, *American Buildings*, p. 298; see also Kirker, *Bulfinch*, p. 12.

10 See especially the south elevation of Doddington Hall, Cheshire, and Woolley Park, Berkshire, reproduced in George Richardson, ed., *The New Vitruvius Britannicus*, 2 vols., London, 1802, I, pl. 60, and II, pls. 36, 37.

11 On Adam style in America, see Pierson, *American Buildings*, pp. 215–21.

12 Town and Davis supplied Trumbull with a preliminary drawing for the Trumbull Gallery, a classical temple with skylights in the roof, that may have influenced Trumbull's own subsequent design; see Gebhard and Nevins, *Two Hundred Years*, p. 100, and Jaffe 1975, p. 278. The Trumbull Gallery is also discussed in Helen Searing, *New American Art Museums*, exh. cat., Whitney Museum of American Art, New York, 1982, pp. 23–24.

List of Figures

page

Frontispiece. John Trumbull, *General George Washington at the Battle of Trenton*, 1792. New Haven, Yale University Art Gallery; Gift of the Society of the Cincinnati in Connecticut.

1 *Fig. 1.* John Trumbull, *The Declaration of Independence*, 1787–1820. New Haven, Yale University Art Gallery; Trumbull Collection.

23 *Fig. 2.* Samuel Lovett Waldo and William Jewett, *Colonel John Trumbull*, c.1821. New Haven, Yale University Art Gallery; Gift of Alfred Wild Silliman and Benjamin Silliman IV.

23 *Fig. 3.* John Trumbull, *The Death of Paulus Aemilius at the Battle of Cannae*, 1773. New Haven, Yale University Art Gallery; Trumbull Collection.

24 *Fig. 4.* Domenico Cunego (after Gavin Hamilton), *The Oath of Brutus*, 1768, engraving. London, The Trustees of the British Museum.

24 *Fig. 5.* John Trumbull, *Brutus and His Friends at the Death of Lucretia*, 1777. New Haven, Yale University Art Gallery; Gift from the Heirs of David Trumbull Lanman.

25 *Fig. 6.* Valentine Green (after Benjamin West), *Elisha Restoring the Shunammite's Son*, 1768, mezzotint. New Haven, Yale Center for British Art; Paul Mellon Collection.

25 *Fig. 7.* John Trumbull, *Elisha Restoring the Shunammite's Son*, 1777. Hartford, Wadsworth Atheneum; Gift of Mrs. John T. Roberts.

26 *Fig. 8.* John Trumbull (in the studio of Benjamin West), *The Battle of La Hogue*, 1785. New York, The Metropolitan Museum of Art; Harris Brisbane Dick Fund.

27 *Fig. 9.* Benjamin West, *The Death of General Wolfe*, 1771. Ottawa, The National Gallery of Canada; Gift of the Duke of Westminster.

28 *Fig. 10.* John Singleton Copley, *The Death of the Earl of Chatham*, 1779–81. London, The Tate Gallery.

28 *Fig. 11.* Benjamin West, *The Death of the Earl of Chatham*, 1778. Fort Worth, Kimbell Art Museum.

30 *Fig. 12.* John Trumbull, *The Death of General Montgomery in the Attack on Quebec*, detail, 1786. New Haven, Yale University Art Gallery; Trumbull Collection.

30 *Fig. 13.* John Trumbull, *The Death of General Warren at the Battle of Bunker's Hill*, 1786. New Haven, Yale University Art Gallery; Trumbull Collection.

31 *Fig. 14.* John Singleton Copley, *The Death of Major Peirson*, 1782–84. London, The Tate Gallery.

33 *Fig. 15.* Jacques-Louis David, *The Oath of the Horatii*, 1785. Paris, Musée du Louvre.

34 *Fig. 16.* John Trumbull, *The Surrender of Lord Cornwallis at Yorktown*, detail, 1787–c.1828. New Haven, Yale University Art Gallery; Trumbull Collection.

36 *Fig. 17.* John Trumbull, *The Death of General Warren at the Battle of Bunker's Hill*, 1786. New Haven, Yale University Art Gallery; Trumbull Collection.

36 *Fig. 18.* John Trumbull, *The Death of General Montgomery in the Attack on Quebec*, 1786. New Haven, Yale University Art Gallery; Trumbull Collection.

39 *Fig. 19.* John Trumbull, *Peter the Great at the Capture of Narva*, 1812. New Haven, Yale University Art Gallery; Trumbull Collection.

42 *Fig. 20.* Hubert Gravelot, *Hannibal after the Battle of Cannae*, 1742. Engraving from Charles Rollin, *The Roman History*, London, 1768.

44 *Fig. 21.* Charles Le Brun (after), *Le Ravissement*. Engraving from *Conférence . . . sur l'Expression . . . des Passions*, Verona, 1751. Cambridge, Mass., The Houghton Library, Harvard University, Department of Printing and Graphic Arts.

45 *Fig. 22.* Hubert Gravelot, *The Death of Virginia*, 1739. Engraving from Charles Rollin, *The Roman History*, London, 1768.

45 *Fig. 23.* Domenico Cunego (after Gavin Hamilton), *The Oath of Brutus*, 1768, engraving. London, The Trustees of the British Museum.

page

47 *Fig. 24.* Robert Strange (after Salvator Rosa), *Belisarius*, c.1745, engraving. Boston, Museum of Fine Arts; George Wales Collection.

49 *Fig. 25.* John Trumbull, Study for *The Death of General Warren at the Battle of Bunker's Hill*, 1785. Philadelphia, The Historical Society of Pennsylvania.

49 *Fig. 26.* John Trumbull, Study for *The Death of General Warren at the Battle of Bunker's Hill*, 1785. Collection of Susan Silliman Pearson.

53 *Fig. 27.* John Trumbull, Study for *The Death of General Montgomery in the Attack on Quebec*, 1785 or 1786. New York, Fordham University Library; Charles Allen Munn Collection.

56 *Fig. 28.* John Trumbull, *General Elliot at Gibraltar, May 20, 1786*. Hartford, The Connecticut Historical Society.

56 *Fig. 29.* John Trumbull, Study for *The Sortie Made by the Garrison of Gibraltar*, 1786. Boston Athenaeum.

58 *Fig. 30.* John Trumbull, Study for *The Sortie Made by the Garrison of Gibraltar*, 1786–87. Boston Athenaeum.

59 *Fig. 31.* John Trumbull, Study for *The Sortie Made by the Garrison of Gibraltar*, 1786–87. Boston Athenaeum.

59 *Fig. 32.* John Trumbull, Study for *The Sortie Made by the Garrison of Gibraltar*, 1786–87. Boston Athenaeum.

59 *Fig. 33.* John Trumbull, Study for *The Sortie Made by the Garrison of Gibraltar*, 1786–87. Boston Athenaeum.

60 *Fig. 34.* John Trumbull, Study for *The Sortie Made by the Garrison of Gibraltar*, 1786–87. Boston Athenaeum.

62 *Fig. 35.* John Trumbull, Study for *The Sortie Made by the Garrison of Gibraltar*, c.1789. Collection of Jonathan Trumbull Isham.

64 *Fig. 36.* John Trumbull, *Figure Studies*, 1786. New Haven, Yale University Art Gallery; Trumbull Collection.

75 *Fig. 37.* John Trumbull, Study for *The Capture of the Hessians at Trenton*, 1787 or 1788. New York, Fordham University Library; Charles Allen Munn Collection.

79 *Fig. 38.* John Trumbull, Study for *The Declaration of Independence*, detail, 1786 or 1787. Philadelphia, The Historical Society of Pennsylvania.

80 *Fig. 39.* John Trumbull, Study for *The Declaration of Independence*, 1786 or 1787. Philadelphia, The Historical Society of Pennsylvania.

81 *Fig. 39a.* John Trumbull, *The Declaration of Independence*, 1832. Hartford, Wadsworth Atheneum; Museum Purchase.

82 *Fig. 40.* John Trumbull, Study for *The Surrender of Lord Cornwallis at Yorktown*, 1787. The Detroit Institute of Arts; Gift of Dexter M. Ferry Jr.

82 *Fig. 41.* John Trumbull, Study for *The Surrender of Lord Cornwallis at Yorktown*, 1787. The Detroit Institute of Arts; Gift of Dexter M. Ferry Jr.

82 *Fig. 42.* John Trumbull, Study for *The Surrender of Lord Cornwallis at Yorktown*, 1787. Private collection.

87 *Fig. 43.* John Trumbull, Landscape study for *The Surrender of General Burgoyne at Saratoga*, 1791. New York, Fordham University Library; Charles Allen Munn Collection.

88 *Fig. 44.* John Trumbull, *The Resignation of General Washington*, 1822–24. Washington, D.C., Architect of the Capitol.

89 *Fig. 45.* John Trumbull, Study of the State House at Annapolis (recto), 1822. New Haven, Yale University Art Gallery; Gift of the Associates in Fine Arts at Yale.

89 *Fig. 46.* John Trumbull, Study of the State House at Annapolis (verso), 1822. New Haven, Yale University Art Gallery; Gift of the Associates in Fine Arts at Yale.

95 *Fig. 47.* John Trumbull, *Self-Portrait*, 1774. Private collection.

96 *Fig. 48.* John Singleton Copley, *Paul Revere*, 1768–70. Boston, Museum of Fine Arts; Gift of Joseph W., William B., Edward H. R. Revere.

96 *Fig. 49.* John Trumbull, *Self-Portrait*, 1777. Boston, Museum of Fine Arts; Bequest of George Nixon Black.

97 *Fig. 50.* John Trumbull, *Major General Jabez Huntington*, 1777. Hartford, Museum of Connecticut History, Connecticut State Library.

97 *Fig. 51.* John Trumbull, *George Washington*, 1780. New York, The Metropolitan Museum of Art; Bequest of Charles Allen Munn.

98 *Fig. 52.* John Trumbull, *Sir John Temple and Family*, 1784. Collection of Mr. and Mrs. Albert L. Key.

100 *Fig. 53.* John Trumbull, *Patrick Tracy*, 1784–86. Washington, D.C., National Gallery of Art; Gift of Patrick T. Jackson.

102 *Fig. 54.* John Trumbull, *George Clinton*, 1791. Art Commission of the City of New York.

103 *Fig. 55.* John Trumbull, *John Jay*, 1805. Art Commission of the City of New York.

105 *Fig. 56.* John Trumbull, *Richard Varick*, 1805. Art Commission of the City of New York.

105 *Fig. 57.* Samuel Lovett Waldo and William Jewett, *Henry La Tourett de Groot*, c.1825. New York, The Metropolitan Museum of Art; Bequest of Mrs. Thomas Hastings.

108 *Fig. 58.* John Singleton Copley, *Mr. and Mrs. Isaac Winslow*, 1774. Boston, Museum of Fine Arts; M. and M. Karolik Collection.

110 *Fig. 59.* John Singleton Copley, *Mr. and Mrs. Thomas Mifflin*, 1773. Philadelphia, The Historical Society of Pennsylvania.

117 *Fig. 60.* Mather Brown, *Thomas Jefferson*, 1786. Collection of Charles Francis Adams.

118 *Fig. 61.* Thomas Gainsborough, *George, Prince of Wales*, 1782. Waddesdon Manor, England (National Trust, copyright reserved).

121 *Fig. 62.* *Parthenon Frieze*, 1789. Engraving from James Stuart and Nicholas Revett, *The Antiquities of Athens*, London, 1762–94.

134 *Fig. 63.* John Trumbull, Study for *The Treaty of Peace*, c.1790. Philadelphia, The Historical Society of Pennsylvania.

156 *Fig. 64.* Gottfried Eichler, *Conversio*. Engraving from Cesare Ripa, *Iconologia*, ed. J. G. Hertel, Augsburg, 1758–60.

169 *Fig. 65.* Joseph Nollekens, *Design for Monument to Mrs. Howard*, c.1789. London, Victoria and Albert Museum.

170 *Fig. 66.* Samuel F. B. Morse, *Benjamin Silliman*, 1825. New Haven, Yale University Art Gallery; Gift of Bartlett Arkell to Silliman College.

181 *Fig. 67.* John Trumbull, *The Apotheosis of Washington*, c.1800. New York, Columbia University; Avery Architectural and Fine Arts Library.

182 *Fig. 68.* John Trumbull, Study for *Joshua at the Battle of Ai—Attended by Death*, 1786. New York, Fordham University Library; Charles Allen Munn Collection.

183 *Fig. 69.* John Trumbull, Study for *The Last Family Who Perished in the Deluge*, c.1786. New York, Fordham University Library; Charles Allen Munn Collection.

186 *Fig. 70.* John Trumbull, *Infant Savior and St. John*, 1801. Hartford, Wadsworth Atheneum; Bequest of Daniel Wadsworth.

187 *Fig. 71.* John Trumbull, *Madonna au Corset Rouge (Madonna and Child with St. John the Baptist)*, 1802. New Haven, Yale University Art Gallery; Trumbull Collection.

187 *Fig. 72.* John Trumbull, *Holy Family*, 1802–6. New Haven, Yale University Art Gallery; Trumbull Collection.

188 *Fig. 73.* Benjamin West, *Christ Healing the Sick in the Temple*, 1815. Philadelphia, Pennsylvania Hospital.

189 *Fig. 74.* John Trumbull, *Our Savior and Little Children (or Suffer Little Children)*, 1812. New Haven, Yale University Art Gallery; Trumbull Collection.

189 *Fig. 75.* Benjamin West, *Suffer the Little Children*, 1792. London, The Governors of the Thomas Coram Foundation for Children.

190 *Fig. 76.* John Trumbull, *The Woman Taken in Adultery*, 1811. New Haven, Yale University Art Gallery; Trumbull Collection.

192 *Fig. 77.* John Trumbull, *"I Was in Prison and Ye Came unto Me,"* c.1834. New Haven, Yale University Art Gallery; Trumbull Collection.

192 *Fig. 78.* John Trumbull, Study for *"I Was in Prison and Ye Came unto Me,"* c.1784–85. New Haven, Yale University Library; Benjamin Franklin Collection.

197 *Fig. 79.* Charles Le Brun (after), *Veneration*. Engraving from *The Compleat Drawing-Master*, London, 1766. New Haven, Yale Center for British Art; Paul Mellon Collection.

200 *Fig. 80.* Annibale Carracci, *Pietà*, c.1599–1600. Museo e Gallerie Nazionali di Capodimonte.

200 *Fig. 81.* Anonymous (after Annibale Carracci), *Pietà*, c.1660. Hampton Court, Collection of Her Majesty Queen Elizabeth II (copyright reserved).

202 *Fig. 82.* Parmigianino, *Madonna of the Long Neck*, c.1535. Florence, Galleria degli Uffizi.

203 *Fig. 83.* Benjamin West, *The Call of the Prophet Isaiah*, 1784. Greenville, S.C., Bob Jones University.

207 *Fig. 84.* John Trumbull, *Landscape*, c.1783. The Dayton Art Institute; Gift of Mr. I. Austin Kelly III, in memory of his great-great-grandfather, Ironton Austin Kelly, founder of Ironton, Ohio.

page

208 *Fig. 85.* John Trumbull, *Niagara Falls from an Upper Bank on the British Side*, 1807 or 1808. Hartford, Wadsworth Atheneum; Bequest of Daniel Wadsworth.

209 *Fig. 86.* Frederic E. Church, *Niagara Falls*, 1857. Washington, D.C., The Corcoran Gallery of Art.

211 *Fig. 87.* Edward Hicks, *The Peaceable Kingdom of the Branch*, c.1825. New Haven, Yale University Art Gallery; Gift of Robert W. Carle.

213 *Fig. 88.* John Trumbull, *Norwich Falls* (or *The Falls of the Yantic at Norwich*), c.1806. New Haven, Yale University Art Gallery; The Mabel Brady Garvan Collection.

213 *Fig. 89.* John Trumbull, *The Falls of the Yantic at Norwich*, c.1806. Norwich, Conn., The Slater Memorial Museum, The Norwich Free Academy.

214 *Fig. 90.* Thomas Cole, *Sunny Morning on the Hudson River*, 1827. Boston, Museum of Fine Arts; M. and M. Karolik Collection.

218 *Fig. 91.* John Trumbull, *Landscape with Dead Tree*, 1783. Cambridge, Mass., Fogg Art Museum, Harvard University; Bequest of Stephen Bleeker Luce.

227 *Fig. 92.* John Trumbull, *Niagara Falls Two Miles Below Chippewa*, c.1808. The New-York Historical Society.

228 *Fig. 93.* J. Merigot (after John Vanderlyn), *A Distant View of the Falls of Niagara*, 1804, engraving. Peebles Island, Waterford, New York, New York State Parks, Recreation and Historic Preservation Bureau of Historic Sites.

233 *Fig. 94.* John Trumbull, *"And Look thro' Nature, up to Nature's God,"* 1782. New York, Fordham University Library; Charles Allen Munn Collection.

235 *Fig. 95.* John Trumbull, *Maternal Tenderness*, 1809–after 1815. New Haven, Yale University Art Gallery; Trumbull Collection.

236 *Fig. 96.* John Trumbull, *Priam Returning to His Family, with the Dead Body of Hector*, 1785. Richmond, Virginia Museum of Fine Arts.

237 *Fig. 97.* Peter Paul Rubens, *The Family of Lot Departing from Sodom*, 1625. Paris, Musée du Louvre.

238 *Fig. 98.* John Trumbull, *The Earl of Angus Conferring Knighthood on De Wilton*, 1810. New Haven, Yale University Art Gallery; Trumbull Collection.

239 *Fig. 99.* John Trumbull, *Lamderg and Gelchossa*, c.1792. The Toledo Museum of Art; Gift of Florence Scott Libbey.

242 *Fig. 100.* John Trumbull, *Joshua at the Battle of Ai—Attended by Death,* 1839–40. New Haven, Yale University Art Gallery; Trumbull Collection.

243 *Fig. 101.* William Hogarth, *Satan, Sin and Death*, c.1735. London, The Tate Gallery.

248 *Fig. 102.* Benjamin West, *Devout Men Taking the Body of St. Stephen*, 1776. London, St. Stephen, Walbrook.

251 *Fig. 103.* Thomas Burke (after Angelica Kauffmann), *Trenmor and Inibaca*, 1772, mezzotint. New York, The Metropolitan Museum of Art; Gift of Georgiana W. Sargent in memory of John Osborne Sargent.

251 *Fig. 104.* John Trumbull, *Lamderg and Gelchossa*, 1809. New Haven, Yale University Art Gallery; Trumbull Collection.

253 *Fig. 105.* Benjamin West, *Prince John's Submission to Richard I*, 1795. Unlocated.

255 *Fig. 106.* John Trumbull, *Mother and Child*, c.1786. New Haven, Yale University Library; Benjamin Franklin Collection.

256 *Fig. 107.* Joseph Haynes (after John Hamilton Mortimer), *Death on a Pale Horse*, 1784, etching. New Haven, Yale Center for British Art; Paul Mellon Collection.

257 *Fig. 108.* Benjamin West, *Death on a Pale Horse*, 1783 (retouched 1803). London, Royal Academy of Arts.

258 *Fig. 109.* Francesco Faraone Aquila (after Raphael), *The Expulsion of Heliodorus*, detail, engraving. London, The Trustees of the British Museum.

261 *Fig. 110. Interior of the Rotunda with Paintings by John Trumbull*. Engraving from Philip Maas, *Public Buildings and Statuary of the Government . . .*, Washington, D.C., 1840.

261 *Fig. 111.* William Strickland (after George Munger), *View of the Capitol after the Burning by the British*, detail, c.1814, aquatint. Washington, D.C., Library of Congress.

265 *Fig. 112.* Benjamin Latrobe to John Trumbull, July 11, 1817, detail. New Haven, Yale University Library; Yale University Archives.

265 *Fig. 113.* John Trumbull to Benjamin Latrobe, September 25, 1817. The New-York Historical Society.

266 *Fig. 114.* Benjamin Latrobe, *Section through the North Wing of the Capitol*, detail, October 1817. Washington, D.C., Library of Congress.

267 *Fig. 115.* John Trumbull, *Section through the Capitol Rotunda*, 1818. The New-York Historical Society.

267 *Fig. 116. Schematic Reconstruction of the Sketch of Trumbull's Proposal for the Interior of the Rotunda*. Drawn by Mary Bahr.

268 *Fig. 117.* Charles Bulfinch, *Plan No. 2 Showing the Interior of the Rotunda*, February-March 1818. Washington, D.C., Library of Congress.

270 *Fig. 118.* Balthasar Frederic Leizelt (after Richard Paton), *Combat mémorable entre le Pearson et Paul Jones*, 1781, engraving. Washington, D.C., Library of Congress.

271 *Fig. 119.* Bernard Romans, *An Exact View of the Late Battle at Charlestown*, 1775, engraving. The New York Public Library, Astor, Lenox and Tilden Foundations; I. N. Phelps Stokes Collection, Art, Prints and Photographs Division.

276 *Fig. 120.* John Trumbull, *An Anglo-Palladian Villa*, 1777. The New-York Historical Society.

276 *Fig. 121.* John Trumbull, *Meetinghouse at Lebanon*, built 1804–6, subsequently restored.

277 *Fig. 122.* John Trumbull, *Trumbull Gallery*, photograph, c.1861. New Haven, Yale University Library; Yale University Archives.

282 *Fig. 123.* Antoine Rousseau, *Hôtel de Salm*, Paris, 1784. Engraving from A. C. Pugin, *Paris and Its Environs*, London, 1829–31.

Index to Trumbull's Works

Citations are given for all of Trumbull's works reproduced or discussed in the catalogue entries and essays. Page numbers refer to citations other than those in catalogue entries. Each work in the catalogue is illustrated in its respective entry; figure numbers indicate additional reproductions.

Abraham's Servant Meeting Rebekah at the Well, 23, 184

John Adams: National Portrait Gallery, 101, Cat. 44; miniature, 124, Cat. 68

Roger Alden, Cat. 36

Fisher Ames, Cat. 62

"And look thro' Nature, up to Nature's God," 234, 245, Cat. 151, *Fig. 94*

Apotheosis of Washington, 181, *Fig. 67*

Architecture: buildings, *Meetinghouse at Lebanon*, 277, *Fig. 121, Trumbull Gallery*, 18, 91, 192, 204, 277, *Fig. 122;* studies for the Capitol Rotunda, 266, 267–68, Cats. 161–63, *Figs. 113, 115;* other studies, *Anglo-Palladian Villa*, 277, *Fig. 120, Elevation and Plan of a Residence*, Cat. 164, *Garret Floor Plan, Two Sections through a Four-story House*, Cat. 170, *Landscape Plan for Yale College*, Cat. 167, *Plans for an Artist's House*, Cat. 166, *Plan for the Development of Yale College*, Cat. 169, *Three Elevations of Three-story Buildings*, Cat. 168, *Two Interior Views*, Cat. 165

Attack on Charlestown, 143

Battle of Eutaw Springs, 38, 126, 138

Battle of La Hogue, 27, 30, *Fig. 8*

Belisarius, 25, 26 n.9, 33, Cat. 3

Egbert Benson, Cat. 74

Captain Blodget, Cat. 101

John Brooks, 86, Cat. 50

John Brown, Cat. 65

Brutus and His Friends at the Death of Lucretia, 24, 47, Cat. 2, *Fig. 5*

Richard Butler, Cat. 79

Capture of the Hessians at Trenton: Yale, 8, 32, 35, 37–38, 39, 65, 80 n.2, 84 n.8, 91, 120, 126, 151, Cat. 24; study, 73, *Fig. 37;* Wadsworth Atheneum, 91

Giuseppe Ceracchi, Cat. 56

Harriet Chew, 89, Cat. 55

Sophia Chew, Cat. 54

Christ Crowned with Thorns, 192

Mrs. John Barker Church, Son Philip, and Servant, 97–98

George Clinton, 101, 104, 116, 120, *Fig. 54*

Cohoes Falls, 219, Cat. 140

College and Village of Princeton, Cat. 23

Crucifixion, 23, 184

Eleanor (Nelly) Parke Custis, 90 n.4, Cat. 51

Tristram Dalton, Cat. 57

Death of General Mercer at the Battle of Princeton: Yale, 8, 32, 33, 35, 37–38, 39, 61, 73, 74, 84 n.8, 120, 138, 149, 152, 169, Cat. 14; studies, 65–66, 218, 222 n.5, Cats. 16–23, *Fig. 36;* unfinished version, 33, Cat. 15; Wadsworth Atheneum, 91

Death of General Montgomery in the Attack on Quebec: Yale, 8, 10, 11, 30, 32, 33–34, 37–38, 39, 62, 169, 251 n.9, Cat. 7, *Figs. 12, 18;* studies, 52, Cats. 8, 9, *Fig. 27;* Wadsworth Atheneum, 92

Death of General Warren at the Battle of Bunker's Hill: Yale, 8, 10, 11, 30, 31–32, 33, 35, 37–38, 39, 62, 67, 69, 80 n.2, 92, 99, 169, Cat. 4, *Figs. 13, 17;* studies, 48, 50, Cat. 5, *Figs. 25, 26;* Wadsworth Atheneum, 54 n.13, Cat. 32

Death of Paulus Aemilius at the Battle of Cannae, 4, 23, 25, 44, 110, 186, Cat. 1, *Fig. 3*

Declaration of Independence: Yale, 8, 9, 32, 33, 34–35, 37–38, 39, 40, 89, 90, 92, 117, 124, 134, 154, 172, 264, 270, Cat. 25, *Fig. 1;* studies, 78, Cat. 26, *Figs. 38, 39;* Capitol, 15, 39, 40, 78, 80, 90, 262–63, 264, 271; Wadsworth Atheneum, 80, 92, *Fig. 39a*

Deputation from the Senate Presenting to Cincinnatus the Command of the Roman Armies, 27

Count Deuxponts, Cat. 28

Asher B. Durand, Cat. 124

Earl of Angus Conferring Knighthood on De Wilton, 14, 240–41, Cat. 157, *Fig. 98*

Elisha Restoring the Shunammite's Son, 24, 44, 184, 195, *Fig. 7*

General Elliot at Gibraltar, May 20, 1786, 58, *Fig. 28*

Oliver Ellsworth, Cat. 60

Evacuation of New York by the British, 38

Falls of the Yantic at Norwich, 164 n.6, 212–14, 228, 250 n.5, Cat. 144, *Fig. 89*

Figure Drawings: Female, *Reclining Female Figure*, Cats. 130, 131; Male, *Male Figure*, Cats. 127, 128, *Seated Male Figure*, Cat. 129, *Studies of Male Torsos*, 194, 204 n.6, Cat. 125; see also *Meleager*

William Temple Franklin, Cat. 70

"Good Peter," Chief of the Oneida Indians, Cat. 93

Christopher Gore, 159, Cat. 113

Great Falls of the Connecticut River at Walpole, Cat. 141

Nathanael Greene, 74, Cat. 46

John Faucheraud Grimké, Cat. 85

Lieutenant Thomas Grosvenor and His Negro Servant, Cat. 6

Alexander Hamilton: New York Chamber of Commerce, Cat. 43; National Gallery of Art, 122 n.2; New York City Hall, 104

George Hammond, Cat. 69

Elnathan Haskell, 86, Cat. 72

Rev. Enos Hitchcock, 86, Cat. 108

Holy Family: 1802–6, *Fig. 72;* 1839–40, 192

Rev. Edward Holyoke, 22

Lemuel Hopkins: Yale, 101–2, 158, Cat. 45; miniature, 125, Cat. 94

Stephen Hopkins, 78, Cat. 109

Hopothle Mico, 150

William Hull, 86, Cat. 47

Major General Jabez Huntington, 96, 110, *Fig. 50*

Inauguration of the President, 38, 131, 132, 134, 138, 140

"The Infant," Chief of the Seneca Indians, Cat. 63

Infant Savior and St. John, 186, 191, 204 n.10, *Fig. 70*

"I Was in Prison and Ye Came unto Me," 193, *Fig. 77;* study, 193, *Fig. 78*

Ralph Izard, Cat. 84

John Jay: New York City Hall, 104, *Fig. 55;* miniature, Cat. 67

Thomas Jefferson: White House, Cat. 40; Metropolitan Museum, 117; Jefferson Memorial Foundation, 117

Joshua at the Battle of Ai—Attended by Death, 185, 242–43, 249, 254, Cat. 159, *Fig. 100;* study, 182, 184–85, 204 n.6, Cat. 160, *Fig. 68*

Rufus King, Cat. 61

Lady of the Lake, 240, 250 n.5, 252, 255 n.13

Lamderg and Gelchossa: Toledo Museum, 237, 240, Cat. 156, *Fig. 99;* Yale, 240, 250, 252, 252 n.9, *Fig. 104*

Landscape, 208–9, 249, Cat. 139, *Fig. 84*

Landscape with Dead Tree, 218, *Fig. 91*

John Langdon, Cat. 64

Last Communion of St. Jerome, 192

Last Family Who Perished in the Deluge, 185, 249, 254, Cat. 137; study, 184–85, Cat. 138, *Fig. 69*

Henry Laurens, Cat. 66

Thomas Lawrence as the Dying Spaniard, Cat. 13

Arthur Lee, 90 n.4, Cat. 80

Robert Lenox, Cat. 117

Mrs. Robert Lenox: New York Public Library, 104, Cat. 116; New-York Historical Society, 104

Major Lithgow, 86, Cat. 107

Samuel Livermore, Cat. 77

Madonna and Child with Sts. Joseph and John, 254, Cat. 134

Madonna au Corset Rouge (Madonna and Child with St. John the Baptist), 38, 185, 186, 200 n.3, *Fig. 71*

Madonna della Sedia 5, 26, 184, 194, 234

Laurence Manning, Cat. 78

Maternal Tenderness, 196, 234, 249, Cat. 158, *Fig. 95*

Meleager, Cat. 126

General Hugh Mercer, 38, 69, Cat. 106

Thomas Mifflin, 69, 90 n.4, Cat. 76

Mrs. Stephen Minot, 104, 166

Daniel Morgan, Cat. 73

Mother and Child, 254, *Fig. 106*

William Moultrie, Cat. 90

Murder of Jane McCrea, 131, 132, 144, 222 n.4

John Murray, 166

Mrs. John Murray, 104, Cat. 121

Niagara Falls, Cat. 150

Niagara Falls below the Great Cascade on the British Side, 209–11, 212, Cat. 149

Niagara Falls from an Upper Bank on the British Side, 209–11, Cat. 148, *Fig. 85*

Niagara Falls Two Miles Below Chippewa, 225–26, *Fig. 92*

Norwich Falls: Yale, 164 n.6, 212–14, 228, 250 n.5, Cat. 145, *Fig. 88*; Fordham, Cat. 146

Our Savior and Little Children (or *Suffer Little Children*), 188–89, 191, *Fig. 74*

Peter the Great at the Capture of Narva, 39, *Fig. 19*

Charles Cotesworth Pinckney, Cat. 89

Thomas Pinckney, Cat. 87

Preparation for the Entombment of the Savior, 192, 235, Cat. 136

President Received by the Ladies of Trenton at the Arch, 38

Priam in the Tent of Achilles, 248 n.1

Priam Returning to His Family, with the Dead Body of Hector, 27, 235–37, Cat. 153, *Fig. 96*; studies, 196, 236, Cats. 154, 155

Rufus Putnam, 86, Cat. 82

Jacob Read, 90 n.4, Cat. 83

Resignation of General Washington: Capitol, 15, 39, 40, 80 n.10, 89, 128, 137, 138, 140, 143, 146, 264, *Fig. 44*; studies, 89, *Figs. 45, 46*; Yale, 27, 32, 38, Cat. 31

Rock-Bound Lake, see *Norwich Falls*, Fordham

John Rutledge, Cat. 88

Major General Arthur St. Clair, 74, Cat. 104

St. Jerome, at Parma, 26, 184, 204 n.6, Cat. 133

St. John and the Lamb, 187 n.30, 200 n.3

St. Paul Preaching at Athens, 44, Cat. 132

Major Winthrop Sargent, Cat. 102

Cornelia Schuyler, Cat. 52

Philip John Schuyler, 86, Cat. 75

Theodore Sedgwick, Cat. 59

Self-Portrait: 1774, 95, 106, *Fig. 47*; 1777, 4, 23, 95–96, 159, 159 n.3, Cat. 33, *Fig. 49*; c. 1802, 159, 163, Cat. 114

Julia Seymour, Cat. 100

Thomas Youngs Seymour, 86, 146, Cat. 49

Shakespeare Cliff, Dover, 220

Siege of Savannah, 140, 143

Benjamin Silliman, 172, Cat. 123

William Smallwood, 90 n.4, Cat. 71

William Loughton Smith, Cat. 81

Sortie Made by the Garrison of Gibraltar, 9, 10, 11, 35–37, 38, 39, 65, 69, 72 n.11, 74, 101, 120, 166, 169, 188, 252, Cats. 10–12; studies, 58, 61, 62, Cat. 13, *Figs. 29–36*

Ebenezer Stevens, 86, Cat. 48

Suffer Little Children, see *Our Savior and Little Children*

Mrs. Thomas Sully, 104, Cat. 120

Surrender of General Burgoyne at Saratoga: Capitol, 15, 39, 40, 86, 263, 264; study, 86, *Fig. 43*; Yale, 32, 38, 80 n.2, 126, 137, 140, 152, 153, Cat. 30

Surrender of Lord Cornwallis at Yorktown: Yale, 9, 32, 35, 37–38, 39, 73, 74, 80 n.2, 86, 92, 122, 126, 144, 155, 270, Cat. 27, *Fig. 16*; studies, 84, Cats. 28, 29, *Figs. 40–42*; Capitol, 15, 39, 40, 84, 263, 264

Maurice Swabey, 103

Sir John Temple and Family, 97–98, 115, *Fig. 52*; study, 248 n.3

Nathaniel Tracy, 116 n.4

Patrick Tracy, 99, Cat. 39, *Fig. 53*

Transfiguration, 192

Treaty of Peace, 33 n.23, 38 n.32, 134, 138, 271, *Fig. 63*

Treaty with France, 38

Faith Trumbull, Cat. 97

John Trumbull, see *Self-Portrait*

John Trumbull in Prison, 193, 194

John Trumbull (cousin): Detroit, 125 n.4; miniature, 251 n.7, Cat. 95

Mrs. John (Sarah Hope Harvey) Trumbull, Cat. 118

Jonathan Trumbull, Jr., Cat. 91

Mr. & Mrs. Jonathan Trumbull, Jr. and Their Daughter Faith, 4, 95, 110, 146, 164, Cat. 34

Jonathan Trumbull, Sr., Cat. 92

Governor and Mrs. Jonathan Trumbull, Sr., 95, Cat. 35

Mrs. Jonathan Trumbull, Sr., Cat. 98

Joseph Trumbull: Private collection, Cat. 37; Connecticut Historical Society, 113

Sarah Trumbull in a White Dress, 12, 38, 103, 163 n.1, 255 n.19, Cat. 112

Sarah Trumbull on Her Deathbed, Cat. 122

Sarah Trumbull with a Spaniel, 103, 159, 163 n.1, 255 n.19, Cat. 115

Unidentified subject, Cat. 152

Richard Varick, 105, *Fig. 56*

John Vernet, 164 n.4

Vernet Family, 212, 222, 222 n.6, Cat. 119

View of the Falls of Niagara from under Table Rock, Cat. 147

View on the West Mountain near Hartford, 218, 249, Cat. 142; study, 222 n.5, Cat. 143

Catherine Wadsworth, Cat. 99

Faith Trumbull Wadsworth, Cat. 111

Harriet Wadsworth, drawing, 10, Cat. 105; miniature, 10, 89, 151, Cat. 96

Jeremiah Wadsworth and His Son Daniel Wadsworth, 97, 146, Cat. 38

Rev. Jonathan Mayhew Wainwright, 105

George Washington: Metropolitan Museum, 96, *Fig. 51*; New York City Hall, 101, 104, 116, 118, 120; *General George Washington at the Battle of Trenton*, 89, 101, 116, 122, Cat. 42; *Washington at Verplanck's Point*, 101, Cat. 41

Mrs. George Washington, 90 n.4, Cat. 53

Brigadier General Anthony Wayne, Cat. 110

Otho Holland Williams, 90 n.4, 143

Woman Taken in Adultery, 14, 14 n.69, 188, 191, 252, Cat. 135, *Fig. 76*

"The Young Sachem," A Chief of Six Nations, Cat. 58

Credits

Photography: Photographs of works of art reproduced have been provided in most cases by custodians of the works. The following list applies to photographs for which additional acknowledgment is due. Archivi Alinari: *Figs. 14, 80, 97;* E. Irving Blomstrann: Cats. 105, 149, *Figs. 26, 39a, 70;* Brenwasser: Cat. 139, *Fig. 84;* Courtauld Institute of Art: *Figs. 61, 81, 102;* Naomi Foster: Cat. 57, *Figs. 29–34;* John Freeman & Co.: *Figs. 4, 23, 109;* Frick Art Reference Library: Cats. 8, 29, 37, 103, 109, 110, 112, 125, 126, 128, 132, 134, 138, 141, 146, 151, 152, 154, 160, *Figs. 27, 37, 43, 52, 60, 68, 69, 94;* Helga Photo Studio: Cat. 43; Library of Congress: *Fig. 119;* Geraldine T. Mancini: Cats. 24, 81–85, 114, *Figs. 45, 46;* Eugene Mantie: Cat. 40; James Maroney Incorporated: *Fig. 42;* Michael Marsland: *Figs. 6, 62, 79, 107;* The Paul Mellon Centre for Studies in British Art Limited (London): Fig. 105; The Metropolitan Museum of Art, Photograph Services: frontispiece, Cats. 42, 135, 157, *Figs. 76, 98;* The New-York Historical Society: *Fig. 112;* Joseph Szaszfai: cover, pp. 205, 259, Cats. 1–4, 7, 14, 25, 27, 31, 32, 38, 45–50, 61–70, 108, 115, 119, 122, 136, 137, 142, 143, 145, 155, *Figs. 1, 3, 5, 7, 12, 13, 16, 18, 35, 74, 88;* Bob Wharton: *Fig. 11;* Williamstown Regional Art Conservation Laboratory, Inc.: Cat. 35; John D. Woolf: p. 179; *Fig. 102:* reproduced by permission of the Rector and Churchwardens of St. Stephen Walbrook in the City of London.

Production: This catalogue was composed with the Galliard types of Matthew Carter by Typographic Art of Hamden, Connecticut. Allied Color Corporation of Guilford made films for the full-color illustrations which were printed by The William J. Mack Company of North Haven. The black illustrations were printed by Rembrandt Press, Milford. Eastern Press, New Haven, made film and printed paperback covers and jackets. The papers are Warren's Lustro Dull and Multicolor Endleaf from the Lindenmeyr Paper Company. The paperback edition was bound by the Mueller Trade Bindery of Middletown, the cloth edition by Publishers Book Bindery, Long Island City, New York. The University Printer, Greer Allen, designed the catalogue, assisted by Kimbrough Bean Higgins and David Steinberg.

Editor: Sheila Schwartz.